the **geometry** of **hope** Latin American Abstract Art from the
Patricia Phelps de Cisneros Collection

Blanton Museum of Art
The University of Texas at Austin

Editor
Gabriel Pérez-Barreiro

The Blanton

FUNDACIÓN
CISNEROS

Published by the Blanton Museum of Art (formerly the
Archer M. Huntington Art Gallery), The University of Texas
at Austin, on the occasion of the exhibition *The Geometry
of Hope: Latin American Abstract Art from the Patricia
Phelps de Cisneros Collection*

Generous funding for the exhibition is provided by the
Eugene McDermott Foundation. The catalogue is made
possible by the support of the Fundación Cisneros.

Exhibition itinerary:
Blanton Museum of Art: February 20 through April 22, 2007
Grey Art Gallery, New York University: September 12
through December 8, 2007

The New York presentation of the exhibition is organized
in collaboration with the Grey Art Gallery, New York
University

The softcover edition of this book is available through
D.A.P./Distributed Art Publishers, Inc.
155 Sixth Avenue, 2nd Floor
New York, NY 10013
Tel: (212) 627-1999 Fax (212) 627-9484
www.artbook.com

Library of Congress Cataloging-in-Publication Data
 The geometry of hope : Latin American abstract art
 from the Patricia Phelps de Cisneros Collection / editor,
 Gabriel Pérez-Barreiro.
 p. cm.
 English and Spanish.
 Published on the occasion of the exhibition held
 Feb. 20–Apr. 22, 2007, Blanton Museum of Art, Austin,
 and Sept. 12–Dec. 8, 2007, Grey Art Gallery, New York
 University, New York.
 Includes bibliographical references and index.
 ISBN 978-0-9771453-6-2 (softcover : alk. paper)
 ISBN 978-0-9771453-7-9 (hardcover : alk. paper)
 1. Constructivism (Art)—Latin America—Exhibitions.
 2. Art, Latin American—20th century—Exhibitions.
 3. Colección Patricia Phelps de Cisneros—Exhibitions.
 I. Pérez-Barreiro, Gabriel. II. Blanton Museum of Art.
 III. Grey Art Gallery & Study Center.
 N6502.57.C66G46 2007
 709.8'07476431—dc22 2006037648

Front cover: Willys de Castro, *Objeto ativo—amarelo
[Active Object—Yellow]*, 1959–1960 (detail, plate 35)
Pages 1–3: Jesús Rafael Soto, *Vibración—Escritura
Neumann [Vibration—Neumann Writing]*, 1964 (details,
plate 42)
Pages 4–5: Alfredo Hlito, *Ritmos cromáticos III [Chromatic
Rhythms III]*, 1949 (detail, plate 11)
Page 7: Alejandro Otero, *Estudio 2 [Study 2]*, 1952 (detail,
plate 17)
Page 9: Geraldo de Barros, *Abstrato [Abstract]*, from the
series Fotoformas [Photoforms], 1951 (detail, plate 14)
Page 11: Jesús Rafael Soto, *Penetrable*, 1990 (detail,
plate 29)
Pages 86–87: Geraldo de Barros, *"Pampulha"—Belo
Horizonte, Brasil*, 1951 (detail, plate 15)
Pages 218–19: Lygia Pape, *Sem título [Untitled]*, from the
series Tecelares [Weavings], 1959 (detail, plate 31)

General editor: Gabriel Pérez-Barreiro
Managing editors: Courtney Gilbert, Gina McDaniel Tarver

Translators: Trudy Balch (Spanish to English); Steven Mines
(Portuguese to English); Jordi Palou, Tony Beckwith, and
Liliana Valenzuela (English to Spanish)

Copyeditor: Xavier Callahan (English text, excluding Paulo
Herkenhoff's "Rio de Janeiro: A Necessary City" and Serge
Guilbaut's "Squares and Stains: The Impossible Mix in
Cold-War Paris")
Proofreader and indexer: Beth Chapple
Designer: Zach Hooker
Separations by iocolor, Seattle
Produced by Marquand Books, Inc., Seattle
 www.marquand.com
Printed and bound in China

Contents

Index of Entries

It is a most welcome coincidence that the title of the exhibition organized by the Blanton Museum of Art, *The Geometry of Hope*, reflects one of the core beliefs of the Colección Patricia Phelps de Cisneros (CPPC): that geometric abstraction and the art that has emerged from it represent hope and potential for Latin America, concepts that are very distant from the stereotypes that are too often associated with the continent. It is our wish that this inspiring publication will communicate that sense of hope and potential to people interested not only in Latin American geometric abstraction, but also in the context in which the movement and its artists developed, including the rich and original cultures of our continent.

My husband, Gustavo, and I firmly believe that education is a key to building a better future in Latin America. We therefore place our collection at the service of scholars, curators, teachers, and students. In this way, it may be used as a resource for research and learning, and for the creation of new ideas that may be shared with a broad audience.

One of the most fruitful and cooperative examples of this sharing has been the long-standing relationship that the CPPC has maintained with The University of Texas at Austin and the Blanton Museum of Art. This relationship was established in 1999 as a loan and research program designed to showcase modern Latin American art in major U.S. museums. Its first concrete product was the exhibition *Dynamic Oppositions: Venezuelan Abstract-Constructive Art from the Patricia Phelps de Cisneros Collection*, presented in September 1999 at the Blanton. Additionally, the Blanton and the CPPC organized a series of seminars in collaboration with the Center for the Study of Modernism at The University of Texas at Austin. These seminars enabled students, scholars, and curators from the museum, the university, and the CPPC to study works on loan from the collection and, through them, to explore the theories and methods of twentieth-century Latin American art.

More recently, the Cisneros Research Seminar on Abstraction and Contemporary Art at The University of Texas at Austin has been an exceedingly active and productive research project. This is due in large part to the vision and efforts of Gabriel Pérez-Barreiro, who, upon becoming Curator of Latin American Art at the Blanton, revitalized the seminar, integrating it for the first time into the university's graduate curriculum. Under Gabriel's

direction, it became a vibrant forum for interaction among scholars, students, and curators, from the university as well as diverse institutions internationally. It was also Gabriel's idea to direct the research at the heart of the seminar toward the creation of an exhibition and accompanying publication, which have happily become *The Geometry of Hope: Latin American Abstract Art from the Patricia Phelps de Cisneros Collection*. Nothing is more meaningful for us than to know that the collection's works have inspired scholars to create and share with others new research and an expanded understanding of modern and contemporary Latin American art.

It is also a great satisfaction that, following the presentation of *The Geometry of Hope* in Austin, the Blanton Museum and the Grey Art Gallery at New York University (NYU), another prestigious center of learning, will collaborate to present a version of the exhibition at the Grey. Additionally, The University of Texas at Austin and NYU are organizing a two-part scholarly symposium based on *The Geometry of Hope*, to be held in both Austin and New York, creating yet another forum for the development and circulation of new ideas on Latin American art.

The range and quality of resources that The University of Texas at Austin possesses for education, documentation, and research on Latin America make it one of the most important U.S. centers dedicated to the history and cultures of the region. We wish to express our immense gratitude to the university for having welcomed us as partners in this rewarding cultural alliance. We offer special thanks to our admired friend Gabriel, whose interest, dedication, and scholarship have informed *The Geometry of Hope*, and to Jessie Otto Hite, Director of the Blanton Museum, for her continued support of the joint programs we have launched over the years. On behalf of the Colección Patricia Phelps de Cisneros, I thank them, as well as all the professors, students, and other participants in the project, for creating an exhibition and publication that are, indeed, imbued with both knowledge and hope.

I am also thankful to the dedicated staff members of the CPPC itself, most notably its director, Rafael Romero, for their many contributions to the scholarly collaboration with the Cisneros Seminar, and to Peter Tinoco, President and Executive Director of the Fundación Cisneros, for enabling the CPPC to fulfill its educational mission.

Patricia Phelps de Cisneros

The Geometry of Hope: Latin American Abstract Art from the Patricia Phelps de Cisneros Collection is much more than an exhibition; it is the result of a multi-year research collaboration between the Blanton Museum of Art and the Colección Patricia Phelps de Cisneros, with the common goal of furthering scholarship on the development of abstraction in Latin America. This project aims to establish a model for university museums by fully integrating the development of the exhibition into an academic program, and stimulating the rich crossover between academic and curatorial modes of thinking. Central to this project was the creation of the Cisneros Research Seminar on Abstraction and Contemporary Art, first established in 1997 under the initiative of Mari Carmen Ramírez, and further developed and expanded by Gabriel Pérez-Barreiro in 2003. The Cisneros Research Seminar provided a rare opportunity for students and faculty to participate in the intellectual development of an exhibition and to shape its narrative and structure. The seminar allowed for guest speakers to visit the university and share their viewpoints with graduate students; we were honored to have Luis Camnitzer, Cecilia de Torres, Andrea Giunta, Luis Pérez-Oramas, and Ariel Jiménez as participants in the seminar.

Of course none of this would have been possible without the Colección Patricia Phelps de Cisneros (CPPC). This collection is justly famous for its quality and depth, and for its curatorial rigor, and this exhibition and catalogue pay homage to all three. This collaboration between the CPPC and the Blanton Museum makes sense at many levels. The Blanton is at the heart of the University of Texas's unparalleled resources for the study of Latin American art. With the first graduate program in Latin American art in the country, and the amazing depth of the Nettie Lee Benson Latin American Collection, the Harry Ransom Humanities Research Center, and the Teresa Lozano Long Institute of Latin American Studies, you would be hard pressed to find a greater concentration of material and minds focused on Latin America anywhere in the world.

On a more philosophical level, we share the CPPC's questioning of the framework in which Latin America is traditionally represented in the United States or Europe as exotic, folkloric, or "other." For four decades, the Blanton has been collecting and presenting art from Latin America as a core part of its program, thus avoiding the boom-bust cycle through which many museums "discover" Latin America every ten years or so in a reenactment of an old colonial model. In April 2006 we opened our new facility to the public, presenting our modern and contemporary collections fully integrated in order to better tell a history of modern art in which we can explore how artists in north and south America responded to the common concerns of the twentieth century. The students and members of the public who visit our museum are already fully aware that culture is mobile and contagious, that ideas and lifestyles spread across national boundaries and create their own cultural geographies. If this is something we recognize in our own everyday life, museums can shed valuable light on the complexity of these relationships.

There are many people to thank on a project of this scale. First and foremost I must extend my deepest gratitude to Patricia Phelps de Cisneros for her long-term commitment to the Blanton. Patty's collecting and philanthropy are exemplary, and we are honored to be associated with her. Peter Tinoco, President and Executive Director of the Fundación Cisneros, was instrumental in supporting our efforts. The CPPC is ably managed by its director Rafael Romero, and I am grateful to him and his staff for their dedication to this project, in particular to Mariela Guilarte, general manager, to William Parra and Guillermo Ovalle, registrars, and to William Phelan, Fundación Cisneros U.S. representative. Ariel Jiménez, Curator of Modern and Contemporary Art of the CPPC, and consultant Luis Pérez-Oramas, now Adjunct Curator at The Museum of Modern Art, New York, are old friends of the museum, and we have benefited greatly from their wisdom and insights as we moved ahead. I am delighted that we are able to send this exhibition to the Grey Art Gallery at New York University, and praise Lynn Gumpert and her staff for their commitment. Edward Sullivan at New York University has been a powerful and lucid advocate for the project, and we look forward to collaborating on our common educational programs. Jeanne Collins and her staff in New York were extremely helpful in developing the communication strategies for this project. Marquand Books produced the book you are holding, and we thank Ed Marquand and his staff for their excellent work. Courtney Gilbert and Gina McDaniel Tarver were extremely competent and committed managing editors, and did a first-rate job coordinating a very complicated project. Ursula Dávila took on much of the production

and management of the exhibition project with characteristic professionalism and attention to detail. Carmen Araujo intelligently developed the exhibition design. Fran Magee provided warm hospitality to many of our visitors. The authors who contributed to this book deserve praise for the quality and rigor of their scholarship. I would also like to mention the participants in the Cisneros Seminar, who all contributed to the success of this project: Erin Aldana, Cecilia Brunson, Ursula Dávila, Courtney Gilbert, Gina McDaniel Tarver, Alberto McKelligan, Ana Pozzi-Harris, Annie Laurie Sánchez, Michael Wellen, and Edith Wolfe. Gabriel Pérez-Barreiro deserves credit for having the vision to conceive and manage a project of this scale and ambition, and for bringing his academic training to bear on the exhibition and catalogue. All of the staff at the Blanton helped to make this exhibition possible, and I thank them all.

I am deeply grateful to the Fundación Cisneros for its generous financial support of this catalogue, and to another dear friend of the Blanton and the University, Margaret McDermott, who provided underwriting for the exhibition through the Eugene McDermott Foundation.

Jessie Otto Hite
Director, Blanton Museum of Art

The *Geometry of Hope* provides a remarkable opportunity to reappraise four decades of geometrical abstraction in Latin America. The Grey Art Gallery is honored and delighted to collaborate with the Blanton Museum of Art by hosting a version of this landmark exhibition at New York University. The cosmopolitan and international nature of Latin American abstraction is too often overlooked, and many New Yorkers, unfortunately, still often regard our rich cultural metropolis as *the* center of the art world. Presenting alternative histories that expand our understanding of art history and visual culture into the global arena remains central to the Grey's mission.

That this impressive show and volume were organized by the Blanton Museum of Art comes as no surprise. The Blanton, along with its sister institutions at The University of Texas at Austin, has long been at the forefront of researching and collecting Latin American art. What the Grey shares with the Blanton is a strong commitment to presenting exhibitions that draw on the abundant resources provided by our university settings, taking advantage of colleagues and resources that reside, as it were, on our respective doorsteps. We also share a commitment to devising innovative exhibition formats; like the Blanton, the Grey strives to shake up standard assumptions and to provide new curatorial paradigms.

We are thus especially grateful to Jessie Otto Hite, whose aversion to outmoded art-historical classifications is visible in the Blanton's installations of its permanent collection. Absolutely key, of course, is Gabriel Pérez-Barreiro, who conceived the exhibition and oversaw both it and this volume's realization. He, along with Ursula Dávila at the Blanton and Carmen Araujo, the exhibition's designer who is based in Caracas, engaged the challenges of this international project with the utmost intelligence, aplomb, and good grace.

Teaming up with the Colección Patricia Phelps de Cisneros was crucial. Patty's support of academic excellence and curatorial innovation are especially welcome in a climate where museums increasingly present blockbusters to lure audiences and generate income. Here, again, is where we in the university museum community can offer alternative strategies. We join our colleagues at the Blanton in thanking Patty and her extensive staff for their vision and generosity. Particularly helpful in New York were Adriana Cisneros, Luis Pérez-Oramas, María del Carmen González, and Guillermo Ovalle. We also gratefully acknowledge Jeanne Collins and Lucy O'Brien at Jeanne Collins & Associates for their insight and expertise.

A passionate advocate of all things Hispanic, Edward Sullivan, NYU's Dean of Humanities, first brought this project to the Grey's attention. Along with Lucy Oakley at the Grey, he has encouraged enthusiastic colleagues at NYU to create related courses and programs. In particular, Bruce Altshuler and Miriam Basilio of Museum Studies have been welcome collaborators from the very beginning. Grey staffers Frank Poueymirou, Michèle Wong, Philip Hall, David Colosi, Alyssa Plummer, and Shauna Young have, as always, demonstrated an amazing work ethic and the utmost professionalism. It is, truly, a privilege to work alongside them.

Lynn Gumpert
Director, Grey Art Gallery
New York University

What is *The Geometry of Hope?* The title of this catalogue and exhibition brings together the two threads that epitomize abstract art from Latin America: on the one hand, geometry, precision, clarity, and reason; on the other, a utopian sense of hope. The title arose as a contrast to the "geometry of fear," a term coined by Herbert Read in 1952 to describe the atmosphere of postwar angst in British art and its expression through aggressive and unstable geometrical forms, as in the work of Kenneth Armitage, Lynn Chadwick, and others. A quick overview of Latin American geometrical art from the same period reveals a completely different panorama: colorful and playful kinetic sculptures, experimental objects as catalysts for community building, manifestos calling for joy and the negation of melancholy. And yet this glimpse of postwar Latin America could not offer a sharper contrast with our current worldview, accustomed as we are to associating Latin America with failure, poverty, and pessimism, whereas we associate Europe with reason and progress. The exhibition and this catalogue, if they do nothing else, should remind us that there was a time when Latin America was a beacon of hope and progress in a world devastated by war, genocide, and destruction.

Although there is still no authoritative account in English of the development of abstract art in Latin America—from Joaquín Torres-García's return to Montevideo in 1934, to the Venezuelan Kinetic art of the 1970s—the Colección Patricia Phelps de Cisneros (CPPC) offers a unique opportunity to present an overview of this history; no other public or private collection in the world comes close to its range and depth of material. The CPPC is also unique in its support of academic ventures: the Cisneros Research Seminar on Abstraction and Contemporary Art at The University of Texas at Austin provided the forum at which the ideas and structure for the exhibition were developed, and many of the authors whose work is published in this book attended the seminar. Our intention in compiling the book was to assemble, in one volume, new scholarship on Latin American abstraction from a diverse range of voices in the United States, Europe, and Latin America.

The first issue raised by any project of this nature concerns the question of a suitable framework within which to present these similar but nevertheless different artworks. What ties the works together, and what sets them apart from each other? More specifically, how do we deal with the fact that the works in the exhibition, although they appear similar in style and language, were produced by artists who often had little knowledge of each other, and whose geographical and temporal contexts—not to mention their artistic intentions—were often radically different? Most exhibitions of Latin American abstraction fall into one of two models: contextual or formalist. The contextual model—epitomized by such exhibitions as *Art in Latin America; Brazil: Body and Soul; Art from Argentina;* and *Inverted Utopias*—takes a geographical region as its starting point.[1] In these exhibitions, abstraction is one part of the story of how a particular region's culture developed, one step in a history about the formation of an identity. At its worst, this model reduces each movement to an illustration of a context. Moreover, exhibitions with "Latin America" or "Latin American" in their titles present contexts that have little or no connection as the same (Montevideo and Caracas, for example), in the interests of an overriding story about the development of a Latin American culture that is defined in opposition to another monolithic bloc (Europe or the United States). By contrast, the formalist model radically decontextualizes artists, presenting works in terms of relationships that are based on optical or formal similarities. This is the model developed by Ariel Jiménez for previous presentations of the CPPC, and it is the model used in exhibitions like *Beyond Geometry* and *Les figures de la liberté.*[2] In this model, Mira Schendel, Jesús Rafael Soto, and Kasimir Malevich, for example, might converse in terms of the tension between icon and ground, in a true "constellation" of meanings, one in which there is no a priori geographical or contextual framework.

Is there a third way between these models? Can we discuss context without being illustrative, while also recognizing that context is an essential element in the configuration of meaning? The first step in answering this question is to establish the *unit* of context. If "Latin America" is too big a term, encompassing too much diversity and disconnection, is the name of a nation any better? Does "Brazil," for example, allow us to distinguish between São Paulo and Rio de Janeiro? When we talk about "Argentina," do we really mean Mendoza, Salta, and Córdoba?

The Geometry of Hope is structured around the *city* as the unit of context. The city is where ideas circulate, where different voices and intentions collide in the same physical

space; a city is the hub of a network that is simultaneously local and international. As soon as we established a city-based model, we found it natural, indeed inevitable, to include Paris alongside the Latin American cities as a key reference in the development of geometrical abstraction in Latin America, thus sidestepping the sterile Europe/Latin America opposition and recognizing the rich interdependence between (for example) Caracas and Paris. This geography of specific cities also allows us to see that geometrical abstraction was largely a phenomenon of the large port cities on the Atlantic coast. These are the cities that received the most European immigrants, industrialized most rapidly, and created the most modern urban cultures. Therefore, rather than discuss abstraction in terms of its being a paradigm for Latin American culture as a whole, it might be more accurate for us to talk about abstraction as a paradigm for an urban Atlantic culture, just as we might talk about different paradigms for the Andean, Pacific, or pampas cultures. This kind of multidimensional cultural geography allows us to move away from stereotypical cultural generalizations based purely on language and difference, thus letting us use a more specific and complex model.

Once we had established the cultural geography of this exhibition, we faced the next issue: reading the works themselves. How could we attribute specific meanings to abstract objects that aspired to speak in a universal language? If the aim of the exhibition's framework was to avoid the extremes of contextual illustration and decontextualized formalism, then we needed to look at the *intention* behind a particular work. The question, therefore, was not what the work looked like but *why* it looked that way. Charles Harrison has posited the issue as follows:

A tendency to identify and exalt works of art in terms of their "formal properties," their "optical characteristics," their "ineffable appearance," leaves representation of the experience they produce highly vulnerable to encapsulation within the typical terms of a dominant culture. Talk about works of art has nowhere else to go if it does not lead into enquiry into conditions and mechanisms of production.[3]

Therefore, context should be seen not as an essentialist determinant of form and meaning, but rather as the stage on which ideas are processed and discussed.[4] Just as a

foreign language seems incomprehensible at first, revealing nuances over time, so does all abstraction appear, at first glance, to reiterate the same meanings. Only by looking at intention within a context can we begin to distinguish radical differences between works that share the same formal vocabulary. Only through this examination of intention within context can we distinguish, for example, Madí's quasi-Dada questioning of the limits of the artwork from Tomás Maldonado's search for "good form," or between Lygia Pape's narrative constructions and Lygia Clark's dissolution of meaning into tactile sensation.

Broadly speaking, there are two tendencies, or rather two *propositions,* within Latin American geometrical abstraction. One is based on a belief in reason, in an international language of abstraction that represents the highest stage in the evolution of modern art. For the artists whose work exhibits this tendency—Maldonado, María Freire, Willys de Castro, Soto, Carlos Cruz-Diez—the rules of the game are clear, and the practice of abstraction represents an ideological affiliation with an idea of progress based on Enlightenment beliefs. Where the other tendency is concerned, artists have used the same visual language to express the opposite of reason: a desire to undermine the rationalist discourse of modernity in favor of a deep questioning of the role of art in human experience (Madí, Clark, Hélio Oiticica). In this regard, Peter Bürger and Renato Poggioli have made useful distinctions between these two attitudes, emphasizing that the avant-garde, rather than reflecting an absolute characteristic, is entirely dependent on the circumstances of its creation.[5] Poggioli's distinction between *movements* and *schools* is particularly useful as a way of articulating relationships between Latin America and the rest of the world. The artist who joins a school does so by accepting a pre-established set of values, essentially "buying in" to a style and its associated meanings. A movement emerges in order to oppose and question a school; its intention is to alter the rules of the game. Both attitudes are present in the Latin American art in *The Geometry of Hope,* just as they are present in Russia, England, or anywhere else in the world. Working with these active, propositional, necessarily contextual categories, perhaps we can finally move away from discussions about who came first, or which art is "derivative" and which "original."

A final point concerns the reading of specific artworks in this book. In reviewing the

literature on Latin American abstraction, we clearly saw that most discussion sidesteps any real analysis of individual artworks. Too often an artwork has been included merely as an illustration of a pre-existing opinion rather than as an object of study. Therefore, this book is divided into two sections. The first deals with the intellectual contexts of the cities of Montevideo, Buenos Aires, São Paulo, Rio de Janeiro, Paris, and Caracas; the second contains essays on specific works in the CPPC. Our interest here was to commission new scholarship that would look at the physical evidence of the objects in question, the works themselves. Each of these texts was commissioned with explicit instructions that all discussion of a work would be related to physical and visual evidence within the art object itself. In the best cases, we found that if discussion started from the artwork, many of the conventional historiographical classifications were no longer applicable, and the object demanded considerable shuffling of terms and concepts. Another rationale for this exercise was to encourage connoisseurship skills in the viewing of abstract art. A major challenge, now that Latin American abstract art is being more widely collected and exhibited, concerns the lack of solid curatorial competence in dating works accurately, distinguishing between apparently similar works by the same artist, and telling the difference between an original work and a reconstruction. There are many reasons why these skills are not widely present, among them the inherent difficulty of the material, a lack of scholarly training, and the ideological and politicized nature of the Latin American curatorial field. And while it may be unfashionable to speak of connoisseurship, it remains a skill that is necessary to the writing of art history, for it is only by looking hard at an object that we can generate structures and material to support a more sensitive contextualization of the artist's intention and its relationship to a context.

In an age of cynicism about politics, society, and the relationship of art to social change, it is refreshing to encounter these works and propositions, and to recall a period when artists were committed to a radical transformation of their environment. Our enthusiasm for the modernist project in Europe is inevitably clouded by our knowledge that those ideals of purity and hygiene were translated —inevitably, it seems—into concentration camps and genocide. And in the United States,

the history of high modernism has become rarified to such an extreme degree that we find it hard to extract a strand of idealism from an increasingly market-led art system. In the case of Latin America, the modernist project was certainly a failure in that dreams of development and progress were swept away by decades of dictatorship and social conflict, but modernism was also saved from association with social engineering and nationalist triumphalism. These relics from a recent past—paintings, sculptures, magazines, and manifestos—seem to contain and embody a rich legacy that reminds us of another, alternative history of Latin America, a history of hope and optimism.

Notes

1. See, for example, Dawn Ades, ed., *Art in Latin America: The Modern Era, 1820–1980* (New Haven, Conn.: Yale University Press, 1989); Edward J. Sullivan, ed., *Brazil: Body and Soul* (New York: Guggenheim Museum, 2001); David Elliott, ed., *Art from Argentina* (Oxford: Museum of Modern Art Oxford, 1994); and Mari Carmen Ramírez and Héctor Olea, eds., *Inverted Utopias: Avant-Garde Art in Latin America* (New Haven, Conn.: Yale University Press in association with the Museum of Fine Arts, Houston, 2004).

2. See, for example, Lynn Zelevansky, *Beyond Geometry: Experiments in Form, 1940s–70s* (Cambridge, Mass.: MIT Press, 2004); and *Les figures de la liberté* (Geneva: Musée Rath, 1995).

3. Charles Harrison, "Modernism and the 'Transatlantic Dialogue,'" in Francis Frascina, ed., *Pollock and After: The Critical Debate* (London: Harper and Row, 1985), 221–22.

4. For example, Mari Carmen Ramírez's remarkable claim that Rhod Rothfuss's geometrical compositions recall "eyes," or carnival masks from Montevideo, can be read as a subtle continuation of stereotypes presenting Latin America as a land of anthropomorphism and carnivals; such a claim avoids any examination of the sophisticated debates about abstraction in the Río de la Plata of that period. See Ramírez and Olea, eds., *Inverted Utopias,* 197.

5. See Peter Bürger, *Theory of the Avant-Garde,* trans. Michael Shaw (Minneapolis: University of Minnesota Press, 1984); and Renato Poggioli, *The Theory of the Avant-Garde* (Cambridge, Mass.: Harvard University Press, 1981).

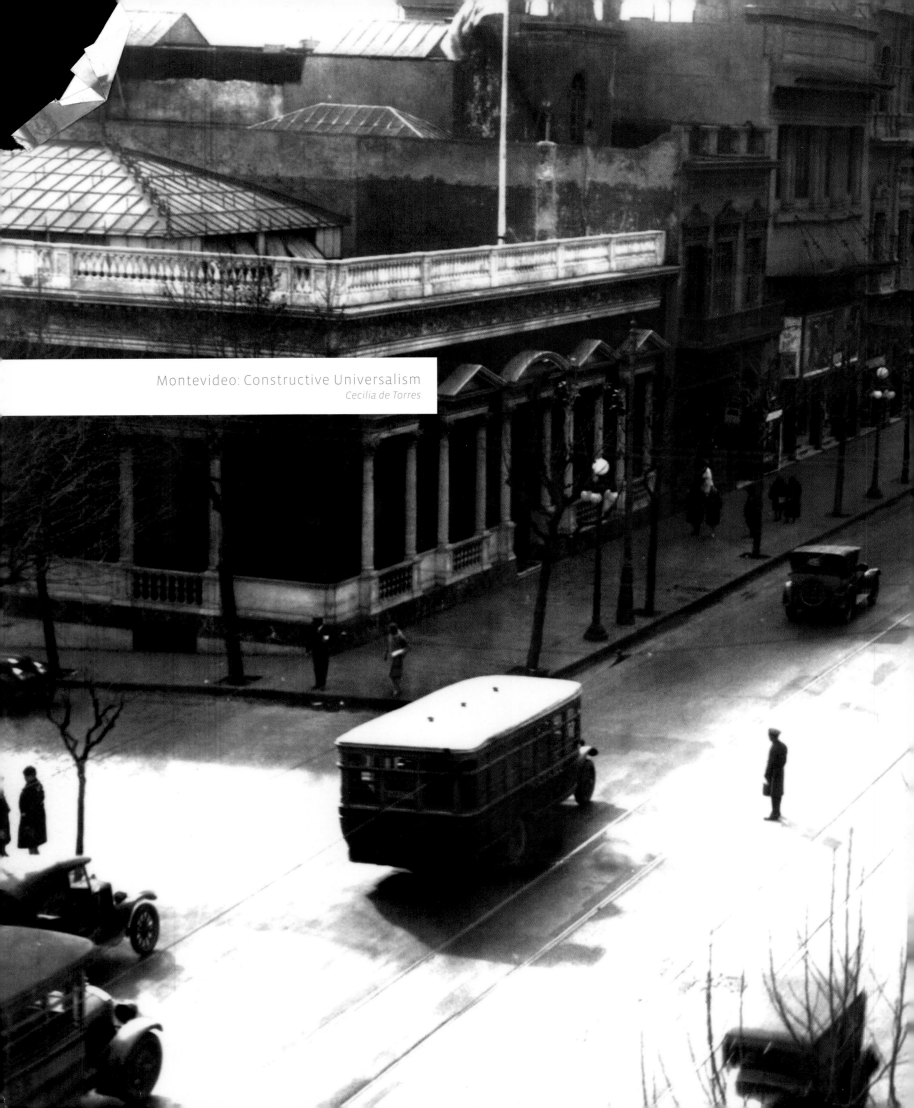

Montevideo: Constructive Universalism
Cecilia de Torres

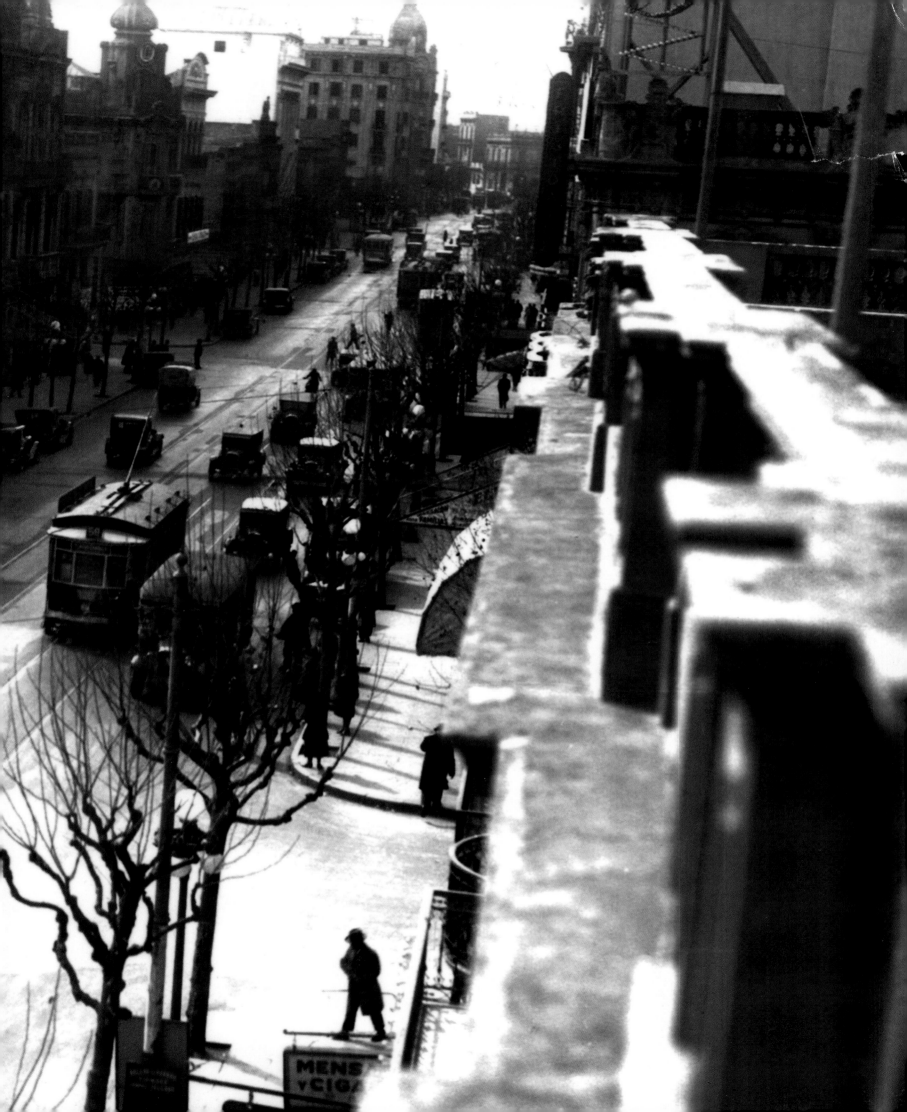

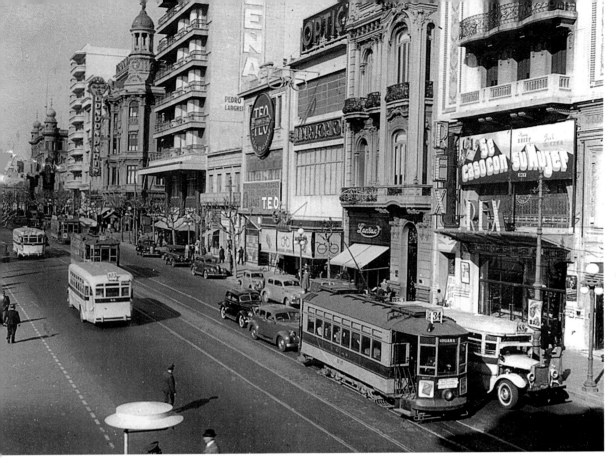

Previous pages, Figure 1. Avenida 18 de Julio, c. 1930.

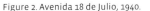

Figure 2. Avenida 18 de Julio, 1940.

On April 30, 1934, Joaquín Torres-García returned home to Montevideo after forty-three years abroad, bringing his family and a determination to make his impact felt.[1] Beyond the obvious and well-known manifestations of his legacy—his art and writings; the art and artists of the Asociación de Arte Constructivo (AAC); his *taller,* or workshop, the Taller Torres-García—the visual language of Montevideo and Uruguay was changed forever by the artist's decision to return.[2] Today Torres-García's influence is visible in the city's architecture, signage, paper currency, postage stamps, and even in a wide variety of souvenir trinkets featuring ersatz Constructivism.

Torres-García arrived to a booming city. Uruguay was profiting from the international demand for beef and from the labor of an influx of skilled immigrants and refugees from Europe. The cultural life of Montevideo centered on music and theater; it was a city of words, but not of painting. Torres-García, influenced by his own schooling in the academies of Barcelona, his teaching at Mont d'Or, his lifelong interest in interactive pedagogical toys, and his organizing of the group Cercle et Carré [Circle and Square] in Paris, would become a committed proselytizer of the cultural unification of the Americas. On May 1, 1934, the day after his three-week sea voyage to Montevideo from Cádiz, he gave his first lecture and thus began the work that was to consume the next fifteen years, the rest of his life. In the process, he transformed the cultural landscape of Montevideo.

Montevideo was perhaps an unlikely place from which to launch a project for the cultural unification of the Americas. Unlike the great cities of Peru and Mexico, Montevideo, the southernmost capital in the Americas, had not been built on the ruins of past civilizations. European colonization of the region had disbanded and practically exterminated the area's indigenous nomadic tribes, mainly the Charrúa and the Chaná, by the early nineteenth century.

Montevideo was founded in 1726 by Bruno Mauricio de Zabala, governor of Buenos Aires, and thereafter the history of the two cities on opposite banks of the wide Río de la Plata would be intertwined in every respect—politically, culturally, and socially.[3] In a poem from 1964, the Argentine writer Jorge Luis Borges marked the similarities between the Argentine and Uruguayan capitals, noting "the flavor of what is alike and a little different."[4] European immigrants arrived in Montevideo primarily in search of better economic and social opportunities, unlike the English pilgrims, who had fled religious persecution by emigrating to North America.

In 1830, Uruguay declared its independence after repelling Portuguese and English invasions and waging internal wars. The citizens of Montevideo proved quite creative in their quest for self-sufficiency; in 1852, for example, an Italian pharmacist devised a way to light the town with gas derived from animal waste in the meat-processing plants.[5] By the end of the century, Montevideo was thriving, and the city enjoyed a prosperity that lasted for decades. Prosperity also brought education and democracy to a liberal and secular society.

In 1829, the walls that surrounded the original colonial core had been torn down, and a "new city" (the Ciudad Nueva) was laid out, with streets aligned in square blocks extending from the central axis of the Avenida 18 de Julio. From that point on, Montevideo grew to become one of the most modern and best-designed cities in the Americas. Urban development unfolded along the shore of the Río de la Plata. Although Montevideo is home to 45 percent of the country's population of three million, the city has a calm pace and a provincial air to which its inhabitants cling defiantly. Its plazas and parks, and its streets and avenues lined with buildings in diverse styles from successive periods, make it an open-air museum of nineteenth- and twentieth-century architecture (figure 2).

A national identity gradually emerged out of the shared customs and traditions brought by immigrants from all over Europe. ("Montevideo is like a Babel of nationalities," the Argentine writer Domingo Faustino Sarmiento complained. "The citizens of Montevideo are neither Uruguayan nor Argentine; it's the Europeans who have taken hold of this corner of American soil."[6]) They were sailors from Genoa; stevedores from Galicia; stonemasons from the Basque country; farmers from the Canary Islands; Italian pharmacists and merchants; French dressmakers, gilders, upholsterers, and hairstylists; English shopkeepers; and German artisans.

Each of the European populations affected the city in different ways. A powerful French colony had a strong impact on politics, culture,

and business in nineteenth-century Uruguay, and Montevideo was the birthplace of three of France's great modern poets: the Comte de Lautréamont (Isidore Ducasse), Jules Laforge, and Jules Supervielle.[7] But France's commercial interest in the region waned; as Anglo-Saxon positivism in commerce gained ground, it was only the allure of French intellect and culture that remained appealing to Uruguayans. Britain controlled Uruguay's main industry—beef packing and export. The British later built the railroads and public utilities (gas, electricity, water, and telephone and telegraph lines). The United States also had a strategic interest in the region. Thus the Mexican intellectual José Vasconcellos described Uruguayans as "French in literature, English in business, and American in international politics."[8] But the French influence remained important in the development of national character and idiosyncrasy. Radical and revolutionary France inspired the twice-elected president José Batlle y Ordóñez to create a decidedly secular state.[9] Batlle's democratic rule brought security and social benefits to the expanding urban population, creating an egalitarian society with a strong middle class and an aversion to ostentatious wealth. Free, high-quality education brought students to Montevideo from the provinces as well as from other South American countries.

The secularization of mores, institutions, and education prevailed; divorce was legal in Uruguay as early as 1907, and the separation of church and state resulted in a rare intellectual and social freedom. Batlle imposed progressive social laws to combat poverty and to promote education, following José Artigas's exhortation for Uruguayans to be as educated as they were brave.[10] Secularization removed religious teaching from public schools, required civil registration of matrimony before a religious ceremony could be performed, and banned religious images from public hospitals and schools. Even Latin was removed from the school curriculum because of its association with the Roman Catholic Church.

The Cultural Scene from the Late 1800s to 1936

In 1856 the emerging bourgeoisie, thirsty for culture, built the Teatro Solís, one of the oldest theaters in South America and a potent symbol of the aspirations of the cultured elite (figure 3). The Solís, along with the Teatro Colón in Buenos Aires, made the Río de la Plata region an obligatory destination for great performers. The theater played host to the renowned opera singers Enrico Caruso and Adelina Patti as well as to orchestras that performed works by the composers Giacomo Puccini, Pietro Mascagni, Camille Saint-Saëns, and Richard Strauss, and sometimes to the composers themselves. Also among the many international figures who performed at the Solís were Arturo Toscanini, the Ballets Russes with Tamara Karsavina, and Vaslav Nijinsky, in what would be his last stage appearance.[11]

While Montevideans were able to enjoy performances by internationally acclaimed stars of music, ballet, and opera, they did not have access to the same caliber of work in the visual arts, and there were few venues for it. The National Museum had opened in a side room of the Solís in 1872, and it was there that the young Joaquín Torres-García had seen paintings for the first time; in 1911, the Círculo para el Fomento de las Artes [Circle for the Promotion of Fine Arts], itself established only six years before, founded another museum. Two art galleries opened as well, answering the demands of the new bourgeoisie: the Bazaar Maveroff, and Moretti y Catelli (where Rafael Barradas had his first show before leaving for Europe in 1913).

Lack of understanding of the visual arts, compounded by anti-elitist policies, prevented the acquisition of art for the National Museum's collection at a time when the nation could have afforded to buy the work of modern European masters. There was even talk of the government's commissioning Italian painters to make copies of famous paintings instead of buying originals. To gain recognition, Uruguayan artists had to go to Europe to study and to see the great masterworks. The painter Milo Beretta (1875–1935), who had studied in Paris with Medardo Rosso, took back to Montevideo several of Rosso's

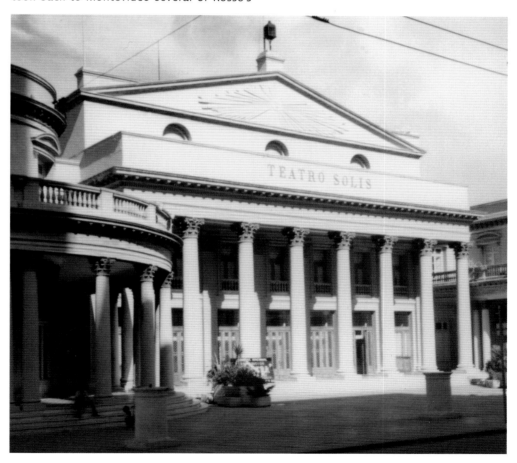

rare sculptures as well as paintings by Van Gogh, Pierre Bonnard, and Édouard Vuillard. Beretta's collection could have formed the basis for a public museum of modern art, but his efforts failed; soon after his death, the works were dispersed abroad.

Juan Manuel Blanes (1830–1901) was Uruguay's first important native painter.[12] A self-taught artist, Blanes was already successful when the government awarded him

Figure 3. The Teatro Solís, built in 1856.

a scholarship to study in Florence and Rome. Later he was commissioned to depict events central to the national histories of Uruguay, Chile, and Argentina. His solid craft and his masterful handling of light and color make him an important artist beyond the historical relevance of his paintings.

The 1898 Spanish-American War for the liberation of Cuba inspired the Uruguayan José Enrique Rodó to write *Ariel,* one of the first texts from the region to oppose U.S. hegemony. Addressed to the young, and stressing moral over material values, *Ariel* analyzed the conflicts and cultural differences between Latin America and the United States; in Rodó's view, the materialism and positivism of the United States and its expansionist politics were a threat to Latin America. Written in clear, elegant prose, *Ariel* awakened a generation to the idea of a Latin American identity, despite the fact that it was widely criticized and based on the imaginary idea of a Latin American race.[13]

Rodó was a regular at the Tupí Nambá, the legendary café that opened in 1889, where Montevideo's artists, politicians, and poets gathered in the bohemian atmosphere of the city's emerging intellectual life (figure 4). Other regulars were the modernist poet Julio Herrera y Reissig and the dramatist Florencio Sánchez (1875–1910). Some of the writers who gathered at the Tupí Nambá created literature that reflected a unique *rioplatense* culture. For example, Sánchez's genre comedies of everyday urban life depicted the miseries

and hopes of an emerging working class of immigrants striving to make a better living and climb the social ladder. His characters had particular traits and habits recognizable to anyone from Montevideo or Buenos Aires; they spoke the same slang as Sánchez's readers, mixing Castilian with an Italian accent. Bartolomé Hidalgo, a barber from Montevideo, was the first poet to use the gaucho linguistic style.[14] Gauchos, cowboys of the pampas, were dear to the rioplatense imagination because they embodied rebellion against the established order. Stereotyped as half European and half native Indian, they lived a seminomadic life. Javier de Viana (1868–1926), a writer of well-received short stories, described the gaucho as "copper-skinned, his coarse long mane held by a headband, with high cheeks, a square jaw, small deep-set black eyes, and a skimpy beard," attributing to the gaucho a brutal, primal, heroic courage.[15] Viana's portrayal reveals that if Montevideans admired the gaucho for his independent spirit, they also feared him as potentially disruptive to an urban society that was just beginning to feel securely established.

Foremost among the visual artists who translated the gaucho myth to painting were Blanes and Pedro Figari (1861–1938), whose paintings include scenes of gaucho life, the salons of Montevideo's upper class, and freed black slaves dancing in the style of candombe.[16] Figari had a long career as a lawyer, writer, and statesman. A positivist committed to improving and updating education and teaching methods, he was director for a time of the School of Arts and Crafts, and during his brief tenure he abolished the routine copying and drawing of gesso casts, encouraging students to study nature directly. He promoted a regional style in decorative arts, with indigenous materials and production adapted to local needs and functions. Late in his career, he was deeply disappointed when a reform he had proposed for the Industrial School was rejected, and he decided from that point on to devote himself fully to painting.

Figari moved to Buenos Aires in 1921 and then to Paris, where he lived from 1925 to 1933. Although he was self-taught, the simplified representations of figures and objects in his work should not be considered naive or primitive; he was an expressive draughtsman and colorist. "My purpose wasn't to paint well," he acknowledged, "but to do it in a way that would be interesting independent of technique."[17] In a text titled "Industralización de América Latina" (1919), Figari warned of an impending "hybridizing cosmopolitanism," which was indeed to sweep across South American cities in the 1920s.

With the end of the civil wars in Uruguay, the differences between the two leading political parties had become less radical, and the parties were able to work out alliances and compromises. The outcome had been a new plurality, which brought increased state control to every aspect of culture: legislation controlled the construction of public monuments, established university courses, and determined prizes for painting and sculpture in

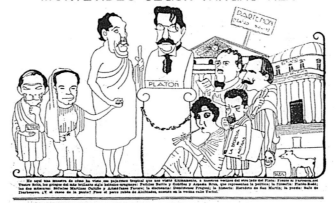

Figure 4. Cover of *Martín Fierro* no. 4 (May 1924) featuring a caricature by Vargas Vila.

the official salons, where the state favored a non-polemical, naturalistic style.[18] During this period a debate emerged on how to reconcile native culture with urban modernity. Alberto Zum Felde, editor of the magazine *La Pluma*, suggested that Uruguayans nationalize aesthetic culture and universalize native themes. The Peruvian poet Parra del Riego, who had settled in Montevideo in 1917, believed that poetry had to return to its original social function; in his futuristic poems, he celebrated trains, motorcycles, airplanes, speed, and sports. Other proponents of modernity were Alfredo Mario Ferreiro, author of poems that "smell[ed] of gasoline," published in his book *The Man Who Ate a Bus*,[19] and Idelfonso Pereda Valdés, who wrote in 1927 that it was "impossible to make native art while a jazz band exists"; he added, "At this moment, I am willing to write about a native theme, but the syncopated rhythm of a foxtrot prevents me. In Montevideo, I think of the countryside, and nothing comes to mind."[20]

The painter Rafael Barradas (1890–1929) did not share this dilemma, since he had left Montevideo in 1913. Before his departure, he had painted elegant black women in ball gowns and men in tuxedos. Barradas spent time in Paris and Milan, where he became acquainted with the Futurist movement. He then moved to Spain, and in 1917 he met Torres-García in Barcelona, where they collaborated on the creation of a dynamic style that they called Vibracionismo.[21]

The city leapt into a modernist fever during *los años locos* (the Roaring Twenties), and architecture flourished, but painting remained a secondary art form.[22] André Lhote's Académie Montparnasse, in Paris, attracted many Uruguayans, who brought back a style they called Planismo, an offspring of Lhote's late Cubism. Back home, they adapted post-Impressionist techniques to render the local light and color. They painted landscapes, urban scenes, portraits, and depictions of outdoor activities that reflected the nation's optimistic outlook. They reduced their subjects to interacting planes, with well-defined contours and heavy impasto in vivid colors: acid greens, pinks, reds, yellows, and blues. Their collective style was called the School of Montevideo. José Cúneo, who also studied with Lhote, painted idiosyncratic interpretations of the native landscape.

The 1929 visit of the architect Le Corbusier had a lasting impact on Montevideo's modern architecture. Five Uruguayan architects greeted Le Corbusier at the harbor. One, Rafael Lorente Escudero (1907–1992), would be central to the building of modern Montevideo. In 1935, he was commissioned to design gas stations, distilleries, and offices for the National Fuel, Alcohol, and Cement Administration, known as ANCAP. His daringly asymmetrical sculptural buildings, with curved walls, extended horizontal lines, and long projected roofs, make clear reference to ships and docks (figure 5).[23]

In Montevideo, Art Deco and rationalist architecture were popular with a society where the collective goal was material

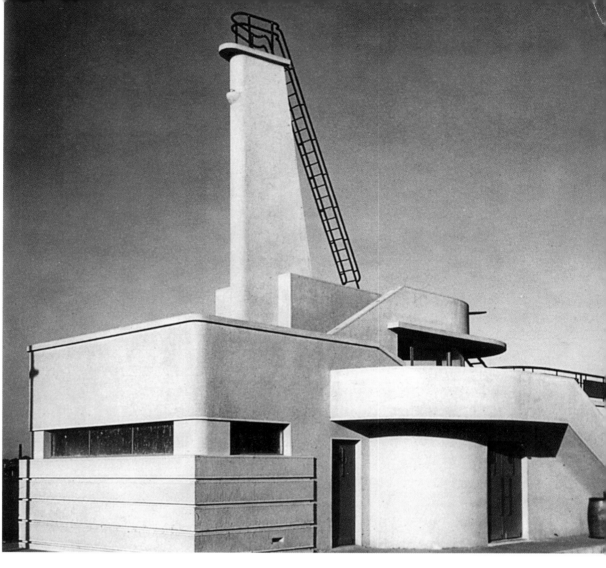

Figure 5. ANCAP Firehouse, Lorente Escudero, Architects, 1935.

progress. Uruguayan architects built Deco government buildings, private homes, movie theaters, and apartment houses with geometric wrought-iron gates, stained glass, and reliefs. In 1930, to mark the centennial of the national constitution, the Estadio Centenario was built, with a streamlined winged tower. It was here that the first World Cup of soccer was played; Montevideo was swept into a frenzy when the national team of Uruguay won.[24]

A growing current of leftist ideology was already taking hold of Montevideo's intellectual and working classes when the city was chosen to host the 1929 Congress of Latin American Unions. The Mexican delegate was the charismatic David Álfaro Siqueiros. Four years later, he was back in Montevideo to present an exhibition of his paintings at the Círculo de Bellas Artes. He appealed to painters to abandon "bourgeois" easel painting in favor of murals with a political message. But Social Realism did not resonate with Uruguayan artists; dependent as they were on government support, they enjoyed a reasonably secure life in the emerging welfare state. Uruguay broke off diplomatic relations with the Soviet Union in 1936, with the outbreak of the Soviet-backed Spanish Civil War. Nevertheless, the Confederación de Trabajadores e Intelectuales del Uruguay [Uruguayan League of Workers and Intellectuals] and the left-leaning Agrupación Intelectuales, Artistas, Periodistas, Escritores

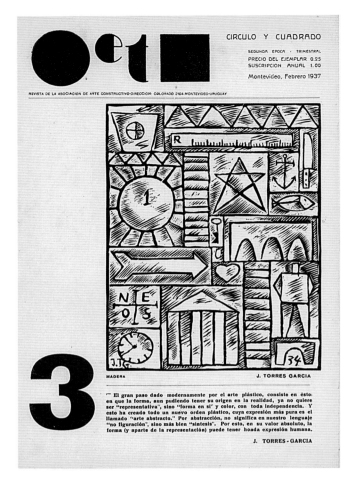

Figure 6. Cover of *Círculo y Cuadrado* no. 3 (1937).

[Group of Intellectuals, Artists, Journalists, and Writers] remained active.

Joaquín Torres-García and the Taller Torres-García

In 1934, the return of Joaquín Torres-García shook Montevideo's art scene and in time would change its course. In Paris, Torres-García had succeeded in uniting two apparently irreconcilable artistic worlds: abstraction and representation. By placing symbols within a geometric structure, he was able to convey meaning while bypassing narrative. He called this style Constructive Universalism. Because it encompassed all aspects of life, he believed it to be a modern manifestation of the art of world civilizations.

Torres-García's name, unlike his work, was well known in Uruguay, and he introduced himself to local artistic circles through frequent lectures, press conferences, and exhibitions (he opened a retrospective at Amigos del Arte only two months after his arrival). His assessment of the state of artistic development in Uruguay was negative; he noted that artists and the public alike were unreceptive to the avant-garde and reluctant to commit themselves to anything that would upset the status quo. By the same token, however, Uruguay's lack of a strongly defined artistic character led Torres-García to see Montevideo as a blank canvas on which to express his vision.

In 1935, Torres-García succeeded in engaging a group of artists to make a commitment to geometric abstraction. He established the AAC with Julián Álvarez Márquez, Carmelo de Arzadún, Héctor Ragni, Amalia Nieto, Zoma Baitler, Gilberto Bellini, Carlos Prevosti, Lia Rivas, and Rosa Acle. The paintings and sculptures of the AAC, following in the footsteps of Neo-Plasticism and Constructivism, were among the earliest abstractions in South America. Although very few of these early works survive, reproductions in the magazine *Círculo y Cuadrado* indicate their level of sophistication (figure 6).[25] Torres-García's famous 1936 drawing of an inverted map of South America symbolized his determination to end Uruguay's cultural dependence on Europe and signaled a new beginning for the art of the region. In Inca civilization he found Constructivist archetypes on which he hoped to base an authentic American identity in modern art.[26] Aware, however, of the dangers of folkloric *criollismo* and *nativismo,* he warned against "falling into the archaeological" and "making South American pastiches," instructing artists to "avoid folklore, another stumbling block that is just as dangerous."[27] He was ultimately unable to involve Uruguayans in this project—Amerindian art was foreign to them, and outside the range of their interests—but his approach to pre-Columbian art would prove vital to future generations of Latin American abstractionists.

Torres-García's tireless proselytizing, his exhibitions in Montevideo and Buenos Aires, his newspaper articles, and his several books, including *Estructura* (1935), as well as the publication of his collected lectures in the book *Universalismo Constructivo* (1944), made him a controversial but nevertheless authoritative proponent of modern art. His studio was an obligatory stop for local and foreign artists, writers, musicians, and critics. Among the many visitors were Julian Huxley, René

Figure 7. Gonzalo Fonseca, drawing in a letter from New York to a friend in Montevideo, 1966.

D'Harnoncourt, and Lincoln Kirstein of New York; René Huyghe of Paris; and from across the Río de la Plata the composer Alberto Ginastera, the critic Jorge Romero Brest, the painter Emilio Pettoruti, and the young artists who would create the Madí group and the Asociación Arte Concreto–Invención in Buenos Aires.

While Torres-García was engaged in the formulation of a truly American art form, news of the Spanish Civil War and the threat of a second world war reached Montevideo. Like many intellectuals, Torres-García feared for the future of Western culture. In spite of his calls to forget about Europe, he had remained inextricably linked to the Old World. This dilemma forced him to define his position in relation both to Europe and to the indigenous cultures of the Americas and added urgency to his desire to educate and prepare artists who would be able to study and continue the cultural legacies of both regions.

As the AAC dispersed, a group of aspiring artists who had little or no artistic training, but who were receptive to Torres-García's utopian ideas, started to attend his lectures. He taught them painting and drawing geared to abstraction and the principles of Constructive Universalism. In his *taller,* Torres-García created a vital learning environment from which exceptional talents emerged. Gonzalo Fonseca recalled the lively atmosphere: "One talked of painting, compared and corrected works of art, prepared publications and manifestoes.... Everything was a subject for discussion—from anthropology and the origin of man to the petty intrigues between artists."[28] Fonseca (figure 7), Julio Alpuy, José Gurvich, Francisco

Matto, Manuel Pailós, and Torres-García's sons Augusto and Horacio formed the core of the Taller Torres-García, which lasted twenty years and played an important role in the development of contemporary art throughout South America.[29]

In Montevideo, the Taller Torres-García loomed large. The members/students/artists applied the "constructive" style to objects, ceramics, furniture, tapestries, stained glass, iron gates, and graphic design, and their productions appeared in private homes and cinema-club flyers as well as on café walls, at gas stations, and in other public and commercial spaces. Conservative political forces, both academic and cultural, were bitterly antagonistic. Between 1945 and 1952, the Taller Torres-García published twenty-eight issues of *Removedor* [*Paint Remover*]. The magazine contained articles, reviews, and images of Taller work, promoted the Taller artists' exhibitions, and editorialized against their detractors.

The artists of the Taller believed that the fusion of painting with architecture was so important that they attempted to flood Montevideo with murals. (The large number of Constructivist murals in Montevideo rivals the number of figurative murals in Mexico City.) In 1944, Torres-García and twenty Taller artists were invited to decorate the walls of St. Bois Hospital. The murals that they created for this project were the summation of Torres-García's experience as a painter, theoretician, and teacher. In the collective spirit of earlier times, when artists worked according to the canons of a unified style, the Taller artists painted thirty-five murals

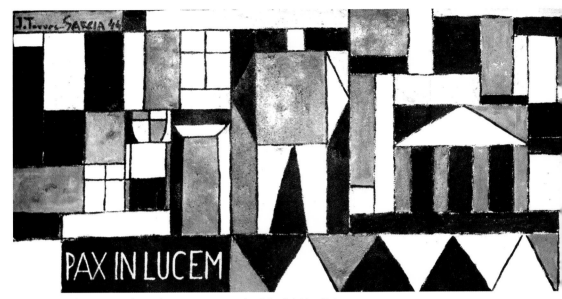

Figure 8. Joaquín Torres-García, *Pax in Lucem,* 1944, mural at Saint Bois Hospital.

in all, using bright primary colors. The subjects were Montevideo's streets and harbor; ships, docks, cranes, locomotives, and streetcars packed the paintings. Indeed, Torres-García had called for murals that were "strongly linked to the city—commenting on it and singing its life, emphasizing it, displaying it, and, in a way, even guiding it."[30] The murals, ordered by a structured, rhythmic, synthetic design, were a demonstration of Torres-García's principle that artists working in a particular style can achieve depiction without relying on naturalism (figure 8).

The work of the Taller artists emerged from a core of essential and universal rules regarding not only aesthetic but also moral principles. The cohesion between their lives and the faith they placed in their art had a powerful impact. Some critics did object to their work, but they left an enduring stamp on the art of the region; the style they generated became synonymous with the art of Montevideo (figure 9).[31]

The Cultural Scene after 1936

During the Spanish Civil War, artists, writers, and intellectuals from Spain settled in Montevideo and Buenos Aires and enriched the cultural life of both capitals. As already mentioned, in 1936, when the war began, Uruguay broke off diplomatic relations with the Spanish Republic and with its backer, the Soviet Union, but that did not prevent many Uruguayans from supporting the Spanish Republicans and mobilizing to aid them. The Catalan actress Margarita Xirgú (1888–1969), an exile from the Franco regime, invigorated the theater in Montevideo with her masterful performances of Federico García Lorca's plays. She was also a renowned teacher, and the actors and directors she trained later created Montevideo's many independent theater companies.

At the outset of World War II, Uruguay declared neutrality but in December 1939 became witness to the Battle of the Río de la Plata: the British navy's pursuit and bombing of the German pocket battleship *Graf Spee* occurred literally in front of Montevideo for all to see from the seaside walkways known as the Ramblas; thereafter, Uruguay assumed a pro–Allied powers stance.[32] During the war, political considerations aside, Montevideo enjoyed the work of the great artists and famous performers who were fleeing Europe. For example, the French poet Jules Supervielle spent the war years in Uruguay, where he had been born, and invited the famous French actors Louis Jouvet and Madeleine Ozeray to perform his play *La belle au bois*. A 1941 traveling exhibition of contemporary

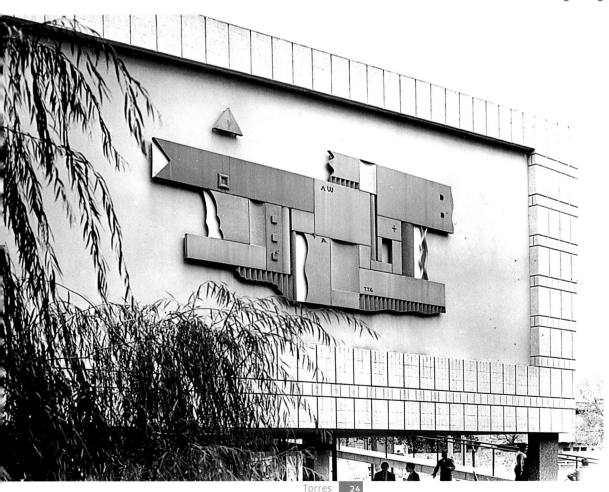

Figure 9. Horacio Torres and Augusto Torres, Untitled, 1958, painted steel relief at Liceo Miranda N.º 9.

paintings from the United States brought Edward Hopper, Georgia O'Keeffe, George Grosz, John Sloan, and many other U.S. masters to Montevideo. Most of these paintings were figurative. One that was not was *Argula* (1938), by Arshile Gorky, from the collection of The Museum of Modern Art in New York; it caught Torres-García's eye.[33]

Beginning in 1945, Uruguay enjoyed a decade of unprecedented and still unequaled prosperity. Increased industrial development benefited a large middle class, which built modern houses in the expanding suburbs and furnished them in a style indebted to fashionable Swedish design. Shops sold local artisan glass, ceramics, and textiles.

In 1946, with the establishment of the humanities department at the National University, the Argentine critic Jorge Romero Brest began to teach the new generation that would shape Montevideo's artistic future through competitions, salons, prizes, and the selection of artists for the Uruguayan pavilions in the Venice Biennale and the Bienal de São Paulo. In Montevideo, where radio and cinematography had been pioneering popular enterprises—Montevideo had eighty movie theaters in 1930—the Art Deco movie house of the 1930s gave way to the independent *cine club* that proliferated in its place, screening old and avant-garde international films (figure 10). After the war, the only complete copy to be found of the legendary German silent film *The Cabinet of Dr. Caligari* was in the archives of the Cine Club del Uruguay.

After Torres-García's death, in 1949, many Taller members went to Europe to see art at first hand in the museums. Meanwhile, in Montevideo, a group who had resisted Torres-García's ideas—its members included María Freire, José Pedro Costigliolo, and Antonio Llorens—explored hard-edged abstraction in painting and sculpture modeled on Russian Suprematism and the geometric art of Georges Vantongerloo, Naum Gabo, and Max Bill. In their compositions, form and line create visual balance and tension (figure 11). They favored synthetic paint applied on flat and even surfaces to create a machine-made

look.[34] Freire experimented with materials produced in local industries and made sculptures of molded acrylic, steel, and enamel, on metal from the household-appliance factory of Kraft-Imesa. Llorens was an accomplished graphic designer who had mastered silkscreen technique. Other artists, such as Manuel Espínola Gómez, Américo Spósito, Juan Ventayol, and Hilda López, favored an expressive abstraction that relied on gesture and occasionally made reference to reality or organic forms.

By the end of the 1950s, reduced manufacturing and industrial production had appeared as the first symptoms of an impending economic crisis that would in turn bring cuts in the benefits offered by Uruguay's generous welfare state. The economic slowdown notwithstanding, Montevideo's art scene continued to thrive. Two new exhibition halls, sponsored by the newspaper *El País* and General Electric, energized the art scene by providing additional opportunities for artists to exhibit.

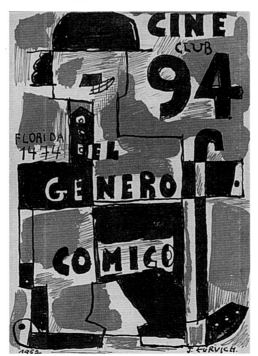

Figure 10. José Gurvich, Cine Club program no. 94 (1952).

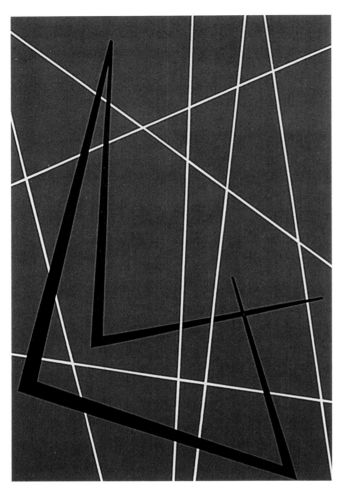

Figure 11. María Freire, *On a Blue Plane,* 1966.

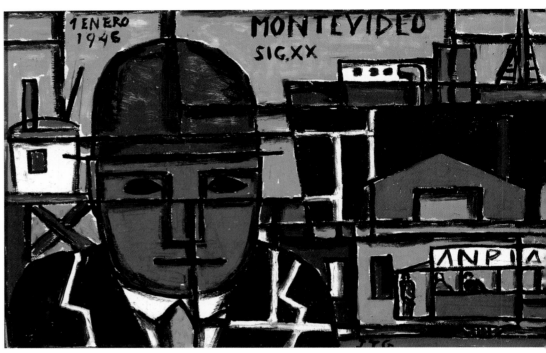

Figure 12. Joaquín Torres-García, *Puerto constructivo con hombre de cara roja [Constructive Port with Red-faced Man],* 1946.

Important traveling shows also had an impact on local artists, and the Bienal de São Paulo became a point of convergence for South American and international art.

Like the 1950s, the 1960s were an important decade for the arts in Uruguay, despite the encroaching economic, social, and political hard times. Shows of contemporary Spanish artists (including Antoni Tápies and the Informalist group El Paso), of the Brazilian Manabu Mabe, and of the Italian Alberto Burri acquainted local artists with Action Painting, Tachisme, and Informal art. The foreign artists' rough, heavily textured, ripped canvases, and their collages of discarded materials, evocative of irrational disorder and urban deterioration, mirrored the Montevidean artists' state of mind. Agustín Alamán, Washington Barcala, José Gamarra, and Leopoldo Novoa explored paths in abstraction that made materials and elaborate textures into subject matter. Seven painters—among them Oscar García Reino, Miguel Ángel Pareja, Jorge Páez Vilaró, Lincoln Presno, and Américo Spósito—joined the photographer Alfredo Testoni to form the Grupo de los 8 [Group of 8]. They advocated total freedom in artistic expression, but their alliance served more to promote group events than to promulgate a common ideology.

At the end of the 1960s, Uruguay's "brain drain" began; Montevideo was losing its best and brightest professionals, artists, writers, and craftsmen. At some point in the 1970s, fifty-five Uruguayans were leaving every day for Europe, Australia, Argentina, and North America in search of better jobs.[35] The heavy taxes and regulatory burdens that paid for Uruguay's advanced social policies also made its products uncompetitive in world markets; an economic crisis brought a downward spiral of deterioration to every aspect of life. With social unrest came increasing suppression of civil rights, and this process culminated in the 1973 coup that put a military regime in power for a decade. Montevideo's patrimony of urban architecture suffered greatly during this period as whole neighborhoods were razed and replaced by apartment buildings.

After decades of hardship, the country is gradually making an economic recovery. Uruguay is one of Latin America's major exporters of software and communications technology. There is also increased awareness of Montevideo's unique character, and efforts have begun to preserve and restore the city.[36]

Montevideo has inspired poets, painters, and writers. The novelist Juan Carlos Onetti advised writers to "do" Montevideo so that life would imitate art; he urged them to dig into its soul, its unique essence, and then to write about themselves so that the city and its people would bear a resemblance to writers' creations. The writer Mario Benedetti found that Montevideo's "slight pseudo-European color, which began as a somewhat hypocritical pose, turned out to be inevitably, shamefully sincere."[37] And for Torres-García, the city was as unique as its name, "with those ten letters aligned hauntingly in an expressionless evenness: M-O-N-T-E-V-I-D-E-O" (figure 12).[38]

Notes

All translations are the author's unless otherwise noted.

1. It is said that the city's name comes from a Portuguese sailor who announced, "Monte vi eu!" ("I see a hill!") when El Cerro, emerging from the flatlands, came into view.

2. The Asociación de Arte Constructivo lasted from 1935 to 1943; the Taller Torres-García lasted from 1943 to 1962.

3. The Viceroyalty of the Río de la Plata was established in Buenos Aires in 1776; hence the adjective *rioplatense,* which designates the two cities' shared identity.

4. "El sabor de lo oriental / con estas palabras pinto; / es el sabor de lo que es / igual y un poco distinto"; see Jorge Luis Borges, *Milonga para los orientales* (Buenos Aires: Emecé Editores, 1995), 304.

5. Milton Schinca, *Boulevard Sarandí,* vol. 1 (Montevideo: Ediciones de la Banda Oriental, 1976), 97.

6. Sarmiento is cited in Schinca, *Boulevard Sarandí,* 65.

7. Lautréamont was thirteen when he left Montevideo, in 1859; Laforgue left in 1866, when he was six years old. Only Jules Supervielle would return periodically and write about his native country.

8. Vasconcellos is cited in Alberto Methol Ferré, "Dos odiseas americanas: Torres y Vasconcellos," *Artes* 2 (August 1959): 12.

9. José Batlle y Ordóñez was president from 1903 to 1907 and from 1911 to 1915.

10. José Gervasio Artigas (1764–1850) is honored as the father of Uruguayan nationality; he was largely influenced by the U.S. Declaration of Independence and by French political thought.

11. See Susana Salgado, *The Teatro Solís: 150 Years of Opera, Concert, and Ballet in Montevideo* (Middleton, Conn.: Wesleyan University Press, 2003).

12. Blanes, who traveled to Italy four times, died in Pisa.

13. See Juan Acha, *Arte y sociedad latinoamericana* (Mexico City: Fondo de Cultura Económica, 1979), 118.

14. See Jorge Luis Borges, *Poesía gauchesca* (Bruguera: Prosa Completa, 1980), 107.

15. Javier de Viana, *La Trenza* (Montevideo: Ediciones de la Banda Oriental, 1964), 75.

16. Slave ships from Africa arrived in Montevideo's harbor until 1842, when slavery was abolished. The slave trade was an important and very profitable one; buyers arrived from Argentina, Chile, and even Peru. At one time, a third of Montevideo's population was black. Candombe music and dance are related to other musical forms of African origin that are found in the Americas.

17. Rosa Brill, *Pedro Figari Pensador: Cosmos, vida, misterio* (Buenos Aires: Grupo Editor Latinoamericano, 1993).

18. Hugo Achugar, "El 'acuerdismo' y su expresión en lo político-cultural," in *Los veinte: El proyecto uruguayo: Arte y diseño de un imaginario, 1916–1934* (Montevideo: Museo Municipal de Bellas Artes Juan Manuel Blanes, 1999), 67.

19. Pablo Rocca, "Ciudad, Campo, Letras, Imágenes," in *Los veinte: El proyecto uruguayo,* 105.

20. Idelfonso Pereda Valdés, in *La Cruz del Sur* 3 (May/June 1927): 17.

21. Vibracionismo consisted in fixing on canvas "a simultaneity of visual stimuli and motion that is determined by the shifting from one sensation of color to the next corresponding one"; see Joaquín Torres-García, "Rafael Barradas," in *Universalismo constructivo: Contribución a la unificación del arte y la cultura de América* (Buenos Aires: Editorial Poseidón, 1944), 556. An important collection of Barradas's paintings and drawings is housed in Montevideo's Museum of Visual Arts. According to the art historian Gabriel Peluffo, it was only in the 1950s that Montevideo awakened to the importance of Barradas's work; see Gabriel Peluffo, *Historia de la pintura uruguaya,* vol. 2 (Montevideo: Ediciones de la Banda Oriental, 1986), 24.

22. The Sociedad de Arquitectos del Uruguay, founded in 1914, promoted competitions for public commissions, an arrangement that improved the quality and ethics of the selection process. Between 1903 and 1949, eighty-seven architecture competitions were held in Montevideo. See Adolfo Maslach, "La arquitectura nacional," *Joaquín Torres-García: Sol y luna del arcano* (Caracas: UNESCO, 1998), 620.

23. See Juan Pedro Margenat, *Barcos de ladrillo: Arquitectura de referentes náuticos en Uruguay, 1930–1950* (Montevideo: Typeworks, 2001). The Yacht Club, the Hotel Planeta in Atlantida, and many private homes offer great examples of ship-like buildings.

24. See Juan Pedro Margenat, "La arquitectura renovadora uruguaya," in *Los veinte: El proyecto uruguayo,* 93.

25. Torres-García intended *Círculo y Cuadrado* to be the continuation of the Parisian review *Cercle et Carré,* which he had co-founded in 1930 with Michel Seuphor. Ten issues of *Círculo y Cuadrado* appeared before it ceased publication, in 1943. Like the French review *Plastic/Plastique* (founded in 1937), which had opened communication between American and French artists, *Círculo y Cuadrado* created a dialogue between Uruguayan and European artists, since it was published in both Spanish and French.

26. Torres-García's interest in Amerindian art dates to as early as 1920, with his visits to New York's Museum of Natural History. In Montevideo, in 1936, he saw an exhibition of pre-Columbian Peruvian textiles, and he kept clippings about archeological sites in South America from the cultural supplements of the Argentine newspapers *La Nación* and *La Prensa.*

27. Joaquín Torres-García, "El nuevo arte de América," in *Universalismo constructivo.*

28. Gonzalo Fonseca, "Torres-García's Symbols within Squares," *Arts Magazine,* March 1960: 30.

29. The Taller Torres-García held more than 150 exhibitions between 1943 and 1962, both in Montevideo and abroad.

30. Torres-García, "La Escuela del Sur," in *Universalismo constructivo.*

31. This style was so pervasive that it entered popular consciousness: Uruguay has no tradition of folk art; rather, Torres-Garcia's Constructivism has become the popular vernacular. Artisans today, decorating objects with watered-down, ornamental versions of Torres-García's symbols within a grid, have strayed far from his original intention.

32. In 1940, the Uruguayan government began an investigation of Nazi sympathizers and finally, in 1942, broke off relations with the Axis powers.

33. The exhibition, organized by the Art Committee of Cultural and Commercial Relations with the United States, prompted Torres-García to publish a critical commentary; see Joaquín Torres-García, *Mi opinión sobre la exposición de artistas norteamericanos* (Montevideo: La Industrial Gráfica Uruguaya, 1942).

34. As Gabriel Pérez-Barreiro has observed, at first glance their works on paper look like screen prints, and only close examination reveals that they are hand-painted gouaches; see Gabriel Pérez-Barreiro, *María Freire* (São Paulo: Cosac & Naify, 2001), 31.

35. David L. Marcus, "Uruguayan Exodus," *Dallas Morning News,* September 11, 1991.

36. See the book and video *Montevideo: Una ciudad sin memoria* (Montevideo: Grupo de Estudios Urbanos, 1980), intended to rescue the images of Uruguay's lost architecture. The architectural guides published by Elarqa also catalogue every building of interest in the city.

37. Mario Benedetti, *Andamios* (Buenos Aires: Seix Barral, 1996), 103.

38. Torres-García, "La Escuela del Sur," 194.

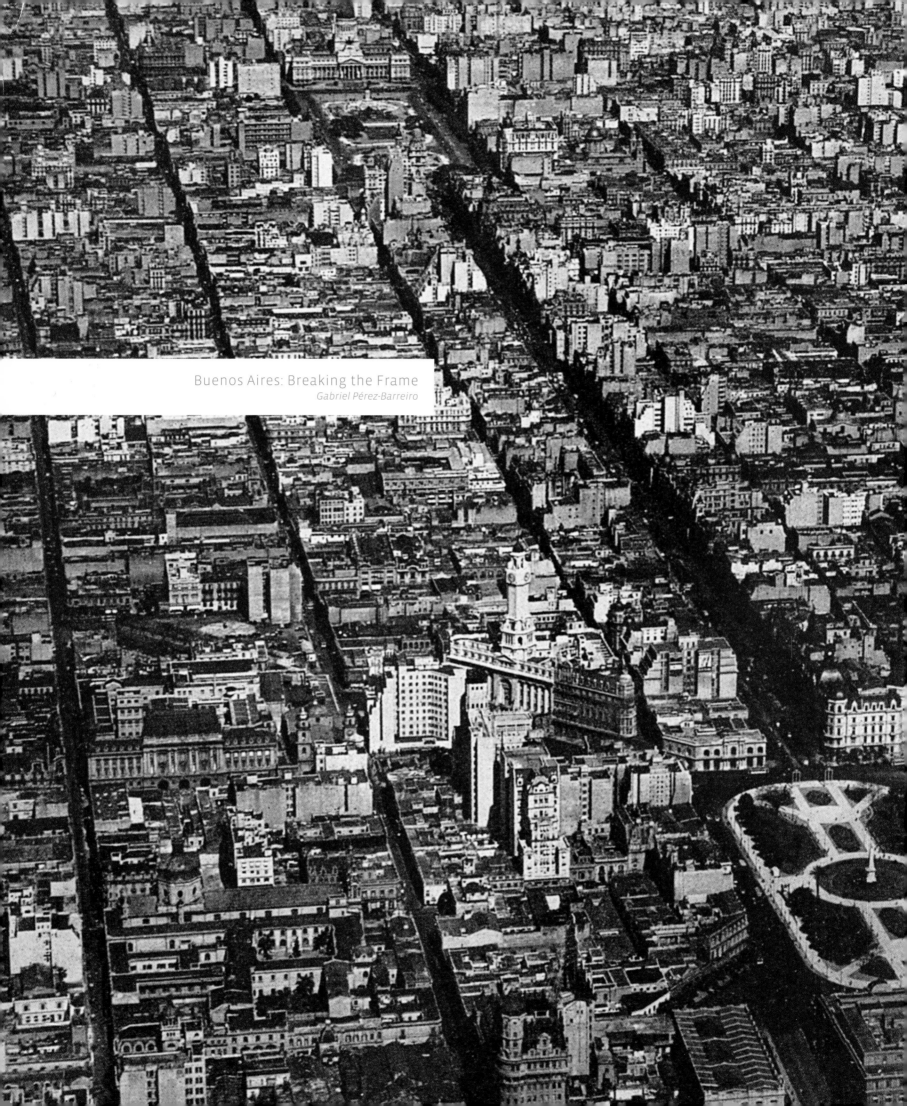

Buenos Aires: Breaking the Frame

Gabriel Pérez-Barreiro

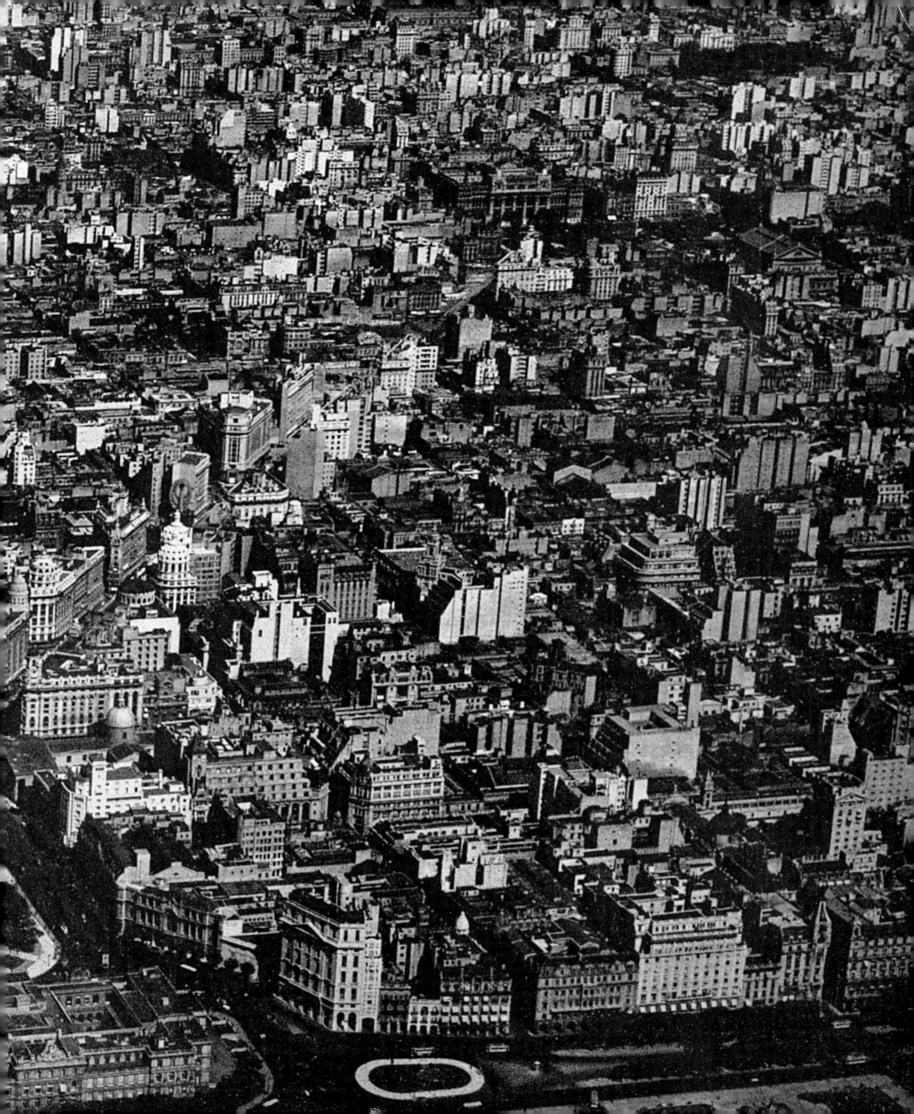

Previous pages, Figure 13. Aerial view of Buenos Aires from east to west showing the Plaza and Avenida de Mayo and Plaza Congreso. Photograph by Horacio Coppola, 1936.

Of all the Latin American metropolises, Buenos Aires is probably the one that least fits the exotic or timeless stereotypes common in European and North American imagery of Latin America. As we can see from Horacio Coppola's 1936 photograph of central Buenos Aires (figure 14), this was a city of skyscrapers, elegant boulevards, traffic, and urban lifestyles. For the thousands of immigrants who arrived in this city from Europe, Buenos Aires presented a vision of modernity the likes of which they could not have found anywhere in their homelands. Although we have since become accustomed to thinking of the cultural and economic map of the world in terms of a developed north and an undeveloped south, in the prewar years there was little to distinguish Buenos Aires from New York, Chicago, or any other major North American city, and plenty to distinguish it from the rural European regions from which most of its inhabitants came. In the mid-1930s, the illiteracy rate in Buenos Aires, home to the world's fifth-largest economy, was a mere 6.64 percent, an astonishingly low figure for anywhere at that time.[1]

Not only was Buenos Aires a fully urban and developed city, it was also a relatively new one in South American terms. As Nicolas Shumway has pointed out, "Until Independence, the Argentine was merely an area of the Spanish Empire, neither a country nor even an idea for a country."[2] Although Buenos Aires was founded in 1536, it was subsequently abandoned and only became the seat of a viceroyalty in 1776, just thirty-four years before Independence. Not until mass immigration, in the late nineteenth and early twentieth centuries, did the city become of any great significance.

The first decades of the twentieth century saw the rapid formation of a modern culture in Buenos Aires. The protagonists of this transformation were the large numbers of European immigrants who arrived in a series of waves starting in the 1880s. The influx of European immigrants into an area with almost no pre-conquest population or slaves created a mix of Spaniards, Italians, and Central Europeans that resulted in a city whiter than perhaps any other in the Americas. For most of the early *porteños,* as the inhabitants of Buenos Aires are called, personal or family memories were of people and events thousands of miles across the Atlantic, and few of these immigrants could identify with Argentina as anything more than a new home. The characteristically Argentine sense of nostalgia or longing and the fervor for all things European are probably due in part to this original sense of detachment and dislocation. In the 1910s, half of all *porteños* were born abroad; by 1947, this proportion had dropped to 25 percent as families settled and created a new generation of Argentines who were born into European families but had little or no first-hand knowledge of their original homelands.[3] With the outbreak of the Spanish Civil War, the Italian Abyssinian war, and World War II, Europe became embroiled in conflict, but Argentina offered a relative sanctuary of modernity, social calm, and wealth. Of course, the 1930s and 1940s were conflictive times for Argentine society, too, with a series of labor disputes that were violently repressed, but Argentines were saved the widespread carnage and destruction of Europe even while they felt connected to the Old World through personal or family ties.

By the 1940s, Buenos Aires had developed an urban, sophisticated, politicized, and literate lifestyle. A new generation of native-born Argentines was battling for the reform of a political structure that, ever since Independence, had been concentrating power in the hands of relatively few. The rise of Juan Domingo Perón in 1946 reflected Argentina's search for a new political system in response to the new domestic social makeup and the new world order after the war. The nature, effects, and significance of Peronism are hugely controversial, even to this day. For the purposes of this essay, it is enough to point to the transformation of the political discourse and to the break with a tradition of quasi-aristocratic rule.

In this context of debate and discussion about Argentina's social makeup and its role in the world, the issue of so-called high culture holds a special place. Jean Franco makes the bold claim that "the salient factor in Argentinean culture is its elite nature," thereby distinguishing Argentine culture from the populism or nativism of Mexican Muralism or Peruvian indigenism.[4] "Elite," in this context, can be read as a virtual synonym for "European."

In this case, however, the term "European" refers not to the masses who arrived as immigrants but to a special relationship between the Buenos Aires elite and the high culture of the European bourgeoisie. Thus in Buenos Aires, as perhaps nowhere else in the Americas, social class rather than ethnicity became the key to accessing European culture. The members of the Argentine elite created their own version of the European Grand Tour, and in the nineteenth and early twentieth centuries they put together great art collections that now form the basis of the fine national museums in Buenos Aires. Under this paradigm, which persisted well into the twentieth century, European culture was understood to be a matter of good taste or, in artistic terms, a question of style. Therefore, any artist, writer, or connoisseur who aspired to participate in cultural discussions would first have to spend time in Europe learning the latest artistic styles and visiting museums. Given the expense and difficulty of traveling for leisure, this was a privilege reserved for the few. Through the 1920s and 1930s, a number of upper-class groups of patrons—Amigos del Arte being the most famous—provided financial support for aspiring artists to study in Europe, which is how Xul Solar, Emilio Pettoruti, and many others were able to travel. Upon returning to Buenos Aires, these artists and intellectuals would find a spiritual home in the elegant salons of central Buenos Aires (the so-called Florida group was named after the central avenue) and in magazines like *Sur,* run by the quintessential patron, Victoria Ocampo.

This model of educational trips to Europe created a very particular paradigm whose primary feature was that, for Argentines, access to European artistic modernity was virtually limited to those who had access to money (their own or that of patrons). This feature in turn created a particular connection between Argentine aristocracy and the avant-garde, a relationship that was less common in Europe, where patronage of the arts was largely a project of the professional middle class. For the upper-class *criollos,* as the native-born patrician class in Argentina was called—that is, for people like Victoria Ocampo and Jorge Luis Borges—high European culture was something to be protected from the new ideologies that were emerging among the urban proletarian immigrants who continued to arrive every day. John King, describing Ocampo, wrote that for her "there was only one history in Argentina, that which had been forged by her family and friends, and which had to be defended against the mass movements of Fascism and Communism spawned by the late 1920s and early 1930s."[5] In this context, the "import" of advanced European culture was both a statement of a somewhat conservative, broad humanism and an anti-populist defense of a sophisticated liberal tradition.

The irony of this position, of course, is that the European avant-garde was anything but conservative and was often closely related to socially transgressive or revolutionary ideals.

What happened, in broad terms, was that the visual style of a particular movement became somewhat detached from its intent. At its worst, this tendency created the decorative sub-Cubism of Emilio Pettoruti; at its best, it produced Xul Solar's original reworking of Klee and Symbolism. In any case, what it did was to create and perpetuate a paradigm in which the more revolutionary proposals of the European avant-garde either were not known or were domesticated and turned to the purposes of a decorative style and were thus understood only in traditional terms of connoisseurship or narrative. To give just one example, in 1942 a leading art critic, Julio Payró, published a history of modern European art, *Pintura Moderna [Modern Painting],* in which he dismissed analytical Cubism for not creating masterpieces and rejected Dada for not being justifiable as art. Payró made no mention of Russian Constructivism or De Stijl; his book created a version of the European avant-garde as a mere succession of pictorial styles that were unrelated to manifestos or to any type of questioning about the limits of the work of art or its relationship to society.[6]

Arturo and the Birth of Invencionismo

Large transformations are often announced in modest ways. The appearance of a single-issue small magazine, *Arturo,* in 1944 was the first concrete manifestation of a new direction in Buenos Aires's artistic history, one that would eventually spawn a plethora of artists, movements, and ideas concerning the future of geometrical abstraction in the Río de la Plata region.[7] *Arturo* was nothing if not contradictory: the abstract expressionist cover by Tomás Maldonado seems at odds with the several statements against Surrealism and automatism inside the magazine. Carmelo Arden Quin's mythological poems have little to do with Gyula Kosice's declarations for a scientific future, just as the Brazilian poet Murilo Mendes's evocative texts have little in common with a percussive poem by Joaquín Torres-García. Derek Harris has suggested that *Arturo's* contradictions are "reflections of the ambiguities and contradictions of the Argentinian cultural and political environment of the middle 1940s" as well as "a paradigm of all Latin American avant-garde phenomena."[8]

Despite announcing itself as a *revista de artes abstractas,* there is little visual art in the pages of *Arturo,* and what is there is far removed from what we have come to understand as the visual language of the Argentine avant-garde: shaped canvases, pure geometry, and articulated sculptures. In this sense, it is important to note that the Buenos Aires avant-garde was not

Figure 15. Corner of Calle Florida and Avenida Roque Sáenz Peña, showing the Bank of Boston Building and La Torre del Concejo Deliberante (City Council Building), 1937.

INVENTAR: Hallar o descubrir a fuerza de ingenio o meditación, o por mero acaso, una cosa nueva o no conocida. /Hallar, imaginar, crear su obra el poeta o el artista/

INVENCIÓN: Acción y efecto de inventar. /Cosa inventada. /HALLAZGO/

INVENCIÓN
contra
AUTOMATISMO

Figure 16. Inside-front cover of *Arturo* no. 1 (1944).

launched from *Arturo* as a fully formed proposition; rather, the magazine was a symptom of a new spirit of renovation, but one that was primarily literary, despite the magazine's stated interest in the visual arts. Proof of this can be seen in the contributions of Arden Quin, Edgar Bayley (Maldonado's brother), Kosice, and Rhod Rothfuss, the four editors. Of the four, only Rothfuss had visual work in the magazine: a wood relief, and a semifigurative painting reminiscent of Torres-García, along the lines of Rothfuss's *Sin título (Arlequín)* (plate 3).[9] Moreover, the Portuguese artist Vieira da Silva's organic geometrical paintings, and Augusto Torres's figurative work, paired with Maldonado's expressive automatist cover, made *Arturo* anything but a coherent statement of a new visual style.

This raises an important point surrounding the dating and chronology of works from this period. The chronic pre-dating and post-fabrication of these works has led to a very deceptive sense of the development of abstract art in Buenos Aires. If one were to believe the dating of numerous works that have frequently been reproduced and exhibited, even in major international museums, one would have the impression that by the time *Arturo* was published there was a fully formed mature style among the young artists involved in its publication. (But if that had been the case, why were none of these works reproduced in the magazine itself?) One would also think that the period of most intense artistic production had been between 1944 and 1946, or even earlier. But a more careful and rigorous analysis of the primary documentation of the period would suggest that from 1944 to 1946 the discussion took place primarily through the written word, and that only after 1946 did a coherent visual style begin to emerge, and even then only very slowly and tentatively. The fact remains that the production of these artists was very small, and that little of their original production has survived decades of total neglect by local museums, collectors, and art historians. A more accurate history of this period would require a major effort to redate and reauthenticate many of the works currently in circulation. Given the animosity and litigious nature of the *Arturo* participants who are still alive, however, and the difficulty of deauthenticating works in major public and private collections, this remains a pending concern.

What, then, if anything, can we extract as a coherent proposal from the pages of *Arturo*? There are two answers to this question. The first is that the mere appearance of the magazine was significant in terms of its role as a catalyst and convener of the major thinkers of the next generation. The second involves

an analysis of the particular philosophy that was developing around the idea of invention. Several of the texts published in *Arturo* suggest that a reformulation of terms and meanings was taking place, whereby certain ideas that seem intrinsically linked in European art history (such as Surrealism and automatism) were being realigned in relation to a specific concept of invention. The inside cover of *Arturo* (figure 16) gives a dictionary definition of invention:

TO INVENT: To find or discover something new or previously unknown by ingenuity or meditation, or by mere chance. / Discovery, imagination, creation of a work by a poet or artist /

INVENTION: Action and effect of an invention / Invented thing / DISCOVERY /

INVENTION against AUTOMATISM

In the second definition, the word "discovery" (*hallazgo*) is in capitals, emphasizing this meaning of the word "invention." Discovery, or chance, was a favorite concept of the Surrealists and Dadaists, and they considered automatism (frottage and automatic writing, for example) to be a way of making precisely the type of discovery that overrides the conscious mind. The declarations on the inside cover of *Arturo*, however, propose that invention is not to be achieved through a technique (such as automatic writing) but can be achieved by any means ("by ingenuity or meditation, or by mere chance," words added by the editors to the original dictionary definition).[10]

The addition of these words would suggest that there is indeed a difference between invention and automatism (as understood through Surrealism), between automatism's insistence on the application of a technique to overcome conscious limitations and invention's freedom to use techniques for their own sake. Seen in this way, the anti-Surrealist posturing in *Arturo* is far from being as simple as it seems. Surrealist automatism proposes the supremacy of the unconscious and explores the mechanisms through which the actions of the conscious mind can be diminished. But if invention can be the result of logic, meditation, or chance, then it belongs as much to the conscious world as to the unconscious. What matters is the inventive character of the final work, not the means by which it came about. This distinction between inventive means and ends lies at the heart of the avant-garde project of this generation: the desire to create a world of inventive, non-representational objects, rather than to explore the subconscious.

The concept of invention as an end rather than a means is underlined in Arden Quin's manifesto-like text in *Arturo*: "Thus *invention* becomes rigorous, not through aesthetic means but through aesthetic ends."[11] The same idea is implied in the final statement of Arden Quin's text: "INVENTION. Of any thing; of any act; myth; through pure games; through pure sense of creation: eternity. FUNCTION."[12]

This use of the word "function" points to the other determining factor in the birth

of abstraction in Buenos Aires: Marxism. Many of the declarations made by the artists throughout 1945 and 1946 are explicitly Marxist, even Stalinist (figure 17). Marxism provided this generation with a model that was materialist, functional, and social. Such was the enthusiasm for Soviet Communism that, in November 1946, the statutes of the Asociación Arte Concreto–Invención included the phrase "inventionism declares its solidarity with all of the world's peoples and with their great ally: the Soviet Union."[13] The irony of this position, of course, was that by the 1940s the Soviet Union, having fully reversed its initial support for experimental geometrical abstraction, now favored Socialist Realism.[14] Nevertheless, there was a period, from 1944 through 1946 or 1947, in which the artists of the Asociación Arte Concreto–Invención—Maldonado, Alfredo Hlito, Alberto Molenberg, and others—appear to have been tolerated by the Argentine Communist Party. A clear sign of this can be seen in the publication of Edgar Bayley's important text "Sobre Arte Concreto" ["About Concrete Art"] in the magazine *Orientación*, the weekly organ of the Argentine Communist Party, which had been outlawed during World War II but was re-established in August 1945. In this article, Bayley made a claim for Concrete art or Invencionismo to be understood as a truly Marxist and revolutionary artistic language; indeed, the article included a justification of abstraction in terms of its relationship to class struggle: "Concrete art is defined as a substantial contribution to the liberation of mankind by affirming his control over the world. And working against fiction through the inventive act and the furthering of propaganda and educational techniques."[15]

It was against the backdrop of very little visual art production that debates took place around the definitions of Invencionismo and Arte Concreto between the publication of *Arturo* and the consolidation, in 1946, of two artistic groups—the Asociación Arte Concreto–Invención and Arte Madí. The proliferation of publications, articles, and magazines discussing the future of abstract art was not matched by a comparable flurry of exhibitions. It appears that the desire for debate and the need to establish a theoretical and political justification for the new art preceded most actual production. Only by late 1946, and through 1947, did a coherent aesthetic emerge from these discussions.

The Structured Frame

The single most important text in *Arturo* is the final article: Rothfuss's "El marco: un problema de plástica actual" ["The Frame: A Problem in Contemporary Art"]. With this article, Rothfuss became the first to theorize on the subject of the structured frame, or *marco recortado*. The article is something of a mystery, not least because Rothfuss himself is such an enigmatic figure. Rothfuss's writings are minimal (the *Arturo* text, and a handful of articles in *Arte Madí Universal*), and in comparison with Arden Quin or Kosice, whose literary ambitions were arguably as strong

as their pictorial ones, there is no sense of Rothfuss as a theorist. Unlike his three co-editors, Rothfuss did not write an introductory editorial text/manifesto, and his article seems almost to have been slipped in at the end.

For Rothfuss, no European art movement had yet resolved a key issue in how paintings are constructed: the frame. Rothfuss pointed out that the rectangular frame, invented as a support for illusionism and realism—a "window on the world"—is at odds with the anti-illusionism implicit in abstract art. Suggesting that a regular frame disrupts the composition of a work, Rothfuss proposed a more organic compositional method, in which forms radiate from a center rather than being determined a priori by a frame. Only in the last two paragraphs did Rothfuss explicitly propose the solution to this problem—structuring the frame in accordance with the composition inside:

> Most of these [abstract] paintings continued the concept of [the] window, developed in naturalist painting, giving us a fragment of a theme, but not its totality. Any painting in a regular frame suggests a continuation of the theme, which disappears only when the frame is rigorously structured according to the painting's composition.

The implication that an artwork should be an autonomous unit is in line with much orthodox modernist thought. Dawn Ades has related it to the call by Albert Gleizes and Jean Metzinger, in their 1912 book *Cubism*, for a painting to carry its own raison d'être within it.[16] Clement Greenberg has also identified the tendency in modernist art for the plane to resist efforts to destroy its physical properties: "The history of avant-garde painting is that of a progressive surrender to the resistance of its medium; which resistance consists chiefly in the flat picture plane's denial of efforts to 'hole through' it for realistic perspectival space."[17]

Rothfuss's article is illustrated with a painting by Wassily Kandinsky in which the organic composition is clearly in tension with the rectangular frame. On the following page, a work by Mondrian (now in The Museum of Modern Art, New York) is reproduced alongside an early "structured frame" work by Rothfuss.

Rothfuss's own work, as illustrated in the article, is surprising in many ways. Even more important than the work itself, however, is its strategic placement next to the Mondrian painting. This placement created a visual challenge to Mondrian and implicitly conveyed the message that Rothfuss was resolving the contradictions in European non-figurative art. Moreover, this critical approach to the development of European art was symptomatic of

EL B-AVIOR TIENDE
A UNIFICAR A TODO EL ARTE CONCRETO

en leyes exactas de composición e invención, con la aplicación del MARXISMO - LENINISMO a la historia del arte, y de la DIALÉCTICA REAL como instrumento de análisis y exploración EN TODOS LOS ÓRDENES DEL CONOCIMIENTO.

Con este objeto el B-AVIOR invita a todos los artistas constructivos, como también al arquitecto, al ingeniero, al físico, al psicoanalista, al geómetra, al matemático, al arqueólogo, al sociólogo, al historiador, al inventor obrero o sabio, hombre o mujer, a ingresar en este movimiento, para dar la batalla contra EL IDEALISMO BURGUÉS que, encerrado en su dualismo escolástico, ENTORPECE EL DELIRANTE JUBILO CREADOR DEL HOMBRE.

Estamos contra el expresionismo porque es una deformación de la realidad; contra el naturalismo porque es una copia de la realidad; contra el surrealismo porque intentó pasar una nube metafísica sobre el espejo de la conciencia.

¡Por un arte y ciencia exactos!
¡Por un orden geométrico y matemático en la composición!
¡Por una pintura, música, escultura, literatura, poesía libres de toda atadura romántica, naturalista o bizantina.!

B-AVIOR Buenos Aires 24 de Septiembre de 1945

Figure 17. B-Avior flyer, 1945.

a new confidence about Argentina's role in the development of modern art in general. For the previous generation, European art had been, by definition, more advanced and something to be learned from. The twenty-four-year-old Rothfuss had never traveled overseas (Europe, of course, was just emerging from the war), but he was already trying to participate in the most advanced discussions about the future of art, with no sense of any disadvantage brought about by his youth or his geographical location. This attitude, shared by many of his generation, was ultimately to create an entirely new paradigm for the development of modern art in Argentina, one in which the issue was no longer to catch up but rather to take the lead.

From Invencionismo to Arte Concreto–Invención

The four editors of *Arturo* were soon to coalesce into two groups, each attracting its own followers. There is some debate about whether the original *Arturo* group held an exhibition at the Comte furniture store in 1945,[18] but the next early events to be fully documented were two exhibitions in private homes. The first, an exhibit called *Art Concret–Invention,* took place in the home of the psychoanalyst Enrique Pichón-Rivière in October 1945 and offered the first sign of a split between the organizers Kosice, Arden Quin, and Rothfuss, on the one hand, and, on the other, Bayley and Maldonado, who were simultaneously bringing together the artists who in 1946 would form the Asociación Arte Concreto–Invención. Documentation of this event shows that many of the founders of the Argentine Psychoanalytical Association attended, along with eminent figures in the cultural (if not the visual arts) scene. The few artworks that are visible in the group photograph of the event show that the shaped canvas was certainly in wide use, but the paintings themselves were far from a fully non-figurative and geometrical art. In this taste for organization and impact over art making, and in the search for non-traditional audiences, the future of the Madí movement was already being established.

Within two months, the same group of artists organized their second private exhibition, a daylong event at the home of the German photographer Grete Stern in her functionalist house in Ramos Mejía, on the fringes of Buenos Aires. This event, now under the name *Movimiento de Arte Concreto–Invención,* included many other art forms—music, dance, even children's drawings. Again, the documentation suggests that any paintings on display were still somewhat tentative in form. The list of artists for this event includes a number of names that are likely to be pseudonyms, among them Sylwan Joffe-Lemme, Alejandro Havas, Raymundo Rasas Pet, and Dieudone Costes.[19]

Figure 18. Aerial view of downtown Buenos Aires, showing Calle Corrientes and Avenida Sáenz Peña. Photograph by Horacio Coppola, 1936.

Asociación Arte Concreto–Invención

While Arden Quin, Kosice, and Rothfuss were busy organizing multimedia events in private homes and inventing artistic pseudonyms, Tomás Maldonado and Edgar Bayley were bringing visual artists together to form the Asociación Arte Concreto–Invención. Maldonado recruited most of the Asociación's members from the Escuela de Bellas Artes, particularly from the evening classes, which were more popular with working-class artists. From the outset, the Asociación Arte Concreto–Invención artists were more rigorous than their Madí counterparts; they aspired to create a movement that would be collective, organized, and committed to a systematic analysis of issues in the visual arts. A simple comparison between the magazines, events, and statements of the two groups is enough to show that everything that was chaotic and bombastic in Madí was organized and rational in the Asociación. Maldonado and Bayley took the idea of invention from *Arturo,* combined it with a Marxist framework, and took the irregular frame as their initial starting point. The development of the Asociación Arte Concreto–Invención is relatively easy to trace through visual artworks and texts (the Colección Patricia Phelps de Cisneros owns examples from each of these movements that are discussed in greater detail elsewhere in this book).

The collective nature of the Asociación meant that there were few differences among the individual members. In early 1946, the artists were making shaped canvases along the lines of Juan Melé's *Marco recortado n.º 2* (plate 6). From their desire to make artistic objects more tangible and "real" (that is, even farther from the idea of a containing frame), they separated forms in space in what they defined as a "coplanar" (*coplanal*) arrangement, as in Lozza's *Relief* (plate 4) and Melé's *Coplanal* (plate 5). In 1947, as a result of several factors—debates about the coplanar works' new dependence on a supporting wall, the tension between the group's Marxist intentions and its increasing rejection by the Communist Party itself, and increased contact with European Concrete art through Max Bill—the *coplanal* was abandoned in favor of a return to the regular frame. Gradually, the collective and social aspirations of the Asociación Arte Concreto–Invención found expression in graphic and industrial design, through Maldonado's and Hlito's commitments to finding a rationalist discourse in the world of architecture and design throughout the 1950s. The Asociación's interest in resolving the contradictions of the *coplanal* took another turn with Raúl Lozza's creation of Perceptismo in 1947–1948, a development that moved the debates in the direction of a new form of abstract muralism.[20]

Arte Madí

Arden Quin, Kosice, and Rothfuss went on to form the Madí movement in 1946. The term "Madí" first appeared in June 1946, in a series of small flyers that were distributed on the streets of Buenos Aires and contained such

statements as "For an ESSENTIAL art, down with all romantic-naturalistic figuration For REAL invention!"; again, it is appropriate to note that the desire for provocation and publicity among the Madí artists antedated their actual exhibition of work. The distribution of manifesto-like flyers is typical of avant-garde activity and speaks more to the wish to establish a provocative presence than to engage in real dialogue with an audience.

The first Madí exhibition was in August 1946 at Salón Peuser and lasted only four days; characteristically, it featured, according to the program, literature, painting, sculpture, drawing, architecture, objects, music, and dance.[21] The program also lists fourteen *integrantes* of Madí, now including the artist Martín Blaszko, the musician Esteban Eitler, and the dancer Pauline Ossona; the four pseudonymous artists already mentioned are also listed there as well. There is an interesting contradiction in Madí between the openness to including almost any proponent of experimental art in any form (such as music or dance) and a closed, almost esoteric sense of membership, with the resulting infighting and mystification. This contradiction characterized the Madí group throughout its history.

Madí held two more exhibitions in 1946, always in alternative spaces, and in 1947 published the first issue of *Arte Madí Universal,* a journal that would last until 1954. *Arte Madí Universal* was the best representation of the Madí world; it featured an impressive list of international collaborators, many of whom seemed to have little idea of what Madí actually was.[22] A typical spread in the magazine presented musical scores, group photographs, Madí works (sometimes the same work appears in different issues under different names), bombastic statements about the importance of Madí, and reviews of fictional books. After the first issue, Arden Quin separated from the group by moving to Paris, where he formed his own Madí group, which is still active.

Subsequent discussion of this period has been dominated by the conflict between Kosice and Arden Quin over the authorship of Madí, but it is a mistake to understand the battle between them only in terms of personal rivalry. While personality may have had some part in it, there were also substantial aesthetic and political differences between the two. Arden Quin defended a more orthodox political position and a universalist view of art that was based to some extent on the views of Torres-García.[23] From the small handful of reliable primary reproductions from this period, it is extremely difficult to reconstruct Arden Quin's development, but we can see the importance of the golden section in his compositions, suggesting a belief

in an underlying order. For Arden Quin, the picture plane, whatever shape it might be, is the surface on which art is created, and the frame, however irregular, serves to separate this composition from the outside world. In Kosice's worldview, the breaking of the frame is only a stage in the dissolution of all art forms into a radical re-evaluation of art and its functions. This utopian, transformative aspect of Kosice's ideas would have what was perhaps its fullest expression in his 1971 project for the Hydrospatial City, an environment suspended in space, where art dissolves into pure experience.

Whereas the artists of the Asociación Arte Concreto–Invención aimed to eliminate individual differences among themselves in favor of a collective aesthetic, the Madí artists seemed relatively unconcerned with the actual works being produced, being much more interested in organizing events and publishing declarations. Madí always had a keen sense of public relations, and many of its strategies seemed to be designed to convey a certain image of the group as seen from the outside rather than from within. Madí's co-optation of fiction and myth—as in the invention of certain artists, or the bombastic nature of its declarations—was to become a central aspect of its activities, and of its subsequent mystique.

So, given Madí's lack of a coherent aesthetic, its internal contradictions, and its lack of reliable production, what can we consider to be its lasting significance? I would argue that Madí represents Argentina's first truly avant-garde movement in the visual arts. By "avant-garde," I mean transgression involving a particular model of art production rather than one involving a particular style. Peter Bürger's distinction is an important one:

> Avant-garde movements can be defined as an attack on the status of art in bourgeois society. What is negated is not an earlier form of art (a style) but art as an institution that is unassociated with the life praxis of men. . . . The demand is not raised at the level of contents of individual works. Rather, it directs itself to the way art functions in society, a process that does as much to determine the effect that works have as does their particular content.[24]

In this light, Madí's distribution of flyers, for example, is as important to an assessment of its significance as a movement as are its shaped-canvas paintings. Before Madí, Argentina never had a visual art movement that did what Dada did to European art—namely, introduce the power of the ridiculous or the unstable by undermining the very expectation of what an artwork should look like and how it should behave in the world. With Madí, the terms of discourse shifted away from discussions about geometry and form and toward proclamations about how the world would be transformed forever through Madí aesthetics. Therefore, it is just as important to consider the destructive elements of Madí as it is to consider the purely constructive elements. Madí was far from being merely

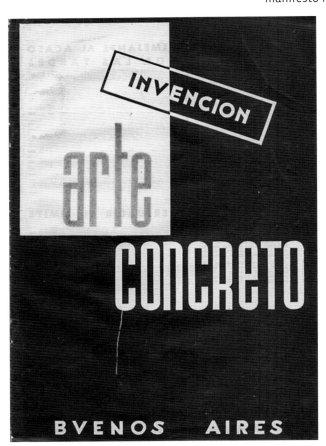

Figure 19. Cover of *Arte Concreto Invención* no. 1 (1946).

Argentina's importation of a rationalist idea of Concrete art.

More than sixty years after the publication of *Arturo*, it is still difficult to assess the impact of the Asociación Arte Concreto–Invención and Madí on a national or international scale. Despite the temptation to draw a line connecting the Argentine 1940s with the Brazilian 1950s or the Venezuelan 1960s, there is little real contact or context to justify such an effort. The indifference with which these artists were greeted in 1944 persisted for many decades, with no serious scholarship on or collection and exhibition of the work until the 1980s and 1990s.[25] The international market's current enthusiasm for this type of art arose without previous mediation and classification of the period by institutions and scholars, and that is what has created many of the problems of authenticity and historical inaccuracy that we face today. In the national context, subsequent abstract art movements in Argentina, such as Arte Nuevo and Arte Generativo in the 1950s and 1960s, returned to an essentially decorative sense of abstraction, sidestepping the social, literary, and transformative aspirations of this first group of utopian pioneers.

Notes

All translations are the author's unless otherwise noted.

1. Beatriz Sarlo, *Jorge Luis Borges: A Writer on the Edge* (London: Verso, 1993), 14.

2. Nicolas Shumway, *The Invention of Argentina* (Berkeley: University of California Press: 1991), 7–8.

3. John King, "Xul Solar: Buenos Aires, Modernity and Utopia," in Christopher Green, ed., *Xul Solar: The Architectures* (London: Courtauld Institute Galleries, 1994), 11. See also Richard J. Walter, *Politics and Urban Growth in Buenos Aires, 1940–1942* (Cambridge: Cambridge University Press, 1993), 235.

4. Jean Franco, *The Modern Culture of Latin America: Society and the Artist* (London: Pall Mall Press, 1967), 259.

5. John King, *Sur: A Study of the Argentine Literary Journal and Its Role in the Development of a Culture, 1931–1970* (Cambridge: Cambridge University Press, 1986), 7.

6. Julio Payró, *Pintura Moderna* (Buenos Aires: Editorial Poseidón, 1942).

7. A facsimile of *Arturo* was published by the University of Aberdeen in 1994. After legal action from Carmelo Arden Quin, it was withdrawn from commercial circulation. Documentation of the legal dispute can be found in the archives of the Blanton Museum of Art, The University of Texas at Austin.

8. Derek Harris, "Arturo and the Literary Avant-Garde," in Derek Harris and Gabriel Pérez-Barreiro, eds., *The Place of* Arturo *in the Argentinian Avant-Garde* (Aberdeen: Centre for the Study of the Hispanic Avant-Garde, University of Aberdeen, 1994), 3.

9. See my contribution on Rothfuss's *Sin título (Arlequín)*, this book.

10. The definition in the current dictionary of the Real Academia Española is very similar to the one in *Arturo*.

11. "Así la invención se hace rigurosa, no en los medios estéticos, sino en los fines estéticos."

12. "INVENCIÓN. De cualquier cosa; de cualquier acción; forma; mito; por mero juego; por mero sentido de creación: eternidad. FUNCIÓN" [capitals in original].

13. Unpublished statutes of the Asociación Arte Concreto–Invención (stating that they were approved in 1946), 1948, author's archive.

14. For a discussion of this issue, see Ana Longoni and Daniela Lucena, "De cómo el 'júbilo creador' se trastocó en 'desfachatez': El pasaje de Maldonado y los concretos por el Partido Comunista, 1945–1948," *Políticas de la memoria* (summer 2003–2004): 117–28.

15. Edgar Bayley, "Sobre Arte Concreto," in Nelly Perazzo, *Vanguardias de la década del cuarenta* (Buenos Aires: Museo Sívori, 1980), n.p. (originally published as Edgar Bayley, "Sobre Arte Concreto," *Orientación* [February 1946]). See also Robert Alexander, *Communism in Latin America* (New Brunswick, N.J.: Rutgers University Press, 1957), 171.

16. See Dawn Ades, ed., *Art in Latin America: The Modern Era, 1820–1980* (New Haven, Conn.: Yale University Press, 1989), 242. See also the first English edition of Albert Gleizes and Jean Metzinger, *Cubism* (London: T. F. Unwin, 1913).

17. Clement Greenberg, "Toward a Newer Laocoon," in Francis Frascina, ed., *Pollock and After: The Critical Debate* (London: Harper and Row, 1985), 43.

18. For a full discussion, see Gabriel Pérez-Barreiro, "The Argentine Avant-Garde, 1944–1950" (Ph.D. diss., University of Essex, 1996), 86–89.

19. There has been considerable discussion about the use of pseudonyms. The most tenable position is that Kosice used Raymundo Rasas Pet and Alejandro Havas, whereas Arden Quin used Sylwan Joffe-Lemme and Dieudone Costes. Nevertheless, the particular "ownership" of these names is hotly debated by Arden Quin and Kosice. It is interesting to note that works attributed to some of these pseudonymous artists have made it into public and private collections under those names; the issue of fictional characters in Madí deserves a study of its own.

20. For a more complete discussion of Lozza's artistic ideas, see my contributions on Lozza's *Invencion n.º 150* and *Relief*, this book.

21. The Madí manifesto of 1946–1947 includes definitions of Madí painting, drawing, architecture, dance, short stories, music, and so forth. Whether or not the manifesto, or some version of it, was read at the Salón Peuser event remains unknown. For a full discussion of the authorship and dating of the Madí manifesto, see Pérez-Barreiro, "The Argentine Avant-Garde," 287–97.

22. For example, Nikolai Kasak and Masami Kuni, both of whom were featured in *Arte Madí Universal,* claim to have little knowledge of Madí (Nikolai Kasak and Masami Kuni, correspondence with the author, various dates between 1991 and 1996).

23. Carmelo Arden Quin, "Corta reseña histórica sobre la influencia de Torres-García sobre la formación del arte abstracto en Uruguay, Argentina, y Brasil," unpublished manuscript, c. 1992, archives of the Blanton Museum of Art, The University of Texas at Austin.

24. Peter Bürger, *Theory of the Avant-Garde,* trans. Michael Shaw (Minneapolis: University of Minnesota Press, 1984), 49.

25. The first overview of this generation was an exhibition, *Vanguardias de la década del 40,* organized by Nelly Perazzo at the Museo Sívori in 1980; see Nelly Perazzo, *Vanguardias de la década del cuarenta* (Buenos Aires: Museo Sívori, 1980). See also Nelly Perazzo, *El Arte Concreto en la Argentina en la década del 40* (Buenos Aires: Ediciones de Arte Gaglianone, 1983). These were the first publications to bring together the primary material, although the critical framework was clumsy at best. The first international presentation was at the exhibit *Art in Latin America,* organized by Dawn Ades in 1989 at the Hayward Gallery in London. Since then there have been numerous exhibitions in Argentina and around the world.

Mechanisms of the Individual and the Social: Arte Concreta and São Paulo
Erin Aldana

Previous pages, Figure 20. Copan Building, completed in 1957, Oscar Niemeyer, Architect. Photograph by Marcel Gautherot, c. 1960.

Arte Concreta, the São Paulo–based version of geometric abstraction, is the movement that many people love to hate. The Neo-Concrete poet Ferreira Gullar accused it of dogmatism.[1] Ronaldo Brito went a step farther and said that Arte Concreta "represses the class struggle" and "appears ludicrous in its crude (although ambiguous) submission to dominant social standards, in its fetishizing of technology, and in its ingenuous project of overcoming underdevelopment in this way. There is something obviously colonized in its mimesis of Swiss rational formalism."[2] Even Alfred H. Barr, director of New York's Museum of Modern Art, referred to Arte Concreta as mere "Bauhaus exercises."[3] Such statements are in themselves reductive, making the movement appear to be limited in scope, obsessed with its European origins, ignorant of the social inequalities present in Brazil, and nothing more than a stepping-stone on the route to Neo-Concrete art.

Arte Concreta enjoyed its heyday during the 1950s, particularly the first half of the decade. Its adherents made works that were usually deceptively simple, using primary colors and incorporating geometric shapes and lines, with the goal of creating images of complete geometric precision, seemingly devoid of any human emotion. Although a version of Arte Concreta had developed simultaneously in Rio de Janeiro, the Rio-based artists soon departed from their *paulista* colleagues, making works of art that emphasized color to the point where it took on emotional and physical qualities that drew the viewer into a phenomenological relationship with the work. By the middle to late 1950s, the contrast had grown so strong that the *carioca* artists formed a

new movement, Neo-Concretism, which distinguished itself from Arte Concreta through an emphasis on individuality and viewer interaction.[4]

If one ignores the context in which Arte Concreta developed and considers the movement in strictly formal terms, its detractors' arguments may appear to have some foundation. The works' emphasis on geometry gives many of them an apparently banal appearance. The Concretists were famously unconcerned with color, even arguing that one could completely change a painting's colors and not alter anything significant in the work itself.[5] On the surface, such works can indeed seem dry, emotionless, and dull. But if one begins to explore the context in which they were made—São Paulo in the early 1950s—another story emerges, one in which Arte Concreta was a result of contemporary political and cultural events whose origins were to be found in the late nineteenth century.

During the 1950s in São Paulo, all of the city's potential seemed readily apparent. Prosperity was widespread, people enjoyed more leisure activities, and *paulistanos*, without even a hint of negativity, proclaimed São Paulo's status as the industrial center of Brazil:

"São Paulo is the largest industrial center in Latin America. . . ." This was written with pride, for foreigners to read. To be the largest industrial center in Latin America, to observe São Paulo's growth, was a positive thing.[6]

São Paulo's newly attained status as an industrialized city gave *paulistanos* a reason to be optimistic and even brash. These attitudes found their architectural form in the early designs of Oscar Niemeyer: the buildings of Ibirapuera Park, the Galeria California, and the Copan Building (figure 20). And in the visual arts, they were manifest in the sleek abstraction of Arte Concreta.

Perhaps the connection of Concrete art to its context is no longer so apparent, because today São Paulo tends to evoke the chaotic and the irrational more than geometry and precision. Over the course of the twentieth century, São Paulo has grown so rapidly in population and area that it seems to have erased any sense of its own history. The center of the city was also the center for Arte Concreta—it was the original site of the Museu de Arte Moderna, the Domus Gallery (the first in the city to exhibit geometric abstraction), and the Municipal Library (figure 28), where many of the artists met. Now São Paulo's many social problems have eclipsed the historical importance of the city's center; homeless people and street children inhabit the few public spaces downtown, and businesses increasingly are moving to the southwest quadrant of the city, its newest and most affluent section.[7] This does not mean that the rest of the city has been abandoned—with approximately twenty-two million inhabitants, it is an eternal present of urban monotony, full

of traffic jams, crowds of people in the metro and on the street, the smell of bus exhaust, and endless buildings reaching as far as the eye can see.

All this urban chaos—including poverty, automobile factories, shopping malls, skyscrapers, art museums, and exponential growth—would never have existed if not for the coffee boom of the late nineteenth century and the eventual transformation of coffee-generated wealth into industrial capital. Coffee was the agricultural basis for the city's later industrialization; it spawned a cash economy, the use of paid immigrant workers instead of slave labor, and the development of an infrastructure that in the beginning existed solely to serve the needs of a coffee-based economy. Railroads and the port city of Santos existed solely for the purpose of exporting coffee. The earliest factories made products either directly related to the process of coffee production or for the use of the coffee plantations' owners and workers. By 1920, local manufacturers were producing bricks, tiles, cement, and many other construction materials as well as a variety of consumer goods. During the early twentieth century, however, all these industries remained of secondary importance to the production of coffee.[8]

Those who eventually became the artistic patrons of São Paulo came from two elite groups: the families of coffee planters, and immigrant entrepreneurs, the most successful of a vast horde of people who transformed São Paulo from a backwater town into a thriving city. In 1872, São Paulo's population was only 23,000; by 1920 it had grown to 580,000, and almost two-thirds of its inhabitants were of immigrant origin. Most of these people were Italian peasants who had come to Brazil to work on coffee plantations and either had been unsuccessful or had settled in the city without ever having reached the plantations.[9] Immigrants in smaller numbers came from Syria and Lebanon and eventually also from Japan and Central Europe.[10]

According to the economic historian Warren Dean, the immigrant families that were most successful, such as the Matarazzos, were not of peasant origin but instead already possessed capital from their native countries that they reinvested in Brazil. The plantation elite complained that the immigrant entrepreneurs had come to Brazil in third class and ended up impoverishing Brazil's rural aristocracy. This aristocracy had existed for generations, and its members considered themselves "true Brazilians," claiming that they could trace four centuries of history in São Paulo (although this was rarely actually the case). They saw recent immigrants as mere impostors. The relationship between the two elite groups remained contentious. Members of the plantation elite intermarried with immigrants, yet there was still a tendency to snub immigrants and to forbid them entry into elite social organizations like the Jockey Club and the Automobile Club.[11]

The São Paulo that the coffee barons built was a far cry from the city of today. European visitors during the early twentieth century found its tree-lined boulevards, Neoclassical buildings (by Francisco Paula Ramos de Azevedo, the architect who designed the Municipal Theater), and English-style train station, the Estação da Luz (figure 22), strangely comforting. Georges Clemenceau famously said, "The city of São Paulo is so peculiarly French that for one week I can't remember having felt that I was in a foreign land."[12] The commercial, social, and political center of São Paulo was an area of a few square blocks known as the Triangle, bounded by the 15th of November, Direita, and São Bento streets. Until World War II, this was the location of the best stores (figure 23), the most prestigious banks, political party headquarters, newspapers, and the best restaurants in the city.[13] Prosperity, however, was limited to a very small area of the city, while much of the rest of São Paulo, where factory workers and their families lived, was packed with substandard housing structures known as *cortiços*.

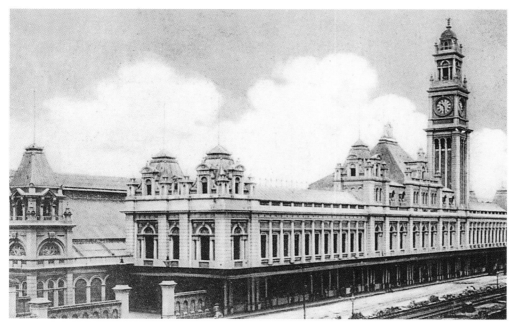

Figure 22. Luz Train Station, early twentieth century.

One could almost say that there were two São Paulos: one a sprawling mass of overworked and overcrowded laborers living in squalor, and another that had the appearance of a European city, full of elegant shops that had European names like Au Printemps and Au Palais Royal.[14]

The Brazilian elite's love of all things European found its way into the visual arts. Brazil's modernist artists of the 1920s established a precedent for Arte Concreta in their unapologetic use of European sources to create a uniquely Brazilian artistic style, and even produced some of the earliest examples of geometric abstraction: Lasar Segall's design of the ceiling mural for the "modernist salon" of Olivia Guedes Penteado, a well-known patron of the arts; the background of a painting by Tarsila; Regina Gomide Graz's Art Deco designs for rugs.[15] These precedents reveal a nascent interest in geometric abstraction as early as the 1920s, undermining the argument that Concrete art arrived in the 1950s as a strictly European import. The relationship that the modernists maintained with Europe was more than stylistic. Many of the artists and writers of this period came from the coffee aristocracy and kept apartments in Paris, where they traveled regularly.

The avant-garde writers Oswald and Mário de Andrade, the painter Emiliano di Cavalcanti, and many others organized the Week of Modern Art in 1922 with the financial sponsorship of Paulo and Marinette Prado, a married couple from one of the wealthiest *paulista* families. It took place at the Municipal Theater (figure 24), near the center of São Paulo, and involved performances of dance, music, and poetry as well as an art exhibition. The Week, as it came to be called, was a response to outdated tendencies in Brazilian cultural

production, dominated in literature by the Parnassian movement, which

> reflected the archaic, highly stratified class structure of Brazilian society, with poetry the privilege of an intellectual and aristocratic elite. . . . Properly metrified form was more important than substance, and poetry became a static, decorative mode of literary expression, out of touch with the rapid transformations Brazilian society was undergoing.[16]

Visual artists solved this problem by combining indigenous and Afro-Brazilian subject matter with Cubist and Expressionist artistic styles, while writers incorporated elements of vernacular speech, words in Tupi-Guarani, and parody into their work. The Week linked São Paulo forever to modernism and Futurism, but it also exposed Brazilian modernism's inherent contradictions: the early Brazilian modernists accepted some European influences but rejected others, overstated the degree to which the movement had broken with the past, and created an image of Brazilian identity that few Brazilians actually understood.[17]

As a result of these problems, some critics accused the early modernists of being elitist and out of touch with Brazilian society. Perhaps this was true. After all, Olivia Guedes Penteado—a good friend of many of the modernists, including the painter Tarsila do Amaral—once declared, somewhat self-mockingly, "When the store windows at Mappin [the first and largest department store in Brazil at the time] start to look good to me, that is when I know it is time to return to Paris."[18] Tarsila herself eventually received a great deal of criticism for her many trips to Paris and her love of couture. Her critics felt that her privileged position meant that she did not really understand what it meant to be Brazilian.[19] This controversy surrounding the modernist movement of the 1920s marked the beginning of a decades-long, heated debate regarding the question of regionalism and nationalism in Brazilian art versus internationalism.[20] It was also evidence of a shift in the fine arts toward an increasing interest in depicting the lives and experiences of members of São Paulo's considerable working class.

By the 1920s, many social groups, including urban workers, rebellious army officers, and members of the middle class, were eager to overthrow the First Republic (1889–1930). There were many unsuccessful revolts during this period. The year 1922 saw not only the Week of Modern Art but also the founding of the Communist Party of Brazil and the military revolt that took place in Copacabana. These events set off a chain of others: the São Paulo Revolution of 1924; the Prestes Column (1924–1927), in which Luis Carlos Prestes, leader of the Brazilian Communist Party, marched with a group of rebellious soldiers through the countryside; and the Revolution of 1930, which in turn led to the rise of President Getúlio Vargas, who would later become dictator.[21]

The turmoil of the political situation affected the art world as well. The transition from the

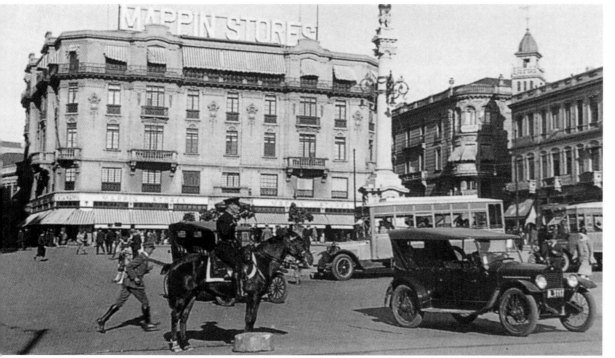

Figure 23. Plaza del Patriarca and Mappin Building, c. 1930.

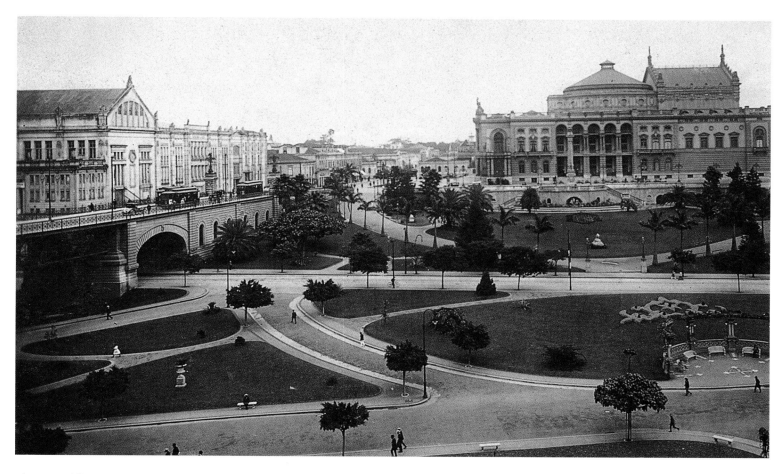

First Republic to Vargas's Estado Novo manifested itself as a turn from the modernism of upper-class artists in the 1920s to the Social Realism of artists of the 1930s. Art began to reflect a growing interest in the working class andits concerns, as depicted in the woodblockprints of Lívio Abramo and in the founding, in 1933, of *O Homem Livre,* a leftist journal to which the art critic Mário Pedrosa regularly contributed.[22] The Santa Helena group comprised artists of Italian descent who had worked as housepainters and later took up easel painting, first as a hobby but then with increasing professionalism.[23] The fact that São Paulo's mainstream art world eventually took them seriously indicates that major changes had taken place since the Week of Modern Art in 1922. The growing impetus to explore the concerns of the working class, both in Brazil generally and in São Paulo, eventually compelled the modernist writer Mário de Andrade to criticize his own colleagues from the 1920s, arguing: "This absence of a social art is a considerable omission among us, even though we understand quite well the aesthetic dilettantism, characteristically bourgeois, in which we persist."[24]

Also during this time, the growth and diversification of the art world made the lack of modern art museums increasingly noticeable. Indeed, the only major art museum was the Pinacoteca do Estado, which had been founded in 1905 and was a bastion of academic art. Although two groups of artists, the Sociedade Pró-Arte Moderna and the Club of Modern Artists, formed in 1932 as a remedy for this problem, they were unstable organizations that lacked consistent funding and at times openly invited the wrath of the Vargas regime. As a result, both organizations were dissolved two years later.[25]

By the late 1940s, two major museums of modern art had sprung up as an outcome of the rivalry between two São Paulo businessmen, Ciccillo Matarazzo and Francisco de Assis Chateaubriand. Assis Chateaubriand was a journalist and owner of the first communications network in Brazil, which included newspapers, radio, and television. He founded the Museu de Arte de São Paulo in 1949 and acquired its permanent collection by taking advantage of the postwar crisis in the European art market to purchase works of art at very low prices. Matarazzo inherited a metalworking business from his uncle and invested a great deal of his personal money in the founding of the Museu de Arte Moderna, also in 1949.[26] While competition between Chateaubriand and Matarazzo existed at one level, there was also a more general sense of competition between São Paulo, as Brazil's largest and most industrialized city, and Rio de Janeiro, which in the early 1950s was still the nation's capital and, at least from the time of the Imperial period (1822–1889), had held the reputation of being Brazil's center of high culture.[27]

The museums that Chateaubriand and Matarazzo founded were mixed blessings, for they brought the international art world to the doorstep of São Paulo and with it North American political intervention.[28] International politics strongly influenced the art of the postwar period, and artistic style acquired new levels of meaning. After World War II, a sense of opposition between realism and abstraction had started to develop, which, according to Aracy Amaral, actually masked

Figure 25. The Atelier Abstração, showing Jaques Douchez, Leyla Perrone, Samson Flexor, 1954.

a debate about nationalism (figuration) and internationalism (abstraction) in Brazilian art. In the postwar context, realism came to have associations with humanism, since it placed importance on the human figure rather than on technology, which for the realists was symbolic of war and had been made manifest in the atomic bomb.[29] This understanding of artistic style eventually fueled the misconceptions that Arte Concreta was anti-humanist and was also somehow a manifestation of Euro-American imperialism.

In fact, the rising popularity of geometric abstraction (as well as the development of new museums and cultural institutions) resulted from the growing economic prosperity in Brazil in the early 1950s, focused around the city of São Paulo. The first wave of modernism had occurred because of the vast wealth accumulated through the export of coffee in the early 1920s. After 1929, the Great Depression created a drop in the price of coffee that eventually forced Vargas to intervene in the economy, although reluctantly. Vargas provided loans to businesses and other financial incentives, while World War II opened up markets that had previously been closed to Brazil. As a result, industry expanded in the 1930s and 1940s, and the country worked toward the goal of reducing Brazil's reliance on imported goods by producing them at home.[30] During the early 1950s, when Arte Concreta was developing, the country had not yet achieved the vast expansion in industrialization that would occur with the regime of Juscelino Kubitschek (1956–1960). Still, the

economy was growing, and people felt a wave of optimism after the end of Vargas's authoritarian regime (although they still elected him president in 1951).

Many consider the early 1950s to have been an ideal time in São Paulo. The city was just the right size, with just the right amount of infrastructure, luxury goods, and culture to make it an enjoyable place to be—mostly from a middle- and upper-class point of view. The year 1954 seems to have been a transitional one for São Paulo, a moment when the city stood poised between what it had been and what it would eventually become. During the first wave of modernism, the main achievements in São Paulo's urban development had been very basic: paved streets, buildings that echoed the French Neoclassical style, the widespread use of electricity and telephones, and the construction of the city's first museums and first department store. During the Vargas regime's Estado Novo period (1937–1945), Francisco Prestes Maia, a civil engineer, became mayor of São Paulo. He was responsible for taking São Paulo to a new level of modernity, in terms of its urban design. He widened many of the streets in the city's center, making them more accessible to cars, and built a series of new bridges, including the new Viaduto do Cha, which led to the relocation and expansion of the city center.[31]

After the renovations undertaken by Prestes Maia, the focus of the city's affluence moved from the Triangle to the Praça Ramos de Azevedo, giving more *paulistanos* than ever access to its pleasures. In a highly symbolic gesture, the department store Mappin moved to this location, where it remained until its closure. During the 1950s, the people of São Paulo walked the streets of the city's center, looking in shop windows, visiting teahouses, bars, and theaters, and generally enjoying the pleasures of urban life. It was a time when the streets were clean and people could dress up in public without fear of attracting the attention of criminals—a time viewed with much nostalgia today.[32]

São Paulo developed a thriving café and bar scene at this time. The *clubinho,* for example, was the meeting place of the most famous art critics, writers, and artists. "Everybody knows what the *clubinho* is," proclaimed Paulo Mendes de Almeida. "It is the Club of Artists and Friends of Art, which still exists today, in its headquarters at the Rua Bento Freitas #306, in the basement of the building at that location."[33] This was one of the favorite hangouts of Waldemar Cordeiro, the self-appointed spokesman of Arte Concreta. It was the place to be seen, to discuss art, and even to get into a fight. In this heightened atmosphere, Cordeiro began to gather a group of people around him, including Luiz Sacilotto, Anatol Wladyslaw, and others. Many of these young artists had participated in the *19 Painters* exhibition at the Prestes Maia Gallery in 1948, and they occasionally discussed ways in which their work, which in the beginning was strongly based on Expressionism, could be pushed in a more experimental direction. Some, such as Sacilotto, had already begun

to move toward abstraction; Cordeiro, an art critic for the *Folha da Manhã,* pushed them even farther with his thorough knowledge of abstractionist movements in Europe.[34]

The artists who joined Cordeiro's group came from diverse backgrounds that reflected São Paulo's status as a city of immigrants. Luiz Sacilotto and Geraldo de Barros were Brazilian. Sacilotto, the son of Italian immigrants, had grown up in Santo André, an industrial area on the outskirts of the city. Lothar Charoux was Austrian, Kazmer Fejer and Anatol Wladyslaw were Polish, and Cordeiro himself was the son of an Italian father and a Brazilian mother, both of whom eventually opted for Brazilian citizenship. Leopoldo Haar, a Hungarian, also eventually joined the group. He became an instructor at the Museu de Arte de São Paulo in the Instituto de Arte Contemporânea, where a generation of some of the most famous designers in Brazil had received training. These included people like Alexandre Wollner, Mauricio Nogueira Lima, and Antonio Maluf, who designed the poster for the first I Bienal de São Paulo. Many of these artists maintained strong ties with Europe, either because of their families or because their education took them there, and as a result they began to espouse an abstract style that revealed the influence of Swiss and Russian Constructivism and the Bauhaus. Max Bill, the Swiss director of the Hochschule für Gestaltung in Ulm, where many Brazilian abstractionists had trained, was another major influence.[35]

From the very beginning, Arte Concreta generated controversy, less because of its style than because of the reputation of its founder, Waldemar Cordeiro. When the tall, handsome, extremely outspoken Cordeiro showed up at the Instituto de Arte Contemporânea, the students would whisper, "'Do you know who that tall guy is over there?' 'Yes, that's Cordeiro, the agitator. Don't let him in—he's

dangerous!'"[36] The inaugural moment of Arte Concreta—the Ruptura exhibition of 1952—became notorious for the distribution of the Ruptura manifesto (figure 27) on opening night, which further emphasized the group's radicalism. In the manifesto, Cordeiro argued that "the scientific naturalism of the Renaissance—the old process of rendering the (three-dimensional) external world on a (two-dimensional) plane—has exhausted its historical task." He then distinguished between "the Old," which included everything from "all varieties and hybrids of naturalism" to "the mere denial of naturalism (e.g., Surrealism, art of the insane)" and "hedonistic non-figuration, the product of gratuitous taste." In contrast, "the New" was "artistic intuition endowed with clear and intelligent principles as well as with great possibilities of practical development."[37] The manifesto made such an impression that the art critic Sérgio Milliet devoted most of his review of the exhibition to a critique of it. He dismissed it as the product of young, impetuous artists and complained that it was unclear whom it was meant to attack.[38]

Cordeiro responded to Milliet's criticism in his 1953 essay "Ruptura," in which he explained in much greater detail what he meant by "hedonistic non-figuration"—namely, a certain sentimentality in Milliet's own writing about the work of Cícero Dias, a Brazilian modernist painter who spent most of his time living in Paris. Cordeiro further condemned the work of fellow abstractionists Samson Flexor and Dias as "hedonistic." He criticized Dias for creating abstract compositions based on old forms (his own still lifes and landscapes), and Flexor for his paintings that seemed to evoke a sense of perspective, thus failing to respect the plane of the canvas.

The Romanian-born artist Samson Flexor ran a studio inside his home, the Atelier Abstração, where he taught abstract painting

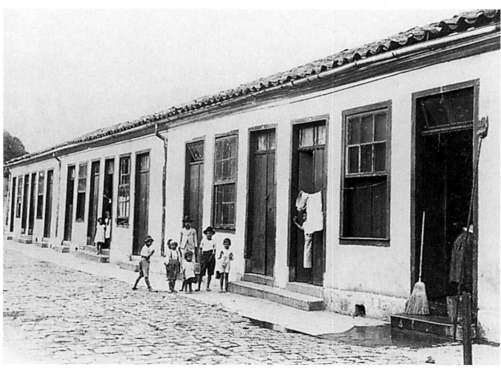

ruptura

charroux — cordeiro — de barros — fejer — haar — sacilotto — wladyslaw

a arte antiga foi grande, quando foi inteligente.
contudo, a nossa inteligência não pode ser a de Leonardo.
a história deu um salto qualitativo:

não há mais continuidade!

então nós distinguimos
 ● os que criam formas novas de princípios velhos.
 ● os que criam formas novas de princípios novos.

por que?

o naturalismo científico da renascença — o método para representar o mundo exterior (três dimensões) sôbre um plano (duas dimensões) — esgotou a sua tarefa histórica.

foi a crise foi a renovação

hoje o novo pode ser diferenciado precisamente do velho. nós rompemos com o velho por isto afirmamos:

é o velho

● tôdas as variedades e hibridações do naturalismo;
● a mera negação do naturalismo, isto é, o naturalismo "errado" das crianças, dos loucos, dos "primitivos" dos expressionistas, dos surrealistas, etc. . . . ;
● o não-figurativismo hedonista, produto do gôsto gratuito, que busca a mera excitação do prazer ou do desprazer.

é o novo

● as expressões baseadas nos novos princípios artísticos;
● tôdas as experiências que tendem à renovação dos valores essenciais da arte visual (espaço-tempo, movimento, e matéria);
● a intuição artística dotada de princípios claros e inteligentes e de grandes possibilidades de desenvolvimento prático;
● conferir à arte um lugar definido no quadro do trabalho espiritual contemporâneo, considerando-a um meio de conhecimento deduzível de conceitos, situando-a acima da opinião, exigindo para o seu juízo conhecimento prévio.

arte moderna não é ignorância, nós somos contra a ignorância.

Figure 27. Front cover of the Ruptura manifesto, 1952.

Figure 26. Housing complex in Bella Vista quarter.

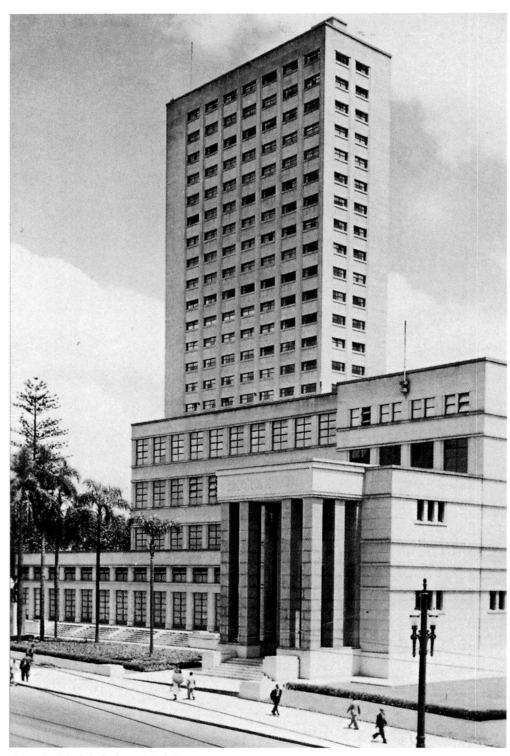

Figure 28. Mário de Andrade Municipal Library.

techniques (figure 25). He instructed students to start with a physical object—a guitar or a still life—and reduce it to a series of geometric forms, using techniques similar to those of Cubism. This approach differed strongly from Cordeiro's, which was to conceive of the work of art as free of all representational references. The stylistic differences between the Ruptura artists and those of the Atelier Abstração eventually led to more vociferous disagreements. Flexor referred to the Ruptura artists as the "concretinoids," and Milliet sided with Flexor, criticizing Arte Concreta as being purely decorative, inaccessible to the public, and lacking in inventiveness.[39]

Cordeiro's antagonistic relationship with other artists and art critics eventually expanded geographically to include colleagues from Rio de Janeiro. The National Exhibition of Concrete Art, which occurred from 1956 to 1957 in both São Paulo and Rio, was the beginning of a long rivalry between the São Paulo–based Concrete artists and poets and their Rio counterparts, the Neo-Concretists. As the Rio-based Concrete artist Hermilindo Fiaminghi pointed out in an interview, the goal of this exhibition was not to provoke a confrontation between the two groups but rather to present a comprehensive retrospective of Arte Concreta that included poetry and visual arts from both Rio and São Paulo. The works in the exhibition dated from 1951–1953 and earlier, long before any rivalry between the two groups existed. According to Fiaminghi,

"The *cariocas* gave themselves credit for the progressiveness of their ideas and theories and credited the *paulistanos* with nothing more than being obsolete in everything they said and did."[40] Still, rather than align himself with the *paulistanos,* Fiaminghi wrote a letter officially expressing his break with them. For him, they had grown elitist and had reduced themselves to "a few cats that only meowed when they were allowed to."[41]

In retrospect, this charge of elitism seems inaccurate. Unlike the modernists of the 1920s, the artists involved in Arte Concreta were generally members of the working class who needed to earn a living from something besides their art. They worked as chemists, writers, architects, and designers and made art in their spare time.[42] But the details of their lives have been lost in the debate over style. Similarly, Cordeiro's own outspokenness as a writer has overshadowed the fact that he, like the Concrete poets, was interested in a kind of populism as expressed through geometric abstraction. Their particular type of leftist thinking sought a revolutionary form of art that would elevate the masses intellectually. Their approach differed from that of the Neo-Concretists, who conceived of art as a way to create awareness among the masses and to spur them to action. Changing political and social circumstances—the creation of Brasília in 1955–1960 and its failure as a modernist utopia, the eventual rise of the military government in 1964—also doomed Arte Concreta, linking it erroneously with the military government and therefore tarnishing its image.

It also seems, in retrospect, that the critics misunderstood Arte Concreta. Precisely because the Concretists made works of art that were purely abstract, Arte Concreta left itself open to any reading that viewers imposed on it. After the rise of the military government, the city of São Paulo acquired many negative associations. It was the home of many ultraconservative student and business organizations that wholeheartedly supported authoritarianism; it was where the death squads of the military police killed the urban guerrilla and leftist hero Carlos Marighella, and where purges of Communists caused the complete destruction of the philosophy department building at the University of São Paulo.[43] During the so-called Economic Miracle of 1969–1974, also the years of the worst political oppression and torture in Brazil, the military government funded technological and industrial development. This investment led directly to the vast urban sprawl for which São Paulo is known today, as thousands and eventually millions of people from Brazil's impoverished northeast relocated to the city, hoping for a better future. One can well imagine that, in this context, Arte Concreta was seen as irrelevant, imperialist, and even fascist for attempting to impose a vision of order that in Brazil was simply impossible.

São Paulo eventually regained some of its reputation as a progressive city in the late 1970s with the metalworkers' protests, the efforts of the Catholic Archdiocese of São Paulo to expose the government's continued practice of torture, and the mid-1980s movement called Elections Now! That movement led to the first truly democratic presidential elections in twenty years. Arte Concreta, however, was not so quick to recover.

Somehow, amid the political strife and the growth in popularity of such Rio-based artists as Hélio Oiticica and Lygia Clark, the original goals of Arte Concreta have been lost in the

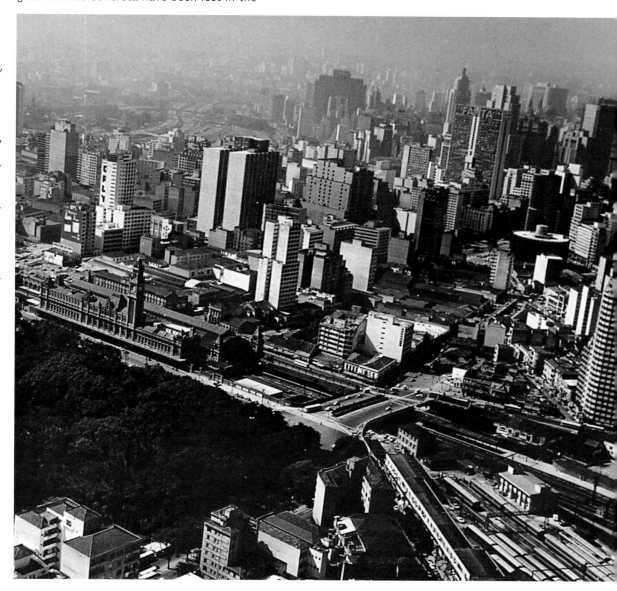

Figure 29. Downtown São Paulo, c. 1950.

shuffle. Few remember Cordeiro's interest in the Italian political theorist Antonio Gramsci, or Cordeiro's statement that the Concretists believed, like Gramsci, that

culture comes to exist historically only when it creates a unity of thinking between [the masses] and artists and intellectuals. Indeed, it is only in this symbiosis with the masses that art purifies itself of intellectualizing elements and of its subjective nature, and becomes [truly] alive.[44]

This was a radically different understanding of the relationship between the working class and the intelligentsia than the one that most Brazilian leftists tended to espouse. Cordeiro was suggesting the integration of intellectuals with workers, whereas many

noigandres 4

poesia concreta

Figure 30. Cover of *Noigandres 4, Poesia Concreta,* 1958.

leftists, including members of Ferreira Gullar's own Centro Popular de Cultura, took a much more patronizing approach, arguing that artists needed to show the working class appropriate forms of art and lead it to an awareness of its own oppression.[45]

In spite of this difference, it is important to remember that both movements sought radical new ways of relating to the viewer. The Concretists created works that were, they claimed, pure products of the imagination, totally divorced from any sort of context, while the Neo-Concretists sought complete integration of the work of art with both the viewer and the environment. Ferreira Gullar often questioned Cordeiro's insistence on the work of art as a product, critiquing the idea that a work of art could be totally separated from its context. In so doing, he made a statement that reminds us today of Arte Concreta's connection with São Paulo and the 1950s: "Cordeiro . . . agrees that a work of art is the product of its time. It is not an expression, but rather the fruit of an inevitable coincidence between the mechanisms of the individual and social."[46]

Notes

All translations are the author's unless otherwise noted.

1. Ferreira Gullar, "Da Arte Concreta à Arte Neoconcreta," in Aracy Amaral, ed., *Projeto construtivo brasileiro na arte (1950-1962)* (Rio de Janeiro: Museu de Arte Moderna do Rio de Janeiro; and São Paulo: Secretaria da Cultura, Ciência e Tecnologia do Estado de São Paulo, Pinacoteca do Estado, 1977), 108 (originally published as Ferreira Gullar, "Da Arte Concreta à Arte Neoconcreta," *Jornal do Brasil,* July 18, 1959).

2. Ronaldo Brito, *Neoconcretismo: Vértice e ruptura do projeto construtivo brasileiro na arte,* 2nd ed. (São Paulo: Cosac & Naify, 2002), 51.

3. Cited in Beverly Adams, "Locating the International: Art of Brazil and Argentina in the 1950s and 1960s" (Ph.D. diss., The University of Texas at Austin, 2000), 83–84.

4. The term *carioca* refers to a person from Rio de Janeiro; *paulista or paulistano,* to a person from the city of São Paulo.

5. Ferreira Gullar, "Concretos de São Paulo no MAM do Rio," in Amaral, ed., *Projeto construtivo brasileiro na arte,* 140 (originally published as Ferreira Gullar, "Concretos de São Paulo no MAM do Rio," *Jornal do Brasil,* July 16, 1960).

6. The architect and urbanist Ernesto Mange, cited in Cláudio Willer, "A cidade e a memória," *Cidade: Revista do Museu da Cidade de São Paulo* 1 no. 1 (1994): 7.

7. Nabil Bonduki, "São Paulo at the Turn of the Twenty-First Century: The City, Its Culture, and the Struggle against Exclusion," *Parachute* 116 (2004): 99.

8. Warren Dean, *The Industrialization of São Paulo, 1880–1945* (Austin: University of Texas Press, 1969), 4–10.

9. Dean, *The Industrialization of São Paulo,* 51.

10. Michael Hall, "Imigrantes na Cidade de São Paulo," in Paula Porta, ed., *História da Cidade de São Paulo* (São Paulo: Paz e Terra, 2004), 121–51.

11. Dean, *The Industrialization of São Paulo,* 73, 76–77.

12. Cited in Aracy Amaral, *Plastic Arts in the Week of '22,* trans. Elsa Oliveira Marques, rev. ed. (São Paulo: BM & F, 1992), 82.

13. Zuleika Alvim and Solange Peirão, *Mappin: Setenta años* (São Paulo: Ex Libris, 1985), 28–30.

14. For more information on the *cortiços,* see Raquel Rolnik, "São Paulo in the Early Days of Industrialization: Space and Politics," in Lúcio Kowarick, ed., *Social Struggles and the City: The Case of São Paulo* (New York: Monthly Review Press, 1994), 77–93.

15. Aracy Amaral, "Surgimento da Abstração Geométrica no Brasil," trans. Izabel Burbridge, in Aracy Amaral, ed., *Arte Construtiva no Brasil: Coleção Adolpho Leirner/ Constructive Art in Brazil: The Adolpho Leirner Collection* (São Paulo: Companhia Melhoramentos/Dórea Books and Art, 1998), 29–63.

16. Randal Johnson, "Brazilian Modernism: An Idea Out of Place?," in Anthony L. Geist and José B. Monleón, eds., *Modernism and Its Margins: Reinscribing Cultural Modernity from Spain and Latin America* (New York: Garland, 1999), 193.

17. Two sources that present a critical view of Brazilian modernism are Tadeu Chiarelli, *Um Jeca nos vernissages* (São Paulo: Edusp, 1995), and Annateresa Fabris, *O futurismo paulista* (São Paulo: Editora Perspectiva, 1994). Chiarelli argues that the modernists took advantage of Monteiro Lobato's harsh criticism of the work of Anita Malfatti to emphasize the subversive nature of their work. Fabris analyzes how Futurist writers constructed an image of São Paulo as the modernist city par excellence. Daryle Williams's study of Vargas's use of culture includes a description of audience members heckling modernist writers when they performed readings of their work during the Week of Modern Art; see Daryle Williams, *Culture Wars in Brazil: The First Vargas Regime, 1930–1945* (Durham, N.C.: Duke University Press, 2001), 41.

18. Dona Olivia Guedes Penteado, cited in Aracy Amaral, "Dona Olivia na cena modernista," in Denise Mattar, ed., *No tempos dos modernistas: D. Olivia Penteado, a Senhora das Artes* (São Paulo: Fundação Penteado, 2002), 107.

19. Dawn Ades, ed., *Art in Latin America: The Modern Era, 1820–1980* (New Haven, Conn.: Yale University Press, 1989), 136.

20. Two sources that explore this argument in detail are Adams, "Locating the International," and Aracy Amaral, *Arte para quê? A preocupação social na arte brasileira, 1930–1970* (São Paulo: Nobel, 1984).

21. Marshall Eakin, *Brazil: The Once and Future Country* (New York: St. Martin's Press, 1998), 40–43.

22. The title of the journal means "the free man"; see Amaral, *Arte para quê?*, 36–38, 40.

23. For more on the Grupo Santa Helena, see Paulo Mendes de Almeida, *De Anita ao museu* (São Paulo: Editora Perpectiva, 1976); Walter Zanini, *A Arte no Brasil nas décadas de 1930–40: O Grupo Santa Helena* (São Paulo: Livraria Nobel, 1991); and Walter Zanini, *O Grupo Santa Helena* (São Paulo: Museu de Arte Moderna de São Paulo, 1995).

24. Mário de Andrade, cited in Amaral, *Arte para quê?*, 41.

25. Walter Zanini, *História Geral da arte no Brasil,* vol. 2 (São Paulo: Instituto Walther Moreira Salles/Fundação Djalma Guimarães, 1983), 583.

26. Rosa Artigas, "São Paulo de Ciccillo Matarazzo," in Agnaldo Farias, ed., *50 Anos Bienal de São Paulo, 1951–2001* (São Paulo: Fundação Bienal de São Paulo, 2001), 50–51.

27. Leonor Amarante, *As Bienais de São Paulo, 1951–1987* (São Paulo: Projeto, 1989), 13.

28. In 1932, the Roosevelt administration initiated the Good Neighbor Policy, which used American cultural institutions, both high and low, to promote political interests in Latin America. Nelson Rockefeller, an heir to Standard Oil and president of The Museum of Modern Art (MoMA), New York, worked with a group of people who wanted to establish museums of modern art in Brazil, using MoMA as a model. Rockefeller donated thirteen pieces to be divided between the museums of modern art in Rio de Janeiro and São Paulo. This new North American interest in Brazil and its culture took many other forms, ranging from the creation of Zé Carioca, a Disney cartoon parrot representing Brazil, to a proliferation of U.S. films starring Carmen Miranda. At first glance, these would not seem to have been much of a threat, but many Brazilians viewed them as quite insidious and as perpetuating stereotypes. For more on the Good Neighbor Policy and U.S. involvement in Brazilian art, see Artigas, "São Paulo de Ciccillo Matarazzo," 48–49; Donald Marquand Dozer, *Are We Good Neighbors? Three Decades of Inter-American Relations, 1930–1960* (Gainesville, Fla.: University of Florida Press, 1959); Antonio Pedro Tota, *O imperialismo no sedutor: A americanização do Brasil na época da segunda guerra* (São Paulo: Companhia das Letras, 2000); and Sérgio Augusto, "Hollywood Looks at Brazil: From Carmen Miranda to Moonraker," in Randal Johnson and Robert Stam, eds., *Brazilian Cinema* (New York: Columbia University Press, 1995), 351–61.

29. Amaral, *Arte para quê?*, 229–30.

30. Dean, *The Industrialization of São Paulo,* 207–23.

31. Hugo Segawa, "São Paulo, veios e fluxos, 1872–1954," in Porta, ed., *História da Cidade de São Paulo,* 381–84.

32. For more on nostalgia for São Paulo's past, see Teresa P. R. Caldeira, *City of Walls: Crime, Segregation, and Citizenship in São Paulo* (Berkeley: University of California Press, 2000); Cristina Freire, *Além dos mapas: Os monumentos no imaginário urbano contemporâneo* (São Paulo: SESC Annablume, 1997); and Cláudio Willer, "A cidade e a memória," *Cidade: Revista do Museu da Cidade de São Paulo* 1 no. 1 (1994): 4–21.

33. Mendes de Almeida, *De Anita ao museu,* 197.

34. Maurício Nogueira Lima and Flávio Motta, cited in Enock Sacramento, *Sacilotto* (São Paulo: Orbitall, 2001), 56.

35. Nogueira Lima and Motta, cited in Sacramento, *Sacilotto,* 58.

36. Nogueira Lima and Motta, cited in Sacramento, *Sacilotto,* 57.

37. Waldemar Cordeiro, "Manifesto Ruptura," in Amaral, ed., *Arte Construtiva no Brasil: Coleção Adolpho Leirner,* 266. For more on the Ruptura exhibition, see Rejane Cintrão and Ana Paula Nascimento, "The Exhibition of the Rupture Group in the São Paulo Museum of Modern Art, 1952," trans. Anthony Doyle and David Warwick, in *Grupo Ruptura: Revisitando a exposição inaugural* (São Paulo: Cosac & Naify/ Centro Universitário Maria Antônia, 2002).

38. Sergio Milliet, "Duas exposições," in João Bandeira, ed., *Arte concreta paulista: Documentos* (São Paulo: Cosac & Naify, 2002), 46 (originally published as Sergio Milliet, "Duas exposições," *O Estado de São Paulo,* December 13, 1952).

39. Maria Alice Milliet, "Atelier Abstração," in Amaral, ed., *Arte Construtiva no Brasil: Coleção Adolfo Leirner,* 65–93.

40. Fernando Cocchiarale and Anna Bella Geiger, "Interview with Hermelindo Fiaminghi," in Anna Bella Geiger and Fernando Cocchiarale, eds., *Abstracionismo, geométrico e informal: A vanguarda brasileira nos anos cinqüenta* (Rio de Janeiro: FUNARTE/Instituto Nacional de Artes Plásticas, 1987), 135.

41. Cocchiarale and Geiger, "Interview with Hermelindo Fiaminghi," 136.

42. Aracy Amaral, "Duas linhas de contribuição: Concretos em São Paulo/Neoconcretos no Rio," in Amaral, ed., *Projeto construtivo brasileiro na arte,* 312.

43. Two excellent sources on the military government in Brazil are Maria Helena Moreira Alves, *State and Opposition in Military Brazil* (Austin: University of Texas Press, 1985), and Thomas E. Skidmore, *The Politics of Military Rule in Brazil, 1964–1985* (New York: Oxford University Press, 1988). For a more concise description of the military regime's rise to power, see Joan Dassin, ed., *Torture in Brazil: A Report by the Archdiocese of São Paulo* (New York: Vintage Books, 1986), 60–67.

44. Waldemar Cordeiro, "O objeto," *Arquitectura e Decoração* (December 1956), reprinted in Anna Bella Geiger and Fernando Cocchiarale, eds., *Abstracionismo, geométrico e informal,* 224.

45. The Neo-Concrete movement lasted from the late 1950s to 1961. Afterward, Ferreira Gullar became involved with the Centro Popular de Cultura (CPC), a leftist organization that sought to help the masses develop a sense of class consciousness by performing agit-prop plays on streets and in front of factories, publishing books of poetry, and producing other types of books as well as recordings. The CPC, which lasted from 1962 to 1964, was disbanded after the rise of the military government. For a critical analysis of the CPC, see Christopher Dunn, *Brutality Garden: Tropicália and the Emergence of a Brazilian Counterculture* (Chapel Hill, N.C.: University of North Carolina Press, 2001), 40–43; and Carlos Estevam, "For a Popular Revolutionary Art," in Johnson and Stam, eds., *Brazilian Cinema,* 58–63.

46. Gullar, "Da Arte Concreta à Arte Neoconcreta," 109.

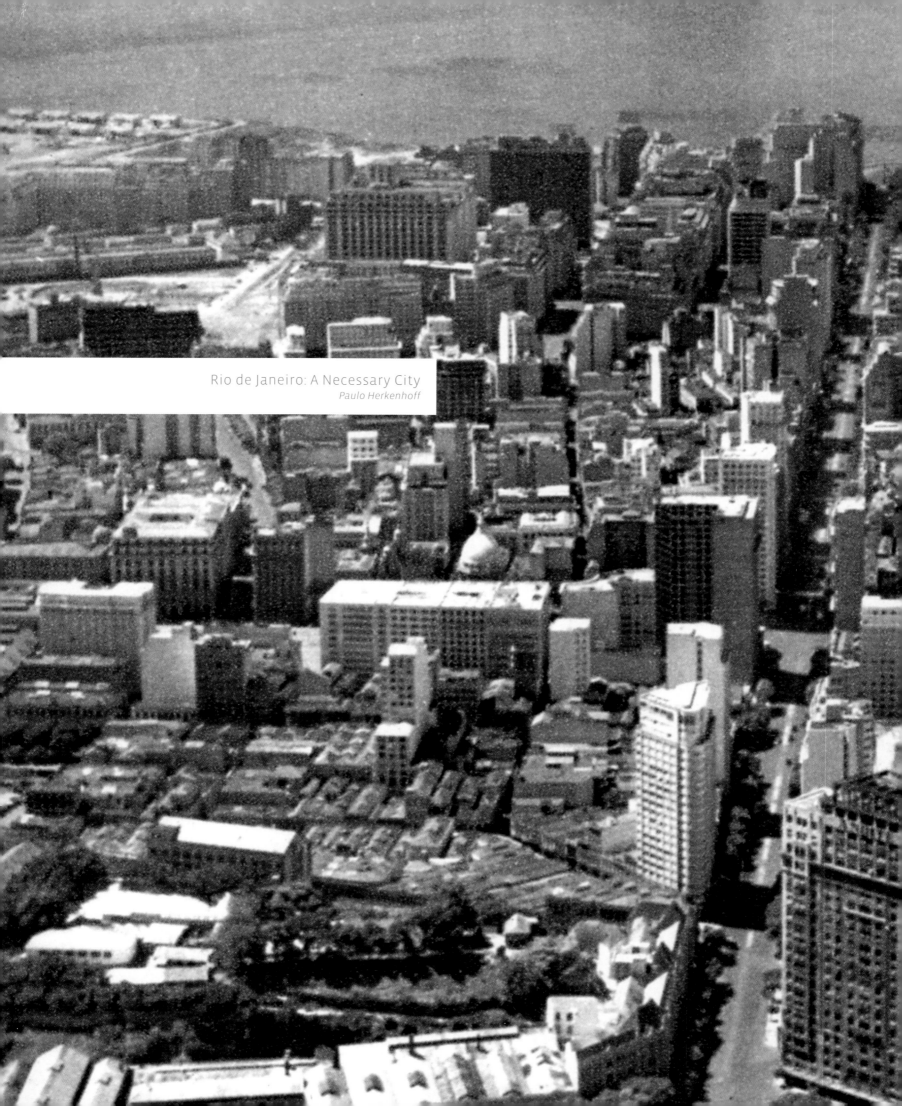

Rio de Janeiro: A Necessary City

Paulo Herkenhoff

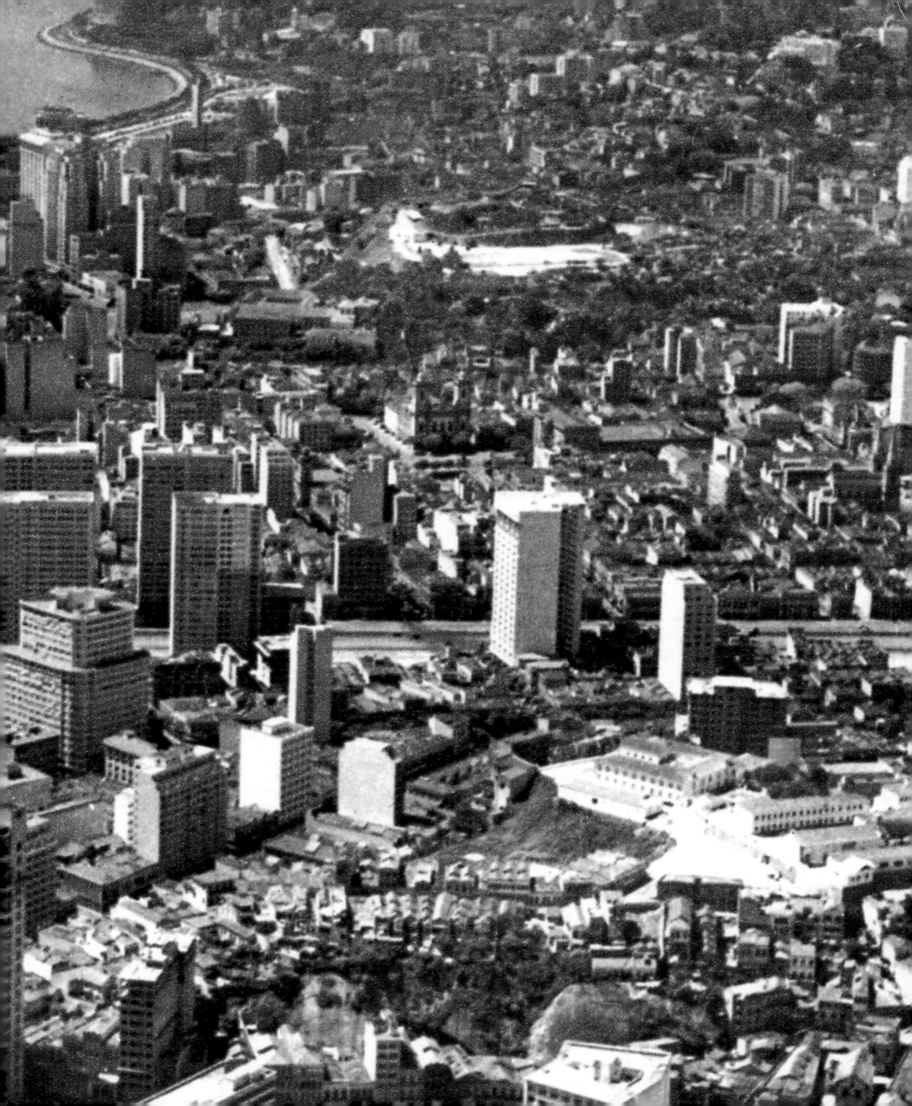

Between the end of the Vargas dictatorship, in 1945, and the beginning of military rule, in 1964, Rio de Janeiro—the cosmopolitan capital of Brazil until 1961—became a cultural center of international significance.[1] But Europe and the United States did not have the critical capacity to recognize the city for what it was. This incapacity is evident in Bernard Myers's 1958 essay "Painting in Latin America: 1925–1956," where Myers, on the basis of a weak relationship of forms, compared an atypical Concretist collage by Ivan Serpa to the work of Willem de Kooning.[2] In the prevailing thinking of the North, Latin America is either a mirror or nationalism. And so everything became dissolved in a "continentalism" that failed to distinguish among works, artists, and countries, which were all lumped together under the geographical label "Latin America." A fabric woven of specific signifiers was unraveled. The region became a place without *another* history.

The critic Mário Pedrosa evaluated Brazil's participation in the IV Bienal de São Paulo in an article he titled "Pintura Brasileira e Gosto Internacional" ["Brazilian Painting and International Taste"].[3] He attacked the biennial's international jury (writing "They pretended they hadn't seen Volpi"), focusing particularly on Alfred Barr, director of The Museum of Modern Art in New York (MoMA). He accused Barr of being irritated by Max Bill's importance in Brazil, and of not understanding the genesis of the Argentine group Nueva Visión. Pedrosa asked, ironically, whether South Americans should refuse to allow themselves to be influenced by Picasso, Rouault, Soutine, or even by the "glorious discoveries" of MoMA in the "Peter Blume genre." He accused the members of the jury of defining as "indigenous" everything that showed "primitivism, romanticism, wilderness-ism—that is, at the end of the day, exoticism."

Modern Rio

From 1923 to 1950, the Palace Hotel in Rio de Janeiro housed the only continuously functioning space for modern art in Brazil. The hotel developed the most important modernist program in the country, exhibiting the work of Oswald Goeldi, Tarsila do Amaral, Lasar Segall, Tsuguharu Foujita, Cândido Portinari, Emiliano di Cavalcanti, Alberto da Veiga Guignard, Ismael Nery, and others. In the postwar period, favorable economic conditions would further Brazil's industrialization and lead to additional development of the arts, all while terrible poverty in rural Brazil accelerated the process of urbanization. In 1945, the Askanazy Gallery opened in Rio as the country's first commercial art gallery, with a show of art—by Marc Chagall, Lovis Corinth, Wassily Kandinsky, Paul Klee, and Segall—that had been condemned by the Third Reich. The Museu de Arte de São Paulo was inaugurated in 1947, the modern art museums of Rio de Janeiro and São Paulo in 1948, and the Bienal de São Paulo in 1951. In a number of fields, the intense cultural life of Rio exploded with new sensitivity.

The Brazilian "Constructive project"[4] emerged toward the end of the 1940s through the activity of such artists as Almir Mavignier, Ivan Serpa, and Abraham Palatnik and the critic Mário Pedrosa in Rio de Janeiro, and in São Paulo with the production by Geraldo de Barros of his series of abstract photographs titled Fotoformas (plates 14 and 15). It was Pedrosa who, having studied in Germany and worked in Washington, finally professionalized art criticism in Brazil, abandoning the modernist model of the critic-essayist as exemplified by Mário de Andrade, Oswald de Andrade, Manuel Bandeira, and Murilo Mendes.

Pedrosa, a reader of Edmund Husserl and Ernst Cassirer, initially engaged in a solid cultural criticism rooted in philosophy and international artistic currents. He wrote for the *Correio da Manhã*, a newspaper belonging to Niomar Muniz Sodré, President of the Museu de Arte Moderna do Rio de Janeiro (MAM-Rio). Pedrosa represented an epistemological leap in the Brazilian art world. He transformed both criticism and art into the production of knowledge. Neo-Concretism—the *carioca*[5] difference—was the source of discussions on aesthetics, visual ideas, philosophical positions, conceptions of history, theories of perception, strategies concerning the social practice of art, and dialogue between the arts.

The Dance of All the Arts

The literary nerve center of Brazil was Rio de Janeiro, a city of abundant literary production. In 1945, a generation of writers emerged in Rio. Theater in the city revealed, with biting precision, the conformist morality of the bourgeoisie; in the plays of Nelson Rodrigues, for example, desire shines forth disturbingly. The works of João Guimarães Rosa, Clarice Lispector, and João Cabral de Melo Neto exhausted the modernist paradigm of regionalism. One indication of the city's cosmopolitan character is that each of these writers was involved in the diplomatic world; for instance, João Cabral, a geometrician of language, was posted to Seville, where he met Joan Miró and Antoni Tàpies.

Some of Lispector's writings can be compared to Lygia Clark's works, in terms of the imaginary world they represent. *Mineirinho* (1962), Lispector's account of the death by gunfire of a bandit by the same name, is a piercing reflection on urban social marginalization and collective responsibility: "The thirteenth bullet is the one that kills me—because I am the other." This desire for alterity is also found in Oswald de Andrade's "Antropofagia" (1928), the theory of a Brazilian culture formed through a metabolization of all contributions. It was in the work of Lygia Clark, Hélio Oiticica, and artists of subsequent generations, however, that the desire for alterity was realized. It became a hallmark of the art of contemporary Rio, and today it has spread throughout the country. A work by Oiticica in his Bolides series, titled *Homenagem a Cara-de-Cavalo [Homage to Cara-de-Cavalo]* (1966), relates the story of another

dead criminal, and this work has something of Lispector's ethos.

During the 1950s, Concrete poetry reached new heights in São Paulo, while Rio saw the emergence of Neo-Concrete variants, always connected to art. Certain differences—over questions of semantics, semiotics, space and time—pitted the brothers Haroldo and Augusto de Campos, Concrete poets, against the Neo-Concrete poet Ferreira Gullar. For Gullar, in Rio, Neo-Concrete poetry operated in verbal time, whose duration had a Bergsonian pedigree; it located a non-objective, organic space-time that was present in phenomenological perception: "The engine of a poem is not an automatic result of formal and external factors . . . the engine of a poem is the word itself."[6] The visual poet Osmar Dillon made the word itself the basis of poetic form. At one extreme of the inventive spectrum, Reinaldo Jardim and other poets—like the visual artist Lygia Pape, in her Livro da Criação [Book of Creation] (plate 30)—constructed what Gullar called "the infinite book"[7] vis à vis poetic circularity, which is also present in Lygia Clark's Bichos [Critters].

Cinema in Brazil lagged after Mário Peixoto's cult film Limite [Limit] (1931), even though the country had directors of the caliber of Alberto Cavalcanti and Humberto Mauro. Musicals, melodramas, and lowbrow comedy were booming in the postwar period. A politicized Cinema Novo [New Cinema] emerged with great difficulty in the early 1960s. Based in Rio, Cinema Novo was a focal point of the cultural life of the city. It focused on poverty, alienation, and the lack of social mobility. This was a Brechtian undertaking for Nelson Pereira dos Santos, Cacá Diegues, Glauber Rocha, Joaquim Pedro de Andrade, Leon Hirzsman, and others. It was cinéma d'auteur with a sharp eye for social concerns, class warfare, and national and popular culture: the Third World had acquired its missing aesthetic.[8]

The 1950s was the era of radio. All of Brazil listened to Rádio Nacional. Broadcasting from Rio, it was the single most important bridge uniting the whole country. But television was emerging, too. Its first revelation had been a demonstration that took place in Rio in the 1930s. Brazilian television programming began in São Paulo in 1950 with TV Tupi, which later on began broadcasting from Rio as well. The country's other unifying links were two Rio-based magazines, O Cruzeiro and Manchete, which were dedicated to the photojournalism of such professionals as José Medeiros and Flávio Damm. For the first time, the means of mass communication presented a broad portrait of Brazilian society in all its cultural diversity and striking social differences. Mass communication provided Brazil with a self-image.

Rio de Janeiro was the great laboratory of Brazilian music. "All the arts aspire to the condition of music," wrote Pedrosa.[9] Following the path trod by Roger Fry, and by Susanne K. Langer in Philosophy in a New Key (1948), Pedrosa discussed the abstract nature of music among artistic languages. And Hélio Oiticica, having explored the samba, as

reflected in his Parangolés, shifted his interest to rock. He noted that it wasn't only the formal categories of visual artistic creation (painting, sculpture, and so on) that had lost their borders and boundaries; the divisions between the so-called arts had been eliminated as well. "I discovered," Oiticica wrote, "that what I do is MUSIC, and that MUSIC isn't 'one of the arts' but the synthesis of the consequence of discovering the body."[10]

If we leave aside the presence of the carioca Heitor Villa-Lobos, the great musical parallel of Neo-Concretism was bossa nova. It was tantamount to what Hélio Oiticica called the "general constructive will" as a point of arrival for experimental processes.[11] A great many musicians in the city developed what would come to be known as bossa nova, beginning with the recording by João Gilberto of Tom Jobim's song "Chega de Saudade" ["Enough Sadness"] in 1958, the key year for Neo-Concretism. Bossa nova substituted popular music's base of a memorable melody with a construction that integrates melody (frequently non-diatonic), harmony, rhythm, and counterpoint.[12] Its lack of melodic variety gives importance to the harmonic structure, which is placed in harmonic-tonal tension. The chords of bossa nova serve harmonic and percussive functions, in contrast to previous traditions in Brazilian music. An urban musical genre, bossa nova added elements from the Afro-Brazilian tradition, cool jazz, and bebop. Bossa nova's rhythmic beat coexisted with lyrics whose sonorous value constituted a significant element of the overall mix. Interpretations are intimate and lacking in rhetorical effects. It has a Constructivist character or, according to Dominique Dreyfus, is "nearly minimalist."[13]

While musicians in Rio were constructing bossa nova, the carioca architect Lúcio Costa was designing Brasília, a city that was to replace Rio as the new federal capital. Built between 1957 and 1961, Brasília would set the standard for Brazilian urban design. Pedrosa wrote nearly twenty-five articles in the Rio de Janeiro press about architecture and urbanism during the construction of Brasília. For him, "the task of architecture wasn't to discover or rediscover the country. The country had always been there, present with its ecological characteristics, its climate, its soil, materials, nature, and all that is in it that is inescapable."

As the showcase of President Juscelino Kubitschek's developmentalist social democracy, Brasília presented itself as a national symbol, the promise of development, and a rush to a future that would leave social backwardness behind. This promise was to be frustrated, though, by the coup of 1964. By the time the military dictatorship emerged, most of Brazil's geometric art was already in existential crisis.[14] Toward the end of the 1950s, however, Brasília was a social utopia. The country's new capital city had been built on a geographical blank slate, and in the center of the country. Oscar Niemeyer, another carioca architect, was responsible for its major buildings. Starting with the Pampulha project

Figure 32. The Sugar Loaf. Photograph by Antoine Bon, c. 1950.

use of such public and communal spaces as the beach, Carnaval, and the soccer field (for example, with the construction of Maracanã Stadium, with an initial seating capacity of two hundred thousand).[16]

Design followed two paths in the postwar period in Rio. Joaquim Tenreiro came out of the Portuguese cabinetmaking tradition. He created an organic modern style of furniture, which took advantage of Brazilian wood and wicker, light structures, and tropical amenities. In 1962, the designer Charlotte Perriand traveled to Rio. In close partnership with the architect Maria Elisa Costa, she worked on projects in the city. Graphic designers, with the Bauhaus as their point of departure, produced first-rate work, such as the artist Amilcar de Castro's layouts for the newspaper *Jornal do Brasil*. The *Jornal do Brasil*'s Sunday supplement, under Gullar's leadership, became the voice for avant-garde currents and for the momentum of Brazilian culture. A course in typography at the MAM-Rio in 1961, proposed by Aloísio Magalhães, led to a plan by Alexandre Wollner and Tomás Maldonado to create the Advanced School for Industrial Design (ESDI) in 1962. At that time, Maldonado published "O problema da educação artística depois da Bauhaus" ["The Problem of Artistic Education since the Bauhaus"] in the *Jornal do Brasil*.[17] ESDI, the first school of its kind in Latin America, followed the functionalist maxims of Max Bill's Hochschule für Gestaltung, in Ulm, Germany.

Popular culture, excluded by the modernist elite,[18] experienced its own twentieth-century modernization through such outlets as Carnaval, music, and cheap paperback books sold by street vendors. For Mikhail Bakhtin, carnival drove out obsolete genres, and in Rio it wasn't any different. If Carnaval was the "feast of races," as Oswald de Andrade proclaimed in "Manifesto da Poesia Pau-brasil" ["Brazil-Wood Poetry Manifesto"] (1928), then Rio de Janeiro was its cauldron of African, indigenous, and European rhythms. In 1960, the Salgueiro Samba School invited Fernando Pamplona, set designer at the Teatro Municipal, Rio's opera house, to plan its Carnaval parade. From that point, Carnaval evolved to its current grandiose form. In 1963, the Mangueira Samba School asked the Neo-Concrete sculptor Amilcar de Castro to design an allegorical carnival float (the school's participants had difficulty understanding his green-and-pink geometric proposal).[19] And the relationship between Carnaval and elite culture went both ways: it was in the process of integrating his work with Carnaval that Oiticica was first taken to the Mangueira School by the sculptor Jackson Ribeiro, and the *favela* where the school was located became the source and inspiration for his work *Tropicalia* (1967). Under the influence of the 1965 Carnaval designs by Pamplona and Arlindo Rodrigues for the Salgueiro Samba School, Oiticica developed his Parangolés (1966), which used cloaks and flags, thus maintaining a close relationship between Carnaval and an operatic, popular fusion of the senses. This was the culmination of supersensorality as Oiticica labeled the

in Belo Horizonte, the capital of the state of Minas Gerais, Niemeyer adopted a baroque sensuality in his architecture. The buildings of Brasília and the architectural symbols of the cities of Belo Horizonte and São Paulo (the Parque do Ibirapuera and the Copan Building) are based on the architecture of Rio de Janeiro. In Rio, the landscape architect Roberto Burle Marx incorporated the vegetation of the tropics, the sensual design of planters, and plants as elements of sculpture and natural history. His work was integrated into urban planning throughout all of Brazil, and into the new developmentalist architecture of Venezuela in the 1950s as well.[15]

The great centralizing metropolis of Rio de Janeiro is itself is a mix of engineering and the tropics. Throughout the twentieth century, major urban and social projects were undertaken in Rio. Flattened hills and coastal landfills produced an invented geography right on top of nature, in harmony with an exuberant natural landscape. The colonial center disappeared. No other Brazilian city went through structural changes as important as these. In Rio, there was an expansion in the democratic

multiplicity of the senses in open, collective situations.[20]

Reason and Madness

In the 1940s, the Jungian psychiatrist Nise da Silveira introduced the occupational therapy practices of the Psychiatric Hospital Dom Pedro II to the Engenho de Dentro neighborhood of Rio. This was the most productive experiment blending art and psychotherapy in all of Brazil. Silveira invited Almir Mavignier and, later on, Serpa and Palatnik to assist her. According to Palatnik, "One day Mavignier said to me, 'Let's go meet some colleagues.' I didn't know he was taking me to the hospital. Along the way, I was surprised at the things he said to me, because they were things of great interest to me."[21] These artists became the first group of abstract-geometric artists in Rio. They were shaped by their experiences at the psychiatric hospital and by Pedrosa's text *Da Natureza Afetiva da Forma na Obra de Arte [On the Affective Nature of Form in Art]* (1949). Similarly, at the hospital called Colônia Juliano Moreira in Rio, "praxis therapy" maintained the perspective that art "showed unknown aspects of illnesses." In that hospital, Arthur Bispo do Rosario, a patient from 1960 to 1989, carried out his monumental work of reconstructing the world through the production of a thousand objects. Nevertheless, these two experiments in therapy remained isolated from each other. Silveira's approach, based on Jungian theory, included the concepts of archetypal images, the collective unconscious, and systems of symbols. Silveira strongly criticized Ugo Cerletti's use of electroshock therapy and the abusive chemical treatments employed with institutionalized patients. Her practices aimed at "the rehabilitation of the individual, returning him to his community at a level of functioning superior even to where he was before the psychotic break,"[22] and they opposed the Cartesian concept of the subject in terms of a mind/body dichotomy.[23]

Nise da Silveira was jailed during the Vargas dictatorship.[24] Psychiatric hospitals were akin to brutal prisons. Pedrosa became involved in Nise de Silveira's work. Although she wasn't a militant activist, she sympathized with Trotskyist ideals.[25] Pedrosa, having been a member of the Brazilian Communist Party, opposed the counterrevolutionary positions of Stalin in the III International. From that point on, he aligned himself with Trotsky's ideas, creating the International Communist League in 1931. This shared vision, the mirage of social utopia through the lens of art, brought together both critic and doctor.

In Germany, Pedrosa studied Gestalt theory. The critic was a careful reader of Sigmund Freud, Roger Fry, Hans Prinzhorn, Rudolf Arnheim, Herbert Read, and others. In spite of the irreconcilable epistemological differences between the theories of Freud and Jung, Pedrosa and Silveira shared an understanding of expression as a kind of social utopia. They both had a certain affinity for Trotsky's views as a system of thought that integrated the relationship between art and life. Faced with the visual energy of the paintings of children and the mentally infirm, Pedrosa saw the impossibility of apprehending modern art: the public is unable to "discern the basis of the artistic phenomenon."[26] This was his first attempt at coming to terms with the mechanical rationality of abstract intellectualism after an understanding of the unconscious. Pedrosa understood that art as therapy may lead to a "harmony of the complex character of the subconscious and a better alignment of human emotions." That idea of treatment is present in the artistic production of Lygia Clark, after her experience of undergoing psychoanalysis with Pierre Fédida in Paris and her activities as a professor at the Sorbonne (1970–1975). Clark researched the therapeutic potential of her "relational objects" in the context of her theories on the infrasensory.

The psychiatric hospital harbored a surprise. In 1949, Arthur Amora, an outpatient, painted "dominoes" reduced to simple black squares on a white surface. He arranged modular rhythms, optical contrasts, an ordered play of form, and tricks of perception. Mavignier was impressed with his "consequential geometrism."[27] For Mavignier, Amora was involved in therapy, not art. In Rio, the first experiences of rational images of Concrete form occurred in a mental hospital. This was the contagion between reason and emotion, which found a place between the distant sources of tension within the offerings of Neo-Concrete art.

The Museum of Modern Art

In 1952, Maria Martins donated Jean Dubuffet's *Portrait d'Antonin Artaud* (1947) to the Museu de Arte Moderna do Rio de Janeiro. The work was the homage of the *art brut* theorist to the writer whose psyche had been withered by electroshock treatments. In 1945, Artaud wrote a letter from the sanatorium in Rodez: "Electroshock therapy drives me to despair . . . it turns me into an absent person who knows he is absent and sees himself for weeks on end in search of himself."[28]

From its founding in 1948, the MAM-Rio further deepened its connections with the artistic avant-garde. Following the example of MoMA, the modern art museums of Rio de Janeiro and São Paulo in part reflected the involvement of Nelson Rockefeller with Latin America. As Assistant Secretary of State for Inter-American Affairs (1944–1945), Rockefeller sought to create anti-Nazi alliances in the Americas.

Beginning with Niomar Muniz Sodré Bittencourt's term as Director of the MAM-Rio in 1952, Concrete art came to be interwoven with the museum.[29] The museum first operated out of the Ministry of Education building, a project of Le Corbusier, Lúcio Costa, Oscar Niemeyer, Affonso Eduardo Reidy, and others. Bittencourt entrusted the design of the MAM-Rio's new buildings to Reidy, expanded the collection, sponsored innovative exhibitions, and organized courses. These were some of the bases for the emergence of Neo-Concretism. Under Bittencourt, the collection of the Museum of Modern Art grew rapidly, with the objective of achieving historic coherence.[30] His private collection included

works by Piet Mondrian, Mark Rothko, and Alberto Giacometti.

Young people studying in Rio would be surrounded by the works of Cubist, geometric, or Concrete art at the MAM-Rio: Pablo Picasso's *Tête cubiste* (1909), Constantin Brancusi's *Melle Pogany* (1920), and works by Fernand Léger, André Lhote, Paul Klee, Josef Albers, Max Bill, Friedrich Vordemberge-Gildewart, César Domela, Lucio Fontana, Bruno Munari, Michel Seuphor, Yacov Agam, and the South Americans José Pedro Costigliolo, María Freire, Alfredo Hlito, and Enio Iommi, among others. Rio had significant links with the Surrealists. Living in Paris between 1927 and 1929, Pedrosa came into contact with Joan Miró, Yves Tanguy, André Breton, and Benjamin Péret, Pedrosa's brother-in-law. The sculptor Maria Martins, wife of the Brazilian ambassador to the United States, belonged to a New York art circle that included Alfred Barr, Marcel Duchamp, Piet Mondrian, Jacques Lipchitz, William S. Hayter, and Louise Bourgeois. Under Maria's guidance, the Surrealist collection of the MAM-Rio took form with works by Jean Arp, Salvador Dalí, Max Ernst, Alberto Giacometti, Jacques Lipchitz, René Magritte, Roberto Matta, Miró, and Tanguy. The collection juxtaposed the rationality of Cubist and Concrete art with Surrealism's logic of the unconscious, a tension that was transferred to Neo-Concretism.

Abstract Expressionism and the New York School made their first appearance in Rio de Janeiro with the MAM-Rio's acquisition in 1952 of the paintings by Mark Rothko (*No. 4-A,* 1947 and *Orange and Yellow,* 1951), William Baziotes, and donations by Nelson Rockefeller of paintings by Robert Motherwell and Jackson Pollock (*No. 16,* 1950). Understanding the differences between the two cities, Rockefeller kept his more conservative donations (Chagall) for the São Paulo MAM. While in Brazil, the Clubes de Gravura (Printmaking Clubs) multiplied, following the Mexican example of the Talleres de Gráfica Popular (Graphic Arts Workshops) of Communist Party and Zdanovian inspiration; the new museums and the São Paulo Bienal became strategic pieces in the cultural chess game of the Cold War. Nevertheless, Rothko and Pollock's works were never reduced to being pawns in that game. In Rio as in New York, their work was understood as visual thought. Neo-Concretism and Minimalism assumed divergent positions with regard to Abstract Expressionism.

Education

In the postwar period, Brazilian art schools were not responsive to this new restlessness. Rather, the education of many artists took place in private studios. Lygia Clark studied with Burle Marx, who was assisted by Zélia Salgado.[31] Two salons that existed in Rio during the 1950s—Mário Pedrosa's house, which was open to artists, and gatherings on Sundays at Ivan Serpa's—were spaces for critical debate on cultural production. The didactic experimentation of Serpa at the MAM-Rio had been supported conceptually by Pedrosa

since 1952. Serpa's students included Aluisio Carvão, Rubem Ludolf, João José Costa, and Hélio and César Oiticica.

The MAM-Rio became a center for the exploration of form, permeated by reflections on the experience of psychiatric art therapy and discussions on Gestalt theory and the phenomenology of perception. The courses at the MAM-Rio constituted a second phase of Concrete art in Rio de Janeiro, since they produced artists who succeeded the trio from Engenho de Dentro (Mavignier, Palatnik, and Serpa) prior to the formation of the Grupo Frente.

Serpa published *Crescimento e Criação [Growth and Creation]* in 1954, when Oiticica, seventeen years of age, was his student. In the foreword, Pedrosa pointed out the role of phenomenology and Gestalt theory in the "conceptualization of perception" in Serpa's method. Pedrosa highlighted Arnheim's ideas in *Art and Visual Perception* (1954) regarding the fearlessness of emotions and children's understanding of the development of visual concepts. For Pedrosa, Serpa's method went beyond some of Arnheim's observations regarding the genesis of form. He acknowledged that the rigor required of students was in stark contrast to the liberating effects of childlike designs that interfered with the appearance of form and resulted in a "growing complexity of form."

In his writings *Crianças na Petite Galerie [Children in the Petite Galerie]* and *Frade cético, crianças geniais [Skeptical Monk, Genius Children]* of 1957, Pedrosa highlighted aspects of the development and plurality of an understanding of the world from daily life. In the first text, he explored drawings by children and adolescents, such as Carlos Val. Pedrosa also demonstrated familiarity with Read's views in *The Aesthetic Method of Education* (1946),[32] such as those regarding the need to approach "infantile art" with specific criteria: children would not necessarily become artists. Art, he wrote, is a disciplined exercise of mechanical gestures; the role of the teacher was also to be an apprentice to the child. In the second article, he argued for "disarming the arrogance of adults toward children." Pedrosa was in line with what would be the first modern pedagogical movement in Brazil with Anísio Teixeira in Rio (the theory of democratization through education, inspired in part by John Dewey), a forerunner of Paulo Freire's *Pedagogy of the Oppressed* (1970).

Recognizing promising students, Serpa treated them as equals and included them in his exhibitions. Carvão and Val participated in the first show of the Grupo Frente (1954), and Ludolf and the Oiticica brothers participated in the second. The Grupo Frente reflected the eclecticism of his students. The works in Hélio Oiticica's initial Metaesquemas of the mid-1950s, from the group named "dry,"[33] followed Serpa's rigorous emphasis on geometry, precision, and clean lines in a work of art.[34] Serpa demanded vast amounts of production between classes, believing that producing a great deal demonstrated an artist's

professional commitment. This explains why, over the course of two years, Oiticica painted nearly 450 Metaesquemas (mostly gouache on paper), divided into subseries that were generally painted within the space of a week. Serpa encouraged focus.

Constructivist Rio

Between Rio de Janeiro and São Paulo lies an abyss, opened by Mário de Andrade and paved over by some of the historiography produced by the University of São Paulo, ignoring sources of information from Rio de Janeiro.[35] As part of this process, the exclusivist "Bienal phenomenon" ignores or erases other historical factors that are equally determinative. Pedrosa recalled that "above all, Bienal de São Paulo was to broaden the horizons of Brazilian art."[36] The importance of Max Bill, who was awarded the grand prize at the first Bienal, is acknowledged in the history of Concretism, but it should not overshadow the role played by the work of Josef Albers. In Rio there was less attention paid to the mathematics sought by Bill—with the exception of Mavignier in Ulm—and more interest in Albers's series Homage to the Square, as seen in works such as Pape's *Livro da Criação* and Clark's *Unidades [Unities]* (1958). The intellectual field of Neo-Concretism included Gestalt theory, the phenomenology of perception, the sensory, the symbolic character of form, the precise idea of a history of art, correlations among the arts, Bergsonian duration, and non-Euclidian geometry. Experimentalism was highly valued, even as a means of resisting political oppression: "Art is the experimental exercise of freedom," Pedrosa argued. Susanne K. Langer and Maurice Merleau-Ponty were read. In São Paulo, the prevailing interests were in the semiotics of Charles Peirce, and the theory of information of Norbert Wiener. In Rio, critical thinking built on the work of Paul Cézanne, Kasimir Malevich, Mondrian, Georges Vantongerloo, Albers, Alexander Calder, Pollock, and Rothko. Rio's artists were privileged to have benefited from the robust knowledge of Pedrosa and the interpretive capacity of the poet Ferreira Gullar.

In Rio de Janeiro, the "general constructive will" manifested itself in a variety of options in addition to Neo-Concretism. There was everything from technological experiments to spiritual geometry. The gestural and informal were solidly represented by the work of Antonio Bandeira, Flávio Shiró, and Iberê Camargo.

Concretist Rio

The geometrical art of Serpa, Mavignier, and Palatnik made the Concretist difference in the I Bienal de São Paulo. The Grupo Frente (1952) created an experiential tendency through the invention of spaces based on the paradigms of the Bauhaus, the Neo-Plasticists, Vantongerloo, Albers, and Bill. With the determination of Gestalt, Rubem Ludolf's painting was a field for geometrical progressions and modulations that rested or vibrated with optical tension points in the shape of dissonant and centrifugal rhythms. The mirrored surfaces of Ubi Bava created a kinetic seduction. José Oiticica Filho, the father of Hélio, was the most radical geometrical photographer in Brazil. His vision as a mathematician influenced his Constructivist eye. His experiences with amateur photography groups were instrumental in leading him to use the optical, chemical, and technical potential of photography. At one extreme of experimentalism, the concreteness of photography lacked any references to the real: "Photography is made in the laboratory," he said.[37]

Kinetic Rio

Despite Alexander Calder's long stay in the city in the 1950s, Kinetic art had its own development in Rio de Janeiro. The debate surrounding the crisis of paintings as objects, which followed the impasses foreseen by Malevich and Mondrian,[38] led the painter-engineer Abraham Palatnik to engage in daring experiments. His painting was reduced to pure light projected onto the milky translucent surfaces of a box (containing motorized mechanisms that triggered the sources of light). A moving and immaterial painting is purely a phenomenon of light. An international precursor of Kinetic painting, Palatnik's work was shown in the I Bienal de São Paulo (1951). Lacking in knowledge about Brazil, Guy Brett merely cited Palatnik in the show *Force Fields,* even though he included artists who are marginal to Kinetic art, such as Sergio Camargo. Palatnik is an example of an artist's difficulty in being considered part of history when working outside the hegemonic centers.

Sensitive Rio

Fleeing Fascism, the couple Maria Helena Vieira da Silva and Arpad Szènes became refugees in Rio de Janeiro from 1940 to 1947, where they developed the most radical research on space to date in Brazil. Using a play of lines, the grid of the canvas in da Silva's paintings expanded and contracted in virtual movements. Da Silva's work was the first model of sensitive geometry in Brazil. Her circle included Mavignier and Ione Saldanha. Following her example, Saldanha reduced the landscape to flat geometrical structures. Her Matissean eye was the best Brazilian dialogue with Alfredo Volpi on the chromatic chords and the lightness of painting. As few others were able to, Salhanha experimented with ordinary materials for support, such as bamboo and industrial spools, to place the pictorial object in real space.

Another couple, Maria Leontina and Milton Dacosta, developed a poetic geometry. Both arrived at abstract art through the slow reduction of form. The painting of Leontina and Dacosta fits fairly well within the concept of "sensitive geometry," as Damian Bayón and Aldo Pellegrini described the geometry of Latin America.[39] Rather than imbuing form with subjectivity, they painted without the programmatic label of excessive objectivity. Faced with the clashes proposed by Concretism, such as the verbal machine gun of Waldemar Cordeiro, Leontina and Dacosta

found refuge in painting, as the Italian Giorgio Morandi had done during the war.

Metaphysical Rio (Time)

The intense thinking about time in the experimentation of Neo-Concretism was initially based on the ideas of Henri Bergson, as had also been true with regard to Umberto Boccioni for Futurism and to Malevich for Suprematism.[40] The Bergsonian concept of duration was useful to the theories of perception and metaphysics and to the subjectification processes of Neo-Concretism, whose salient characteristic over time was made evident in the experience of a work and in theoretical reflections.[41]

(Under)Developed Rio

Parallel to Cinema Novo, Pedrosa, Gullar, and Haroldo de Campos researched the possibility of an autonomous culture in the Third World.[42] Drawing on the work of Friedrich Engels, Georg Lukács, and Karl Popper, they abandoned the idea of progress in art. In São Paulo, Campos tackled the deterministic fallacy of Brazil's having produced only a culture of dependence. In his text *Da razão antropofágica: diálogo e diferença na cultura brasileira [On Anthropophagic Reason: Dialogue and Differences in Brazilian Culture]* (1980), he explored the possibilities of genuine and experimental avant-garde literature in a country of the periphery: "In relation to art, it is known that certain periods of artistic flowering are in no way related to the general levels of development of society, nor, consequently, to the material basis, the bone structure if you will, of its organization." In the article "Vicissitudes do Artista Soviético" ["Vicissitudes of the Soviet Artist"] (1966), Pedrosa deplored the regulatory role of the capitalist market in art as well as the oppression of Soviet bureaucracy within the context of the Cold War. In the Third World, the artist has a better chance of avoiding the conditioning role of capital or of ideological subjugation. In his book *Vanguarda e Subdesenvolvimento [The Avant-Garde and Underdevelopment]* (1969), Gullar publicly proclaimed resistance by means of a struggle for the emancipation of culture through resistance to alienation.

The Narcissism of Minor Differences

In *Civilization and Its Discontents,* Freud discussed the "narcissism of minor differences" in relation to disputes between cities.[43] This phrase is perfectly applicable to the case of São Paulo and Rio. The 1952 Ruptura manifesto, a model of São Paulo's Concretism, led by the Gramscian Waldemar Cordeiro, would introduce a kind of rationalism. It opposed the "old," understood as the "natural mistakes" made by children, the demented, "primitive" expressionists, Surrealists—in sum, much of the experience that had already been seen in Rio de Janeiro.[44] This was Henri Lefèbre's thesis when he attacked Sartre's existentialism.[45] In defense of the writer, Merleau-Ponty argued that the social phenomenon should not be separated from the description of the essence and the existence of Others. He argued that Idealism and Existentialism did not understand liberty or intersubjectivity. His arguments regarding non-Cartesian perception and development of a way of seeing became more relevant. Pedrosa adjusted Trotskyism to phenomenology.

Neo-Concrete Rio

In 1959, Gullar's Neo-Concrete manifesto set out the organizing principles of the group, in a schism with the Concrete movement of São Paulo. For Pedrosa, the Concrete painter "would like to be a machine for creating and developing ideas." Against such excessive objectivity, Neo-Concretism rescued subjectivity, affirmed the presence of the arts, and turned the public into the subject of aesthetic actions, calling for a "life experience" that would conform to art itself, as in Clark's *Bichos*. Neo-Concretism included Lygia Clark, Hélio Oiticica, Lygia Pape, Aluisio Carvão, Décio Vieira, Amilcar de Castro, and Franz Weissman in Rio as well as Hercules Barsotti and Willys de Castro in São Paulo. The manifesto, drawing on some of Pedrosa's ideas, proclaimed that

the Neo-Concrete, born of the need to express the complex reality of modern man within the structural language of newer plastic arts, negates the validity of positivist and scientifically oriented attitudes in art and restates the problem of expression, incorporating the new "verbal" dimensions created by non-figurative constructive art ... so that the concepts of form, space, time, structure—which in the arts are linked to an existential, emotional, affective meaning—are confused with the theoretical application that science makes of them.

Discussions about Gestalt and the phenomenology of perception found their way into Gullar's "Teoria do Não-Objeto" ["Theory of the Non-Object"] (1959): "No one fails to understand that our human experiences are never limited to only one of our five senses, since a person reacts as a totality." In his essay, Gullar establishes "hermeneutical parallels" to the theory of space, color, the symbolic character of form, and status of the object in the works of Clark, Oiticica, and other Neo-Concretists.

Steps toward Autonomy

It was not by accident that Neo-Concretism was the first reckoning between Brazilian art and the history of art. If we restated the scattered opinions of critics and artists, we would be able to reach conclusions about the steps taken by Neo-Concretists to position themselves in a productive and strategic relationship to the history of art:

1. A Hegelian and Marxist view of history, grounded in the philosophical education of Pedrosa, which did away with any positivist remnants of the history of art in Brazil.

2. Pedrosa first introduced method into Brazilian criticism. His German training

Figure 33. Aerial view of Copacabana, Urca, and Botafogo beaches. Photograph by Marcel Gautherot.

encouraged openness toward phenomenology, as a means of understanding the production and reception of art. Upon his return to Brazil, after having been exiled in New York (1943–1945), Pedrosa lived in Rio, where he solidified his relationship to art. Rio de Janeiro was the environment that learned best the phenomenology of Merleau-Ponty, and this had fertile consequences for art—perhaps better than in France, and before Minimalism.

3. Without the anxiety of the new, the Neo-Concretists did not have a desire to impress abroad. In "Pintura Brasileira e Gosto Internacional" ["Brazilian Painting and International Taste"] (1957), Pedrosa stated that Brazilian artists (and, with the exception of Volpi, he focuses on those from Rio) "do not care if what they are currently doing is not that which is fashionable in Europe or in the United States."[46] Neo-Concretism did not seek external validation, nor did it have oblique intentions.

4. History was no longer understood as a progression of movements, or "isms" to be overcome under the requirement to constantly be updating, as was true for mod-

ernism. The concepts of "influence" were revoked. Pedrosa criticized notions such as "style" and models that were endlessly being substituted. Oiticica stated that "'style' no longer 'exists': with Duchamp, all that had already reached its limit."[47]

5. Neo-Concretism anchored itself in knowledge of modern art, its theoretical principles, origins, and development, with a level of discernment never before seen in Brazil.[48] The Neo-Concrete evolution of the 1960s, as well as other manifestations of art, broke all limits. Pedrosa asserted, "We are no longer within the parameters of what has been called modern art. You will call this postmodern art, to account for the difference."[49] Thus Rio de Janeiro was a global precursor in the construction of postmodern theory.

6. Neo-Concretism defined itself within the history of art. Gullar noted in his "Teoria do Não-Objeto" that "it is with Mondrian and Malevich that the elimination of the object continues. . . . Painting is what remains, unconnected, in search of a new structure, of a new way of being, of new meaning." Pedrosa argued that the object

faced a crisis with Breton and disappeared in Brazil's avant-garde, whose decisive limits in 1959 were Lygia Clark's *Bichos* and Gullar's "Teoria do Não Objeto," which concluded: "The non-object is not an anti-object but a special object in which a synthesis of sensory and mental experiences is expected: a body that is transparent to phenomenological knowledge, wholly perceptible, and which tends to perception without leaving a trace."

7. History would not be a cluster of heroes to be admired. All would be subject to critical evaluation. In "Bienal, Panorama do Mundo" ["Bienal, The Global Panorama"] (1954), Pedrosa noted that modern architecture does not operate according "solely to the attributes of great personalities."[50] In his aforementioned attack, Pedrosa ironically wondered if Barr wasn't frustrated not to see the influence of Picasso in Brazil. In "Reposta a Cordeiro" ["Response to Cordeiro"], Gullar provoked the Concretists by stating, "They continue to walk in step and work out in orderly unison, following the whistle of Max Bill. . . . The true lesson of the masters is in their independence and in the search for their own expression."[51]

8. The key was the act of valuing difference. We saw Pedrosa's harsh commentary on the members of the jury at the IV Bienal de São Paulo: the international jury did not see Volpi. The productive world had by then lost its center.

9. In "Cézanne's Doubt" (1956), Merleau-Ponty stated that, according to Cézanne, the artist founds a culture anew: "He speaks as the first man spoke and paints as if no one had ever painted before."[52] Thus, in his rejection of mechanistic Concretism, Gullar asserted that "a work of art cannot be merely the illustration of concepts which had already existed."[53] To produce art is not to make prior thought visible.

10. Nor would history become a repertoire of images to be reinterpreted. As Oiticica observed, "The INVENTOR artist does not need to add works of art."[54] Neo-Concretism was a process of invention.

11. Neo-Concretists understood that the history of art was not univocal but was instead a collection of plastic problems, as in science. Art is a process of knowing, and for this reason experimentation and invention are worthwhile. Cezanne's lesson about the cognitive process of painting and its philosophical character deserves attention.

12. An artist's challenge is to respond to the legacy of questions unanswered by his predecessors. His challenge is what has been left unresolved. Without the "anguish of influence," Clark writes a "Carta a Mondrian" ["Letter to Mondrian"] (1959): "You already know that I am working on *your problem,* which is painful."[55] What most interested Clark, Oiticia, and Pape in the work of Mondrian may have been

Broadway Boogie Woogie, but starting from the limits that had held Mondrian back. Using the concept of a project, they understood their ontological task. In Neo-Concretism, Brazilian art for the first time was included in the modern history of art as an established autonomous voice and a unique poetics.

The precise strategies of Neo-Concretism responded to the aspiration for Brazil's cultural emancipation. Art was shifting from the modernist model of nationalist representation (as translations of European parameters in local color) toward a search for a language of its own, which would follow a new semantic model. In spite of the dynamic furor of modernism, painting would remain pre-Cubist, nationalist, and dependent on those regionalist notions. Neo-Concretism overcame the limitations of Brazil's sociocultural environment.

The richness of the aesthetic and theoretical results of Neo-Concretism and the way in which it was involved with the city of Rio de Janeiro suggest a final paraphrase. In "Cézanne's Doubt," Merleau-Ponty concluded about the painter that "this work which still had to be made required this life," and we may suggest that the production of Neo-Concretism, its development, required this city of Rio de Janeiro.

Notes

1. This essay draws on and expands some of the author's previous work on the culture of Rio de Janeiro. See also the writings of Paulo Venancio Filho on Rio de Janeiro in Iwona Blazwick, ed., *Century City: Art and Culture in the Modern Metropolis* (London: Tate Modern, 2001).

2. In Charles M. Curdy, ed., *Modern Art: A Pictorial Anthology* (New York: Macmillan, 1958), 204.

3. Mário Pedrosa, "O Brasil na IV Bienal," in Otília Arantes, ed., *Acadêmicos e Modernos* (São Paulo: EDUSP, 1998), 280. All the citations from Pedrosa in this paragraph are taken from this source.

4. The expression was coined with the exhibit *O Projeto Construtivo Brasileiro na Arte [The Brazilian Constructivist Project in Art]* organized by Aracy Amaral and Ronaldo Brito in the Pinacoteca do Estado in São Paulo and in the Museu de Arte Moderna of Rio de Janeiro in 1977.

5. The term *carioca* means "of or from Rio de Janeiro."

6. Ferreira Gullar, "Da Arte Concreta à Arte Neoconcreta," *Jornal do Brasil,* July 18, 1959.

7. Ferreira Gullar, "Palavra, Humor, Invenção," *Jornal do Brasil,* December 10, 1960.

8. Evidence of the integration of the arts through Cinema Novo can be seen in that Hélio Oiticica was one of the actors in Glauber Rocha's film *Câncer* (1963). Lygia Pape designed posters or banners for films made by Cinema Novo directors: *Mandacaru Vermelho [Red Mandacaru]* (1960) and *Vidas Secas [Barren Lives]* (1963), by Nelson Pereira dos Santos; *Ganga Zûmba* (1963), by Cacá Diegues; *Deus e o Diabo na Terra do Sol [God and the Devil in the Land of the Sun]* (1964), by Glauber Rocha; and *O Padre e a Moça [The Father and the Young Man]* (1965), by Joaquim Pedro de Andrade.

9. Mário Pedrosa, "Pintores da Arte Virgem," in *Dimensões da Arte* (Rio de Janeiro: Ministério da Educação e Cultura, 1964), 105.

10. Hélio Oiticica, "DE HÉLIO OITICICA PARA BISCOITOS FINOS," unpublished manuscript, Rio de Janeiro, November 11, 1979 (emphasis in original). Handwritten notes conform to the original. For a synthesis of Oiticica's interest in music, see Paulo Herkenhoff, "O q ele fazia era música," *Letras & Artes* 5, no. 12 (1991): 30–31.

11. Hélio Oiticica, "Esquema Geral da Nova Objetividade," in *Nova Objetividade Brasileira* (Rio de Janeiro: Museu de Arte Moderna, 1967), n.p.

12. Diana Goulart, "Bossa Nova: Uma batida diferente," unpublished manuscript, 2000.

13. Dominique Dreyfus, *O Violão Vadio de Baden Powell* (São Paulo, Editora 34, 1999), 85.

14. All over the country, rationalist discourse was being abandoned by such geometric artists as Geraldo de Barros, Lygia Clark, Waldemar Cordeiro, Milton Dacosta, Maria Leontina, Maurício Nogueira Lima, Hélio Oiticica, Lygia Pape, Ivan Serpa, and Franz Weismann.

15. Roberto Burle Marx was first taken to Venezuela in the 1950s by Diego Cisneros, the father-in-law of Patricia Phelps de Cisneros.

16. In her text "Do ato" ["The Act"] (1965), Lygia Clark described "the totality of the world with a single global rhythm, which extends from Mozart to the movements of soccer."

17. Tomás Maldonado, "O problema da educação artística depois da Bauhaus," *Jornal do Brasil,* January 7, 1961.

18. For example, Mário de Andrade excluded from the 1922 Week of Modern Art popular musicians of the caliber of Pixinguinha, who played in Paris in 1922, and Ernesto Nazareth, of whom Darius Milhaud noted "rhythmic richness, the continually reinvented fantasy, verve, vivacity and melodic inventiveness typical of a prodigious imagination."

19. Information on the samba schools is from Sergio Cabral, *As escolas de samba do Río de Janeiro* (Rio de Janeiro: Lumiar Editora, 1996).

20. Clark, by contrast, developed her theory of the infra-sensory in terms of the articulation of one's senses in relation to alterity, or to one's own innermost being.

21. Abraham Palatnik, conversations with the author, 2005.

22. Nise da Silveira, *O Mundo das Imagens* (Rio de Janeiro, Editora Ática, 1992), 19.

23. Similarly, the Concretism of São Paulo involved a confrontation with the persistent Cartesian concept of form.

24. In prison, she got to know the writer Graciliano Ramos, whose sharply observant writing hovers somewhere between Brazilian social drama and memoir, reflecting on life in jail.

25. Luiz Carlos Mello, conversation with the author, June 5, 2006. According to Mello, Nise da Silveira's interest in Trotsky's ideas cannot be denied, but there is scant evidence of it, since she was not a political activist.

26. Mário Pedrosa, *Arte, Necessidade Vital* (Rio de Janeiro: Livrari–Editora da Casa do Estudante do Brasil, 1949), 142. All the citations in this paragraph were taken from this source.

27. Almir Mavignier, *Museu de Imagens do Inconsciente* in *Brasil: Museu de Imagens do Inconsciente* (São Paulo: Câmara Brasileira do Livro, 1994), 25.

28. Antonin Artaud, *Oeuvres Complètes,* vol. 11 (Paris: Gallimard, 1974), 13.

29. The collection was lost in the fire of 1978 while the museum was under the directorship of Heloisa Lustosa.

30. The best catalogue of this institution's collection prior to the 1978 fire is *Patrimônio do MAM,* published in August 1966.

31. Rarely referenced, Zélia Salgado is the pioneer of abstract sculpture in Brazil. Her exclusion from historical accounts is due to the fact that 95 percent of her abstract production was lost in an exhibit that traveled through Europe; it was Salgado who, in 1950, steered Lygia Clark to study in Paris with Isaac Dobrinsky, Clark's best art teacher. Zélia Salgado, interview with the author, September 16, 2004.

32. Herbert Read was cited by Mário Pedrosa in 1947 in an article on art and its relationship to education; the article is reproduced in Pedrosa, *Arte: Necessidade Vital,* 219.

33. César Oiticica, communication with the author, June 6, 2006.

34. Rubem Ludolf, interview with the author, 2004.

35. Mário de Andrade also spun a web of silence around the subject of the modernist artists from the state of Pernambuco (the brothers Vicente and Joaquim do Rego Monteiro, and after 1931, Cícero Dias); see Paulo Herkenhoff, *Pernambuco Moderno* (Recife: Instituto Cultural Bandepe, 2006).

36. Mário Pedrosa, "A Bienal de cá para lá," in Aracy Amaral, *Mundo, homem, arte em crise* (São Paulo: Editora Perspectiva, 1975), 251.

37. Interview with Ferreira Gullar, *Jornal do Brasil,* September 24, 1958.

38. On this point, see Yve-Alain Bois, *Painting as Model* (Cambridge, Mass.: MIT Press, 1991).

39. See Roberto Pontual, "Do Mundo, a América Latina entre as Geometrias, a Sensível," in *América Latina Geometria Sensível* (Rio de Janeiro: Edições Jornal do Brasil, 1978), 8. Others have been credited with the invention of this concept.

40. See Charlotte Douglas, "The New Russian Art and Italian Futurism," *Art Journal* (spring 1975): 238.

41. Ferreira Gullar dealt with time in several of his writings; see, for example, Ferreira Gullar, "Arte Neoconcreta, uma contribuição brasileira," *Revista Crítica de Arte* [Rio de Janeiro] 1 (1962): 108, and Gullar, "Da Arte Concreta à Arte Neoconcreta." Hélio Oiticica wrote "Cor, tempo e estrutura," *Jornal do Brasil,* November 26, 1960.

42. According to Hobsbawm, the term "Third World" was coined in 1952; see Eric Hobsbawm, *The Age of Extremes* (New York: Vintage Books, 1996), 357.

43. Sigmund Freud, *Civilization and Its Discontents,* trans. James Strachey (New York: W. W. Norton, 1961), 61.

44. The manifesto was signed by Waldemar Cordeiro, Geraldo de Barros, Lothar Charroux, Fejer, Haar, Luiz Sacilotto, and Anatol Wladyslaw.

45. Henri Lefèbre, "Existentialisme et Marxisme: Réponse à une mise au point," *Action,* June 8, 1945.

46. Pedrosa, "O Brasil na IV Bienal."

47. Oiticica, "DE HÉLIO OITICICA PARA BISCOITOS FINOS."

48. Pedrosa took on the never-ending task of educating the public and the elites through his writings in the press; on the current situation of art and the history of art in the twentieth century, see Mário Pedrosa, *Panorama da Pintura Moderna* (Rio de Janeiro: MES, 1952).

49. Mário Pedrosa, "Crise do conhecimento artístico," *Correio da Manhã,* July 31, 1966. The term "postmodern" was used countless times by Pedrosa over the years.

50. Mário Pedrosa, *Dimensões da Arte* (Rio de Janeiro: Documentation Service of the MEC, 1964), 184.

51. Ferreira Gullar, "Responsa a Cordeiro," *Jornal do Brasil,* August 13, 1960.

52. In Marcel Merleau-Ponty, *Os Pensadores,* vol. 41, trans. Nelson A. Aguilar (São Paulo: Editora Abril, 1975), 303–16.

53. Ferreira Gullar, "Arte Neoconcreta, uma contribuição brasileira," 108.

54. Oiticica, "DE HÉLIO OITICICA PARA BISCOITOS FINOS."

55. Lygia Clark, "Carta a Mondrian," in *Lygia Clark* (Barcelona: Fundació Antoni Tàpies, 1997), 115.

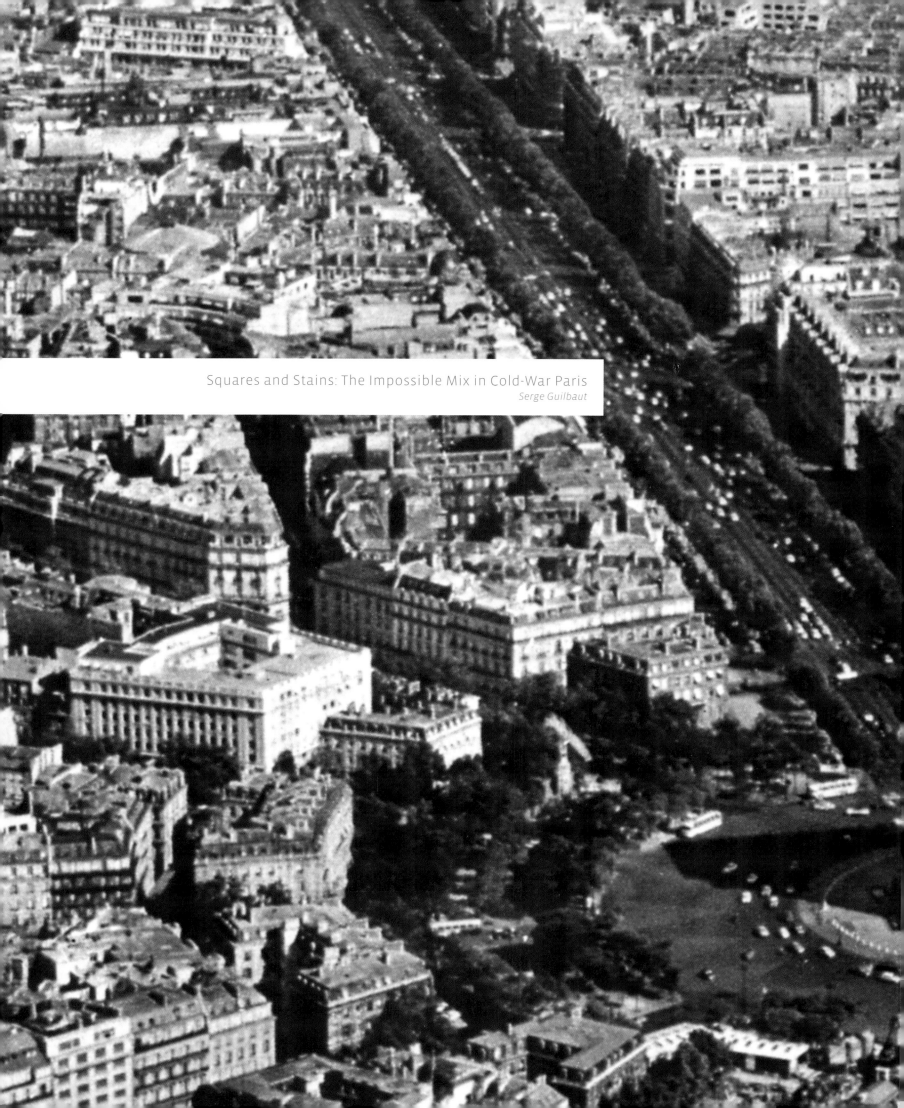

Squares and Stains: The Impossible Mix in Cold-War Paris
Serge Guilbaut

Figure 35. The Arc de Triomphe, the Tuileries, and the Champs-Elysée. Photograph by Willy Ronis, 1961. Copyright Willy Ronis/Rapho.

ing to normal. After the war, in the eyes of its establishment, France was paving the way both culturally and politically, moving toward a new social system, with many characteristics derived from the popular front. This political reorganization, rejecting human exploitation, was able to gain the respect and approval of the Communist Party and the Christian Democratic Party. It was this new realignment, which Courthion saw in action in France and in Paris, in particular, that enabled his bright optimism:

> The French people permit today many great hopes. . . . Yes, grandeur and the reality of France! We can say it without fanfare, as we enunciate something serious, certain, irrefutable, because every free man feels a bit of France in himself and is better for it.[2]

Even if this was hyperbolic, Courthion did indeed capture the general feeling in France immediately after the liberation of Paris. For several months, this hope of transforming a corrupt bourgeois state into a socialist heaven seemed a real possibility. In fact, upon Liberation and for a few years after, France spoke openly of revolution, of a radical transformation in the way the country was run. Albert Camus, Jean-Paul Sartre, Maurice Merleau-Ponty, Louis Aragon, and even the Catholic Emmanuel Mounier were all in agreement. But this postwar ecstasy was short-lived. Indeed, after the intoxicated celebrations of Liberation, it seemed that people were not only hung-over but also stunned. Stunned because if the war was over, life, surprisingly, had not returned to normal; the world had changed forever, and France faced a difficult adjustment. In fact, Liberation left France not only with a blurry historical memory but also with a catastrophic economy. Only foreign aid helped to manage France's initial economic woes. Nevertheless, if France was undeniably on her knees, she might be able recover some of her earlier symbolic aura through the resuscitation of Parisian cultural hegemony. The new elite sought French reconstruction—a renaissance, as it was called—through a return to the aesthetic glories of the past. This reconstruction, then, was not only to be made of bricks and mortar but also to be achieved through the imaginary. The "renaissance" did not draw on the Greek past, since the Nazis had just deployed that particular past to horrible ends, but instead reached back into a historical past and, later, into a prewar avant-garde. It was assumed that the assimilation and development of the ideas of France's prewar avant-garde would restore France's power, her nobility and visibility, and, most important, her universalism.

A long and difficult conquest of a lost paradise thus marked the immediate postwar period. International relations were in a state of disintegration, and art and culture began to play a critical role in East-West foreign policy during the early years of the Cold War.

Previous pages, Figure 34. La Place de L'Etoile. Photograph by Alain Perceval, 1971.

In a lecture from 1944, sometime after the liberation of Paris, the Swiss art critic and historian Pierre Courthion delved into a sharp description of what he thought still constituted the core of French civilization, after an elaborate and lengthy emotional description of the new postwar situation. Even through the typed transcript, one can hear the quavering voice, the slow, profoundly emotional pace of the recitation of what were still, temporarily, for a while, French qualities and vitalities:

> The gift of transmission is a constant of this people. The French do not ignore the fact that man—to be whole—needs alternatively, sun and fog, dream and reality, and far from bringing everything to herself in an arrogant gesture, France has, on the contrary, the power to go toward others, to communicate, to disseminate her thought through the universe. . . . France has the ability to maintain herself between the beast and the angel in a subtle equilibrium made of confidence and humility, of knowledge and intuition, of heavy matter and spiritual flight.[1]

For Courthion, as for some other Frenchmen, it seemed life in France was finally return-

It was in the artistic realm that France, after losing almost everything during the war and the Occupation, hoped to find something to propel her back onto the international stage. The crucial question was the kind of image that would be appropriate for this attempt at international reinclusion—a question not easily resolved. In fact, the severe factional division in the political sphere also violently permeated the cultural sphere. Art critics, writing for politicized newspapers, actively defended different aesthetic strategies according to their individual political positions.

The idea of reconstruction had already been in play before the end of the war among a variety of underground groups and in certain pockets of cultural resistance. Its first theorist was, surprisingly, a medievalist scholar: Pierre Francastel. Right under the noses of the Fascists—even during the Occupation—Francastel had been articulating a reappreciation of the old image of France by using Pétain's own rural imagery against itself. He developed a kind of subversive construction of identity that emphasized the importance of a return to the medieval roots of France—a return on a very different footing than the Fascist one. In his book *l'Humanisme médièvale [Medieval Humanism]*, written in 1944 but censored by the Nazis, Francastel proposed an interesting new type of humanism located in the rural culture of the countryside—the very culture that the French Fascists so cherished. Bypassing urban and international Gothic style, Francastel argued that rural Romanesque art had been the real source of French specificity and identity, and that it was from this important base that France would be able to reconstruct an identity in opposition to Pétain's simplistic one. Differentiating this active Romanesque culture from the passive one elaborated by Pétain would require a certain amount of skill.

Impelled by his experience of the war, Francastel began writing a book in August 1943 about the importance of modern art, simultaneously learning of the ban on his work on medieval humanism. The new book, *Nouveau dessin, nouvelle peinture: L'école de Paris [New Design, New Painting: The School of Paris]* (published only in 1946), showed from its first pages that the writer was a committed historian who had decided to wage an anti-Fascist (and thus anti-German) struggle precisely where it most mattered: in the reading and writing of history. The entire book was an attempt to demonstrate that the formal and social innovations of French art in the nineteenth century were now culminating in the work of a group of young artists who had emerged from the experience of the Occupation.[3] Under the strain of the Occupation, this generation apparently had been able to analyze the great French tradition, not only to preserve the endangered modern culture but also to continue the interrogation of painting itself through formal investigations. This study affirmed the proposals of the painter and theoretician of the Romanesque revival, Léon Gischia, regarding the importance of distinguishing between tradition and the academy.[4] Tradition, he said, was active, positive, and progressive, whereas the academy was dead and inert. Thus, by finding inspiration in Romanesque art and Fauvist colors, the generation emerging from the Occupation was in fact reorganizing painting's paradigms in order to reconnect with what had made French art great in the past but been forgotten during a period of decadence. Francastel's text was both a brilliant and a damning defense of French modernist art as well as an incisive reconstruction of Parisian identity, linked to a specific, newly rediscovered French tradition: Romanesque art. The Romanesque could now play a role similar to that of African art or Russian ballet in earlier avant-garde traditions. This time, however, the helpful primitives not only would offer all the advantages of their being French but would also contribute to the rebirth of French identity and specificity. Francastel's proposal was a homegrown primitivism.[5] According to Francastel, the Romanesque had influenced the art of the new generation and had played a role similar to that played by antiquity for young artists of the Renaissance. But now the decorative flatness of medieval design replaced the exaggerated, Greek-influenced German sculptural musculature of Arno Brecker. This new art exuded a type of humanism rooted not in brute force and exaggeration but in delicate, measured beauty. The brilliant aspect of Francastel's analysis was his ability to use the public's attraction to agrarianism and primitivism, to a certain simplicity that was in vogue during the Vichy regime, in order to reinscribe this public into modernity, to pull it into supporting the Parisian modern art tradition. In this way, he could release all those trapped and seduced by the fascist myth of archaism and bring them right back into the modern world. These modern artists, the *jeunes peintres de tradition française* (young painters in the French tradition),[6] had been articulating a soft modernism, advocating French tradition and evolution rather than revolution and rupture in their defense of a certain idea of French specificity based on a balance between reason and emotion; they had been playing an ambiguous but dangerous game of double-talk in Vichy France. After the war, Francastel successfully unscrambled their works in his writing, giving them a liberating status previously obscured by layers of ambiguous messages. His enthusiasm was such that he applied his humanistic thesis about medieval art directly to their modern painting. For him, the greatness of these new painters resided in the fact that, despite their allegiance to modern technique, they were keeping traditional subject matter alive.

Figure 36. The Avenue de l'Opéra and the National Opera Theater. Photograph by Willy Ronis, 1961. Copyright Willy Ronis/Rapho.

Subject matter, he believed, allowed the artist to communicate with the public and, in an anti-elitist move, to ease the public into a relationship with modern art through a legible story:

There is no great art without legends and without anthropomorphism. Man recognizes himself only in his actions or in dreams. He does not content himself for long with philosophy or pure art.[7]

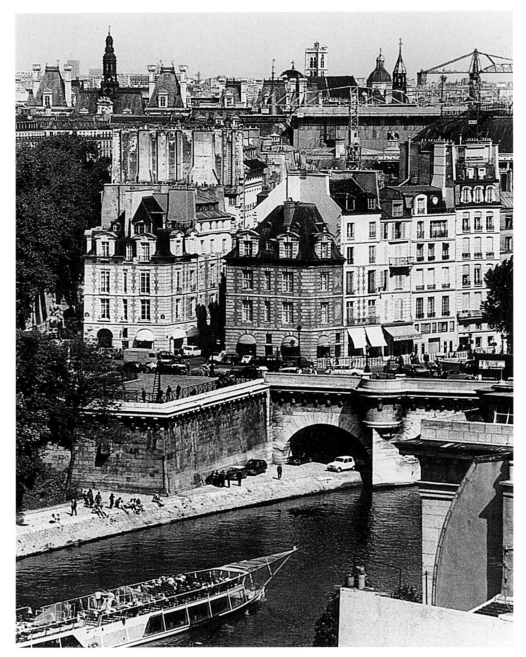

Figure 37. The Place du Pont-Neuf and the Rue des Orfévres. Photograph by Willy Ronis, 1968. Copyright Willy Ronis/Rapho.

The role of the artist was to "lift the crowd toward summits, not to bend over toward them. But it also seems to me that the duty of an artist is to be an intermediary, I was going to say intercessor, between the masses and the elite,"[8] a description that parallels his understanding of great medieval art but that already announces a problematic rejection of what was becoming essential in postwar France: abstract art.

What was at stake for Francastel, then, was the possibility of saving modernism from two opposite poles. On the one hand, Francastel's

brand of medieval modernism worked against the dreadful folksiness of realism through continued artistic experimentation; on the other hand, it avoided "non-French" abstract forms through its connection to humanism. These were the accepted parameters of France's postwar renaissance: a neo-medieval culture championing an erudite humanistic individualism that would eventually lead the masses toward greatness. The fundamental problem was that Francastel, just like the traditionalists Gaston Diehl and Bernard Dorival, had rooted his construction of avant-garde art in deeply simplistic but highly effective nationalist convictions. Medieval culture, nurtured from the beginning of the war by Vichy, was at the end of the war so thoroughly infiltrated by the ideas of the Resistance that out of its heavy protective armor sprang a youthful, renewed France. But this renewed France bore the deep imprints of tradition. At last, through Francastel's writings, the populist, Fascist frog had transformed itself into a flamboyant avant-garde hero.

Even though Francastel had visited the famously controversial Salon d'Automne of 1944, which established Picasso as the quintessential modern resistant artist, his description of the salon in his book's short conclusion suggested that he had seen only the work of the young "medievalists." His faith was unshakable. Paris, according to Francastel, seemed unavoidably destined to resume its role as the center of the world: "The Americans already visit this salon, the galleries, they visit studios. French painting is ready to affirm its absolute supremacy. . . . The School of Paris is not exhausted."[9] The new minister of fine arts, Joseph Billiet, a Communist sympathizer, reinforced this optimism in September 1944 by agreeing with Francastel's analysis:

I will seriously look at the role art should play in the wonderful renaissance promised by the Resistance grouped around General de Gaulle. I feel that in this renewal, like the one which followed the terror of the first millennium, French art can and must, as in the eleventh century, serve as guide and cohesive agent to diverse forms of the new civilization that will come, and in so doing, serve as a symbol for the radiance of France.[10]

As Bernard Ceysson put it, "In every case, one needed the certitude that an immutable France with eternal values had not perished with the defeat."[11] Francastel explained that Paris was continuing the modern tradition, with its roots in Cubism, but his version of Cubism was that of Braque (the boss) rather than that of Picasso (the worker).[12] While Francastel was admiring the work of his medieval/ modern painters, next door Picasso was exhibiting a retrospective of his work produced during the years of Occupation. This gallery became the center of a controversy over the return of modernist art to Paris, as did the fact that Picasso had just joined the Communist Party and had become head of the Purification (*Épuration*) Committee for collaborator artists—a Communist modernist! The new

postwar era was indeed starting on a confusing note. What would have seriously disturbed Francastel's medieval/modern set-up was Picasso's *Bacchanal*, painted in the furious elation of the days of Liberation, a new and violent Dionysian joie de vivre reinjecting the force and violence that Poussin, in his very "French" classical *Triumph of Pan* of 1638, had beautifully controlled through reason. Picasso's pleasure and joy exploded, liberated the classical Poussin in its exuberance, paganism, and sexuality, miles away from the medieval world of the recent past. It signaled the forceful return of the Mediterranean, of Greek myths, of music and dance intertwined in the same celebration of recovered freedom. In restoring the joyfulness of the exuberant side of Greek myth, in insisting on the earthiness of agrarian dancing, Picasso erased years of monumental Fascist classical nudes and sad, measured, religious medieval images. His return to earth was neither pitiful nor charming but explosive and carnal. The erotic Dionysian surge pulverized the teachings of the church; lust and frenzy, whirlwinds of agitation, washed away suffering/redemption and discourses of stillness. In his description of this famous Salon d'Automne, Francastel did not utter one word about Picasso, because the Spanish artist did not fit his bill. In the postwar period, newer, crisper, and more relevant positions were rapidly overwhelming the model that Francastel had forged during the Occupation.

The Picasso retrospective at the salon was undoubtedly the signal that France, emerging from the Resistance and spearheaded by the Communist Party, was making a definitive break with Vichy France and was renewing its progressive values. By contrast, Francastel and the French cultural establishment seemed to propose a kind of "great leap backward" in order to reconnect with a brilliant past, and thus to erase four years of dreadful and somber Occupation and collaboration. But this therapeutic occultation was unable to contend with the enormous international ideological and emotional transformations of the postwar period. The leaders of France's cultural and artistic sphere were still fighting an old war, trying to salvage the advances of the Resistance without seeing that by now, in the Cold War, the targets had shifted dramatically. They were still fighting a national war when the stakes had become international. For the French establishment, which supported Francastel's position, only the values of the School of Paris (those Cartesian qualities of clarity, charm, and organization) held any hope. Gaston Diehl and Bernard Dorival, for example, in a special issue of the magazine *Confluences,* defended a type of traditional painting that represented the values of an imaginary France, Cartesian and classical, one that elided the fundamental changes that the war had inflicted:

Deliberate, reserved, intellectual in its sensibility, logical and reasonable, our modern French painting seems to continue, to prolong the one of the past. Like

that one, it merits the name "classic." What does that mean? It means that an art that merits this name has a universal appeal, and a universal value can come only from an intellectual and rational content. . . . It has always been the purpose of French art to give to all movements, including the most baroque, their classical and universal modalities.[13]

One can understand the need for an art similar to that made by the young painters of French tradition under the Occupation, as well as art historians' publication of nationalistic texts under such pressures, but it remains surprising that after the war was over, these cultural architects still truly believed in their own ludicrously exaggerated constructions and in the propagandistic, nationalistic language they had employed during the war to fight the occupiers. Their blindness to other trends, to other possibilities and activities after the war, is astonishing. Critics like Francastel, Dorival, and Diehl were looking for an art of modern reality, expanding the lessons of Cubism and Fauvism in a balanced mixture of reason and emotion. If France, the story went, had two universal and complementary geniuses in Picasso and Matisse, would it not be wonderful if the young generation were able to unite their strengths in a single gesture? It is this utopian image of France's artistic future that the establishment sought, and believed it had found in artists like André Marchand, Léon Gischia, Maurice Estève, and Eduard Pignon. But what these manipulations of aesthetic genes produced was, in the end, not a series of giants but a deformed, if colorful, series of amusing hybrids. As early as 1946, these artists were sent abroad in one of the most tragic tactical errors of the cultural postwar period.[14]

Thus it is fascinating that during the same year, 1946, while the celebrated art historian Francastel was defending the *jeunes peintres de tradition française* against attacks coming from anti-modernist academic quarters, some intellectuals grouped around the Surrealist movement announced that they could find nothing of value in these artists' outworn aesthetic recipes. In their view, this "traditional" modern painting was no different from that of the academics. With a few well-chosen

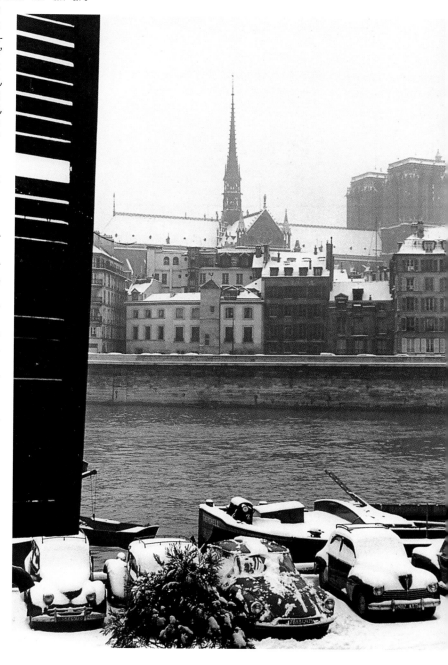

Figure 38. L'île de la Cité and the Pont des Arts. Photograph by Willy Ronis, 1962. Copyright Willy Ronis/Rapho.

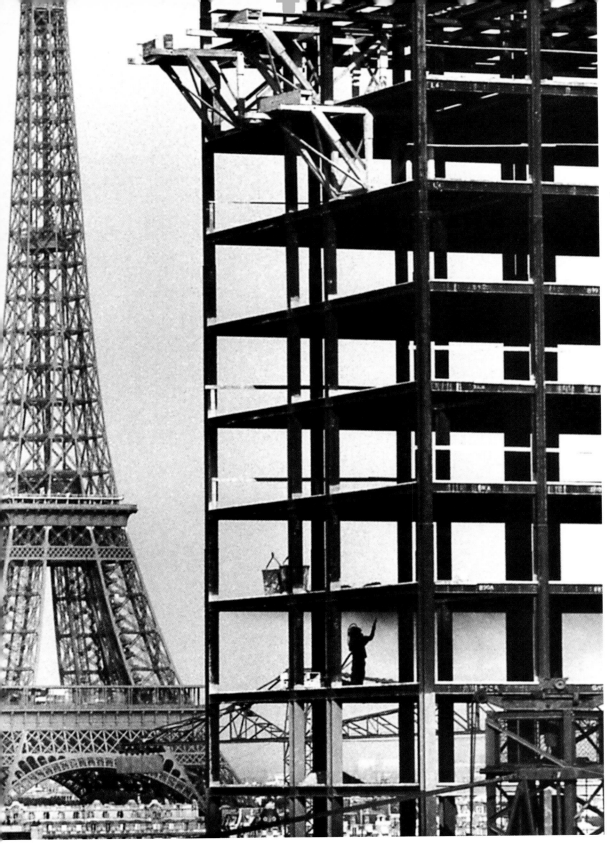

Figure 39. Construction of the ORTF Building at Rue La Fontaine. Photograph by Willy Ronis, 1959. Copyright Willy Ronis/Rapho.

flimsy and poised to collapse under the slightest breeze. A good sailor, he described the phenomenon in terms he knew well: "Whether we like it or not, figuration is crippled. All of this, all these old topics—as old sailors say about old boats—are still standing thanks only to the paint. It has no future."[15]

The art critic Edouard Jaguer, seeking a new form of engaged art, was able to articulate a different position in a 1946 article titled "Les Chemins de l'abstraction" ["The Paths of Abstraction"], which was published in a socialist newspaper called *Juin*. This very important but little-known article immediately put Dorival, Francastel, and Diehl's nationalist artistic concoctions into limbo. The article did not look backwards, as Francastel had done in forging a connection to Romanesque art, but ahead, toward a new art with an international flavor, in step with the Surrealist tradition. What Jaguer sought was an international idiom that could reflect the new abstract age and the new postatomic environment. Jaguer's article made the crucial contribution of defining, fairly accurately, what many young artists were then debating: how and what to paint after authoritarianism, after the Holocaust, and after Hiroshima and Nagasaki.

As early as 1946, then, Jaguer asked for a renewed abstraction, one related to the apocalyptic world, an abstraction based on automatism, like the work of Hans Hartung, whose work was, in Jaguer's article, placed symbolically between Mondrian and early Kandinsky. Jaguer provided the theoretical description— flavored by Surrealism, no doubt—of the type of abstraction that would dominate Paris several years later, but only after a long and convoluted battle.

Several artistic currents struggling for visibility confronted the strong presence of the art aligned with the old School of Paris. The year 1946 was a key one for this battle, which was fought in France's cultural trenches. Many felt it was primordial to retrieve the modern force of abstraction. Denise René opened her gallery to this progressive style (a socially relevant art, as had been proposed in the 1930s), in direct opposition to the *jeunes peintres de tradition française*, who continued to cover figuration with all-over abstract patterns, often lacing their works with spiritual overtones, as in the art of Bazaine and Manessier. The most advanced circles did not always approve of this aesthetic compromise, as the critic Léon Degand mockingly pointed out: "Figuration was their wife and abstraction their mistress." The duplicity and corruption implied in this statement were the precise qualities that critics rejected in those postwar days. Instead, purity and authenticity were the defining terms in the aesthetic and political debate. That is why, even in the most abstract circles, a split soon opened up between those like Auguste Herbin, who wanted complete adherence to geometric abstraction, and those who thought it was important to accept some lyricism. Lyricism, the latter group argued, would reflect the newly discovered importance of the individual, whose value had been eroding under

words, the Surrealists succeeded in hurling Francastel's prodigies into the darkness of a distant past. The future, the Surrealists announced, should start with today's problems rather than with the recycling of past solutions. Because terms like "the new," "the modern," and "humanism" became key words loosely defining postwar culture, voices representing multiple artistic positions were able to use these terms to defend very different aesthetic approaches, fueling a healthy but confusing debate.

The art critic Charles Estienne, for example, could see that all these constructions were

the authoritarian control of Communist and Fascist regimes as well as in the nascent consumer culture. If the 1946 exhibitions of abstract art at the Galerie Denise René presented a wide array of abstract expressions (from Jean Dewasne, Jean Deyrolle, and Marie Raymond to Hans Hartung and Gérard Schneider),[16] it soon became impossible to sustain such liberal eclecticism; the differences between an abstraction signifying individualistic expressionism and one expressing an ideal reality, rationally constructed so as to propose a coherent utopian common social space, inevitably took on political meaning. Audiences soon faced a radical and antithetical choice between self-centered expressions, on the one hand, and a socially oriented, constructed utopia, on the other. The new Salon des Réalités Nouvelles reflected this dilemma. When the salon opened, in 1946, it allowed a multitude of abstract experimentations. Rapidly, however, it became the stage for the presentation of a radical and somewhat authoritarian geometric Concrete art that excluded, under the watch of August Herbin, the use of any curvilinear shape in geometric expression. This intense surveillance quickly disenchanted many young artists, who feared a creeping academicism, one that finally took form in 1950, with Edgard Pillet and Jean Dewasne's creation of an academy of abstract art, which Charles Estienne violently denounced in his pamphlet *L'Art abstrait est-il académique? [Abstract Art, Is It Academic?]* Rejecting the notion of the formal education of the atelier, Estienne denounced the stifling effect of an emphasis on technique rather than on the poetics of painting. He proposed an exploration of inner life, not happy decoration, as the basis for an art that would reflect the contemporary world. Estienne used an impersonal, clean geometry as a code for the old illusion of cultural coherence. Quoting Kandinsky at length, he attacked those who wanted to codify personal feelings into universals. The pamphlet seriously shook the Parisian world of abstract art, and it offered new routes toward the appreciation of newly fashionable individual and expressionist tendencies. It also opened up the salon to many other forms. This was the period when several Latin American artists—such as Jesús Rafael Soto, who showed there in 1951—got involved with the salon, taking the opportunity to present their work to a Parisian audience and opening up opportunities for others. Lygia Clark, for example, studied with Fernand Léger from 1948 to 1950, and Martha Boto stayed in Paris from 1951 to 1955. Many of them participated in *Le Mouvement,* the famous and important 1955 exhibit at the Galerie Denise René, where Julio Le Parc and Soto presented their experimental works, which were seen by a visiting—and impressed—Carlos Cruz-Diez.

The New Cold War: Paris in 1948

The year 1948 was politically and culturally pivotal in Paris; it became apparent that art production, painting, film, and writing were unquestionably enmeshed in a larger ideological struggle. Whatever one did or said, one entered into the polemics of the developing Cold War; no apolitical havens remained. In painting, critics focused their attention on realism, which a very important and visible Communist press relentlessly presented. Fougeron's painting *Les Femmes au Marché [Women on the March]* became a kind of focal point around which artists and critics could position themselves. Art theories revolved around the notion of the artist's public, central to Parisian artistic life. From geometric abstraction to Tachisme and on through Surrealism, the core of the debate was the question of the artist's responsibility toward his or her public versus the protection of individual creativity from political interference.

With the collapse of untenable alliances forged during the Resistance under the pressures of the Cold War, artists had to take clear-cut positions and, on this continually shifting ground, make hard aesthetic and political choices. In July 1948, Jaguer and Michel Tapié organized a large group exhibition at the Galerie des Deux Îles. Here, the new abstraction was present in numbers (Jean Arp, Camille Bryen, Jean Fautrier, Hans Hartung, Georges Mathieu, Francis Picabia, Michel Tapié, Raoul Ubac, Wols). A text/manifesto printed on the invitation, obviously directed against Communist Party Social Realism, foreshadowed future events. On the invitation, Tapié questioned the catchword "reality" in a fairly traditional Surrealist manner, and Jaguer, in another short and shrewd text, feverishly asked painters to address the new postwar subjectivity:

Figure 40. Boulevard Bonne-Nouvelle, in the forefront Porte Saint-Denis, in the distance Porte Saint-Martin. Photograph by Willy Ronis, 1951. Copyright Willy Ronis/Rapho.

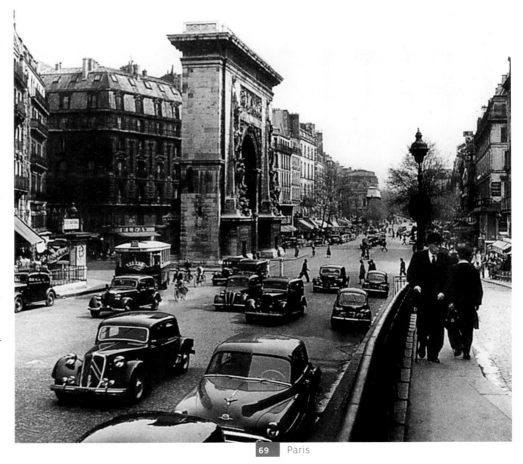

One cannot live with an open heart in old houses. And the mountainous slices of chosen forms and of the . . . rectangle do not have anything to do with a world turned upside down by expressivity. For the artists reunited here, what is at stake is the conquest of a subconscious but real site, and not the derisive satisfaction of having accomplished a plastic task.

This jab at geometric or Constructivist art signaled new life for an abstraction connected with Dada and Surrealism, or at least with subjectivity, the new cultural keyword of the postwar period.

Indeed, many artists in Paris regarded beauty and decorative impulses as the residue of a past age, a time when the artist was in harmony with the world or at least had the feeling that he or she could organize and master the forces of nature in order to represent and reorder it in plastic terms. But, thanks to the 1947–1948 political split in the Western world, and thanks to the growing fear of a third world war (which would be nuclear, as newspapers and magazines were constantly stressing), many artists suddenly realized that a United Front of whatever sort was no longer possible. Aesthetic lines were drawn for the most part along political demarcations—Social Realism, bourgeois realism (including both the optimistic brand and the pessimistic one à la Buffet), the utopian and optimistic geometric abstraction, and the individualistic and depressed informal abstraction. All these styles seemed to be negotiating, jockeying for position, in order to represent, in order to be, the voice of postwar France.

In the midst of this continuous brouhaha of debates and violent eruptions, the ideological positions of the painters themselves were at times quite difficult to define. Many artists felt that the language of painting was itself a trap, and that the painter could not represent anything without reproducing some of the prisons that he or she was desperately trying to avoid. Many artists also found that being in a position to talk without saying anything definitive, in order to avoid the authority of the word, was a worthwhile project in 1950s Paris. In fact, it was because they knew so much, or too much, that they had to do and say so little, that they had to disengage themselves, leaving only the traces—at times sumptuous, at times pathetic—of their everyday struggle. That was the difficult position of some then unrecognized artists, like Wols and Bram Van Velde. This sense of helpless yet principled indifference made some painters want to lie down, to let the world go by, but not without a painful cry for attention to their adamant refusal to participate. Wols and Bram Van Velde deliberately refused to respond actively and directly to the postwar debate, yet they remained painfully aware of it. They chose instead to dismantle the structures of painting itself: the definition of style, the idea of representation, and even the notion of what constituted painting or art. This does not mean that painters like Jean Dubuffet and Pierre Soulages were not questioning such issues, but they did so in a less tragic fashion, in a more analytical or more ironic way. To be a responsible artist or critic in those days was not always easy. In 1947, for example, Léon Degand was still writing and defending geometric abstraction for the communist cultural newspaper *Les Lettres Françaises* at a time when the French Communist Party, in an aesthetic reversal, had begun for purely political reasons to promote realism.

Degand began to look for an alternative to his career as a journalist, constantly in jeopardy because of his keen interest in abstraction, which the Communist Party increasingly viewed as a plot to destroy working-class morale. At that precise moment, he met a rich Brazilian businessman, Francisco Matarazzo.

Figure 41. Facade of Vasarely Building. Photograph by John R. Johnsen.

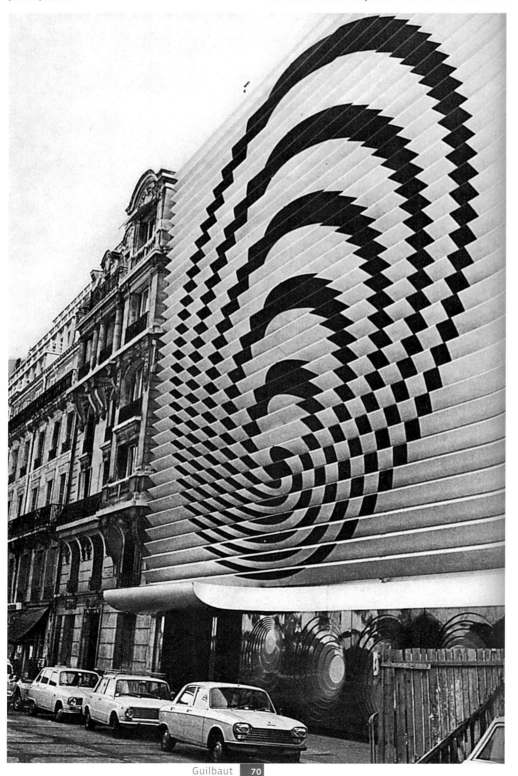

Matarazzo was looking for a director for a new museum of abstract art that he wanted to open in São Paulo in order to demonstrate that he and Brazil were fast moving into modernity, into a sophisticated urban society worth the attention of the industrialized nations engaged in reorganizing the Western world. Abstract art, Matarazzo believed, stood for these ideas and signaled Brazil's postwar progress. Abstraction, in its pure form, became a symbol of individual creativity, of a unique, separate, modern entity free from referents to the everyday, the philosophical expression of a modern, urban, rational world. Degand fit well into Matarazzo's program, since he had been defending abstract art in Europe from the time the war ended. Abstraction, Degand claimed, was a creation rather than a representation, a free space for the independent expression of individual creativity and experimentation. Degand's vision of abstraction paralleled the public image of economic development in Brazil. Indeed, following a brief period of democratization after 1945, the country was solidifying a tightly controlled government, run by a healthy free economy. Just as the new abstract language of modern art dazzled Matarazzo, so did Brazil's urban rush toward modernity dazzle Degand. The two men seemed to have been destined to meet, although Degand never understood the complicated symbolic, political, site-specific implications of Brazilian modernity. He was determined to show the French what he could do on this virgin and fertile soil, to graft a misunderstood European idea onto this new world and watch it bloom. It could be, he thought, a liberating move away from the quicksand of conservative French intellectual life. Indeed, in Paris Degand had been fighting an important but depressing battle. He had been facing a well-organized Communist offensive against abstraction and a fast-developing promotion of Social Realist art, as well as the strength of the renewed, at times abstract, School of Paris promoted by Michel Ragon and Charles Estienne. Even at the First Congress of International Art Critics, which Degand attended in 1948, a few weeks before leaving for Brazil, he had to listen to several speeches extolling the greatness of Parisian culture but employing a discourse developed to garner consensus around the old School of Paris. According to this discourse, art—and in particular the art produced in Paris—was or should naturally be anti-nationalist, international, and, even in the mind of Jean Cassou, universal. Cassou, the newly appointed director of the reopened Museum of Modern Art in Paris, confidently told an audience of art critics, "Art is a universal language, and . . . French art since the nineteenth century has been universal. It represents an amazing spiritual adventure, which needs the participation of every country. French art has always been the incarnation of humanism."[17] In the face of such a traditionally Parisian line of defense, Degand left Paris full of hope, only to be disappointed by his experience in São Paulo. The world was obviously not yet ready for the type of abstraction that Degand championed, even if he was able to show French abstract art in Brazil and Argentina before returning home.[18]

After returning to Paris, Degand still had to fight against prevailing definitions of the specific qualities of Parisian painting, as they had been set forth since 1946 in a series of books by Bernard Dorival and Pierre Francastel. Both saw French art as somewhat Cartesian, with flair, delicacy, and a rational beauty, reconstructions deeply rooted in nationalistic convictions—or, in other words, the opposite of what German art was supposed to be: expressionist. This ideology saw man as part of nature, but without the destabilizing effect of instinct: in man, nature was mixed with reason, because the nature of man was nothing other than instinct controlled by reason. Thus Dorival dismissed Mondrian and Kandinsky, preferring Léger's and Modigliani's elegant reserve. This, to a large extent, was why Léon Degand believed the work of Mondrian and Kandinsky to be crucial to his project, and why he particularly loved the oeuvre of his friend the painter Alberto Magnelli, an oeuvre that, by introducing fantasy and emotional formal elements, considerably relaxed the pure geometric grid. Thus, on the one hand, Degand despised the unsophisticated realist line—he even wrote against the Brazilian painter Cândido Portinari's show in Paris, to the ire of André Fougeron, the French Communist Party Social Realist painter—and, on the other hand, he championed total abstraction, which he viewed as the most advanced cultural production of his day. But, and this is important, this was an abstraction not totally dependent on the strictly geometric Cercle et Carré[19] definition; rather, it was an abstraction open to feeling, to intuition, a *peinture* akin to music. In Degand's view, one needed simplicity of both mind and heart in order to understand abstract painting, in order to be able to access the new language without preconceptions, without routinely wanting to read nature into it. That is why, as noted earlier, Brazil could offer him such a fresh start. In his search for the development of a new idiom to represent the modern era, Degand felt that the work of Alberto Magnelli epitomized modern painting. For example, Magnelli was fond of explaining to Degand that the stain, at the core of the work of Schneider and Deyrolle, was too romantic. "We need," Magnelli used to say, "a classical form like abstract painting." Magnelli used clean shapes, without exuberance but with humor, with oil but without the dreaded spilling. Magnelli believed that Degand spoke for himself, without engaging in visual propaganda. This type of abstraction, classical but still intuitive without being wild, was the art of the "present" because it generated optimism without being enslaved to geometry.

The awarding of the 1948 Prix de la Critique to two painters whom Degand felt were atrocious, Bernard Lorjou and Bernard Buffet, drove the final nail into Degand's geometrical coffin. Even if judges did choose these two realist painters in order to counter the controversial success of the Social Realist painter

André Fougeron at the Salon d'Automne, the decision convinced Degand that there was an abyss into which French modern painting had finally crashed. By 1947, it seemed that all the vitality the Liberation had promised was trapped in a stagnant French quagmire, while dreams of rapid modernization of the country were fading fast. To add to this degenerate state of affairs, in 1947 Jean Cassou inaugurated the Museum of Modern Art without presenting Surrealism, abstraction, or any kind of Expressionism.[20]

By 1950, the critical art scene had become polarized. Degand, writing for the new magazine *Art D'Aujourd'hui [Art of Today]*, defended geometric abstraction and formalism; Charles Estienne moved toward a new expressionist abstraction, which he saw coming out of automatic Surrealism; and Michel Tapié, influenced by Dada, preferred to support what he called "Art Autre," a container for a hodgepodge of different types of artistic production that did not seem to fit into any established category. What this intense coverage ignored, however, was the work of artists like Wols and Bram Van Velde, who could not, in their deconstructive manner, truly respond to the art scene's need for reconstruction and evolution. Their extraordinary comments about the catastrophic postwar situation of the individual were simply inaudible, despite the efforts of Georges Duthuit and Jean-Paul Sartre.

The Abstract Year: Victory in 1953

One can say without hesitation that by 1953 abstraction had won a major victory in Paris. Several books addressed the topic, and many galleries were handling the work, despite sometimes lagging sales. As always, symbolic victory preceded triumph in the market. The market was divided among types of abstraction, each gallery handling and promoting a stylistic type. Denise René, for example, promoted geometric abstraction; Galerie Drouin and Studio Facchetti preferred what Michel Tapié called Art Autre. Perhaps more important, the Galerie Arnaud, a small bookstore/gallery, was strictly devoted to lyrical abstraction and published its own art magazine, *Cimaise*, to promote it. Now it was lyrical abstraction, or Art Autre, that represented the most advanced Parisian culture. Even André Breton, after many years of resistance, helped in 1953 to set up a Surrealist gallery called L'Étoile Scellée, where he presented the abstract work of Marcelle Loubchansky and Jean Degottex, among others. Estienne and Tapié were eclectic in their tastes, but both remained suspicious of geometric abstraction and its utopian social message. Like many artists, they sought an art that could represent the renewed interest in individualism as an alternative to the authoritarian security of certitudes. In their desire to divide the developing market among themselves, they created new artistic labels. Tapié saw an amalgamated and consolidated Art Autre as the basis for a new School of Paris, which would include individual artists, both French and American, under the umbrella of free and diverse expression in a rekindled Paris. That was also the goal of Estienne, who

wanted to define a national aesthetic[21] but was interested, in a way that Tapié was not, in producing an art with ties to France's tradition of painting. Tapié believed in total erasure of the past, orgiastic drowning of the artist in the present, complete liberation of the individual. Estienne used Surrealist concepts in order to recover a forgotten, basic human sense of revolt. He saw in this, as he put it, "the only path between the 'political messianism' of the Communist Party and the pessimism of the philosopher of the absurd."

By 1952, it had become possible for Estienne, in a show presented at one of the galleries he directed, to announce the blossoming of a new School of Paris that was totally independent of the old Parisian clichés. What was important about this announcement was that Estienne felt confident enough to assert that Paris was still Paris, that it had been able to regenerate itself, and that a particular avant-garde had finally surged ahead of competing factions to dominate the French art world. Like Tapié, who wanted to show that Paris was still determining the future of Western culture (after all, French artists like Matisse and Dufy still won prizes at the Venice Biennale), Estienne announced his new abstraction's definitive victory over the reactionary forces of all kinds of realisms and Cartesian geometries.

As an illustration of this point, in 1953 Robert Lebel published a book in which he examined and compared the art produced throughout the Western world. The book asserted that its author, after conducting this international investigation, had lost all hope of discovering the "magical," heretical, and different works that he had been seeking; instead, he had discovered their absorption into the "safe" worlds of museums and bourgeois interiors.[22] Magic, surprise, irreverence—all had disappeared into the banality of everyday business. Nevertheless, what Lebel's study made clear was that abstraction was everywhere, even if victory had blunted some of its edges and its aggressive quality: "Today artists are to their prewar predecessors what showers of parachutists are to Icarus."[23] The sheer number of good abstract painters in Paris was a sign that the French capital retained its importance, but a nagging question crept in at the end of Lebel's book: the "apparition du continent Américain," and even the influence of that continent's so-called Northwest School (Mark Tobey, Kenneth Callahan, Morris Graves, and Guy Anderson), more or less invented for French consumption in order to counteract the rise of the School of New York, seemed simultaneously a tribute to Paris but also, for some, an added threat from America.

Tapié, Estienne, and Lebel proclaimed the triumph of a new abstract avant-garde over the forces of tradition, believing in the renewed supremacy of Paris, and ready to reap the riches of this success, but anxiety invaded their writings. In an article published in the liberal Catholic magazine *Esprit* in 1953, Camille Bourniquel bluntly asked the question on everyone's mind: Is the Parisian succession open? Taking precautions against the

pitfalls of cultural arrogance, Bourniquel displayed a keen understanding of the workings of international culture. He discussed the symbolic importance of avant-garde culture for recognition on the international stage, but ultimately decided that no cultural center anywhere in the world was as important as Paris. In so doing, he could not avoid sending a few barbs toward America and its "protectionist cultural behavior," scorning what he perceived as American suspicion of French artistic production. What he acknowledged, though, was that the United States' traditional acceptance of French culture as *the* universal culture—"a fact of civilization," as he put it—was evaporating. Indeed, French culture—the one described by Francastel, or the one Paul Strand photographed for *La France de Profil [France in Profile],* that rural and stubborn country—was being rapidly replaced by a sweeping Americanized consumer society, which flourished unabated after the Communist repression of Hungary in November 1956. France was definitively different, as Jean Pierre Mocky illustrated in his film *Les Dragueurs [The Chasers]* (1958). Youngsters were not singing "I Hate Sundays," as Juliette Gréco used to do; instead they preferred to read Françoise Sagan's *Bonjour Tristesse [Goodbye Sadness]* and watch Roger Vadim's *Et Dieu Créa la Femme [And God Created Women].* Brigitte Bardot's warm, appetizing curves were replacing Juliette Gréco's black humor just as the first overflowing supermarkets began to appear. Even Roland Barthes, writing his *Mythologies,* sent the clear signal that a petit-bourgeois mass culture was replacing deep popular culture. A world was disappearing. The year 1955 was also one of movement, when Denise René opened her exhibition space to *Le Mouvement* (with Yaacov Agam, Pol Bury, Alexander Calder, Marcel Duchamp, Robert Jacobsen, Jesús Rafael Soto, Jean Tinguely, Victor Vasarely), an exhibition in which humor and fun finally penetrated the old geometric abstraction. Paris was ready for this new experimental, participatory art. The Latin American artists arrived just in time to help the grim postwar French public realize that life could be fun, even if the French public was buying into another type of "orientalist" cliché. But all that is another long and tangled story.

Notes

All translations are the authors unless otherwise noted.

1. Pierre Courthion, "Réalité de France" [Reality of France], lecture, 1944 (Pierre Courthion's papers, acc. no. 89 0007-17, Getty Archives, Los Angeles).

2. Courthion, "Réalité de France."

3. He was particularly enthusiastic about the young painters showing at the Galerie de France, among them Jean Bazaine, Jean Estève, André Fougeron, Léon Gischia, Charles Lapicque, Jean Le Moal, Alfred Manessier, Edouard Pignon, Gustave Singier, Jacques Villon, Louis Chauvin.

4. It bears repeating here that some intellectuals—for example, André Breton in New York, and Michel Tapié in the underground magazine *La main a plume*—were still advocating modernist rupture rather than continuity.

5. For the many sources that aided French artists in rediscovering the Middle Ages, see Laurence Bertrand Dorléac, *Histoire de l'art à Paris, 1940–1944: Ordre national,* *traditions et modernités* (Paris: Publications de la Sorbonne, 1986), 182–90.

6. Jean Bazaine, André Beaudin, Maurice Estève, André Fougeron, Léon Gischia, Charles Lapicque, Lucien Lautrec, Jean Le Moal, Alfred Manessier, Edouard Pignon, Gabriel Robin, and Gustave Singier.

7. Dorleac, *Histoire de l'art à Paris, 1940–1944,* 174.

8. Dorleac, *Histoire de l'art à Paris, 1940–1944,* 173.

9. Pierre Francastel, *Nouveau dessin, nouvelle peinture: L'école de Paris* (Paris: Librairie de Médicis, 1946), 178.

10. Joseph Billiet, "La culture artistique dans la renaissance de la France," *Les lettres françaises* (September 1944): 1.

11. Bernard Ceysson, *L'art en Europe, les années décisives 1945–1953* (Paris: Musée d'Art Moderne de St. Étienne, 1987), 40.

12. Braque was French, of course, and, as Paulhan explained, represented French genius; see Jean Paulhan, "Braque le Patron," *Poésie* (March/April 1943). Picasso, of course, was Spanish and allied with the working class through his connection with the Communist Party—a far cry from being a boss.

13. Michel Florisoone had said something similar: "There is a cycle of French art as there is a cycle for water, and for the rivers to flow, it is imperative that clouds, coming from far away—from the sea, from foreign lands—swell the springs. French art perpetually transforms itself, reproduces itself, disperses, but it grows on a humus wet with rain. It needs a vital minimum of imported products"; see Michel Florisoone, "Le Patrimoine artistique," *Les Nouvelles Littéraires.*

14. Greenberg used this show to lambaste the quality of French art and dismiss postwar French culture; see Clement Greenberg, "Review of an Exhibition of School of Paris Painters," *The Nation* (June 1946), cited in John O'Brian, ed., *The Collected Essays and Criticism: Clement Greenberg,* vol. 2: *Arrogant Purpose, 1945–1949* (Chicago: University of Chicago Press, 1986), 87–90.

15. Charles Estienne, "Salon d'Automne 1945 ou la bonne conscience," *Terres des Hommes* (October 1945): 2.

16. The Galerie René Drouin had already tested the water in June 1945 by presenting a show called *Art Concret,* organized by Nelly van Doesburg, who in 1930 had taken the same name as Theo van Doesburg, in order to signal a continuation, but this was also a gesture that was clearly in opposition to the group Cercle et Carré (that is, in opposition to Michel Seuphor and Piet Mondrian)—an attempt to delimit, without much success, the borders of postwar abstraction. For more about Cercle et Carré, see n. 19, below.

17. Jean Cassou, "La critique d'art et la tradition française," *Arts* (August 1948): 5.

18. For a detailed account, see Serge Guilbaut, "Dripping on the Modernist Parade: The Failed Invasion of Abstract Art in Brazil, 1947–46," in Gustavo Curiel, ed., *Patrocinio, Colección y Circulación de las Artes* (Mexico City: Universidad Nacional Autónoma de México, 1997), 807–17.

19. Cercle et Carré was created in Paris in 1930 as a way of reorganizing abstract geometric artists and developing the ideas that had been put forward by the first generation of abstract artists.

20. In the spring of 1947, the work of all the new young Parisian artists was presented at the Whitney Museum in New York, but with alarming results. Clement Greenberg labeled the show mediocre, as did Charles Estienne and Léon Degand in France. This show of disdain, coupled with the disappointing Surrealist show of the same year, prompted a number of questions from critics regarding whether Paris could survive as a world center of art.

21. For more on the events of this period, see Serge Guilbaut, "1955: The Year the Gaulois Fought the Cowboy," in Susan Weiner, ed., *The French Fifties,* Yale French Studies no. 98 (New Haven, Conn.: Yale University Press, 2000).

22. Robert Lebel, *Premier bilan de l'art actuel, 1937–1953* (Paris: Soleil Noir, 1953), 12–13.

23. Lebel, *Premier bilan de l'art actuel,* 14.

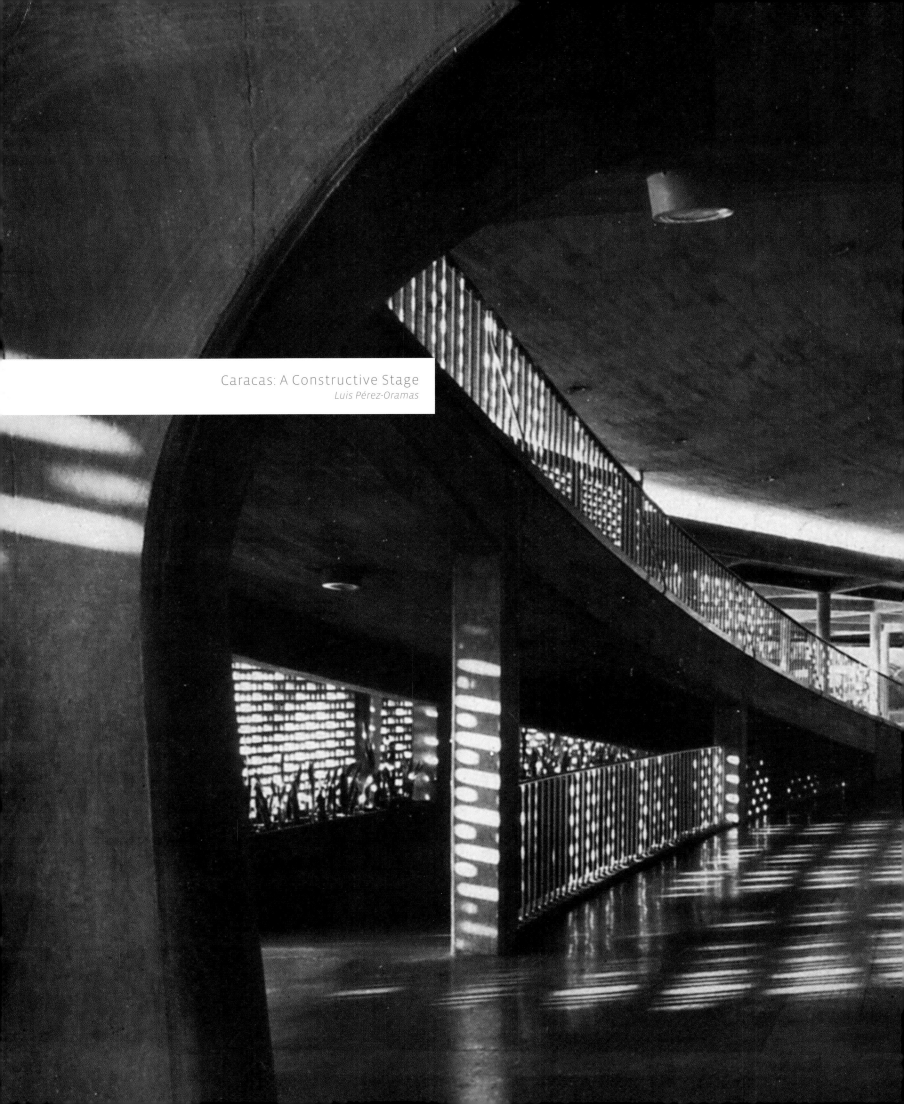

Caracas: A Constructive Stage
Luis Pérez-Oramas

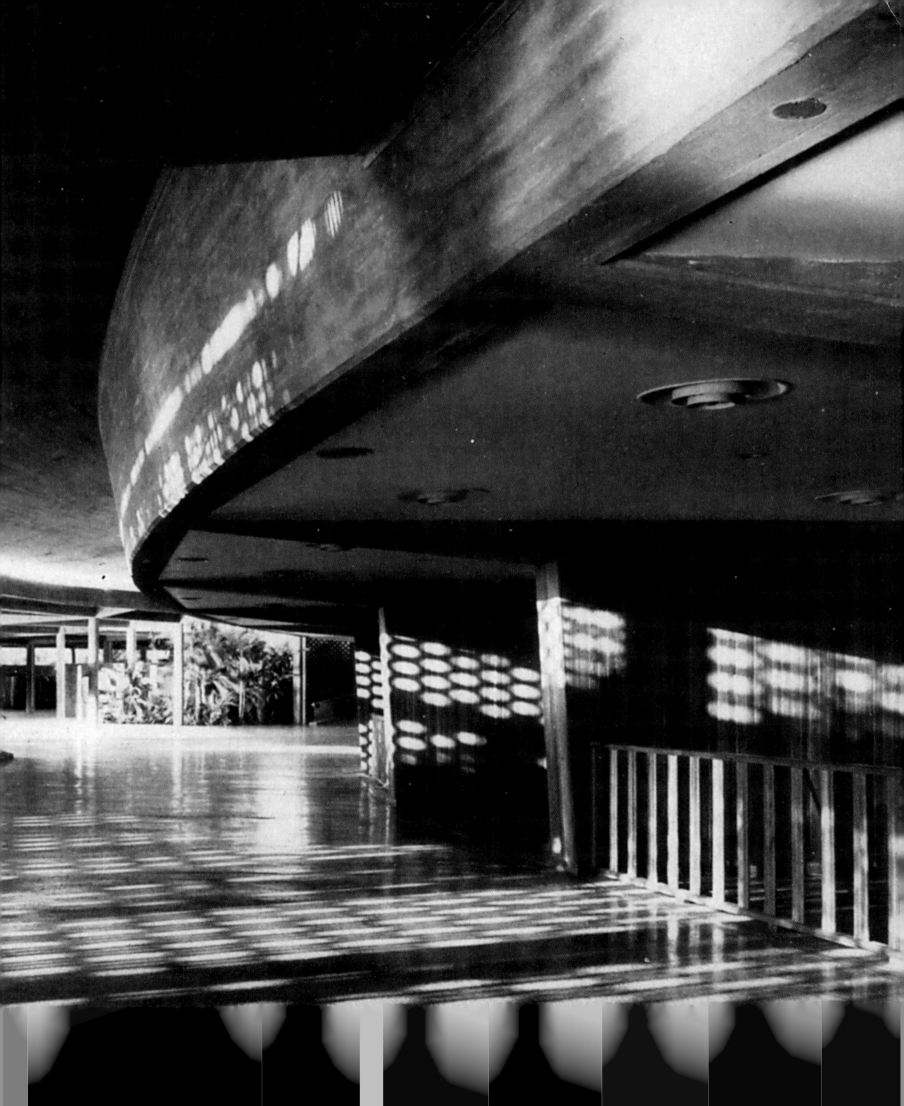

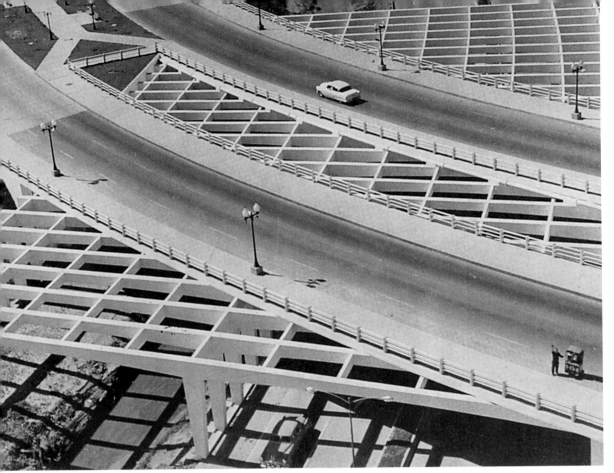

Figure 43. Autopista del Valle, Avenida Nueva Granada, and Autopista Panamericana. Photograph by Alfred Blander.

Previous pages, Figure 42. Corridor connecting the Aula Magna and the Plaza Cubierta (Covered Plaza), Ciudad Universitaria, Carlos Raúl Villanueva, Architect. Photograph by Paolo Gasparini.

1.

I was in Buenos Aires at the end of one summer with a group of travelers from the United States, all of whom were visiting a Latin American capital for the first time. As it happens, my work as a curator had brought me on this trip, and my function consisted of clarifying information for my traveling companions, of being the "expert" in the impossible—because it is so vast—field of Latin American art, a fiction that exists only in places where Latin America does not. I was in Buenos Aires, then, at the end of one summer, sampling some of the best French wines I had ever had the good fortune to savor, contentedly seated in the imposing living room of an art collector who had been kind enough to open his doors to us. During our trip, my traveling companions had been able to admire—probably for the first time—a considerable number of works by Concrete Argentine artists linked to the Grupo Madí and Arte Concreto–Invención, including Raúl Lozza, Alfredo Hlito, Tomás Maldonado, Gyula Kosice, Carmelo Arden Quin, Enio Iommi, Grete Stern, Rhod Rothfuss, Gregorio Vardánega, Lidy Prati, Martín Blaszko, Juan Melé, and Virgilio Villalba. This list becomes a kind of ostinato, perhaps causing the reader to have an experience like that of the travelers every time they found themselves considering the questions "Whose work is that? And the date? 1946, 1948, 1945, 1950, 1949, 1952?" I was taken aback, then, when one of them came up to me to comment that he felt puzzled: How was it possible, he asked, that these artists, in such a faraway place, were not "isolated" from the world? Wasn't Latin America an "isolated" continent? What had enabled these artists to produce such powerful works so early on? How was

it possible that in Buenos Aires someone had been able to paint, shall we say, "before Kelly, [but] in Kelly's style"?

Perhaps it was this unexpected lack of precision (in every sense) that made me answer with a certain impatience, responding with an argument that was simply comparative: the connection these artists may have with the Constructivist tradition is analogous to the connection between Sor Juana Inés de la Cruz's poetry and that of Spain's Golden Age, between the façades of churches in Cuzco and Quito and those in Prague and Seville, between the great paintings of vice-regal Mexico and the works of Alonso Cano and Francisco de Zurbarán, between Don Andrés Bello's *Gramática de la lengua castellana* and the work of Wilhelm von Humboldt, and between the letters of Bolívar and the literature of Sturm und Drang. The reality, I added, is that the nations of Latin America and Europe have never been "isolated" from one another. The issue is a different one, very diverse and varied.

Because there is, without a doubt, more than one problem, and they are worth parsing as much from the perspective of artistic production as from the perspective of international reception. To what extent can one properly claim that works by Latin American artists—who at various times and places produced abstract-geometric solutions—belonged to stages that were genuinely "Constructive"? To what extent is it legitimate to use the term "Constructivism" to describe the vast—and necessarily deformed—field denoted by the habits and digressions of twentieth-century Latin America's non-objective artistic vocabularies? More than a "'misplaced idea' of Constructivism,"[1] this would mean a "displaced" practice; not, therefore, an "assimilation," and even less an "inversion." It would mean, as will be argued here with regard to Caracas, Venezuela, between 1948 and 1976, its "survival," its afterlife, its modification, and therefore also its deformation, manifested in a repertoire of Constructive "alter-forms."

The notion of "alter-form" is nothing more than a supplemental variation of such concepts as "survival" or "afterlife" (*nachleben*) proposed in the field of art history by historians who are sensitive to the anthropological roots of artistic problems. These historians are therefore critical of the prevailing genealogism and organicism that continues to shape the idea of art history as a "biographical" history of styles.[2] This essay will not, therefore, discuss the assimilation or inversion of a so-called Constructivist style in Latin America. (Indeed, the phrase "Constructivist style" is an oxymoron, to the extent that historically Constructivism made its first appearance in Russia at the beginning of the twentieth century precisely as an anti-stylistic impulse.) Rather, discussion will focus on the incidental effects of a complex process of ideological transfer on the manifestation of Constructive forms and visual languages. Above all, the focus will

be on the extension of the field of application of these languages to other areas, including both historical topography (the physical and geographical world) and artistic topology (the works of art themselves, conceived as sites of significant action and transformation). This essay refers to a history of art conceived as a topology of artistic forms, not one that serves as a pretext for postcolonial demands, in which, inadvertently, a vague definition of the concept of the avant-garde would see itself inverted and therefore also widely and opportunistically multiplied.

2.

The will to modernize—and perhaps modern will in Venezuela—came to its definitive and historical demise, both symbolically and materially, on January 6, 2006. On that date, Antonio José Fernández, Venezuela's greatest popular sculptor, presumably was beaten to death in his modest, Andean-peasant home. That night the marshy areas in the mountains that ring Caracas rose up underneath the framework of the enormous bridge that links the capital city with the coast, causing the cracks that closed the bridge down definitively. This bridge, like the modern, tunnel-dotted highway of which it was a part, was emblematic of the will to modernize that had prevailed in Venezuela since the late 1940s, and whose material execution is generally identified with the dictatorship of Marcos Pérez Jiménez. It was during this period that Venezuelan development policy reached its historic zenith, the symbolic culmination of an authoritarian will to modernize that, as a collective and diverse ideology, guided Venezuela's destiny until its definitive collapse. That the country's vast modern infrastructure reveals a ruinous aspect—similar to the public artworks conceived by the artists studied in this essay, such as Jesús Rafael Soto, Gego (Gertrud Goldschmidt), Alejandro Otero, Carlos Cruz-Diez, Mateo Manaure, Victor Valera, and Lya Bermúdez—should come as no surprise to anyone who understands that Venezuela is living under a populist regime whose leadership views these works as a symbol of the representative democratic "ancien régime," stigmatized by the new authorities as an example of bourgeois shame and partisan decadence. That Venezuela's greatest popular sculptor could be beaten and left dead in his humble dwelling is, however, a paradox in a country that today prides itself on being a republic of the poor and the center for a new kind of popular culture. Each of these events, each of these contradictions, each of these symbols must be integrated into our understanding of Caracas as a stage for modern art.

Many years before, in June 1969, modern art in Venezuela reached its critical limit (something like its "conversion" into a contemporary form in which its own presuppositions came undone) when Gego installed the first of the works belonging to her series of environmental Reticuláreas [titled *Reticulárea ambiential*] in Gallery 8 of what was then the Museo de Bellas Artes.[3] It cannot be claimed

that Gego voluntarily sought, with her work, to bring a modern chapter of Venezuelan art to a close, particularly not one that was embodied by her colleagues and contemporaries practicing non-objective languages. But it is obvious that, in the intimacy of the museum, this work in the Reticuláreas series signaled the conversion of that neutral space into one that is defined—or made—by random decisions that spread like an organism with no center, no roots, no plan, no destination: a topological, adhesive, unexpected, humble, fragile, shadowy, and fortuitous organism. In this sense, the type of work known as a Reticulárea contradicts every axiom that has governed modern will—in its Constructive form—in Venezuelan art: the master plan, the techno-rational program, political and aesthetic centrality, structural teleology, public megalography, the aesthetic will to power (and the will to aesthetic power), soundness of structure, optical illusion, ornamental reason, elimination of shadows, affirmation of transcendence, ideology of the avant-garde. This contradiction, which merits more discussion than can be undertaken in these pages, contains an accidental—

and therefore involuntary—variable. By using the same artistic and ideological codes as her modern contemporaries (and perhaps by manipulating that modernity in a minor key), and surely with a greater awareness of technique than many of them had, and with more openness to intuition than was possessed by others, Gego was able to show, from within, how exhausted these modern vocabularies had become in the visual arts of Venezuela.

Figure 44. Sculpture of Andres Bello and *Fisiocromía* by Carlos Cruz-Diez. Photograph by Jorge Cruz, c. 1970.

Figure 45. Twin Towers of the Centro Simon Bolívar and La Basílica de Santa Teresa. Photograph by George Steinheil.

neglected today, which is perhaps another consequence—if involuntary—of the preeminence of a "Constructive stage" in Venezuela.

3.

The period between 1948 and 1952 is of key importance in understanding the foundation of a Constructive art stage in Caracas. The year 1948 was both brilliant and tragic in Venezuela's political history, with the election of the great writer and novelist Rómulo Gallegos—known for his depiction of Venezuela and Venezuelans—in the first genuinely free elections in the country's history. The enormous civic (and civil) figure he cut as he took office on February 15, 1948, heralded the end of a historic cycle of brutal authoritarianism in the life of Venezuela. For the first time, the president was the political leader and humanistic symbol of the nation: the incarnation of democratic egalitarianism, the man who would restore Venezuela's great social aspirations, and the country's "heraldic" novelist.[4] For the first time, Venezuela's learned class, its reformist intelligentsia, had come to power, not the telluric visionaries, not those bound to earth, race, blood. Despite this, or perhaps because of it, on November 24, 1948, Gallegos's presidency was ended by a coup d'état and replaced by a development-oriented, military, tyrannical regime that ran the country until 1957. In 1952, the dictatorship dared to call elections and lost overwhelmingly, with the result that Colonel Marcos Pérez Jiménez, the defense minister, was imposed as de facto president until he was overthrown by a civilian and military revolt at the end of the decade. To this day, unfortunately, Venezuela's collective imaginary focuses on the mediocre figure of the dictator as a symbol of the infrastructure-modernization projects begun by the conservative democratic regime of Isaías Medina Angarita, from 1941 to 1945, and continued or expanded by the socialist democratic regimes of Rómulo Betancourt and then Gallegos, from 1945 through most of 1948. The fact that many of these infrastructure plans came to fruition during the dictatorship has contributed to two different outcomes: ignorance of Venezuela's democratic roots before the dictatorship, and ignorance of the immense contribution to infrastructure and overall development made by the legitimate post-dictatorship regimes from 1957 to 1998.

And she did it inside the museum, turning a place that was public and universal into one that was intimate, private, and marked.

Thus, from the very intimacy of modern will, Gego offered an artisan's version of modernity, producing a work of delicate balances and obvious material precariousness in which the factive "habitus" of Constructive art is made indistinct from that of popular artists. It is the Constructivist weft woven, as manual labor, with materials that lack aura and are sometimes neutral when not simply poor. Gego's oeuvre is not hierarchical, and this is true to the point where her work corresponds, although it is unmistakably modern and contemporary, to an artisanal labor in which the hand does not cease to leave its mark, its tiny bit of feeling. This is relevant to an understanding of why this essay began with a comment on the collapse of a modern bridge—the collapse of modernity as a historical bridge, as a source of structures that would lead to a particular end—and the murder, amid overall indifference, of one of Venezuela's greatest popular artists. We must begin, then, by understanding that kinetic, non-objective modern art was not the only kind of modern art in Venezuela, but simply the most visible. Moreover, its many artistic and aesthetic virtues did not include an ability to take root in local environments or a willingness to engage in fruitful dialogue with popular traditions in art and craftwork. Henri Rousseau had other interlocutors in Venezuela and is still

The 1948–1952 period is also important in the specific environment of the arts. Venezuela's first exhibition of non-objective art opened in 1948 at the Taller Libre de Arte, presenting works by Venezuelan artists who belonged to the exhibition's organizing group and also pieces by Argentine artists who actively took part in Argentina's Concrete art movements.[5] In the same year, Carlos Raúl Villanueva, the architect who most symbolized modernization in Venezuela, finished the first master plan for Caracas's Ciudad Universitaria, home of the Universidad Central de Venezuela. Construction of this campus during the 1950s would capitalize on images of modernity in Venezuelan art, constituting the

first and perhaps the only place truly attained for the arts in modern Venezuelan history. In 1950, the group known as Los Disidentes [The Dissidents] formed in Paris, upon publishing the magazine that carried its name; it was the first artists' group clearly identified with non-objective visual expression and opposed to local Venezuelan artistic traditions. In 1952, also in Paris, Soto seemed to achieve at last the international acclaim that made him the first Venezuelan modern artist to inscribe his work fully in the seminal context of a European and international artistic movement.

A review of this critical period is all the more important for the ability to understand the internal contradictions that marked the beginnings of a Constructive stage in Caracas. These internal contradictions are also necessary in order to refute the combination of fallacies that critics of Latin American art have been circulating about Venezuelan abstract geometric modern art. One of these fallacies consists in amalgamating, without further consideration, the 1950s abstract geometric stage in Venezuela with the emergence of Kinetic art during the 1960s and 1970s, thus confusing two historical periods—not to mention two differing artistic trends—that are clearly distinct. This has led to the attempt to deduce a common structural basis for "Torres-García, Madí, and Neo-concrete Art," that extends to the "Venezuelan Kinetic artists" and the Ruptura group of São Paulo.[6] It would be difficult if not impossible to demonstrate that Joaquín Torres-García was a key figure in the development of the language of Venezuelan Constructivism. The only exception was one marginal case, usually identified with the practice of a conventional type of easel painting;[7] none of the great figures that embodied non-objective expression in Venezuela is recognizable in the precedent set by Torres-García. Their sources lie elsewhere, and the artists who happened to appear in the exhibitions of the Taller Libre de Arte had distanced themselves by that time from the great Uruguayan master.

The Constructive stage in Venezuela, then, comprises two periods that are very distinct and clear. The first lasted from 1948 until 1957 and for the most part revolved around the huge works of infrastructure built under the dictatorship, specifically Carlos Raúl Villanueva's plan for a synthesis of the arts in Caracas's Ciudad Universitaria. The second period coincides with two events that have a causal link: Venezuela's return to democracy, in 1959, and the return to their "mother country" of the artists exiled in Paris during the 1950s, among them Soto, Otero, Pascual Navarro, Cruz-Diez, and Omar Carreño. The artists' return was merely symbolic, however, based as it was on a decision to inscribe their works within Venezuela's incipient national art market and to respond to the growing number of commissions for public art. These commissions would make Kinetic art—which had not existed as a form or designation in Venezuela during the 1950s—into the country's clearest symbolic manifestation, de

facto if not in principle, of democratic development policy from 1959 to 1976.

The same flippant critical outlook that fused Venezuela's different historical periods, dominant trends in the arts, and leading artists from 1948 to 1957 and from 1959 to 1976 turned the dictatorship into the golden age of modern optimism. Civil democracy, meanwhile, was viewed as an era of decadence, an act of political irresponsibility that only the lively clamor of curators could have committed. These attitudes seemed to turn on themselves in the emblematic case of Villanueva's plan for the Ciudad Universitaria, when it was judged—too quickly—to be a place that had been monopolized by the aesthetics of geometric abstraction.

There is no doubt that this project was key—both instrumentally and causally—to the emergence of a Constructive stage in Caracas. It is not true, however, that Venezuela's abstract geometric artists were the only ones to play a prominent role during this time, just as it is unfair to categorize Villanueva's project as part of the history of Venezuelan Kineticism. There are only two strictly Kinetic works at the Universidad Central de Venezuela, and both arrived there by chance. One is a Kinetic structure by Soto, dated 1957 and offered by the artist as a personal gift to Villanueva after the Ciudad Universitaria was finished; it became the topic of a lecture, after which a decision was made to install it on the

Figure 46. Teresa Carreño Cultural Complex. Photograph by Mariano Aldaca.

grounds of the architecture department. The other is a work by Villanueva himself, in the form of the fascinating *brise-soleil* concrete membranes that comprise the covered plaza of the large assembly hall, offering protection from the blazing Caribbean sun and, as it happens, filtering its rays and projecting them into vibrant shadows on the ground at certain times of day (figure 42).

The other pieces are abstract geometric —not Kinetic—works, lyrical or sensitive abstractions executed by Venezuelan and foreign artists, and also murals and figurative sculptures, whose ideological importance within Villanueva's project has been systematically ignored. I would like to argue that it is impossible to understand the Constructive stage in Caracas, even Venezuelan Kineticism, without integrating the counterpoint, the tension, the contradiction, and the contextual role played by these other forms of expression. They are part and parcel of the modern art stage in Venezuela, on equal footing with Constructive and Kinetic abstraction.

Villanueva's "synthesis of the arts" project made the Universidad Central de Venezuela into a true art space, perhaps the first—given its ambition and comprehensive nature—in the nation's history. But his plan for the university involved more than that. He also wanted the university to be a space for "combat" among the arts, a space where all the artistic trends that had been attempting, from the 1930s to the 1970s, to dominate the fate of our collective modernizing ideology would come together. Sometimes these trends melded together, and sometimes they confronted each other. In this regard, we should note that the first layout still responds to the framework for a structure that is "Elysian," classic, heroic, Beaux-Arts in style, fanning out in a radius from the axis point of the university hospital to the Olympic stadiums. Villanueva radically changed this master plan in 1952, adding a network of covered walkways that deconstructs, in a way, the classical model, transforming it into a modern project. During the development process, the arts also contradicted and combated each other, as modernity was visibly born from an "Elysian" illusion. Nativists, on the one hand, and universalists, on the other, filled the spaces of the Ciudad Universitaria with their works. This "combat" of the arts was organized into four nuclei of artists so that the Venezuelan nativists faced off against the Venezuelan universalists, and the foreign nativists lined up against the foreign avant-garde artists. Héctor Póleo, Pedro León Castro, Francisco Narváez, Alejandro Colina, Braulio Salázar, and Oswaldo Vigas are some of the Venezuelan artists whose language is lyrical or narrative, finding their foreign "counterparts" in the works of such artists as Baltasar Lobo, Wifredo Lam, and Jacques Lipchitz. The Venezuelan artists identified with geometric abstraction are Otero, Victor Valera, Navarro, Carlos González Bógen, Manaure, and Alirio Oramas; they were "paired" with such foreign contributors as Victor Vasarely and Anton Pevsner (perhaps the only rigorous

practitioners of geometric abstraction among the artists represented in the Ciudad Universitaria) and with artists of diverse abstract and lyrical tendencies, such as Jean Arp, Alexander Calder, and Fernand Léger. Still needed is an intelligent analysis of how these works function topologically in the space of the Ciudad Universitaria. What is evident, however, is that the spaces occupied by the figurative and nativist works tend to be intimate and administrative, whereas the abstract and geometric works are in public, monumental spaces. The exceptions—perhaps a trace of the "combat"—are three allegorical sculptures by Narváez (*La Ciencia, El Estudio,* and *El Atleta*) and the monument by Colina to the vernacular goddess María Lionza. The latter work occupied a very important location across from the Olympic stadium, where it served as the cauldron for the Olympic flame, but was later exiled (a decision apparently made by Villanueva) to an off-campus location.

There is some truth in the collective image of the Universidad Central de Venezuela as a melting pot for our geometric abstractions and as a place where Venezuelan art became more international in scope. This is so even though the presence of numerous and diverse works leads one to believe that conflicting currents of artistic nativism and universalism run between the potential for a national style of art and the continuity of foreign, legitimizing stylistic influences. More than irreconcilable and exclusionary, these "opposing" trends are on display at the Ciudad Universitaria like two sides of the same modernizing ideology, which—more than once, like an indomitable ritornello—would need to be broken up into a variety of transfigurations. Thus it was that, at the beginning of the 1960s, these two trends took on the form of two new frontiers: political informalism versus abstraction, and then New Figuration versus Kineticism. Nevertheless, the stage had changed, the dictatorship had ended, the Ciudad Universitaria project remained unfinished, and the civic infrastructure conceived by the democratizing regimes of the 1940s had morphed into a military, hotel, and allegorical (dictatorially powerful) infrastructure executed by the authoritarian regime. Venezuela lacked schools, universities, rural roads, clinics and hospitals, dams, industrial complexes, and parks but had a surfeit of military barracks, military ports and airports, luxury hotels, nightclubs, and presidential mansions.

4.

In 1948, Villanueva presented his first master plan for an integrated art project on the campus of the Universidad Central de Venezuela in Caracas. Eight years before, far away in the United States, Clement Greenberg had published his article "Toward a Newer Laocoon"—the seminal text of aesthetic formalism—in the pages of a Marxist literary magazine.[8] Over the years, this philosophy came to dominate artistic thought, becoming the most emblematic approach to art in Western capitalist society. Revisiting Lessing's classic distinction between arts of time

Figure 47. Olympic Stadium, Ciudad Universitaria, Carlos Raúl Villanueva, Architect. Photograph by Paolo Gasparini, c. 1950.

and arts of space, Greenberg (and, with him, the formalist movement in the United States) posited a thesis that favored separating the arts. In short, Greenberg viewed modern art as characterized by a diligent search for correlation between the works themselves and the constituent materials of their own formal media. Visual arts that legitimately sought the label "modern," for example, were obligated to embody forms that were less narrative. Greenberg's theory did not resonate in Venezuela, nor was it welcomed there. Venezuelan art and Greenberg-style formalism clashed most closely many years later in New York, albeit indirectly. There, in 1974, Soto's first U.S. retrospective, at the Guggenheim Museum, ended in a shrill failure, confirming that these two contexts are mutually untranslatable.

Villanueva's plan to integrate the arts was a response to a poetics of arts integration whose sources may hark back to the artistic rhetoric that had reigned in the West since the age of humanism. Its theoretical foundation lies in the theory of *ut pictura poesis* ["As

is painting, so is poetry"], that is, the humanist wish to view the various arts as a sum of "discourses" that are analogous to one another. This humanist ideology of equivalence among the arts, whose principles were weakened by Lessing in his treatise *Laocoon: An Essay on the Limits of Painting and Poetry,* continued to underpin integrative art projects in the first half of the twentieth century. It is clearly apparent in Villanueva's project, thus marking the origin of the Constructive stage in Venezuela. The utopia of a common space for the arts was able to take shape in the Ciudad Universitaria in Caracas but was not without its contradictions: the art forms that triumphed in the collective imaginary, and that were most effective in the project's architecture, were forms of abstract, antivernacular internationalism. This kind of art does not seek place but is art without place, art whose expression tries to take universal form, to be autonomous, to emancipate itself from all localism.

The aforementioned contradiction marks the evolution of the Constructive stage in

Figure 48. Covered walk with a cantilevered vault, Ciudad Universitaria, Carlos Raúl Villanueva, Architect. Photograph by Paolo Gasparini, c. 1952.

effective, and exciting, Kinetic art was based on a gestalt of certain fundamental features, such as lines, planes, points, and color. All of these could be structured in such a way that optical activation would produce fascinating visual illusions and optical promises. At the beginning of the 1970s, the oil boom and the downfall of the guerrillas had brought bourgeois stability to Venezuela, and the country filled up with artworks—marvelous and monumental, abstract, kinetic, and parallactic— by such artists as Soto, Cruz-Diez, Narciso Debourg, Otero, Manaure, Nedo, Francisco Salazar, Gert Leufert, Gego, Carreño, Luis Chacón, Harry Abend, González Bogen, Juvenal Ravelo, Valera, and Oswaldo Subero.

Today it is clear that this confluence of events constituted a chapter that was completely distinct from the art stage of the 1950s. In the 1950s, the official art of the dictatorial regime had prevailed, in the form of nativist and sometimes indigenous-centered muralism, often heroic and always hagiographically Bolivarian. Although this official art did coexist with the discreet presence of geometric abstraction, the latter was largely reduced to Villanueva's university project. It is also clear today, however, that what happened in Venezuela between 1959 and 1976—at least in terms of public art—constituted another form of muralism: one that had no story line, in which the only trace of narrative structure was reduced to its own optical dynamism, perceived as a process of optical transfiguration. It was "read" like abstract "writing" in the many muralistic configurations and innumerable friezes that once marked public spaces in Caracas and throughout Venezuela, once serving as milestones for a humanistic and promising optimism, but today reduced to the inexorable status of ancient ruins.

5.

Though I have had the advantage, which few Spaniards have shared with me, of having successively visited Caracas, Havana, Santa Fé de Bogotá, Quito, Lima and Mexico, and of having been connected in these six capitals of Spanish America with men of all ranks, I will not venture to decide on the various degrees of civilization, which society has attained in the several colonies. It is easier to indicate the different shades of national improvement, and the point toward which intellectual development tends, than to compare and class things which cannot be considered under one point of view. It appeared to me that a strong tendency to the study of science prevailed at Mexico and Santa Fé de Bogotá; more taste for literature, and whatever can charm an ardent and lively imagination, at Quito and Lima; more accurate notions of the political relations of countries, and more enlarged views on the state of the colonies and their mother countries, at Havana and Caracas. The numerous communications with commercial Europe, with the Caribbean Sea (which we have described as a

Venezuela. Toward 1961, Venezuela, close to overcoming the first political crises that threatened its nascent democracy, embarked on a plan to transform its infrastructure on three fronts: political stability, mass literacy, and consolidation of a heavily state-subsidized capitalism. The main idea behind this development-centered project can be summed up in a few words: Venezuela had survived its historical poverty with difficulty but also had been blessed by an overabundance of natural gifts in the form of resources that could be exploited. To overcome the centuries-old poverty that had alienated it from its own time, to free itself from the atavistic violence and poverty that had characterized it for a century and a half, Venezuela needed to put all its effort into turning these natural resources into energy, into a source of foreign exchange, into wealth. The vast investments in infrastructure had to translate a natural theology of giving—the goddess of nature—into a teleology of the promise of development.

This political functionalism rejected the strength of mythical tales and the power of representation in public spaces, reducing itself to the production of bare and functional structures. In the work of the Kinetic artists, it encountered an aesthetic that was involuntarily proportional. Monumental,

Mediterranean with many outlets), have exercised a powerful influence on the progress of society in the fine provinces of Venezuela and on the island of Cuba. In no other part of Spanish America has civilization assumed a more European character.[9]

Alexander von Humboldt wrote these words not long after he arrived in Caracas, in January 1800. Even today, this German sage's observations can help us understand the spirit of the new, the pleasure taken in what is recent, the interest in the contemporary, the burning desire to keep up with the world across the ocean—all of which, like ritornelli, have marked certain collective obsessions and desires of Venezuelan society. Perhaps we still do not have enough distance to evaluate the meaning—within the repertoire of modern art and modernizing trends in Venezuela and the Americas—of the Constructive art scene that existed (and continues to exist) in Caracas. Perhaps our cognitive abilities and senses of judgment are overly mortgaged by a kind of art history that is too Eurocentrically inclined, swinging like a manic pendulum between two options. One is the affirmation of a radical, vernacular, untranslatable difference, while the other is the desire for a legitimacy that is European, avant-gardist, and theoretical, possibly through the heterotopic shortcut that Michel Foucault, in his celebrated and incorrectly cited lecture, associated with the backyard where children play, with the parental bed in whose vast ocean of sheets adolescents lose their virginity, with the graveyard, with asylums, with prisons.[10]

Rather, the Constructive stage in Caracas should be viewed as another iteration of the vast anthropology of displacement that has controlled the fate of American culture ever since Europe spread its utopia across the American continent. It is not, however, because the European imaginary may have given us the dubious role of playing backyard to its own repressive actions, or parental bed to seminal erotic feelings about its own collective frustrations, that somewhere therein we might lie down. This is why Latin American art historiography is often associated with Europeanizing artistic historicism in two aspects that only appear to conflict with each other. One asserts a triumphant specificity of Latin American-ness, in which all European frustrations are set free. According to this point of view, for example, our Conceptual art would be better than and precede "theirs," while our Constructivism would be on an equal footing, and all our artists would have been avant-garde geniuses who, in addition to their artworks, produced a vast outpouring of treatises and theory. The other viewpoint rejects any possibility that our modern art might be perceived as a legitimate manifestation of modernity. It does not allow us to talk about "Constructivism" in Latin America but only about an insipid, formalist decorativism that is alien to all utopian impulse, as some European academics have professed.[11]

Aby Warburg, digressing on a fragment from Darwin, stressed the antithethical value of certain Renaissance gestural works relative to their classical models. For example, Andrea del Castagno's David, its hand raised to signify youthful, happy heroism, reproduces the gesture of a Hellenistic pedagogue's panic-stricken horror. Using this image as an example, Warburg pointed to an entire repertoire of inverted meanings through which the same gestures and classical forms acquired antithetical meanings in the Renaissance.[12] Nevertheless, perhaps the same "European professors" who reject the use of the term "Constructivism" for most of Latin America's Constructive art scenes in the second half of the twentieth century would not dare cast doubt on the classicism of the Renaissance works, even though the meanings they represent are antithetical to their historical models.

Antithetical "Constructivism," and even an "antithetical" Latin American modernity, would be worth considering if the inverted models were not also being abused from a critical standpoint. I have argued for the idea of understanding some of our modern art scenes as deformed forms of modernity—argued, that is, for the need to establish that the application and the transfer of modern modalities are a response to complex processes, not all of which are fully voluntary or conscious. Through these processes, forms that are analogous to modern European canonical solutions have acquired distinct meanings. They have undergone programmatic or accidental transformations, to the point of becoming less similar to their modern analogues, or else they have been the objects of an effort to make them dissimilar by conceiving of them as transitional forms, that is, as structures that link the field of art and the space of ordinary life.[13]

According to this point of view, access to Modernity, which was presented as a figure of emancipating desire and as a source that regulated the production of symbols, had the same anthropological function in some Latin American countries as did the revisiting of classical Antiquity that occurred in some societies of Europe's Mediterranean basin at the beginning of the Renaissance. The "Constructive stage," then, wherever it has occurred in Luso-Hispanic America, is the deformation of a canonical Constructive canon in the same way that the classic figures of Botticelli and Ghirlandaio were a deformation of the canonical forms of antiquity. In this sense, the anthropological specificity in both cases—classic Renaissance, and the afterlife of modernity—lay in the otherwise palpable fact that gaining access to Modernity in the vast territory where their re-establishment in America took place was as impossible as gaining access to the true contents of ancient forms was for the artists of the Quattrocento. As Aby Warburg clearly understood, in both cases the symbolic production (that is, the work of art) functioned as a fictitious, illusionary substitute for this access, this utopia. In other words, just as a revival of Antiquity

was impossible whenever Europe thrust itself into that retrospective utopia, even though it was possible to make "antique forms," it was perhaps impossible to create a canonical Modernity—that "forward-looking utopia," wherever it may have been—even though it was and still is possible to make modern forms.

The geometric and non-objective abstractions executed during the second half of the twentieth century in some parts of Latin America—and the Constructive stage in Caracas is an example of this—should be considered, then, as forms of the "afterlife" of Modernity. They should be thought of as "survivals" of the abstract geometric solutions associated with various modern projects, as well as Constructive "alter-forms" subjected to complex processes of a selective transformation that is at times unplanned and even involuntary, to the point of resembling a "digression" or a "deformation." Either of the latter enables them to become functional and effective in their respective realities, and in the spaces in which they move.

In the early 1970s, Caracas brimmed magnificently with Kinetic murals, with penetrable, resonant sculptures, with dazzling aluminum pyramids orbiting in the optimistic wind of the tropics; buses sported Physicromies and Additive Colors,[14] as did pedestrian walkways, sidewalks, and containment structures. The silos in the port of La Guaira were colorful machines, like the wall separating the warehouses of the port from Venezuelan territory. The country's border was a symbolic Physicromie by Cruz-Diez, while Manaure's virtual cubes marked the bus stops, and Gego's Cuerdas [Cords] cast their mysterious shadow as they knotted around the most ambitious structure of reinforced concrete on the planet during that era, providing both office and living space: the immense towers of Caracas's Parque Central.

Around the same time, another generation of artists made their seminal inscription within the Constructive scene, heralding its exhaustion. (Until today, their critical fortunes were concealed by the weight of the Constructive masters' powerful thought.) Claudio Perna and Eugenio Espinoza carried Espinoza's Impenetrables—immense fabrics topped with black reticulae, which Espinoza spread out on a canvas stretcher parallel to the floor of the exhibition galleries in order to block public access—to the Coro Dunes and wrapped them around the nude body of a young man, as seen in photographs that represented the reinscription of the human organism within the desert-like Constructive womb. Héctor Fuenmayor covered all the spaces in the Sala Mendoza in a coat of yellow monochrome paint, a sarcastic allusion to the optical chromaticism of his Kinetic senior predecessors; Roberto Obregón dried his rose petals in rhythmic, intimate constructions that reflected the first serial icon of Venezuelan art: the Ávila mountain. Antonieta Sosa filmed herself climbing an enormous scaffold, a monumental metallic net, with the slowness that stems from laziness. All these artists were recognizable in the image of what Gego was producing during those years: series titled Bichos [Critters], Chorros [Cascades], abstract but organic structures, and Dibujos sin papel [Drawings without Paper], in which scarce waste material found an unexpected symbolic fate.

Between 1976 and 1983, the year in which the first foreign-exchange crisis crippled the entire fate of Venezuela's dream and heralded the end of the development-oriented utopia, other monumental, Constructive works rose in the public spaces of Venezuela's cities: Gego's monumental Reticuláreas in the Caracas metro stations, Bermúdez's iron wings, Abend's reliefs covering the dome of the enormous Teatro Teresa Carreño, Soto's virtual spheres and cubes in every park, Max Pedemonte's planks, Cruz-Diez's chromatic gardens, Otero's Abras Solares, which resembled aluminum mirrors. As Gego was remounting her Reticulárea ambiental for the last time (that "small chapel for stasis" in whose knots could be read the involuntary allegory of Venezuelan Kineticism reduced to inconceivable, irregular "impasses"), Cruz-Diez was finishing the enormous turbine chamber in southern Venezuela's Guri dam—that Sistine Chapel of Venezuelan Kineticism, in which material energy production turns into the very support of optical illusions. Thus, the culminating public work of Venezuelan Kineticism, in the region where Soto was born, and where as a child riding a donkey he had seen the blinding vibration of the light in the air, which would lead him many years later to conceive his Penetrables, coincides chronologically with the culmination of the work that closes the historical cycle: Gego's Reticulárea ambiental.

It is not possible to see the exterior landscape from inside the Reticulárea. Nor is it possible to see the landscape from inside Guri's turbine chamber, sunk below the level of the black waters of the Caroní River; nor, strictly speaking, was the landscape visible from inside the Penetrables, where it disappeared—as do our own bodies—in the opacity of a torrent of plastic. Both body and landscape are inscribed as figures of absence, as enormous negative presences, as enigmatic niches in the history and poetics of Venezuelan Constructivism. Both body and landscape were, and are, the key to Villanueva's integrative utopia in Caracas's Ciudad Universitaria: it is the only thing not represented there, because everything has been made for them, to be able to move, to contemplate, to dematerialize.

A few weeks before January 6, 2006, when the battered body of Venezuela's greatest popular artist, abandoned to his killer's blows, would breathe its last, when the modern bridge, the symbol of modernity as a bridge, would be forever closed, leaving Venezuela's capital isolated psychologically and in time, the revolutionary mayor of the city of La Guaira ordered the demolition of Cruz-Diez's Muro Cromático. He consulted no one. Cruz-Diez's work marked the boundary between the most important merchant port in the capital region and the rest of the country. On every

front page of every newspaper there dawned images of workers dressed in red, using their clubs to demolish the Kinetic work that was once a symbolic membrane between Venezuela and the world. The idea of a moving body opposite a work without a body, the idea of a landscape whose chromatic gestalt deconstruction occurs in works without a landscape, gave rise, with the violence of history and the uncertainty of error, to a devastating scene in which the traces of the body are barely read as languages without meaning; and in the countryside it gave rise to the ruins of a failed Constructive modernity that waits, in a country now deprived of a utopia, and clinging more than ever to the myth of its natural gifts, to some soon-to-be, improbable "afterlife."

Notes

All translations are by Trudy Balch unless otherwise noted.

1. See Mari Carmen Ramírez, "Vital Structures: The Constructive Nexus in South America," in Mari Carmen Ramírez and Héctor Olea, eds., *Inverted Utopias: Avant-Garde Art in Latin America* (New Haven, Conn.: Yale University Press in association with the Museum of Fine Arts, Houston, 2004), 191.

2. For the notion of the "afterlife" of artistic forms, see Aby Warburg, *The Renewal of Pagan Antiquity: Contributions to the Cultural History of the European Renaissance,* trans. David Britt (Los Angeles: Getty Research Institute for the History of Art and Humanities, 1999); and Ernst H. Gombrich, *Aby Warburg: An Intellectual Biography* (Chicago: University of Chicago Press, 1986).

3. For a review of the process of conceiving and installing this work, see the enlightening essay by Mónica Amor, "Another Geometry: Gego's *Reticulárea, 1969–1982," October* (August 2005): 101–25.

4. I owe this description of Gallegos as a "heraldic" Venezuelan novelist to the writer José Balza. The novels of Rómulo Gallegos (1884–1968) are emblematic of Venezuela's countryside and ethnicity, and they include texts that are seminal for the imagery of Venezuela's plains (*Doña Bárbara,* 1929; *Cantaclaro,* 1934), the Amazon jungle (*Canaima,* 1935), the Far West and the Guajira, that is, the peninsula (*La brizna de paja en el viento,* 1952), interracial mixing (*Pobre Negro,* 1937), and the decline of the country's aristocracy (*Reinaldo Solar,* 1930).

5. This group includes Juan Melé, Lidy Prati, José Mimó Mena, Jorge de Souza, and Alfredo Hlito as well as more acclaimed figures, such as Juan del Prete; see *Arte Constructivo Venezolano, 1945–1965* (Caracas: Galería de Arte Nacional, 1979), 9.

6. See Ramírez, "Vital Structures," 192.

7. Here, I am referring to the work of the artist Manuel Quintana Castillo, who was not close to the abstract geometric group but was instead somewhat isolated in the Venezuelan art of the second half of the twentieth century.

8. For a more recent reprinting, see Clement Greenberg, "Toward a Newer Laocoon," in Francis Frascina, ed., *Pollock and After: The Critical Debate* (London: Harper and Row, 1985).

9. Alexander von Humboldt, *Viaje a las regiones equinocciales del nuevo continente,* vol. 2, trans. Lisandro Alvarado (Caracas: Monte Avila Editores, 1991), 330; and Alexander von Humboldt, *Personal Narrative of Travels to the Equinoctial Regions of America during the Years 1799–1804,* vol. 1, ed. and trans. Thomasina Ross (London: G. Bell & Sons, 1907–1908), 412–13.

10. This celebrated lecture was one that Foucault gave on the radio in 1967, a recording of which is owned by the French Institut National de l'Audiovisuel. An unauthorized text based on the lecture was published four months after Foucault's death as Michel Foucault, "Des espaces autres: Hétérotopies" [On Other Spaces: Heterotopias], *Architecture/Mouvement/Continuité* (October 1984).

11. As argued by Eduardo Subirats of New York University in a panel discussion held at the Americas Society on April 19, 2006, and organized in conjunction with *Jump Cuts: Venezuelan Contemporary Art, Colección Mercantil.*

12. See Kurt W. Foster, introduction to Warburg, *The Renewal of Pagan Antiquity,* 38.

13. See Luis Pérez-Oramas, "Is There a Modernity of the South?," *Omnibus/Documenta X* (October 1997): 14–16; Luis Pérez-Oramas, "¿Es concebible una modernidad involuntaria?," unpublished paper, Instituto Universitario de Estudios Superiores en Artes Plásticas Armando Reverón, Caracas, 2000; Luis Pérez-Oramas, "Gego, retículas residuales y modernidad involuntaria: la sombra, los rastros y el sitio"/"Gego, Residual Reticuláreas and Involuntary Modernism: Shadow, Traces and Site," trans. Julieta Fombona, in Mari Carmen Ramírez and Teresa Papanikolas, eds., *Questioning the Line: Gego in Context* (Houston: Museum of Fine Arts, 2003), 83–115; and Luis Pérez-Oramas, "Parangolé/Botticelli: Helio Oiticica, Geometric Abstraction, and the Notion of Transitional Form after Aby Warburg," paper presented at the Beyond Geometry International Roundtable, Miami Art Museum, November 30, 2004.

14. References to series of works by Carlos Cruz-Diez.

Selections from the Collection

Joaquín Torres-García, *Construcción en blanco y negro [Construction in White and Black],* 1938

1874–1949, Montevideo

Joaquín Torres-Garcia is best known for his synthesis of gridded compositions and schematic signs, but *Construcción en blanco y negro* (plate 1) is almost entirely devoid of his characteristic symbols. Only three sets of notations interrupt an otherwise pristine grid: in the lower left, Torres-García noted the year in which he made the painting (1938), and he signed the work (reducing his name to the initials "JTG"); in the lower right, he painted the schematized letters "AAC" to indicate his membership in the Asociación de Arte Concreto, which he had founded in Montevideo; and in the lower center, he painted "ENE 1," an abbreviation for *enero* 1 (January 1). Torres-García thus announced this painting as the first work of a new year. In important ways, the painting presaged events of that year: its visual similarity to Inca stonework evokes not only a series of lectures that Torres-Garcia gave in late 1938 and published in 1939 as *Metafísica de la prehistoria indoamericana [Metaphysics of Indo-American Prehistory],*[1] but also the completion, in 1938, of his granite *Monumento cósmico [Cosmic Monument];* moreover, the reference to the AAC was made in what would turn out to be the final year of the organization's existence. This painting, one of a series of empty gridded compositions that Torres-Garcia began in 1935 and continued to make into the early 1940s, recalls Inca stonework, like the others in the series, not only visually but also through metaphorical ties to Inca social and cultural concepts that underpinned Torres-García's own artistic ambitions.

In a seminal essay, Rosalind Krauss wrote: "The grid announces, among other things, modern art's will to silence, its hostility to literature, to narrative, to discourse."[2] But Torres-García's use of the grid in this work, and in others from the series, is not silent; it engages in a discourse regarding the role of abstraction, in the Americas in particular, in terms that are social and cultural as well as formal.

This painting, like all of Torres-García's empty grid paintings, differs from his other compositions not only in its lack of symbolic imagery but also in its play of light and shadow. The artist certainly used shading in other works, but in these paintings he used light and dark to create the effect of modeling—to impose the suggestion of three dimensions onto an otherwise geometrically abstract canvas.

He eliminated his usual earth tones from his palette, in favor of black and white. He painted this work on paper, now mounted on wood, and, particularly near the edges of the black lines that form the grid, sections of paper devoid of paint appear throughout the work. These areas of blank paper allowed Torres-García to reassert the two-dimensionality of the work and to integrate the support into the overall image. Jacqueline Barnitz has written that these paintings are really an engagement with surface rather than an attempt to render three dimensions.[3] But viewers cannot avoid noticing the very deliberate use of light and dark that models the compartments of the grid, which themselves begin to look like interlocking stones in a wall.

Construcción en blanco y negro, painted four years after Torres-García returned from Europe to Uruguay, reflects Torres-García's deep engagement with the art and architecture of the native peoples of the Americas, particularly the Inca and other Andean peoples, as well as his desire to incorporate lessons from these predecessors into a modern South American art. Cecilia Buzio de Torres has pointed out that Torres-García embraced the art of the Inca not only because of its relative geographical proximity to Uruguay but also because of his feeling that the art of the Inca represented what he called "abstract thought."[4] She has also argued that the artist's goal was never to imitate pre-Columbian art but rather to "capture its spirit."[5] That is certainly true of his body of work as a whole, but this painting and others in the same series do indeed visually mimic Inca masonry. It was perhaps precisely because of his desire to "capture the spirit" of the Inca that Torres-García made these paintings, which allowed him to present a complex set of ideas within a deceptively simple visual format.

Scholars generally agree that stonework was among the highest of Inca aesthetic achievements. The Inca reserved mortarless masonry for sacred and elite spaces. Their walls, built to withstand regular earthquakes, consist of stones carefully and seamlessly joined in aesthetically harmonious compositions. High-altitude sunlight on the stones' beveled edges creates an effect of stark geometric patterns. It is precisely this sharp contrast of light and dark that Torres-García captured in *Construcción en blanco y negro.*

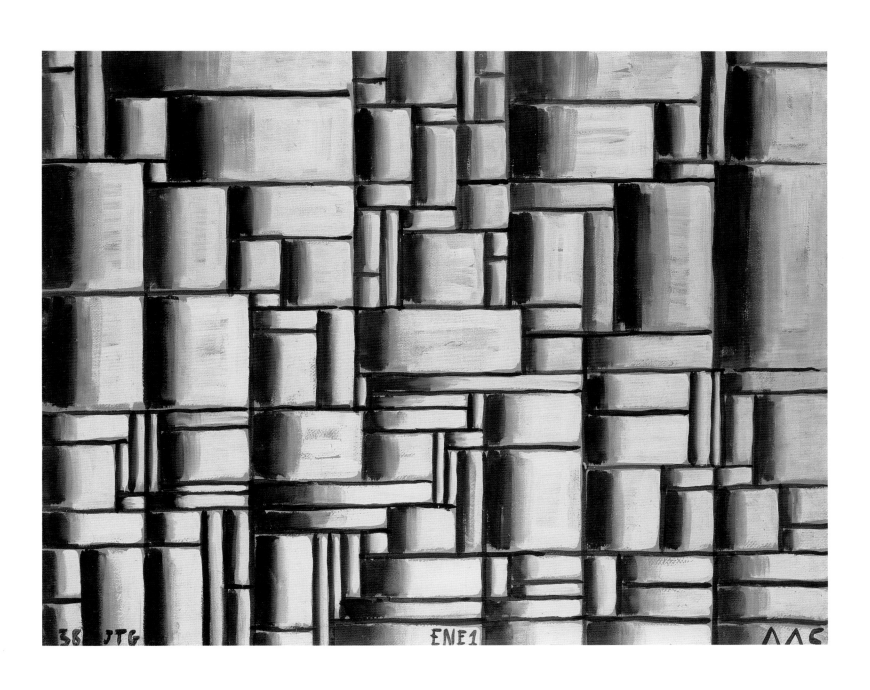

1 *Construcción en blanco y negro [Construction in White and Black]*, 1938
Oil on paper mounted on wood; 80.7 × 102 cm (31¾ × 40⅛ in.); The Museum of Modern Art, New York, fractional and
promised gift of Patricia Phelps de Cisneros in honor of David Rockefeller, 331.2004; copyright Artists Rights Society

In order to construct their mortarless walls, the Inca enlisted the forced labor of *mit'a* workers, who came from various ethnic groups and moved throughout the Inca empire, working on construction projects.[6] As Rebecca Stone-Miller has written, these walls served as a metaphor for the Inca empire: "Divergent people were to interlock, adjust, and resettle into a dynamic whole by pooling their varying forms, smoothing their ethnic edges, and holding together with no visible means to face the hostile environment."[7] This metaphor applies equally well to Torres-García's vision for the AAC, through which he hoped to achieve a modern South American art constructed in much the same way as Inca walls—anonymously, collectively, and by artists of different social, geographical, and ethnic origins. In *Construcción en blanco y negro,* Torres-García conveyed these ideals not only by visually mimicking Inca walls but also by reducing his signature to simple initials and by giving equal prominence to the AAC. Torres-García also gave the work, in Krauss's terms, a "centrifugal" quality: black lines separate the individual units of the painting but do not outline its edges, and thus the viewer is allowed to imagine the painting extending infinitely beyond the limits of the canvas.[8] The painting exists as one element in Torres-García's larger project; its centrifugal character links it to his other paintings and to those of his fellow artists in the AAC.

Ironically, Torres-García first encountered the pre-Columbian art of the Andes not in South America but in Paris, where his son worked at the Musée de l'Ethnographie du Trocadéro, making renderings of Nasca ceramics.[9] The jumbled displays and chaotic storerooms of that museum, which decontextualized and aestheticized the objects it displayed, must have filtered his early understanding of pre-Columbian art, as they had for many modern artists.[10] After returning to Uruguay, Torres-García embarked on a more scholarly investigation of Inca art, but his absorption of Andean aesthetics into his own artistic system, and his assumption that pre-Columbian art contained some kind of essential truth, do pose certain problems. In his adoption of Inca forms and symbols, to what degree did he really differ from European modernists, who frequently engaged in an exoticizing, primitivizing appropriation of non-European art? It seems safe to say that Torres-García, whether or not he fully understood the cultural meanings of the Andean art that inspired paintings like *Construcción en blanco y negro,* adopted Andean forms in the hope of achieving a uniquely South American modernism, aesthetically as well as culturally and socially, through the pursuit of a geometrically based modernism made collectively with fellow artists.

Courtney Gilbert

Notes

1. See Joaquín Torres-García, "Selections from *Metaphysics of Indo-American Prehistory,*" trans. Anne Twitty, in Mari Carmen Ramírez, ed., *El Taller Torres-García: The School of the South and Its Legacy* (Austin: University of Texas Press, 1992), 70–74 (originally published as Joaquín Torres-García, *Metafísica de la prehistoria indoamericana* [Montevideo: Asociación de Arte Constructivo, 1939]).

2. See Rosalind E. Krauss, "Grids," in Rosalind E. Krauss, *The Originality of the Avant-Garde and Other Modernist Myths* (Cambridge, Mass.: MIT Press, 1985), 9.

3. Jacqueline Barnitz, *Twentieth-Century Art of Latin America* (Austin: University of Texas Press, 2001), 132.

4. Cecilia Buzio de Torres, "The School of the South: The Asociación de Arte Constructivo, 1934–1942," in Ramírez, ed., *El Taller Torres-García,* 15.

5. Buzio de Torres, "The School of the South," 15.

6. Torres-García may or may not have been aware of the Inca construction system based on *mit'a* labor. But his study of Andean art did transcend aesthetics and, as Paternosto has illustrated, he did closely read the work of the ethnohistorian Luis E. Valcárcel; see César Paternosto, *The Stone and the Thread: Andean Roots of Abstract Art,* trans. Esther Allen (Austin: University of Texas Press, 1996), 219.

7. Rebecca Stone-Miller, *Art of the Andes from Chavín to Inca* (London: Thames and Hudson, 1995), 194.

8. Krauss, "Grids," 18–19.

9. Jacqueline Barnitz, "An Arts and Crafts Movement in Uruguay: El Taller Torres-García," in Ramírez, ed., *El Taller Torres-García,* 143.

10. For more on this subject, see James Clifford, "On Ethnographic Surrealism," in *The Predicament of Culture: Twentieth-Century Ethnography, Literature, and Art* (Cambridge, Mass.: Harvard University Press, 1988), 117–51.

Joaquín Torres-García, *Composición constructiva 16 [Constructive Composition 16],* 1943

1874–1949, Montevideo

In 1943, Joaquín Torres-García founded the Taller Torres-García (TTG), a workshop where he imparted lessons concerning geometry, structure, and the meanings of mystical symbols. *Composición constructiva 16* (plate 2), made the same year, combines grids and pictograms and exemplifies Torres-García's mature style, which he based on a theoretical system—Constructive Universalism—that he had been formulating since the 1920s. Torres-García believed he and his pupils, by studying and incorporating the basic geometric structures (the constructive) of the ancient and modern worlds, could create art that would be eternally meaningful (universal) to all who viewed it. *Composición constructiva 16,* which fuses pre-Columbian elements, symbolism derived from freemasonry, and objects of contemporary life, embodies these precepts and would have served as a model for the artists in the TTG.

Torres-García began developing his concept of Constructive Universalism while he was living in Paris. There he befriended such artists such as Piet Mondrian and Theo van Doesburg, who promoted an entirely geometric art that they called Neo-Plasticism. While Torres-García appreciated the spiritual value that the Neo-Plasticists assigned to geometric forms, he refused to align himself completely with their artistic circle. In turn, the Neo-Plasticists criticized Torres-García for his incorporation of representational imagery, which, they believed, interfered with the "pure" geometry of the grid. Even the painter Jean Hélion, a close friend of Torres-García, protested in 1930, "Geometry is one thing, humanity is another; their mixture is at once anti-mathematic and anti-human."[1] But Torres-García contended that the pictograms, like the grid, were themselves timeless structures; he believed that they reflected the basic ways in which humans visualize and organize the world around them. Torres-García also stated that man "orders not only his thought, but also everything that he sees, establishing perfectly polarized relations. That is why one could say that, for the primitive, *to think is to geometrize.*"[2]

Thus Torres-García intended that the pictograms in *Composición constructiva 16* should reconnect the artist and the viewer to a geometric art tradition and a mode of thinking dating back to early human civilizations. The stone-gray background indicates endurance and is meant to recall the ancient monuments of South America. And the pictogram of the radiating sun, which Torres-García and his students frequently included in their works, connotes reverence for the Inca deity Inti.[3] Today we may view these paintings, which presume Latin America's primitivism and romanticize pre-Columbian culture, as problematic. But during his lifetime, Torres-García genuinely respected ancient artistry and cultural difference. He warned against superficial copying of ancient and folkloric work: "Imitating or copying the typically folkloric is a mistake," he wrote, "because it is not there that we find the soul of things but rather in the qualities and the structures of their plastic organization."[4] Applying the principles of Constructive Universalism, Torres-García reduced a fish, a twin-mast ship, an anchor, and a man standing alongside a shovel to their most basic structural components.

Torres-García did not mean for the viewer to read these pictograms as if they were hieroglyphics. Rather, he left the meaning of his forms somewhat open to interpretation, laying them out in accord with his intuitive sense of balance and composition. In *Composición constructiva 16,* a black grid, which the artist painted freehand, possesses a rather organic structure, its cells varied and irregular. The pictograms fill the cells with an inventory of shapes that Torres-García had been repeating in his paintings and sculptures since the 1930s; their application was nearly ritualistic.

Several of the esoteric symbols in *Composición constructiva 16* are associated with freemasonry. While living in Paris, Torres-García had visited a Masonic lodge with the Spanish painter Luis Fernández.[5] He appreciated the ways in which the Masons used symbols associated with architecture to represent their most sacred beliefs. In *Composición constructiva 16,* architectural structures from antiquity (for example, the aqueduct and the triumphal arch in the center), as well as builder's tools (the hammer situated on the far right, and the anvil depicted above the body of a guitar), suggest the constructive power of man and of God (to whom the Masons refer as "the Great Architect of the Universe"). Other Masonic emblems and numbers, such as the pentagram and the number 5, also elicit associations between the mundane and spiritual worlds.

For Torres-García, what defined modernization was not industrial development but the

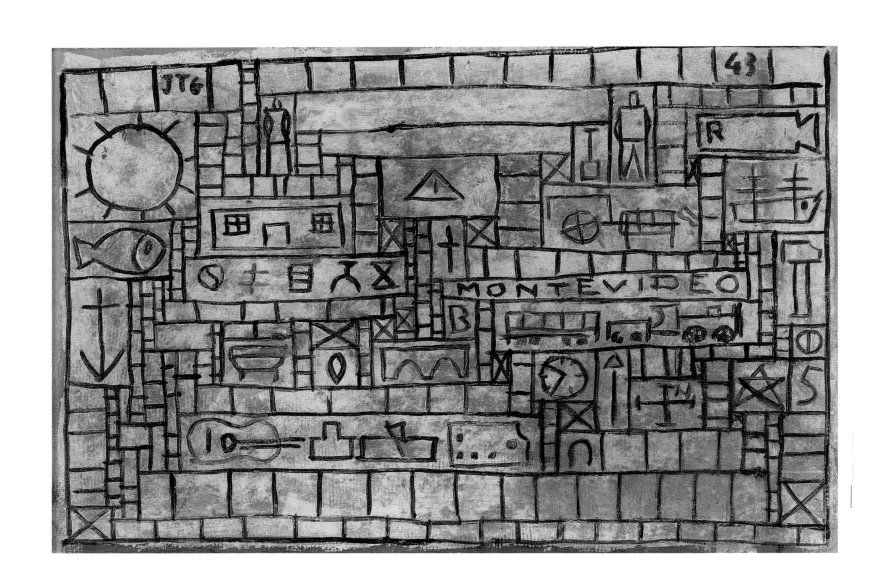

2 *Composición constructiva 16 [Constructive Composition 16],* 1943
Oil on cardboard; 43.2 × 64.5 × 0.3 cm (17 × 25⅜ × ⅛ in.); Colección Patricia Phelps de Cisneros, 1997.33; copyright Artists Rights Society

recovery of spirituality within the city. In the center of *Composición constructiva 16* he includes the name of the city in which he made the painting, Montevideo, not just because it is an autobiographical reference but also because he admired the shape of the word. In a lecture delivered in 1935, he explained that the city's name foretold its inevitable greatness: "The man in this city is as unique as the city itself, with those ten letters in a row, neither rising nor falling, equal in size, and disquieting in their pure lack of expression: MONTEVIDEO."[6] In 1934, Torres-García had returned from Paris to Uruguay determined to make Montevideo into a major artistic center, and in the lower-right portion of the painting (to the left of the pentagram) a cross marked N—like a compass rose—refers to Torres-García's goal to reorient the art world, with South America achieving ascendancy. In various drawings, moreover, he literally inverted the map to give Montevideo geographical prominence. He remarked, "Our compass . . . will incline irremediably and forever toward the South, toward our pole. When ships sail from here traveling north, they will be *traveling down, not up* as before."[7]

Initially, artists in Montevideo embraced Torres-García's idea of Constructive Universalism. Although support for him waned in the late 1930s, *Composición constructiva 16* marks a time when Torres-García had rededicated himself to the study and dissemination of Constructive Universalism. Through public lectures, manifestos, and the production of the magazine *Círculo y cuadrado [Circle and Square]*, he continued to promote his ideas on abstract art. In particular, at the TTG he trained young artists, reviewing their work weekly and familiarizing them with the history of European and Indo-American art. His own work reveals Torres-García's relentless pursuit of cultural harmony and his desire to integrate diverse artistic and spiritual principles.

Michael Wellen

Notes

1. Jean Hélion, "Les Problèmes de l'art concret—art et mathématiques," *Art Concret* (1930), as cited in translation in Margrit Rowell, "Order and Symbol: The European and American Sources of Torres-García's Constructivism," in *Torres-García: Grid-Pattern-Sign, Paris–Montevideo, 1924–1944* (London: Arts Council of Great Britain, 1985), 13.

2. Joaquin Torres-García, "Selections from *Metaphysics of Indo-American Prehistory*," trans. Anne Twitty, in Mari Carmen Ramírez, ed., *El Taller Torres-García: The School of the South and Its Legacy* (Austin: University of Texas Press, 1992), 74 (originally published as Joaquin Torres-García, *Metafísica de la prehistoria indoamericana* [Montevideo: Asociación de Arte Constructivo, 1939]) (emphasis in original).

3. Torres-García, discussing Inti and the god's significance for contemporary South Americans, proclaimed, "If today we can say that Inti (the Sun) is our father, and that our Mother is the Earth, we are not just imitating something, for we always believed this; it was part of our religious conception of life"; see Torres-García, "Selections from *Metaphysics of Indo-American Prehistory*," 72.

4. Joaquin Torres-García, "The New Art of America," trans. Anne Twitty, in Ramírez, ed., *El Taller Torres-García*, 79 (originally published as Joaquin Torres-García, "El nuevo arte de América," *Apex* [Montevideo] 1 [July 1942]: 11–16).

5. Jacqueline Barnitz, *Twentieth-Century Art of Latin America* (Austin: University of Texas Press, 2001), 129.

6. Joaquin Torres-García, "The School of the South," trans. Anne Twitty, in Ramírez, ed., *El Taller Torres-García*, 55 (originally given as a lecture in 1935, then published as "Lección 30" in Joaquin Torres-García, *Universalismo constructivo: Contribución a la unificación del arte y la cultura de América* [Buenos Aires: Editorial Poseidón, 1944]).

7. Torres-García, "The School of the South," 53 (emphasis in original).

Rhod (Carlos María) Rothfuss, *Sin título (Arlequín) [Untitled (Harlequin)]*, 1944

1920–1969, Montevideo

This somewhat clumsy, enigmatic, and probably unfinished work (plate 3) is nevertheless an important missing link in the development of abstract art in the Río de la Plata area. If this painting dates from mid- to late 1945, it is quite possibly the earliest remaining proto-Madí *marco recortado* (structured frame) work in existence. The implications of this work for the still unwritten history of geometrical abstraction in Buenos Aires are very significant and provide a cornerstone from which to construct a more accurate history of the little-understood but key years between the publication of *Arturo*'s first and only issue in 1944, and the foundation of the Madí movement in August 1946.

The best contextual clue to the date of this work is a photograph of the *Art Concret–Invention* exhibition that took place at the Buenos Aires home of the psychoanalyst Enrique Pichón-Rivière on October 8, 1945. This was the first exhibition of the artists who would go on to form the Madí movement the following year—Carmelo Arden Quin, Gyula Kosice, and Rhod Rothfuss. In the group photograph taken at this event, a painting in the background shows some similarities with this untitled work in its semifigurative subject matter and structured frame.[1] Rothfuss used a very similar work, based on a guitar, to illustrate his text/manifesto "The Frame: A Problem in Contemporary Art," published in *Arturo*.

There is a clear difference between these semi-figurative, Cubist-inspired works and Rothfuss's better-known, clean-cut geometrical work of the later 1940s and early 1950s. Nevertheless, the endemic pre-dating of these more rationalist geometrical works to the mid-1940s has created a great deal of confusion regarding the history and development of the Madí movement. Adding to the confusion is the disparity that also exists between, on the one hand, Rothfuss's very upbeat and ambitious denunciation of figuration and Cubism in his *Arturo* text and, on the other, the work he placed alongside a work by Piet Mondrian to show his solution to the limitations of the regular frame. All these factors suggest that the geometrical structured frame was not born fully formed either from the pages of *Arturo,* in 1944, nor from the first *Art Concret–Invention* exhibition, in 1945, but rather that, as in many other avant-garde movements, the texts and ambitions of these young artists were well ahead of their actual visual production.

Sin título (Arlequín)[2] differs from later structured-frame works by Arden Quin, Maldonado, and even Rothfuss himself in that the irregular frame does not mark the limit of the geometrical composition on the canvas. The outline of the frame appears at first to bear no direct correlation to the semi-abstract composition on the inside, but in fact the relationships are fairly subtle, and the jagged frame even creates a sort of *contrapposto* to balance the painted planes. An example of this somewhat playful dialogue between painted form and structured frame appears in the painted form on the top left, creating an angle that echoes both the angle of the frame on the center right and the red form painted along the bottom. All these formal dialogues, and the complex visual planes of the overlapping forms, create an effect that is almost Baroque in its balancing of opposing forces. This work is not a negation of visual illusionism (a topic being discussed contemporaneously by Tomás Maldonado and others); rather, it seems to fully exploit the possibilities created by dynamic optical recession and illusion.

A whimsical sense of humor, particularly in the choice of subject matter, marks *Sin título (Arlequín)*. The inclusion of the slightly bizarre curved hat makes the apparently abstract composition semireferential. This quotation of a favorite subject of early modernist painting seems out of character for Rothfuss, who was criticizing European artists like Mondrian for not being abstract enough. There are two ways to interpret this apparent step backwards: one can focus on the distance between the artist's theoretical and practical propositions, or one can find an ironic sense of humor that seems at odds with the common view of Rothfuss as the most serious and rigorous of the Madí artists. The truth, of course, probably reflects a combination of these two factors: it was easier to identify the problems and contradictions of the European avant-garde than it was to find practical solutions, and it is possible that the enigmatic Rothfuss, an artist about whom almost nothing is known, was not above engaging in some ironic and self-deprecating visual humor. The paucity of reliable information on Rothfuss, one of the few artists of his generation to die young, has made him into something of a myth, a

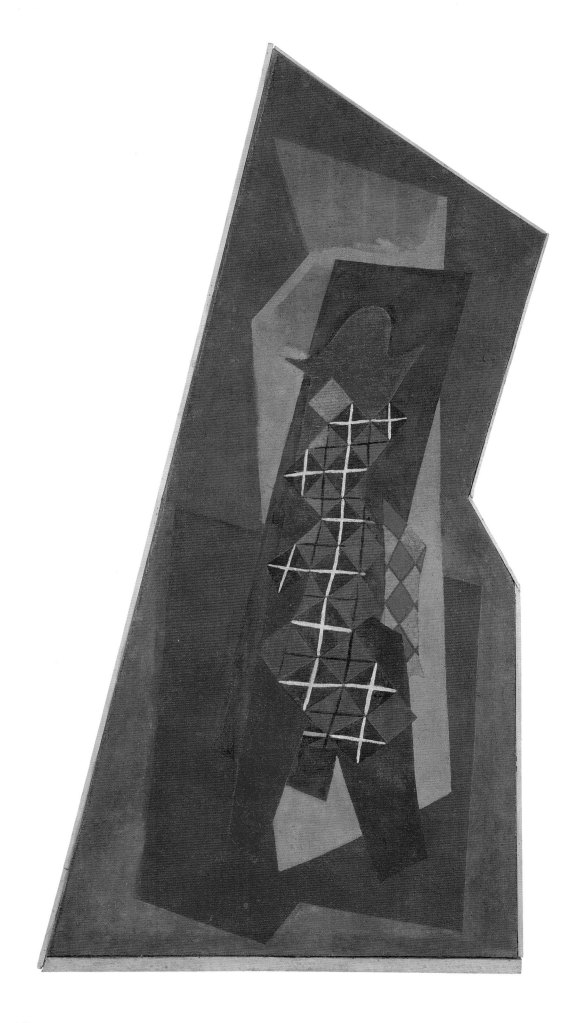

3 *Sin título (Arlequín) [Untitled (Harlequin)]*, 1944
Oil on canvas; 176 × 86.5 × 2.5 cm (69⁵/₁₆ × 34¹/₁₆ × 1 in.); Colección Patricia Phelps de Cisneros, 1998.38

legendary intellectual unmarked by the subsequent infighting among the original members of the movement.[3]

In any case, this work, with all its apparent contradictions, is a useful reminder that history is not always as neat and inevitable as it seems in hindsight. *Arturo* unleashed a broad range of ideas and propositions, from the abstract expressionism of Maldonado's cover to Arden Quin's mythical-Surrealist poetry and Kosice's science fiction proclamations. If we now read Rothfuss's article on the structured frame as the theoretical basis for a subsequent rationalist investigation into the limits of abstraction, we should also remember not only that the text is somewhat vague in its propositions but also that paintings like *Sin título (Arlequín)* reveal the path toward the future as itself somewhat irregular.

Gabriel Pérez-Barreiro

Notes

1. Rothfuss's authorship has been confirmed by Gyula Kosice, interview with the author, April 1993, Buenos Aires.
2. The subtitle *Arlequín* seems to have been added recently. The work itself is untitled, and it is likely that the subtitle was added at the time the work was acquired for the Colección Patricia Phelps de Cisneros.
3. See Mario Sagradini, "Rhod Rothfuss: Vida y producción del artista uruguayo," unpublished research project, archives of the Blanton Museum of Art, The University of Texas at Austin; and Horacio Faedo, "Un momento con Rothfuss: Memorias de Horacio Faedo, dictado a Gabriel Pérez-Barreiro en Colonia del Sacramento, Uruguay 7/6/93," author's archive.

b. 1911, Buenos Aires; lives in Buenos Aires

b. 1923, Buenos Aires; lives in Buenos Aires and Paris

Although these two works appear at first to be somewhat different in construction and character, both are classic expressions of the *coplanal* form, which the Asociación Arte Concreto–Invención developed between 1946 and 1948. After the development of the shaped canvas (*marco recortado*), in 1944–1945, artists of the newly formed Asociación Arte Concreto–Invención, which included both Raúl Lozza and Juan Melé, debated what they saw as the limitations of the shaped canvas until, in 1946, they proposed the *coplanal* as its replacement. The most comprehensive contemporary discussion of the *coplanal* is an article by Tomás Maldonado, "Lo abstracto y lo concreto en el arte moderno" ["The Abstract and the Concrete in Modern Art"].[1]

In that article, Maldonado began his critique of the irregular frame with the recognition that any mark on a surface will generate a figure/ground optical illusion: "As long as a figure is represented as an illusion on a background, there will be representation."[2] Interestingly, almost two decades later, Clement Greenberg would discuss abstract painting in similar terms: "The first mark made on a canvas destroys its literal and utter flatness, and the result of the marks made on it by an artist like Mondrian is still a kind of illusion that suggests a kind of third dimension."[3] What both Maldonado and Greenberg were seeking was a completely abstract and non-representational art that would create no visual illusion of any kind. For Maldonado and the artists of the Asociación Arte Concreto–Invención, the patterns contained in the 1944–1945 structured-frame paintings, and indeed in all European abstract painting to date, were still illusionist and therefore failed their creators' stated intention to make artworks that were fully objective and concrete. The contemporary Madí group, in contrast, was not interested in this extreme search for absolute purity, concentrating instead on the quasi-Dada, avant-garde, and ludic possibilities that the shaped canvas unleashed.

The principle behind the *coplanal* is the physical separation of forms in space. The artists of the Asociación Arte Concreto–Invención believed that in giving each form its own shape and color, they entirely avoided visual illusion. The *coplanal* is the most extreme statement of the Argentine Concrete artists' desire to reduce art to its most objective (anti-illusionist) and severe elements. The

1945 statutes of the Asociación state this in no uncertain terms: "The separation of the elements in space, organized as a *coplanal,* is what defines a concrete plastic structure."[4]

Lozza's *Relief* (plate 4) presents a classic *coplanal* as it would have been displayed in 1946: painted wooden forms separated in space by stiff wires. Given the problems of storing and handling these works, very few have survived. Scholars generally accept that Alberto Molenberg's *Función blanca [White Function]* (private collection, Buenos Aires) was the first *coplanal,* and it was the only one reproduced in *Arte Concreto–Invención* alongside Maldonado's article.[5] Therefore, if we accept August 1946 as the date of the first documented expression of the *coplanal,* with Maldonado's text as its virtual manifesto, it seems more likely that Lozza made *Relief* in 1946, the latter of the two dates marked on the reverse. By the same evidence, the original title appears to have been *N.° 30* rather than *Relief.*

The composition of Lozza's piece may seem random at first, but in fact its careful construction created precise formal relationships between and among the individual pieces. The individual pieces relate to one another across the empty space; the edges echo, parallel, or intersect one another in quite sophisticated ways. For the artists of the Asociación Arte Concreto–Invención, a *coplanal* could never be mobile, since the relationships between and among the work's parts were carefully planned. The Madí artists, in contrast, did produce several mobile *coplanales* in which interaction with viewers was more important than precise formal relationships. This difference is much more than an expression of the well-known personal animosity between the leaders of the two groups; it points as well to a deep philosophical disagreement.

Melé's *Coplanal* (plate 5) is now a construction on a transparent base, but there is evidence to suggest that, as Lozza had done with *Relief,* Melé originally connected the pieces with wires or rods. The artist has described how he later mounted the work to protect it.[6] In addition, the individual forms all have traces of holes on the reverse, marks indicating that screws were used to secure them in an earlier structure. A preparatory drawing for this work also shows dotted lines connecting the forms. The inscription

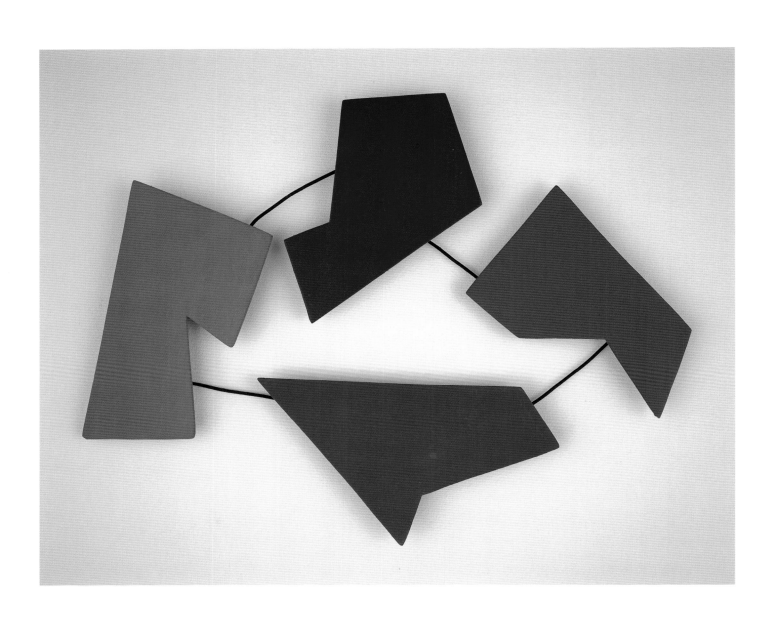

4 Raúl Lozza, *Relief,* 1945
Casein on wood and painted metal; 40.6 × 53.3 × 3.8 cm (16 × 21 × 1½ in.); Colección Patricia Phelps de Cisneros, 1998.52; copyright Raúl Lozza

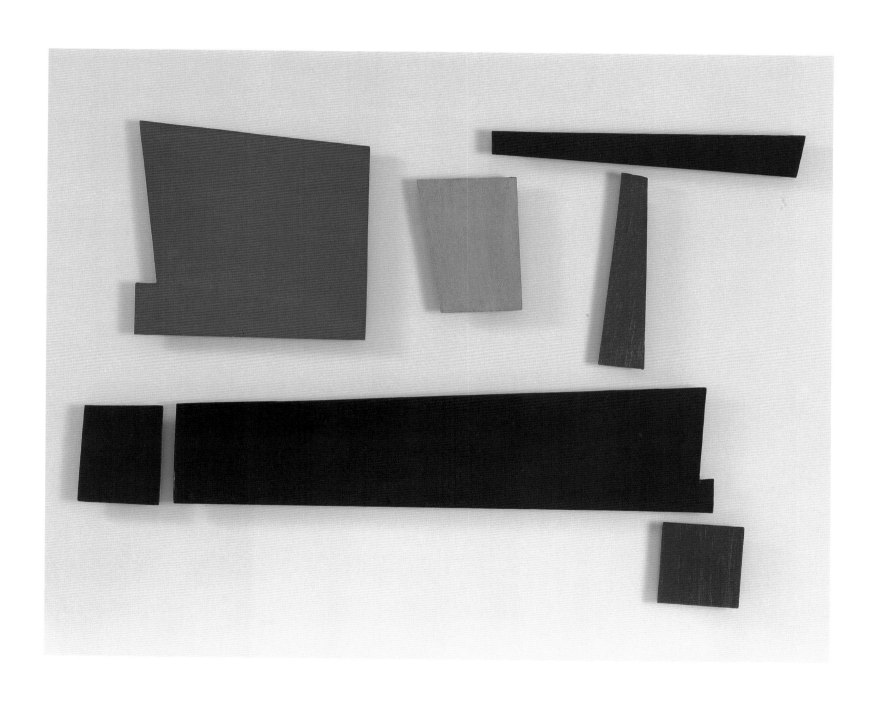

5 Juan Melé, *Coplanal [Coplanar],* 1947
Painted wood panel mounted on acrylic; 87.9 × 109.9 × 2.9 cm (34⅝ × 43¼ × 1⅛ in.); Colección Patricia Phelps de Cisneros, 1998.53; copyright Juan Melé

suggests that this work had *N.º 15* as its original title, one that reflects and reinforces the objective, quasi-scientific ambitions of this group of artists. Their aspirations for the *coplanal* were that it should be not only absolute in its form and composition but also collective (the artists of the Asociación originally did not sign their works, and they agreed to work collectively), but there are significant compositional differences among the artists. Lozza, for example, became a master of the centrifugal composition implicit in *Relief,* and he developed it as the central principle of his Perceptista movement from 1947 on (plate 10), whereas Melé's work seems less confident, with an apparently more random placement of individual forms.

For a brief period of just over a year (mid-1946 to late 1947), the artists of the Asociación Arte Concreto–Invención felt that, with the development of the *coplanal,* they had achieved their intention to make fully objective and concrete art. As they created more of these *coplanal* works, however, they soon realized that, in their search for absolute autonomy of form, they had overlooked a basic fact about the *coplanal:* the intervening empty space could not be divorced from its surroundings. In other words, the placement of a work on a blue wall would create formal relationships different from those created by the same work's placement on a yellow wall, let alone on a patterned one. This dependence of the work on the circumstances of its display weakened the Asociación artists' claims to have achieved a completely self-contained statement. For today's audience, accustomed to the white cube as the dominant forum for the presentation of artwork, this dependence on context may seem a minor point; for these artists, it was a catastrophic failing.

This formal problem, combined with the growing hostility of the Communist Party to these utopian abstract artists, led to a deep crisis in the Asociación. By 1948, most of the Asociación artists—Maldonado, Alfredo Hlito, Lidy Prati, and Juan Melé among them—had adopted a more orthodox, Max Bill–inspired Concrete art within a regular frame and had moved toward graphic or industrial design, although Lozza continued to develop the tenets of the *coplanal* in his own movement, Perceptismo. At any rate, the brief period of the *coplanal* can be seen as the most extreme and synthetic expression of the Argentine abstract artists' desire to encourage a Marxist and utopian "direct relationship with things rather than with fictions of things."[7]

Gabriel Pérez-Barreiro

Notes
All translations are the author's unless otherwise noted.
1. Tomás Maldonado, "Lo abstracto y lo concreto en el arte moderno," *Arte Concreto Invención* (August 1946): 5–7.
2. Maldonado, "Lo abstracto y lo concreto en el arte moderno," 5.
3. Clement Greenberg, "Modernist Painting," in Francis Frascina and Jonathan Harris, eds., *Art in Modern Culture: An Anthology of Critical Texts* (London: Phaidon, 1992), 311–12.
4. Statutes of the Asociación Arte Concreto–Invención (September 1948), unpublished manuscript, n.p., author's archive.
5. See Maldonado, "Lo abstracto y lo concreto en el arte moderno." The *coplanal* by Raúl Lozza reproduced in the same article can be seen, on close examination, to be a pencil drawing rather than a photographed object.
6. Juan Melé, interview with the author, May 1993, Buenos Aires.
7. Edgar Bayley, Antonio Caraduje, Simón Contreras, Manuel Espinoza, Claudio Girola, Alfredo Hlito, Enio Iommi, Rafael Lozza, Raúl Lozza, R. V. D. Lozza, Tomás Maldonado, Alberto Molenberg, Primaldo Mónaco, Oscar Nuñez, Lidy Prati, and Jorge Souza, "Manifesto invencionista," first published in the brochure for the Asociación Arte Concreto–Invención exhibit held at Salón Peuser, Buenos Aires, in March 1946, and later reprinted in *Arte Concreto Invención* (August 1946) and in *Arte Abstracto Argentino* (Buenos Aires: Fundación Proa, 2002), 160.

Juan Melé, *Marco recortado n.º 2 [Irregular Frame No. 2]*, 1946

b. 1923, Buenos Aires; lives in Buenos Aires and Paris

One way to approach Juan Melé's *Marco recortado n.º 2* (plate 6) is as an analytical systemization of the break with the conventional format of painting, a process that had its beginnings in the mid-1940s in Buenos Aires. The irregular frame, based on a theory proposed by Rhod Rothfuss,[1] signified a rupture with orthogonality (Renaissance art's "window on the world") while heralding a new concept of what comprises a work of art. Rothfuss's theory of the irregular frame posited a visual object whose format derived solely from the objective conditions of its physical reality. At the same time, however, both the short-lived magazine *Arturo*, where Rothfuss propounded his theory, and early experiments with the irregular frame must be understood as embryonic developments that contained their own fissures and contradictions, not only in terms of theoretical conceptualization but also in terms of how Rothfuss's and other theories would be expressed in art.

Thus the irregular frame originated in the context of artistic experiments carried out by various groups that, in 1945, splintered from the nucleus of artists and writers who initially had participated in *Arturo*. (These divisions were triggered as much by personal disputes among the groups' members as by theoretical and aesthetic differences.) Carmelo Arden Quin, Gyula Kosice, and Rothfuss subsequently headed the Movimiento Madí, while Tomás Maldonado and Edgar Bayley led the Asociación Arte Concreto–Invención, which Juan Melé joined in October 1946. Indeed, it was among the artists in the latter group that the irregular frame developed into a systematic exploration of the limits of abstraction and of the potential offered by a nonfigurative approach.

Around 1944, Melé attended the Escuela Nacional de Bellas Artes. There, his activities included editing the journal *Inquietud,* which brought together such groups as the Centro de Estudiantes de Bellas Artes [Center for Students of Fine Arts] and the Mutualidad de Estudiantes de Bellas Artes [Fine Arts Students Mutual Benefit Society]. He also published his own articles in *Inquietud,* with titles like "Let Us Live in the Moment" and "Toward a Historical Consciousness," in which he praised artists' rejection of war and totalitarian regimes.[2] *Inquietud,* unlike *Arturo,* did not adhere to Marxist theory or address the issue of aesthetic innovation, but both

journals shared a focus on social commitment as an integral component of art. This outlook, common among the artists of the 1940s generation, linked Melé's work from the early years of the decade with his later adherence to the Concretist project. As a student, he formed ties with other artists involved in these student groups, including Albino Fernández, Gregorio Vardánega, and Virgilio Villalba, who all shared a studio with him on Juan B. Justo street.

Melé first established contact with the Asociación Arte Concreto–Invención through Tomás Maldonado, with whom he had studied in the Escuela Nacional de Bellas Artes. In late 1945, Maldonado invited Melé to an exhibition of Concrete art at his studio on San José street, an experience that Melé later recalled in his memoirs:

> It had a tremendous impact on me. . . . I was familiar with geometricized Cubism, but not with Constructivist works; once I got to know them, however, the shock I felt in front of them wore away. Besides being pure and geometrical, these works introduced me to a new structure: the "irregular frame."[3]

Melé promptly joined the group, and from that moment on, all of his oeuvre—including his *Homenajes a Mondrian* [Homages to Mondrian] series, his works with irregular frames, and, later, his *coplanales*—followed the Asociación Arte Concreto–Invención's artistic orientation.

Melé's first official appearance as a member of the Asociación Arte Concreto–Invención was in the October 1946 exhibition of the Sociedad Argentina de Artistas Plásticos [Argentine Society of Visual Artists]; from that point on, he participated in all the group's activities.[4] In the same year, he published an article in the second issue of the association's journal, *Arte Concreto Invención,* which marked his efforts to distance himself from his former teacher, the Romanian sculptor Cecilia Marcovich.[5] In 1940, while trying to fill the gaps in his academic training, he had been drawn to Marcovich's teachings. At that time, Melé was seeking a thorough understanding of the problems of composition, of ways to structure a painting, of the golden ratio, and of harmonic structures. His readings of Matila Ghyka's *Esthétique des proportions dans la nature et dans les arts [The Aesthetics*

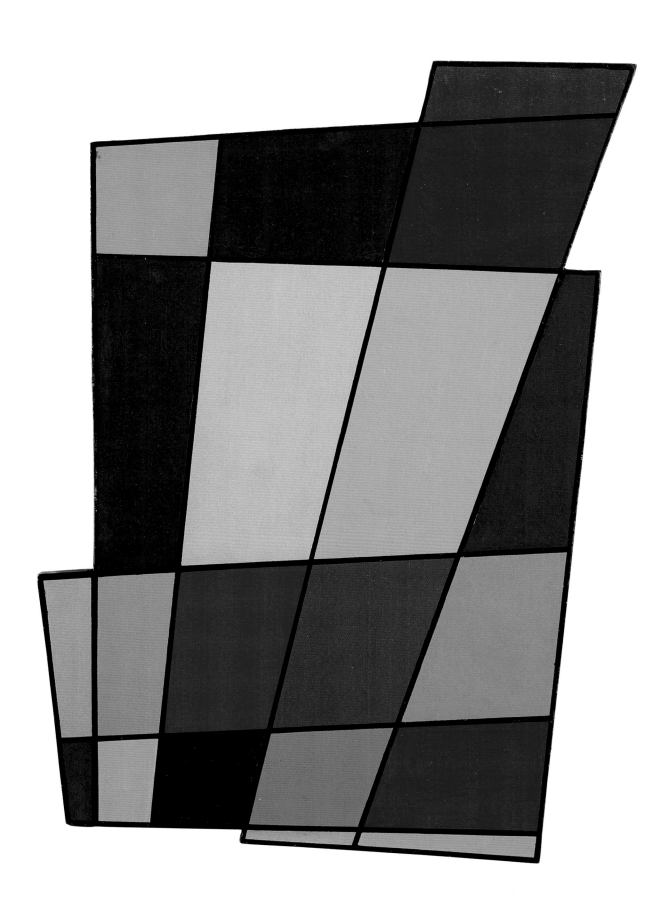

6 *Marco recortado n.º 2 [Irregular Frame No. 2]*, 1946
Oil on Masonite; 71 × 46 × 2.5 cm (27¹⁵⁄₁₆ × 18⅛ × 1 in.); Colección Patricia Phelps de Cisneros, 1997.102; copyright Juan Melé

of *Proportion in Nature and the Arts*] and the writings of Leonardo da Vinci and Luca Paccioli enabled him to devise a compositional system based on mathematics as a source of harmony.[6]

Although Melé's Concretist dedication to "the new" appeared to be irreconcilable with artistic tradition, he succeeded within his Concrete work in uniting art's old tools and new aesthetic forms in a distinctive mode. A detailed analysis of *Marco recortado n.º 2* illustrates this point.

The structure of this work, which focuses on "making space and forms concrete,"[7] is based on a solidly proportional system. Overall, it looks like a network of colored planes whose reticular appearance is reinforced by horizontal and vertical black lines that project outside the work itself. Its central unit is a quadrilateral, which then combines with four "structured edges"—one on each side—to create the complete composition. It is precisely the articulation of these five dissimilar figures that creates the irregular structure. The quadrilateral's construction is based on the golden ratio, as are the relationships among the different sections created by the lines and planes. The 1:6 ratio, although not calculated with extreme precision, is the basis of the formal decisions that define this work. Melé's *Marco recortado n.º 3,* in the collection of the Museo Sívori in Buenos Aires, is similar in structure. The construction and the titles of both works confirm Melé's interest in using scientific concepts to create art. Melé transformed the golden ratio, which Renaissance artists had used to fashion a reflection of the world around them, into one of a number of tools for exploring a system that focused on its own material nature.

María Amalia García
Translated by Trudy Balch

Notes

All translations are Trudy Balch's unless otherwise noted.

1. Rothfuss proposed his theory in the first and only issue of the magazine *Arturo* (summer 1944).

2. See Juan Melé, "Vivamos la hora," *Inquietud* (December 1944): 12–13; and Juan Melé, "Hacia una conciencia histórica," *Inquietud* (July 1945): 7–8.

3. Juan N. Melé, *La vanguardia del '40: Memorias de un artista concreto* (Buenos Aires: Ediciones Cinco, 1999), 87–88.

4. *Exposición Arte Concreto Invención,* Sociedad Argentina de Artistas Plásticos, Buenos Aires, October 11–23, 1946. At the opening, Raúl Lozza gave a lecture on "inventiveness as concrete reality in art."

5. Juan Melé, "En torno al taller Escuela de C. Marcovitch," *Arte Concreto Invención* (December 1946): 8.

6. Gabriela Siracusano, *Melé* (Buenos Aires: Fundación Mundo Nuevo, 2005).

7. Tomás Maldonado, "Lo abstracto y lo concreto en el arte moderno," *Arte Concreto Invención* (August 1946): 5–7.

Alejandro Otero, *Cafetera azul [Blue Coffeepot],* 1947
Líneas coloreadas sobre fondo blanco [Colored Lines on White Ground], 1950

1912, El Manteco, Venezuela–1990, Caracas

Cafetera azul (plate 7) and *Líneas coloreadas sobre fondo blanco* (plate 8) are representative of the commitment that Alejandro Otero made, during his extended stay in Paris (1945–1951), to the expression of utopian ideals through abstraction. Not only do these oil paintings reflect Otero's active engagement in the theoretical debates of Paris's post–World War II avant-garde artistic communities, they also anticipate his pioneering role in challenging Venezuelan artistic traditions. Otero drew on his early investigations of Cubist abstraction and Existentialist theory to find a new language of color and line with which to express a highly personal spiritual freedom. That expression would eventually become the starting point for a specifically Venezuelan form of abstraction. An examination of Otero's artistic development through *Cafetera azul* and *Líneas coloreadas,* and of these two works' historical context, reveals the underlying utopian character of Otero's evolution.

Otero painted *Cafetera azul* soon after a scholarship allowed him to go to Paris. In numerous letters to the art critic and historian Alfredo Boulton, Otero wrote excitedly about being able to see at first hand the works of the modern masters, in a city energized by a rush of artistic renewal. By November 1946, Otero had written that he was doing something "so very different" that it would have major significance for Venezuela.[1] *Cafetera azul* is one of the paintings in the still-life series titled Cafeteras, and it is these that Otero described as "so very different." With this series, Otero began his initial phase of "the denaturing of objects."[2]

Although Otero was inspired by Cézanne during his studies in Caracas, Picasso became his "second God" after the Venezuelan arrived in Paris. And, indeed, *Cafetera azul*'s Cubist fragmentation of space, and its multiple viewpoints, surface flattening, and schematized representation of the still-life object, all reflect Picasso's significant influence on Otero's painting at the time. But Otero's personal style emerges in the depiction of the coffeepot's structure and its reduction to simple black lines that dynamically push and pull the viewer in and out of the implied space. The clear cobalt blue of the painted coffeepot, against veils of lightly applied muddied browns and blues, punctuates and reinforces a sense of rhythm and spatial uncertainty. By late 1948, Otero had abbreviated the still-life

form to the simplest shorthand of colored and black-and-white lines. The coffeepots became virtually unidentifiable as objects, and the late paintings in the series were already heralding Otero's next series, titled Líneas inclinadas, of which *Líneas coloreadas sobre fondo blanco* is a prime example.

Líneas coloreadas shows Otero's work to be no longer driven by Cubism but rather by the artist's desire to paint what he referred to as Piet Mondrian's "nothing." *Cafetera azul* had made clear reference to the shape of the coffeepot; in *Líneas coloreadas,* Otero explored the universalist aesthetic theories of Mondrian as well as Kandinsky's individual spiritualism and the Existentialist philosophy that was then emerging in Paris. He succeeded in creating an autonomous internal order and coherence, thus establishing a newfound freedom for himself. Breaking with the use of a referential object, he devised an independent system of values in which color and line defined space and movement. In *Líneas coloreadas,* the subject is "nothing" except the act of painting itself. In a letter to Boulton of February 1950, Otero described this phase of his career as one in which he was working on many canvases "bearing no relationship to reality"; describing them as "just as good" as his figurative paintings, he expressed his hope that from this new work he would have "attained the freedom of our times," from which point painting could "only expand."[3]

In *Líneas coloreadas,* Otero built layer upon layer of white impasto paint on vestiges of blue swatches of color, reinforcing the materiality of the surface. He created a system in which color became line, the edges of the paint became drawing, and the internal structure of the work conveyed a painterly order. These choices reflect a highly personal expression of freedom, which might be contrasted with other abstract artists' determination to minimize the artist's personal intervention in the work. Furthermore, the patches of paint reveal gaps in which light and space seem to float, and the parallel lines of color offer a rhythmic patterning that signals Otero's future use of color/line relationships in his series Coloritmos.

Otero showed the Cafeteras series in Caracas in early 1949, and this exhibition set a benchmark for evaluating the significant changes that were taking place in Venezuela's artistic

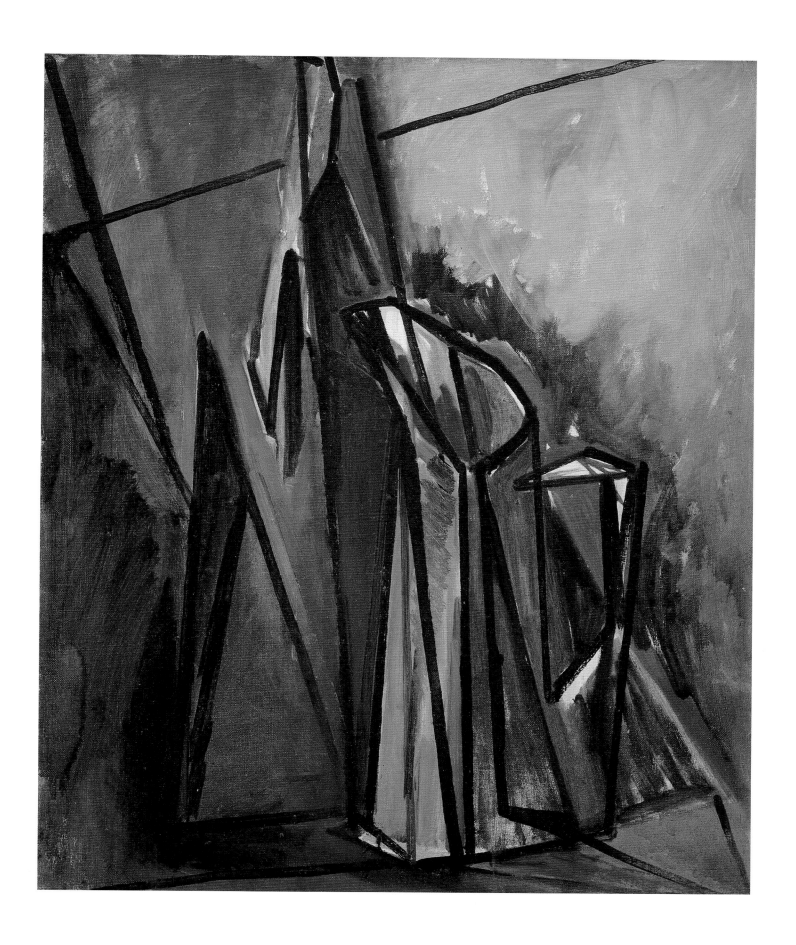

7 *Cafetera azul [Blue Coffeepot],* 1947
Oil on canvas; 65.1 × 54 cm (25⅝ × 21¼ in.); Colección Patricia Phelps de Cisneros, 1998.23; copyright Alejandro Otero Estate

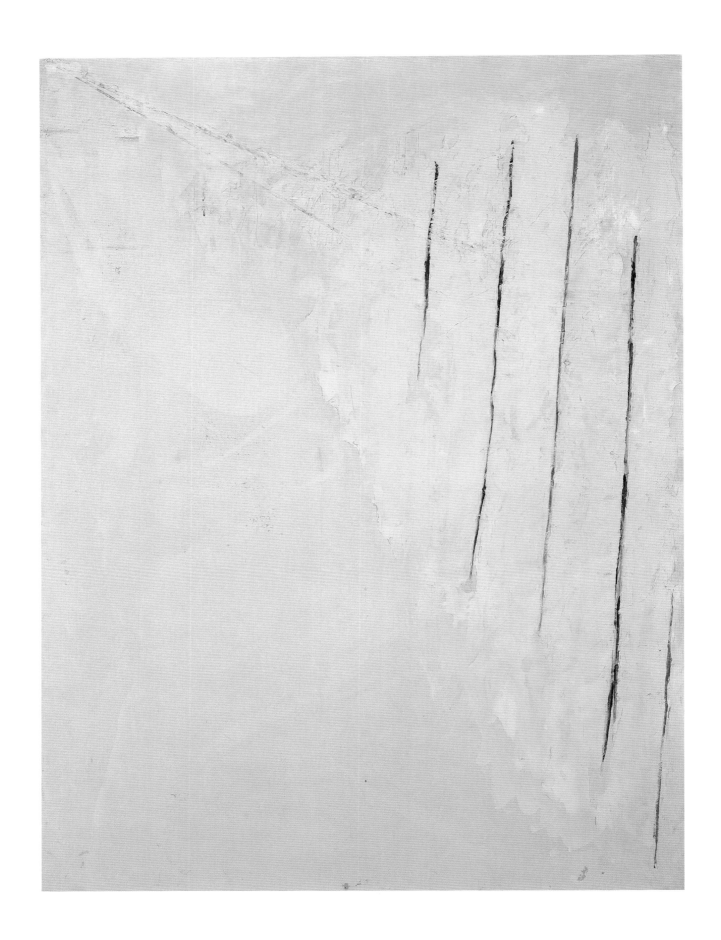

8 *Lineas coloreadas sobre fondo blanco [Colored Lines on White Ground],* 1950
Oil on canvas; 130 × 97 cm (51³⁄₁₆ × 38³⁄₁₆ in.); Colección Patricia Phelps de Cisneros, 1990.22; copyright Alejandro Otero Estate

community. It also symbolized the country's engagement with the contemporary artistic universe outside Venezuela's academic world of cultural institutions, which included the Museo de Bellas Artes, the official salons, and the academic art schools. Alfredo Boulton summarized the significance of the Cafeteras exhibition by saying that it "awakened in the consciousness of Venezuela the presence of an artistic unrest that went beyond what we had known up till then."[4] Whereas the Cafeteras series appears to have been a response to Otero's initial engagement with the Parisian avant-garde, his Líneas inclinadas series was the result of his very personal application of avant-garde theories. Otero not only reacted to the Neo-Plastic theories of the De Stijl artists, whose work he saw in Holland in late 1949, but also found in contemporary Existentialist theory a way for Latin American artists to define a new and independent future.[5]

But Otero, by developing a unique method of abstraction in Líneas coloreadas that was based on an Existentialist primacy of nothingness and on freedom of action, created much more than a personal mode of expression. He also proposed a way for Latin American artists, and Venezuelans in particular, to build an independent, contemporary aesthetic. With this utopian vision, Otero returned to Caracas in 1952 to take part in one of the most optimistic attempts to bring contemporary aesthetic values to the public: the building of the Ciudad Universitaria with the architect Carlos Raúl Villanueva. Through this and later projects, Otero continued to find more expansive expressions of his utopian ideals of abstraction.

Estrellita B. Brodsky

Notes

All translations are the author's.

1. In Ariel Jiménez, ed., *He vivido por los ojos: Correspondencia Alejandro Otero/Alfredo Boulton, 1946–1974* (Caracas: Alberto Vollmer Foundation/Fundación Museo Alejandro Otero, 2000), 41.

2. Quoted in José Blazo, *Alejandro Otero* (Caracas: Ernesto Armitano, 1982), 21.

3. Letter from Alejandro Otero to Alfredo Boulton, February 1950, in Jiménez, ed., *He vivido por los ojos,* 100.

4. Alfredo Boulton, *Historia de la Pintura en Venezuela,* vol. 3: *Época Contemporánea* (Caracas: Ernesto Armitano, 1964), 100.

5. The Venezuelan philosopher J. R. Guillent Pérez, a fellow founder of Los Disidentes, observed that Venezuelan artists and writers who were in Paris in 1950 became co-participants in Western culture, seeing Existentialism as a way to free Latin American artists (and European artists as well) from the constraints of European aesthetic traditions. In particular, the nihilistic aspects of Existentialism provided artists with a means of extolling the primacy of free action based on no pre-existing order, or "nothing." The Venezuelans, Pérez said, could use that starting point as a way to put themselves on an equal footing with their European counterparts and to grasp an opportunity to be of their own time rather than "feeding on historical cadavers." See J. R. Guillent Pérez, *Venezuela y el hombre del siglo XX* (Caracas: Ediciones Reunión de Profesores, 1966), 157.

Gyula Kosice, *Escultura móvil articulada [Mobile Articulated Sculpture]*, 1948

b. 1924, Kosice, Hungary (now Slovakia); lives in Buenos Aires

Gyula Kosice's articulated brass sculptures are among the most successful manifestations of a new spirit of Dada-like subversion, artist-viewer interaction, and transformation in mid-1940s Buenos Aires. Kosice's first documented brass sculpture of this type, albeit on a smaller scale, appears in the group photograph taken at the first *Art Concret–Invention* exhibition, which took place in Buenos Aires at the home of the psychoanalyst Enrique Pichón-Rivière in October 1945. In that year, abstract painting in Buenos Aires was still coming to terms with the concept of the irregular frame, best illustrated by Rhod Rothfuss's *Sin título (Arlequín)* (plate 3).[1] Although few physical examples have survived, Kosice's sculptures of this period, a number of which Grete Stern documented photographically, embody some of the most radical and original ideas of the Argentine avant-garde.[2]

Kosice is perhaps best known for *Röyi* (1944), which consists of eight pieces of lathed wood hinged together to make a transformable sculpture. In making *Escultura móvil articulada* (plate 9), Kosice again hinged together individual elements that he intended the viewer to manipulate. This work differs from *Röyi*, however, in that it has no base, and therefore no default position. Whereas *Röyi* tends naturally to fall always into the same compositional arrangement, is best viewed from the front, and is almost always displayed in the same way, none of this is true of *Escultura móvil articulada,* which changes shape whenever it is handled.

One of the most interesting aspects of this sculpture is its use of materials. According to Kosice, he constructed the work from metal bands of the type used to reinforce leather handbags.[3] The Kosice brothers owned a *marroquinería,* a small leather workshop, in Buenos Aires, and several of Kosice's first sculptures, as photographed by Stern, appear to use materials—brass, springs, cork, and the like—that the artist could have found there. Aside from the plain ingenuity and simplicity of Kosice's process, the artist's materials themselves speak to a desire to fundamentally change the nature and perception of art making in Buenos Aires. Throughout the nineteenth century, and particularly in the 1920s and 1930s, the model of the gentleman artist was an important cultural paradigm for Buenos Aires. Social convention required any artist aspiring to engage in dialogue with the advanced cultural traditions of Europe to secure funds from aristocratic patrons, such as the Amigos del Arte, and travel to Europe to learn the latest artistic styles. Upon returning to Buenos Aires, the artist would become a member of the cultural elite embodied by such magazines as *Martín Fierro* and *Sur.* In this manner, elite Argentine cultural circles largely understood the European avant-garde in stylistic terms. They generally ignored some of the more radical statements of the avant-garde's desire to change the terms of art's relationship to life (for example, Dada and Futurism), or they domesticated these statements into sets of visual elements, as in the work of Emilio Pettoruti.

In this light, both the bald simplicity and the interactivity of Kosice's *Escultura móvil articulada* suggest a radically new spirit in Argentine art, one that aspired to transform the ground rules of art rather than merely replace one style with another. If we compare Kosice's sculpture with any contemporary sculpture by a member of the Asociación Arte Concreto–Invención, such as Enio Iommi, we can also see that two totally different tendencies were operating within the language of Constructivist sculpture in Buenos Aires. Iommi's refined representation of directions in space functions within a classical ideal of sculpture, although it is one reduced to its most elegant and minimal elements. Kosice's sculpture, by contrast, does not seek beauty or the expression of absolute values but rather generates instability and a direct physical relationship with the viewer. Thus it challenges one of the most traditional precepts of art making: the ideal relationship between an artwork and a viewer, in which the viewer contemplates an object made for the purpose of viewing. The scale of *Escultura móvil articulada* is such that to manipulate it requires considerable physical effort and prevents the viewer from ever achieving a comfortable, and therefore neutral, viewing distance.

Although Kosice's brass sculptures antedate the establishment of the Madí movement by almost a year, they do embody many of the principles that the movement would later develop. The Madí manifesto of 1946 defined sculpture as "three-dimensionality, no color. Total form and solids with environment, with movements of articulation, rotation, shifting, etc." The idea of movement was to become central to Kosice's practice, particularly in his

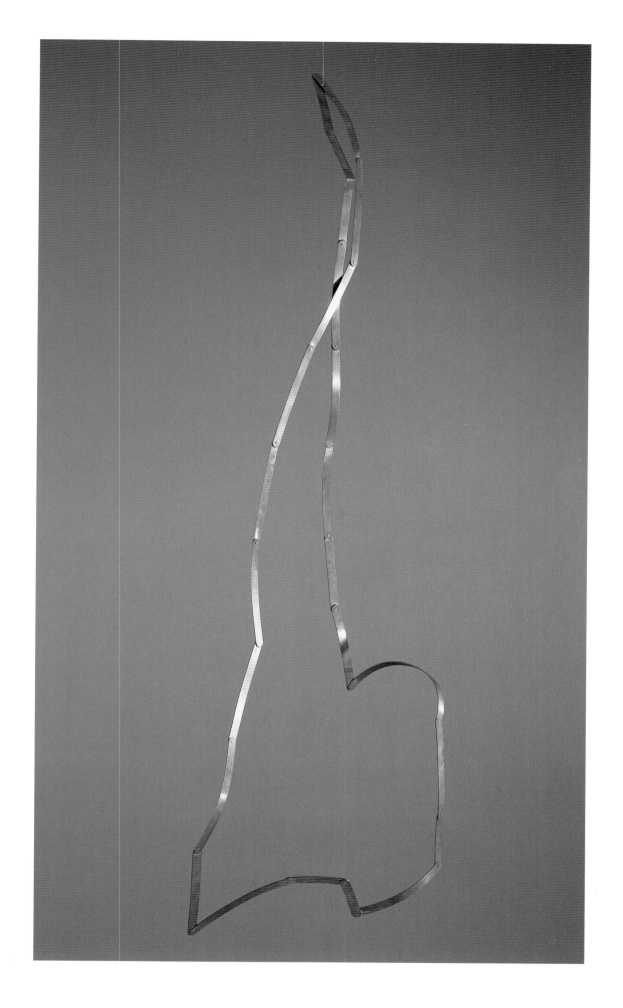

9 *Escultura móvil articulada [Mobile Articulated Sculpture]*, 1948
Brass; 165.1 × 30.5 × 1.3 cm (65 × 12 × ½ in.); The Museum of Modern Art, New York, fractional and promised gift of Patricia Phelps
de Cisneros in honor of Jay Levenson, 321.2004; copyright Gyula Kosice

hydrokinetic constructions of the 1960s and 1970s. Movement would also become a central idea in the Brazilian Neo-Concrete movement of 1959, and Kosice's articulated sculptures of the mid-1940s prefigured many of the formal characteristics of Lygia Clark's Bichos series, for example. Whereas Clark rooted the interactivity of the Bichos series in explorations of psychological subjectivity and Gestalt theory, the Argentine artists looked to interactivity more for a provocative Dadaist and anarchic spirit. In this regard, it would be wrong to assume that the language of geometrical abstraction always contains progressive, rationalist, mathematical ideals. Dawn Ades, writing about such figures as Kurt Schwitters and Theo van Doesburg, has pointed out the historical connections between Constructivism and Dada.[4] The same connections reappeared in 1940s Buenos Aires, where artists sometimes used the formal alphabet of Constructivism in the service of subverting the very idea of art as an autonomous and absolute expression.

Gabriel Pérez-Barreiro

Notes

All translations are the author's.

1. See my contribution on Rothfuss's *Sin título (Arlequín),* this book.

2. The chronic pre-dating, reconstruction, and invention of works of this period by a number of artists has obscured a better understanding of the importance of these sculptures.

3. Gyula Kosice, interview with the author, June 1993, Buenos Aires.

4. Dawn Ades, *Dada–Constructivism: The Janus Face of the Twenties* (London: Annely Juda Fine Art, 1984).

All of Lozza's post-1947 works embody the principles behind the movement he founded: Perceptismo. Although scholars usually date the birth of Perceptismo to 1947, the year Lozza stopped exhibiting with the Asociación Arte Concreto–Invención, the movement emerged to the public only in October 1949, with the I Exposición de Pintura Perceptista at the Galería van Riel in Buenos Aires. The first issue of Lozza's magazine, *Perceptismo: Teórico y Polémico,* appeared in 1950, and Lozza continued to publish it until 1953. Perceptismo was only nominally a movement, having just four members (two of whom were Lozza's brothers; the other was the art critic Abraham Haber), but it was very much Lozza's invention. The need to create a movement, with a manifesto, a magazine, and unsigned works, speaks to the avant-garde fervor of the period, and to the search for a collective and universalist art form.

While most of the abstract artists of 1940s Buenos Aires passed through a dizzying number of styles and artistic experiments in a short period of time, Lozza's work after 1947 stands alone in its commitment to a set of aesthetic and stylistic principles that he continues to practice to this day. For this reason, it is almost impossible to date Lozza's vast post-1947 production in terms of stylistic development. The best clues to his works' dates of composition can be found in the drawings he has produced for each one, and in the reproductions in *Perceptismo*. The compositional drawing for *Invención n.º 150,* dated 1948, is attached to the reverse of the painting, and the caption accompanying the publication of this image in 1950 dates the composition to 1948.[1]

Lozza split with the Asociación Arte Concreto–Invención in late 1946, just as that group was debating the problems of the coplanar composition. Whereas Tomás Maldonado, Alfredo Hlito, and others returned to the rectangular frame, and to closer stylistic proximity to Swiss Concrete art, Lozza attempted to preserve the innovations developed in the *coplanal*.[2] The Asociación Arte Concreto–Invención artists had conceived the *coplanal* as an open, centrifugal composition, with no frame to limit the composition or to inscribe it within an illusionistic "window." Although Lozza presented his Perceptista works, such as *Invención n.º 150* (plate 10), on a rectangular or square frame, in his works the role of

this frame was diametrically opposed to the Asociación Arte Concreto–Invención artists' contemporaneous use of it. Hlito, Maldonado, Lidy Prati, and others created compositions that were limited or determined by the regular frame, but Lozza merely used the frame as a color field, as a replacement for a wall. In this way, Lozza's construction of the frame/support resolved the problem that had plagued the *coplanal* since its development in 1946: the impossibility of controlling the compositional and chromatic relations between forms when real space exists between them. The blue background of *Invención n.º 150* provides a neutral field against which to view the three colored forms. At the same time, the limits of the blue "frame" did not affect or interact with the composition of these three forms, which Lozza further separated from the "frame" by mounting rather than painting them onto the blue background.

The three essential elements of Perceptismo, as defined by Lozza, are the notion of the field (*noción de campo*), open structure (*estructura abierta*), and a new theory of color.[3] The notion of the field has to do with the need to place forms against a uniform visual background in order to isolate them from their surroundings. Open structure has to do with Lozza's centrifugal compositional method, in which the artist lets the compositional lines reach out from the forms and into the surrounding area instead of allowing them to be determined by the limits of a frame (figure 1). The new theory of color involves Lozza's invention of *cualimetría,* a neologism formed from

Figure 1.

the words *cualidad* (quality or attribute) and *geometría* (geometry). Lozza claims to have developed a mathematical equation that takes into consideration not only the mathematical description of a form but also the form's quality, as determined by its size, shape, and color. In other words, two identical shapes that are of equal size but that are differently colored are not the same and would generate different qualimetric values. Likewise, two forms with the same surface

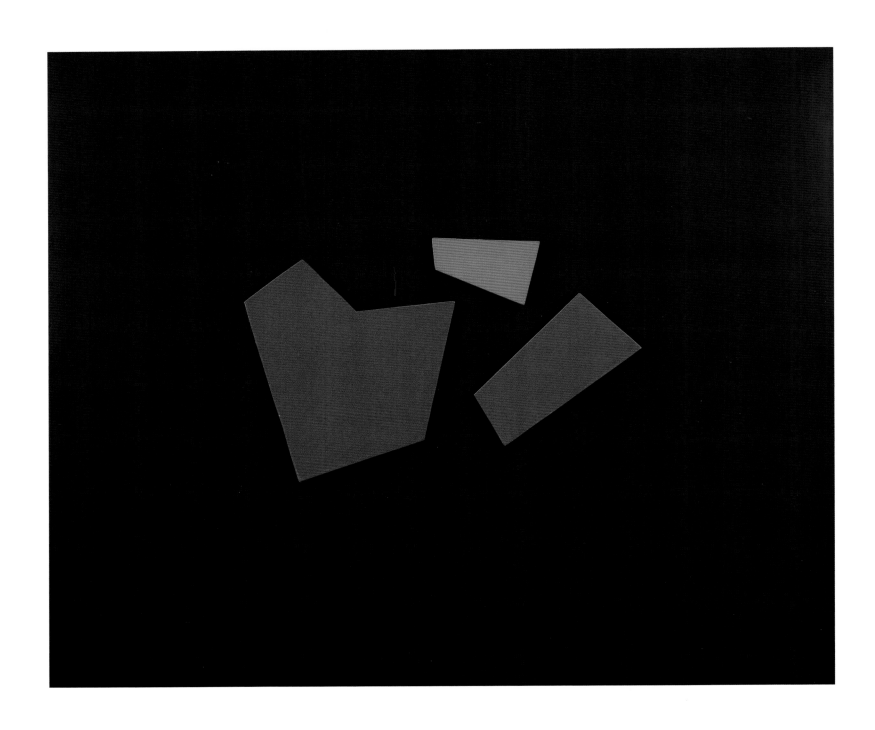

area but different shapes would yield different results. Lozza's qualimetric equation supposedly takes these values, including the base color, and calculates them to arrive at a zero value—the point at which there is no visual illusionism or optical recession of any type. And looking at *Invención n.º 150,* one sees that no form actually does appear to protrude or recede in relation to the others; thus this work fulfills the central aim of the Asociación Arte Concreto–Invención and of Perceptismo: the abolition of pictorial illusion in art. The ideal Perceptista work is one in which there is no visual perspective of any kind, and in which all the forms coexist on one visual plane.

One of the most interesting aspects of Perceptismo is its relationship to architecture and muralism. Lozza, like all the other abstract artists of his generation, sought a more collective and socialist art form. Whereas the Madí artists sought direct provocation in the public sphere (through the distribution of manifestos and flyers, for example), and Maldonado and Hlito became increasingly interested in industrial and graphic design, Lozza re-engaged a recurrent theme of the European avant-garde: the relationship of art and architecture.

The desire to integrate art into the built environment has been at the heart of the abstract art project, as reflected in Bruno Taut's 1918 declaration that there would be "no frontiers between the applied arts and sculpture or painting" and that everything would be "one thing: architecture," and in the 1923 De Stijl statement that "painting separated from the architectonic construction [that is, the picture] has no right to exist."[4] Lozza has made a similar claim:

> Painting has always needed a support: the wall. It is not something to carry under your arm. Painting is a wall, but it is a muralism that does not contradict the architect's space. It harmonizes with everything without creating a window.[5]

Lozza was never able to realize a built environment in which the rectangular temporary frame could disappear, but he did produce and publish montages or collages showing his forms in architecture. In fact, the montage published in the first issue of *Perceptismo* shows *Invención n.º 150* in a domestic setting (figure 2), with the title *Estructura perceptista*

Figure 2.

de Raúl Lozza. Mural n.º 150 del año 1948. In this image, one sees that the temporary frame is no longer necessary, since the forms are mounted directly onto the wall.

In many ways, Lozza's work represents two unrealized dreams. One is his dream of *cualimetría,* which probably exists more in the artist's mind than it ever will on paper as a real, usable equation. The other is Lozza's dream of seeing his work as part of a new architectural environment. Therefore, despite the mathematical, impersonal appearance of works like *Invención n.º 150,* viewers should approach them not as definitive, closed statements but as fragments of a new, and ultimately Romantic, utopia.

Gabriel Pérez-Barreiro

Notes

1. Lozza's numbering system is difficult to follow and seems not to be simply chronological. The painting on the front of the catalogue for the I Exposición de Pintura Perceptista, mounted in 1949, is called *Pintura Perceptista n.º 161.* It is possible that the numbers correspond to some calculation contained within the work, or to another classification system.

2. For further information, see my contribution on Raúl Lozza's *Relief* and Juan Melé's *Coplanal,* this book.

3. Raúl Lozza, interview with the author, March 1993, Buenos Aires.

4. See Bruno Taut, "A Programme for Architecture," in Ulrich Conrads, ed., *Programmes and Manifestoes on Twentieth-Century Architecture* (London: Lund Humphries, 1970), 41. See also "Manifesto V: -□+=R4," in Conrads, ed., *Programmes and Manifestoes on Twentieth-Century Architecture,* 66.

5. Raúl Lozza, interview with the author, March 1993, Buenos Aires. Author's translation.

Alfredo Hlito, *Ritmos cromáticos III [Chromatic Rhythms III],* 1949

1923–1992, Buenos Aires

Alfredo Hlito's *Ritmos cromáticos III* (plate 11) is a painting in the artist's Ritmos cromáticos series, which Hlito painted between 1947 and 1949. In all these works, despite the presence of vertical and horizontal lines and small planes of color, the composition forces the viewer to focus on the large portions of the canvas that remain empty. As the poet Edgar Bayley commented about a 1948 painting in this series, Hlito "uses chromatic linear elements and pays attention to their distance and equilibrium, that is, he makes the empty sectors of the plane relevant."[1] In Hlito's canvases of this period, then, the empty portions became active elements in his compositions.

Scholarship on Hlito's work has not addressed these empty areas of his paintings, but they played an important role in his artistic practice after 1947. Hlito's inscription of empty spaces onto the plane, as presented in the Ritmos cromáticos series, is the pictorial equivalent of the sculptural and architectural conceptions of space as open-ended. This is not surprising, since discussions about open-ended space dominated the practice and theory of Argentine Concrete artists who worked closely with Hlito, namely, Enio Iommi and Tomás Maldonado.[2] Bayley, describing a sculpture by Iommi, stated that the work "practically affirms the Concretist tendency to exalt space, characterizing it as a fundamental element in sculpture."[3] Bayley also described Iommi's capacity to evoke "a kind of sculpture that we would call open, whose elements project in all directions, and where the physical base of the object plays a minimal role."[4] Bayley did not explicitly connect Hlito's empty portions on the plane with Iommi's open-ended spaces, but these ideas have a common root in the notion of spatiality that is associated with modern architecture. Indeed, at the time when Hlito was creating the Ritmos cromáticos series, these ideas were intensely debated among a close-knit group of friends that included Argentine architecture students and the Concrete artists.[5]

In a 1947 article published in *Revista de Arquitectura,* the journal of the Central Association of Architects in Argentina, Tomás Maldonado, painter and main theoretician of the Argentine Concrete group, argued that modern artists and architects needed to focus on making space an active component of their works and buildings, and not on filling space with volumes.[6] Architects, according to Maldonado, had always concentrated on organizing volumes in space rather than on delimiting spaces that one could walk through (*recorrer*), physically or visually. This volumetric conception, he argued, was appropriate to the sculpture and architecture of the past, which responded to an understanding of space as a negative void in which the universe existed, but the latest scientific developments suggested that space and mass were interdependent—that space and mass reciprocally shaped each other. In sculpture, Cubism and Futurism had initially explored this new conception of space and mass as these movements challenged the idea that a sculpture was an object that represented a figure and thus filled space with volume. Non-figurative sculptors (the Russian Constructivists, the Dutch Neoplasticists), liberated from the obligation to represent figures, definitively created works in which an open and directional concept of space predominated, as opposed to a volumetric one. Modern architects who expressed the notion of spatiality (for example, Le Corbusier and Walter Gropius) used open plans and façades as well as transparent materials that allowed visual continuity.

These ideas provide clues for interpreting *Ritmos cromáticos III* as a work that evokes the notion of open-ended space, or of architectural spatiality. In this painting, vertical and horizontal lines create a grid. This grid literally marks the pictorial plane without suggesting figures, just as the steel frame of a glass building marks the space occupied by the building without turning the building into a volume. The stripes of white canvas, alternating with colored stripes, function as "peepholes" through which space continues without interruption. In this work, then, Hlito used a grid to give shape to the space of the painting (the plane) and to signal the absence of volumes (or figures). In other words, he evoked real space without sacrificing the specificity of the pictorial medium (its planarity).[7]

It is possible that *Ritmos cromáticos III* is the pictorial equivalent of a sculptural work that itself has strong connections to architecture. This is the *Memorial to the Dead in the German Concentration Camps,* designed by the Italian architects Ernesto Rogers, Ludovico Barbiano di Belgiojoso, and Enrico

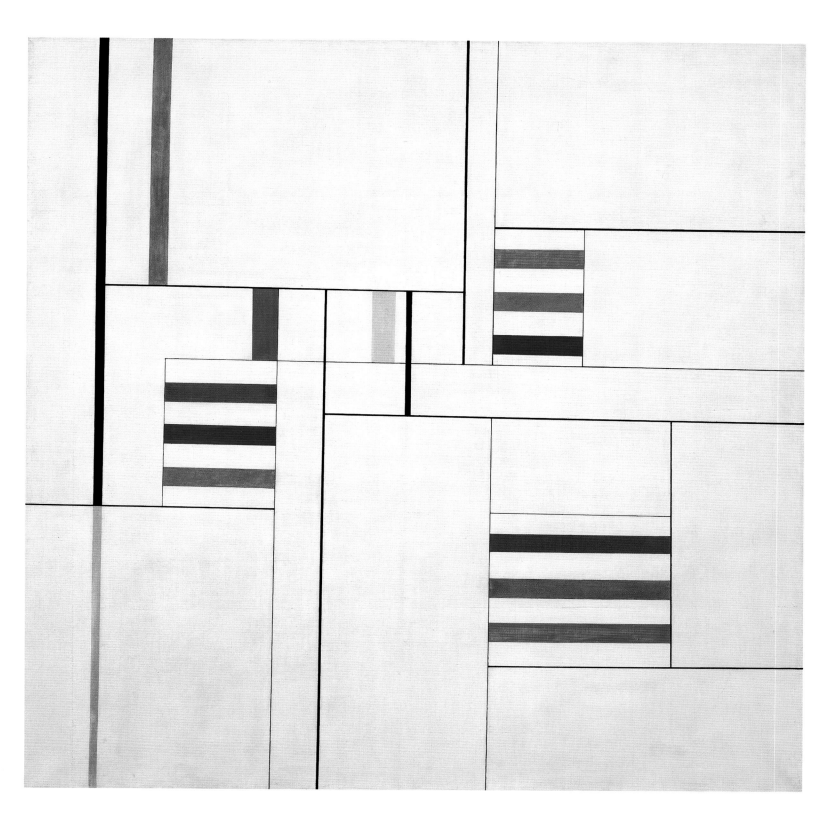

11 *Ritmos cromáticos III [Chromatic Rhythms III],* 1949
Oil on canvas; 100 × 100 cm (39⅜ × 39⅜ in.); Colección Patricia Phelps de Cisneros, 1997.67

Peressutti and erected in a Milan cemetery in 1945. Hlito would have seen photographs of this work at the 1948 Salón de Nuevas Realidades, in which he took part.[8] This sculpture consists of a hollow cube that uses metal rods to trace linear directions. Rods placed within the cube fragment the internal space, while the uninterrupted views of the surrounding landscape suggest spatial continuity. Within the cube, the rods virtually delimit several quadrangular planes, some of which are covered by black and white panels that block portions of the view into real space. *Ritmos cromáticos III,* with its thin vertical and horizontal lines, wide stripes, and empty portions, may have re-created the spatial openness of this memorial in Milan.

If Concrete artists were indeed exploring sculptural and pictorial strategies that evoked the modern architectural notion of spatiality, why was this so? Again, Maldonado's essay provides clues. Maldonado rejected a volumetric conception of space because, he argued, this conception embodies a particular lifestyle. Thus he wrote, "In the present day, the experience of the closed shape, of the mass-shape, with a convex exterior and concave interior that are perfectly delimited, summarizes the two most prevalent characteristics of our society's lifestyle: individualism and fear."[9] If, as Maldonado argued, volumes and figures are the signifiers of individualism and fear, then this implies that those artists and architects who signaled the presence of space in their works—Hlito, Iommi, Maldonado, and others—did so in order to signify their belief in social communion and liberation. These beliefs, in fact, were congruent with the ideals that Argentine Concrete artists had been upholding since 1944 as part of their revolutionary program.[10]

Ana Pozzi-Harris

Notes

All translations are the author's.

1. Edgar Bayley, "Nuevas realidades," *Ciclo* (November/December 1948): 89.

2. Observing these works from another perspective, Gabriel Pérez-Barreiro has stated that the works in the Ritmos cromáticos series "are very similar, if not almost identical, to contemporary paintings by the Swiss artist Richard Paul Lohse"; see Gabriel Pérez-Barreiro, "The Argentine Avant-Garde, 1944–1950" (Ph.D. diss., University of Essex, 1996), 277.

3. Bayley, "Nuevas realidades," 88.

4. Bayley, "Nuevas realidades," 88 (emphasis in original).

5. A few primary documents as well as memoirs of the architects account for the interaction between Concrete artists and architecture students. See, for example, Tomás Maldonado, "Volúmen y dirección en las artes del espacio," *Revista de Arquitectura* (February 1947), and Tomás Maldonado, "Diseño industrial y sociedad," *Boletín del Centro de Estudiantes de Arquitectura* (October/November 1949), both reprinted in Tomás Maldonado, *Escritos preulmianos* (Buenos Aires: Ediciones Infinito, 1997), 59–62 and 63–65, respectively. See also Juan Manuel Borthagaray, "Universidad y política, 1945–1966," *Contextos: 50 años de la FADU-UBA* (October 1997): 20–29; and Carlos Méndez Mosquera, "Veinte años de diseño gráfico en la Argentina," *Summa* (February 1969).

6. Tomás Maldonado, "Volúmen y dirección en las artes del espacio."

7. For a discussion of the pictorial effects of the grid in modern painting, see Rosalind E. Krauss, "Grids," in Rosalind E. Krauss, *The Originality of the Avant-Garde and Other Modernist Myths* (Cambridge, Mass.: MIT Press, 1985), 9–22.

8. Two photographs of this work, juxtaposed with photographs of works by the Argentine Concrete artists, are reproduced in Bayley, "Nuevas realidades."

9. Maldonado, "Volúmen y dirección en las artes del espacio," 62.

10. Several texts speak explicitly about these "values." See, for example, Edgar Bayley, Antonio Caraduje, Simón Contreras, Manuel Espinoza, Claudio Girola, Alfredo Hlito, Enio Iommi, Rafael Lozza, Raúl Lozza, R. V. D. Lozza, Tomás Maldonado, Alberto Molenberg, Primaldo Mónaco, Oscar Nuñez, Lidy Prati, and Jorge Souza, "Manifesto invencionista," first published in the brochure for the Asociación Arte Concreto-Invención exhibit held at Salón Peuser, Buenos Aires, in March 1946, and later reprinted in *Arte Concreto Invención* (August 1946) and in *Arte Abstracto Argentino* (Buenos Aires: Fundación Proa, 2002), 160. See also Edgar Bayley, "Sobre Arte Concreto," *Revista Orientación* (February 20, 1946), reprinted in *Arte Abstracto Argentino,* 160–61; and Tomás Maldonado, "Los artistas concretos, el 'realismo' y la 'realidad,'" *Arte Concreto Invención* (August 1946), reprinted in Tomás Maldonado, *Escritos preulmianos,* 49–50.

At first glance, it seems strange that the work of Anatol Wladyslaw ever had more than a superficial relationship with the Ruptura movement in São Paulo.[1] Many art historians have observed a strong connection between São Paulo's ascendance as the industrial center of Brazil and the Ruptura artists' interest in using such industrial materials as enamel paint, Plexiglas, particleboard, and aluminum, and such techniques as airbrush painting to create works with hard-edged geometric shapes and primary colors, works that appear to convey no emotional content.[2] The São Paulo Concrete artists famously argued that color, in comparison to form, was of such little importance to their compositions that one hue could be substituted for another without alteration of anything significant in the work.[3] In light of such statements, Wladyslaw's painting *Abstrato* (plate 12) appears rebellious in its use of such pastel hues as lavender and lemon yellow, and of hand-painted lines that waver ever so slightly.

Ana Maria Belluzzo has observed a cloisonné effect in the colored outlines that Wladyslaw painted around the rectangular shapes in his compositions. She has also noted that Wladyslaw's works from this period (1950–1952) belong to a phase of Concrete art in São Paulo during which artists focused on elements of line and plane.[4] These are certainly important aspects of *Abstrato,* but the most notable aspect of the composition remains its use of color. In fact, Wladyslaw generally focused on color in his work of this period; the use of vibrant greens and luscious shades of pink distracts the eye from the presence of geometry in the work.

Wladyslaw's evocative use of color, and his evident lack of interest in creating a work of art that appears machine-made, suggest that he actually felt more of an affinity with the ideals of Neo-Concrete artists than with those of his São Paulo–based colleagues. The Neo-Concrete spokesman Ferreira Gullar, writing many years after the fact, argued that Concrete art's emphasis on the mechanical undermined the viewer's intuitive experience of the work of art. He contended that Neo-Concrete art, in contrast, "believes that the geometric vocabulary it utilizes can render the expression of complex human realities."[5] The same statement could apply to Wladyslaw's early geometric compositions, which share a great

deal with the works of Grupo Frente, the Rio-based Concretist movement. Wladyslaw's early works give primary importance to color, allow brushstrokes and subtle modulations in tone to remain visible, and utilize geometry for aesthetic rather than analytical ends.[6]

In fact, Wladyslaw was only briefly involved with the Ruptura group (from 1952 to 1954), and he left because of his "emotional temperament."[7] The curators Rejane Cintrão and Ana Paula Nascimento speculate that Waldemar Cordeiro probably invited Wladyslaw to participate in the Ruptura show of 1952 after seeing his one-man exhibition at the Domus Gallery in São Paulo in 1951.[8] One may ask what drew Cordeiro to Wladyslaw, whose work bore much less resemblance to Cordeiro's own than to that of Cordeiro's archrivals Cícero Dias and Samson Flexor. Indeed, Wladyslaw was associated with Flexor's Atelier Abstração, a fact that may explain his lack of interest in two of the Ruptura artists' major concerns: Gestalt theory, and the relationship between time and movement.

Wladyslaw's early training as a civil engineer gave him a background similar to that of many other Concrete artists working in São Paulo during the 1950s. These artists, as Aracy Amaral has observed, worked in such fields as industrial design, chemistry, graphic design, architecture, and other professions related to the city's industrial growth.[9] Also, like the other Ruptura artists, Wladyslaw was a European immigrant.[10] Born in Warsaw, Wladyslaw emigrated to Brazil at an early age. While still working as an engineer, he took up painting and sought the advice of Lasar Segall, another European immigrant artist, who encouraged him to paint more. Eventually Wladyslaw pursued painting as a profession, and it was through his professional world that he became friends with the abstract painter Samson Flexor.

Around 1958, Wladyslaw abandoned geometric abstraction completely. He began to paint in a gestural style, creating works reminiscent of the drip paintings of Jackson Pollock. Although Wladyslaw's paintings apparently were executed by means of a technique almost identical to the one used by Pollock, he insisted that his paintings differed in crucial ways from Pollock's (the arabesque in Pollock's work was rhythmic, whereas in Wladyslaw's it was dynamic; one could cut a piece out of one of Pollock's paintings without

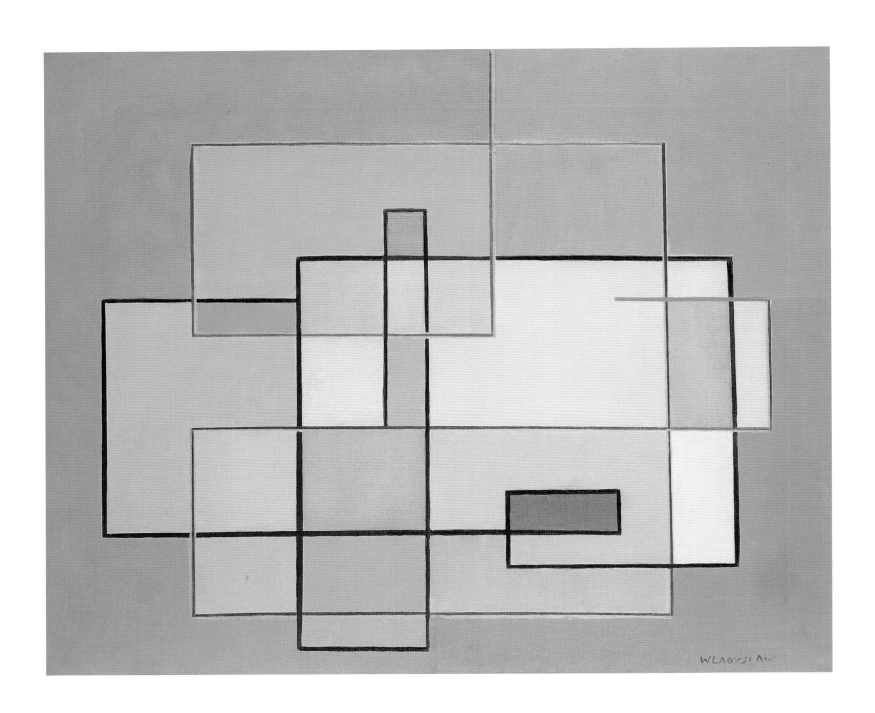

12 *Abstrato [Abstract],* 1950
Oil on canvas; 60 × 73 × 2.5 cm (23⅝ × 28¾ × 1 in.); Colección Patricia Phelps de Cisneros, 1997.46

lowering the quality of the composition; and so on).[11] While defending his work against the implication that he was copying Pollock, he also explained his relationship to Tachisme, the more general European term (also used by Brazilians) for Abstract Expressionism, or for gestural or informal abstraction. Wladyslaw admitted that Tachisme was "much more instinctive and intuitive" than his own work, but that "without a doubt" there was "a certain affinity."[12]

Meiri Levin has argued that spirituality in Wladyslaw's paintings has "a more religious, almost mystical connotation" than is the case even in the work of Wassily Kandinsky, which was a major influence on Wladyslaw.[13] (Wladyslaw, after reading Kandinsky's *Concerning the Spiritual in Art,* dedicated himself to research on the same topic.) For many of the Concretists, geometric forms held a significance that was material rather than spiritual, but the opposite seems to have been true for Wladyslaw. Levin has read Wladyslaw's work as an expression of his Jewish identity, but has focused almost exclusively on his more recent figurative work, drawing comparisons between Wladyslaw and other artists of Jewish heritage, such as Marc Chagall, Ben Shahn, and Segall. But the question of whether the arrangement of rectangles in Wladyslaw's use of geometric abstraction has any connection with Mondrian's ideas regarding Neo-Plasticism, which also linked abstraction to spirituality, remains tantalizingly unanswered.

Although Wladyslaw received prizes at the Bienal de São Paulo and participated in some of the most influential movements in Brazilian art, his position in the history of Brazilian art is unsure, and there is little published research on his work, perhaps because his work is so difficult to characterize. The Brazilian art critic Radha Abramo has argued that there are "three tendencies" in Wladyslaw's work; as the artist himself told her, "I am Poland, Judaism, and Brazil."[14] But in possessing three tendencies, he possessed none; that is, in denying the labels "geometric abstraction" and "Tachisme," he may also have denied himself a larger role in the history of Brazilian art.

Erin Aldana

Notes
All translations are the author's unless otherwise noted.
1. I would like to thank Dalton Delfini Maziero of the Arquivo Wanda Svevo at the Bienal de São Paulo and Francisco Zorzete for their help in obtaining sources for this essay.
2. Ana Maria Belluzzo, "Ruptura e Arte Concreta," trans. Izabel Burbridge, in Aracy Amaral, ed., *Arte Construtiva no Brasil: Coleção Adolpho Leirner/Constructive Art in Brazil: The Adolpho Leirner Collection* (São Paulo: Companhia Melhoramentos/Dórea Books and Art, 1998), 139.
3. Ferreira Gullar, "Concretos de São Paulo no MAM do Rio," in Aracy Amaral, ed., *Projeto construtivo brasileiro na arte (1950–1962)* (Rio de Janeiro: Museu de Arte Moderna do Rio de Janeiro; and São Paulo: Secretaria da Cultura, Ciência e Tecnologia do Estado de São Paulo, Pinacoteca do Estado, 1977), 140 (originally published as Ferreira Gullar, "Concretos de São Paulo no MAM do Rio," *Jornal do Brasil,* July 16, 1960).
4. Belluzzo, "Ruptura e Arte Concreta," 102.
5. Ferreira Gullar, "O Grupo Frente e a Reação Neoconcreta," trans. Izabel Burbridge, in Amaral, ed., *Arte Construtiva no Brasil,* 160.
6. For example, works including João José da Silva Costa's *Idéia múltipla* (1956), César Oiticica's *Sem título* (1959), and Rubem Ludolf's *Sem título* (1950s). See Amaral, ed., *Arte Construtiva no Brasil,* 147, 148, 150.
7. "Anatol Wladyslaw," trans. Anthony Doyle and David Warwick, in *Grupo Ruptura: Revisitando a exposição inaugural* (São Paulo: Cosac & Naify/Centro Universitário Maria Antônia, 2002), 52.
8. Rejane Cintrão and Ana Paula Nascimento, "The Exhibition of the Rupture Group in the São Paulo Museum of Modern Art, 1952," trans. Anthony Doyle and David Warwick, in *Grupo Ruptura: Revisitando a exposição inaugural* (São Paulo: Cosac & Naify/Centro Universitário Maria Antônia, 2002), 67.
9. Aracy Amaral, "Duas linhas de contribuição: Concretos em São Paulo/Neoconcretos no Rio," in Amaral, ed., *Projeto construtivo brasileiro na arte,* 312.
10. Cintrão and Nascimento, "The Exhibition of the Rupture Group," 67.
11. "Anatol Wladyslaw admite afinidades mas não filiação entre a sua pintura e o tachismo," *Folha da Tarde,* January 10, 1959. See also "Três pintores expôem na Galeria das Folhas," *Folha da Noite,* December 22, 1958.
12. "Anatol Wladyslaw admite afinidades."
13. Meiri Levin, "Um artista da vanguarda brasileira dos anos cinqüenta/sessenta: Anatol Wladyslaw" (master's thesis, University of São Paulo, 1997), 33.
14. Radha Abramo, "As tres vertentes na obra de Anatol," *Folha de São Paulo,* May 12, 1984.

Tomás Maldonado, *Desarrollo de 14 temas [Development of 14 Themes],* 1951–1952

b. 1922, Buenos Aires; lives in Milan

Upon initial consideration, *Desarrollo de 14 temas*[1] (plate 13) appears to be simply a visual expression of Tomás Maldonado's admiration for the European representatives of Concrete art, especially Max Bill.[2] Maldonado had met Bill during his first European visit, in 1948, and had found Bill's principle of the "good form" extremely compelling.[3] He probably knew Bill's series Fifteen Variations on the Same Theme (1935–1938), in which, according to Maldonado, Bill had explored the concept of variation, not as limited change within a pattern, but as an "infinite multiplicity of possibilities" given by a limited repertoire of forms.[4] *Desarrollo de 14 temas,* like the paintings in Bill's series, generates variation through the irregular, non-repetitive arrangement of lines, planes, and dots.

To read this painting in this manner is to confirm the prevailing notion that, starting around 1949, the work and ideas of Max Bill were a powerful influence on the Argentine Concrete artists.[5] And yet, without any discounting of Bill's influence, it is useful to explore another set of personal encounters and ideas that may have contributed to the creation of *Desarrollo de 14 temas:* the artist's contacts with the Argentine musician Juan Carlos Paz and the musical ideas that Paz promoted and defended. The most important of these, as Paz's many articles and books demonstrate, was Arnold Schönberg's twelve-tone scale.[6] The Argentine Concrete artists may have encountered Paz as early as 1944, but the earliest documented contacts exist in the pages of the journal *Nueva Visión: Revista de cultura visual,* which Maldonado founded in 1951.[7] Paz contributed important articles to the first two issues of the journal, published in 1951 and 1953.[8] According to *Nueva Visión*'s former secretary, Carlos Méndez Mosquera, Paz and other musicians from the Agrupación Nueva Música frequently gave concerts for the Concrete artists and architecture students at Maldonado's studio at 1371 Cerrito, in Buenos Aires.[9]

It is very possible, then, that in the early 1950s Paz would have been discussing the "new music" with the proponents of the "new vision." Paz's article on non-thematic and microtonal music, published in *Nueva Visión* in January 1953, may reflect the content of these discussions. In that article, Paz explained that non-thematic music, as developed by the Czech composer Alois Haba, is one of the logical consequences of Schönberg's twelve-tone scale. The term "non-thematic," Paz explained, "originates with and challenges the old definition of thematic work, where the theme, motif, or exposed melodic phase reappears in the course of a composition."[10] "Non-thematic" referred to a style that lacked "reprises, sequences, correspondences, and any sort of thematic and melodic repetition."[11] Paz noted, however, that although Haba's style did away with melodic sequences, he continued to use rhythmic sequences, which became the structure of his compositions.[12] Another of Haba's achievements, Paz explained, was "microtonal music." This music used sounds that composers produced by dividing the semitone into its intermediary sounds: fourths, sixths, eighths, and tenths of tone, and so forth. These divisions were "the point of departure of an unknown universe of sounds," since they implied the extension of what is known as "the natural scale." Paz commented,

> We all know that this scale, which is the basis of all of our [Western] educated music and most of our popular music from the Renaissance to now, is as conventional as any musical value.... The only thing that justifies this scale is that it is based on the auditory perception of those who established it and of those who then accepted it and grew used to it.[13]

This so-called natural scale, Paz contended, "does not exclude the possibility of new scales."[14] In sum, the "natural" scale was not natural but a mere convention.

Do the visual problems present in *Desarrollo de 14 temas* have parallels in the concepts of non-thematic and microtonal music? Maldonado can be said to have found in the concept of non-thematic music a stimulating source that could be used to reformulate what had been his central preoccupation since the 1940s: the avoidance of representation.[15] The Concrete artists, in the irregular frames and *coplanales* of the 1940s, had sought to avoid representation by disrupting the shape of the pictorial plane; in *Desarrollo de 14 temas,* Maldonado avoided representation by disrupting the legibility of the work as a coherent unit.[16] To become a representation, an image must not only evoke the natural world; it must also be legible as a structure, as a composition. Painting and music both

13 *Desarrollo de 14 temas [Development of 14 Themes],* 1951–1952
Oil on canvas; 201.5 × 211.5 × 2.5 cm (79⁵⁄₁₆ × 83¼ × 1 in.); Colección Patricia Phelps de Cisneros, 1998.46; copyright Tomás Maldonado

achieve legibility through the repetition of forms, that is, through symmetry, balance, and consistent variation. If all compositional patterns are suppressed, legibility is not possible, and neither is representation. Thus, just as non-thematic music could avoid a "theme" by excluding "reprises, sequences, correspondences, and any sort of thematic and melodic repetition," so too could Concrete artists avoid representation by not repeating clusters of pictorial elements—"themes"—within a single work. In fact, *Desarrollo de 14 temas* avoids repetition by depicting irregular polygons instead of rectangles or squares, and diagonal lines instead of horizontal or vertical lines. These polygonal planes and diagonal lines create internal angles that are unequal, and the overall arrangement of the lines and planes within the pictorial frame is asymmetrical. The lines and planes, then, neither generate repetitive relations throughout the composition nor echo the rectangular shape of the frame. Maldonado did sustain a minimal degree of rhythm by using a limited repertoire of forms (straight lines and quadrangular planes), but he reduced the work's legibility by avoiding repetitive combinations of these elements throughout the canvas.

The idea that a natural musical scale is a mere convention, and that the splitting of known sounds could challenge this convention, may also have sparked the pictorial strategies used in *Desarrollo de 14 temas*. The painting, in fact, questions the conventional role of lines in two-dimensional media. Traditionally, lines have served to define figures. In drawing, they are purposely visible elements that separate the figures from the background. In painting, they are imaginary barriers that separate extensions of color. In *Desarrollo de 14 temas*, however, the lines perform neither of these functions. Several lines, rather than forming closed figures, meet and explicitly describe wide angles, whereas others merely suggest angles. Maldonado also placed lines around the edges of the polygonal planes, but these lines do not coincide with the edges of the planes that they seem to define. Thus Maldonado highlighted the fact that outlined figures are illusory conventions, and therefore that representation is merely a visual fabrication.

Both Maldonado and Paz sought to avoid representation, whether musical or pictorial, by disturbing the principle of repetition and the conventions of visual and auditory perception. Each of them, in his respective field, found analogous concepts to represent his antagonism to traditional artistic forms. Perhaps the most suggestive aspect of Maldonado's dialogue with Paz is this painting's title. The fourteen themes are probably different combinations of pictorial elements that, evoking the process behind non-thematic music, do not consistently repeat one another, and that, ironically, do not therefore emerge coherently as a "theme." The term *desarrollo* (development, unraveling) gives the title a temporal quality that parallels the constant change inherent in non-thematic music—what Paz calls "a perpetual development of musical discourse."[17] With its non-repetitive disposition of lines and planes, *Desarrollo de 14 temas* also evokes constant internal change.

The concepts of non-thematic and microtonal music provide an alternative conceptual framework for the interpretation of *Desarrollo de 14 temas,* and this framework adds an intriguing extra-artistic connection between this work and the history of Argentine Concrete art. What is perhaps more important, this framework also undermines the prevailing notion that the Argentine artists changed the direction of their production only by virtue of their direct exposure to European art. Instead, in the early 1950s, Paz's musical tenets provided a local source of inventive ideas that energized the artistic production of the Argentine Concrete artists.

Ana Pozzi-Harris

Notes

All translations are the author's.

1. In a recent catalogue, *Desarrollo de 14 temas* is dated c. 1947, but the work was probably painted in 1951 or 1952; see Mario Gradowczyk and Nelly Perazzo, *Abstract Art from the Río de la Plata* (New York: The Americas Society, 2001), 117, pl. 25. The painting was included in an exhibition at Galería Viau in 1952. This show, which featured the Grupo de Artistas Modernos de la Argentina, included four independent artists (Hans Aebi, José Antonio Fernández Muro, Sarah Grilo, and Miguel Ocampo) and five Concrete artists (Claudio Girola, Alfredo Hlito, Enio Iommi, Tomás Maldonado, and Lidy Prati). It was organized by the critic Aldo Pellegrini. Two photographs of the exhibition were published in *Nueva Visión* (January 1953): 26, and *Desarrollo de 14 temas* is visible in one of the two.

2. Maldonado repeatedly documented, in writing, his admiration of the Swiss Concrete artists. See, for example, Tomás Maldonado, "Georges Vantongerloo," *Nueva Visión* (December 1951): 19; and Tomás Maldonado, "Vordemberge-Gildewart y el tema de la pureza," *Nueva Visión* (January 1953): 12–18. See also Tomás Maldonado, *Max Bill* (Buenos Aires: Ediciones Nueva Visión, 1954), a thoroughly illustrated volume, reprinted as "Max Bill" in Tomás Maldonado, *Escritos preulmianos* (Buenos Aires: Ediciones Infinito, 1997).

3. The "good form" was an aesthetic principle that valued not a particular form or forms but the coherence of forms. According to Maldonado, Bill's forms achieved aesthetic coherence when they followed their own "law of development." The principle of formal coherence was applicable to all objects, "from spoon to city." Art objects, then, played a role on a par with that played by objects of practical use.

4. See Tomás Maldonado, "Max Bill," 106. (The artist originally discussed Bill's series Fifteen Variations on the Same Theme in Maldonado, *Max Bill*).

5. Such a notion is well established in the literature on Argentine Concrete art. See, for example, Nelly Perazzo, *El Arte Concreto en la Argentina en la década del 40* (Buenos Aires: Ediciones de Arte Gaglianone, 1983), 97; Mario Gradowczyk and Nelly Perazzo, "Abstract Art from the Río de la Plata: Buenos Aires and Montevideo," in Gradowczyk and Perazzo, *Abstract Art from the Río de la Plata,* 48, 51; and Gabriel Pérez-Barreiro, "The Argentine Avant-Garde, 1944–1950" (Ph.D. diss., University of Essex, 1996), 273–85.

6. A composer, music teacher, critic, and writer, Paz introduced Arnold Schönberg's twelve-tone scale to Argentina in 1934. In 1937, he founded the Conciertos de la Nueva Música, concerts that provided an "anthology of contemporary trends." These concerts eventually grew, in 1950, into the Agrupación Nueva Música, an institution devoted to promoting the most advanced musical trends. Before 1955, Paz published his writings in various cultural journals besides *Nueva Visión,* such as *Sur, Cabalgata,* and *Contrapunto.*

7. In a retrospective article, the artist Gyula Kosice cites Juan Carlos Paz as one of the intellectuals who met at the Rubí and La Fragata cafés in Buenos Aires, and who stimulated the ideas that emerged in the single issue of the journal *Arturo* (summer 1944); see Gyula Kosice, "A partir de la revista Arturo," *La Nación* (October 1, 1989).

8. *Nueva Visión* published nine issues between 1951 and 1957, and Paz contributed two articles. See Juan Carlos Paz, "Qué es nueva música," *Nueva Visión* (December 1951): 10–11; and Juan Carlos Paz, "Música atemática y música microtonal," *Nueva Visión* (January 1953): 28–30.

9. Carlos Méndez Mosquera, interview with the author, May 2003, Buenos Aires.

10. Paz, "Música atemática and musica microtonal," 28.

11. Paz, "Música atemática and musica microtonal," 28.

12. Paz, "Música atemática and musica microtonal," 28.

13. Paz, "Música atemática and musica microtonal," 29.

14. Paz, "Música atemática and musica microtonal," 29.

15. Several writings by Maldonado reveal this preoccupation; see Tomás Maldonado, "A dónde va la pintura?," "Manifesto Invencionista," and "Los artistas concretos, el 'realismo' y la 'realidad,'" in Tomás Maldonado, *Escritos preulmianos* (Buenos Aires: Ediciones Infinito, 1997), 35–36, 39–40, and 49–50, respectively.

16. For a discussion of the cut-out frame and the *coplanal,* see Gabriel Pérez-Barreiro's contributions on Raúl Lozza's *Relief* and Juan Melé's *Coplanal,* this book.

17. See Paz, "Música atemática y música microtonal," 28.

Geraldo de Barros, *Abstrato [Abstract]*, from the series Fotoformas [Photoforms], 1951
"Pampulha"—Belo Horizonte, Brasil, 1951

1923, Xavantes, Brazil–1998, São Paulo

In his 1951 photographs, Geraldo de Barros captured wondrous glimpses of an unfamiliar world. Since 1948, Barros had been creating abstract photographs with his Rolleiflex camera, using multiple exposures to render common objects unidentifiable and to convert industrial structures into geometric patterns. He called this series Fotoformas, and shortly after exhibiting these works at the Museu de Arte de São Paulo (MASP), in 1950, he received a scholarship from the French government to further his artistic studies abroad. Barros spent much of the following year in Paris, where he studied at the École des Beaux-Arts and met leading photographers, such as Henri Cartier-Bresson and Georges Brassaï. The photographs he took in Paris indicate his continual interest in Constructivism and geometric design. Works from the period, such as *Abstrato* (plate 14) and *"Pampulha"—Belo Horizonte, Brasil* (plate 15) also relate to Barros's active search for a Concrete art form, a type of abstract art that would be neither representational nor symbolic and that would stand as completely autonomous with respect to the outside world.

In *"Pampulha"—Belo Horizonte*, five dark vertical lines taper toward the top of the photograph; they are the partitions of a tall window that reappears in at least two other photographs by Barros from his time in Paris.[1] By turning his 1939 Rolleiflex 90 degrees and creating a double exposure, Barros used the window's partitions to produce a grid. Against the grid, the spidery organic forms of tree branches produce a delicate overlay of texture, which creates a conflicting sense of depth: the grid appears to enclose the branches; the texture also seems to cover the grid.

While the architectural elements in the photograph suggest that Barros created this image in Paris, the title of the photograph recalls his native country: Pampulha is a suburban area of Belo Horizonte, the capital of the state of Minas Gerais. The photograph's architectonic patterning, combined with the title, indicates the artist's awareness of and appreciation for the modern building designs of the Brazilian architect Oscar Niemeyer, whose unorthodox design for the Church of Saint Francis stirred controversy when it was constructed in Pampulha in 1943. But Barros's photograph blurs its associations with specific locations, whether in France or in Brazil, to create a separate, more conceptual place.

Rather than documenting a particular site, his images challenge the viewer's perception of light and structure.

Barros's abstract photography denotes a precedent to his later involvement in the Concrete art movement, which took strong root in Brazil in the early 1950s. But Barros's Fotoformas series, begun in the late 1940s, indicates that Brazilian artists were avidly exploring abstraction before 1950 and creating an atmosphere receptive to the ideas of European Concrete artists like Max Bill.

Shortly before leaving for Paris, Barros had encountered Bill's work at first hand, at the 1951 Max Bill retrospective at the MASP. During the installation of the retrospective, Barros helped unpack works for the exhibition. (At the time, he was running the museum's photography lab, which he had been asked to set up in 1949.) Impressed by Bill's paintings and sculptures, Barros sought Bill out twice while studying in Europe. First he traveled to Bill's home in Zurich, and then he found the artist in Ulm, Germany, where Bill was rector of the Hochschule für Gestaltung. Bill distinctly recalled Barros's Fotoformas series. He commented, "I was immediately seduced by his creative strength and was very much impressed by his photographic research, which he undertook as a parallel activity to his work in painting."[2] Through his travels in Europe and his exchanges with Max Bill, Barros cultivated his knowledge of international design and Concrete art. And while he applied stringent mathematical concepts to the creation of his geometric paintings, his photographs relied more heavily on improvisation. He stated, "Photographic creativity lies within the 'mistake,' the exploration and command of chance."[3]

By scratching film negatives and painting over photographic prints, Barros combined elements of drawing with photography. "For me," he claimed in 1996, "photography is an engraving process."[4] Indeed, several 1951 works from his Fotoformas series reflect his combined interests in photography and engraving. In *Abstrato,* for example, Barros scraped diagonal lines, looping forms, and triangles onto a film negative. These ambling forms appear to fade away into the white background, but they also reveal traces of an underlying image, suggesting a wiry activity. The viewer may wish to know what the photograph originally depicted, but Barros

14 *Abstrato [Abstract],* from the series Fotoformas [Photoforms], 1951
Silver gelatin photograph; 28.2 × 30.4 cm (11⅛ × 11¹⁵⁄₁₆ in.); Colección Patricia Phelps de Cisneros, 1995.37; copyright de Barros Family

15 *"Pampulha"—Belo Horizonte, Brasil,* 1951
Silver gelatin photograph; 29.7 × 40.4 cm (11¹¹⁄₁₆ × 15⅞ in.); Colección Patricia Phelps de Cisneros, 1995.36; copyright de Barros Family

deliberately obscured the image, creating a purely abstract composition.

In 1952, upon his return to Brazil from Paris, Barros formed the Grupo Ruptura with other São Paulo artists, including Waldemar Cordeiro and Luis Sacilotto; together they assumed a fundamental role in Brazil's Concrete art movement. In their manifesto, the members of Grupo Ruptura called for "new art principles" and the elimination of representational art. They claimed, "The process of rendering the (three-dimensional) external world on a (two-dimensional) plane—has exhausted its historical task."[5] Photography seemed contrary to their artistic aims, since cameras by their very nature permit one to capture images of the external world. But, paradoxically, Barros used photography to break free from the representational. Through his photographs, he transformed the shapes and modern structures he saw around him. His photographic compositions freed the images from their referents. As he became more involved with the polemics surrounding the Concrete art movement and Brazil's modernization, he photographed less and less. By 1954, he had dedicated himself primarily to industrial design and created Unilabor, a cooperative furniture-production company. A few works exist in his Fotoformas series that are based on his Unilabor furniture, but the work from Paris and his native Brazil that he created between 1948 and 1951 is what best represents his innovative approach to abstract photography.

Michael Wellen

Notes

1. Reproductions of two works that include the same window and view of trees, both titled *Paris (1951),* can be found in Reinhold Misselbeck, *Geraldo de Barros, 1923–1998: Fotoformas* (New York: Prestel, 2004), figs. 26, 44.
2. Max Bill, "Geraldo de Barros," in *Geraldo de Barros: A Precursor* (São Paulo: Centro Cultural Banco do Brasil, 1996), 8.
3. *Geraldo de Barros: A Precursor,* 7.
4. *Geraldo de Barros: A Precursor,* 7.
5. The Ruptura manifesto was published and circulated by Waldemar Cordeiro, Luiz Sacilotto, Geraldo de Barros, and other abstract artists who exhibited together at the São Paulo Museum of Modern Art in 1952. The manifesto is reprinted in translation in Mari Carmen Ramírez and Héctor Olea, eds., *Inverted Utopias: Avant-Garde Art in Latin America* (New Haven, Conn.: Yale University Press in association with the Museum of Fine Arts, Houston, 2004), 494.

Geraldo de Barros, *Função diagonal [Diagonal Function],* 1952

1923, Xavantes, Brazil–1998, São Paulo

This iconic work by Geraldo de Barros serves as a perfect illustration of the combination of Euclidean geometry and Gestalt perception that was characteristic of Brazilian Concretism in the 1950s. In composition, *Função diagonal* (plate 16) is almost a textbook illustration of the three classic operations of symmetry—rotation, reflection, and inversion—as formulated from Euclid's basic axioms of plane geometry. Each form is a logical consequence of the square formed by the edge of the frame. The work is constructed entirely on the principle of equidistant division of a line. Thus Barros constructed the largest white square by connecting the halfway points on each side of the frame, the next black form from the halfway points on the white, and so on. The visual effect that these divisions create is of rotation and recession, with the smaller central forms appearing farther away, creating a perceptual central void in the composition.

In its logical and deductive composition, *Função diagonal* recalls a classic work of European abstraction: Theo van Doesburg's *Arithmetic Composition* (1930). This painting was van Doesburg's visual manifesto of the principles of Concrete art that were articulated in the Concrete art manifesto published in the same year. Concrete art aspired to be the most objective and non-symbolic form of art, in which "a pictorial element has no other meaning than 'itself' and thus the picture has no other meaning than 'itself.'"[1] After van Doesburg's death, in 1931, Max Bill and other artists in Switzerland picked up the baton of Concrete art, and their version arrived in São Paulo with an important Max Bill exhibition at the Museu de Arte Moderna in 1950.

Art history generally has interpreted the introduction of Concrete art in Brazil as a straightforward reflection of São Paulo's industrialization, and of the city's desire to engage with a rationalist and internationalist movement, but few studies have analyzed the differences between Brazilian and Swiss Concrete art. The fact of the emergence of Neo-Concrete art in Rio in the 1960s has encouraged a reading of the previous Concrete movement as one of mathematical orthodoxy and uncritical assimilation of European models. Nevertheless, a work like *Função diagonal* points to a concern with psychological perception that places it and other such works in a phenomenological and conceptual realm different from that of their European counterparts. Van Doesburg's *Arithmetic Composition* uses a mathematical operation (division by two, and rotation on a diagonal) almost identical to that employed in *Função diagonal,* but the forms in van Doesburg's painting reach out to the upper left, suggesting a continuation beyond the frame, whereas *Função diagonal*, by using an operation directed toward the center of the painting, presents all its operations within a whole, without extending beyond the frame. This presentation of a whole structure with all its constituent parts raises the issue of the relationship of part to whole—a central emphasis in Gestalt theory.

Gestalt theory developed in the 1920s as an aspect of behavioral psychology. The theory concerns problem solving and its implications for understanding the human mind. According to Max Wertheimer, the first theorist of Gestalt, "The fundamental question can be very simply stated: Are the parts of a given whole determined by the inner structure of that whole, or are the events such that, as independent, piecemeal, fortuitous and blind, the total activity is a sum of the part-activities?" Simply put, Gestalt theory asserts that a whole is greater than the sum of its parts. The question of visual perception is an important one in Gestalt theory, for it is here that certain ways of comprehending the world become tangible. *Função diagonal* expresses many of the laws through which Gestalt theory is understood, the most famous of which is the effect of simultaneous contrast, or "multistability," in which a form can be read in two alternating ways but never in both ways at once (the facial profiles/vase image is the example most typically invoked). Perception is determined more by the mind's desire to see an organizing "whole" (that is, a gestalt) than by constitutive parts. Therefore, a geometrical operation can never contain an absolute value, since any value will be subject to the perception of the *Gestaltqualität* (the quality of the whole). Also inherent in *Função diagonal* are three more perceptual effects arising from operations characteristic of visual gestalt: emergence (an effect of the viewer's ability to see a complete form emerge from a context), reification (the viewer's mental completion of an incomplete form), and invariance (an effect of the viewer's recognizing the iterations of a form as equivalent,

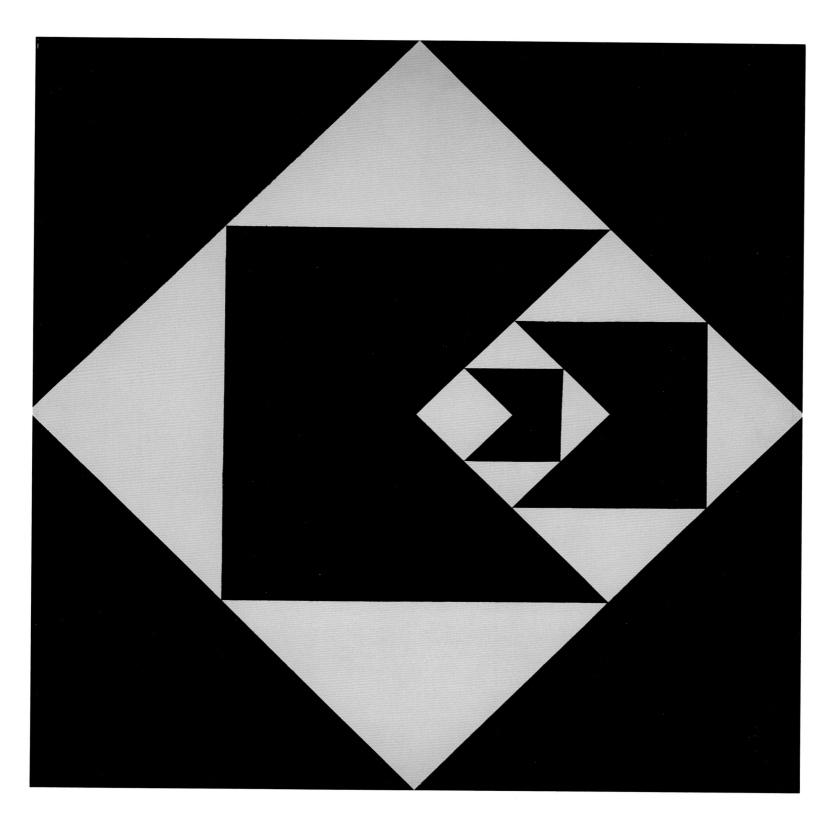

16 *Função diagonal [Diagonal Function]*, 1952
Lacquer on cardboard; 60 × 60 × 0.3 cm (23⅝ × 23⅝ × ⅛ in.); Colección Patricia Phelps de Cisneros, 1995.16; copyright de Barros Family

even when the form has been rotated, resized, or distorted).

Thus *Função diagonal,* together with many other works of Brazilian Concretism, moves beyond European Concrete art's straightforward progressive belief in the absolute value of mathematics for its own sake. Barros's work generates a perceptual tension between a mathematical operation (simple subdivision) and the perception (notwithstanding recession and rotation) of a gestalt, or whole. In so doing, it implies its own deep, meaningful connection with human perception and psychology, a connection vehemently denied by the more orthodox applications of geometry to art. Moreover, the beauty of the work lies in its simplicity and rigor. Barros did not express the work's perceptual complexity through individual brushstrokes or even through color but rather through a profound understanding of the human mind's ability to organize material by means of perception.

The implications of this application of Gestalt theory to geometric art were huge. Unlike those Argentine artists of the previous decade who had attempted to produce absolutely objective anti-illusionist art, the *paulista* artists acknowledged the viewer's subjectivity as part of the equation. This combination of subjectivity with absolutely classical geometry was to develop fully not only in the Neo-Concrete movement but also in the Kinetic art practiced in Caracas and Paris, in which perceptual color determined the relationship of the individual viewer to a visual phenomenon.

Gabriel Pérez-Barreiro

Note

1. The manifesto was originally published in the first and only issue of *Art Concret* (1930); see Carlsund, van Doesburg, Hélion, Tutundjian, and Wantz, "The Basis of Concrete Painting," trans. Stephen Bann, in Stephen Bann, ed., *The Tradition of Constructivism* (New York: Da Capo, 1974), 193.

Given the iconic status of Alejandro Otero's Coloritmos (1955–1960), it is difficult not to view *Estudio 2* (plate 17), *Estudio 3* (plate 18), and *Tablón de Pampatar*[1] (plate 19) primarily as works that foreshadow that better-known series. In fact, the three works discussed here did introduce compositional elements and, in the case of *Tablón de Pampatar,* materials and techniques that were to characterize the later Coloritmos series. It would be a mistake, however, to see these early geometric abstractions merely as precursors. Generated as a result of Otero's involvement in projects that pursued an integration of the arts, they offer insight into how such projects contributed to the development of the artist's version of Constructivism.

In 1952, Otero returned from Paris to Caracas in order to participate in the building of the Ciudad Universitaria under the direction of the architect Carlos Raúl Villanueva. It was in Paris, where he had been living since 1945, that Otero first discussed artistic integration. In 1951, he had proposed sending to Caracas an international exhibition of abstract art titled *Unity in Art.* Of this exhibition he wrote:

> What we are striving for is a close collaboration among painting, architecture, sculpture, etc. . . . Painting and sculpture for the benefit of architecture and vice versa. Their interrelations and the influence of all this on what is practical, on the objects that comprise daily life in the home, on the street, etc., etc.[2]

For Otero the integration of the arts was crucial to his goal of contributing to "the harmony and equilibrium of future society" through art.[3]

Otero's first opportunity to attempt the integration of the arts came with his design of five small panels, completed in 1953, for the José Ángel Lamas amphitheater in Caracas.[4] *Estudio 2* and *Estudio 3* are two of five studies for those panels. Otero followed these gouache-on-paper studies quite closely in the final works, which are aluminum and mosaic. These works, early examples of Otero's use of a grid, help us understand the trajectory of the artist's stylistic development. Inspired by Piet Mondrian, Otero had first used grids in his series titled Collages orthogonales (1951). The grids in these two studies differ, however, since he created them not with orthogonals

but with diagonal lines. Slanted, the lines float in an undefined space, much like the lines in his even earlier Líneas inclinadas series (plate 8).

These paintings have a free-flowing, dynamic quality reminiscent, in some ways, of Wassily Kandinsky's abstract geometric works of his Bauhaus period (1922–1933). This is not to suggest that Kandinsky's work directly influenced Otero's, though Otero considered him, along with Mondrian and Robert Delaunay, one of the "grand trilogy" of abstract artists.[5] Rather, the paintings have an affinity with Kandinsky's work that comes, perhaps, from a shared interest in synesthesia—specifically, an interest in suggesting the sensation of sound through visual means. The irregular, obliquely situated grids suggest the ebb and flow of sound, its changing vibrations. The grid modules that are filled in with black, white, or vibrant colors create rhythm. Thus these are studies not just for the integration of painting with architecture but also for the integration of painting with music.[6] Otero himself admitted, however, that as an integration project the panels were not entirely successful.[7] Their suggestion of music complements the function of the amphitheater, but they do not formally affirm the structure itself. Indeed, the artist's use of non-parallel diagonals in these two studies creates a suggestion of recession in space that pictorially denies the plane of the wall. Even the two panels that include no diagonals seem merely to decorate the wall like conventional paintings, in part because of their relatively small scale.[8]

In the midst of his involvement with the design of the Ciudad Universitaria, Otero created *Tablón de Pampatar,* a painting that brings into play elements introduced in the *Estudios,* which the artist would later use in other integration projects as well as in the Coloritmos series. The work consists of rectangular modules of equal size, painted white, black, blue, red, and yellow. They create a vertically accented grid like those in the two *Estudios,* but here the grid is orthogonal, like the grids in the 1956 double mural that Otero created for the School of Engineering at the Ciudad Universitaria. *Tablón de Pampatar,* in its palette, its orthogonal grid composition, its precise edges, and its smooth surface, is a tribute to Mondrian's classic period. Otero achieved the work's precise, smooth look by painting, for the first time, with an

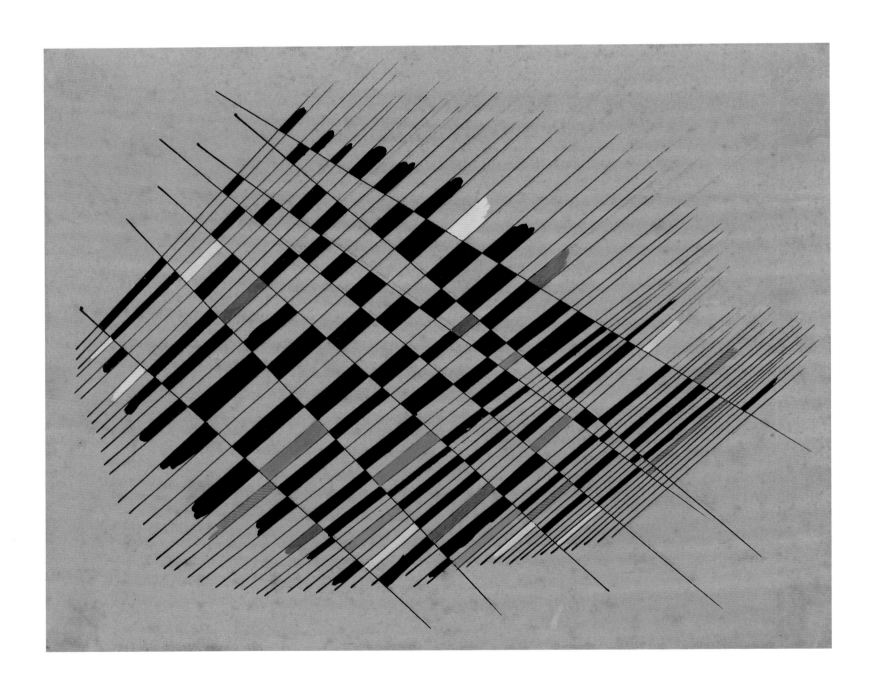

17 *Estudio 2 [Study 2]*, 1952
Gouache on paper; 19.5 × 25 cm (7¹¹⁄₁₆ × 9¹³⁄₁₆ in.); Colección Patricia Phelps de Cisneros, 1990.95; copyright Alejandro Otero Estate

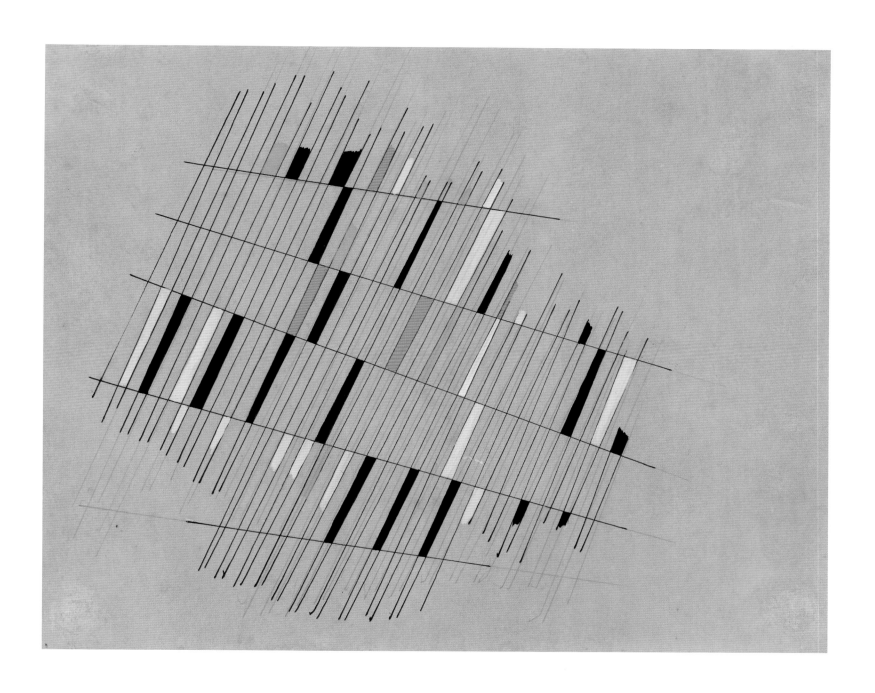

18 *Estudio 3 [Study 3]*, 1952
Gouache on paper; 19.5 × 25 cm (7¹¹⁄₁₆ × 9¹³⁄₁₆ in.); Colección Patricia Phelps de Cisneros, 1990.96; copyright Alejandro Otero Estate

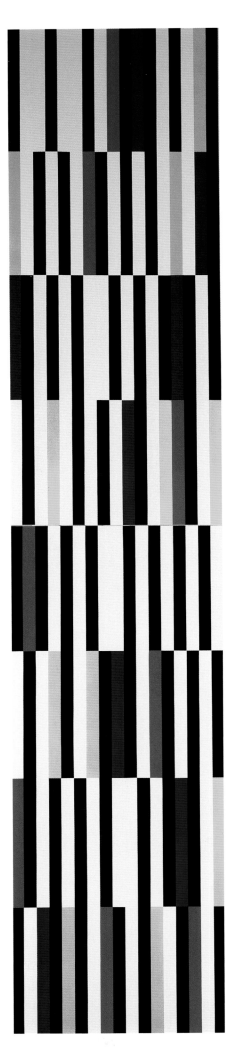

19 *Tablón de Pampatar [Pampatar Board],* 1954
Lacquer on wood; 320.5 × 65 × 2.5 cm (126³/₁₆ × 25⁹/₁₆ × 1 in.); Colección
Patricia Phelps de Cisneros, 1990.58; copyright Alejandro Otero Estate

airbrush, applying lacquer to a vertical plank of wood—the same materials, technique, and format that he would use for the Coloritmos series. In *Tablón de Pampatar,* unlike in his *Estudios,* the grid is defined by modules of color rather than by black lines. Like the *Estudios* and other works from the 1950s, however, *Tablón de Pampatar* evokes music. It even formally approximates systems of musical notation, its eight stacked registers suggesting musical staves in which the bright colors are disposed and seem to resound like notes.[9]

At first glance, the work seems simple enough. But from simple elements Otero created a composition of great complexity. For example, each of the eight registers is linked to the registers below and above it by vertically aligned black modules that read as continuous bars. The fourth and fifth registers, however, are separated by the slightest of gaps; thus the artist effectively halved the composition horizontally, further evoking musical notation, which separates the treble stave from the bass. The white, black, and color modules repeat without discernible pattern, and, despite the lack of dynamic lines, both this variable repetition and the bright colors create a composition that is lively and dynamic nevertheless.

In addition to creating rhythm, Otero's colors create space. *Tablón de Pampatar*'s colored modules appear either to recede or to project into space, as determined by their proximity to other colors, to black, or to white. Otero's use of flat color to define space is like an architect's use of walls, and it reflects his interest in and increasing understanding of architectural space. His spatial use of color also relates to that of Delaunay, who first explored the spatial interaction of colors within grids in his *Simultaneous Windows* of 1912. But even while the colors in *Tablón de Pampatar* create a sense of space, the precise finish and the orthogonal grid composition emphasize the continuous planar surface of the painting, working against spatial illusion. In terms of pictorial space, *Tablón de Pampatar* creates a wonderful ambivalence, which Otero would develop further in the Coloritmos series.

Unless one reads Otero's impassioned utopian statements, it is difficult to see how such works, whether independent paintings or murals integrated into architecture, might effect social change. And, indeed, from the perspective of the twenty-first century, the utopian claims of Otero and his colleagues seem naive, overblown, and—ironically—shortsighted. Constructivist art may have failed to produce a social utopia, but Otero's utopian vision did succeed in producing a highly refined and stimulating Constructivism that reminds us what a vibrant, creative force hope can be.

Gina McDaniel Tarver

Notes

All translations are the author's unless otherwise noted.

1. Pampatar is a colonial city on the Venezuelan island of Margarita; Alfredo Boulton, Otero's friend and patron, commissioned Otero to create *Tablón de Pampatar* for a large house he owned there (Luis Pérez-Oramas, correspondence with the author, July 3, 2006).

2. Letter from Alejandro Otero to Alfredo Boulton, October 5, 1951, in Yve-Alain Bois et al., *Geometric Abstraction: Latin American Art from the Patricia Phelps de Cisneros Collection/Abstracción Geométrica: Arte Latinoamericano en la Colección Patricia Phelps de Cisneros,* various translators (Cambridge, Mass.: Harvard University Art Museums; Caracas: Fundación Cisneros, 2001), 150.

3. "Alejandro Otero polemiza con Mario Briceño Iragorry," in *Alejandro Otero* (Caracas: Museo de Arte Contemporáneo de Caracas, 1985), 22 (originally published as "Alejandro Otero polemiza con Mario Briceño Iragorry," *El Nacional,* July 5, 1952).

4. This amphitheater, now called the Concha Acústica de Bello Monte, was constructed in 1953–1954 in the Municipio Baruta area of Caracas as the home of the Orquesta Sinfónica Venezuela.

5. "Alejandro Otero polemiza con Mario Briceño Iragorry," in *Alejandro Otero,* 21.

6. The integration of music with the visual arts and architecture was also a goal of Villanueva; he even conceived of his plan for the Ciudad Universitaria as a musical score, designing areas of the campus as "movements." For a brief explanation, see Jacqueline Barnitz, *Twentieth-Century Art of Latin America* (Austin: University of Texas Press, 2001), 171.

7. Otero wrote of the Concha Acústica project, and of his projects at the Ciudad Universitaria, "But none of this truly coincided with the possibilities that I had glimpsed"; see "Alejandro Otero polemiza con Mario Briceño Iragorry," in *Alejandro Otero,* 21.

9. Jiménez has noted that Otero and other artists arranged color and form rhythmically to introduce time, "approaching even formally the systems of musical notation"; see Ariel Jiménez, "Geo-metrías," in *Geo-metrías: Abstracción geométrica latinoamericana en la Colección Cisneros* (Caracas: Fundación Cisneros, 2003), 42.

Jesús Rafael Soto, *Desplazamiento de un elemento luminoso* [*Displacement of a Luminous Element*], 1954

1923, Ciudad Bolívar, Venezuela–2005, Paris

Desplazamiento de un elemento luminoso (plate 20) was a pivotal work for Jesús Rafael Soto, both artistically and critically. Shown in the historic *Le Mouvement* exhibition at Denise René's Paris gallery in April 1955,[1] it is one of a series of Plexiglas constructions in which Soto renounced the primacy of painting and created a new language with which to express movement through visual effects. *Desplazamiento* not only expands on Soto's use of repetition and progression to negate representation and traditional concepts of perspective and spatial illusion, it also actively engages the viewer through optical vibration, and it anticipates his later, more complex Kinetic pieces. Moreover, *Desplazamiento*'s inclusion in the *Le Mouvement* exhibition, and its critical reception, illuminate the work's decisive role in establishing Soto as a member of an international community of avant-garde artists.

Soon after his arrival in Paris, in 1950, Soto passed through successive and rapid phases of experimentation. His 1951 painting series Búsquedas dinámicas [Dynamic Searches] undermines any conventional sense of form or composition by rhythmically repeating identically colored elements across wood structures, to imply a seemingly limitless continuum beyond the frame. By 1952, Soto, inspired by dodecophonic music theory, had painted two new series of works, titled Progressions and Rotations, in which he systematized the individual artist's role in deciding composition, form, and color harmonies. In both series, the compositional logic is at once arbitrary yet regular. Soto applied a limited palette of colors according to a randomly selected sequential order, assigning each color a position on the wood support's grid. The result in both cases was the undermining of any central composition or traditional vanishing point. Visually, the works can be cut off at any given point while still presenting a multitude of possibilities to the viewer. The viewer can decide between experiencing the work as a self-sufficient entity or continuing the patterning beyond the frame's edges.[2]

With *Desplazamiento,* Soto applied his explorations of repetition and rotation to Plexiglas, a new material for him. He transferred overall composition/non-figurative painting onto a structure consisting of a transparent Plexiglas plane superimposed on an opaque wooden one. The serial distribution of white dots seen through the black rectangular grid affixed to the wooden plane is identical to the distribution of white dots on the Plexiglas plane.[3] But Soto destabilized and animated the composition by shifting the angle of the Plexiglas overlay. *Desplazamiento*'s ambiguous perspective produces a sense of movement that confuses figure and ground. The viewer's compositional frame of reference dissolves into a shimmering screen of dots merging and separating with the viewer's movement. Ultimately, it is the spectator, rather than Soto, who determines the work's outcome as a kinetic optical vibration.

In *Desplazamiento,* as in similar works, Soto attached Plexiglas directly onto a flat wooden support, but in late 1955 Soto raised the Plexiglas plane away from the surface and built, to use his own term, his first Kinetic structure, *Spirale.*[4] Inspired by Marcel Duchamp's Rotoreliefs series (1935) and by Duchamp's *Rotative Demi-sphère* (1950), which Soto had seen at the *Le Mouvement* exhibition, he used a painted spiral form on both the Plexiglas overlay and the wooden support. These more complex Plexiglas structures offered Soto new methods of creating dynamic optical vibration, "the methodical destruction of all stable form, the molecular shattering of solids, the dissolution of volumes."[5] For Soto, this movement was critical to integrating real time into the piece, or to what he would later call "spatiotemporal situations."[6] Furthermore, the changing luminescent form challenges the viewer to actively participate in the creation of the work, which the artist had ceased to encode with a predetermined artistic form.

Many of Soto's contemporaries in Paris shared his desire to introduce movement into abstraction, to reject the subjective expression of the artist, and to actively engage the viewer. By the early 1950s, Madí artists had exhibited works in Paris that incorporated dynamism into abstract geometric art. Jean Tinguely and Yaacov Agam, with whom Soto exhibited at *Le Mouvement,* had also been investigating non-pictorial ways of investing the visual object with active play.[7] Nevertheless, the artist whose work is most closely related to Soto's *Desplazamiento* is Victor Vasarely. Vasarely, arguably the most recognized and influential of the younger generation of artists shown at *Le Mouvement,* had

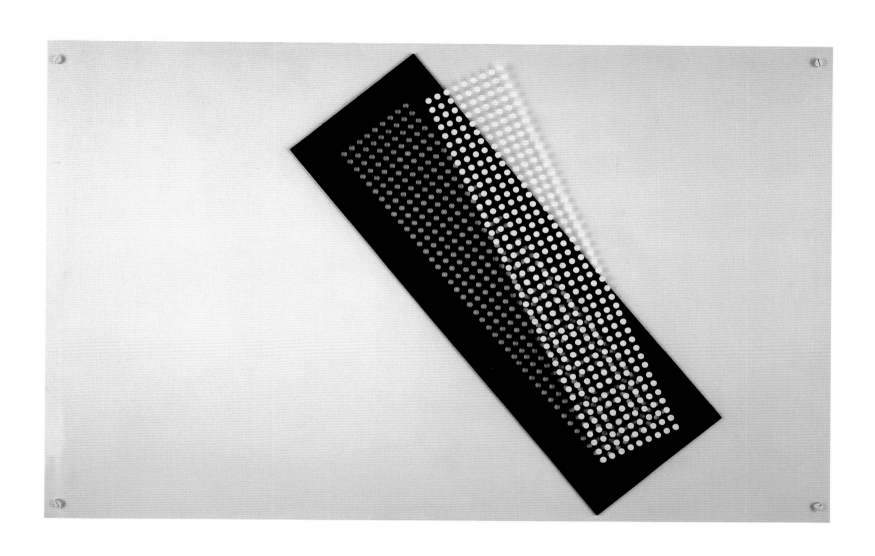

20 *Desplazamiento de un elemento luminoso [Displacement of a Luminous Element],* 1954
Plexiglas and tempera on wood; 49.8 × 80 × 3.2 cm (19⅝ × 31½ × 1¼ in.); Colección Patricia Phelps de Cisneros, 1989.36; copyright Jesús Rafael Soto Estate

been experimenting since 1952 with optical effects produced through the use of black-and-white transparent collages, both in Plexiglas and on tracing paper. In the so-called Yellow Manifesto that accompanied the exhibition, Vasarely, defining how non-objective art could triumph over *l'anecdote* of Manet, noted that "through the effect of opposite perspectives"— the positive and the negative—"these elements alternately cause the appearance and disappearance of a 'spatial feeling,' thus giving the illusion of movement and duration."[8] This description is directly related to the technique that Soto deployed in *Desplazamiento*. Although Soto later distanced himself from Vasarely, works like *Desplazamiento* illustrate the early importance of Vasarely for Soto.

Soto's work, including *Desplazamiento*, received extensive critical attention as part of the *Le Mouvement* exhibition. The Paris press covered the exhibition and its participants thoroughly, highlighting the impact of the new movement on abstraction. In particular, Louis-Paul Favre praised the exhibition in a review published in *Le Combat*.[9] Suddenly critics considered Soto, whose work until then had received limited coverage in the Paris art press, to be one of an important new wave of international avant-garde artists. It is true that Léon Degand, the enthusiastic defender of abstraction in *Art d'Aujourd'hui*, criticized the proponents of *Le Mouvement* as unoriginal, and he cited Soto specifically as not yet being a true *créateur*, but Carlos Raúl Villanueva, the prominent Venezuelan architect of the Ciudad Universitaria in Caracas, appreciated the important implications of the group, and of Soto in particular. Villanueva's critical support advanced Soto's career, both in Venezuela and in Europe. Soon after *Desplazamiento*'s exhibition at *Le Mouvement*, Villanueva organized major exhibitions for Soto in Caracas and in Brussels, referring to him as a genius.

Still, despite the overall critical success of *Desplazamiento*, one could interpret the piece as a naive form of Neo-Plastic homage to Kasimir Malevich's Suprematist compositions, or to László Moholy-Nagy's constructions/collages; it also strongly suggests Vasarely's Plexiglas murals. Only after Soto further developed his own personal kinetic language, in works such as *Spirale,* and created increasingly challenging compositions, did he secure his own place, in both Venezuela and Europe, as a leader of the international avant-garde.

<div align="right">Estrellita B. Brodsky</div>

Notes
All translations are the author's unless otherwise noted.
1. Popper has written that although the origins of Kinetic art as a major artistic movement date to the 1920s, the movement took form in the 1950s and was finally confirmed in Denise René's influential exhibition; see Frank Popper, introduction to *Lumière et mouvement* (Paris: Galerie Denise René, 1996), n.p.
2. In discussing the work of Piet Mondrian, Rosalind Krauss, in an essay from 1978, questions whether it can be seen as "a section of an implied continuity" or whether "the painting [is] structured as an autonomous, organic whole"; see Rosalind E. Krauss, "Grids," in Rosalind E. Krauss, *The Originality of the Avant-Garde and Other Modernist Myths* (Cambridge, Mass.: MIT Press, 1985), 19.
3. In an interview with Ariel Jiménez, Soto described the construction of the work. He explained that the black rectangle affixed to the wood support was a metal grille commonly used for radio components, which he bought at a department store in Paris. He painted the white dots onto the Plexiglas through the grille. See Ariel Jiménez, *Conversaciones con Jesús Soto/Conversations with Jesús Soto,* trans. ITEMS, C.A. and Evelyn Rosenthal (Caracas: Fundación Cisneros, 2005), 75, 164.
4. Jean Clay, *Visages de l'Art moderne* (Paris: Éditions Rencontre, 1969), 300–301.
5. Clay, *Visages de l'Art moderne,* 301.
6. Jiménez, *Conversaciones con Jesús Soto,* 65.
7. See Arnauld Pierre, "L'immatériel de Soto et la peinture du continuum," in Françoise Bonnefoy, Sarah Clément, and Isabelle Sauvage, eds., *Jesús Rafael Soto* (Paris: Galerie Nationale du Jeu de Paume/Le Seuil, 1997), 22–23.
8. Victor Vasarely, "Notes pour un manifeste," *Aujourd'hui: Art et architecture* 6, no. 2 (1955): 10.
9. Louis-Paul Favre, "Le mouvement," *Le Combat* (May 1955): 6.

At first glance, Carlos Cruz-Diez's *Proyecto para un mural* (plate 21) seems a relatively simple work of art. The artist has presented a number of wooden cylinders of different sizes and colors. Given the artwork's dimensions and its resemblance to children's toys, some viewers may feel the urge to touch the objects or rearrange them into different formations. Cruz-Diez mounted the cylinders onto a white background that almost reflects their colors, but *Proyecto para un mural* does not produce the optical effects of the artist's later, iconic artworks. For instance, the cylinders are not so densely packed that they allow the spectator to perceive an interplay of complementarity and contrasting colors; they do not seem to shimmer as though the entire artwork contained some buzzing form of energy. And yet, even though it does not produce such visual effects, *Proyecto para un mural* stands as a representative example of Cruz-Diez's long-term artistic goals and strategies: the work reveals the artist's continuous interest in expanding the role of art in contemporary society. Instead of creating works of art for galleries or museums, Cruz-Diez has attempted to insert his projects into the public arena, providing general audiences with an opportunity to engage and interact with his works. *Proyecto para un mural* thus reveals a different aspect of the career of an artist who is known mostly for his explorations of the optical effects of color.

Cruz-Diez, born in Caracas in 1923, completed his artistic training at the Escuela de Bellas Artes. Commenting on his artistic development, the artist has explained that the year he completed *Proyecto para un mural* marked a crucial moment in his life:

> In 1954 I started having the same thoughts that, in principle, all artists have at one point in their lives when they doubt the validity and transcendence of their own painting. At that point, I structured a conceptual platform which so far has allowed me to do my work based on a nontraditional perspective on color.[1]

Cruz-Diez realized that he could not simply consider color a secondary element within his artistic production. Instead, he explored colors, and the optical effects they could produce on viewers, as a way of encouraging his audiences to engage with his art objects. For example, many of the works in his Physichromies series feature a large number of semitransparent strips attached perpendicularly onto a support, the artist having chosen the specific colors and angles of these elements. With the finished artwork hanging on a wall, the viewer can experience the work's continuous transformation: as the viewer moves from side to side in front of it, the work seems to shift in shape and color, producing the sensation of an artwork that is never quite finished but rather is completed each time a viewer chooses to engage with it.[2] Thus, even though *Proyecto para un mural* lacks the optical effects of a work in the Physichromies series, like them it represents Cruz-Diez's desire to produce works of art that transcend mere visual observation.

In other works completed in 1954, Cruz-Diez created objects that required more than passive observation. In *Proyecto para un muro exterior manipulable [Project for an Outdoor Manipulable Wall],* for instance, the artist created columns of colored tubes pierced by mounted wires, an arrangement that allowed viewers to rotate the cylinders at will. In *Muro de cilindros excéntricos manipulables [Wall of Excentric Manipulable Cylinders],* a work that physically resembles *Proyecto para un mural,* Cruz-Diez placed colored cylinders on top of a white board; viewers could manipulate the arrangement of the cylinders as though they were colored checkers.

In this regard, *Proyecto para un mural* and other works from the early 1950s anticipated the explorations that Cruz-Diez undertook in the 1960s and 1970s, large-scale endeavors that transcended his earlier models and literally transformed public spaces in cities like Paris and Caracas. In *Chromosaturation* (1968), for instance, which the artist placed outside a Paris subway station, the general public was invited to walk through several linked booths, each lit with a specific color, and be fully immersed in colored light. In another monumental project, he transformed one of Caracas's freeways by painting red, green, and blue stripes along a wall about 1.3 kilometers long that ran parallel to the vehicular road, thus inserting his artistic investigations into Venezuelans' daily commute. Finally, in a series of projects that required extensive collaboration with local authorities, Cruz-Diez attempted to transform the whole of Caracas's downtown through a "chromatic action." During December 1975 and January

b. 1923, Caracas; lives in Paris and Caracas

21 *Proyecto para un mural [Project for a Mural],* 1954
Industrial paint on wood; 40 × 55.2 cm (15¾ × 21¾ in.); Colección Patricia Phelps de Cisneros, 1997.144; copyright Carlos Cruz-Diez

1976, he covered the pedestrian walkway of an avenue in the city with his typical color combinations. Simultaneously, buses painted with "chromatic inductions"—stripes of different colors that resembled those used in the Physichromies—carried passengers around the city. For fifteen days, the artist also projected beams of light onto clouds over the city, producing visual effects that he described as "chromoprisms," or sculptures made of light.[3] Thus residents and pedestrians in Paris and Caracas participated in various art-viewing experiences, even those who had never felt compelled to visit a traditional museum or an art gallery.

In short, *Proyecto para un mural* can hardly be considered an anomalous example of Cruz-Diez's projects. Standing before its colored cylinders, and considering the whole of Cruz-Diez's artistic career, one can understand how the artist came to say,

> The interactive artworks to be installed in the streets that I created in 1954 did not emerge from purely aesthetic reflections; they are motivated by a social uneasiness. I considered it pretentious that "the artist" expressed his uneasiness or fantasy over a canvas so that people could passively arrive to venerate that product.[4]

Present-day viewers may have to remember that Cruz-Diez is not only a skilled artist who has deployed spectacular sensations of color, but also one who has consistently attempted to transform his audience members' perceptions, at times even demanding that they modify their movements or actions by walking through passages filled with colored light or by rotating colored objects. In this way, Cruz-Diez's work parallels the attempts of other twentieth-century avant-garde artists who have attempted to redefine the role of art in contemporary society.

Alberto McKelligan

Notes

All translations are the author's unless otherwise noted.

1. Carlos Cruz-Diez, "My Reflections on Color," http://www.cruz-diez.com/Reflexioneng.pdf [July 20, 2006].

2. For a lengthier discussion of the artist's Physichromies series, see Martha Sesín's contributions on Cruz-Diez's *Physichromie No 21* and *Physichromie No 126,* this book.

3. A full description of these and other projects appears in the catalogue for the artist's exhibition at Galería Aele, Madrid, February 11–March 18, 1975.

4. Carlos Cruz-Diez, "Obras de los años 50," http://www.cruz-diez.com/espanol/obracol1.htm [July 20, 2006].

Lygia Clark, *Composição n.º 5 [Composition No. 5]*, 1954

1920, Belo Horizonte, Brazil–1988, Rio de Janeiro

Composição n.º 5 dates to Lygia Clark's participation in Grupo Frente, the Rio de Janeiro branch of Brazilian Constructivism. In the developmental boom that followed World War II, members of Grupo Frente and their Grupo Ruptura colleagues in São Paulo undertook a reinvestigation of the geometric idiom, inspired in part by the mathematical abstraction of Max Bill and by the project of the Hochschule für Gestaltung to integrate art into modern industrial society. Despite the groups' shared interest in Constructivism, disagreements arose surrounding the theoretical and practical interpretation of international questions of Concretism.[1] The Rio contingent rejected what its members saw as the São Paulo project—the pursuit of objectivity through strict adherence to scientific method—and called for a more "spontaneous" approach to geometry, one based on "creative intuition." In this way, the members of Grupo Frente aimed to ameliorate the threat of doctrinaire rationalism that they (mis)perceived in the work of Grupo Ruptura.[2] *Composição n.º 5* reflects this initial and contentious emergence of a Concrete aesthetic in Brazil. While revealing Clark's faith in the expressive potential of Constructivism, *Composição n.º 5* is likewise a harbinger of her frustration with the limitations of rationalist orthodoxy, and it anticipates the Neo-Concrete departure.

The I Exposição Nacional de Arte Concreta [First National Exhibition of Concrete Art], mounted in São Paulo in 1956, triggered a radical schism between the two groups. The members of the São Paulo faction, declaring themselves the legitimate representatives of Concretism in Brazil, criticized the Rio artists' deviation from Concretist norms, taking it as evidence of Grupo Frente's misunderstanding of the basic postulates of Constructivism.[3] Clark, however, was curiously immune to the criticism, falling comfortably within both schools. She later recalled the irony of her having been associated with the São Paulo agenda: "The *paulistas* began to cite me as the one most similar to them, when in reality I was perhaps the most different of us all."[4] But works like *Composição n.º 5,* which Clark exhibited at the 1956 event, help explain her compatriots' acceptance of her work. The segmenting of the composition into analogous rectangular divisions, painted in the complementary colors red and green, produces an ambivalent figure-ground relation and a

visual tension characteristic of the optical exercises, based in Gestalt theory, that were at the core of much early Brazilian Concretism. Yet the off-center forms, and the measured area of gray paint on the lower left corner of the otherwise black frame, suggest that Clark, instead of participating in a search for the purely visual, was in fact indifferent to it.

Clark's simple gesture of painting on the frame, using it as an extension of the canvas, defied the regularity of Concrete forms and revealed instead the philosophical —indeed, existential—dimension of her geometric explorations. "In reality," Clark explained, "what I wanted to do was express space in and of itself, and not compose within it."[5] *Composição n.º 5* initiated this search for what she referred to as "organic" space and line. The application of color to the presumably neutral device that separated the picture from the wall allowed Clark to open the traditional border of the picture, both to the painted forms within and to the architecture of the room around it. The porous perimeter thus became a conduit for the merging of art and life, subverting the role of the frame as a device for dividing the two. While the application of color transformed the frame into a formal element, the actual physical space between the canvas and the frame—the line where picture and frame abut, which is not "composed" but rather exists in the world of the viewer—became the basis of the "organic" line, which Clark, in her subsequent work, would continue to explore in various capacities. The concept of an "organic" line reflects Clark's desire to free line from its inanimate condition and descriptive function, thus unleashing the vitality of formal elements and transforming space.[6] *Composição n.º 5* maintains structural discipline but defies the normative promises of objectivity; the work declares perception and interpretation to be highly subjective and fundamentally irresolute. Moreover, Clark's negotiation of the ambiguity between the protected space of the canvas and the lived space of the viewer involves more than simple vision; it engages the spectator cognitively and spatially, inviting the haptic gaze.

This incipient inquest into human subjectivity and the mechanics of perception beyond sight was not unique to Concretism in Rio de Janeiro, but it foreshadowed the emergence of Neo-Concretism. Grupo Frente viewed

more orthodox interpretations of Concretism as increasingly dogmatic and reductionist in character, and the Rio artists' collective impatience came to a head in 1959, when disgruntled geometric artists mounted the I Exposição de Arte Neoconcreta [First Exhibition of Neo-Concrete Art] in Rio de Janeiro. Without abandoning the basic principles of Constructivism, the Neo-Concrete movement aimed to undo, through the individual and idiosyncratic treatment of theoretical postulates, what it viewed as Concretism's overreliance on formula. The Neo-Concrete manifesto, which codified the terms of the movement, cautioned against the "dangerous hypertrophy of rationalism" and denounced "mechanistic objectivity."[7] It outlined an artistic program based in the principles of phenomenology—specifically, in the writings of Maurice Merleau-Ponty and Susanne K. Langer—that advocated the stimulation not only of vision but also of multiple senses simultaneously, to more closely approximate the corporeal experience of reality.

Composição n.° 5 suggests that for Clark and the Rio de Janeiro contingent, Concrete art was a point of departure and not the ultimate goal. In Clark's personal trajectory, the work signaled a turning point, where a broad field of expressive possibilities opened up within the geometric idiom. The work also unleashed a systematic investigation into the spatial and temporal dimensions of the plane, aimed at reinvigorating moribund formalism. *Composição n.° 5* marked the transition between geometric painting and works like Clark's series titled Superfícies moduladas [Modulated Surfaces] (1956–1958), which juxtaposed and overlapped planes into multicolored, flat geometric assemblages, and her Casulos [Cocoons] (1959–1960), three-dimensional superimposed planes that unfolded into physical space. In 1960, Clark mandated the "death of the plane" as a necessary step toward resolving the fragmentation of the modern subject.[8] Attributing the invention of the square to man's drive for balance, she reasoned that "the plane arbitrarily marks off the limits of a space, giving humanity an entirely false and rational idea of its own reality"; with its elimination, she declared, "the primal experience begins."[9] This shift toward process-based means with existential ends heralded her subsequent artistic path as she gradually subordinated object to subject and

moved from the physical to the metaphysical space of art.

Edith Wolfe

Notes

1. "Concretismo e neoconcretismo: Uma polêmica," in *Concretismo e neoconcretismo,* vol. 1 of *Abstração geometrica/Projeto Arte Brasileira* (Rio de Janeiro: FUNARTE/Instituto Nacional de Artes Plásticas, 1987), 7. This text is an extract from the introduction to Fernando Cocchiarale and Anna Bella Geiger, eds., *Abstracionismo, geométrico e informal: A vanguarda brasileira nos anos cinqüenta* (Rio de Janeiro: FUNARTE/Instituto Nacional de Artes Plásticas, 1987).

2. Although such art historians as Ana Maria Belluzzo have suggested that this division resulted in part from a misreading of São Paulo Constructivism, participants in the Rio de Janeiro branch of the movement—particularly the theorist and critic Ferreira Gullar—advanced then and continue to uphold this division. See, for example, Ana Maria Belluzzo, "Ruptura e arte concreta," and Ferreira Gullar, "O Grupo Frente e a reação neoconcreta," in Aracy Amaral, ed., *Arte Construtiva no Brasil: Coleção Adolpho Leirner/Constructive Art in Brazil: The Adolpho Leirner Collection* (São Paulo: Companhia Melhoramentos/Dórea Books and Art, 1998), 118 and 143–81, respectively. On the original division between the groups, much of the language of which is attributed to Gullar and to the critic Mário Pedrosa, see Ronaldo Brito, *Neoconcretismo: Vértice e ruptura do projecto construtivo brasileiro na arte* (Rio de Janeiro: FUNARTE/Instituto Nacional de Artes Plásticas, 1985), 11–12, and Belluzzo, "Ruptura e arte concreta," 119–21.

3. Geiger and Cocchiarale, eds., *Abstracionismo, geométrico e informal,* 7–8.

4. Geiger and Cocchiarale, eds., *Abstracionismo, geométrico e informal,* 146. See also Ricardo Nascimento Fabbrini, *O espaço de Lygia Clark* (São Paulo: Editora Atlas, 1994), 25. Author's translation.

5. From unpublished text in Lygia Clark archives, cited in Suely Rolnik, "Molding a Contemporary Soul: The Empty-Full of Lygia Clark," in Rina Carvajal, Alma Ruiz, and Susan Martin, eds., *The Experimental Exercise of Freedom: Lygia Clark, Gego, Mathias Goeritz, Hélio Oiticica, Mira Schendel* (Los Angeles: Museum of Contemporary Art, 1999), 72.

6. Rolnik, "Molding a Contemporary Soul," 71.

7. See Ferreira Gullar et al., "Neo-Concrete Manifesto," in Yve-Alain Bois, "Nostalgia of the Body: Lygia Clark," *October* (summer 1994), 91 (originally published as Ferreira Gullar et al., "Manifesto neoconcreto," *Jornal do Brasil,* March 22, 1959).

8. Lygia Clark, "A morte do plano" in Lygia Clark et al., *Lygia Clark* (Rio de Janeiro: FUNARTE, 1980), 13. See also Lygia Clark, "Death of the Plane," trans. Tony Beckwith, in Mari Carmen Ramírez and Héctor Olea, eds., *Inverted Utopias: Avant-Garde Art in Latin America* (New Haven, Conn.: Yale University Press in association with the Museum of Fine Arts, Houston, 2004), 524–25.

9. Clark, "A morte do plano," 13; Clark, "Death of the Plane," 524–25.

Hélio Oiticica, **Untitled**, from the series Grupo Frente [Frente Group], 1955
Pintura 9 [Painting 9], 1959

1937–1980, Rio de Janeiro

In 1972, Hélio Oiticica remarked disparagingly about his work, "There is no reason to take seriously my pre-'59 production."[1] Despite this seemingly self-effacing proposition, an exploration of the artist's pre-1959 work reveals several ideological and historical factors at play. The year 1959 was one of personal transformation for Oiticica, but that is not all. That year several other artists and poets staged the first Neo-Concrete exhibition in Rio de Janeiro and signed the poet Ferreira Gullar's accompanying manifesto, in which they announced their desire to break with Concrete art and reinterpret the foundational movements of European geometric abstraction, with an eye toward phenomenology and expression.[2] Though the term "Neo-Concrete" does not appear in his 1972 text, Oiticica affirmed the separation between Concrete and Neo-Concrete art in suggesting that the period before 1959 was for him merely an "apprenticeship" that he had served under the banner of Concretism.

Contrary to Oiticica's assertions, there are threads connecting his pre- and post-1959 production to his early works, and these connections merit serious study. As the artist's 1955 gouaches and his 1959 oil paintings demonstrate, Oiticica had been engaging since the beginning of his career in some of the activities called for in the Neo-Concrete manifesto; he had bypassed contemporary Concrete art trends and focused on rethinking the proposals of European masters of geometric abstraction, specifically Piet Mondrian and Kasimir Malevich.[3] From these artists he extracted a geometric vocabulary, grid organization, and an abiding interest in the effects of color and negative space as well as the aspiration to imbue art with universal, human expression.

The untitled 1955 work (plate 22) belongs to a series of gouaches titled Grupo Frente that Oiticica completed between 1955 and 1956.[4] The series derives its name from the Rio de Janeiro–based Grupo Frente, which, along with its São Paulo counterpart, Grupo Ruptura, practiced Concrete art and poetry. Oiticica's painting professor, Ivan Serpa, introduced him to the group, which included Lygia Clark and Lygia Pape. In 1955, at just eighteen years of age, he became the youngest member of what was decidedly Rio's most avant-garde circle.

In this 1955 painting, Oiticica arranged flat geometric shapes into an implicit grid structure, which he had appropriated from Mondrian. Oiticica, limiting his palette, also repeated the same hues throughout the work. But the gouache deviates from the prototypical Neo-Plasticist vocabulary of black orthogonal lines framing areas of white and primary colors, more closely approximating Mondrian's late aesthetic. For example, in Mondrian's *Broadway Boogie Woogie* (1942–1943), exhibited in the winter of 1953–1954 at the II Bienal de São Paulo, the artist utilized multiple blue hues and created multicolored, pulsating orthogonal lines.[5] In fact, Oiticica's painting, with its keyed-up color contrasts and subdivided rectangles, could be a detail study of Mondrian's late masterpiece.

The border that Oiticica reserved at the periphery of his paper, and elements of the compositional organization, distance the work from that of Mondrian. Oiticica anchored the four rectangles to the outer edge of the composition and extended his vibrant blue ground up to a ruler-drawn perimeter, delineating a firm separation between the pictorial space inside the border and the non-pictorial space outside. Oiticica chose not to employ Mondrian's strategy of suggesting the composition's continuation beyond its edges, an approach that he felt failed to transform the art object into a vital, dynamic entity.[6] Instead, he elected to concentrate and intensify the visual activity within the picture plane; consequently, the viewer's eye dashes across the vivid ground and between similar, self-contained shapes.

Pintura 9 (plate 23) is among a handful of oil paintings completed around 1959 that are formally and conceptually related to the gouache series Metaesquemas [Metaschemes] (1957–1958). In that series, Oiticica multiplied geometric forms in a grid pattern across a white or untreated rectangular ground surrounded by a border. He derived this grid organization, he said, from Mondrian, describing the series as "infinitesimated mondrianstructure."[7] The rectilinear grid is not only repeated but also jostled as irregular and off-axis polygons and uneven gaps between forms become the norm. In most of the Metaesquemas series, Oiticica suspended his exploration of color contrasts and created monochromatic works. As a result, the series recalls Malevich's Suprematist paintings.

At first glance, *Pintura 9* is indistinguishable from the works in the Metaesquemas series. The black rectangles and squares occupy the

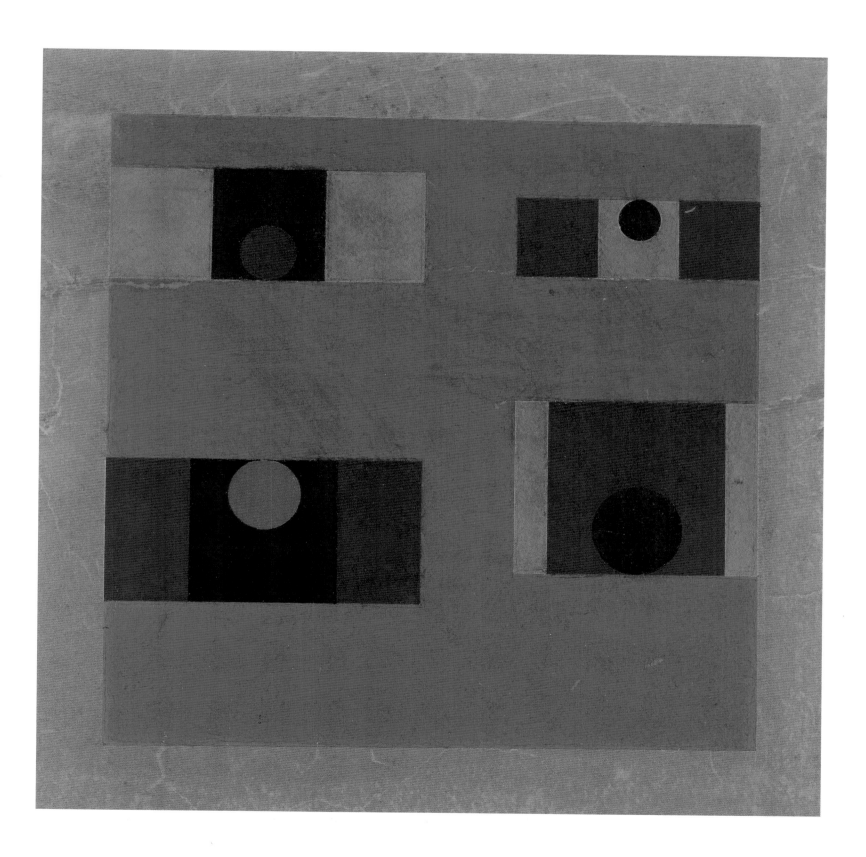

22 Untitled, from the series Grupo Frente [Frente Group], 1955
Gouache on paper; 40 × 40 cm (15¾ × 15¾ in.); Colección Patricia Phelps de Cisneros, 2001.92; copyright Projeto Hélio Oiticica

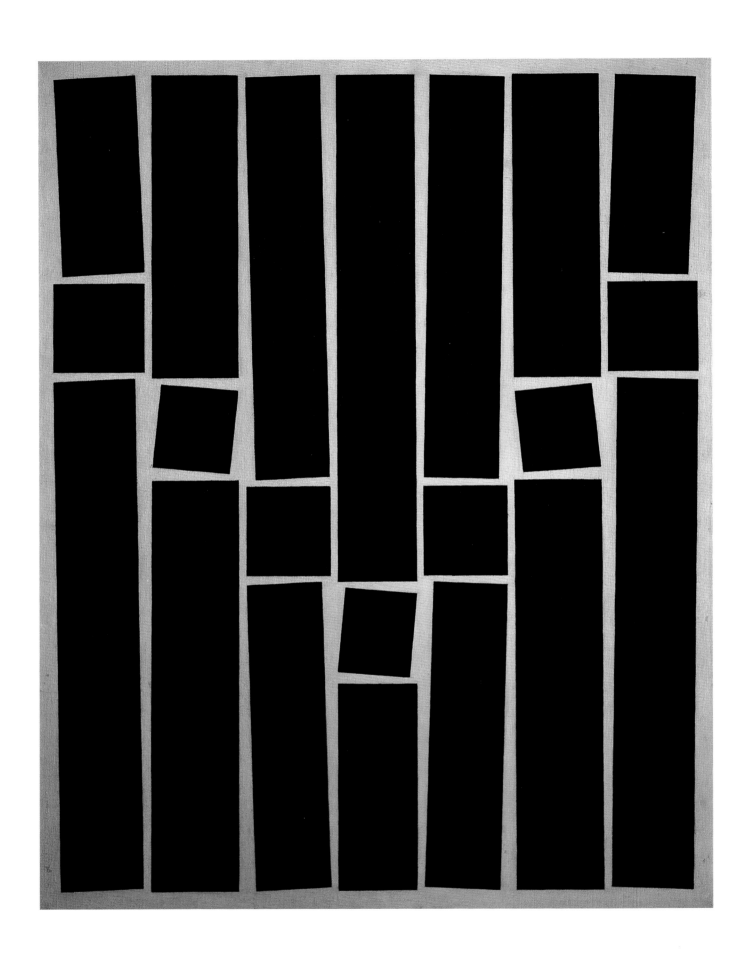

23 *Pintura 9 [Painting 9],* 1959
Oil on canvas; 116.2 × 89.2 cm (45¾ × 35⅜ in.); Colección Patricia Phelps de Cisneros, 1996.44; copyright Projeto Hélio Oiticica

same agitated grid on a white ground. Oiticica subtly altered several elements, however. For one thing, the medium changed from gouache to oil, which Oiticica continued to cultivate through the early 1960s, when he achieved rich, saturated fields of color. For another, he elected to use stretched canvas and a much larger scale than in his previous works on paper. These shifts toward a more physically substantial medium and support helped transform the artwork into something more object-like, a modification fully realized in his 1970s use of wood, glass, dirt, and cloth.

Oiticica also eliminated the border of untreated support that he had used throughout his early oeuvre. This alteration draws *Pintura 9* into closer formal company with Malevich's work, where white ground alone frames the often centrally placed forms. Unlike Malevich, however, Oiticica crowded the white ground with an almost regular pattern of related monochromatic shapes. As a result, the slivers of visible white ground, as well as the geometric figures, attract and hold the viewer's attention. Like the untitled 1955 gouache, *Pintura 9* compels the viewer's gaze to dodge around the composition. Instead of using Malevich's iconic geometric forms or Mondrian's infinitely expanding system, Oiticica attempted to achieve their ends, "pure sensibility" and "pure vitality," through alternative formal means—namely, by creating spaces of condensed, variegated visual energy.[8]

In his 1972 text, Oiticica proposed 1959 as the bellwether of yet another rupture: the end of painting. Here, however, he had to tread carefully because it was not until 1960 that he and his Neo-Concrete colleagues created three-dimensional experiments. Of his 1959 series Monocromáticos [Monochromatics], he wrote, "They foresee possibilities beyond painting." Embedded in this logic is a problem that haunts the study of 1959 works by Neo-Concrete artists: paintings like *Pintura 9* and Lygia Clark's *Ovo [Egg]*—not yet released into space, not yet inciting viewer participation, not yet fully Neo-Concrete—tend to be interpreted in a manner that reflects the heavy influence of the ideas and art of ensuing years.[9] But what these two paintings by Oiticica reveal is the bedrock of innovations to come: the stunningly intelligent consideration of the formal and conceptual proposals of the historical vanguard.

Adele Nelson

Notes

1. Hélio Oiticica, "Metaesquemas 57/58," in Guy Brett, Catherine David, Chris Dercon, Luciano Figueiredo, and Lygia Pape, eds., *Hélio Oiticica,* various translators (Minneapolis, Minn.: Walker Art Center; and Rotterdam: Witte de With Center for Contemporary Art, 1993), 27–28; for text in the original Portuguese, see Hélio Oiticica, "Metaesquemas 57/58," in *Metaesquemas 57/58* (São Paulo: Galeria Ralph Camargo, 1972).

2. The exhibition was at the Museu de Arte Moderna in Rio de Janeiro. Ferreira Gullar et al., "Manifesto neoconcreto," *Jornal do Brasil,* March 22, 1959. Oiticica neither exhibited at the Rio exhibition nor signed the manifesto, but he participated in the Neo-Concrete exhibition in Salvador in November 1959 as well as in subsequent exhibitions in 1960 and 1961.

3. Oiticica was a prolific writer, and in his early published and unpublished texts he frequently discussed Mondrian and Malevich, describing them as the only artists, along with the Russian vanguard, who had brought representation to its limit. See Hélio Oiticica, "Maio 1960," in Luciano Figueiredo, Lygia Pape, and Waly Salomão, eds., *Aspiro ao Grande Labirinto* (Rio de Janeiro: Rocco, 1986), 18. Oiticica focused particular attention on Mondrian; see, for example, Hélio Oiticica, "Cor, tempo e estrutura," *Jornal do Brasil,* November 26, 1960.

4. The series title—Grupo Frente, which has been in use at least since the mid-1980s—does not appear in early exhibition catalogues.

5. It is very possible that Oiticica attended the II Bienal. In any case, journalists for the Rio papers discussed the II Bienal at length, including substantial illustrated essays on Mondrian. Furthermore, the Museu de Arte Moderna in Rio de Janeiro, where Oiticica was a student, received and sold numerous U.S. texts on Mondrian as part of its exchange with the Museum of Modern Art in New York, and Oiticica's texts show that he took advantage of this new influx of artworks and writing by and about the artist. For example, Oiticica quoted Mondrian's writings and phrases frequently; a lengthy passage from Mondrian's "Plastic Art and Pure Plastic Art" is included in Hélio Oiticica, "Natal de 1959," in Figueiredo, Pape, and Salomão, eds., *Aspiro ao Grande Labirinto,* 17.

6. Oiticica, "Cor, tempo e estrutura."

7. Oiticica, "Metaesquemas 57/58."

8. Gullar characterizes Malevich's contribution as recognizing the primacy of "pure sensibility"; see Gullar et al., "Manifesto neoconcreto." Oiticica writes that Mondrian sought "pure vitality"; see Oiticica, "Cor, tempo e estrutura."

9. The phrase "not yet released into space" alludes to an untitled 1962 text by Oiticica, reprinted in Mari Carmen Ramírez and Héctor Olea, eds., *Inverted Utopias: Avant-Garde Art in Latin America* (New Haven, Conn.: Yale University Press in association with the Museum of Fine Arts, Houston, 2004), 522.

Waldemar Cordeiro, *Idéia visível [Visible Idea],* 1956

1925, Rome–1973, São Paulo

Waldemar Cordeiro's *Idéia visível* (plate 24) is one of a series of paintings dating mostly from 1957, all with the same title. Each painting consists of dynamic compositions of lines, many containing forms that mirror one another. As early as 1955, in fact, Cordeiro made a study with the same title, overlapping triangles in simple black lines on a white background.[1]

The work under discussion depicts two arrangements of spiraling lines, one in white and one in black, on a red background. The two sets are identical except that Cordeiro rotated the black set 180 degrees and superimposed it on the white set. Curved lines demarcated by the outer points of the triangles, suggesting the curve of a logarithmic spiral without depicting it in its entirety. The basis of the logarithmic spiral is the golden rectangle, which possesses the proportions of 1:1.618. This shape has been one of the most important in Western design, dating back at least as far as classical Greece. It was also well known to geometric abstractionists, such as Piet Mondrian and the artists of the Madí movement in Argentina, who used it in many of their compositions. Artists historically have found the golden rectangle and the logarithmic spiral (figure 1)[2] so compelling in part because both occur frequently in nature—in the proportions of the human body, in the spirals of many different types of shells, and in the arrangements of seeds in sunflowers, pinecones, and other plants.

Cordeiro was interested in the dynamic properties of spirals, and he based at least two other compositions on the spiral of Archimedes, in which there is an equal amount of space between the levels of the spiral. These two works were *Desenvolvimento ótico da espiral de Arquimedes [Optical Development of the Spiral of Archimedes]* (1952) and a Plexiglas construction also titled *Idéia visível* (1956).[3] The interest in creating an illusion of movement through rotating forms is one that Cordeiro shared with other Concrete artists, such as Judith Lauand, Lothar Charoux, and Mauricio Nogueira Lima.[4] This work bears a striking resemblance to Nogueira Lima's *Triângulo espiral [Spiral Triangle]* (1956), which consists of triangles unwinding in a spiral pattern.[5] In addition, Cordeiro designed at least one residential garden in São Paulo that incorporated a spiral pattern.

Cordeiro's fascination with the spiral suggests an interest in dynamic symmetry, a term that the Canadian designer Jay Hambidge created in reference to the use of harmonious proportions in design. This term may have originated with Hambidge, but the concept itself did not, and although none of Cordeiro's writings mention Hambidge, his interest in spirals suggests that he may have had some knowledge of dynamic symmetry, perhaps through the writings and work of European abstractionists. Hambidge himself explained that static symmetry involves "the employment of the regular figures of geometry such as the square and equilateral triangle," while dynamic symmetry involves the use of numbers that are literally "incommensurable."[6] Mastery of the principles of dynamic symmetry involves the study of shapes, such as rectangles and spirals, that incorporate visually pleasing proportions "suggestive of life and movement."[7] The frontispiece of the 1966 book *Dynamic Symmetry: A Primer* shows a series of rectangles that are built from the diagonal of a square, and that unfold in the shape of a spiral (figure 2).[8] Such a diagram may have inspired both Cordeiro and Nogueira Lima to create their own, more idiosyncratic studies of spirals based loosely on arrangements of triangles.

Hambidge, in arguing that such geometry is the basis of good design, expressed ideas with which Cordeiro no doubt would have agreed: "Effective composition is impossible without design. When design is weak, realism is likely to be dominant."[9] This statement illustrates the shared concerns of the fields of design and geometric abstraction. Cordeiro developed a similar notion of the work of art

Figure 1.

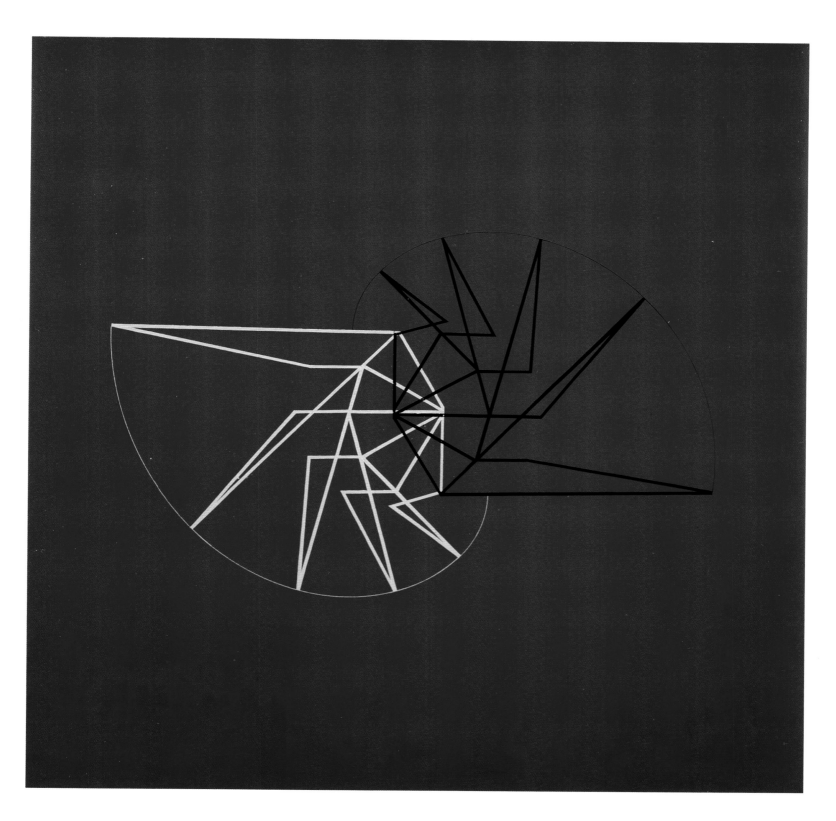

24 *Idéia visível [Visible Idea]*, 1956
Acrylic on Masonite; 59.9 × 60 cm (23⁹⁄₁₆ × 23⁵⁄₈ in.); Colección Patricia Phelps de Cisneros, 1996.190

as a "product" rather than an illusion or expression of beauty, apparently drawing on the writings of Conrad Fiedler, a nineteenth-century German art critic, who influenced Cordeiro with his concept of "pure visuality." In his 1953 essay "Ruptura," Cordeiro quoted Fiedler twice. In one statement, Fiedler criticized traditional notions of beauty: "A work of art can offend, and be just as valuable.... Those who judge works of art solely in terms of taste show that they consider works of art as little more than a means of aesthetic excitation."[10] Given the period in which Fiedler wrote, it appears that he was criticizing the continued yet outdated influence of German academic painting. Cordeiro, with his paintings that consisted of nothing but starkly geometric shapes, must have found himself in a parallel situation, battling the legacies of two movements: the modernism of the 1920s, and Social Realism, which had grown in popularity throughout the 1930s.

According to the Concrete artist and designer Alexandre Wollner, the geometric/scientific tenets of visual design that influenced modern art through the teachings of the Bauhaus came to Brazil via two separate but related paths: the Hochschule für Gestaltung, founded in 1952 by the Swiss Constructivist Max Bill, where those Brazilians who studied there learned about Fibonacci and the proportions present in music, mathematics, quantum physics, and nature; and the Institute of Contemporary Art, Brazil's first school of modern design, founded in 1951 by Pietro Maria Bardi, the first director of the Museu de Arte de São Paulo.[11] Although Cordeiro never studied at either institution, he associated with several artists who did, and so he would have learned about the tenets of dynamic symmetry either through his acquaintances or through his own artistic studies in Italy before he emigrated to Brazil.[12]

As yet another manifestation of the logarithmic spiral, the two curves of the spirals in *Idéia visível* turn around each other like the two arms of a galaxy unwinding slowly in space, thus creating a triple rotation—those of the two individual groupings of lines, and that of the forms grouped together. The composition begins to approach the level of the cosmic.[13] Although at first glance it appears to be a rigid study of geometric lines, almost monochromatic in its simplicity, it is actually

much more complicated: an intuitively assembled collection of lines that references the diagrams used in studies of proportion and design without actually replicating them. *Idéia visível* celebrates geometry, not as the underlying foundation of another composition, but rather as an end in itself.

Erin Aldana

Notes

1. These works are reproduced in Ana Maria Belluzzo, *Waldemar Cordeiro: Uma aventura da razão* (São Paulo: Museu de Arte Contemporânea de São Paulo, 1986), 25, 38, 40, 44, 45. The Colección Patricia Phelps de Cisneros painting is not included in Belluzzo's book.

2. Jay Hambidge, *The Elements of Dynamic Symmetry* (New York: Brentano's, 1926), 6.

3. Belluzzo, *Waldemar Cordeiro,* 20.

4. See my contribution on Judith Lauand's *Concreto 61,* this book.

5. Reproduced in Aracy Amaral, ed., *Projeto construtivo brasileiro na arte (1950–1962)* (Rio de Janeiro: Museu de Arte Moderna do Rio de Janeiro; and São Paulo: Secretaria da Cultura, Ciência e Tecnologia do Estado de São Paulo, Pinacoteca do Estado, 1977), 218.

6. Jay Hambidge, *Practical Applications of Dynamic Symmetry* (New Haven, Conn.: Yale University Press, 1932), 1, 17.

7. Hambidge, *The Elements of Dynamic Symmetry,* xviii.

8. Christine Herter, *Dynamic Symmetry: A Primer* (New York: W. W. Norton, 1966), ii.

9. Hambidge, *Practical Applications of Dynamic Symmetry,* 3.

10. Waldemar Cordeiro, "Ruptura," in Belluzzo, *Waldemar Cordeiro,* 63 (originally published as Waldemar Cordeiro, "Ruptura," *Correio Paulistano,* January 11, 1953). Author's translation. See also Conrad Fiedler, *On Judging Works of Visual Art,* trans. Henry Schaffer-Simmern and Fulmer Mood (Berkeley: University of California Press, 1949).

11. See André Stolarski, *Alexandre Wollner e a formação do design moderno no Brasil,* trans. Anthony Doyle (São Paulo: Cosac & Naify, 2005), 90–91; and Alexandre Wollner, "The Emergence of Visual Design in Brazil," in Aracy Amaral, ed., *Arte Construtiva no Brasil: Coleção Adolpho Leirner/Constructive Art in Brazil: The Adolpho Leirner Collection* (São Paulo: Companhia Melhoramentos/Dórea Books and Art, 1998).

12. For more on Constructivism in Italy, see George Rickey, *Constructivism: Origins and Evolution* (New York: George Braziller, 1967), 63. See also Luciano Caramel, *MAC: Movimento arte concreta* (Milano: Electa, 1984); and Klaus Honnef, ed., *Arte Concreta: Der italienische Konstruktivismus* (Munster: Westfalischer Kustverein, 1971).

13. Guy Brett, in a lecture titled "Force Fields: Phases of the Kinetic," delivered at The University of Texas at Austin on March 23, 2006, argued that he views certain compositions of Kinetic art—some of the mobiles of Alexander Calder, for instance—as models of the cosmos. São Paulo–based Arte Concreta, with its similar emphasis on movement, could be viewed as a precursor of Kinetic art.

Jesús Rafael Soto, *Doble transparencia [Double Transparency],* 1956

Although unconventional in form, *Doble transparencia* (plate 25) is fundamentally the work of a painter. The piece consists of painted lines and rectangles repeated, layered, and juxtaposed in a square composition that hangs on the wall. *Doble transparencia* makes use of a formal geometric language that was increasingly widespread after World War II, but Jesús Rafael Soto also pushed his work a step farther than did many of his colleagues who were making traditional two-dimensional Concrete paintings at the time. By prying his composition apart and distributing the geometric elements across three superimposed transparent surfaces, Soto deconstructed the painting, giving equal importance to each line, pattern, and shape of the foreground, middle-ground, and background compositions.

Trained as a painter in Venezuela in the 1940s, Soto moved in 1950 to Paris, where he embraced the geometric language that would dominate his career. He began working with industrial paints and supports after his arrival, and in 1953 he became one of the first artists to incorporate Plexiglas into his work. Although he was dedicated to the medium of painting, Soto was also motivated by what he called the optical "vibration" that takes place when two lines intersect. The art critic and curator Guy Brett, describing this effect, wrote, "The optical interference [between two elements] releases a third [element]—the vibration—which is real to the eye but has no material existence."[1] Soto used the common mathematical principles of repetition and geometry in order to engineer an optical reaction (the "vibration") devoid of material properties. The transparency of the Plexiglas allowed him to separate his patterns and superimpose them on one another, creating the possibility of an endless number of such vibrations. The success of his experiments, and of this new type of composition, relied on another crucial element: the viewer. Because these optical reactions are triggered only when viewed by a pair of eyes, the viewer's role became central to Soto's entire enterprise. With the viewer's every step, his or her perception of the relationship between foreground and background is altered, and waves of new vibrations are set off, which the viewer can arrest only by standing still. Unfortunately, photographs of Soto's works cannot convey their dynamic dimension, given the static nature of the photographic medium; the vibrations exist, literally, only in the eye of the beholder.

Soto made *Doble transparencia* in Paris when he was conducting some of his first "vibration" experiments. He began by superimposing on one another pieces of Plexiglas that had been painted with patterns, which in turn relied on repeated forms, such as dots, stripes, and spirals. He then expanded his experiment to consider the visual effects of collisions between different colors, working initially with primary and secondary colors as well as with black and white, as in *Doble transparencia.* The typical Soto work from this period consists of a panel of Plexiglas bolted to a square board, both of roughly similar dimensions. The board hangs on the wall in the manner of a painting, while the Plexiglas protrudes from the surface and into the room. The distance between the background and foreground panels differs from work to work and is one of the variables with which Soto played. In *Doble transparencia,* he toyed with the effect created by stripes that were painted in several colors and directions and then juxtaposed against a background of consistent vertical blue stripes. It is worth noting that this piece pushed the experiment a bit farther, since Soto, moving beyond what had become for him the predictable vibration of two surfaces, incorporated a third panel by bifurcating the piece of Plexiglas protruding from the wooden background. The two panels of Plexiglas—the "double transparency" indicated in the work's title—protrude at different distances from the wooden panel, and they also overlap down the center of the composition, since neither is the same size as the panel. Thus the work consists of three vertical registers: a single panel of Plexiglas on the left, the overlapping of the Plexiglas panels in the center, and the single Plexiglas panel on the right. These registers mimic the stripes that fill the work. The advancing, receding, and overlapping effects of the parallel lines play with three-dimensional space and create the opportunity for still further active vibrations. The addition of the second piece of Plexiglas in *Doble transparencia* foreshadowed Soto's later interest in the ambiguous space between panels. Although he worked with Plexiglas for only a few years, these pieces provided him with a springboard for many more years of experimenting with optical vibrations. In

1923, Ciudad Bolívar, Venezuela–2005, Paris

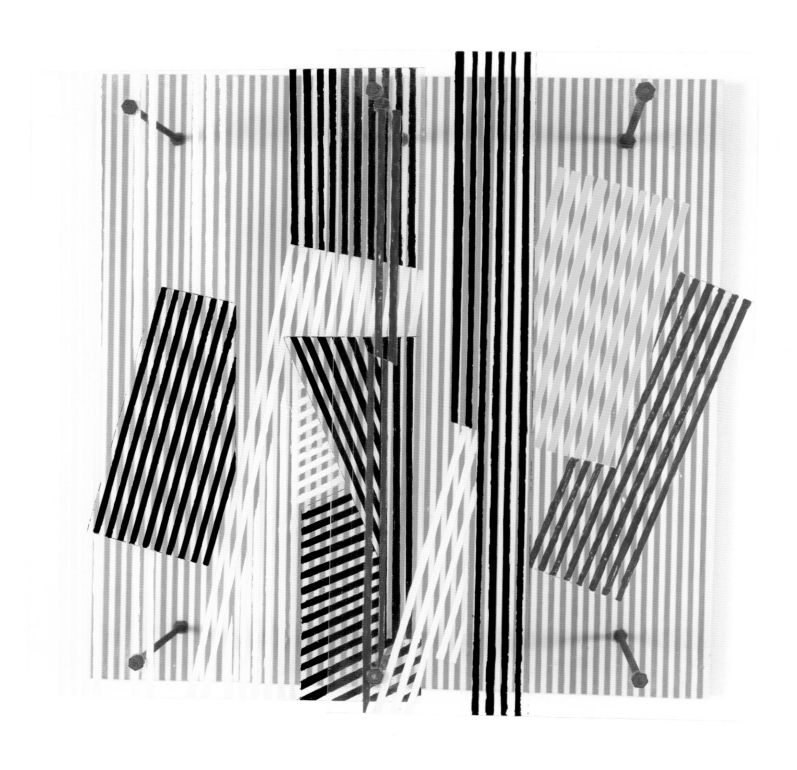

25 *Doble transparencia [Double Transparency],* 1956
Industrial paint on Plexiglas mounted on wood; 55 × 55 × 32 cm (21⅝ × 21⅝ × 12⅝ in.); Colección Patricia Phelps de Cisneros, 1989.35/3; copyright Jesús Rafael Soto Estate

the 1960s, for example, he revitalized the repeated colored stripes, transforming them into room-size installations that viewers could enter. These works, in the series titled Penetrables, completely enveloped the viewer in a "vibration."

Upon his arrival in Paris, Soto became familiar with the gallerist Denise René and the artists she represented, many of whom worked in a geometric language. In 1955, he participated in her gallery's groundbreaking *Le Mouvement* exhibition, which highlighted kinetic and optical art from several generations. Some of Soto's Plexiglas pieces appeared in this exhibition, and the following year (the same year *Doble transparencia* was made), he had a solo show at the same gallery. Although Soto was never affiliated with an official group, he participated in the Op art and Kinetic art movements, which had found a home at Galerie Denise René and then swept through Europe, the United States, and South America in the 1950s, reaching their zenith in the 1960s.

Aleca Le Blanc

Note

1. Introduction to Guy Brett, *Soto* (New York: Marlborough-Gerson Gallery, 1969), n.p. See also Martha Sesín's contribution on Carlos Cruz-Diez's *Amarillo aditivo,* this book.

Judith Lauand, *Concreto 61 [Concrete 61]*, 1957

b. 1922, Pontal, Brazil; lives in São Paulo

The painting *Concreto 61* (plate 26) consists of four sets of black bars rotating around a central void against a white background. This work is similar to paintings by Lothar Charoux, Waldemar Cordeiro, and Mauricio Nogueira Lima that depict rotating shapes, usually in black and white. The total lack of color in these works emphasizes the attempt to create an illusion of movement in space—one of the major concerns of Concrete artists at the time of *Concreto 61*'s creation.[1] In *Concreto 61*, one edge of each of the black bars is angled, enhancing the appearance of movement. Cordeiro argued for depiction of movement as one of the most important elements of Arte Concreta:

> Bidimensional painting reached its apogee with the work of Malevich and Mondrian. Now a new dimension is arising: time. Time as movement. The representation transcends the plane, but it is not perspective, it is movement.[2]

This statement, contrary to the typical understanding of São Paulo Arte Concreta as being concerned only with the depiction of pure geometry, reveals an interest among Concrete artists in the viewer's experience and perception of the work of art.

Lauand's work, like that of many other Concrete artists, reveals the influence of Gestalt theory on the depiction of the illusion of movement in a painted image. The psychologist Rudolf Arnheim has written a great deal about the use of Gestalt theory in learning how people interpret images; his ideas also help in understanding Lauand's work. According to Arnheim, the viewer knows that shapes in an image are not actually moving but appear to be striving in certain directions; he refers to this phenomenon as "directed tension."[3] Lines of force radiate outward from the center of geometric shapes; in the case of the square, which frequently forms the basis of a Concrete composition, the lines of force flow outward, both to the sides and to the corners. The Gestalt principle of grouping would cause the viewer to interpret arrangements of black bars similar to those in *Concreto 61* as single units, like the individual arms of a windmill, with each one appearing to twist and stretch toward the picture plane. Differences in size among the bars create the illusion of depth in the painting, even though all the forms depicted in it are two-dimensional;

the simplicity of black and white emphasizes the optical illusions that occur in the composition when color does not create a distraction.[4]

Lauand was a relative latecomer to the Concrete art movement in São Paulo. She did not participate in the Ruptura exhibition of 1952 but joined the other Concrete artists several years later in the I Exposição Nacional de Arte Concreta [First National Exhibition of Concrete Art], which originated in São Paulo in 1956 and then traveled to Rio de Janeiro in 1957, bringing together for the first time, along with Concrete poets, artists from both cities who were working in geometric abstraction. This exhibition deepened the relationship between Concrete poetry and Concrete art, and one result was the exploration of parallels between visual images and the written word. According to the Concrete poet Décio Pignatari, "The display of Concrete poetry has an almost didactic character: phases of formal evolution, the passage from verse to ideogram, from linear rhythm to spatial-temporal rhythm: new conditions for new structures of language, this relation of verbivocovisual elements, as Joyce would say."[5]

Concrete poems have no real verses or rhythm, as one might find in traditional poetry. Rather, they usually consist of a few individual words, often incorporating some play on words that may differ by only a few letters or a single syllable. The visual aspect of the words is very important; often their arrangement on the page contributes to the meaning of the poem or suggests physical movement, such as a "falling" down the page or a jumping back and forth across it. The intertwining of word and image increased between the Brazilian Concrete artists and Concrete poets, and as the poets incorporated color into their works, through the use of carbon paper, the Concrete artists' stark compositions in black and white somehow recalled the arrangement of words on a page. This intertwining of word and image—in many cases also incorporating the aspect of movement—eventually became complete in the logo designs of Alexandre Wollner, Willys de Castro, and Hércules Barsotti. In the recalling of such relationships as those between Concrete artists and Concrete poets, and between the visual image and the written word, the possibilities are expanded for understanding such an apparently simple work as *Concreto 61*.[6]

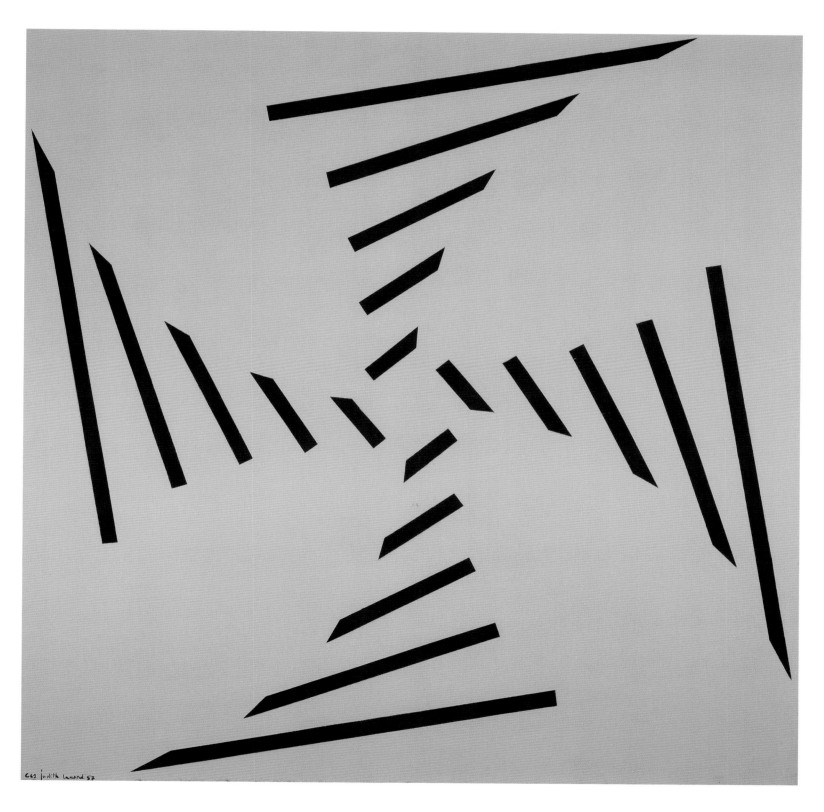

Concreto 61 [Concrete 61], 1957
Synthetic paint on Eucatex panel; 60 × 60 cm (23⅝ × 23⅝ in.); Colección Patricia Phelps de Cisneros, 1996.37

But the I Exposição Nacional de Arte Concreta, for all its importance as a connecting force between Concrete artists and poets, also marked the beginning of what would become a growing rift between the Concretist factions based in São Paulo and in Rio de Janeiro. The Rio-based art critics lamented the fact that São Paulo Concretism appeared coldly rational, even dogmatic, in its pursuit of pure geometrical forms. Certainly Lauand's work, at least at first glance, appears to reinforce this idea, and Lauand herself, when asked why she was involved in Concrete art, replied: "Because I love synthesis, precision, and exact thinking."[7] Moreover, another comment by Lauand—"A work of art does not represent anything. A work of art is"—implies some affinity with Waldemar Cordeiro's idea of the work of art as product rather than representation.[8] Nevertheless, Lauand also made several statements that tend to undermine interpretations of her work as having a theoretical basis; her work, she said, "does not have a base that is philosophical, literary, social, or what have you. It is based on elements that are inherent in the painting itself: form, space, color and movement."[9] Yet the multiple and sometimes contradictory layers of meaning that emerge from Lauand's apparently simple work suggest that it transcends the mere arrangement of colors and forms.

Lauand is one of the few Concrete artists who did not come from Europe and who have not had a career outside the arts. Born in the state of São Paulo, she studied at the Araraquara School of Fine Arts, where she worked with Lívio Abramo, an artist who became well known for his woodblock prints of manual laborers in São Paulo in the 1930s.[10] In 1950, Lauand moved to São Paulo and began working in an Expressionist style that was popular there at the time, and that other abstractionists, such as Luiz Sacilotto, had practiced. According to biographical sources, she worked in a Concrete phase from 1953 to 1958, but one could argue that her entire career, from 1953 onward, has been Concretist.

Lauand was the only woman among the members of the São Paulo Concrete art movement and was one of its strictest adherents. She continued to work in the style even into the 1970s, long after most other artists had abandoned it. She also participated in the *Konkrete Kunst [Concrete Art]* exhibition, which took place in Zurich in 1960.[11] In 1961,

Lauand participated in the inaugural exhibition of the Galeria Novas Tendencias, which was a regrouping of many of the artists who had been involved in the Concrete art movement, and who, at a time when Concrete art was no longer considered relevant, were attempting to find a new direction for their work. Lauand experimented with materials and composition, producing works in which staples replaced lines while geometric rigidity remained.[12] In 1972, however, she returned to working in a strictly Concretist style.

Erin Aldana

Notes

All translations are the author's.

1. The Cordeiro painting *Idéia visível* (1957) is reproduced in Ana Maria Belluzzo, *Waldemar Cordeiro: Uma aventura da razão* (São Paulo: Museu de Arte Contemporânea de São Paulo, 1986), 45. (This is not the version in the Colección Patricia Phelps de Cisneros.) It contains similar arrangements of bars that appear to float through space, a fact that suggests that Cordeiro and Lauand may have been looking at each other's work. See my contribution on Cordeiro's *Idéia Visível* (1957), this book.

2. Waldemar Cordeiro, "O objeto," in Anna Bella Geiger and Fernando Cocchiarale, eds., *Abstracionismo, geométrico e informal: A vanguarda brasileira nos anos cinqüenta* (Rio de Janeiro: FUNARTE/Instituto Nacional de Artes Plásticas, 1987), 225 (originally published as Waldemar Cordeiro, "O objeto," *Arquitectura e Decoração* [December 1956]).

3. Rudolf Arnheim, *Art and Visual Perception: A Psychology of the Creative Eye* (Berkeley: University of California Press, 1969), 336.

4. Arnheim, *Art and Visual Perception,* 340–41.

5. Décio Pignatari, "Arte concreta: objeto e objetivo," in Aracy Amaral, ed., *Projeto construtivo brasileiro na arte (1950–1962)* (Rio de Janeiro: Museu de Arte Moderna do Rio de Janeiro; and São Paulo: Secretaria da Cultura, Ciência e Tecnologia do Estado de São Paulo, Pinacoteca do Estado, 1977) (originally published as Décio Pignatari, "Arte concreta: objeto e objetivo," *Arquitetura e Decoração* [December 1956]: 103).

6. See the logo designs included in Amaral, ed., *Projeto construtivo brasileiro na arte,* 210, 227.

7. "Judite [*sic*] Lauand entre os concretistas que vão expor na Galeria de Arte das 'Folhas,'" *Folha de Manhã,* January 7, 1959.

8. "Judite Lauand entre os concretistas."

9. "Judite Lauand entre os concretistas."

10. For more on Lívio Abramo, see Aracy Amaral, *Arte para quê? A preocupação social na arte brasileira, 1930–1970* (São Paulo: Nobel, 1984).

11. Amaral, ed., *Projeto construtivo brasileiro na arte.*

12. See Daisy Peccinini, *Figurações Brasil anos 60* (São Paulo: Edusp, 1999), 49; and José Geraldo Viera, "Judith Lauand," *Folha Ilustrada* (September 23, 1961).

1896, Lucca, Italy–1988, São Paulo

Upon first glance, *Composição concreta em preto/branco* (plate 27) appears to share little with Volpi's better-known work: his images of abstracted building façades covered in the brightly colored banners of *junina* festivals, a series that he began in the early 1950s.[1] Volpi painted the façades of buildings from the working-class neighborhoods of São Paulo at the level of the street, the square shapes of the banners establishing an unintentional connection to geometric abstraction. The medium of tempera allowed the brushstrokes and the canvas underneath to show through in these works, adding some variation of tone and a certain personal touch to the paintings. Unlike these banner paintings, *Composição concreta em preto/branco* in no way refers to the outside world; in other ways, however, it shares important characteristics with the earlier series.

As in the *junina* banner paintings, in *Composição concreta em preto/branco* Volpi used straight-edged lines that he filled with color. In the *junina* works he used tempera, but in this work he used gouache to achieve a level of opacity not possible with tempera.[2] This work is almost identical to an untitled serigraph in the Adolpho Leirner collection. Volpi's choice of medium, however, established a crucial difference between the two works: modern printmaking techniques gave the harder-edged serigraph a precise, almost machine-made appearance, while the presence of visible brushstrokes in the gouache painting creates a tension between traditional and modernist artistic practices that is typical of Volpi's work.

Volpi's unique painting style resulted from his experiences first as a decorative housepainter, from the 1910s to the 1930s, and later as a self-trained artist. During the 1930s and 1940s, he was affiliated loosely with the Grupo Santa Helena, a group of artists of Italian descent (Volpi himself was an Italian immigrant) who rented studios in the Santa Helena building in central São Paulo. Many of these artists came from working-class origins and had painted houses before starting to paint canvases. Some of the Santa Helena artists worked in styles directly opposed to the modernism of the 1920s, drawing on the influences of Cézanne, Impressionism, and academic painting. Others adopted styles that revealed a complete lack of formal training. Volpi himself never rented a studio but did take advantage of the weekly figure-drawing sessions that the other artists organized, as well as of their weekend trips to paint landscapes in the suburbs of São Paulo.[3]

Like the other Santa Helena artists, Volpi depicted the life of Italian immigrants in São Paulo during the first half of the twentieth century. He made paintings of saint sculptures from Catholic churches, and he painted landscapes of Mogi das Cruzes, one of the suburbs of São Paulo. The Brazilian art critic Sônia Salzstein has observed that "the beginning of the 'urban' and abstract phase in Volpi's painting—the famous phase of the banners—coincided with the beginning of the end of a suburban and healthy way of life in São Paulo."[4] With the advent of mass industrialization during the 1950s, São Paulo began its transformation into the megalopolis of the present day, a change reflected in Volpi's work. Salzstein has also argued that the serial repetition of forms in Volpi's more abstract paintings resulted from his experiences as a housepainter, work that involved repeating floral and other decorative motifs.[5] In contrast to the hard-edged forms and references to industrialization in the work of the Concrete artists, the repetition in Volpi's work developed from artisanal traditions of architectural decoration, and his banner paintings derived from popular festivals. In this way, Volpi's work represents a tension between handicraft and machinery, one that paralleled the transformations taking place in Brazilian society at the time.

The art historian Walter Zanini has argued that Volpi's increasing interest in pure geometric abstraction developed from the powerful influence of the Bienal de São Paulo. His work had grown increasingly hard-edged and purist in its exploration of geometry, but Volpi still denied any theoretical connection with the Concrete artists.[6] Rodrigo Naves has suggested that a 1950 trip to Italy, which gave Volpi the opportunity to view in person the works of Giotto and Paolo Uccello, strongly influenced his interest in "rigidity" and the "bidimensionality of the support."[7] In spite of Volpi's claim that he had no connection with geometric abstraction, many of his works from the mid-1950s, including *Composição concreta em preto/branco,* do reveal an interest in the same principles that the Concrete artists were exploring. He shared their interest in the depiction of movement in rotating

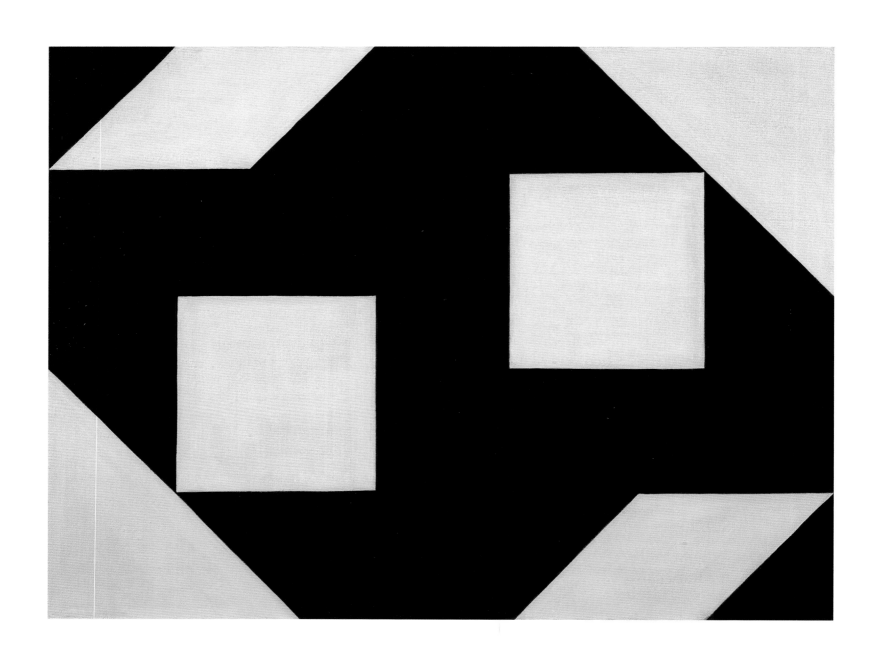

27 *Composição concreta em preto/branco [Concrete Composition in Black/White]*, 1957
Gouache on canvas; 50.1 × 67 × 2 cm (19¾ × 26⅜ × ¹³⁄₁₆ in.); Colección Patricia Phelps de Cisneros, 1999.68; copyright VOLPI Ó Imaginação

forms, in an emphasis on form over color, and in the exploration of Gestalt theory, which is evident in this painting's ambiguous depiction of space and in its tension between form and ground.

In an interview, the Concrete poet Décio Pignatari recounted how he had learned to paint in egg tempera in the early 1960s, while sharing a home and a studio with Volpi. Pignatari said that many people had asked him why the Concrete artists were willing to accept a painter who worked in a medium as ancient as egg tempera, and he explained that an aspect of the paradox of Concrete art and Brazilian culture in general was that they could both include the pre-modern medium of egg tempera as well as modern enamel paint.[8] According to Maria Alice Milliet, the Concrete artists viewed Volpi as one of their own, in spite of the fact that he consistently denied having any connection to them.[9] In any event, his Concrete period was only a brief phase in a career that spanned several decades and explored a wide variety of artistic styles and subject matter.

According to Paulo Sérgio Duarte, "Volpi solved in advance the problem with which Brazilian art was to be confronted in its Concrete and Neo-Concrete movements."[10] Duarte has asserted that Neo-Concrete art emphasized the personal and the subjective to an excessive degree, whereas Concrete art, with its extreme impersonality, took the opposite direction. Volpi's achievement was that he established a balance between these two extremes, simultaneously combining Concrete art (often condemned as elitist) with an untrained style that explored popular subject matter—the way of life of São Paulo's Italian immigrant working class.

Erin Aldana

Notes

All translations are the author's unless otherwise noted.

1. The *junina* festivals, held during the month of June, originated in northeastern Brazil and celebrated rural culture with traditional dances and clothing as well as with brightly colored paper banners hung across the façades of buildings. These festivals brought a touch of color to otherwise drab city streets and helped migrants to São Paulo maintain ties to the *nordestino* culture they had left behind.

2. Aracy Amaral, ed., *Arte Construtiva no Brasil: Coleção Adolpho Leirner/Constructive Art in Brazil: The Adolpho Leirner Collection* (São Paulo: Companhia Melhoramentos/Dórea Books and Art, 1998), 208.

3. For more on the Grupo Santa Helena, see Paulo Mendes de Almeida, *De Anita ao museu* (São Paulo: Editora Perpectiva, 1976). See also Walter Zanini, *O Grupo Santa Helena* (São Paulo: Museu de Arte Moderna de São Paulo, 1995).

4. Sônia Salzstein, "Moderno no Suburbio," in Sônia Salzstein and Sílvia Roesler, eds., *Volpi* (Rio de Janeiro: Campos Gerais, 2000), 17.

5. Salzstein, "Moderno no Suburbio," 21.

6. Walter Zanini, *História Geral da arte no Brasil,* vol. 2 (São Paulo: Instituto Walther Moreira Salles/Fundação Djalma Guimarães, 1983), 679.

7. Rodrigo Naves, "Anonimato e singularidade em Volpi," in Rodrigo Naves, *A forma difícil: Ensaios sobre arte brasileira* (São Paulo: Editora Ática, 1996), 191.

8. Fernando Cocchiarale and Anna Bella Geiger, "Décio Pignatari," in Anna Bella Geiger and Fernando Cocchiarale, eds., *Abstracionismo, geométrico e informal: A vanguarda brasileira nos anos cinqüenta* (Rio de Janeiro: FUNARTE/Instituto Nacional de Artes Plásticas, 1987), 75, 77.

9. Maria Alice Milliet, "From Concretist Paradox to Experimental Exercise of Freedom," in Edward J. Sullivan, ed., *Brazil: Body and Soul* (New York: Guggenheim Museum, 2001), 394–95.

10. Paulo Sérgio Duarte, "Modernos Fora dos Eixos/Modernity on the Fringes," trans. Izabel Burbridge, in Amaral, ed., *Arte Construtiva no Brasil,* 203.

Jesús Rafael Soto, *Pre-Penetrable,* 1957
Penetrable, 1990

1923, Ciudad Bolívar, Venezuela–2005, Paris

From the time he embarked on his first artistic investigations, Jesús Rafael Soto appears to have followed the intuition that led him in his mature years to produce artworks that allowed him to experiment with the complete integration of the spectator's body. In this sense, Soto's work spans two categories (among others) that relate to the spectator's presence in two apparently mutually exclusive ways. Some works function as optical-effects machines (provided that the spectator maintains a particular distance), requiring the spectator to move. Within this category, it is possible to trace a line of continuity from such seminal works as *Dos cuadrados en el espacio [Two Squares in Space]* (1953), sealed in its box and therefore not accessible to any kind of tactile experience, to the series of virtual forms that, like Kinetic ostensoria, offer their visual illusions from structures that do not even allow spectators any physical proximity.

But other works by Soto require the experience of physical contact, and therefore of touch. This category encompasses the so-called Pre-Penetrables through the Penetrables and also includes the Penetrables sonoros [Sonorous Penetrables] and Vibraciones [Vibrations]. These works invite the spectator to activate their optical or sound qualities through physical contact.

The Kinetic structure titled *Pre-Penetrable* (plate 28) is part of a group of works that Soto executed immediately after his series of wood-and-Plexiglas "optical vibration" works known generically as Dobles transparencias [Double Transparencies] (plate 25).[1] In those pieces, the transparent qualities of Plexiglas accommodated Soto's desire to multiply the pictorial plane and yet make it disappear at the same time. The resulting works were three-dimensional objects whose optical effects occurred in an environment delimited by a number of Plexiglas planes, each of which was incised with patterns of lines and suspended from a wooden support by fixed metal rods. Thus these volumetric structures were virtually penetrable. The Pre-Penetrables began with an expansion of that experience and grew to become a series of freestanding structures made of planes and colored metallic rods.[2] Soto offered the first of these works to the architect Carlos Raúl Villanueva, who integrated it into his design for the Universidad Central de Venezuela

as a conventional sculpture, which was installed on a pedestal on the grounds of the architecture department. This collaboration between artist and architect—if that is what it was—continues to be significant: the only, and relatively discreet, presence of Soto's work in Villanueva's project for the Ciudad Universitaria in Caracas anticipated the architectural and topological goal that Soto was to achieve in the late 1960s with his series of Penetrables.

Some years after giving that work to Villanueva, Soto saw the grandchildren of the art historian Alfredo Boulton playing in Boulton's garden, which contained another of Soto's Kinetic sculptures. Recalling the sight of their little bodies climbing on the work—which he had initially conceived to be viewed at a distance—Soto decided to call it *Pre-Penetrable.* In this way he acknowledged, albeit anachronistically, the complexity of the process through which he had succeeded, with the creation of the Penetrables, in fulfilling his old ambition of producing a work that could envelop the spectator.

Soto executed the first work in this series in 1967, as a logical extension of an in situ work—still not penetrable—that he had produced for the Venice Biennale in 1966.[3] Guy Brett called the Penetrables "brilliant inventions of visuality (though they have no surface or plane)," and he wrote that they "extend the contradiction between the pictorial space and the world out into the public arena" so that the spectator can "pass bodily from one state to the other."[4] Thus the Penetrable (plate 29) is the locus in which Soto both synthesized and condensed the contradictions and utopias implicit in his artistic project. As an optical work seen from a distance, the Penetrable functions as a kind of dematerialization machine, absorbing into the extraordinary transparency of its interior the bodies that penetrate it. As a tactile work experienced physically, the Penetrable functions in the manner of a coarse-textured, visual-saturation machine as viewers' bodies penetrate its skein of plastic lines and become immersed in its opaque environment. Soto said that at one point he had dreamed of a work that could absorb the entire planet—a utopian, humanistic vision that, in order to be realized, would require the impossible supposition of an ideal viewing point beyond the planet.

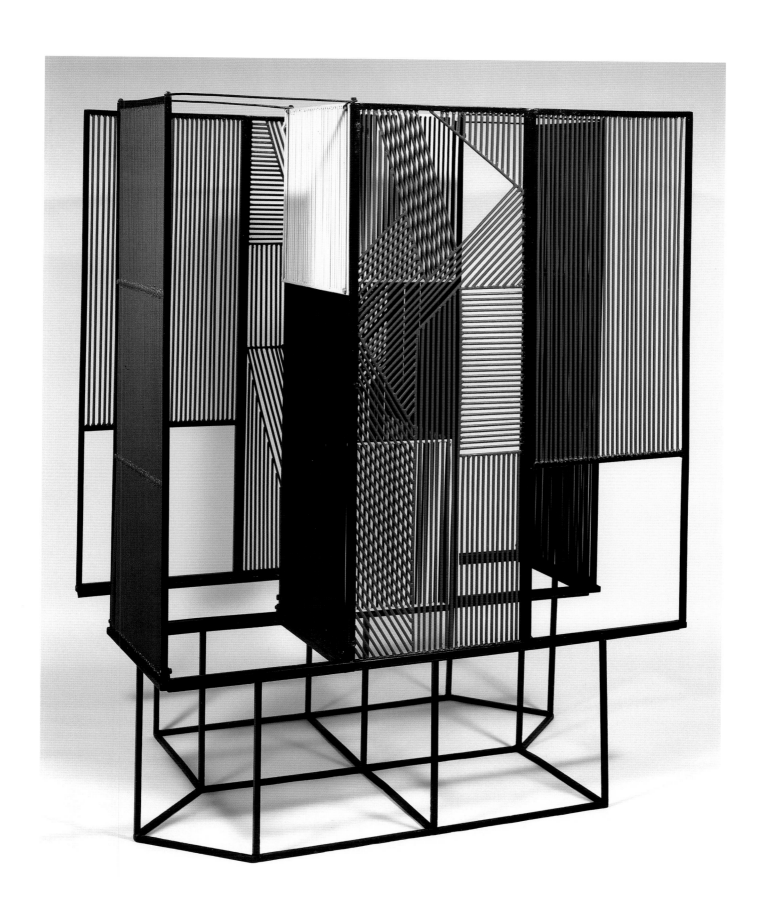

28 *Pre-Penetrable,* 1957
Industrial paint on steel structure; 165.5 × 126 × 85 cm (65³⁄₁₆ × 49⁵⁄₈ × 33⁷⁄₁₆ in.); Colección Patricia Phelps de Cisneros, 1997.118; copyright Jesús Rafael Soto Estate

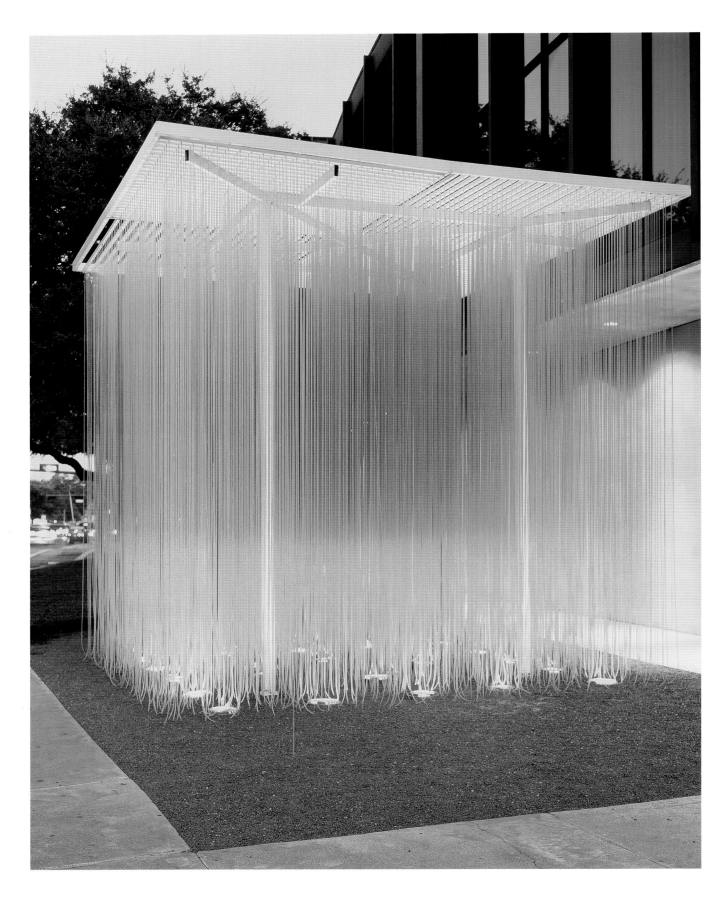

29 *Penetrable,* 1990
Steel, aluminum, and plastic hoses; 508 × 508 × 508 cm (200 × 200 × 200 in.); Colección Patricia Phelps de Cisneros, 1998.84; copyright Jesús Rafael Soto Estate

In this sense, the Penetrable is the theoretical culmination of Soto's oeuvre and represents a point of inflection within the modern Constructivist repertoire. The Penetrable is virtually infinite and can adjust to any surface, spreading out over any topography like a "topological film." In the imaginal sources of Soto's work, the topographical adaptability of the Penetrable is linked to an experience of landscape: the young Soto riding a donkey through an open field in the blinding mid-afternoon light of his native Guayana, fascinated by "the vibration of the air through the reflection of the sun on the earth ... that vibrating mass floating in space."[5] Again, and for good reason, the Penetrable is ambivalent with regard to landscape and topography: seen within and against the landscape, it looks like a surprising, artificial homotopic extension; experienced by the spectator who is immersed inside it and looking out, it seems to close off the viewer's sense of the landscape in which it exists.

Thus, in 1967, a time when art criticism in the United States was dominated by debates about Minimalism, and by such figures as Clement Greenberg and Michael Fried, the repertoire of late modernity found itself facing a chasm: on one side were works marked by their potential for absorption; on the other, works marked by their theatricality. Soto's Penetrables, because they were produced outside this polemic, have the virtue of neutralizing it. They are as theatrical (because they demand the spectator's participation) as they are absorbing (because they dematerialize the spectator); they are capable of both a "pastoral" absorption, in which they function as self-sufficient visual objects, and of a "dramatic" absorption, in which the spectator is made to participate in their functioning.[6] Perhaps this is because the Friedian theory of pictorial absorption and the imaginative qualities of the Penetrable share a point of reference: the fascinating presence of a pictorial illusion made real in the world but at the same time kept apart from it, as in the image of Diego Velázquez's *Las Meninas*.

Luis Pérez-Oramas
Translated by Trudy Balch

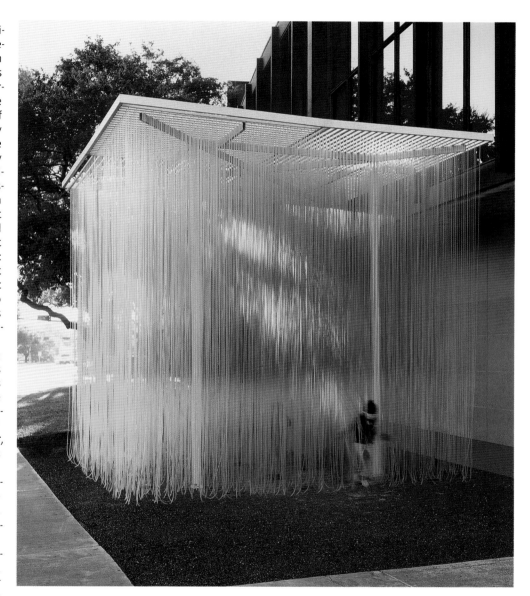

Notes

1. See Aleca Le Blanc's contribution on Soto's *Doble transparencia*, this book.

2. Ariel Jiménez, *Conversaciones con Jesús Soto/Conversations with Jesús Soto,* trans. ITEMS, C.A. and Evelyn Rosenthal (Caracas: Fundación Cisneros, 2005), 111, 174.

3. Jiménez, *Conversaciones con Jesús Soto,* 70.

4. See Guy Brett, "The Century of Kinesthesia," in Guy Brett et al., *Force Fields: Phases of the Kinetic* (London: Hayward Gallery and Barcelona: Museu d'Art Contemporani de Barcelona, 2000), 31.

5. Jiménez, *Conversaciones con Jesús Soto,* 22, 138.

6. Michael Fried, *Absorption and Theatricality: Painting and Beholder in the Age of Diderot* (Chicago: University of Chicago Press, 1988).

Lygia Clark, *Casulo [Cocoon],* 1959

1920, Belo Horizonte, Brazil–1988, Rio de Janeiro

At first glance, Lygia Clark's *Casulo* appears to be a simple two-dimensional geometric composition of black and white triangular shapes. On closer inspection, one can see that it is a carefully calculated arrangement of five triangles that form a square measuring approximately one foot by one foot. Clark used only diagonal lines, purposely eliminating horizontal and vertical lines except those that form the perimeter of the work. On even closer examination, one realizes that each triangular shape is actually an individual element carefully layered and joined to the others. This revelation converts into a relief a work that initially appears to be a simple two-dimensional geometric painting. The subtlety of the layered pieces lures the spectator closer, and only with physical proximity does one realize that these carefully overlapped elements in fact create a small protective cavity. (It is almost impossible to see this in a photographic reproduction of the work.) This shallow hidden space, about four inches deep, is accessible only from the upper right quadrant of the work; presumably, it inspired Clark's title, *Casulo,* which translates to *Cocoon* in English. And this discovery transforms the work yet again: what originally appears to be a two-dimensional geometric painting has now quietly metamorphosed not only into a relief but also into a three-dimensional sculpture, its title imbuing it with an organic quality seemingly at odds with Concrete art.

While this compositionally rigorous approach is consistent with the tradition of Concrete painting that was prevalent in Brazil in the mid-1950s, *Casulo*'s form and title signal the beginning of a transition away from a strictly Concrete idiom. The Grupo Frente, of which Clark was a member, represented the Concrete movement in Rio de Janeiro between 1954 and 1958. By the end of the decade, however, Clark and a number of the other artists affiliated with the group had left the severity of Concrete art behind. They retained many of the guidelines of its formal language but began to expand their notion of the art object itself to incorporate three-dimensional space, movement, viewer participation, and organic subjects and materials; they classified their new creations as Neo-Concrete. In 1959, Clark made a series of similar works titled *Casulo.* Sometimes square and sometimes lozenge-shaped, each was constructed of multiple layers concealing and revealing small hidden

spaces. All these works hung on the wall and projected out into the room, epitomizing this transitional moment.

It is not surprising, given the oppositional nature of *Casulo*'s palette, that the true structure of the work emerges only under close examination. The contrast between black and white almost overpowers the work's three-dimensional aspects. It is true that the paint has darkened and chipped with age, but viewers should try to imagine Clark's original version, executed in pristine white and jet black. Industrial paints and supports—in this case, nitrocellulose on tin—made the brushwork almost invisible, thereby virtually eliminating any trace of the artist's hand. Clark's choice of media highlights the industrial and completely non-representational nature of the work. Only when viewers begin to perceive gray shadows do they realize the subtlety of the construction and the three-dimensionality of the piece.

The title of the piece, like the tension between black and white, highlights another opposition embodied in the work. A cocoon is an organic object, created to protect a fragile larva during its maturation process. The organic quality of the title appears to contradict the cool rationality of black-and-white Concrete art. Subject matter and execution seem to directly oppose each other. This tension between the organic and the geometric, common in Clark's larger body of work, also exists in a number of pieces from this period. In fact, these works represent her attempt to synthesize two qualities in apparently dialectical opposition—the organic and the geometric—at a time when she was beginning to make increasingly organic work. For example, these "cocoons" gave birth to the Bichos series, begun in 1960, which also relied on the tension between organic subject matter and geometric form.[1]

Shortly after Clark began her Bichos series, the poet, critic, and theorist Ferreira Gullar published his essay "Teoria do não-objeto" ["Theory of the Non-object"], which discussed the new works being made under the Neo-Concrete rubric.[2] Using a work from the Bichos series as the prime example of this movement, Gullar's essay explored the hybrid nature of these works; possessing qualities of both painting and sculpture, they belonged to neither category. Clark did a considerable amount of writing during this period as well,

providing textual documentation that expli-cated the formal development occurring in her visual works. In a 1960 essay, "A morte do plano" ["Death of the Plane"], she discussed the limitations of working exclusively in two dimensions, stating that

the plane arbitrarily marks off the limits of a space. . . . To demolish the picture plane as a medium of expression is to become aware of unity as an organic, living whole. We are a whole, and now the moment has come to reassemble all of the pieces of the kaleidoscope into which humanity has been broken up, has been torn into pieces.[3]

Casulo is one of the first works in which Clark began to push what she experienced as the arbitrary limits of the plane, the remnants of Concrete painting. A reassembling of "all of the pieces of the kaleidoscope" into an organic object, *Casulo* functioned as the evo-lutionary predecessor of her Bichos series, and of Gullar's "non-object."

Aleca Le Blanc

Notes
1. See Jodi Kovach's contribution on Lygia Clark's *Bicho,* this book.
2. See Ferreira Gullar, "Theory of the Non-object," trans. Tony Beckwith, in Mari Carmen Ramírez and Héctor Olea, eds., *Inverted Utopias: Avant-Garde Art in Latin America* (New Haven, Conn.: Yale University Press in association with the Museum of Fine Arts, Houston, 2004), 521–22 (origi-nally published as Ferreira Gullar, "Teoria do não-objeto," *Jornal do Brasil,* November 21, 1960).
3. Lygia Clark, "A morte do plano"/"Death of the Plane," in Yve-Alain Bois et al., *Geometric Abstraction: Latin Ameri-can Art from the Patricia Phelps de Cisneros Collection/ Abstracción Geométrica: Arte Latinoamericano en la Colección Patricia Phelps de Cisneros,* various translators (Cambridge, Mass.: Harvard University Art Museums; and Caracas: Fundación Cisneros, 2001), 159.

Lygia Pape, *Livro da Criação [Book of Creation],* 1959

1929, Novo Fribugo, Brazil–2004, Rio de Janeiro

Lygia Pape's sculpture/book/poem *Livro da Criação [Book of Creation]* (plate 30) is one of the archetypal works of early Neo-Concrete art. Although the fame of Hélio Oiticica and Lygia Clark later overshadowed Pape's, in the late 1950s and early 1960s she was a central figure of the Rio de Janeiro art scene and was a signatory of the Neo-Concrete manifesto of 1959. The *Livro da Criação* is one of three books that Pape produced between 1959 and 1962, the other two being the *Livro do Tempo [Book of Time]* and the *Livro da Arquitetura [Book of Architecture]*.[1] The *Livro da Criação* consists of sixteen unbound cardboard "pages," each of which measures twelve by twelve inches when unassembled.[2] Like many other interactive works of the Neo-Concrete movement, such as Lygia Clark's Bichos, or Oiticica's Parangolés, this book requires an element of viewer participation in order to be properly appreciated. The viewer can fully understand and *feel* the artist's original intention only by manipulating the pages up close, as if reading an actual book.

Pape did not choose the *Livro da Criação*'s book format in order to create a purely abstract interactive sculpture—a proto-Bicho, as it were. Rather, a series of narrative titles accompanies the work, creating a story that unfolds as the viewer handles and assembles each page. These titles give both sequence and meaning to the work. The "story" is that of the creation of the world, from the recession of water through the discovery of fire and agriculture, hunting, navigation, and other key moments of human development. The narrative does not correspond precisely to an existing creation myth, and the sequence can be hard to follow.[3] Some of the pages are more poetic than descriptive—for example, the "keel" or the final page, "light." The relationship of these quasi-captions to the individual pages is essentially loose. Had Pape wanted a more determined relationship, she could have inscribed the text on the pages. What we have instead is more akin to the lyrics of a song that is to be sung as the pages are handled, a poetic evocation of the situation, which the viewer then projects onto the abstract page. Looking at the perforated white page, for example, and hearing that it corresponds to the moment when man first planted seeds, the viewer experiences a shift in perception as he or she reads the white plane as a field. Likewise, the rotation of a red

disk becomes the discovery of time, recalling the hands of a clock.

As Guy Brett has pointed out, the idea of creation is twofold in this work: the narrative of the creation of the world finds a counterpart in the viewer's own creative process of assembling the pages and understanding the poetic narrative.[4] Pape reinforced this open nature of the book when she stated:

> It's important to say that there are two plausible readings: for me it is the book of the creation of the world, but for others it can be the book of "creation." Through each person's experiences, there is a process of open structure through which each structure can generate its own reading.[5]

This shared creative process between artist and viewer, by way of an artwork, is one of the legacies of Neo-Concrete art, one expression of how artists of this generation overcame the distinction between reason and emotion that has governed European art since the Renaissance, particularly within the abstract/ Constructivist tradition. The Neo-Concrete manifesto stated that Neo-Concretism "denies the validity of scientific and positivist attitudes in art, and re-proposes the issue of expression, incorporating the new 'verbal' dimensions created by Constructive non-figurative art."[6] This concept of a "verbal" dimension, while not fully explained in the manifesto, seems to refer to a certain grammar or syntax, implying a sense of sequence even within an abstract and formal language.

Text played a fundamental role in the development of Neo-Concretism. It was a poet, Ferreira Gullar, who wrote the Neo-Concrete manifesto, and from the outset the Neo-Concrete movement involved artists working in different media. The poets Haroldo and Augusto de Campos and Décio Pignatari developed Concrete poetry through the Noigandres group and shared many interests with the Neo-Concrete group. Pape's *Neo-Concrete Ballet* (1958) is another example of her interest in crossing traditional disciplines; in this case, she collaborated with a musician to create a totally abstract composition of geometrical shapes in movement. Pape's incorporation of text into the *Livro da Criação* reflects her knowledge of Concrete poetry but also questions the Greenbergian notion that each artistic medium has its own innate qualities. Neo-Concretism, and Pape's work in

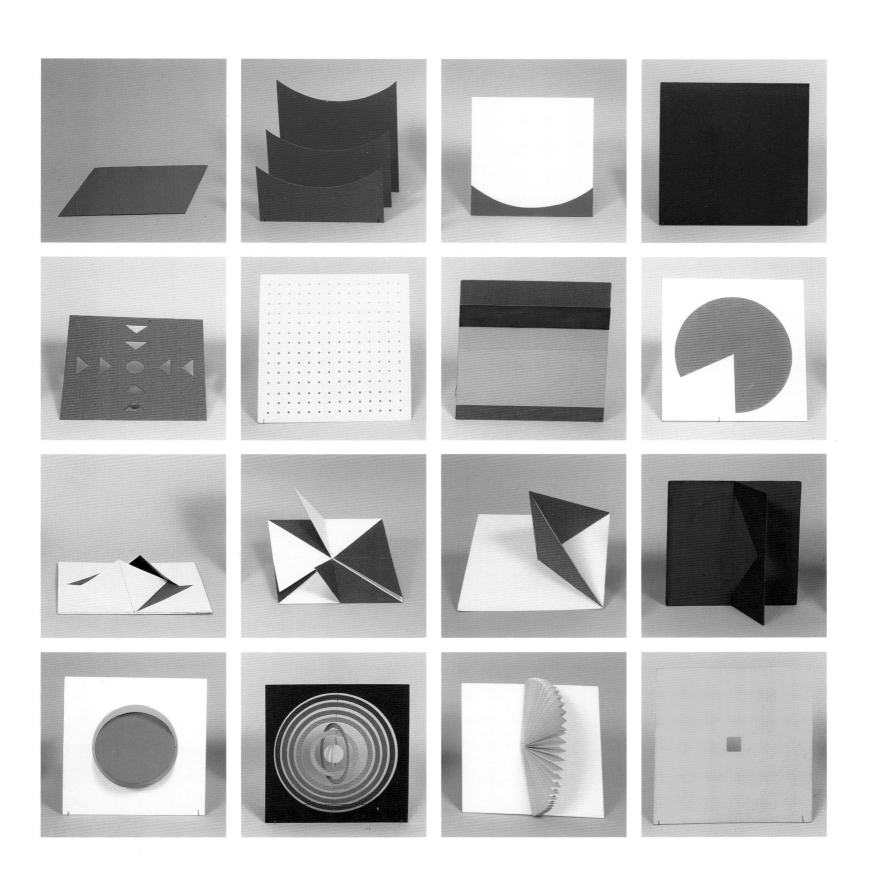

30 *Livro da Criação [Book of Creation],* 1959
Gouache on cardboard; each leaf 30.5 × 30.5 cm (12 × 12 in.); The Museum of Modern Art, New York, fractional and promised
gift of Patricia Phelps de Cisneros, 1349.2001.a–r; copyright Paula Pape

particular, embraced the productive contamination of media, and a search for an unstable, encompassing multimedia experience.

As part of this search for a multimedia, non-museum experience, Pape collaborated with the photographer Mauricio Cirne to produce a series of photographs of the *Livro da Criação* in everyday settings around the city of Rio de Janeiro—in a bar, by a public telephone, leaning against a wall, and so on. For many years these photographs were the primary format through which the work was known.[7] The integration with everyday life that these images suggest reflects the Neo-Concrete desire to create a geometrical art that could live seamlessly in the vernacular culture of Brazil.

Gabriel Pérez-Barreiro

Notes

1. Pape declared that the *Livro da Criação* and the *Livro da Arquitetura* were originally one project, and that she had decided to split them into two books; see Denise Mattar, *Lygia Pape: Intrinsecamente anarquista* (Rio de Janeiro: Relume Dumará, 2003), 68.

2. Pape has reconstructed the *Livro da Criação* several times, since viewers' handling has destroyed the original. At some point in the 1980s or 1990s she editioned three copies of the work, with two artist's proofs; see *Lygia Pape: Entrevista a Lúcia Carneiro e Ileana Pradilla* (Rio de Janeiro: Lacerda Editores/Centro de Arte Hélio Oiticica/Secretaria Municipal de Cultura, 1998), 34.

3. In 2001, the author assembled this book with the artist for an exhibition at the Americas Society in New York. Pape's constant variations and adaptations suggested that there was a certain amount of flexibility in the sequence of the pages. Likewise, the actual wording of the titles was hard to pin down, and to the author's knowledge they are not formally recorded anywhere. The most complete published presentation of the work is in *Lygia Pape: Gávea de Tocaia* (São Paulo: Cosac & Naify, 2000), 133–55, but only fifteen pages are reproduced there.

4. Guy Brett, "The Logic of the Web," in *Lygia Pape* (New York: Americas Society, 2001), n.p.

5. Mattar, *Lygia Pape,* 68.

6. Ferreira Gullar et al., "Manifesto neoconcreto," in Ronaldo Brito, *Neoconcretismo: Vértice e ruptura do projecto construtivo brasileiro na arte,* 2nd ed. (São Paulo: Cosac & Naify, 1999), 10 (originally published as Ferreira Gullar et al., "Manifesto neoconcreto," *Jornal do Brasil,* March 22, 1959). Author's translation.

7. A selection of the photographs was reproduced with captions in Dawn Ades, ed., *Art in Latin America: The Modern Era, 1820–1980* (New Haven, Conn.: Yale University Press, 1989), 270, 271, and again in *Lygia Pape: Gávea de Tocaia.*

1929, Novo Fribugo, Brazil–2004, Rio de Janeiro

Lygia Pape produced the series of wood-block prints titled Tecelares over the course of half a decade of monumental change in the Brazilian art world.[1] She began the series in 1955 as a founding member of Grupo Frente, the Rio de Janeiro Concrete art group formed in 1954, and continued to produce the woodblock prints through the dissolution of that group in 1957 and the advent of the Neo-Concrete group in the spring of 1959. Pape's early Tecelares were understood to be emblematic of Concrete art when they were exhibited in São Paulo and Rio at the Exposição Nacional de Arte Concreta [National Exhibition of Concrete Art] in 1956–1957. But in 1959, Pape chose several works in the series as her contribution to the first Neo-Concrete exhibition, and Ferreira Gullar used a work from this series as an illustration in the Neo-Concrete manifesto of the same year. Thus the Tecelares are both Concrete and Neo-Concrete.

Given these works' inconsistent dating, and their lack of stylistic "development," it is not possible to map changes between early and late works from the Tecelares series. For example, two works that are nearly identical to these woodblock prints from 1959 and 1960 (plates 31 and 32) are dated 1957 and 1956, respectively.[2] Furthermore, when one looks at Pape's Tecelares series as a whole, the works that comprise it do not demonstrate a shift similar to the one that occurred over the same period in the work of Pape's colleague Hélio Oiticica—namely, Oiticica's move from more controlled, geometrically rigid Concrete works to a looser, more expressive geometric vocabulary in his Neo-Concrete works. Instead, Pape created similar woodblock prints years apart, and precise geometric forms appear in the 1958 and 1959 works as well as in the earlier ones. In fact, Pape may have intended to thwart the tracking of changes within the Tecelares series. She described herself as "intrinsically anarchist" and created a heterogeneous and at times sporadic oeuvre that ignored the market pressure for an artist to establish a clear identity and consistent progression in his or her work.[3] Therefore, because it is impossible to trace formal or conceptual shifts over the course of the Tecelares series, rather more interesting questions remain about Pape, Neo-Concretism, and this woodblock print series: What is an appropriate approach to Pape's

heterogeneous production? How can the works in the Tecelares series be accurately interpreted, given their dual parentage as both Concrete and Neo-Concrete? In light of this series, does the usual black-and-white distinction between Concrete and Neo-Concrete art stand up to scrutiny?

Pape's 1959 woodblock print consists of the most minimal components: planes of black ink, and thin lines revealing white translucent rice paper. The production of the work seems equally straightforward: the artist incised the entire surface of the woodblock with thin, more or less precise parallel lines and, within this field of parallel lines, added several non-orthogonal lines. Nevertheless, the complexity of the composition reveals itself when the viewer notes that the two large, horizontally oriented diagonal lines that span the width of the composition also disturb the continuity of the vertical lines. At these diagonals, the parallel lines covering the composition jog over to the left. As a result, the areas confined within the diagonals appear to be distinct planes, separate from the ground of uniform parallel lines. With this additional, small alteration to her already pared-down technique, Pape created the suggestion of space and movement within an otherwise static two-dimensional work.

Because of the way Pape handled her materials, her sleight of hand did not result in a high-octane moiré distortion. Though the artist used a ruled edge and a compass to create the lines that compose the work, slight variations in her mark making, and in the size of the lines, betray the fact that a hand rather than a machine made the forms. The delicate support made of rice paper also absorbs the ink and creates feathered, imprecise edges. Moreover, the black ink surface is not uniform but instead delicately reveals the wood grain of its original source. Pape has written about the Tecelares, "The line is totally controlled. ... The only thing that I allowed myself was to let the porousness of the wood emerge in the black like a small vibration."[4] Instead of a slick, hard-edged work in sync with the ideas of the São Paulo Concrete artists, Pape, with her sensitive handling of her materials, imbued her work with the expressive, non-mechanical qualities called for in the Neo-Concrete manifesto, characteristics also embedded in the time-consuming practice and handmade qualities that give the series its title.

169

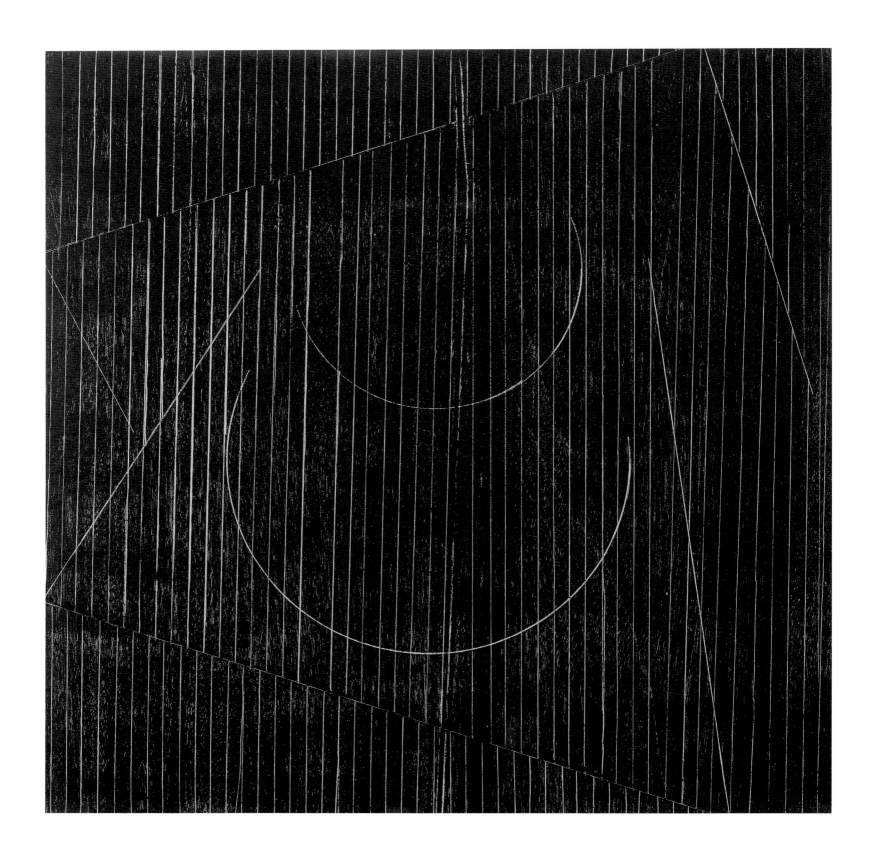

31 *Sem título [Untitled],* from the series Tecelares [Weavings], 1959
Woodblock print on paper; 49.5 × 49.5 cm (19½ × 19½ in.); Colección Patricia Phelps de Cisneros, 1998.146; copyright Paula Pape

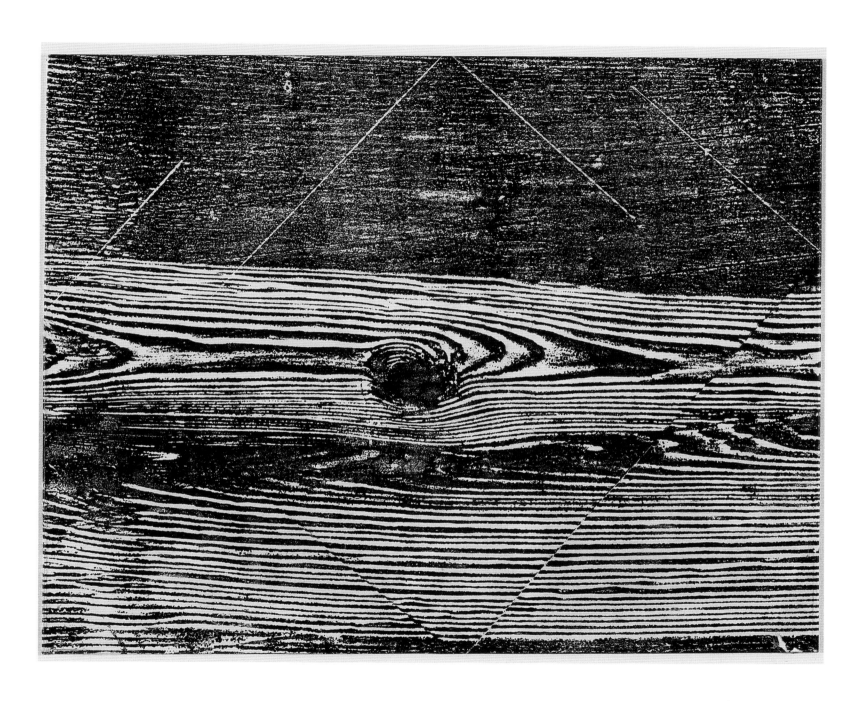

32 *Sem título [Untitled],* from the series Tecelares [Weavings], 1960
Woodblock print on paper; 21.9 × 27.7 cm (8⅝ × 10⅞ in.); Colección Patricia Phelps de Cisneros, 1993.45; copyright Paula Pape

The 1960 woodblock print records the wood grain of the matrix much more overtly. The lower half registers the knot and the prominent swirls of the wood's surface, and the upper half reveals a muted, more regular wood surface like the one seen in the 1959 work. As in the earlier work, several diagonal cuts or disjunctions in the original woodblock have created a distortion in the print. In the lower half of the composition, two large diagonal lines emerge from a break in the continuity of the growth rings. On the right, this line reveals a shift in two planes of wood; on the left, the line is more disguised and suggests a ripple in the paper. Again, these diagonal lines seem to create a distinct plane, and thus space enters into a planar object. The plane and the space created by the diagonals are more subtle and uncertain, however, than those in the 1959 work.

With the Tecelares series, Pape provided an operational metaphor—that of weaving—as an alternative to the notions and metaphors of construction that postwar Brazilian artists had adopted from the European avant-garde. Weaving evokes not only handiwork but also a connection to traditional culture. Pape possessed a lifelong interest in indigenous Brazilian culture, and she spoke of how indigenous peoples had used geometry to express fundamental concepts, such as collective identity.[5] For Pape, geometry did not represent a new or industrial vocabulary but rather a transcendent idiom. It is in this context that we can understand both Pape's choice of the woodblock over more precise or mechanized print media and her subtle suggestion of space within the works; Pape linked her practice to a tactile craft and thereby distanced it from machine art. Instead of using a gridded, regular composition, Pape blended designed and natural geometries, transforming incised lines and wood grain into intertwined warp and weft.

The Tecelares series—along with Pape's *Livro da Criação [Book of Creation]* (plate 30), her *Livro da Arquitetura [Book of Architecture]*, and her *Livro do Tempo [Book of Time]*, all produced between 1959 and 1962—belongs to the part of Pape's early oeuvre that sought essential rather than modern or current themes.[6] Therefore, the Pape of the Tecelares series is only marginally a Concrete artist. These woodblock prints should be understood as models for and embodiments of the radical Neo-Concrete idea that an artwork can incorporate expression without being expressionist. Instead of utilizing gesture or brooding content to create expressive verve, Pape minimally altered her simple materials, allowing the vitality embedded in wood grain, rice paper, and ink to emerge. Writing about this series, she referred to "the relationships of the open and closed space, the sensitive and non-discursive thing."[7] The subtle arrangements and materiality of the Tecelares series create just that—sensitive and non-discursive things.

Adele Nelson

Notes

All translations are the author's.

1. The series dates from 1955 to 1960; see *Lygia Pape: Gávea de Tocaia* (São Paulo: Cosac & Naify, 2000). Pape's woodblock prints were not exhibited with the series title Tecelares in the 1950s. Original titles include *Xilogravura 1–8 [Woodblock Prints 1–8]* (III, IV, and V São Paulo Biennials, 1955–1959); *Composición [Composition]* (1956) (*Arte Moderno en Brasil* exhibit at the Museo Nacional de Bellas Artes, Buenos Aires, 1957); and *Sem título [Untitled]* (1954–1955) (Grupo Frente exhibitions, 1954–1956).

2. The 1956 work is reproduced in *Lygia Pape* (New York: The Americas Society, 2001); the 1957 work, in *Lygia Pape: Gávea de Tocaia*. Pape lent the works and was directly involved in the organization of these two exhibitions and publications.

3. Pape's self-description is quoted in Denise Mattar, *Lygia Pape: Intrinsecamente anarquista* (Rio de Janeiro: Relume Dumará, 2003).

4. Mattar, *Lygia Pape*, 63–64. See also Luís Otávio Pimentel, ed., *Lygia Pape* (Rio de Janeiro: FUNARTE, 1983), 49.

5. *Lygia Pape: Entrevista a Lúcia Carneiro e Ileana Pradilla* (Rio de Janeiro: Lacerda Editores/Centro de Arte Hélio Oiticica/Secretaria Municipal de Cultura, 1998), 14–19.

6. See Gabriel Pérez-Barreiro's contribution on Pape's *Livro da Criaçao*, this book.

7. Mattar, *Lygia Pape*, 64.

b. 1923, Caracas; lives in Paris and Caracas

Color theory—particularly the mixing and manipulation of color for psychological or physical effect—lies at the center of the Venezuelan artist Carlos Cruz-Diez's oeuvre. *Amarillo aditivo* (plate 33) and *Physichromie No 21* (plate 34), completed roughly a year apart, are works that exemplify Cruz-Diez's developing research into and understanding of how the viewer perceives and conceptually processes color.

Amarillo aditivo appears at first glance to be a black square bisected by a thin diagonal line, but closer inspection clarifies this intervention. Cruz-Diez actually composed the diagonal of two almost superimposed lines, one green and the other red, that form a compressed and elongated X. This seemingly indiscernible yet critical intrusion of color into an otherwise austere black void plays with the spectator's vision. When the spectator is standing close to and directly in front of the work, these distinct colors, their overlap, and the interplay of the stripes are clear and unmistakable. But any shift in this stable viewing position also destabilizes this reading. For example, the two narrow bands of color, viewed at a distance, seem to blend, and hints of yellow appear at the points of overlap. This interplay creates the illusion of a third color that is never physically present in the work. As Cruz-Diez has explained, "The juxtaposition of these two fragments, now transformed into 'chromatic event modules,' creates a third color, one that is constantly changing and dependent on the distance and angle of vision of the spectator as well as on the light source present at a particular moment in time."[1]

It is with the unstable and volatile nature of color in mind that Cruz-Diez engages in a centuries old debate: What takes precedence—form or color? By studying past theorists, such as Isaac Newton and J.W. Goethe, and the more contemporary color theory of Josef Albers, Cruz-Diez began his life's work: the study of color and its boundless and ever-changing possibilities. His research and work led him to conclude that we live in a "hyper-baroque polychromatic society," a society that requires artists to question preconceived notions about color, which have become fixed over time. According to Cruz-Diez, specific cultural conventions and beliefs exert significant control over our responses to color, making us "visually deaf" and "auditorily blind."[2]

Working with this idea, Cruz-Diez began a series of investigations intended to explore the physiological and psychological impacts of color on the spectator and to challenge what the artist believed were socially programmed responses to color.

In *Amarillo aditivo,* as the work's title implies, Cruz-Diez employed the theory and practice of additive color synthesis, which deals with the color effects of varying light stimuli. Whereas subtractive color synthesis involves the use of pigments and dyes to create colors,[3] additive color synthesis deals primarily with the color effects of light—as, for example, in a cathode-ray TV monitor, which employs a combination of red, green, and blue phosphor dots. At a significant distance from the TV screen, the eye does not distinguish the individual dots but rather melds them together to create the final image. *Amarillo aditivo* functions in similar fashion. Cruz-Diez's focus on the properties of color demonstrates his belief that color is not fixed but instead changes according to external circumstances, such as the interactions of light and shadow and the position of the spectator. Thus what is important here is not just the fleeting experience of a third color generated by the interplay of the red and green lines; also significant is the experience of the viewer, whose particular stance—whether the viewer is stationary before the work or meanders around it—destabilizes what would otherwise appear to be a stable work, creating new optical and sensory effects.

Pushing this idea farther, Cruz-Diez began his Physichromies series. The artist invented this term from the phrase "physical chromatism." Whereas *Amarillo aditivo* is a study in additive color theory, the works in the Physichromies series combine additive, subtractive, and reflective color synthesis.[4] In 1959, a year before he moved to Paris, Cruz-Diez completed his first work in this series, putting into play what he called "color radiation," by which the reflections of a work's adjacent painted surfaces "color" blank or unpainted portions of the work. The resulting, ever-changing effect depends, of course, not only on the intensity of the light hitting the work itself but also on the spectator's angle of vision. In *Physichromie No 21,* for example, the spectator's lateral movement in front of the work continually alters his or her perception of the piece. The art critic Julio César Schara summed up Cruz-Diez's language of color as follows:

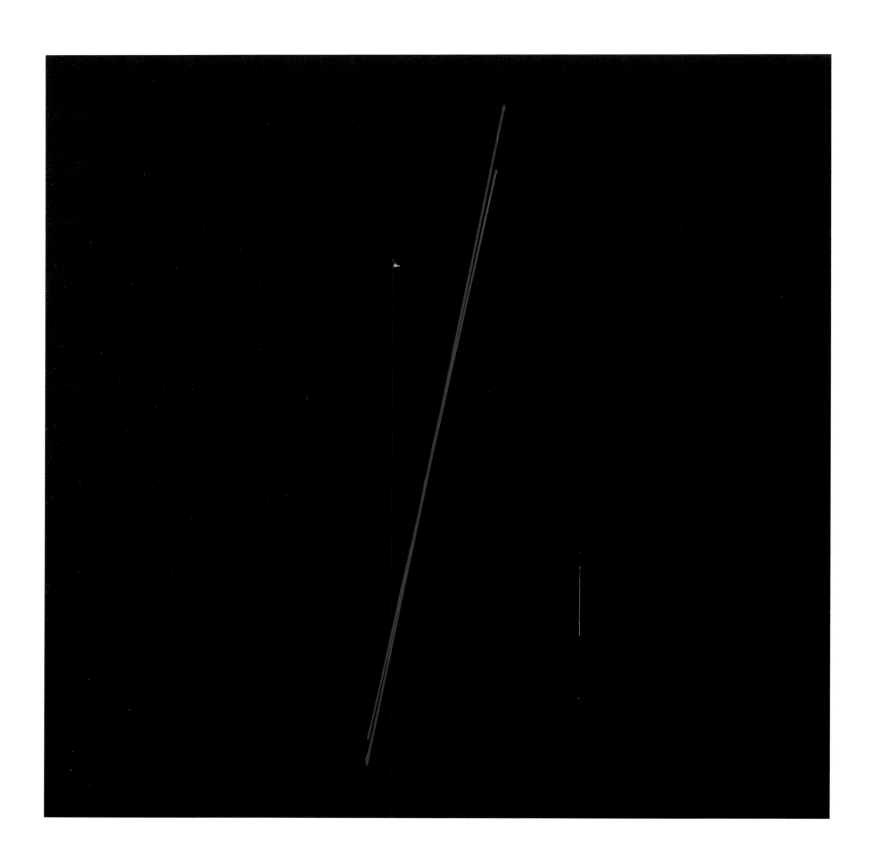

33 *Amarillo aditivo [Additive Yellow],* 1959
Acrylic on paper; 40 × 40 cm (15¾ × 15¾ in.); Colección Patricia Phelps de Cisneros, 1997.176; copyright Carlos Cruz-Diez

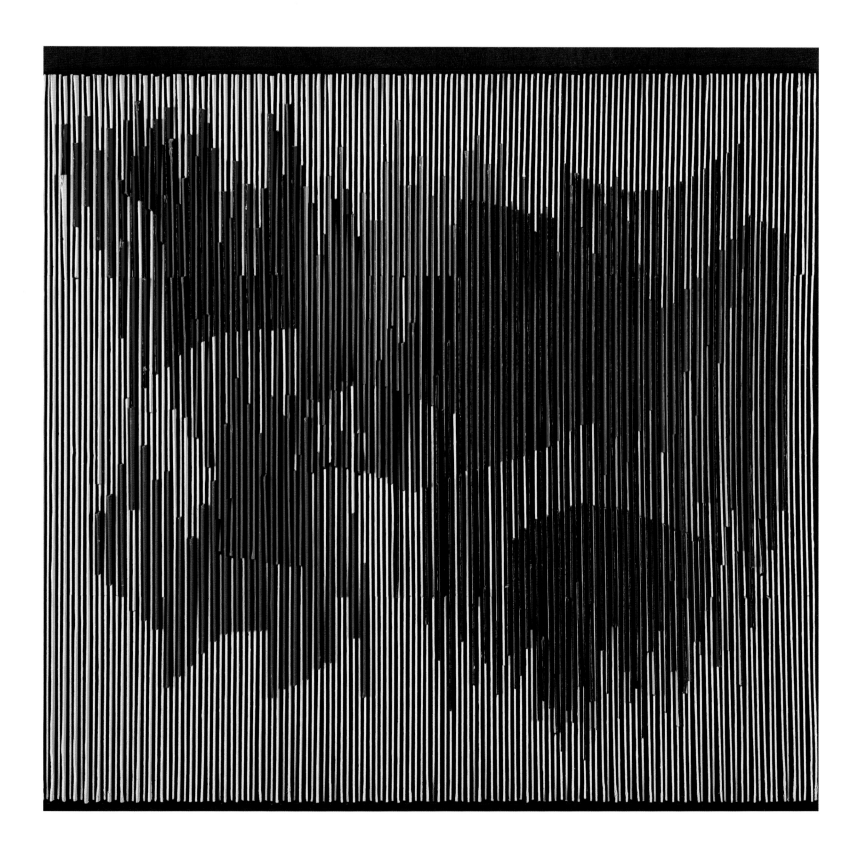

34 *Physichromie No 21,* 1960
Metal on cardboard, acrylic, and plastic; 103.4 × 106.4 × 6.5 cm (40¹¹⁄₁₆ × 41⅞ × 2⁹⁄₁₆ in.); Colección Patricia Phelps de Cisneros, 1997.145; copyright Carlos Cruz-Diez

Color in continuous mutation creates *autonomous realities.* Realities, because these events are produced in time and space. Autonomous, since they do not depend on that which viewers are accustomed to seeing in a painting. In this way, another *dialectic* between spectator and work is initiated.[5]

Each of the works in the Physichromies series consists of a succession of long, narrow strips of wood, cardboard, plastic, or metal that are placed at right angles to a canvas or other surface. The artist painted the sides of these thin panels with different colors, and the spectator barely notices these colors when viewing the work from the front. As he or she moves from one side of the work to the other, however, these thin strips take on an individual existence, appearing to float as if unattached to any support. *Physichromie No 21,* like *Amarillo aditivo,* engages the spectator in an active visual and perceptual dialogue but takes it a step farther. As the viewer shifts his or her position in front of *Physichromie No 21,* the image appears to be in continuous motion, and the bands of different colors morph into various geometric shapes. *Physichromie No 21,* at nearly three times the size of *Amarillo aditivo,* adds white to the mix of green, red, and black. An internal chromatic dynamic emerges as the colors meet and melt into one another, creating other colors that are projected onto the white support.

As already mentioned, Cruz-Diez moved to Paris in 1960, hoping for a more favorable reception of his work than what he had experienced in Caracas. In Paris he became involved with other Latin American artists who were working in a similar vein. His subsequent success in Paris, fostered in great part by Denise René and her gallery, came at a moment in postwar France when audiences were seeking an artistic alternative to the more individualistic style of lyrical and gestural abstraction. The Parisian public, tired of the elitist language of art critics, welcomed this participatory art that seemed to break down the barrier between the everyday viewer and high art.

Martha Sesín

Notes

All translations are the author's.

1. Julio César Schara, *Carlos Cruz Diez y el arte cinético* (Mexico City: Arte e Imagen, 2001), 71.

2. Schara, *Carlos Cruz Diez y el arte cinético,* 68.

3. Subtractive color synthesis uses paints, inks, dyes, and other colorants to create color by absorbing some wavelengths of light and reflecting others.

4. Schara, *Carlos Cruz Diez y el arte cinético,* 73. Referring to the works in his Physichromies series, Cruz-Diez defined reflective color as "light that hits the background 'modules' and bounces back onto the sections perpendicular to the structure."

5. Schara, *Carlos Cruz Diez y el arte cinético,* 69 (emphasis in original).

Willys de Castro, *Objeto ativo—amarelo [Active Object—Yellow],* 1959–1960
Objeto ativo [Active Object], 1961

1926, Uberlândia, Brazil–1988, São Paulo

In a 1967 catalogue essay for an exhibition in the Museu de Arte Moderna in Rio de Janeiro, the artist Hélio Oiticica identified and defined what he considered the general characteristics of contemporary Brazilian avant-garde art, itself a loose association of efforts that he labeled the New Objectivity.[1] The New Objectivity did not consist of art objects that viewers could enjoy passively; it consisted of projects that required audience members to perceive the objects with their entire bodies in order to grasp the radical propositions of this different form of art. Brazilian artists of the New Objectivity were those who were working with artistic media that defied clear-cut categorization, and who were producing works that audiences could not easily define as sculptures or paintings.

Willys de Castro's series titled Objetos ativos, created during the 1960s, emerged in this context of radical experimentation as painted works in different colors and shapes. In particular, *Objeto ativo—amarelo* (plate 35) and *Objeto ativo* (plate 36) exemplify Castro's move from an art that can be comprehended through mere observation to one that actively engages the audience's faculties of memory and perception. Understanding Castro's Objetos ativos series, one can better understand the goals and aspirations of Brazil's artistic avant-garde in the 1960s.

Standing before *Objeto ativo—amarelo,* the viewer confronts an almost monochromatic painting: a seemingly vast plane of yellow broken up by a thin strip of blue along its left side. At the middle of the thin strip, however, we find a small yellow square, as though the yellow plane had expanded into the strip. Castro echoed this small geometric shape by placing a blue square of the same size on the work's right side. These details do not entirely obscure the fact that one is observing an actual object, a canvas covered by paint. But the thin blue strip and minuscule square prompt audience members to experience the work in particular ways; viewers "remember" the intentional absence on the left side of the canvas, finding a resolution on the right side of the work. In the words of Renato Rodrigues da Silva, these details represent a "positive-negative" artistic strategy, a process through which Castro managed to interrelate different areas of the finished work to produce a unified whole.[2] Nevertheless, this strategy does not merely serve as a compositional aid;

rather, "the displacement creates a negative space, or an absence, that one's gaze repeatedly tries to reject through the reconstruction of the original planes; these attempts result in a temporal dynamic that culminates in the integration of the painting."[3] One's very act of seeing and experiencing the work through one's senses becomes a part of the work of art. In other words, the work functions as art only when the viewer's senses interact and integrate with it. The piece depends on the audience's perception, a strategic decision on Castro's part that makes his Objetos ativos series subjective works of art, entirely dependent on a continuous rediscovery.

Castro further developed this "positive-negative" strategy in pieces such as *Objeto ativo* (1961). Instead of being mounted on the wall, like a painting, this work stands on the gallery floor as though it were a sculpture. Viewers thus confront a slender, geometric wooden pole covered in areas of red and white. On the one hand, the particular arrangement of colors produces an interplay that might be described as rhythmic, revealing the artist's interest and earlier involvement in Concrete music and poetry, as when he participated in the Ars Nova group of the 1950s. On the other hand, once viewers engage with the object, the artist's "positive-negative" strategy becomes evident: as they confront the piece, they compare the colored areas right in front of their eyes with those encountered immediately before. (Again, this process of comparison resonates with the goals of the New Objectivity artists.) Since all the sides of this particular work in the Objeto ativo series can never be seen simultaneously, Castro seems all the more intent on engaging his audience's memory. Moreover, because the artist painted over flat surfaces, one cannot avoid thinking of the work's relationship to traditional painting, even though the work stands as a three-dimensional object in the gallery.

Through his Objetos ativos series, Castro engaged with the debates of Brazil's avant-garde concerning artistic categories and media. For example, a 1960 "painting" from the series hangs at right angles to the gallery's wall. Each of its painted surfaces could serve independently as a geometrically abstract painting, since the work itself hangs unconventionally; in fact, the canvas does not even appear to be perfectly rectangular, since

35 *Objeto ativo—amarelo [Active Object—Yellow],* 1959–1960
Oil on canvas mounted on hardboard; 35 × 70 × 0.5 cm (13¾ × 27⁹⁄₁₆ × ³⁄₁₆ in.); Colección Patricia Phelps de Cisneros, 1997.56

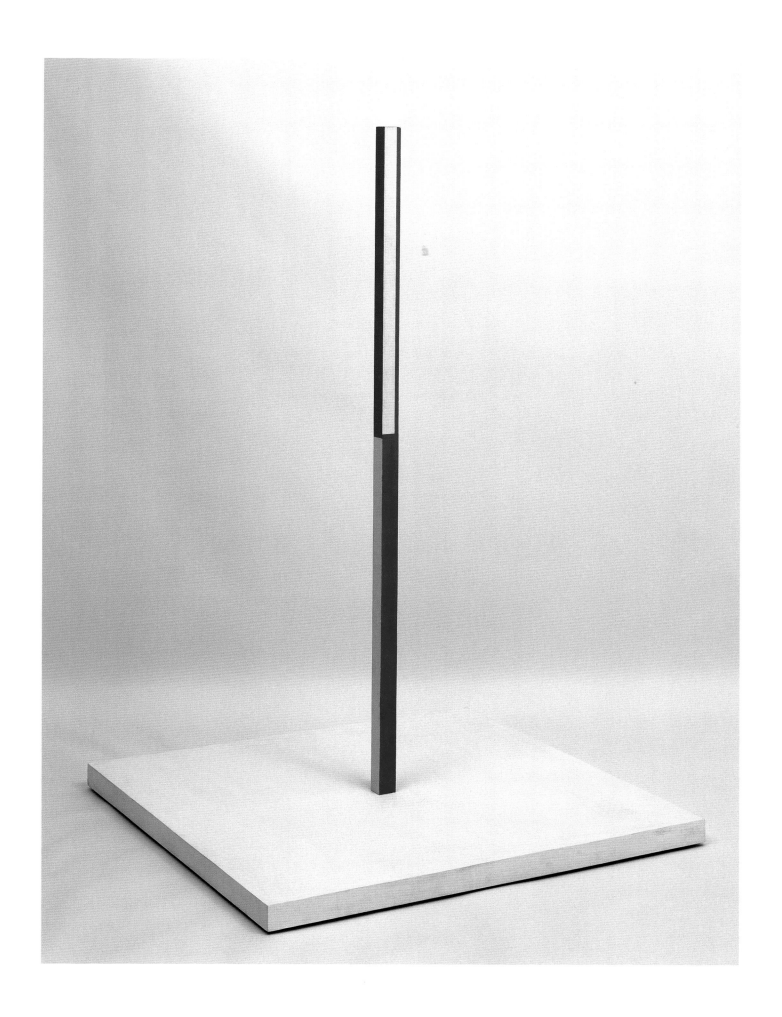

36 *Objeto ativo [Active Object],* 1961
Enamel and acrylic-vinyl paint on canvas and wood; 155 × 100 × 100 cm (61 × 39⅜ × 39⅜ in.); Colección Patricia Phelps de Cisneros, 1996.81/2

the artist painted certain areas to create the appearance of a dent in the structure, an optical illusion that depends on the painting's being viewed from a particular perspective against a white gallery wall. Other works from the series, such as the ones the artist completed in 1962, consist of cubes that appear to break up into smaller pieces, as though Castro had attached small blocks together. The artist produced these visual effects by strategically painting particular areas of the flat surfaces in different colors—creating the illusion, for example, that a white cube is attached to a larger red three-dimensional structure.

It may seem that these different investigations of geometric forms are formal exercises or optical effects meant to dazzle viewers, but Castro was not deploying these effects for their value as spectacle. His innovations reflect his desire to push the limits of artistic categories—to change the way audiences perceive paintings and sculpture—and they result in the "disintegration of the traditional picture, later of the plane, of pictorial space."[4] By exploring the limits of traditional painting and sculpture, and by producing works of art that represent something entirely different from these two realms, Castro followed the desire to alter artistic practice fundamentally, to create works of art that transform audiences and, eventually, society. With this goal of the artist in mind, one can understand how Castro himself described these objects: "Such works, . . . upon entering the world, alter it, for their emergence deflagrates a current of perceptive and significant phenomena, bearing new revelations, until then unknown in the exact same space."[5]

By experiencing the Objetos ativos series in the gallery space, we continue the never-ending active process of revelation and transformation that the artist hoped to produce through his work.

Alberto McKelligan

Notes

All translations are the author's unless otherwise noted.

1. Hélio Oiticica, "General Scheme of the New Objectivity," in Guy Brett, Catherine David, Chris Dercon, Luciano Figueiredo, and Lygia Pape, eds., *Hélio Oiticica,* various translators (Minneapolis, Minn.: Walker Art Center; and Rotterdam: Witte de With Center for Contemporary Art, 1993), 110–20.

2. See Renato Rodrigues da Silva, "Os Objetos ativos de Willys de Castro," *Estudos Avançados* 20 no. 56 (2006): 254.

3. Rodrigues da Silva, "Os Objetos ativos de Willys de Castro," 254.

4. Oiticica, "General Scheme of the New Objectivity," 111.

5. Willys de Castro, "Objeto ativo," *Habitat* 64 (1961): 50, cited in Rodrigues da Silva, "Os Objetos ativos de Willys de Castro," 264–65.

Hélio Oiticica, *Relevo neoconcreto [Neoconcrete Relief]*, 1960

1937–1980, Rio de Janeiro

Neither conventional painting nor sculpture, the non-representational work *Relevo neoconcreto* (plate 37) comes from Hélio Oiticica's Neo-Concrete period, as its title indicates. An outgrowth of the Concrete works that the artist made in the mid-1950s, during his affiliation with the Grupo Frente, it is an excellent example of the generative powers of the cool, analytical approach mandated by Concrete art. As can be seen in this work, Oiticica began expanding his notion of the Concrete art object by simultaneously embracing its geometrically abstract formal language and moving away from the strict method of application that its proponents demanded.

In the late 1950s and early 1960s, many artists in Rio de Janeiro, including Lygia Clark, Lygia Pape, and Franz Weissmann, among others, used the legacy of Concrete art as a springboard for experimentation and formed what became known as the Neo-Concrete group. Although they exhibited together as an officially organized group only from 1959 to 1961, many of their concepts and concerns resonated in their works both before and long after the group's dissolution. In 1960, an influential essay by the poet Ferreira Gullar addressed the new work that these artists were making.[1] Most of the work evaded strict categorization as either painting or sculpture and instead used properties of both, existing somewhere between the two media.

Oiticica's *Relevo neoconcreto* is an excellent example of this in-between state. The artist used conventional materials of painting —pigment and panel—but did not adhere to the traditional model of the rectangular frame. Three triangular points jut from the top and bottom of the oddly shaped, horizontally oriented wood support, giving the work a sculptural quality. Neither a frame nor a pedestal, either of which would announce the work as a painting or a sculpture, separates it from the viewer's space. Although it is installed on a wall, the work does not rest against it but instead projects out a few inches so that the panel, like a sculpture, is isolated in space, even though the viewer cannot walk around it; it projects into the viewer's space in a way that is reminiscent of relief sculpture (again, as signaled by the work's title). Many of Oiticica's Neo-Concrete experiments involved a play with space, often characterized by unusual installation methods. For example, in addition to his deployment of the relief concept in this painting-sculpture hybrid, Oiticica hung painted panels from the ceiling in the middle of the room, further exacerbating the ambiguity in his works between painting and sculpture.

Considered in the larger context of his career, *Relevo neoconcreto* is an important transitional work. From 1957 to 1958, Oiticica experimented with grids and triangles, using the formal language of Concrete art and gouache on paper to make hundreds of geometrically shaped compositions. Many of these works, later called the Metaesquemas [Metaschemes] series, have a strong formal relationship to the panel paintings that he executed in subsequent years. When he made *Relevo neoconcreto,* he was already exploring the possibilities of three-dimensional space. Three-dimensionality would monopolize much of his production throughout the following decade as he played with and deconstructed painting, sculpture, installation, and performance art with his Bolides, Nuclei, and Parangolés series. *Relevo neoconcreto* provides a crucial bridge in his development between the Metaesquemas of the 1950s and his work of the 1960s.

Throughout his career, Oiticica was a prolific writer. He published widely in journals and catalogues, maintained a lively correspondence with other Brazilian intellectuals and artists while traveling, and kept numerous personal diaries. In fact, Oiticica's writing was as integral to his development as an artist as were his visual works.[2] In 1960, the same year he made *Relevo neoconcreto,* he wrote about the relationships among color, time, space, and structure. He understood these elements to be inseparable and always present in each of his works. Thus *Relevo neoconcreto* engages the viewer not only with the artist's concern for structure and space but also with his consuming interest in color. Indeed, color played a dominant role in each of his projects, and Oiticica's cumulative body of work reveals his overwhelming desire to give color a material existence. *Relevo neoconcreto,* for example, is divided into two color regions, the one on the left painted a velvety beige and the one on the right painted a creamy copper. This use of creamy tones is something of an anomaly in that Oiticica worked principally in brightly saturated hues, such as yellow, blue, pink, orange, and red. Nevertheless,

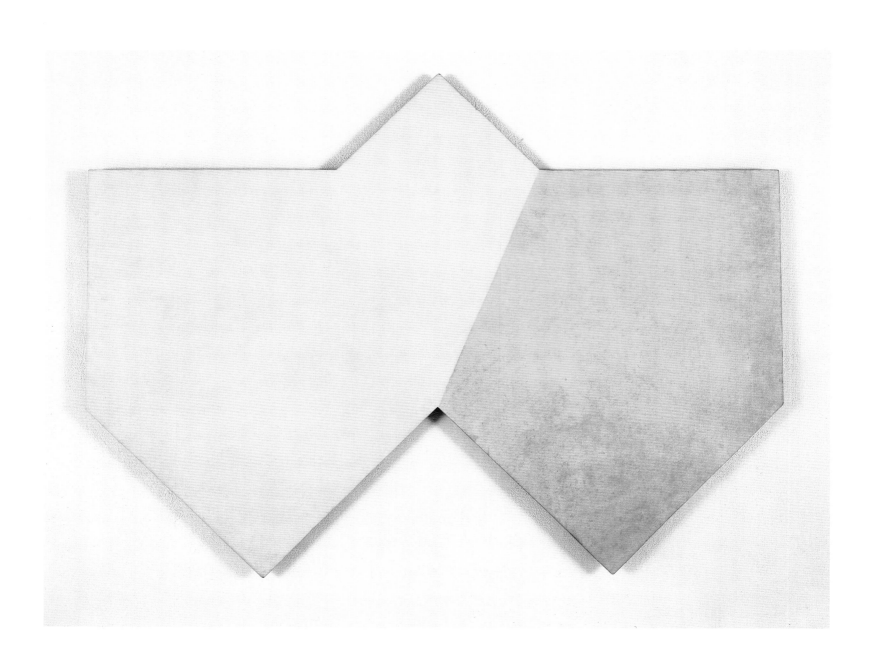

37 *Relevo neoconcreto [Neoconcrete Relief]*, 1960
Oil on wood; 96 × 130 cm (37⅞ × 51¼ in.); The Museum of Modern Art, New York, fractional and promised gift of
Patricia Phelps de Cisneros in honor of Gary Garrels, 325.2004; copyright Projeto Hélio Oiticica

this juxtaposition of two colors within a single work is consistent with a number of his other projects in 1960 and later. Like *Relevo neoconcreto,* many of these are composites of such geometric shapes as parallelograms, rectangles, triangles, and squares that are frequently painted two closely related colors (for example, yellow and orange, or white and gray). Also in 1960, when he experimented with the creamy colors of *Relevo neoconcreto,* he wrote about his experiments with white, stating, "The meeting of two different whites occurs in a muffled way, one having more whiteness, and the other, naturally, more opaqueness, tending to a grayish tone."[3] Oiticica was as interested in the subtle distinction between the shades of a single color (white) as he was in a dialogue between the richly saturated hues of beige and copper. Although *Relevo neoconcreto* is a somewhat unusual example of Oiticica's experimentation with color in 1960, it is consistent with an obsession that would sustain him for decades.

Aleca Le Blanc

Notes

1. See Ferreira Gullar, "Theory of the Non-object," trans. Tony Beckwith, in Mari Carmen Ramírez and Héctor Olea, eds., *Inverted Utopias: Avant-Garde Art in Latin America* (New Haven, Conn.: Yale University Press in association with the Museum of Fine Arts, Houston, 2004) (originally published as Ferreira Gullar, "Teoria do não-objeto," *Jornal do Brasil,* November 21, 1960).

2. Guy Brett, "Note on the Writings," in Guy Brett, Catherine David, Chris Dercon, Luciano Figueiredo, and Lygia Pape, eds., *Hélio Oiticica,* various translators (Minneapolis, Minn.: Walker Art Center; and Rotterdam: Witte de With Center for Contemporary Art, 1993), 207.

3. Hélio Oiticica, "Colour, Time and Structure," in Brett, David, Dercon, Figueiredo, and Pape, eds., *Hélio Oiticica,* 34 (originally published as Hélio Oiticia, "Cor, tempo e estrutura," *Jornal do Brasil,* November 26, 1960).

Lygia Clark, *Bicho [Critter],* 1961

1920, Belo Horizonte, Brazil–1988, Rio de Janeiro

Sharp, pointed folds, circular edges, and highly reflective, bronze-colored metal surfaces animate the sleek aluminum planes of Lygia Clark's *Bicho*, which resembles a delicate origami sculpture. According to how it is displayed, *Bicho* can also exhibit the severe industrial features and cold aggressive qualities of a reductive Minimalist sculpture. But its small scale and apparent flexibility make it accessible to spectators, who must remember that Clark expected each viewer, or participant, to bring this object to life through active manipulation of its parts.

Bicho is one work in the series titled Bichos, flat aluminum sculptural forms, articulated with hinges, that Clark produced in Rio de Janeiro between 1959 and 1966. *Bicho,* pictured here, measures over two feet in diameter, but some of the other works in the series are small enough to be held in the hand, and the dimensions of each one change according to how the participant bends and folds it. Each time a participant handles a work in the Bichos series, his tactile response to the material, and his interactive play with the properties of physicality, space, and movement, give the object a different formal character. Although Clark constructed these works in metal, she conceived of them as "living forms," or transmutable extensions of the participant's body that stimulate a dynamic activity. Like all the other works in this series, this one has an austere planar geometry that embodies a pristine quality, akin to that of Minimalist sculpture, which initially facilitates an immediate comprehension of its form. Nevertheless, the mutability of this metal object compels the viewer to touch it and, through a palpable experience of its physical properties, understand its meaning—a variable meaning, and one that emerges each time a participant acts on the object and responds to the ways in which it is transformed. This interplay, stimulating both a visual and a tactile response in the participant, prompts a dialogue between the art object and an active, viewing subject (as opposed to a passive spectator).[1]

The ambivalence of *Bicho*'s cold geometric austerity, on the one hand, and its organic mutability, on the other, also parallels the antagonism between an avant-garde artwork that seeks autonomy from the realm of the everyday and one that directly intersects real life.[2] *Bicho*'s interactive component recalls Russian and European Constructivist strategies for advancing the autonomous art object into life praxis, as reflected, for example, in El Lissitsky's 1919–1924 *Proun* projects, which proposed the practicality of abstract designs for posters, architecture, or urban planning projects. Lygia Clark inserted abstract design into lived experience by joining the subject and the object in an ephemeral activity that enlivens both the form and the participant's senses. She thereby transformed the self-referential abstract artwork into a living structure that opens up in relation to the efflorescence of the human subject.[3] In this way, *Bicho* exemplifies the main objectives of the Neo-Concrete movement, which Clark spearheaded in the late 1950s in Rio de Janeiro along with Ferreira Gullar, Franz Weissmann, Lygia Pape, Amilcar de Castro, Theon Spanudis, and Reynaldo Jardim. These artists and poets incorporated international and Brazilian modernist aesthetic strategies into their practice to generate a peculiarly Brazilian avant-garde project that bridged the conventional distinction between art as objective material form and art as agent of human expression.[4] But since museums and galleries now tend to display *Bicho* so that viewers cannot touch it, they also eliminate the viewer's subjectivity as an element of the artwork. Thus the subject-object dialectic essential to *Bicho*'s variable and contingent meanings is lost. Nevertheless, Clark, in conceiving the Bichos series, transformed her previous geometric abstractions from autonomous, unified entities, or visual objects, to phenomenological "non-objects."[5] This transformation in her formalist approach reflects the break between the São Paulo contingent of Concrete artists, also known as the Grupo Ruptura, and the Grupo Frente in Rio, whose denunciation of Concretist rationalism gave way to the emergence of Neo-Concrete art in the late 1950s and early 1960s. During this time, Clark's use of an abstract geometric vocabulary evolved from planar modulations of two-dimensional surfaces—intended to be understood through detached, intellectual, and optical modes of perception—to the hinged, volumetric structures of her Bichos. The unique interactive component of *Bicho* rejects the rational viewing processes explored by the Ruptura group and sparks moments of individual creative expression. *Bicho* therefore exemplifies the Neo-Concretist theory of haptic perception, which associates the sense of touch with

that of sight to intensify the perception of the object's tangibility, and which encourages the active subject to realize the artwork through a heightened awareness of his or her own corporeal state.[6] Rather than maintaining a detached stance, the observer engages *Bicho* in an activity that stimulates a multisensory response and produces meaning through the transformation of the object.[7] As a result, the spectator is made a participant in the experience of realizing both artwork and self, and the meaning of the work becomes dependent on each individual's experience with the art object.[8]

Clark's destabilization of the artwork's unified meaning, and of the homogeneous viewing subject, also invokes the early avant-garde strategies of Brazilian Antropofagia from the 1920s. The modernist concept of anthropophagy, or ritual cannibalism, proposed the symbolic "devouring" or decoding of European mechanisms of power, such as authority, structure, and reason, to reveal the primordial ideals of collectivism, freedom, and magic.[9] Clark, drawing on this legacy, dismantled the primacy of the European objectifying gaze by demonstrating that subjectivity is contingent on physical interaction with the art object that exists independently of one's body and psyche. *Bicho*—folded, bent, and transformed in reaction to the participant's movements—reveals new, unexpected dimensions and shapes that in turn affect the participant's next move. Clark implicates the participant in a dynamic, physical action with the artwork, and she opens up a subjective way of perceiving and experiencing the material world.

Jodi Kovach

Notes

All translations are the author's unless otherwise noted.

1. See Paulo Herkenhoff, "The Hand and the Glove," in Mari Carmen Ramírez and Héctor Olea, eds., *Inverted Utopias: Avant-Garde Art in Latin America* (New Haven, Conn.: Yale University Press in association with the Museum of Fine Arts, Houston, 2004), 327–37. See also Yve-Alain Bois, "Some Latin Americans in Paris," in Yve-Alain Bois et al., *Geometric Abstraction: Latin American Art from the Patricia Phelps de Cisneros Collection/Abstracción Geométrica: Arte Latinoamericano en la Colección Patricia Phelps de Cisneros* (Cambridge, Mass.: Harvard University Art Museums; and Caracas: Fundación Cisneros, 2001), 86–89.

2. See Peter Bürger, *Theory of the Avant-Garde,* trans. Michael Shaw (Minneapolis: University of Minnesota Press, 1984). See also Theodor Adorno, "Commitment," in Andrew Arato and Eike Gebhardt, eds., *The Essential Frankfurt School Reader* (New York: Urizen Books, 1977), 300–318.

3. See Mari Carmen Ramírez, "Vital Structures: The Constructive Nexus in South America," in Ramírez and Olea, eds., *Inverted Utopias,* 191–201.

4. See Ferreira Gullar et al., "Neo-Concrete Manifesto," trans. Laura Pérez, in Ramírez and Olea, eds., *Inverted Utopias,* 496–97 (originally published as Ferreira Gullar et al., "Manifesto neoconcreto," *Jornal do Brasil,* March 22, 1959).

5. See Ferreira Gullar, "Theory of the Non-object," trans. Tony Beckwith, in Ramírez and Olea, eds., *Inverted Utopias,* 521–22 (originally published as Ferreira Gullar, "Teoria do não-objeto," *Jornal do Brasil,* November 21, 1960).

6. See Herkenhoff, "The Hand and the Glove," 329. See also Paulo Herkenhoff, "Zero and Difference: Excavating a Conceptual Architecture," in Milena Kalinovska, ed., *Beyond Preconceptions: The Sixties Experiment* (New York: Independent Curators International, 2000), 57.

7. Herkenhoff, "The Hand and the Glove," 330–31.

8. See Gullar et al., "Neo-Concrete Manifesto"; and Valerie L. Hillings, "Concrete Territory: Geometric Art, Group Formation, and Self-Definition," in Lynn Zelevansky, *Beyond Geometry: Experiments in Form, 1940s–70s* (Cambridge, Mass.: MIT Press, 2004), 57.

9. See Oswald de Andrade, "Manifesto Antropofago," trans. Héctor Olea, in Haroldo de Campos, ed., *Oswald de Andrade: Obra Escogida* (Caracas: Biblioteca Ayacucho, 1981), 67–72 (originally published as Oswald de Andrade, "Manifesto Anthropofago," in *Revista de Antropofagia* [May 1928], 3, 7).

Gego (Gertrud Goldschmidt), *Ocho cuadrados [Eight Squares]*, 1961

1922, Hamburg–1994, Caracas

Ocho cuadrados (plate 38) does not tower over its audience or envelop their entire bodies; this sculptural object does not take over a large room or an entire public court-yard. And yet, despite its scale, *Ocho cuadra-dos* demands much more than a passive appreciation from its audience.

The piece consists of eight metal planes that intersect in the air, as though they had flown into one other to create this particular formation. Even though the specific "lines" or "rods" that make up these planes all align hori-zontally, the artist's careful construction has given the work a vertical emphasis. Moreover, as though the inanimate object were poised to expand, the work emits a particular tension, a buzzing sensation of energy heightened by the multiple grids formed by the planes as they intersect. As the viewer moves around the sculpture, the relationships between the grids and the planes seem to shift, creating the appearance of dynamic movement.

Despite the complex system of relation-ships between and among the lines, grids, and planes of *Ocho cuadrados,* Gego imbued the work with an overall sense of harmony and rhythm. *Ocho cuadrados,* like all of Gego's other aesthetic explorations, conveys a sense of balance that evokes that of nature's cre-ations, even though the artist used industrial materials and techniques to make her art. This comparison with nature, however, has little to do with any remnants of figuration in Gego's work. As the art critic Marta Traba has pointed out, Gego's work "does not relate to the *image* of nature . . . rather, it relates to its sense and profound structures."[1]

A discussion of *Ocho cuadrados* in relation to another of the artist's creations—*Reticulárea* (1969), from the series titled Reticuláreas—illuminates Gego's artistic goals and aspira-tions. In her 1969 *Reticulárea,* the artist used a substantial amount of metal wiring to cre-ate a mesh that filled an entire room. Viewers walking into the gallery space confronted a wire web that enveloped them from all direc-tions. Like Jesús Rafael Soto's Penetrables of the late 1960s, this piece could not simply be perceived from a single, unmoving vantage point; viewers had to physically engage with the work as they moved through the space of the gallery. Moreover, as viewers moved around and within it, they began to perceive the work's individual components, the "mod-ules" that made sense only as parts of the

larger whole. Similarly, the individual pieces and components of *Ocho cuadrados,* on their own, would have little impact on the viewer; they engage the audience only by intersect-ing with one another, by producing the work's distinct rhythms and harmony. As Traba wrote of Gego's carefully composed work, it con-tains "adequate relationships of the part with the whole."[2]

But *Ocho cuadrados* is also related to another issue central to Gego's work: her med-itations on the different genres of art, the very elements that render a particular set of mate-rials as a painting or a sculpture. Given that *Ocho cuadrados* occupies a three-dimensional space, one could simply categorize it as a sculpture and leave it at that. But the domi-nant role that line plays within the individual planes, and the interlocking of the planes with the grids, suggest that the work operates between two dimensions and three, or, more specifically, between drawing and sculpture. In a way, *Ocho cuadrados* anticipates Gego's questioning of the role of drawing in her series titled Dibujos sin papel [Drawings with-out Paper], in which she manipulated metal wiring and other industrial materials to create three-dimensional objects that also function as "drawings" (plate 47).[3] In these later works, Gego would even "depict" particular shapes within the metal meshes by using materials of different colors. In a still later piece, *Espiral roja* (1985), Gego succeeded in creating a seemingly free-floating spiral, a shape that could easily be traced onto a sheet of paper, but that demanded extensive consideration in order to be produced in three dimensions. While *Ocho cuadrados* may differ from all these other aesthetic projects because of its use of a single color and its relatively simple structure, one may ask why Gego chose a three-dimensional medium in order to create those buzzing effects at the intersection of lines. Like the works in the artist's series Dibu-jos sin papel, *Ocho cuadrados* is not merely an exercise in the creation of particular patterns or shapes; more important, the piece stands as an investigation of materials, and of the physical process through which Gego manip-ulated her materials. Although twisting and turning the different pieces of metal allowed Gego to produce a work that may resemble a drawing when it is reproduced photographi-cally, the viewer still must experience the actual piece in order to appreciate Gego's

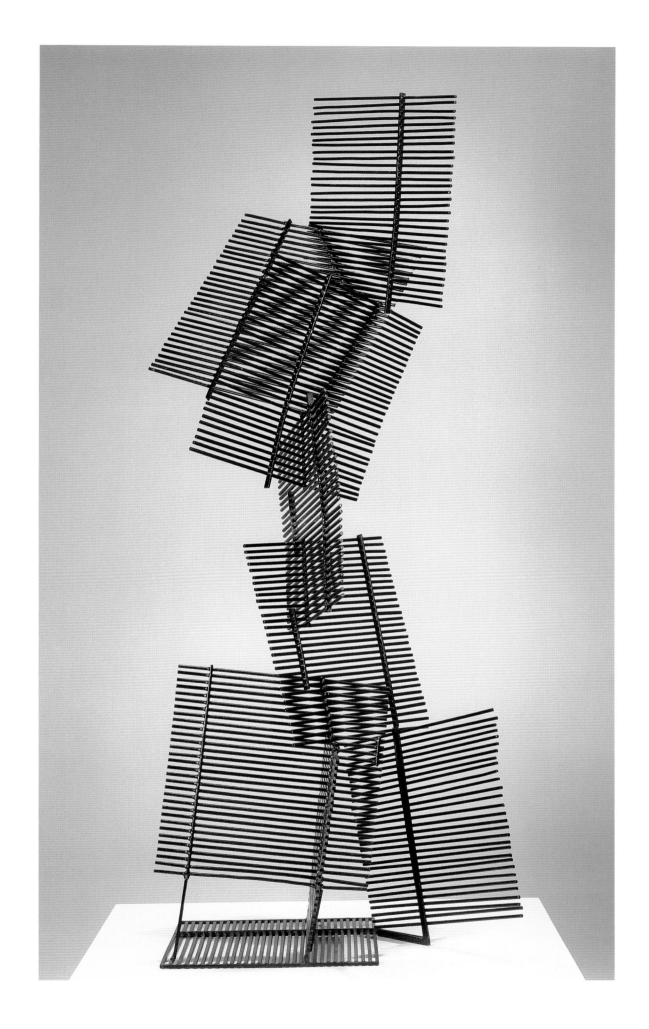

38 *Ocho cuadrados [Eight Squares],* 1961
Welded and painted iron; 170 × 64 × 40 cm (66¹⁵⁄₁₆ × 25³⁄₁₆ × 15¾ in.); Colección Patricia Phelps de Cisneros, 2000.99; copyright Fundación Gego

handling of the materials—a necessary part of the artist's process of creation.

In short, Gego's *Ocho cuadrados* may lack the overwhelming powers of spectacle possessed by the canonical *Reticulárea*. Moreover, it may lack the massive physicality of Gego's public projects, such as the multi-story sculpture built in the Banco Industrial de Venezuela, which strongly resembles the shapes and planes of *Ocho cuadrados*. And yet, if one moves around the sculptural object and considers how it illustrates the whole of Gego's artistic examinations, one can hardly consider the piece a minor exercise, a small model that helped the artist prepare for her larger projects. In *Ocho cuadrados,* Gego created an object that illuminates the whole of her artistic examinations, her concerns with the overlap between painting and sculpture, and the different ways in which the elements of a work harmonize among themselves. Viewing *Ocho cuadrados* in the gallery space, one comes closer to understanding a key figure of Venezuela's modern art movement, an artist who did not need to rely on scale to capture viewers' attention.

Alberto McKelligan

Notes

All translations are the author's.

1. Marta Traba, *Gego* (Caracas: Museo de Arte Contemporáneo, 1977), 7.

2. Traba, *Gego,* 7.

3. For more on Gego's Dibujos sin papel, see Luis Pérez-Oramas's contribution on Gego's *Reticulárea cuadrada 71/11* and *Dibujo sin papel 76/4,* this book.

1923, Ciudad Bolívar, Venezuela–2005, Paris

Two works from 1961, *Leño* (plate 39) and *Hommage à Yves Klein* (plate 40), reflect Jesús Rafael Soto's reaction to the poetic language of avant-garde artists in Paris during the late 1950s.[1] An analysis of these works within this context must pay special attention to the French Nouveaux Réalistes [New Realists] and their unofficial leader, Yves Klein, since their work addressed the same challenges as Soto's: introducing the "real" into non-figurative art; shifting away from mechanical and geometric abstraction, often termed "cold"; and finding approaches to the *perception du réel,* a perception of reality based on its immaterial essence.

The French critic Pierre Restany coined the term Nouveau Réalisme in a manifesto accompanying the group exhibition held in Milan at the Galleria Apollinaire in April 1960. Included in the exhibition were the artists Arman, César, Christo, Daniel Spoerri, Jean Tinguely, and Yves Klein, among others. Restany recognized a new trajectory for these artists: the poetic recycling of the real, the appropriation of ordinary materials and objects in the creation of an art that was actively engaged with society. He described this exciting new venture as a utopian quest:

> the passionate adventure of the real, perceived in itself and not through the prism of conceptual or imaginative transcription, . . . whether in the choice or in the slashing of the poster, the appearance of an object, a piece of household garbage, or a loss of sensitivity beyond the limits of perception.[2]

Although Soto was never technically a member of the Nouveaux Réalistes, by 1961 he had been enthusiastically involved in numerous exhibitions and activities with the group's artists, especially Klein, Spoerri, and Tinguely, as well as with those of the Düsseldorf-based Group Zero—Otto Piene, Günther Uecker, and Heinz Mack. In fact, Soto's commitment to Klein, the most influential and possibly the least typical of the Nouveaux Réalistes, was so strong that he argued with his dealer, Denise René, over her refusal to accept Klein in her gallery.[3] In 1962, after Klein's untimely death and the gradual dissolution of the Nouveau Réalistes, Soto's work abruptly returned to a basic geometric language. This reversion marked the end of a three-year period during which Soto, in an uncharacteristically

personal and expressive way, had sought to use the very materiality of his art's structural elements to unfold their essence. *Leño* and *Hommage à Yves Klein* are representative of this fascinating three-year rupture with the strict optical geometry of Soto's wall reliefs: *Leño* demonstrates a personal and physical reaction against the prevailing rigidity of geometric abstraction and the popular aesthetics of lyrical abstraction, or Art Informel, whereas *Hommage à Yves Klein* demonstrates a more conceptual reaction.

With the creation of *Leño,* a freestanding assemblage of wood, tin, wire, and nails, Soto's quiet collage sensibility exploded into a three-dimensional work of sculpture. In this particular example, Soto deviated radically from his pre-1959 pristine studies of optical vibration, in which he had superimposed painted planes of Plexiglas on wood. *Leño* is relatively small, measuring only seventy-five centimeters in height, and yet it is powerfully expressive. Soto used found materials to integrate everyday life into the work of art (very much a Nouveau Réaliste strategy), affirming the artwork as object (art as an object in and of itself, rather than as a representation of an object) and reinforcing the underlying materialism of the work's pictorial elements, which could no longer be divorced from the real world. He abandoned his earlier use of a flat rectangular wood support with Plexiglas overlays, which suggested a cool modernity, in favor of a heavy wood beam that was imposing in its physicality. The title of the work, *Leño,* implies its rawness. Ragged-edged nails driven directly into the rough sides create an aggressive, even violent, uninviting silhouette. Soto attached a scrap of tin, and he painted tenuous lines of black and white onto a rectangular panel. He embedded tangled, randomly shaped wires into the lined space, eliminating his earlier bold, clean geometric lines of crisply defined colors and replacing them with bits of blue and red commercial paint dabbed randomly onto the attached wire. The impact of the work's allusion to the pierced human body outweighs the subtle vibratory sensation that Soto sought to achieve by using the wires' visual interference. Nevertheless, Soto found in this new use of materials and this new totemic format an alternative to the "cold" optical solutions of Victor Vasarely, to the geometric abstractionists (such as the Madí), and to the lyrical

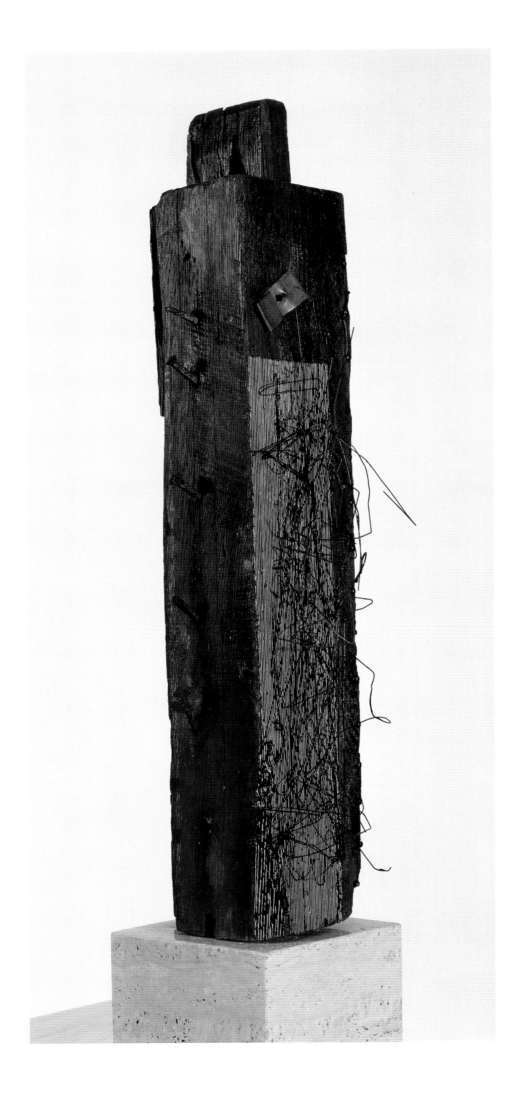

39 *Leño [Log],* 1961 Iron and wire on wood; 75 × 25 × 16 cm (29½ × 9¹³/₁₆ × 6⁵/₁₆ in.); Colección Patricia Phelps de Cisneros, 1991.60; copyright Jesús Rafael Soto Estate

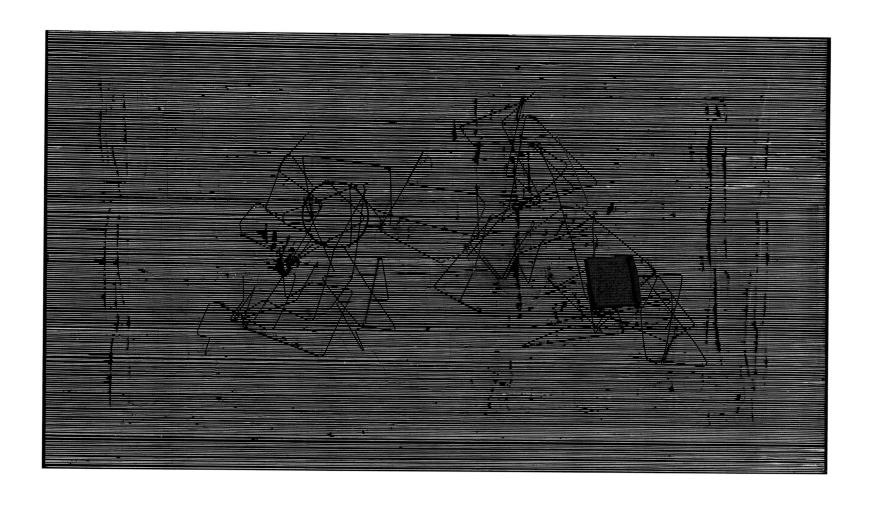

Hommage à Yves Klein [Homage to Yves Klein], 1961
Steel wires, metal, and industrial paint on sheetrock; 55 × 96 × 4 cm (21⅝ × 37¹³⁄₁₆ × 1⁹⁄₁₆ in.); Colección Patricia Phelps de Cisneros, 1995.21; copyright Jesús Rafael Soto Estate

abstractionists of Art Informel. He turned to the use of found, everyday materials to create the *immatériel,* defined as the essence of the visual perception—the spirit, the thing itself, the vibration—rather than its representation.

In contrast to *Leño's* raw power, *Hommage à Yves Klein* served as an acknowledgment of Soto's integral personal relationship with Klein. *Hommage* is one aspect of Soto's conceptual dialogue with Klein about differing approaches to light, movement, and space. His respect for Klein stemmed from his recognition that Klein was, in Restany's words, "of all of us . . . the one who most believed in the immaterial essence."⁴ In a 1969 interview, Soto identified the significance of Klein's monochrome paintings as their ability to convey the real, in a way that paralleled Kasimir Malevich's work:

> In painting white on white, Malevich wanted to say: We paint light as light. Putting it directly on the canvas. . . . It's the same proposition that Yves Klein made in his *Monochromes bleus.* . . . It's the *sign* of the real that he brings to us, and not an academic and naturalistic "rendering."⁵

Hommage makes reference at one and the same time to Soto's and Klein's approaches to the "real." Soto's overlay of gesturally drawn wires piercing the scratched, lined surface allowed him to present his investigation into vibratory sensations of movement. In addition, he interjected a discreet reference to Klein's blue monochromes: the small patch of painted blue metal in the right-hand corner conveys the vibration of light in the manner of Klein. In *Hommage,* as in many of his other works, Soto created pastiches of paint and sculpture to communicate the sensibility of light and movement through vibration. His two versions of *Vibration bleu cobalt [Cobalt Blue Vibration]* (1959) also link his works to Klein's: Soto paired his wire-pierced black-lined supports with blue fields of paint, clearly referencing Klein and creating a union of their ideas, side by side.

By 1963, Soto had returned to the suspension of geometric or open-form elements in front of a flattened wood support. The *passionante aventure du réel* was over, but it continued to influence his work in more subtle ways. His subsequent pieces no longer conveyed the emotional physicality of rough and crude everyday materials, frenetically tangled wire,

or built-up painterly surfaces. Klein's death and the eventual unraveling of the Nouveaux Réalistes, along with Soto's own growing commitment to Venezuela's optimistic modernism, redirected him; his investigations moved toward a more sophisticated voice of structured reason and veered away from Klein's quasi-mystical presence.

Estrellita B. Brodsky

Notes

All translations are the author's.

1. Soto rejected as inaccurate the term *barroco,* often used for this period of his work. He acknowledged that contemporary Parisian art movements such as Nouveau Réalisme and Tachisme, although he was never a full participant in them, offered a new vocabulary for investigating what he called *espacio temporal;* see Ariel Jiménez, *Conversaciones con Jesús Soto/Conversations with Jesús Soto* (Caracas: Fundación Cisneros, 2005), 95–103.

2. Pierre Restany, "'Les Nouveaux Réalistes,' 16 avril 1960, Milan (1er manifeste)," in Pierre Restany, *Les Nouveaux Réalistes* (Paris: Éditions Planète, 1968), 204.

3. Denise René, interview with the author, December 5, 2004, Paris.

4. Pierre Restany, "Soto l'immateriale," *Corriere della Sera Milan,* July 6, 1969.

5. Jean Clay, *Visages de l'Art moderne* (Paris: Éditions Rencontre, 1969), 132.

Lygia Clark, *O dentro é o fora [The Inside Is the Outside]*, 1963

1920, Belo Horizonte, Brazil–1988, Rio de Janeiro

Standing before Lygia Clark's *O dentro é o fora*, one cannot avoid noticing its peculiar physical characteristics: the work is a thin sheet of metal that twists back on itself, producing sensuous curves that are all the more appealing because of the industrial sheen emanating from the metal. The crevices and curves so closely resemble the shapes of natural organisms that one could almost imagine that *O dentro é o fora* is a representational sculpture, as though the artist had attempted to replicate a gnarled tree trunk, for instance. Despite these appealing characteristics, however, Clark did not create *O dentro é o fora* in order to provide audiences with an experience of purely visual pleasure. Instead, this sculptural object relates to the goals of Brazil's Neo-Concrete avant-garde, and to that movement's efforts to prompt viewers' reflection on how they perceive their surroundings through all their senses, and on how they process the continuous barrage of sensory stimuli in their daily lives.

In the text that defined and helped establish Brazilian Neo-Concretism as a particular aesthetic strategy, Ferreira Gullar described how the works that this movement produced would not be simple machines or objects. Instead, Gullar proposed the idea of the quasi-corpus, "something which amounts to more than the sum of its constituent elements; something which analysis may break down into various elements but which can only be understood phenomenologically."[1] The aesthetic projects that Gullar envisioned are not complete within themselves: these works are never finished; instead, viewers continually create and complete them through physical engagement with the art objects. Through modifications that rely on audience participation, the work of art "continuously makes itself present."[2]

Clark's series titled Bichos [Critters], produced during the same period as *O dentro é o fora,* illustrates this element of audience participation in Brazilian Neo-Concretism. The Bichos invite viewers to "play" with the work of art, feeling the interplay of physical forces between person and object. *O dentro é o fora,* although it lacks the mechanical hinges of the Bichos, also provokes this reaction in audience members, prompting them to twist the sensuous arcs of the metal with their hands. Even if viewers do not touch the sculptural object, they can imagine sliding its curves into

different arrangements and trying to perceive fully the structure and shape of the object.

But one cannot simply explain *O dentro é o fora* as an attempt by Clark to provoke her audience into physical engagement with the object. Like the Bichos, *O dentro é o fora* is related to another crucial aspect of the Neo-Concrete movement: the suspicion directed at works of art that focused excessively on rationality. At the very beginning of the Neo-Concrete manifesto, Gullar emphasized the movement's distance from "the kind of concrete art that is influenced by a dangerously acute rationalism."[3] Brazilian artists of the Neo-Concrete movement wanted viewers to reflect on the limitations of reason rather than simply focus on the formal innovations of geometrically abstract art; they wanted audience members to resist a purely scientific and potentially limiting view of the world they inhabited. In other words, artists such as Clark wanted audience members to consider how their own bodies continuously collaborated with the world to produce meaning and understanding.

Throughout her life, Clark repeatedly expressed her interest in producing works of art that provoked these sorts of effects in her audiences. In a letter written to Hélio Oiticica from Paris, Clark expressed her dissatisfaction with the art she encountered in that city: "You see, what is missing is the transposition that *goes beyond* the object. It's the absolute lack of metaphysics."[4] Even before spending time in Paris, she had already expressed an interest in humanity's role in contemporary society, our existence in a universe she described as dense and complex. In her text "A morte do plano" ["Death of the Plane"], she stated:

We plunge into the totality of the cosmos; we are a part of this cosmos, vulnerable on all sides—but one that has even ceased having sides—high and low, left and right, front and back, and ultimately, good and bad—so radically have concepts been transformed.[5]

O dentro é o fora stands as an effort to go beyond the object, as Clark attempts to modify the very perceptual processes of her audience. The twisting sheet of metal not only asks viewers to consider whether they are "inside" or "outside" the work of art but also pushes them to wonder whether the work of art has sides at all. *O dentro é o fora* functions

as the metallic equivalent of Clark's explorations with the Möbius strip, a piece of paper that the artist folded onto itself to form two sides into a single surface. If one only looks at the Möbius strip—if one engages with it only through vision—the paper appears to have two surfaces, each corresponding to one side of the sheet. But if one traces the twisted sheet of paper, if one engages with it by touching and feeling it, one eventually realizes that it has only one surface. The different meanings that vision and our touch produce in contact with the Möbius strip parallel the effects of Clark's *O dentro é o fora.*

In this way, *O dentro é o fora* anticipates Clark's later use of art as therapy, a practice through which she enveloped individuals in masks, gloves, and various body suits. In pieces such as *Estructuraçao do self [Structure of the Self]* (1970–1980), Clark attempted to transform or alter the minds of viewers by barraging their senses with a wide variety of stimuli, such as the sounds of shells being crushed or the smell of coffee. *O dentro é o fora* may seem relatively tame in comparison, a less invasive strategy by the same artist. Nevertheless, standing in the gallery space, one may ask whether Clark's silent sculptural object may not wield, after all, as much power as her therapeutic art pieces loaded with sensory stimuli.

Alberto McKelligan

Notes
1. See Ferreira Gullar et al., "Neo-Concrete Manifesto," in Yve-Alain Bois et al., *Geometric Abstraction: Latin American Art from the Patricia Phelps de Cisneros Collection/Abstracción Geométrica: Arte Latinoamericano en la Colección Patricia Phelps de Cisneros* (Cambridge, Mass.: Harvard University Art Museums; and Caracas: Fundación Cisneros, 2001), 154 (originally published as Ferreira Gullar et al., "Manifesto neoconcreto," *Jornal do Brasil,* March 22, 1959).
2. Gullar et al., "Neo-Concrete Manifesto," 155.
3. Gullar et al., "Neo-Concrete Manifesto," 152.
4. Lygia Clark, "Letter to Oiticica, 1/19/64," in Bois et al., *Geometric Abstraction,* 156 (emphasis in original).
5. Lygia Clark, "A morte do plano"/"Death of the Plane," in Bois et al., *Geometric Abstraction,* 159.

Carlos Cruz-Diez, *Physichromie No 126*, 1964

b. 1923, Caracas; lives in Paris and Caracas

*P*hysichromie No 126 (plate 41) beckons to the viewer in a way that sets it apart from Carlos Cruz-Diez's other Physichromies. Unlike these, *Physichromie No 126* does not rely on the mutable properties of color, nor on the ability of different colors to blend into new tones and form floating, dynamic geometric patterns. Instead, *Physichromie No 126* recalls the works of the Hungarian artist Victor Vasarely, particularly his black-and-white paintings of the 1950s and early 1960s. In these works, Vasarely gave the flat canvas a virtual third dimension by distorting the figure/ground relationship in such a way that the figure simultaneously emerges into and disappears from the spectator's line of vision, often with the help of a gridded base. Similarly, Cruz-Diez focused on the illusionistic interplay of foreground and background in order to jar the viewer's sense of space and to initiate an engaged, participatory experience with the work of art.

Cruz-Diez divided *Physichromie No 126* into four equal panels or squares. Seen from a considerable distance, these sections, predominantly filled with vertical stripes of black and white, blend together and give the effect of various shades of gray. Yet closer inspection reveals that zigzags interrupt this continuous repetition of vertical lines and initiate an optical illusion, apparently darkening or lightening sections within each square. As the viewer approaches the work, its tactile quality becomes apparent; the picture plane is not a smooth surface but consists of thin strips glued perpendicularly onto the support. Cruz-Diez, concerned with the effects of color and light on the retina of the beholder's eye, also incorporated a temporal dimension by initiating a perceptual and phenomenological dialogue based on the position of the viewer vis-à-vis the work.[1] By treating color—or, in this case, the combination of black and white—as an active agent, Cruz-Diez transformed *Physichromie No 126* into more than a static, two-dimensional object. It became an embodied sensory experience.

Cruz-Diez's oeuvre challenges the Renaissance notion that a painting functions as a "window on the world," as a fixed and eternal image. Instead, his work engages the spectator with the object in a perceptual dance that foregrounds the relationship between viewing subject and visual object. Cruz-Diez wrote extensively on his explorations of color theory, and he has described the works in his Physichromies series as:

> structures that reveal different responses to and other conditions of color. Their transformation relies on the quality of light and on the spectator, projecting color in space and creating an evolving situation. The accumulation of "chromatic event modules" initiates different additive, reflective, or subtractive color climates.[2]

It is this continuous evolution of the image that makes Cruz-Diez's works feel more like animated, even kinetic, surfaces than stable works of art.

Upon his arrival in Paris, in 1960, Cruz-Diez found a support network already in place in the Galerie Denise René, where his fellow Venezuelan Jesús Rafael Soto and the Argentines Julio Le Parc, Martha Boto, Gregorio Vardánega, and Luis Tomasello, among others, exchanged ideas and exhibited their work to a public excited about the interactive possibilities of this new art. These recent South American immigrants formed a loosely organized group whose primary goal was to create an art that would be oriented toward mass culture and that would force people to interact with and physically connect with the objects in question.

But at the heart of this work, as Cruz-Diez's *Physichromie No 126* demonstrates, is the question of individual viewership, or how the spectator comes to understand and make sense of the work of art. Cruz-Diez, like many other Latin American artists in the 1960s, was interested in phenomenology and turned to the writings of Maurice Merleau-Ponty. The artist was concerned with optical effects and their corresponding physical and behavioral reactions, and his goal was to use visual and perceptual experiences to involve spectators viscerally in his color environments, thus challenging what he has referred to as the average viewer's "programmed" response to color.[3]

The Physichromies series eventually led Cruz-Diez to his Chromosaturations, works that not only play with the viewer's field of vision and perception of form and color but actually transform the everyday environment into a monochromatic setting. His *Chromosaturation* (1968) consisted of three booths, covered with translucent red, green, and blue acetate on aluminum frames, that he positioned outside the Odéon metro station in Paris. As the

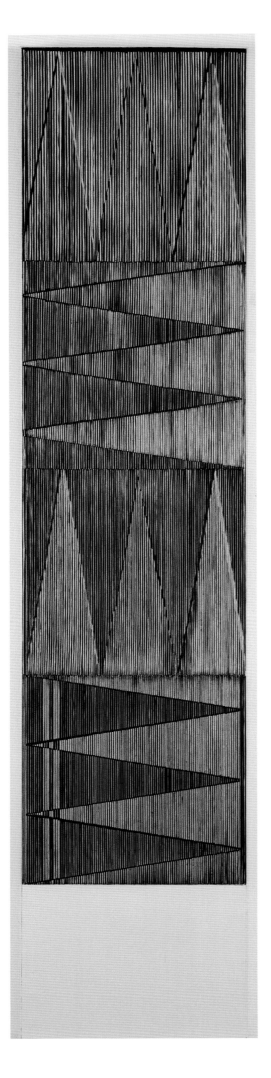

41 *Physichromie No 126,* 1964
Ink, industrial paint, silver metal paper on sheetrock;
143 × 31.8 × 4.5 cm (56⁵⁄₁₆ × 12½ × 1¾ in.); Colección Patricia
Phelps de Cisneros, 2001.87; copyright Carlos Cruz-Diez

viewer walked through each of the chambers, his or her view of the surrounding streets and buildings would be bathed in a different color and momentarily transformed. Cruz-Diez forced the viewer to look at an everyday scene in an unfamiliar fashion, literally in a different light. *Chromosaturation,* like the artist's Physichromies series, reveals Cruz-Diez's interest in redefining the terms of aesthetic experience by empowering the viewer to *feel* rather than *think* the meaning of the work of art. Carlos Cruz-Diez and other Latin American artists of his generation, by exploring the phenomenon of human perception through color, opticality, and motion, opened up a space for viewers' sensory and physical experience, allowing them to intervene in and directly participate in the work of art.

Martha Sesín

Notes

All translations are the author's.

1. Julio César Schara, *Carlos Cruz Diez y el arte cinético* (Mexico City: Arte e Imagen, 2001), 80.

2. Schara, *Carlos Cruz Diez y el arte cinético,* 73.

3. Schara, *Carlos Cruz Diez y el arte cinético,* 68.

Jesús Rafael Soto, *Vibración—Escritura Neumann [Vibration—Neumann Writing]*, 1964

1923, Ciudad Bolívar, Venezuela–2005, Paris

Jesús Rafael Soto's *Vibración—Escritura Neumann* (plate 42), a work in the Escrituras series that the artist began in 1957, consists of thin wire coils that appear to hover in space, the twisted shapes suspended in front of a large rectangular background composed of thin white stripes on a black ground or, conversely, of thin black stripes on a white ground. With an all-over geometric patterning, the piece recalls the geometrically abstract works of previous decades by such artists as Josef Albers, or by artists of the Dutch group De Stijl, except on a larger scale. Yet Soto's piece, with its handcrafted sculptural elements hanging in front of the canvas, disrupts the standard viewing position of post–World War II abstract painting, which places a stationary and disembodied viewer directly in front of the picture plane.

Instead, *Vibración—Escritura Neumann,* which uses both screen and wire to produce an optical and visceral experience based on the vibration of the metal coils in front of the striped ground, encourages the viewer's physical interaction with the work. The movement of the coils in response to changing air currents, and the viewer's movement around the work, initiate a strange perceptual experience. Through strategies of play, Soto not only manipulated the viewer's sense of space but also established a dialogue between the viewer and the work, in which the body of the viewer triggers the movement or the completion (one that is in continuous motion) of the work of art itself. By combining a two-dimensional ground of geometric patterning with three-dimensional items, such as rods, wires, and nylon twine, Soto incorporated kinetics into his production, instilling elements of modern technology, industrial materials, and play.

Soto, one of the first of his generation of abstract artists to move to France from his native Venezuela, settled in Paris in 1950. He participated in the landmark 1955 exhibition *Le Mouvement* at the Galerie Denise René, and his works, like those of other contemporary Op and Kinetic artists, sought to imbue a traditional geometric abstract language with a new dynamic.[1] Soto, influenced by the works of Piet Mondrian and Kasimir Malevich, looked for ways to transform the virtual movement present in early twentieth-century avant-garde production into three-dimensional form.[2] *Vibración—Escritura Neumann,* its

title a reference to the Venezuelan industrialist and collector Hans Neumann,[3] lures the viewer into the interplay of background and foreground. At some moments, the aluminum coils distort the perfectly arranged striped background; at others, the twisted spirals appear to melt into it. As one moves forward and backward and from side to side in front of the work, the hanging elements take on a life of their own, challenging and questioning the spectator's visual acuity. Invariably linked to the presence of the spectator, *Vibración—Escritura Neumann* produces an ambiguous sense of space within the artwork itself, a sense that in turn hinges on the actual distance between the work and the viewer.

Like Carlos Cruz-Diez, his fellow Venezuelan practitioner of Op and Kinetic art, and like the Argentine artists Luis Tomasello, Julio Le Parc, and Martha Boto, Soto left his homeland in search of a more fertile climate for the production of his art, a place that would lend his work legitimacy. Paris ultimately fulfilled these goals. As a city central to the history of avant-garde art, Paris offered Soto and others in this diverse group a place in the grand narrative of art history and, more importantly, a public excited about the possibilities of Kinetic art.

In his Escrituras series, Soto suspended thin coils that form interactive loops in front of geometrically abstract screens, creating the impression of scribbled or doodled lines on a scrap of paper. Initially interested in optical effects, or "optical vibrations," as demonstrated by his Repetitions series (1951), Soto moved on to multilayered works in which he superimposed two or three Plexiglas surfaces of various colors and textures to create the impressions of ambiguous space and optical movement through the active participation of the viewer. Movement, illusory or real, is the central preoccupation of Soto's work. After his early series of works using Plexiglas, Soto began suspending elements between a striated Plexiglas surface and an opaque one, incorporating optical vibrations and actual movement into a single work. This approach led to a series of geometric paintings in which the artist suspended objects, such as metal rods or twisted wire, that disrupt the ground of the painting through visual vibrations. In his Escrituras series, Soto literally drew "in space," liberating himself from any sort of constraint called up by the material

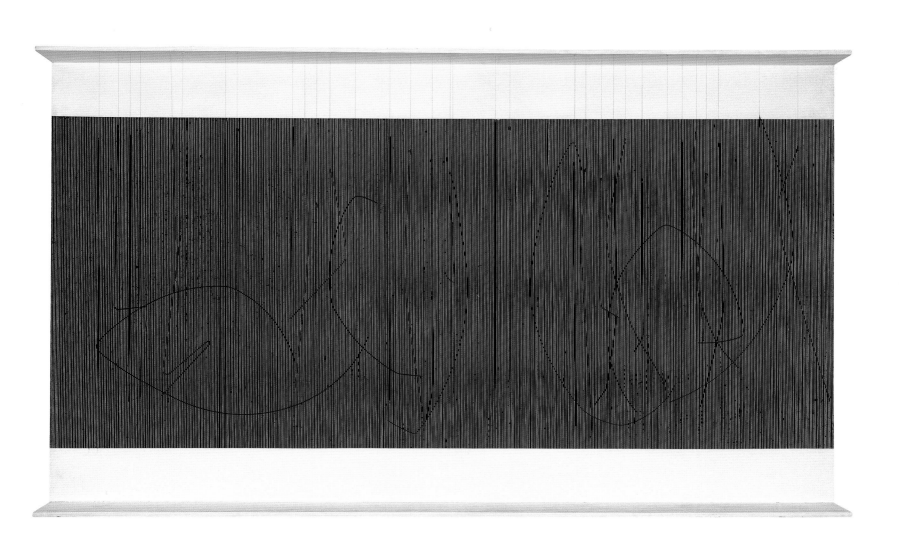

42 *Vibración—Escritura Neumann [Vibration—Neumann Writing],* 1964
Wire, industrial paint, and nylon on sheetrock and wood; 102 × 172.5 × 16 cm (40³⁄₁₆ × 67¹⁵⁄₁₆ × 6⁵⁄₁₆ in.);
Colección Patricia Phelps de Cisneros, 2001.16; copyright Jesús Rafael Soto Estate

support.[4] (The name of the series emerged later, after viewers repeatedly mentioned the twisted wires' resemblance to actual script and expressed curiosity about the supposedly encrypted messages.)

Soto shared with other Op and Kinetic artists in Paris a desire to make abstract art socially relevant. Thus these artists can be understood as belonging to a Constructivist tradition in more than formal terms, although they did not model themselves on the Russian Constructivists' political engagement. Instead, they sought a public art available to the masses. By reinvigorating the tradition of geometric abstraction—which by the late 1940s and early 1950s had come to seem largely irrelevant, despite the advocacy of such earlier groups as Cercle et Carré [Circle and Square] and Abstraction-Création—the Latin American Op and Kinetic artists shook up a public accustomed to the introspective aesthetic of lyrical abstraction, and to the detached or passive stance of the viewer. But the factors behind these artists' success also led to their demise. In fact, the public's embrace of Soto's work, and of work by other Op and Kinetic artists, led many critics to the conclusion that this apparently enjoyable, whimsical art was not to be taken seriously. Unfortunately, that position influenced subsequent art historical scholarship, which has yet to adequately assess the impact of this work on a critical moment in postwar France and on modern art in general.

Martha Sesín

Notes
1. The phrase "traditional geometric abstract language" refers in particular to those artists who were attempting in the early part of the century, and in the 1920s and 1930s, to revive a Constructivist tradition—such artists as César Domela, Georges Vantongerloo, Jean Arp, and Max Bill, and such groups as Abstraction-Création and Cercle et Carré [Circle and Square], among others.
2. Jacqueline Barnitz, *Twentieth-Century Art of Latin America* (Austin: University of Texas Press, 2001), 203. This idea was initially conveyed to the author in an interview with Luis Tomasello in 2003. Tomasello, while showing the author his works, suggested that if Mondrian had lived longer and continued along the path he was on, the virtual movement that he had tried to capture in his works would have morphed into something more three-dimensional.
3. Ariel Jiménez, *Conversaciones con Jesús Soto/Conversations with Jesús Soto* (Caracas: Fundación Cisneros, 2005), 103. Soto, in his discussion with Jiménez, recounted how he borrowed Neumann's studio in Caracas in 1961 in order to complete one of his works.
4. Jiménez, *Conversaciones con Jesús Soto*, 195.

This amorphous rubber organism, with its reliance on participation, is a work that Lygia Clark, in retrospect, was to deem a regression.[1] Nevertheless, it marked an important step forward in her personal artistic trajectory as well as in the broader development of Brazilian Neo-Concretism. Indeed, *Obra mole* occupies a critical intermediary stage—marked by the theorization of the Neo-Concrete *não-objeto* (non-object)—between the radical investigations of the surface that engendered Neo-Concretism in 1959 and Clark's ultimate eradication of the object in the 1970s. *Obra mole* belongs to a group of works from the early 1960s in which the artist challenged traditional sculptural genres by abandoning monumentality and liberating the object from the conceptual and physical constraints of the pedestal.

"Teoria do não-objeto" ["Theory of the Non-object"]—which the poet, critic, and theorist Ferreira Gullar wrote on the occasion of the second exhibition of Neo-Concrete art, held in Rio de Janeiro in 1960—advanced the movement's founding mission to transcend the "figure-ground contradiction."[2] According to Gullar, Concrete art had failed to find a way to prevent the translation of markings on a flat surface into an "object" against a "background." Gullar, reasoning that this paradox was inherent in all categories of representation, even the most abstract, proposed a total rethinking of the notion of art. Gullar defined the "non-object"—not to be confused with an "anti-object," or with the object's negation—as originating "directly in and of space," and he envisioned in it "both a re-creation and a new founding of space."[3]

Implicit in such "spatial transformation" was an emphasis on materiality that engaged the interrelated Neo-Concrete principles of "multi-sensoriality" and the "quasi-corpus," or "almost-body." Neo-Concretism, without abandoning either the geometric vocabulary of Constructivism or that movement's social engagement, challenged the presumed universality of reason and vision. Invoking the Swiss functionalist architect Le Corbusier, who had been immensely influential in Brazil's postwar urbanization, the Neo-Concretists rejected the notion of art as a "machine," likening it instead to a "living organism."[4] The "quasi-corpus" sought to redress the "dangerous hypertrophy of rationalism" to which, the Neo-Concretists charged, the French movement

known as Art Concret had "succumbed"; the "almost-body" restored the primacy of the object over the theory of its realization and, in so doing, reintegrated the subject—the active participant.[5] Clark, exemplifying these goals, introduced her series titled Bichos [Critters] (1960–1964)—articulated metal objects meant to be handled by the participant.[6] These three-dimensional "beings," composed of triangular and rectangular planes connected by multiple hinged spines, had no normative orientation; participants could fold them into a wide variety of positions, giving them a life that was animated through these objects' independent and idiosyncratic relations with the participants.

Clark's efforts to create something more "ambiguous" led her to the formless works she called Obras moles.[7] Unlike the rigid works in the Bichos series, these works, composed of flaccid piles of twisted, buckling rubber, lacked any structure beyond that provided by the participant, who was free to hang the works on the wall, drape them over objects or architecture, or dangle them from trees as he or she saw fit. Thus the Obras moles epitomize the "non-object," simultaneously the product and the engine of "spatial transformation," which originates over and over again in the real world of the participant. Moreover, the common, durable rubber of these works enhances their accessibility while further deconsecrating the art object, in keeping with the original Constructivist spirit.[8] Clark recalled being delighted when she showed an *Obra mole* to the critic Mário Pedrosa, who threw it carelessly on the floor and exclaimed, "At last, a work of art I can kick!"[9]

Despite their resistance to mechanistic causality and notions of artistic objectivity, the Obras moles nevertheless reflect the modern, urban context that conditioned their inception. Whereas an earlier generation of geometric abstractionists in Brazil had celebrated technology through the use of plastics, shiny industrial paints, and aluminum, Clark turned to a more familiar, less fetishized industrial material, deeply embedded in Brazil's urban quotidian existence: the ordinary rubber found in the workshops of auto mechanics. Furthermore, the polysemic Obras moles do not renounce Euclidian geometry but, on the contrary, seek out the expressive potential and existential implications latent in mathematical and physical postulates. Clark was

interested particularly in the Möbius strip, which occupied Euclidean space yet defied rational expectations. *Obra mole* emerged from the artist's various meditations on the Möbius strip, which she explored first through soft metal in 1963 in *O dentro é o fora [The Inside Is the Outside]* and *O antes é o depois [The Before Is the After]* and then, in 1964, in the stainless steel *Trepantes [Climbers]*.[10] The Möbius strip, a two-sided form with only one surface, extracts three-dimensionality from a two-dimensional plane and at the same time instances the infinite. Clark, commenting on the appeal of the Möbius strip, explained, "It breaks with our spatial habits: right/left; front/back, etc. It forces us to experience a limitless time and a continuous space."[11]

Obra mole and its relation to the Möbius strip indicate how Clark's investigations of the plane allowed her to probe deeper issues of human existence. She had long held that the abstract invention of the plane was symptomatic of, if not responsible for, the fragmentation of the subject. Man's futile search for balance through reason, she contended, elicited the "opposing concepts of high and low, front and back—exactly what contributes to the destruction in humankind of the feeling of wholeness."[12] The continuity of the Möbius strip moved toward the restoration of the "organic" in the plane: "To demolish the picture plane as a medium of expression is to become aware of unity as an organic, living whole."[13] *Obra mole* represents the culmination of this search: the flat plane that is not a surface, which drapes over objects, and which folds and bends around corners. It is the plane that responds to environmental forces as a living organism does, that obeys the laws of physics and time, of gravity, inertia, and entropy.

Obra mole's interactive imperative indicates the direction of Clark's aesthetic while bringing the meaning of the "non-object" one step closer to dematerialization of the object. In the privileging of the act, the object assumes a subordinate function. Similarly, the physical experience subsumes the visual. As Clark observed, "Space is now a kind of time ceaselessly metamorphosed through action. Subject and object become essentially identified within the act."[14] Nevertheless, as we have seen, Clark did later regard *Obra mole* as a regression, coming as it did on the heels of her first performance, *Caminhando [Trailings],* in which she carefully halved and halved again a paper Möbius strip; with each cut, the form became paradoxically longer, until the paper could withstand no more dissection. Still, Clark did concede the necessity of a "return to the object," explaining: "In fact [the Obras moles] prefigured my experiences with the sensory: their sensuousness, elasticity, uncon-

sciously indicated what was to come."[15] That is, the materiality of the Obras moles—the mere physical presence of the objects—may have pulled Clark back a step in her progress toward the pure psychotherapeutic experiments, enacted through the body, that would occupy her later career, but the somatic, organic character of these objects approximated and anticipated the real body, thus merging the object and performance in their mutual and inevitable destruction.[16]

Edith Wolfe

Notes

1. Guy Brett, "Lygia Clark: The Borderline between Art and Life," *Third Text* (autumn 1987): 75.

2. See Ferreira Gullar, "Theory of the Non-object," trans. Tony Beckwith, in Mari Carmen Ramírez and Héctor Olea, eds., *Inverted Utopias: Avant-Garde Art in Latin America* (New Haven, Conn.: Yale University Press in association with the Museum of Fine Arts, Houston, 2004), 521–22 (originally published as Ferreira Gullar, "Teoria do não-objeto," *Jornal do Brasil,* November 21, 1960).

3. Gullar, "Theory of the Non-object," 521–22.

4. See Ferreira Gullar et al., "Neo-Concrete Manifesto," in Yve-Alain Bois, "Nostalgia of the Body: Lygia Clark," *October* (summer 1994), 91 (originally published as Ferreira Gullar et al., "Manifesto neoconcreto," *Jornal do Brasil,* March 22, 1959).

5. Gullar, "Neo-Concrete Manifesto," 91.

6. See Jodi Kovach's contribution on Lygia Clark's *Bicho,* this book.

7. Brett, "Lygia Clark," 75.

8. In an effort to eliminate the divide between art and life, Russian and other first-generation Constructivists had abandoned such rarefied traditional media as oils and marble, turning instead to ordinary materials from industrial design—for example, glass, tin, sheet metal, rope, and plywood—that would engage rather than awe the proletarian viewer.

9. Cited in Ricardo Nascimento Fabbrini, *O espaço de Lygia Clark* (São Paulo: Editora Atlas, 1994), 84. Author's translation.

10. See Alberto McKelligan's contribution on Lygia Clark's *O dentro é o fora,* this book.

11. Lygia Clark, "Trailings," in Bois, "Nostalgia of the Body," 99.

12. Lygia Clark, "Death of the Plane," in Bois, "Nostalgia of the Body," 159.

13. Clark, "Death of the Plane," 159.

14. Lygia Clark, "About the Act," in Bois, "Nostalgia of the Body," 104.

15. Cited in Brett, "Lygia Clark," 75.

16. Although Clark, after 1968, increasingly distanced herself from the object, she adamantly opposed comparisons between, on the one hand, her psychotherapeutic work involving individual and collective bodies and, on the other, "body art," "happenings," and even performance (which, by definition, presumes the presence of a passive voyeur). Clark never explicitly labeled the "courses" that she conducted in Paris throughout the 1970s and early 1980s, but Bois recalled her likening them to a "type of social electric shock"; see Bois, "Nostalgia of the Body," 88.

Hélio Oiticica's *Box bolide 12* (plate 43), even displayed on a pedestal, hardly fulfills the traditional standards of sculpture. Oiticica juxtaposed an assortment of materials in different colors and textures that seem discordant; a wrinkled piece of orange fabric stands inside a box painted a glaring shade of yellow, and a pastel pink hue covers other parts of the work. Moreover, the artist did not present the different colors and materials in pristine condition: layers of unevenly applied paint cover the pink-and-yellow box, which contains scattered pieces of debris. On close inspection, viewers even notice pieces of cord that seem to emerge from the edges of the boxes, as though the entire object were the remains of a construction site or some sort of industrial manufacturing process. In *Box bolide 12* Oiticica was not focused on creating a sculptural object that conformed to ideals of beauty, nor was he interested in constructing geometric or abstract works that spoke in a "universal" language. With this work, Oiticica explored artistic production, the ways in which particular materials—a scrap of cloth, a pile of debris—acquire the status of art. Is the wrinkled piece of orange fabric art simply because the artist chose to label it so? Does it matter that the artist chose inexpensive materials, such as dirt, and unevenly applied paint in order to create the piece? *Box bolide 12* stands as the result of Oiticica's attempts to redefine artistic practice, endeavors that placed him at the center of Brazil's avant-garde.

As the title implies, *Box bolide 12* is but a single example in a series of works. In a text originally written in 1963, the artist explained that he originally had intended to explore the "structure of color" with his series of Bolides, a word that loosely translates as "nucleus."[1] Oiticica created three-dimensional objects containing pigments, the raw materials that eventually provide the colors for paints and other art materials. For instance, his *Glass Bolide 4 Earth* (1964) consists of an open glass vessel full of colored earth and a scrap of cloth of the same color. Guy Brett has related the immediate power that these explorations in color exercised over audience members: "It was Oiticica's colour which instantly magnetized me when I first saw some of his Bolides in 1965."[2]

As Oiticica explained in his own writing, however, the Bolides series eventually led him to explorations that went beyond color. Constructing the Bolides with such raw materials as dirt and pigments, shreds of cloth, and glass jars, he began to question the process through which materials become elements of a work of art. The artist dismissed the idea that he was simply transforming everyday materials by giving them a new context and labeling them art: "What I do, upon transforming [an object] into a work [of art], is not simply to make the object 'lyrical' or place it outside the everyday."[3] And, indeed, Oiticica's *Box bolide 12* was not an attempt to echo Marcel Duchamp's ready-mades. Instead, Oiticica was interested in creating a new category, in between that of the everyday and that of art, in which the objects he presented could exist. In a sense, he wanted his audiences to see that the wrinkled and corrugated materials he had inserted into the Bolides retained all their physical characteristics, their status as "things," even when joined together in and as a work of art. As the artist stated, the piles of debris and the unevenly painted surfaces, incorporated into an "aesthetic idea," thereby became an element of the work's "genesis" and assumed a "transcendental character," each element "participating in a universal idea without losing its previous structure."[4] Viewers perceive this tension between the materials' original status as everyday objects and their new status as elements of a work of art, a tension that makes a work in this series a "Trans-Object," a term coined by Oiticica. As the viewer stands in front of a finished work in the series, the weathered qualities of Oiticica's materials appear essential to it. Oiticica's achievement with the Bolides series lay not in destroying the structure of his materials but in "transporting" them, "closed and enigmatic," from their condition as things to a condition of being elements of the work.[5]

The status of *Box bolide 12* as a Trans-Object makes it characteristic of Brazil's avant-garde practices as Oiticica himself identified and defined them in a text originally published in 1967.[6] In that text, Oiticica explained that Brazilian artists were interested in creating works of art that would radically redefine artistic practice. The artists grouped around what Oiticica labeled the New Objectivity, among them Lygia Clark, were not simply interested in creating paintings or sculptures. Instead, they challenged such strict definitions, creating objects that forced

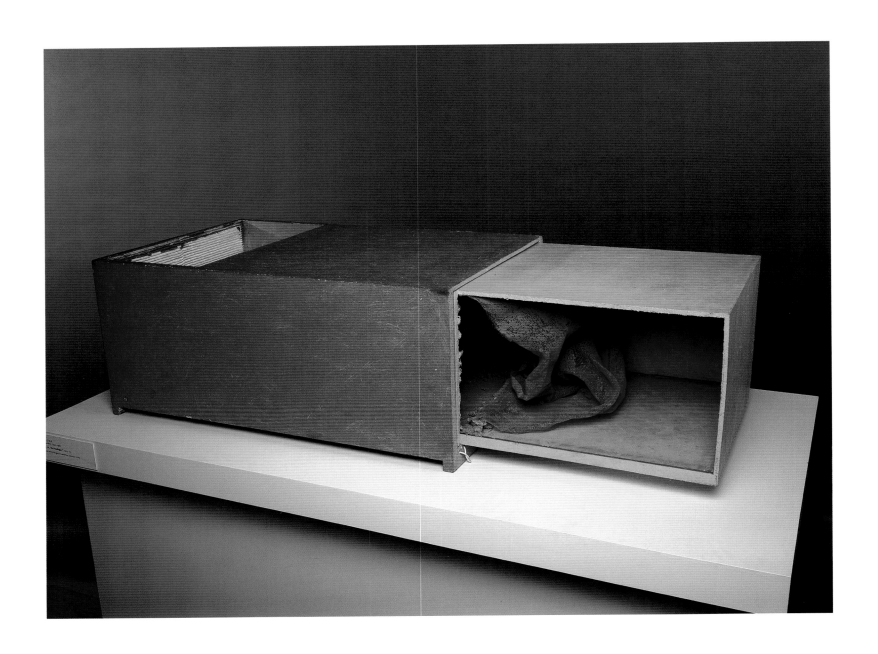

43 *Box bolide 12, "archeologic,"* 1964–1965
Synthetic polymer paint with earth on wooden structure, nylon net, corrugated cardboard, mirror, glass, rocks, earth, and fluorescent
lamp; 37 × 131.2 × 52.1 cm (14½ × 51⅝ × 20½ in.); The Museum of Modern Art, New York, fractional and promised gift of Patricia Phelps
de Cisneros in honor of Paulo Herkenhoff, 326.2004.a–d; copyright Projeto Hélio Oiticica

viewers to question the rigid nature of these distinctions, even as they attempted to transform society by fully engaging their audiences. Admittedly, other works by Oiticica may better exemplify the goals of Brazil's avant-garde. For example, viewers actually had to wear and move around in the works in the iconic Parangolés series in order to activate them as works of art. Moreover, these works more clearly represented "an engagement and a position on political, social, and ethical problems";[7] in fact, Oiticica prompted the residents of Rio de Janeiro's *favelas,* or hillside slums, to participate in an opening at the city's Museu de Arte Moderna by donning Parangolés and then walking and dancing among the city's upper classes.

Even though *Box bolide 12* does not engage the viewer's bodily participation to the extent that the Parangolés do, it still conforms to the goals of Oiticica's New Objectivity. The artist intended that audience members should interact continuously with the work, touching the different materials and feeling the different textures and qualities of its parts. Viewers should slide their hands into the work, allowing their senses of sight, touch, and smell to perceive the work in myriad ways. By prompting audience members to engage with the work, and by asking them to understand it as a Trans-Object, Oiticica challenged them to change how they understood their entire surroundings, how they perceived material objects around them: if a pile of dirt and weathered fabric could be necessary to the completion of a work of art, then other seemingly useless objects around them might also become part of something greater. Thus *Box bolide 12* and other works in the Bolides series asked viewers to look at the world in a different way, using a vision that neither depends exclusively on rationality nor reduces the world to a mass of physical, material objects. Oiticica hoped that this new vision would prompt new kinds of behavior and lead to a different kind of society, one that would not try to insert individuals into easy categories. Present-day viewers of Oiticica's work, no longer able to engage with it in the multisensory way that Oiticica envisioned, must decide whether these aspirations represent unrealistic utopian ideals or a challenge that remains ever present and relevant.

Alberto McKelligan

Notes

1. See Hélio Oiticica, "Bolides," in Guy Brett, Catherine David, Chris Dercon, Luciano Figueiredo, and Lygia Pape, eds., *Hélio Oiticica,* various translators (Minneapolis, Minn.: Walker Art Center; and Rotterdam: Witte de With Center for Contemporary Art, 1993), 66. Originally, in his explorations with the Bolides series, Oiticica was interested in presenting color in its "purest" form. The Venezuelan artist Carlos Cruz-Diez eventually echoed Oiticica's desire, creating his Chromosaturations, where he inundated entire rooms with lights in a single color. The different strategies through which both artists attempted to present pure color reveal their different relationships to materials.

2. Guy Brett, "The Experimental Exercise of Liberty," in Brett, David, Dercon, Figueiredo, and Pape, eds., *Hélio Oiticica,* 224.

3. Oiticica, "Bolides," 66.

4. Oiticica, "Bolides," 66.

5. Oiticica, "Bolides," 66.

6. Hélio Oiticica, "General Scheme of the New Objectivity," in Brett, David, Dercon, Figueiredo, and Pape, eds., *Hélio Oiticica,* 110–20.

7. Oiticica, "General Scheme of the New Objectivity," 110.

1937–1980, Rio de Janeiro

Hélio Oiticica's *Parangolé P16 capa 12* (plate 44) is a cape-like garment constructed of everyday materials that the artist collected from the urban and rural environments in and around Rio de Janeiro. This particular work is one part of Oiticica's Parangolés series of banners, tents, and multilayered capes that he originated in the mid-1960s. Although works in the series are now displayed in galleries as art objects, Oiticica initially de-emphasized their material components by describing these works as merely the structural basis of a collective form of creative expression, which the participant/viewer wearing one of the works would activate through bodily interaction with it. Oiticica created *Parangolé P16 capa 12* as an aesthetic vehicle for extemporaneous collective expression, to reflect the spontaneity and collective dimension of Brazilian popular dances and festivals.

When the participant's body sets *Parangolé P16 capa 12* in motion, layers of color and texture unfurl, revealing an inscription on the layer of white fabric that reads "Da adversidade vivemos" ("We Live from Adversity"). Oiticica used this slogan as part of his effort to distinguish Brazilian art, culture, and society during a period of Latin America's increasing economic dependence on the United States. As used in this work, the slogan shifts in and out of the folds with the movements of the person wearing the cape; the artist's general use of this slogan emerged as an aspect of his avant-garde proposition for cultivating new creative possibilities from the disparity between the modernist concepts that informed his art practice and the social crises created by Brazil's uneven modernization and development. By working within frameworks of European art while reviving the roots of Brazilian popular culture in his artwork, Oiticica attempted to create a counterpoint to European culture.

With his Parangolés series, Oiticica sought to revolutionize Western modes of art making, subjectivity, and sociability. He designed these works to generate interactivity between the participant's body, on the one hand, and geometric form and color, on the other. He also sought to transform the relationship between the participant interacting with one of these works and those watching his or her performance with it, moving them from their respective positions as observed and observer

to the shared position of fellow actors in a collective, co-creative enterprise.[1] The Parangolés series is the culmination of Oiticica's experimental integrations of color, structure, space, and time, which he began in the late 1950s with the Metaesquemas [Metaschemes] series of two-dimensional abstract geometric paintings. In 1960, he extended color into the physical space of the viewer with the two-sided monochrome paintings in two series titled Bilaterals and Spatial Reliefs, and in his Penetrables series of architectural enclosures that required the viewer to move around and between the spaces articulated by the object. With the Parangolés, Oiticica proposed that the participant's dance-like movements should activate color and form in space, thus transforming the artwork from a visual index of the creative act into an action itself. In this way, he pushed the properties of painting beyond the two-dimensional confines of the canvas and into the realm of experience. The participant, by setting the Parangolés into motion in space, becomes the focal point of a collective creative/perceptual experience, or what Oiticica described as a "*Parangolé* environmental system," in which the artistic action intersects the real, lived experiences of participants who watch from the outside.[2]

Oiticica took the name *Parangolé* from a Brazilian colloquial expression that refers to an animated situation and sudden confusion, or to agitation among people, and the name conveys the dynamic, interactive, and intersubjective character of the work.[3] Oiticica's Parangolés parallel the collective artistic manifestations of Brazilian popular festivals, Samba schools, spontaneous street art, and happenings, in which the uninhibited participation of the collective stimulates the transference of symbolic energy among people.[4] Oiticica's desire to achieve genuine human contact and social interactivity through a phenomenological creative process draws on the legacy of Brazilian modernism, particularly the Antropofagia of the 1920s.[5] Oiticica revived this discourse in the 1960s, in conceptualizing the avant-garde strategy of Tropicalismo, which attempted to distinguish Brazilian art and culture internationally by assimilating European art concepts and methodologies and incorporating elements of local popular culture into music and art.[6] In creating the Parangolés, Oiticica embraced uniquely Brazilian cultural characteristics and

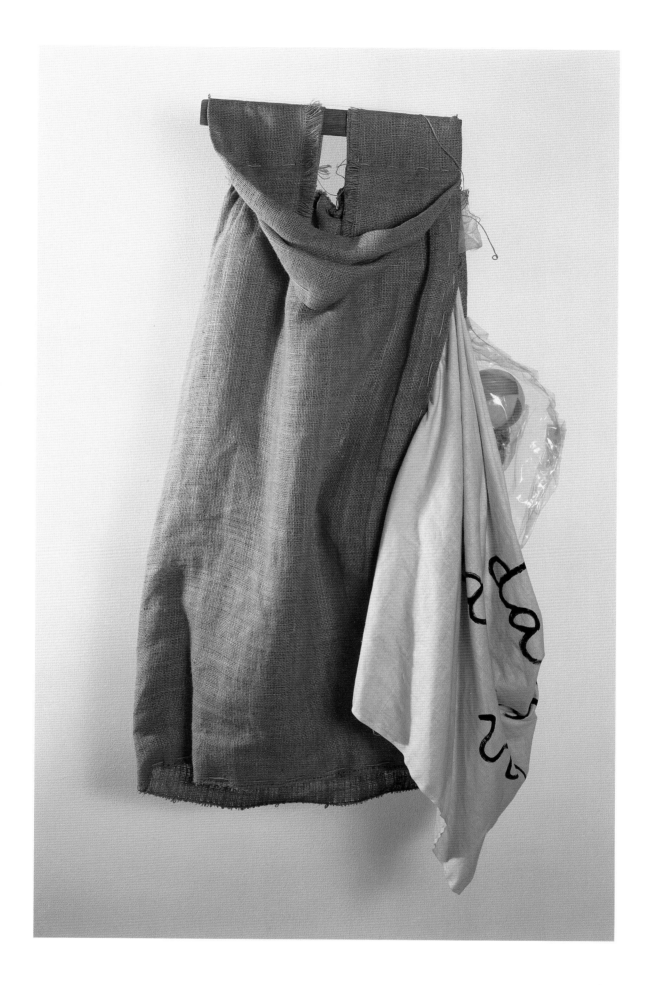

44 *Parangolé P16 capa 12. Da adversidade vivemos [Parangolé P16 Cape 12. We Live from Adversity],* 1965/1992
Yute, fabric, various plastics, burlap, and sawdust, suspended from wooden beam; 127 × 75 × 22 cm (50 × 29½ × 8¹¹⁄₁₆ in.);
Colección Patricia Phelps de Cisneros, 1996.208; copyright Projeto Hélio Oiticica

popular modes of creative expression. His exploration of samba at the Mangueira Samba School, in one of Rio's oldest *favelas,* or hillside slums, led him to experience personally a complete immersion of bodily and psychical self in dance. These works' fluid structure and their organic construction of found materials also recall the improvised architecture of the *favela,* which the artist explored more fully in the late 1960s with the unfixed, random structures of such installations as his *Tropicalia.* Oiticica insisted that his immersion in the Afro-Brazilian culture of the *favelas* did not indicate a folk revival or a primitivist aesthetic. Rather, he recalled the objectives of Antropofagia, explaining that it helped to define a return to a primordial sensibility in art, which liberated creativity and modes of perception, and that it created an experience of marginality, which helped free him from the bourgeois constraints of his own elite social class.[7] Nevertheless, his desire to attain an authentic experience within a peripheral culture still connotes an escape from bourgeois society into the exotic.[8]

Oiticica's exploration of perceptual processes and interactivity also stems from his association with the Neo-Concrete artists with whom he worked closely in the 1960s. The Neo-Concretists proposed that active subjects should realize an artwork through interplay with the art object, a process that would, it was believed, give them a heightened awareness of their own corporeal state. These artists, inspired by the phenomenology of Maurice Merleau-Ponty and the ideas of the Brazilian art critic and theorist Mário Pedrosa, contended that viewer/participants could achieve this enlightened sensibility through the experience of tactile or haptic perception, which associates the sense of touch with sight to intensify the phenomenological understanding of the object.[9]

Similarly, Oiticica, hoping to evoke a total, multisensory experience, required viewer/participants to wear, rather than simply watch, the Parangolés; participants would undergo a process of self-expression and self-realization with the unfolding of the work's formal properties.[10] Although it is true that Oiticica gave prominence to the performative aspects of the work over its role as an aesthetic object, his practice remained distinct from Conceptual strategies for subverting the institutionalization of art by emphasizing concepts and ideas over the material artwork. Instead of eliminating the object of perception, Oiticica redefined the perceptual process as "subjective-experiential," one in which the interaction of the participant's body with the artwork is intended to elicit a physical correlation between body and object.[11] He described the Parangolés as "anti-art par excellence," or as that which undermines the integrity of the museum or gallery by stimulating spontaneous collective creative activity in public spaces.[12]

Paradoxically, Oiticica relied on the support of major institutions to exhibit his work, including The Museum of Modern Art in New York and London's Whitechapel Art Gallery in the late 1960s, and he even accepted a Guggenheim Fellowship in 1970. Oiticica insinuated that museum exhibition of the Parangolés eliminated the open, participatory component of the overall artistic concept, and that it inappropriately presented these works as art objects, but his own ambivalence toward the institutionalizing practices of the museum undermined the social and ethical objectives that had generated his avant-garde program.

Jodi Kovach

Notes

1. Hélio Oiticica, "General Scheme of the New Objectivity," in Guy Brett, Catherine David, Chris Dercon, Luciano Figueiredo, and Lygia Pape, eds., *Hélio Oiticica,* various translators (Minneapolis, Minn.: Walker Art Center; and Rotterdam: Witte de With Center for Contemporary Art, 1993), 110–20.

2. Hélio Oiticica, "Fundamental Bases for the Definition of the *Parangolé*" and "Notes on the *Parangolé,*" in Brett, David, Dercon, Figueiredo, and Pape, eds., *Hélio Oiticica,* 88 and 93, respectively.

3. See Oiticica, "Fundamental Bases for the Definition of the Parangolé," 88. See also Oiticica, "General Scheme of the New Objectivity," 119.

4. Oiticica, "General Scheme of the New Objectivity."

5. See Oswald de Andrade, "Manifesto Antropofago," trans. Héctor Olea, in Haroldo de Campos, ed., *Oswald de Andrade: Obra Escogida* (Caracas: Biblioteca Ayacucho, 1981), 67–72 (originally published as Oswald de Andrade, "Manifesto Antropofago," *Revista de Antropofagia* [May 1928]: 3, 7). The Brazilian artistic and literary avant-garde articulated a concept of anthropophagy, or a form of ritual cannibalism believed to have been practiced in pre-colonial Brazilian societies, as a symbolic act through which the cannibal incorporates and activates within himself the qualities possessed by the person whose body he consumes. For these artists and writers, anthropophagy served as a metaphor for consuming Western culture in defense against cultural colonialism, and it presented a non-European model for achieving social harmony.

6. See Carlos Basualdo, ed., *Tropicalia: A Revolution in Brazilian Culture (1967–1972)* (Chicago: Museum of Contemporary Art, 2005).

7. See Oiticica, "Fundamental Bases for the Definition of the Parangolé," 88. See also Lygia Clark and Hélio Oiticica, *Cartas, 1964–74* (Rio de Janeiro: Editora UFRJ, 1996), 102.

8. Robert Stam, "Of Cannibals and Carnivals," in Robert Stam, *Subversive Pleasures: Bakhtin, Cultural Criticism, and Film* (Baltimore: Johns Hopkins University Press, 1989), 156. According to Stam, "The trope of marginality, in the end, is a Eurocentric misnomer, since life is lived centrally wherever there are human subjects."

9. See Oiticica, "Notes on the Parangolé," 93. See also Paulo Herkenhoff, "The Hand and the Glove," in Mari Carmen Ramírez and Héctor Olea, eds., *Inverted Utopias: Avant-Garde Art in Latin America* (New Haven, Conn.: Yale University Press in association with the Museum of Fine Arts, Houston, 2004), 329–31; and Paulo Herkenhoff, "Zero and Difference: Excavating a Conceptual Architecture," in Milena Kalinovska, ed., *Beyond Preconceptions: The Sixties Experiment* (New York: Independent Curators International, 2000), 57.

10. Oiticica, "Notes on the Parangolé," 93.

11. Oiticica, "Notes on the Parangolé," 96.

12. See Hélio Oiticica, "Environmental Program," in Brett, David, Dercon, Figueiredo, and Pape, eds., *Hélio Oiticica,* 103.

Mira Schendel, *Droguinha [Little Nothing]*, 1966

1919, Zurich–1988, São Paulo

Mira Schendel emigrated to Brazil as an adult and kept the company of philosophers and poets rather than artists. Nevertheless, her adopted country was where she began her artistic career, sharing the interest in geometric abstraction that was widespread among Brazilian artists in the 1950s and 1960s. *Droguinha* (plate 45), created during the most experimental phase of Schendel's career, and during a period of political and artistic upheaval in Brazil, is both exemplary of its time and out of step with the priorities of the artist's younger contemporaries.

Unlike Hélio Oiticica, Antônio Dias, and Cildo Meireles, Schendel chose not to confront overtly the degrading domestic political conditions that the 1964 military coup had precipitated.[1] Instead, her work in the mid-1960s continued to investigate formal rather than social concerns. At this time, she created a body of work that deviated from her previous geometrically abstract and figurative painting, to explore fragmented language and line and the support/medium of rice paper. The works include two series of drawings, Monotipias [Monotypes] and Objetos gráficos [Graphic Objects], as well as the Droguinhas and *Treninho [Little Train]*. These mid-1960s works, like works by many other artists of the time, built on what was then the recent legacy of Neo-Concretism, in terms of their being displayed away from the gallery wall and their movement out into the space of the viewer.[2] Thus the drawings and sculptures created a new viewing experience: they forced spectators out of their static position and encouraged them to walk around and look through the art objects.

At first glance, this 1966 work resembles a tangle of rope, but as one draws closer and notes the actual material—rice paper—several oddities reveal themselves. The facture is unusual. Schendel braided and knotted sheets of rice paper into a mass of plump threads. The artist then used fishing line to suspend this net of interconnected material from one point, allowing the rest of the material to sag with the force of gravity. The twisting of paper into threads, and the weaving and knotting together of those threads, call to mind a nervous or compulsive habit rather than a technique of fine art. Schendel further drew attention to her process with the title *Droguinha,* Portuguese slang meaning "little nothing." The title suggests that the sculpture is of little importance and was created through superfluous activity, or hundreds of "little nothings." Moreover, the artist converted a seemingly fragile, two-dimensional material (thin rice paper) into a bulky form. Although *Droguinha* appears almost to float in space, the object's materiality remains enigmatic, since the viewer is haunted by the first impression of the work, as a hefty mass pulled down by gravity.

From 1964 to 1966, in addition to the work pictured here, Schendel used the same technique to create a handful of other works with the same title. This set of works includes two with dimensions comparable to those of this work as well as several smaller-scale sculptures. The works titled *Droguinha* that are similar in scale to the one pictured here belong to Schendel's daughter, Ada Schendel, and to the British critic Guy Brett, who in 1966 arranged for Schendel to exhibit the Droguinhas for the first time, at Signals Gallery in London.[3] The existence of these other works confirms that the work pictured here was not a single experiment unrelated to the rest of Schendel's oeuvre but rather a project she sustained over several years.

Photographs show Schendel draping one Droguinha around her shoulders while carrying another balled up in her arms, and Brett writes that the artist piled the Droguinhas into a heap at a 1966 exhibition and allowed visitors to arrange them as they saw fit; other scholars and the artist's daughter have contested Brett's account.[4] Nevertheless, these records demonstrate that Schendel did not intend the works to have one stable composition. For example, the Droguinha in Ada Schendel's collection is usually exhibited hanging, but photographs also show the work spread out flat, like the example in Brett's collection. Thus it is necessary to resist the desire to understand this sculpture as unchanging, or to interpret each enchanting formal detail of its current configuration as a permanent feature of the work. Schendel's process and materials ensured that she would not arrive at the specific turns and gaps in the composition by conscious arrangement. The next encounter with the object, or even a steady breeze, shows the nuances of the work to have changed. Embedded in this mutability is the Neo-Concrete reconception of the work of art as an object undergoing transformation in the world.

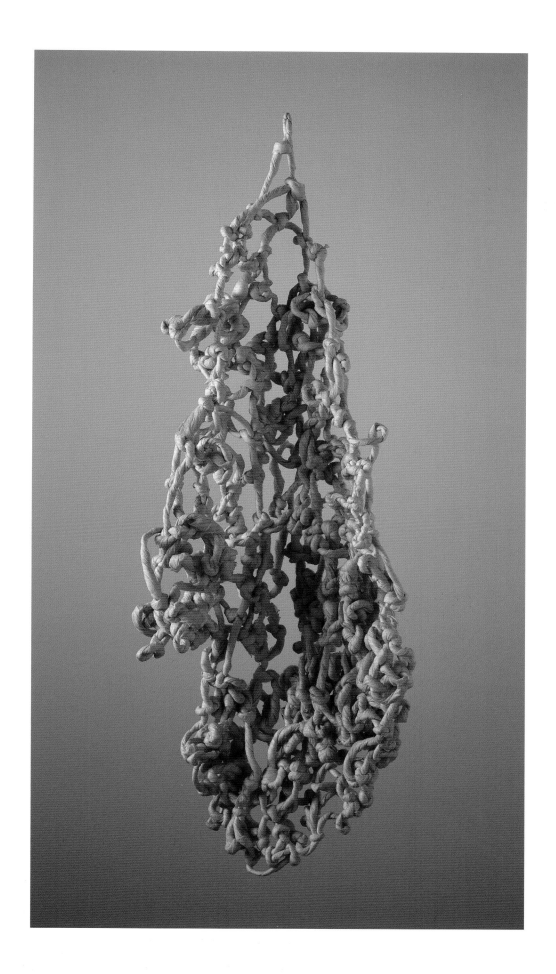

45 *Droguinha [Little Nothing],* 1966
Woven rice paper bags; 66.6 × 26 × 15 cm (26¼ × 10¼ × 6³⁄₁₆ in.); Colección Patricia Phelps de Cisneros, 1997.163; copyright Galería Millan Antonio

In 1963, the Neo-Concrete artist Lygia Clark created *Caminhando [Trailings],* a set of photographs with text. The text and photographs tell viewers how to create a Möbius strip by cutting a piece of paper. In *Caminhando,* the viewer's experience is paramount and supplants the art object—Clark says that the viewer's experience *is* the artwork, not the throwaway swirl of cut paper. Schendel's *Droguinha* is analogous to *Caminhando*'s swirl of paper, but the artist, not the viewer, has created the form, which is displayed rather than thrown away. Schendel also created knots of different sizes and areas of varying density, and the result is an object of far more formal interest and variety than the sliced object that Clark taught viewers to create in *Caminhando.*

Just as *Droguinha* and Schendel's other mid-1960s works show the artist responding to the Neo-Concrete call to activate the spectator, the works also demonstrate that Schendel differed fundamentally from the Neo-Concrete artists with respect to the question of authorship. Schendel loosened her grip on authorship by substituting repetitive, non-purposeful labor for a skilled technique of fine art and by ensuring that the composition of *Droguinha* would undergo constant transformation. The work activates viewers in its being suspended away from the wall and in the artist's use of a quotidian construction technique that viewers can imagine performing themselves. Yet Schendel harnessed all these innovative strategies to deepen contemplation of this surprisingly beautiful artwork. Introspection is part and parcel of the viewing experience of *Droguinha,* for the facture compels reflection on the peculiar nuances of daily activity that are inexplicable both to oneself and to others, but that nevertheless fill one's days.

The Neo-Concrete artists sought to give the viewer an experience that would transcend the mere mental and visual contemplation of a work of art, and that would check the dominance of the artist, physically transforming the viewer into a participant. Although Schendel's viewer is indeed mobile and engaged, *Droguinha*—the artwork—is still the main event, and Schendel remains its sole author.

Adele Nelson

Notes

1. For example, Schendel participated in the X Bienal de São Paulo, in 1969. Many domestic and international artists boycotted the X Bienal, to protest the governing regime's repression of artists and intellectuals. A possible exception to the formally driven work of the mid-1960s is the series of drawings in India ink titled Bombas [Bombs]. These works do not seem to reflect specifically on the Brazilian political situation, and it is possible that the title derives more from the painting technique—quantities of ink dropped onto wet paper. Nevertheless, the title does evoke sociopolitical content.

2. Paulo Herkenhoff argues that Schendel and others "are examples of Brazilian art nourishing itself from its own experience. Their maturity, arrived at in the mid-60s, can be directly related to the new cultural epoch established by neo-concretism"; see Paulo Herkenhoff, "Divergent Parallels: Toward a Comparative Study of Neo-Concretism and Minimalism," in Yve-Alain Bois et al., *Geometric Abstraction: Latin American Art from the Patricia Phelps de Cisneros Collection/Abstracción Geométrica: Arte Latinoamericano en la Colección Patricia Phelps de Cisneros* (Cambridge, Mass.: Harvard University Art Museums; Caracas: Fundación Cisneros, 2001), 116.

3. Brett's *Droguinha* was purchased by The Museum of Modern Art in New York after this article was written [editor's note].

4. Photographs of Schendel in London in 1966 are reproduced in Sônia Salzstein, ed., *No Vazio do Mundo: Mira Schendel* (São Paulo: Editora Marca D'Água, 1996), 89, and Maria Eduarda Marques, *Mira Schendel* (São Paulo: Cosac & Naify, 2001), 121. Brett wrote about the 1966 exhibition at the Museu de Arte Moderna do Rio de Janeiro in Guy Brett, *Kinetic Art: The Language of Movement* (London: Studio Vista, 1968), 46. According to the artist's daughter, however, Schendel did not intend for the viewing public to touch the works (Ada Schendel, correspondence relayed to the author by Sophia Whately of Galeria Millan Antonio, São Paulo). Though scholars have not explicitly refuted Brett's account in their current writings, Salzstein and others do not share his interpretation of the work.

Gego (Gertrud Goldschmidt), *Reticulárea cuadrada 71/11 [Square Reticularea 71/11],* 1971
Dibujo sin papel 76/4 [Drawing without Paper 76/4], 1976

1922, Hamburg–1994, Caracas

Gego installed the first Reticulárea at the Museo de Bellas Artes of Caracas in July 1969.[1] That work titled *Reticulárea ambiental* or *Gran reticulárea [Environmental Reticularea or Large reticularea],* contained the defining elements of the reticular environmental works that Gego executed in varying forms throughout the 1970s.

The process of creating that first Reticulárea involved three clear stages, which Gego herself, in 1977, noted in a brief report for the poet Hanni Ossot, who was preparing the first major analytical essay about her work. The first phase coincided with the creation of the inaugural work itself. Looking back to 1969, Gego wrote:

Escape from the scheme of intercrossing parallel or quasi-parallel lines. Beginning of drawings with clearly interwoven lines forming flat or modulated nets. Highlighting of crossover points. To give these meshes real reality in space with articulated intersections to control modulation, the fields between the lines had to be triangular. Reticule Area. . . .[2]

The next two phases of Gego's art were marked by the creation of the Chorros [Cascades], which involved "parallel lines again, but this time the accumulation of lines [did] not produce flat surfaces . . . but rather [created] mass,"[3] and of various non-environmental Reticuláreas that were titled *Reticulárea cuadrada [Square Reticularea].* The latter type of work, the first of which was executed in 1971 as a sculpture suspended from the ceiling, seemed to represent a stage in the artist's process of defining the Reticuláreas as ceaseless works in progress: "Square reticulárea with different manual solutions for the intersections, and with copper twists, which highlight perfectly the wire crossings so that the fields between the wires are clearly defined."[4]

Reticulárea cuadrada 71/11 (plate 46) belongs to that series of seminal works that Gego executed after having experienced the rhizomatic, topological power of the environmental Reticuláreas and feeling a need to revisit those works' modular principle. In so doing, she produced a group of "pure" Reticuláreas, works that reveal their form and system with exemplary clarity. Also in her report to Ossot, Gego related that in 1972 she had begun experimenting with "double-curve

surfaces and with self-supporting tubular surfaces and suspended spheres"[5] (a reference to the vast repertoire of works titled *Reticulárea* that she would produce in the years to come). Strangely enough—and certainly due to more than chance—the report for Ossot concludes with a comment on works in the artist's series titled Dibujos sin papel that were executed in 1976. "The drawings on paper," she wrote, "are replaced by paperless frameless drawings,"[6] a typology that encompasses *Dibujo sin papel 76/4* (plate 47).

From this point on, Gego's work consisted largely of systems of knots, and the process implied by this shift is far more complicated than the artist's act of simply moving beyond the soldering/welding techniques that she used in her first sculptures. When the eloquence of the knot is dispersed through an utterly unforeseen space—that is, in the space of a Reticulárea ambiental—it is no longer possible to speak of directions or cardinal points, of origin or center, of structural teleology. The Gran reticuláreas are structures that, lacking a goal, are forced to spark their own structural potential, whereas the Reticuláreas cuadradas come closest to fulfilling their potential unity and their own generative principle. Therefore, Gego's emphasis on "clearly interwoven lines" and on the "highlighting of crossover points" is noteworthy. Here, one may recall Karl Ioganson's statement regarding the true beginning of the whole Constructivist tradition, that is, the discussion about the concepts of construction and spatial form that was taking place in Moscow in the 1920s: "All structures, old as well as new and even the most grandiose, are formed upon the *cross.*"[7] This discussion is crucial to an understanding of Gego's contribution to the survival of a Constructivist tradition in Venezuela. In that sense, *Reticulárea cuadrada 71/11* is, like all the other Reticuláreas, an "alter-form" of the Constructivist spatial form, which varies according to several factors—the way it moves, its environment, the viewer's temporal distance, or a particular subjectivity—and which, in so varying, also changes and deforms. Indeed, the Reticuláreas do represent a kind of survival, as well as a new iteration, of the Constructivist typology that

advances space itself—"empty" space—as "concrete" material. It orchestrates this material but does not fill it; it declares

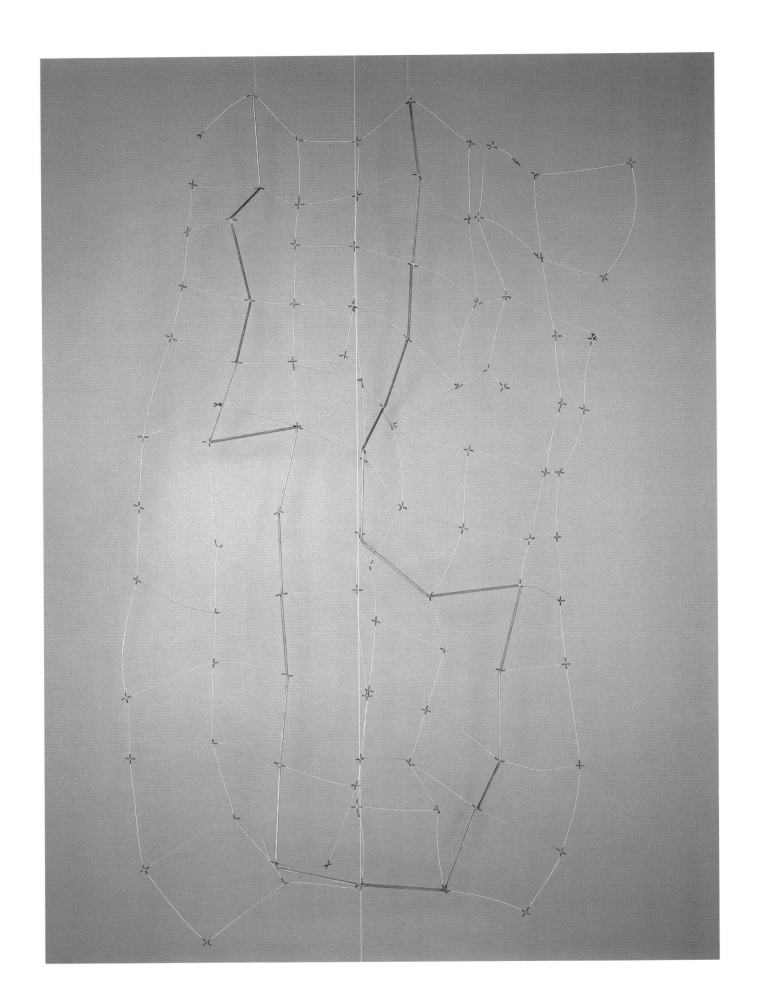

46 *Reticulárea cuadrada 71/11 [Square Reticularea 71/11]*, 1971
Metal, copper, and stainless steel; 205 × 140 × 55 cm (80¹¹/₁₆ × 55⅛ × 21⅝ in.); Colección Patricia Phelps de Cisneros, 2005.47; copyright Fundación Gego

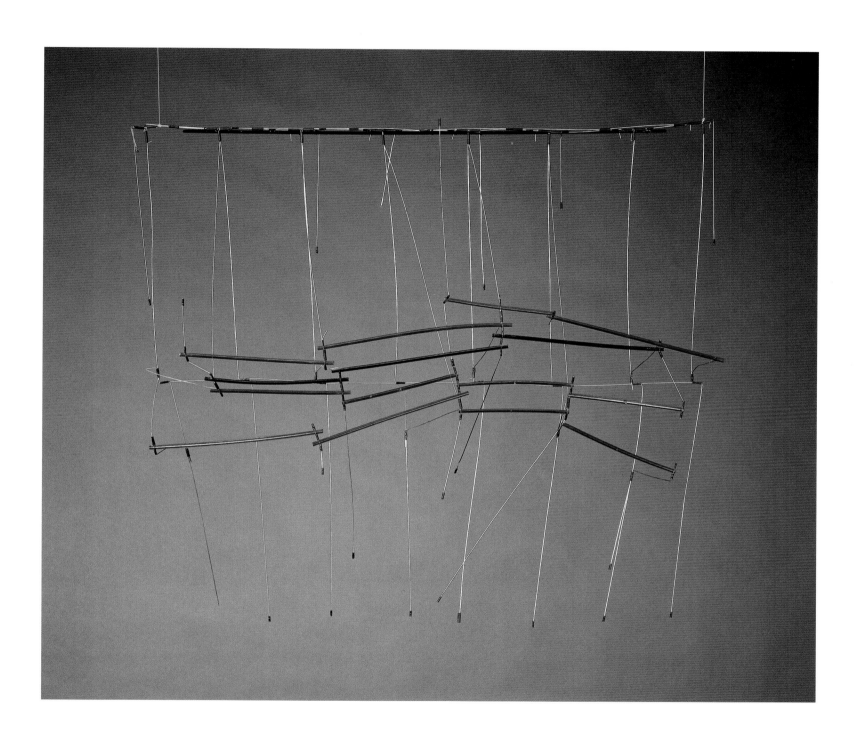

47 *Dibujo sin papel 76/4 [Drawing without Paper 76/4]*, 1976
Steel wire, metal, and Plexiglas; 67.5 × 73 × 19.3 cm (26⁹⁄₁₆ × 28¾ × 7⅝ in.); Colección Patricia Phelps de Cisneros, 2002.4; copyright Fundación Gego

volume with recourse to neither mass nor weight; and it dissolves the customary distinction between the exterior and the interior of form.[8]

The Reticuláreas are the culmination of a formal repertoire of structures in which "a set of discontinuous compressive components interacts with a set of continuous tensile components [for example, the wires] to define a stable volume in space,"[9] and its predecessors include works by such important figures as Ioganson, Vladimir Tatlin, Buckminster Fuller, and Kenneth Snelson.

Nevertheless, there are fundamental differences between Gran reticuláreas and their predecessors because the former are more than the realization of a goal or the manifestation of their own creative principle. They also appear to be derived from a principle of organic analogy. In an invaluable document produced in 1969, while Gego was mounting the first Reticulárea, the artist revealed, in the form of a concrete poem, the concepts that define her work: "Moleculum Gegum, Trace, Constelum, Linkage, Reticuroom, Entanglement, Red Tangle, Re-Entangled. . . ."[10] A modern, tropical transfiguration of the ancient Germanic identification with a forest-like Eden had most eloquently taken the symbolic shape of the Reticulárea. An environment at once artificial and organic, in which all potential lines are visible in a real space, Gego's first work in the series also grew out of a creative drive that she had exhibited early on: "With each line I draw, hundreds more wait to be drawn."[11] Thus the 1976 Dibujos sin papel, aiming to transform the practice of drawing, both poetically and structurally, were a logical outgrowth of the first environmental Reticulárea, in 1969. They gave visibility to the line's potential, and above all they compelled lines to be regarded as shadow lines, or as shadows of lines in space. Paul Klee's influence on Gertrud Goldschmidt was seminal, and in the formal configuration of *Dibujo sin papel 76/4* this distant allusion to Klee continues to surprise. Here, however, the line's radical emancipation toward real space, and the drawing's radical emancipation toward the world, at last enabled Gego—as she herself said—to give form to "the charm of . . . the nothing between the lines."[12]

Luis Pérez-Oramas
Translated by Trudy Balch

Notes

1. The title of this series, a contraction of two words—*retícula* (reticule) and *área* (area)—drawn from the discipline of topology, grew out of discussions with Miguel Arroyo, then director of the museum, and the critic Roberto Guevara, who actually coined the term.

2. Gego, *Sabiduras y otros textos de Gego/Sabiduras and Other Texts: Writings by Gego,* eds. María Elena Huizi and Josefina Manrique, trans. Mark Gregson (Houston: Museum of Fine Arts/International Center for the Arts of the Americas; and Caracas: Fundación Gego, 2005), 150, 153.

3. Gego, *Sabiduras,* 150, 153.

4. Gego, *Sabiduras,* 150, 153.

5. Gego, *Sabiduras,* 150, 153.

6. Gego, *Sabiduras,* 150, 153.

7. Maria Gough, *The Artist as Producer: Russian Constructivism in Revolution* (Berkeley: University of California Press, 2005), 53.

8. Gough, *The Artist as Producer,* 66.

9. Anthony Pugh, *An Introduction to Tensegrity* (Berkeley: University of California Press, 1976), 3, cited in Gough, *The Artist as Producer,* 210.

10. Gego, *Sabiduras,* 68–71, 72–75.

11. Gego, *Sabiduras,* 169, 170.

12. Gego, *Sabiduras,* 169, 170.

Spanish Translations

Introducción
Gabriel Pérez-Barreiro

Qué es *La geometría de la esperanza?* El título de este catálogo y exposición reúne las dos corrientes que se cruzan en el arte abstracto de América Latina: por una parte, la geometría, la precisión, la claridad y la razón; por otra, un sentimiento utópico de esperanza. El título surgió como paráfrasis de la "geometría del miedo", una expresión acuñada por Herbert Read en 1952 para describir la atmósfera de angustia del arte británico de la posguerra y su expresión a través de formas geométricas agresivas e inestables, como en la obra de Kenneth Armitage, Lynn Chadwick y otros. Una rápida visión de conjunto del arte geométrico latinoamericano de la misma época revela un panorama completamente distinto: esculturas cinéticas juguetonas y de vivos colores, objetos experimentales que actúan como catalizadores para el desarrollo comunitario, manifiestos que llaman a la alegría y a la negación de la melancolía. Sin embargo, esta ojeada a la América Latina de la posguerra no podía ofrecer un contraste más intenso con nuestra actual visión del mundo, acostumbrados como estamos a asociar América Latina con el fracaso, la pobreza y el pesimismo, mientras que tendemos a asociar Europa y Estados Unidos con la razón y el progreso. Esta exposición y el catálogo que la acompaña deberían recordarnos—aunque sólo sea eso—que hubo una época en que América Latina era un modelo de esperanza y progreso en un mundo devastado por la guerra, el genocidio y la destrucción.

A pesar de que sigue sin existir un estudio solvente en inglés sobre el desarrollo del arte abstracto en América Latina—desde el regreso a Montevideo de Joaquín Torres-García en 1934, hasta el Arte Cinético venezolano de los años setenta—, la Colección Patricia Phelps de Cisneros ofrece una oportunidad excepcional para presentar una panorámica general de esta historia; ninguna otra colección pública o privada del mundo se acerca a la variedad y la profundidad de este material. La colección también destaca por el apoyo que presta a proyectos académicos: el Seminario de Investigación Cisneros sobre Abstracción y Arte Contemporáneo, celebrado en The University of Texas at Austin, ofreció un foro en el que se desplegaron las ideas y la estructura de la exposición, y muchos de los autores cuya obra aparece publicada en este libro participaron en él. Nuestra intención al compilar el libro era reunir en un volumen nuevos estudios sobre la abstracción latinoamericana que expresaran un variado abanico de opiniones procedentes de Estados Unidos, Europa y América Latina.

La primera cuestión planteada por cualquier proyecto de esta naturaleza afecta al tema de cuál debe ser el marco adecuado en donde presentar estas obras de arte, similares aunque también diferentes entre sí. ¿Qué es lo que tienen en común y qué las separa? Más concretamente, ¿cómo debemos afrontar el hecho de que las obras presentadas en esta exposición, a pesar de parecer similares en su estilo y lenguaje, fueran producidas por artistas que a menudo apenas se conocían entre sí y cuyos contextos geográficos y temporales—por no mencionar sus intenciones artísticas—con frecuencia eran radicalmente distintos? La mayoría de exposiciones de arte abstracto latinoamericano se remiten a uno de estos dos modelos: el contextual o el formalista. El modelo contextual—cuyo paradigma podrían ser las exposiciones *Art in Latin America, Brazil: Body and Soul, Inverted Utopias* y *Art from Argentina*—considera la región geográfica como punto de partida.[1] En estas exposiciones, la abstracción es una parte de la historia de cómo se desarrolló la cultura de una región en particular, un paso en la historia sobre la formación de una identidad. En el peor de los casos, este modelo reduce cada movimiento a una mera ilustración de un contexto. Por otra parte, las exposiciones que incluyen los términos "América Latina" o "latinoamericano" en sus títulos presentan contextos que tienen poca o ninguna conexión entre sí (Montevideo y Caracas, por ejemplo), con el fin de priorizar una concepción del desarrollo de una cultura latinoamericana definida por oposición a otro bloque monolítico (Europa o Estados Unidos). En cambio, el modelo formalista descontextualiza radicalmente a los artistas y presenta las obras en función de relaciones basadas en similitudes ópticas o formales. Este es el modelo desarrollado por Ariel Jiménez en presentaciones anteriores de la Colección Patricia Phelps de Cisneros, así como el modelo empleado en exposiciones como *Beyond Geometry* y *Les figures de la liberté*.[2] En este modelo, Mira Schendel, Jesús Rafael Soto y Kasimir Malevich, por ejemplo, podrían entablar una conversación sobre la tensión entre icono y fondo, en una auténtica "constelación" de significados carente de marco contextual o geográfico a priori.

¿Existe una tercera vía entre estos modelos? ¿Podemos debatir sobre el contexto sin caer en la mera ilustración y reconocer, al mismo tiempo, que el contexto es un elemento esencial en la configuración de significado? El primer paso al responder estas preguntas es establecer la *unidad* de contexto. Si "América Latina" es un término demasiado amplio y abarca demasiada diversidad y desconexión, ¿acaso es mejor recurrir al nombre de un solo país? ¿Nos permite "Brasil", por ejemplo, diferenciar entre São Paulo y Rio de Janeiro? Cuando hablamos de "Argentina", ¿nos referimos realmente a Mendoza, Salta y Córdoba?

La geometría de la esperanza se estructura en torno a la *ciudad* como unidad de contexto. La ciudad es donde circulan las ideas, donde chocan distintas voces e intenciones en el mismo espacio físico; una ciudad es el centro de una red que es a la vez local e internacional. Una vez establecido un modelo basado en la ciudad, encontramos natural—y, de hecho, inevitable—incluir París junto a las ciudades latinoamericanas como referencia clave en el desarrollo de la abstracción geométrica en América Latina, eludiendo así la estéril oposición Europa/América Latina y reconociendo la rica interdependencia entre (por ejemplo) Caracas y París. Esta geografía de ciudades específicas también nos permite advertir que la abstracción geométrica fue en gran parte un fenómeno de las grandes ciudades portuarias de la costa atlántica. Estas son las ciudades que recibieron mayor número de inmigrantes europeos, se industrializaron con

mayor rapidez y crearon las culturas urbanas más modernas. Por consiguiente, más que discutir sobre si la abstracción es un paradigma para la cultura latinoamericana en su conjunto, sería más exacto que habláramos sobre la abstracción como paradigma de una cultura urbana atlántica, al igual que podríamos hablar de distintos paradigmas para las culturas andina, del Pacífico o de la pampa. Este tipo de geografía cultural multidimensional nos permite alejarnos de las generalizaciones culturales estereotípicas basadas meramente en la lengua y la diferencia y sustituirlas por un modelo más complejo y específico.

Una vez establecida la geografía cultural de esta exposición, nos enfrentamos a la siguiente cuestión: la interpretación de las obras en sí. ¿Cómo podíamos atribuir significados específicos a objetos abstractos que aspiraban a hablar en un lenguaje universal? Si la meta del marco de la exposición era evitar los extremos de la ilustración contextual y el formalismo descontextualizado, entonces debíamos fijar nuestra atención en el *proyecto* que se halla tras una obra en particular. La cuestión, pues, no era analizar el aspecto de la obra sino *por qué* tiene ese aspecto. Charles Harrison lo planteó en los siguientes términos:

La tendencia a identificar y ensalzar las obras de arte en función de sus "propiedades formales", sus "características ópticas", su "inefable apariencia", deja la representación de la experiencia que producen muy vulnerable a un encapsulamiento de los típicos términos de la cultura dominante. Hablar de obras de arte no tiene ningún sentido a menos que nos lleve a una indagación sobre las condiciones y los mecanismos de su producción.[3]

Por lo tanto, el contexto debería verse no como un determinante esencialista de forma y significado, sino más bien como el escenario en el que se procesan y debaten las ideas.[4] Al igual que una lengua extranjera al principio parece incomprensible y con el tiempo revela distintos matices, todas las obras abstractas parecen, a primera vista, reiterar los mismos significados. Sólo al fijarnos en la intención dentro de un contexto determinado empezaremos a ver radicales diferencias entre obras que comparten el mismo vocabulario formal. Sólo a través de este examen de la intención en su contexto podremos distinguir, por ejemplo, entre el cuestionamiento cuasidadaísta del grupo Madí sobre los límites de la obra de arte y la búsqueda de la "buena forma" por parte de Tomás Maldonado, o entre las construcciones narrativas de Lygia Pape y la disolución del significado en la sensación táctil que impera en la obra de Lygia Clark.

En líneas generales, existen dos tendencias—o más bien dos *proposiciones*—en la abstracción geométrica latinoamericana. Una se basa en la creencia en la razón, en un lenguaje internacional de la abstracción que representa el estadio más elevado en la evolución del arte moderno. Para los artistas cuya obra exhibe esta tendencia—Maldonado, María Freire, Willys de Castro, Soto, Carlos Cruz-Diez—, las reglas del juego están claras y la abstracción representa para ellos una afiliación ideológica a una noción de progreso basada en las ideas de la Ilustración. Por lo que respecta a la otra tendencia, los artistas emplearon el mismo lenguaje visual para expresar lo contrario de la razón: un deseo de socavar el discurso racionalista de la modernidad en favor de un profundo cuestionamiento del papel del arte en la experiencia humana (Madí, Clark, Hélio Oiticica). En este sentido, Peter Bürger y Renato Poggioli han efectuado útiles distinciones entre ambas actitudes y han subrayado que la vanguardia, más que reflejar una característica absoluta, depende por completo de las circunstancias de su creación.[5] La distinción efectuada por Poggioli entre *movimientos* y *escuelas* resulta particularmente útil como forma de articular las relaciones entre América Latina y el resto del mundo. El artista que se incorpora a una escuela lo hace aceptando un conjunto de valores preestablecidos, básicamente "adquiriendo" un estilo y los significados que éste conlleva. Un movimiento, por el contrario, surge para oponerse a una escuela y para cuestionarla; su intención es alterar las reglas del juego. Ambas actitudes están presentes en el arte latinoamericano de *La geometría de la esperanza,* al igual que lo están en el arte de Rusia, Inglaterra o cualquier lugar del mundo. Al utilizar estas categorías activas, propositivas y necesariamente contextuales, quizás podremos dejar finalmente atrás los debates sobre quién fue primero, o qué arte es "derivado" y cuál es el "original".

Un último punto tiene que ver con la interpretación de las obras de arte que aparecen específicamente en este libro. Al examinar los estudios sobre la abstracción latinoamericana, vimos claramente que la mayoría de los debates eluden cualquier análisis real de las obras de arte individualmente consideradas. Demasiado a menudo se incluía una obra de arte simplemente como ilustración de una teoría preexistente, en lugar de como objeto de estudio en sí mismo. Por este motivo, hemos dividido el libro en dos secciones. La primera se ocupa de los contextos intelectuales de las ciudades de Montevideo, Buenos Aires, São Paulo, Rio de Janeiro, París y Caracas; la segunda contiene una serie de ensayos sobre determinadas obras de la colección. Nuestro interés aquí era encargar nuevos trabajos que examinaran la evidencia física de los objetos en cuestión, las propias obras. Cada uno de estos textos se encargó con instrucciones explícitas de que cualquier estudio de una obra estaría vinculado a la evidencia física y visual contenida en el propio objeto de arte. En los mejores casos, vimos que si el análisis partía de la obra de arte, muchas de las clasificaciones historiográficas convencionales ya no eran pertinentes, de modo que el objeto exigía un considerable replanteamiento de términos y conceptos. Otro motivo para realizar este ejercicio era promover la capacidad para contemplar el arte abstracto con conocimiento de causa. Uno de los principales retos, ahora que el arte abstracto latinoamericano se colecciona y se expone cada vez más, tiene que ver con la ausencia de criterios coherentes a la hora de fechar con exactitud las obras por parte de comisarios y conservadores, diferenciando entre obras aparentemente similares del mismo artista y advirtiendo de las diferencias entre una obra original y una reconstrucción. Existen numerosos motivos que explican que este tipo de conocimiento no sea generalizado, entre los cuales la dificultad inherente del material, la

falta de formación académica y la naturaleza ideológica y politizada de los estudios artísticos latinoamericanos. Y aunque pueda no estar de moda hablar del papel de los *connoisseurs,* para escribir la historia del arte sigue siendo necesario un conocimiento especializado, ya que sólo observando inquisitivamente un objeto podremos generar estructuras y material que apoyen una contextualización más receptiva a la intención del artista y su relación con el contexto.

En una época caracterizada por el cinismo en la política, en la sociedad y en la relación del arte con el cambio social, resulta refrescante salir al encuentro de estas obras y propuestas, así como recordar un periodo en que los artistas estaban comprometidos con una radical transformación de su entorno. Nuestro entusiasmo por el proyecto modernista en Europa se ve inevitablemente empañado porque sabemos que esos ideales de pureza e higiene se tradujeron—al parecer inevitablemente—en genocidios y campos de concentración. Y en Estados Unidos, la historia del alto modernismo se ha enrarecido hasta tal extremo que nos resulta difícil extraer una brizna de idealismo de un sistema artístico regido por el mercado. En el caso de América Latina, el proyecto modernista fue ciertamente un fracaso en el sentido que los sueños de desarrollo y progreso quedaron barridos por décadas de dictadura y conflicto social, pero el modernismo también se salvó de la asociación con la ingeniería social y el triunfalismo nacionalista. Estas reliquias de un pasado reciente—pinturas, esculturas, revistas y manifiestos—parecen contener y encarnar un rico legado que nos recuerda una historia distinta y alternativa de América Latina, una historia de esperanza y optimismo.

Traducción de Jordi Palou

Notas

1. Dawn Ades, ed., *Art in Latin America: The Modern Era, 1820–1980* (New Haven, Conn.: Yale University Press, 1989); Edward J. Sullivan, ed., *Brazil: Body and Soul* (Nueva York: Guggenheim Museum, 2001); David Elliott, ed., *Art from Argentina* (Oxford: Museum of Modern Art Oxford, 1994), y Mari Carmen Ramírez y Héctor Olea, eds., *Inverted Utopias: Avant-Garde Art in Latin America* (New Haven, Conn.: Yale University Press in association with the Museum of Fine Arts, Houston, 2004).

2. Lynn Zelevansky, *Beyond Geometry: Experiments in Form, 1940s–70s* (Cambridge, Mass.: MIT Press, 2004), y *Les figures de la liberté* (Ginebra: Musée Rath, 1995).

3. Charles Harrison, "Modernism and the 'Transatlantic Dialogue'", en Francis Frascina, ed., *Pollock and After: The Critical Debate* (Londres: Harper and Row, 1985), 221–22.

4. Por ejemplo, la sorprendente afirmación de Mari Carmen Ramírez según la cual las composiciones geométricas de Rhod Rothfuss recuerdan los "ojos" o máscaras de carnaval de Montevideo podría interpretarse como una sutil continuación de los estereotipos que presentan a América Latina como una tierra de antropomorfismo y carnavales; dicha afirmación evita entrar a analizar los complejos debates que tenían lugar en aquella época sobre la abstracción en el Río de la Plata. Véase Ramírez y Olea, eds., *Inverted Utopias,* 197.

5. Peter Bürger, *Theory of the Avant-Garde,* trad. de Michael Shaw (Minneapolis: University of Minnesota Press, 1984), y Renato Poggioli, *The Theory of the Avant-Garde* (Cambridge, Mass.: Harvard University Press, 1981).

Montevideo: Universalismo Constructivo

Cecilia de Torres

El 30 de abril de 1934, Joaquín Torres-García regresó a Montevideo[1] después de cuarenta y tres años en el exterior, acompañado de su familia y decidido a causar impacto en su propia tierra. A partir de entonces, y más allá de las manifestaciones obvias y bien conocidas de su legado—su propio arte y sus escritos, el arte y los artistas de la AAC[2] y del TTG[3]—el idioma visual de Montevideo y del Uruguay fue cambiado para siempre. Hoy en día es palpable la influencia de Torres-García en la arquitectura de la ciudad, las señales y los letreros, el papel moneda, las estampillas de correo, e incluso en una gran variedad de baratijas de recuerdo que expresan un Constructivismo artificial.

Cuando Torres-García desembarcó en Montevideo, la ciudad se encontraba en pleno boom. Uruguay se estaba beneficiando de la demanda internacional por la carne, así como de la afluencia de inmigrantes y refugiados calificados procedentes de Europa. La vida cultural en la capital giraba en torno a la música y al teatro: era una ciudad de palabras pero no de pintura. A raíz de sus propios estudios en las academias de Barcelona, su ejercicio como docente en Mont d'Or, el interés que mantuvo durante toda su vida en los juguetes pedagógicos interactivos, y su función como organizador del movimiento *Cercle et Carré* en París, Torres-García se convertiría en promotor apasionado de la unificación cultural de todas las regiones del continente americano. El 1 de mayo de 1934, apenas un día después de las tres semanas en alta mar que había iniciado en Cádiz, dio su primera conferencia, inaugurando así la obra a la cual dedicaría los últimos quince años de su vida y que, de paso, transformaría el paisaje cultural de Montevideo.

Tal vez fue algo insólita la idea de escoger a la capital uruguaya como punto de lanzamiento de un proyecto cuyo fin fuera la unificación cultural de América. A diferencia de las grandes ciudades del Perú o de México, Montevideo—la capital más austral del continente—no fue construida sobre las ruinas de civilizaciones anteriores. Para principios del siglo XIX la colonización europea ya había disuelto y casi exterminado las tribus nómadas indígenas de la región, en particular los Charrúa y los Chaná.

Montevideo fue fundada en 1726 por Bruno Mauricio de Zabala, el Gobernador de Buenos Aires,[4] y a partir de entonces la historia de estas dos ciudades asentadas sobre orillas opuestas del amplio Río de la Plata quedaría plena y irrevocablemente ligada en el ámbito político, cultural y social. Es por eso que se emplea la palabra *rioplatense* para designar su identidad compartida. En su descripción de las capitales de la Argentina y del Uruguay, Jorge Luís Borges dijo que tenían "el sabor de lo que es igual y un poco distinto".[5] Los inmigrantes europeos que llegaban a Montevideo venían principalmente en busca de mejores oportunidades económicas y sociales, a diferencia de los colonizadores ingleses que llegaron a Norteamérica huyendo de la persecución religiosa.

En el año 1830, luego de haber luchado contra invasores portugueses e ingleses y librado una serie de guerras en su territorio nacional, Uruguay declaró su independencia. A fines del siglo XIX, Montevideo fue invadido por la prosperidad. Los ciudadanos de la capital, en busca de auto-suficiencia, demostraron poseer una loable creatividad: en 1852, un farmacéutico italiano inventó un sistema para alimentar el alumbrado público de la ciudad con el gas extraído de los desechos animales en los frigoríficos locales.[6] Montevideo gozó de un período de prosperidad que se extendió por varias décadas a lo largo de los siglos XIX y XX. Gracias a esta prosperidad la sociedad liberal y secular de la ciudad conoció la democracia y pudo financiar la educación de la juventud uruguaya.

En 1829, los muros que circundaban el núcleo colonial original fueron derrumbados y fue diseñada la Ciudad Nueva con calles dispuestas para formar manzanas cuadradas que se extendían a partir del eje central de la Avenida 18 de Julio. De esa fecha en adelante, Montevideo se fue desarrollando hasta convertirse en una de las ciudades más modernas y mejor diseñadas en toda América. La urbanización se desplegaba a lo largo de la orilla del Río de la Plata. A pesar de que un 45 por ciento de los tres millones de habitantes del país están radicados ahí, Montevideo se distingue por su paso calmado y su aire provincial, características a las cuales se aferran los residentes de manera desafiante. Las calles y las avenidas, las plazas y los parques, bordeados de edificios de diversos estilos y períodos, convierten a la ciudad en un museo al aire libre de los estilos arquitectónicos de los siglos XIX y XX (figura 2).

Poco a poco fue emergiendo y consolidándose una identidad nacional a partir de las costumbres y tradiciones compartidas que trajeron los inmigrantes de todas las regiones europeas. "Montevideo es como una Babel de nacionalidades", protestaba el escritor argentino Domingo Faustino Sarmiento. "No son argentinos ni uruguayos los habitantes de Montevideo; son los europeos que han tomado posesión de una punta del suelo americano".[7] Entre ellos se encontraban marineros genoveses, estibadores gallegos, albañiles vascos, agricultores canarios, farmacéuticos y comerciantes italianos, modistas, doradores, tapiceros y peluqueros franceses, tenderos ingleses y artesanos alemanes.

Cada grupo de nacionalidades europeas afectó a la ciudad a su manera. Una fuerte representación francesa tuvo una influencia muy pronunciada en el ámbito político, cultural y comercial durante el siglo XIX; es más, nacieron en Montevideo tres de los más grandes poetas modernos de Francia: Comte de Lautréamont (Isidore Ducasse), Jules Laforge y Jules Supervielle.[8] Pero los intereses comerciales de aquella nación europea se fueron disminuyendo con el tiempo; a medida que el positivismo comercial anglosajón aumentaba, sólo quedaron el intelecto y la cultura franceses para encantar a los uruguayos.

Gran Bretaña controlaba la industria principal del Uruguay: los frigoríficos y la exportación de carne. Posteriormente, los ingleses construyeron los ferrocarriles y la infraestructura necesaria para el suministro de gas, electricidad, aguas, teléfonos y telégrafos. Estados Unidos también tenía un interés estratégico en la región. Fue por eso que el intelectual mexicano José

Vasconcellos, comentando sobre los uruguayos, los describió como "franceses en la literatura, ingleses en los negocios, y norteamericanos en la política internacional".[9]

Pero la influencia francesa resultó ser importante en el desarrollo del carácter y la idiosincrasia nacional. Aquella Francia radical y revolucionaria inspiró a José Batlle y Ordóñez, elegido dos veces a la presidencia, a crear un estado decididamente secular.[10] El gobierno democrático de Batlle fomentó la seguridad y repartió prestaciones sociales entre la población urbana en vías de expansión, creando una sociedad igualitaria con una clase media fuerte y caracterizada por una aversión a la riqueza ostentosa. La educación de alto nivel, que se ofrecía gratis, atrajo a Montevideo a estudiantes de las provincias y de otros países sudamericanos también.

Prevaleció la secularización de las costumbres y las convenciones, las instituciones y la educación; era legal el divorcio a partir del año 1907, y la separación entre Iglesia y Estado creó una libertad intelectual y social muy poco común. Batlle impuso una serie de leyes sociales sumamente progresivas para luchar contra la pobreza y promover la educación, conforme a la estipulación de Artigas, quien dijo que "los Orientales deben ser tan instruidos como valientes".[11] El movimiento secular eliminó la enseñanza religiosa en las escuelas públicas, exigió el registro civil de los matrimonios antes de la ceremonia religiosa, y prohibió las imágenes religiosas en los hospitales y las escuelas públicas. Incluso se quitó del currículo escolar la enseñanza del latín debido a su asociación con la Iglesia.

El medio cultural: desde fines del siglo XIX a 1936

En el año 1856 la emergente burguesía, sediento de cultura, construyó el Teatro Solís, uno de los más antiguos de Sudamérica, que fue un símbolo potente de las aspiraciones de la elite cultural (figura 3). El Solís, junto con el Teatro Colón en Buenos Aires, convirtió al Río de la Plata en destino obligado para los grandes artistas del mundo. Al teatro uruguayo vinieron las grandes estrellas de la opera Enrico Caruso y Adelina Patti, así como los compositores Puccini, Pietro Mascagni, Camille Saint-Saëns y Richard Strauss. Toscanini, el Ballet Ruso con Tamara Karsavina, y Nijinsky (en su última actuación teatral) estuvieron entre las muchas figuras internacionales que pisaron las tablas en el Teatro Solís.[12]

Si bien los montevideanos de aquella época disfrutaban de la música, el ballet y la opera internacionales, no tenían acceso a las artes visuales del mismo calibre y existían pocos lugares dedicados a exposiciones de este tipo. En 1872 se inauguró el Museo Nacional en un salón del Teatro Solís y fue ahí donde el joven Joaquín Torres-García vio pinturas por primera vez. El Círculo para el Fomento de las Artes, creado en 1905, fundó un museo en 1911. Con el fin de satisfacer la demanda de la nueva burguesía se abrieron dos galerías de arte: Moretti y Catelli—donde Rafael Barradas montó su primera exposición antes de partir para Europa en 1913—y el Bazaar Maveroff.

Una falta de comprensión en cuanto a las artes visuales, complicada por políticas anti-elitistas, obró en contra de la adquisición de obras de arte para la colección del Museo Nacional cuando el país estaba en condiciones de comprarlas de los maestros europeos. Hasta se hablaba de comisionar a pintores italianos para hacer copias de cuadros famosos en lugar de comprar los originales. Para llegar a ser reconocidos, los artistas se veían obligados a trasladarse a Europa para estudiar y ser expuestos a las grandes obras maestras. El pintor Milo Beretta (1875–1935), quien estudió en París con Medardo Rosso, trajo a Montevideo varias esculturas poco conocidas de Rosso, así como cuadros de Van Gogh, Bonnard y Vuillard; esta colección podría haber formado la base de un museo público de arte moderno. No prosperó este intento, sin embargo, y poco después del fallecimiento de Beretta las obras fueron remitidas al exterior.

Juan Manuel Blanes (1830–1901) fue el primer pintor nativo importante del Uruguay. Un artista autodidacto, Blanes ya gozaba de un éxito profesional cuando el gobierno le otorgó una beca para estudiar en Florencia y Roma. Comisionado posteriormente para representar los eventos históricos del Uruguay, Chile y Argentina,[13] el oficio sólido de Blanes, así como su dominio magistral de la luz y de los colores, lo establecieron como un artista importante más allá de la relevancia histórica de sus pinturas.

La Guerra Hispano-Americana de 1899, cuyo objetivo fue la liberación de Cuba, inspiró al uruguayo José Enrique Rodó a escribir *Ariel,* uno de los primeros textos que expresaba oposición a la hegemonía estadounidense producidos en la región. En su obra, Rodó se dirige a la juventud y recomendaba los valores morales por encima de los materiales. Presentó un análisis de los conflictos y las diferencias culturales que existían entre Latinoamérica y los Estados Unidos y manifestó que, en su opinión, el materialismo y positivismo estadounidense, así como su política expansionista, representaban una amenaza para Latinoamérica. Escrito en prosa clara y elegante, *Ariel* despertó toda una generación a la idea de una identidad latinoamericana, a pesar de una crítica generalizada y el hecho de que fue basado en la idea imaginaria de una raza latinoamericana.[14]

Rodó era cliente habitual en el café Tupí Nambá, que abrió sus puertas en 1889 y cuyo ambiente bohemio reflejaba la emergente vida intelectual en Montevideo (figura 4). Entre los artistas, políticos y poetas de la capital que se reunían en el café legendario cabe destacar el poeta modernista Julio Herrera y Reissig y el dramaturgo Florencio Sánchez (1875–1910).

Entre los escritores que se congregaban en el Tupí Nambá, algunos crearon una literatura que representaba fielmente la singular cultura rioplatense. Los personajes de Sánchez, por ejemplo, manifestaban características y hábitos que fácilmente podía reconocer cualquier residente de Montevideo o Buenos Aires. Se expresaban en el mismo lunfardo, hablando el castellano con acento italiano. En sus comedias de la vida urbana cotidiana, revelaba las miserias y las esperanzas de una emergente clase de obreros inmigrantes que luchaban por crearse una vida mejor y ascender la escala social.

Bartolomé Hidalgo, un peluquero en Montevideo, fue el primer poeta que empleó el estilo lingüístico de los gauchos.[15] El gaucho era muy

bien querido en el imaginario rioplatense porque personificaba la rebelión contra el orden establecido. El estereotipo que prevalecía en aquella época lo representaba como medio-europeo y medio-indio nativo; lo cierto es que los gauchos llevaban una vida seminómada. Según Javier de Viana (1868–1926), el autor de unos cuentos cortos muy populares, el gaucho era "un gran indio de crin larga, ruda y lacia, sujeta por la vincha, de rostro cobrizo, flaco, con grandes pómulos y mentón cuadrado, donde lucía escasa y rígida barba, de ojos muy chicos, muy hundidos y muy negros" y poseía un valor brutal, primario y heroico.[16] La descripción que ofrece Viana indica que, si bien los montevideanos de entonces admiraban al gaucho por su espíritu independiente, también lo temían por la influencia perjudicial que podía ejercer en una sociedad que apenas empezaba a sentirse bien establecida.

Entre los artistas visuales uruguayos que expresaron el mito gauchesco en obra plástica se destacan Blanes y Pedro Figari (1861–1938), quien pintó escenas de la vida de los gauchos, antiguos esclavos negros bailando el Candombe,[17] y los salones de la clase alta de Montevideo. Figari era un positivista dedicado a la mejora y la modernización de la educación y de los métodos didácticos; durante su breve gestión como director de la Escuela de Artes y Artesanías, abolió la práctica rutinaria de copiar y dibujar los vaciados de yeso, recomendando en su lugar el estudio directo de la naturaleza. Promovió un estilo regional en las artes decorativas que privilegiaba a los materiales autóctonos y buscaba una producción adaptada a la necesidad y función locales. Quedó profundamente desilusionado cuando una reforma que le había propuesto a la Escuela Industrial fue rechazada y, al cabo de una larga carrera como abogado, escritor y estadista, decidió dedicarse enteramente a la pintura.

Figari se trasladó a Buenos Aires en 1921 y luego a París, donde vivió entre 1925 y 1933. A pesar de ser un artista autodidacto, era un dibujante y colorista de gran expresividad. La representación simplificada de las figuras y los objetos en su obra no se debe interpretar como naif ni primitiva: "Mi objetivo no fue pintar bien", reconoció, "sino hacerlo de manera que sería interesante independientemente de la técnica".[18]

En su "Industrialización de América Latina" (1919), Figari advirtió sobre el "cosmopolitismo hibridizante" que azotaba las ciudades sudamericanas durante la década de los veinte. Una vez finalizadas las guerras civiles uruguayas, las diferencias que existían entre los dos principales partidos políticos se fueron atenuando, permitiéndoles entablar diálogos, alianzas y acuerdos mutuos. El resultado fue una nueva pluralidad que impuso mayor control estatal en todo el ámbito cultural. Se introdujo legislación para controlar tanto la construcción de monumentos públicos y el diseño de cursos universitarios como los premios otorgados para la pintura y escultura en los salones oficiales, donde el estado favorecía un estilo naturalista y no polémico.[19]

Se produjo un debate en el que se discutía cómo reconciliar la cultura autóctona con la modernidad urbana. Alberto Zum Felde, el redactor de la revista La Pluma, sugirió que los uruguayos debían "nacionalizar la cultura estética

y universalizar los temas autóctonos". El poeta peruano Parra del Riego, quien se había radicado en Montevideo en 1917, creía que la poesía debía volver a cumplir la función social que originalmente la había caracterizado; en sus poemas futuristas cantaba a los trenes, las motocicletas, los aviones, la velocidad y los deportes. Otros defensores de la modernidad fueron Alfredo Mario Ferreiro, el autor de poemas que "olían a gasolina" publicados en su colección El hombre que se comió un autobús,[20] e Idelfonso Pereda Valdés quien escribió en 1927 que "Mientras exista el jazz-band es imposible fabricar arte nativista. En este momento quiero hacer un arte nativista, pero, el arte sincopado de un fox-trot me lo impide; pienso en el campo desde Montevideo, y nada".[21]

Rafael Barradas (1890–1929) no tuvo que enfrentar este dilema porque se fue de Montevideo en 1913. Pero antes de irse, pintó cuadros en los que representaba elegantes mujeres y hombres negros vestidos de gala. Barradas pasó una temporada en París y Milán, donde se familiarizó con el movimiento futurista. Cuando se trasladó a España conoció a Torres-García en Barcelona en 1917. Fue ahí donde estos dos artistas colaboraron en la creación de un estilo dinámico que nombraron Vibracionismo.[22]

La ciudad contrajo una fiebre modernista durante los años locos de la década de los veinte pero, mientras florecía la arquitectura,[23] la pintura seguía siendo una forma de arte secundaria. La Académie Montparnasse de André Lhote en París atrajo a muchos artistas uruguayos quienes, al regresar a su tierra llevaron consigo un estilo que llamaban Planismo—una derivación del Cubismo de Lhote de su última época. Ya de vuelta en Uruguay, adaptaron la técnica posimpresionista para interpretar la luz y el color locales. Pintaban paisajes, escenas urbanas, retratos y actividades al aire libre que reflejaban la actitud optimista del país. Reducían lo que interpretaban a planos interactivos dotados de contornos bien definidos, y aplicaban impastos gruesos en colores brillantes: verdes ácidos, rosados, rojos, amarillos y azules. El estilo colectivo de estos pintores se llamaba la Escuela de Montevideo. La obra de José Cúneo, artista que también estudió con Lhote, consistía en interpretaciones idiosincrásicas del paisaje bucólico de la Banda Oriental.

La visita del arquitecto Le Corbusier, en el año 1929, causó un impacto duradero en la arquitectura moderna de Montevideo. Cinco arquitectos uruguayos se presentaron en el muelle para recibir a su célebre colega cuando desembarcó en el puerto de la capital. Uno de ellos, Rafael Lorente Escudero (1907–1992), desempeñaría un papel esencial en la construcción de la versión moderna de la ciudad: en 1935 fue comisionado para diseñar gasolineras, destilerías y oficinas para ANCAP (la Administración Nacional de Combustible, Alcohol y Portland). Sus edificios asimétricos y esculturales dotados de paredes curvadas, líneas horizontales extendidas y techos largos y sobresalientes aluden de manera clarísima a barcos y muelles (figura 5).[24]

En Montevideo, el Art Deco y la arquitectura racionalista gozaban de una marcada popularidad en aquella sociedad cuya meta colectiva era el progreso material. Los arquitectos uruguayos

construían edificios gubernamentales, residencias particulares, teatros de cine y edificios de apartamentos inspirados por el estilo Deco, con portones de hierro forjado, vidrio de colores y abundantes relieves. En 1930, para conmemorar el Centenario de la Constitución, se construyó el Estadio Centenario, rematado dramáticamente por una torre decorada con alas aerodinámicas. Esta cancha de fútbol fue la sede de la primera Copa del Mundo, cuyo encuentro inicial desencadenó una gran euforia en Montevideo cuando ganó el equipo nacional.[25]

Una creciente corriente de ideología izquierdista se estaba apoderando de las clases intelectuales y obreras en Montevideo cuando la ciudad fue seleccionada como anfitrión del Congreso de Sindicatos Latinoamericanos en 1929. El delegado de México en esa ocasión era el carismático David Álfaro Siqueiros quien, cuatro años más tarde, regresaría a Montevideo para presentar una muestra de sus pinturas en el Círculo de Bellas Artes. El artista mexicano instaba a los pintores uruguayos que abandonasen las pinturas "burguesas" de caballete para dedicarse a los murales con mensajes políticos. Pero el Realismo Social no les interesaba mucho a los artistas uruguayos ya que dependían del apoyo del gobierno y tenían una vida relativamente segura bajo los auspicios benefactores del emergente sistema de bienestar social. La CTIU (Confederación de Trabajadores e Intelectuales del Uruguay) y posteriormente la AIAPE (Agrupación Intelectuales, Artistas, Periodistas y Escritores), una asociación izquierdista, permanecían en vigor a pesar de que el Uruguay había decidido romper relaciones diplomáticas con la Unión Soviética en el año 1936.

Joaquín Torres-García

La llegada de Joaquín Torres-García en 1934 también tuvo una influencia pronunciada en el ámbito artístico de Montevideo y, a la larga, alteraría su trayectoria. En París, Torres-García había logrado la unión artística de dos mundos que supuestamente eran irreconciliables: la abstracción y la representación. Al colocar símbolos dentro de una estructura geométrica, pudo expresar un significado carente de narrativa. A este estilo lo nombró Universalismo Constructivo y, porque abarcaba todos los aspectos de la vida, lo consideraba una manifestación moderna del arte de las civilizaciones del mundo.

Su obra se conocía hasta cierto punto en el Uruguay en aquella época, pero no su nombre, y se presentó en círculos artísticos locales por medio de frecuentes exposiciones (montó una retrospectiva en Amigos del Arte apenas dos meses después de haber llegado), conferencias y ruedas de prensa. Fue negativa su conclusión en cuanto al estado de desarrollo artístico que existía en el Uruguay: observó que tanto los artistas como el público se mostraban muy poco receptivos a la vanguardia y se resistían a todo lo que podría afectar el statu quo. Pero fue precisamente la falta de carácter artístico bien definido del Uruguay lo que motivó a Torres-García a ver a Montevideo como un lienzo en blanco sobre el cual podría expresar su visión.

En 1935, Torres-García logró convencer a un grupo de artistas sobre la vigencia de la abstracción geométrica. Estableció entonces la AAC (Asociación de Arte Constructivo) junto con Julián Álvarez Márquez, Carmelo de Arzadún, Héctor Ragni, Amalia Nieto, Zoma Baitler, Gilberto Bellini, Carlos Prevosti, Lia Rivas y Rosa Acle. Siguiendo los pasos del Neoplasticismo y del Constructivismo, las pinturas y esculturas producidas por los integrantes de la AAC figuran entre las primeras obras abstractas creadas en Sudamérica. Aunque muy pocas de ellas se han conservado, las reproducciones publicadas en la revista *Círculo y Cuadrado* indican su nivel de sofisticación (figura 6).[26]

El famoso mapa invertido de Sudamérica, dibujado por Torres-García en 1936, simbolizaba su intención de acabar con la dependencia cultural uruguaya-europea y de inaugurar una nueva época artística en la región. Encontró en la civilización de los Inca ciertos arquetipos constructivistas sobre los cuales pretendió fundamentar una auténtica identidad americana en el arte moderno.[27] Plenamente conciente de los peligros del criollismo y del nativismo folclóricos, previno contra "caer en lo arqueológico" o "hacer pastiche sudamericano" y les aconsejó a los artistas evitar "lo típico, otro escollo no menos peligroso".[28] No logró interesar a los artistas uruguayos en este proyecto: el arte amerindio les resultaba extranjero y ajeno a su campo de interés. Pero las ideas de Torres-García en cuanto al arte precolombino sentarían unas bases importantísimas para futuras generaciones de abstraccionistas latinoamericanos.

El incansable proselitismo realizado por Torres-García, así como sus exposiciones en Montevideo y Buenos Aires, sus notas periodísticas, sus libros—incluyendo *Estructura* (1935) y la publicación en Buenos Aires de sus conferencias en el libro *Universalismo Constructivo* (1944)—lo fueron catalogando como un defensor polémico pero serio del arte moderno. Su atelier se convirtió en destino obligado para artistas, escritores, músicos y críticos tanto nacionales como extranjeros. Entre tantos que lo vinieron a visitar cabe destacar a Julian Huxley, René D'Harnoncourt y Lincoln Kirstein de Nueva York; René Huyghe de París; el compositor Alberto Ginastera, el crítico Jorge Romero Brest, el pintor Emilio Petorutti, y los artistas jóvenes que fundarían los grupos Madí y Arte Concreto–Invención en Buenos Aires.

Mientras planteaba la formulación de una forma artística auténticamente americana, se recibían en Montevideo las noticias de la Guerra Civil en España y amenazaba el espectro de una Segunda Guerra Mundial. Torres-García, como tantos otros intelectuales, temía por el futuro de la cultura occidental. Pese a que recomendaba olvidarse de Europa, permanecía inextricablemente vinculado al viejo continente. Este dilema lo obligó a definir su postura tanto en relación a Europa como a las culturas indígenas del continente americano, y cobró mayor urgencia su deseo de educar y preparar a los artistas que estudiarían y continuarían el legado cultural de ambas regiones.

El Taller Torres-García

A medida que se fue disolviendo la AAC, un grupo de artistas en ciernes que tenían poca o incluso ninguna preparación artística pero sí mostraban mucho interés en las ideas utópicas

de Torres-García, empezaron a asistir a sus clases, donde les enseñó pintura y dibujo con un enfoque abstraccionista y los principios del Universalismo Constructivo. En su Taller, el maestro Torres-García creó un entorno educativo que sirvió para gestar uno talentos realmente excepcionales. Según Gonzalo Fonseca el ambiente del Taller era muy animado y "se hablaba de la pintura, se comparaban y se corregían las obras de arte, se preparaban las publicaciones y los manifiestos.... Todo era tema de discusión—de la antropología al origen del hombre a las intrigas nimias entre artistas".[29] Fonseca (figura 7), Julio Alpuy, José Gurvich, Francisco Matto, Manuel Pailós, y Augusto y Horacio Torres (los hijos del maestro Torres-García) formaron el núcleo de los integrantes del Taller Torres-García (TTG), que duró veinte años y desempeñó un papel muy importante en el desarrollo del arte contemporáneo en toda Sudamérica.[30]

El Taller ocupaba un lugar dominante en Montevideo: los integrantes/estudiantes/artistas aplicaban el estilo "constructivo" a objetos, cerámicas, muebles, tapicería, vidrio de colores, portones de hierro forjado y al diseño gráfico. La producción de estos jóvenes aparecía en las paredes de los cafés, en los folletos de los *Cine Club,* en gasolineras, en residencias particulares y en espacios públicos y comerciales. Toda esta actividad provocó el antagonismo implacable de las fuerzas políticas conservadoras tanto académicas como culturales. La revista *Removedor,*[31] publicación del Taller que incluía artículos, reseñas e imágenes de las obras de sus integrantes, promovía sus exposiciones y contestaba en editoriales a sus detractores.

Los artistas del Taller creían que la fusión de la pintura con la arquitectura era de tanta importancia que intentaron "inundar" la ciudad de Montevideo con murales. La gran cantidad de murales constructivistas en Montevideo es comparable con la propia tradición muralista de la Ciudad de México. En el año 1944, Torres-García y veinte de los artistas del Taller recibieron una invitación para decorar las paredes del Hospital St. Bois. Estos murales (figura 8) representaron un resumen de la experiencia de Torres-García como pintor, teórico y maestro. Emulando el espíritu colectivo de antaño, cuando los artistas se expresaban según los cánones de un estilo unificado, los integrantes del Taller pintaron todos los murales (un total de treinta y cinco) en vivos colores primarios. Las obras representaban las calles y el puerto de Montevideo, y estaban repletas de barcos, muelles, grúas, locomotoras y tranvías. Torres-García buscaba pinturas que fuesen "férreamente vinculadas a la ciudad, comentando o cantando su vida, poniéndola de relieve, mostrándola y hasta como guiándola".[32] Ordenados conforme a un diseño estructurado, rítmico y sintético, los murales comprobaron el principio de Torres-García que decía que dentro de un estilo determinado, los artistas pueden lograr una representación sin recurrir al naturalismo.

La cohesión que existía entre la vida de los artistas del Taller y su fe en el arte que practicaban—porque emergía de un núcleo de reglas esenciales y universales que regían principios no sólo estéticos sino morales—tuvo un impacto potente. A pesar de que algunos críticos objetaban a la obra de los artistas del Taller, éstos dejaron mella en el arte de la región y su influencia perdura hasta el día de hoy—el estilo que generaron entonces se hizo sinónimo del arte de Montevideo (figura 9).[33]

El ambiente cultural: post-1936

Durante la Guerra Civil en España se produjo un éxodo de artistas, escritores e intelectuales españoles que se radicaron en Montevideo y Buenos Aires y enriquecieron la vida cultural en ambas capitales. Aunque el gobierno del Uruguay rompió relaciones diplomáticas con el régimen Republicano de España, muchos uruguayos optaron por apoyarlo y se movilizaron para auxiliarlo. La actriz catalana Margarita Xirgú (1888–1969), exiliada del régimen franquista, vigorizó el teatro montevideano con sus representaciones magistrales de las obras de García Lorca. Era ella una maestra de gran renombre, y los actores y directores que capacitó durante su carrera crearon a su vez las compañías teatrales independientes que florecieron en Montevideo.

Uruguay, que se había declarado neutral al iniciarse la Segunda Guerra Mundial, fue testigo de la Batalla del Río de la Plata en diciembre de 1939. La persecución y el bombardeo del acorazado alemán Graf Spee por parte de la marina británica tuvieron lugar literalmente frente a Montevideo, a plena vista de todos los ciudadanos congregados en las Ramblas de la costa. A partir de entonces, Uruguay modificó su postura para declararse a favor de los Aliados. En el año 1940 emprendió una investigación de los simpatizantes nazi y eventualmente, en 1942, rompió relaciones con el Eje. Montevideo se benefició del gran arte que trajeron los famosos artistas que huían de la guerra. Jules Supervielle, por ejemplo, pasó los años de la guerra en el Uruguay e invitó a los famosos actores franceses Louis Jouvet y Madeleine Ozeray a interpretar su obra *La belle au bois.* En 1941 una exposición itinerante de pintura contemporánea trajo a Hopper, O'Keefe, Grosz, Sloan y muchos otros maestros estadounidenses a Montevideo. La mayoría de las obras eran figurativas, menos *Argula,* un cuadro de la colección del Museo de Arte Moderno de Nueva York, pintado en 1938 por Arshile Gorky, que le interesó a Torres-García.[34]

A partir del año 1945, el Uruguay disfrutó de una década de prosperidad sin precedente y, hasta la fecha, sin igual. El desarrollo industrial cada vez mayor beneficiaba a una amplia clase media que construía casas modernas en los barrios residenciales en expansión y los amueblaba en un estilo claramente influenciado por los diseños suecos que estaban de moda. En las tiendas se vendían productos locales de vidrio artesano, cerámicas y textiles.

Cuando se estableció la Facultad de Humanidades en la Universidad Nacional, en 1946, el crítico argentino Jorge Romero Brest empezó a preparar a la nueva generación que formaría el futuro artístico de Montevideo por medio de concursos, salones, premios, y la selección de los artistas que representarían al Uruguay en las Bienales de Venecia y São Paulo. En Montevideo, donde se había estrenado con gran popularidad la radio y el cine (Montevideo contaba con ochenta cines en 1930), los teatros de los años treinta, decorados en el estilo Art

Deco, se fueron cerrando frente a la proliferación del cine club independiente (figura 10) donde se podían ver películas internacionales tanto viejas como de vanguardia. Después de la guerra, la única versión completa que quedaba de la legendaria película muda alemana *El Gabinete del Dr. Caligari* se encontró en los archivos del Cine Club del Uruguay.

Después del fallecimiento de Torres-García en 1949, muchos de los integrantes del Taller fueron a Europa para ver arte directamente en los museos. Mientras tanto, en Montevideo, un grupo de artistas que se resistieron a las ideas de Torres-García (incluyendo María Freire, José Pedro Costigliolo y Antonio Llorens) exploraban una forma de abstracción, expresada en pintura y escultura, modelada en el Suprematismo ruso y el arte geométrico de Vantongerloo, Naum Gabo y Max Bill. En sus composiciones, forma y línea crean equilibrios y tensiones visuales (figura 11). Preferían usar pintura sintética aplicada sobre superficies planas e uniformes cuyo efecto sugería un material hecho a máquina. A primera vista, como ha observado Gabriel Pérez-Barreiro, sus obras en papel parecen serigrafías; hay que hacer una inspección minuciosa para poder ver que son guaches pintadas a mano.[35] Freire experimentaba con materiales producidos por industrias locales y creaba esculturas con acrílico, acero, y metal esmaltado procedente de la fábrica de productos electrodomésticos Kraft Imesa. Llorens era un diseñador gráfico de gran talento y con amplio dominio de la técnica de serigrafía. Otros artistas, así como Manuel Espínola Gómez, Américo Spósito, Juan Ventayol e Hilda López manifestaban una abstracción expresiva que dependía del gesto y de vez en cuanto se refería a la realidad o a las formas orgánicas.

Para fines de los años cincuenta, una baja en la fabricación y la producción industrial fueron los primeros síntomas de la inminente crisis económica cuyo resultado sería una nueva política de austeridad en cuanto a las generosas prestaciones del sistema de bienestar social uruguayo. Pero a pesar de la disminución en el ritmo económico, seguía floreciendo el medio artístico en Montevideo. Dos nuevas salas de exposición, patrocinadas por el periódico *El País* y la compañía General Electric, infundieron vigor en círculos artísticos al ofrecerles a los artistas mayores posibilidades para la exposición de su obra. Muestras itinerantes importantes también impactaron a los artistas locales, y la Bienal de São Paulo se convirtió en un punto de reunión para el arte sudamericano e internacional.

Así como los años cincuenta, los sesenta también resultaron ser una década importante en el ámbito artístico uruguayo, a pesar del período de vacas flacas que se vivía a nivel económico, social y político en aquél entonces en la Banda Oriental. Por medio de las exposiciones de artistas contemporáneos españoles, incluyendo a Antoni Tápies y el grupo informalista El Paso, del brasileño Manabu Mabe, y del italiano Alberto Burri, los artistas locales pudieron familiarizarse con estilos como la Pintura de Acción, el Tachismo y el Informalismo. Los lienzos rasgados y cargados de textura gruesa, así como los collage de materiales desechados, tan evocativos del desorden irracional y el deterioro urbano,

reflejaban el estado de ánimo de los artistas montevideanos de aquél entonces. Agustín Alamán, Washington Barcala, José Gamarra y Leopoldo Novoa exploraron caminos nuevos en la abstracción que convertían a los materiales y las texturas complicadas en los propios temas de la obra. Siete pintores (incluyendo Oscar García Reino, Miguel Ángel Pareja, Jorge Páez Vilaró, Lincoln Presno, Américo Spósito) y un fotógrafo (Alfredo Testoni) formaron el Grupo 8. Al defender una libertad total en la expresión artística, la alianza de estos artistas sirvió más para promover los eventos grupales que para manifestar una ideología en común.

A fines de los años sesenta, se inició la fuga de cerebros del Uruguay; Montevideo perdía sus mejores y más brillantes profesionales, artistas, escritores y artesanos. Llegó a tal punto que, en un momento determinado de los años setenta, partían cincuenta y cinco uruguayos todos los días rumbo a Europa, Australia, Argentina y Norteamérica en busca de mejores empleos.[36] Gracias a los impuestos altos y las imposiciones reguladoras que financiaban las leyes sociales tan avanzadas del país, los productos uruguayos ya no podían competir en los mercados mundiales y la consiguiente crisis económica precipitó un deterioro desastroso en todos los aspectos de la vida. Con el malestar social vino una creciente represión de los derechos civiles, cuya culminación se produjo con el golpe de 1973 que instaló un régimen militar por una década. El patrimonio arquitectónico urbano de Montevideo sufrió pérdidas lamentables durante este período, ya que barrios enteros fueron arrasados para construir en su lugar edificios de apartamentos.

Después de haber pasado por décadas de dificultades y privaciones, poco a poco se está recuperando el país en el sentido económico. Uruguay es uno de los principales exportadores de software y tecnología de comunicación en Latinoamérica. Hoy en día, hay una mayor conciencia del carácter tan singular de la ciudad de Montevideo y se han iniciado algunos proyectos para conservar y restaurarla. El libro y video *Montevideo: Una ciudad sin memoria*, publicados en 1982, pretendían rescatar las imágenes del patrimonio arquitectónico perdido del Uruguay, y en las guías publicadas por Elarqa están catalogados todos y cada uno de los edificios que tenga algún interés arquitectónico.

Montevideo ha inspirado a poetas, pintores y novelistas. El novelista Juan Carlos Onetti les recomienda a los escritores "hacer" Montevideo para que la vida pueda imitar al arte. Los exhorta a excavar en el alma de la ciudad, en su esencia única, y escribir sobre sí mismos para que la ciudad y los habitantes se parezcan a sus creaciones. Mario Benedetti encontró que el "colorcito seudo europeo, que empezó siendo postizo, mínimamente hipócrita, ha acabado por constituir una inevitable, vergonzante sinceridad".[37]

En la opinión de Torres-García, la ciudad fue tan excepcional como su nombre, "tan único con estas diez letras en hilera, ni bajando ni subiendo, bien igualitas, y que de puro sin expresión son inquietantes: M-O-N-T-E-V-I-D-E-O" (figura 12).[38]

Traducción de Tony Beckwith

Notas

1. Se dice que su nombre originó con el grito de un marinero portugués quien anunció: "Monte vide eu!" (¡Veo un cerro!) al ver aparecer El Cerro a lo lejos.

2. Asociación de Arte Constructivo, 1935–1943.

3. Taller Torres-García, 1943–1962.

4. El Virreinato del Río de la Plata fue establecido en Buenos Aires en 1776.

5. "El sabor de lo oriental / con estas palabras pinto; / es el sabor de lo que es / igual y un poco distinto". Jorge Luís Borges, *Milonga para los orientales* (Buenos Aires, Emecé Editores, 1995 [1964]), 304.

6. Milton Schinca, *Boulevard Sarandí*, vol. 1 (Montevideo: Ediciones de la Banda Oriental, 1976), 97.

7. Citado en Schinca, 65.

8. Lautréamont tenía trece años cuando se fue de Montevideo en 1859; Laforgue se fue en 1866 con seis años de edad. Sólo Jules Supervielle regresaría periódicamente y escribiría sobre su país nativo.

9. José Vasconcellos, en Alberto Methol Ferré, "Dos odiseas americanas: Torres y Vasconcellos", *Artes* [Montevideo] no. 2 (Agosto 1959), 12.

10. José Batlle y Ordóñez fue presidente entre 1903 y 1907 y otra vez entre 1911 y 1915.

11. José Gervasio Artigas (1764–1850) se considera el padre de la nacionalidad uruguaya; fue influenciado en gran medida por la Declaración de Independencia de los Estados Unidos y por las ideas políticas francesas.

12. Susana Salgado, *The Teatro Solís: 150 Years of Opera, Concert, and Ballet in Montevideo* (Middleton, Conn., Wesleyan University Press, 2003).

13. Juan Manuel Blanes viajó a Italia cuatro veces durante el curso de su vida. Falleció en Pisa.

14. Juan Acha, *Arte y sociedad latinoamericana* (México: Fondo de Cultura Económica, 1979), 118.

15. Jorge Luís Borges, *Poesía gauchesca* (Bruguera, España: Prosa Completa, 1980), 107.

16. Javier de Viana, *La Trenza* (Montevideo: Ediciones de la Banda Oriental, 1964), 75.

17. Los barcos cargados de esclavos procedentes de África llegaban al puerto de Montevideo hasta que fue abolida la esclavitud en 1842. El comercio de esclavos era importante y muy rentable, porque venían a comprarlos desde la Argentina, Chile, y hasta del Perú. Durante una época, una tercera parte de la población de Montevideo era negra.

18. Rosa Brill, *Pedro Figari Pensador* (Buenos Aires: Grupo Editor Latinoamericano, 1993).

19. Hugo Achugar, "El 'acuerdismo' y su expresión en lo político-cultural", en *Los veinte: el proyecto uruguayo: arte y diseño de un imaginario 1916–1934* (Montevideo: Museo Municipal de Bellas Artes Juan Manuel Blanes, 1999), 67.

20. Pablo Rocca, "Ciudad, Campo, Letras, Imágenes", en *Los veinte,* 105.

21. "Mientras exista el jazz-band es imposible fabricar arte nativista. En este momento quiero hacer un arte nativista, pero, el arte sincopado de un fox-trot me lo impide; pienso en el campo desde Montevideo, y nada". Idelfonso Pereda Valdés, en *La Cruz del Sur* [Montevideo] 3 (mayo/junio 1927), 17.

22. "El *Vibracionismo,* es, pues, cierto movimiento que se determina fatalmente por *el paso de una sensación de color a otra correspondiente*". Torres-García, "Rafael Barradas", en *Universalismo Constructivo* (Buenos Aires: Editorial Poseidón, 1944), 556. Hay una importante colección de pinturas y dibujos de Barradas en el Museo de Arte Visual en Montevideo. Según el historiador de arte Gabriel Peluffo, fue recién en los años cincuenta que se dio cuenta Montevideo de la importancia de la obra de Barradas. Gabriel Peluffo, *Historia de la pintura uruguaya,* vol. 2 (Montevideo: Ediciones de la Banda Oriental, 1986), 24.

23. La Sociedad de Arquitectos del Uruguay fue creada en 1914; fomentaron concursos para las comisiones públicas, que mejoró la calidad y la ética del proceso de selección. Entre 1903 y 1949, se organizaron ochenta y siete concursos arquitectónicos en Montevideo. Adolfo Maslach, "La arquitectura nacional", *Joaquín Torres-García, Sol y luna del arcano* (Caracas: UNESCO, 1998), 620.

24. Juan Pedro Margenat, *Barcos de ladrillo, arquitectura de referentes náuticos en Uruguay 1930–1950* (Montevideo, Typeworks, 2001). Entre los ejemplos excelentes de edificios en forma de barco figuran el Buceo, el Hotel Planeta en Atlántida, y muchas residencias particulares.

25. Juan Pedro Margenat, "La arquitectura renovadora uruguaya", en *Los veinte,* 93.

26. Torres-García pretendió que *Círculo y Cuadrado* fuera la continuación de la revista parisién *Cercle et Carré* que había co-fundada él en 1930 con Michel Seuphor. Se publicaron diez ediciones hasta el año 1943. Al igual que la revista francesa *Plastic/Plastique* (1937) que entabló el diálogo entre artistas norteamericanos y franceses, *Círculo y Cuadrado* creó un diálogo entre artistas uruguayos y europeos, ya que se publicaba en español y francés.

27. Torres-García se había interesado en el arte amerindio desde los años veinte a raíz de sus visitas al Museo de Historia Natural en Nueva York. En Montevideo, en 1936, vio una exposición de textiles peruanos de la época precolombina, y guardaba recortes sobre sitios arqueológicos sudamericanos de suplementos culturales de los periódicos argentinos *La Nación* y *La Prensa.*

28. Torres-García, "El nuevo arte de América", en *Universalismo Constructivo* (Madrid: Alianza Editorial, 1984), 819.

29. Gonzalo Fonseca, "Torres-García's Symbols within Squares", *Arts Magazine* [Nueva York], marzo 1960, 30.

30. El TTG organizó más de 150 exposiciones entre 1943 y 1962 en Montevideo y en el exterior.

31. El TTG publicó 28 ediciones de *Removedor* entre 1945 y 1952.

32. Torres-García, "The School of the South, La Escuela del Sur", en *Universalismo Constructivo* (Madrid: Alianza Editorial, 1984), 197.

33. Este estilo fue tan omnipresente que se incorporó a la conciencia popular. El Uruguay no tiene una tradición de arte folclórico; es el Constructivismo de Torres-García el que se ha convertido en la lengua vernácula popular. Los artesanos de hoy todavía decoran objetos con una versión diluida y ornamental de símbolos dentro de una cuadrícula que ya está muy lejos de su intención original.

34. Organizada por el Comité de Arte de Relaciones Culturales y Comerciales con los Estados Unidos, la exposición motivó a Torres-García a publicar un comentario crítico: *Mi opinión sobre la exposición de artistas norteamericanos* (Montevideo: La industrial gráfica uruguaya, 1942).

35. Gabriel Pérez-Barreiro, *María Freire* (São Paulo: Cosac & Naify, 2001), 31.

36. David L. Marcus, "Uruguayan Exodus", *The Dallas Morning News,* 11 septiembre 1991.

37. Mario Benedetti, *Andamios* (Buenos Aires: Seix Barral, 1996), 103.

38. Torres-García, "The School of the South, La Escuela del Sur", 194.

Buenos Aires: Rompiendo el marco
Gabriel Pérez-Barreiro

Entre todas las metrópolis latinoamericanas, tal vez sea Buenos Aires la que menos cuadra con los estereotipos exóticos o antiguos que suelen teñir la imagen de Latinoamérica vista desde Europa o Norteamérica. Como podemos ver en la fotografía de la zona céntrica, sacada por Horacio Coppola en 1936 (figura 14), Buenos Aires era una ciudad de rascacielos, elegantes bulevares, tránsito y estilos urbanos. Los miles de inmigrantes que llegaron a esta ciudad procedentes de Europa se encontraron con una visión de modernidad que francamente no existía en sus patrias del viejo continente. Si bien hoy en día nos hemos acostumbrado a pensar en un mundo cultural y económico en el cual el norte está desarrollado y el sur todo lo contrario, durante los años anteriores a la Segunda Guerra Mundial no era tan fácil distinguir Buenos Aires de Nueva York, o Chicago, o cualquier otra ciudad importante en Estados Unidos. En cambio, la capital argentina sí se distinguía dramáticamente de las regiones rurales europeas que habían abandonado aquellos inmigrantes en busca de una vida mejor. A mediados de los años treinta, la tasa de analfabetismo en Buenos Aires, que en aquél entonces representaba la quinta economía más fuerte del mundo, ascendía apenas al 6.64 por ciento—una cifra extraordinariamente baja para cualquier lugar en esa época.[1]

Buenos Aires no sólo era una ciudad plenamente urbana y desarrollada, sino que también era relativamente nueva según la norma sudamericana. En las palabras de Nicolas Shumway: "Hasta que declaró su independencia, la Argentina no era más que una región del Imperio Español; no era un país, ni siquiera una idea para un país".[2] Aunque Buenos Aires fue fundada en el año 1536, ese asentamiento original fue abandonado posteriormente y recién fue establecido ahí el Virreinato en 1776, treinta y cuatro escasos años antes de la Independencia. La ciudad realmente no cobró gran importancia, pues, hasta producirse la afluencia masiva de inmigrantes a fines del siglo XIX y primeros del XX.

Durante las primeras décadas del siglo XX se fue consolidando a paso ligero una cultura moderna en Buenos Aires. Este proceso fue protagonizado por la gran multitud de inmigrantes europeos que llegaron a la Argentina en una serie de oleadas a partir de la década de 1880. La afluencia de europeos en esta ciudad de pocos esclavos donde ya casi no quedaban rastros de la población que había dispersada la Conquista gestó, a partir de la mezcla de recién llegados de España, Italia y Europa Central, la población tal vez más blanca de todo el continente. Los recuerdos personales o familiares de la mayoría de los nuevos porteños (los habitantes de Buenos Aires) estaban totalmente arraigados en su tierra a miles de kilómetros del otro lado del Atlántico, y muy pocos de ellos veían a la Argentina como algo más que el lugar donde habían venido a establecer su nueva residencia. Es probable que la nostalgia, la añoranza y el fervor por lo europeo que suelen caracterizar a los argentinos se deba, hasta cierto punto, a esa sensación de desprendimiento y desplazamiento que sentían aquellos primeros inmigrantes. Durante la década de 1920, el cincuenta por ciento de los porteños habían nacido en el exterior; para el año 1947 esa clasificación demográfica había bajado a un 25 por ciento a medida que los inmigrantes se fueron estableciendo y creando una nueva generación de argentinos cuyas familias eran europeas pero que tenían poca o ninguna experiencia personal de sus patrias ancestrales.[3] Mientras Europa se veía cada vez más envuelto en la Guerra Civil Española, el conflicto italiano en Abisinia, y la Segunda Guerra Mundial, la Argentina era un remanso aislado y relativamente tranquilo donde florecían la modernidad, la calma social y la riqueza. Desde luego que durante los años treinta y cuarenta del siglo XX también se desencadenaron polémicas difíciles en la Argentina, incluyendo una serie de conflictos laborales que fueron violentamente reprimidos, pero los argentinos se salvaron de la matanza y la destrucción generalizadas que se sufrían en Europa—aunque muchos las vivían a través del contacto con familiares y amigos en el viejo mundo.

Para los años cuarenta, Buenos Aires ya disfrutaba de un estilo de vida urbano, sofisticado, politizado y alfabetizado. Una nueva generación de argentinos nativos luchaba para reformar la estructura política imperante que, a partir de la Independencia, había logrado concentrar el poder en manos de un grupo relativamente pequeño. La ascensión de Juan Domingo Perón en 1946 fue una clara manifestación del deseo de los argentinos de encontrar un nuevo sistema político frente a la nueva composición social del país y el nuevo orden mundial que había surgido en el período de la posguerra. Hasta la fecha sigue siendo motivo de acaloradas polémicas el carácter, el efecto, y el significado del Peronismo. Para los fines de este ensayo, alcanza con señalar la transformación del discurso político y la interrupción de la tradición de un régimen cuasi-aristocrático.

Dentro de este contexto de debate y discusión en torno a la composición social de Argentina y el papel que desempeñaría el país en el escenario internacional, ocupa un lugar muy especial la cuestión de la "alta cultura". Jean Franco afirma con cierta audacia que: "El factor más notable de la cultura argentina es su carácter elite", que logra distinguirla del populismo o el nativismo del muralismo mexicano o el indigenismo peruano.[4] En este contexto, el término "elite" se puede interpretar esencialmente como sinónimo de "europeo". Pero la palabra "europeo" en este caso no se refiere a las masas que llegaron como inmigrantes a la Argentina, sino a la relación especial que existía entre la elite de Buenos Aires y la alta cultura de la burguesía europea. Así, pues, en Buenos Aires como tal vez en ningún otro lugar en el continente americano, fue la clase social—y no el origen étnico—el factor decisivo a la hora de abrir las puertas a la cultura europea. La elite argentina creó su propia versión de la Gran Gira Europea y así acumuló magníficas obras de arte a fines del siglo XIX y primeros del XX—obras que hoy en día forman el núcleo de las colecciones de los excelentes museos nacionales de la capital. Conforme a este paradigma, que se extendió hasta bien entrado el siglo XX, la cultural europea era una cuestión

de buen gusto o bien, si se expresara en términos artísticos, de *estilo*. Así, pues, todo artista, escritor o entendido en materia de arte que aspiraba participar en debates culturales, se veía obligado a pasar una temporada en Europa para instruirse en cuanto a los estilos artísticos en boga y hacer peregrinajes a los museos. Dados los gastos que suponía tal estadía y lo difícil que era viajar por razones de ocio, la experiencia europea se limitaba exclusivamente a un pequeño grupo de privilegiados. Durante los años veinte y treinta varios grupos de mecenas de las clases elevadas—siendo Amigos del Arte el más famoso—ofrecían apoyo financiero para los artistas en ciernes que querían estudiar en Europa; fue así como Xul Solar y Emilio Petorutti, entre muchos otros, pudieron emprender el viaje al viejo continente. Al regresar a Buenos Aires, estos artistas e intelectuales encontraban un hogar espiritual en los elegantes salones de la zona céntrica de la ciudad (el grupo llamado Florida adoptó el nombre de la famosa avenida capitalina), y en revistas como *Sur,* la publicación administrada por aquella mecenas por excelencia, Victoria Ocampo.

Este modelo de viajes instructivos a Europa estableció un paradigma muy particular en cuanto a la relación que mantenía Argentina con la modernidad artística europea. En primer lugar, el acceso a ese mundo se limitaba en gran medida a los que contaban con los fondos necesarios, o los que podían encontrarlos. Esta condición engendró, entre la aristocracia y la vanguardia argentinas, una conexión muy concreta que prácticamente no existía en Europa donde el patrocinio solía proceder principalmente de la clase media profesional. Para los criollos de la clase alta (la clase patricia nacida en la Argentina), como Victoria Ocampo o Jorge Luís Borges por ejemplo, había que defender la alta cultura europea contra la arremetida de nuevas ideologías que emergían entre la multitud de inmigrantes proletarios y urbanos que llegaba a diario. John King describe así a Victoria Ocampo: "[Para V.O.] existía una sola historia en la Argentina, aquella que habían forjado su familia y sus amigos, y que se debía defender contra los movimientos masivos del fascismo y el comunismo que fueron generados por los acontecimientos de los últimos años de la década de 1920 y los primeros de la de 1930".[5] En este contexto, la "importación" de la cultura europea avanzada representaba una afirmación de un amplio humanismo ligeramente conservador y una defensa anti-populista de una sofisticada tradición liberal.

Lo irónico de esta postura, obviamente, es que la vanguardia europea no tenía ni un pelo de conservador y, al contrario, solía vincularse estrechamente a los ideales revolucionarios o de transgresión social. En términos generales, lo que entonces ocurrió fue que el *estilo* visual de un movimiento determinado se encontró ligeramente separado de su *intención*. El resultado, en el peor de los casos, fue el sub-Cubismo decorativo de Emilio Petorutti; al otro extremo se produjo la reinterpretación original de Klee y el Simbolismo en la obra de Xul Solar. En resumidas cuentas lo que sí logró esta situación fue crear un paradigma en el cual las propuestas más revolucionarias de la vanguardia

europea o se desconocían o fueron domesticadas por medio de una transformación a un estilo decorativo que se podía entender en términos tradicionales a nivel tanto narrativa como del *connoisseur*. Para dar sólo un ejemplo: Julio Payró, el destacado crítico de arte, publicó en 1942 una historia del arte moderno europeo, *Pintura Moderna,* en la que descarta al Cubismo analítico por no haber creado obras maestras, y rechaza al Dada "por no poder justificarse como arte".[6] No se menciona el Constructivismo ruso ni De Stijl. Este libro representó a la vanguardia europea como una mera secuencia de estilos pictóricos, sin relación ninguna a manifiestos ni a cualquier tipo de indagación en cuanto a los límites de la obra de arte o a su relación con la sociedad.

Arturo y el nacimiento del Invencionismo

Las grandes transformaciones con frecuencia se anuncian de manera muy modesta. La publicación inicial y única de una pequeña revista llamada *Arturo* en 1944[7] representó la primera manifestación concreta de una nueva dirección en la historia artística de Buenos Aires—iniciativa que eventualmente engendraría toda una plétora de artistas, movimientos e ideas sobre el futuro de la abstracción geométrica en la región del Río de la Plata. *Arturo* era el arquetipo de lo contradictorio: la portada, realizada por Tomás Maldonado en un estilo de Expresionismo Abstracto, no parece concordar con varias proclamaciones en contra del Surrealismo y del automatismo que aparecen en las páginas interiores de la revista. Los poemas mitológicos de Arden Quin tienen muy poco que ver con los pronunciamientos de Kosice sobre el futuro científico; y los textos evocativos del poeta brasileño Murilo Mendes no tienen nada en común con el poema percusionista de Torres-García. Derek Harris ha sugerido que las contradicciones que presenta *Arturo* son "reflexiones de las ambigüedades y contradicciones del medio cultural y político argentino a mediados de los años cuarenta" por un lado, y por el otro "un paradigma de todos los fenómenos vanguardistas latinoamericanos".[8]

A pesar de haberse presentado como una "revista de artes abstractas," hay muy poco arte visual en las páginas de *Arturo,* y lo que ahí se encuentra es muy distinto a lo que desde entonces hemos venido a aceptar como el lenguaje visual de la vanguardia argentina: marcos irregulares, geometría pura, y esculturas articuladas. En este sentido, es importante hacer constar que la vanguardia de Buenos Aires no fue lanzada como propuesta ya completamente formada a partir de las páginas de *Arturo,* sino que la revista era síntoma de un nuevo ánimo de renovación, pero un ánimo de carácter esencialmente literario, pese a su interés declarado en las artes visuales. Esto resulta palpable en las contribuciones de los cuatro editores: Carmelo Arden Quin, Edgar Bayley, Gyula Kosice y Rhod Rothfuss. Rothfuss fue el único que publicó alguna obra visual en la revista: un relieve en madera en el estilo de Torres-García y una pintura semi-figurativa que recuerda a *Sin título (Arlequín)* (lámina 3), analizado en este mismo catálogo. Tomando en cuenta la portada automatista tan expresiva de Maldonado, los

cuadros geométricos orgánicos de la artista portuguesa Vieira da Silva, y la obra figurativa de Augusto Torres, la revista *Arturo* parecía ser todo menos una manifestación coherente de un estilo visual nuevo.

Todo esto obliga a plantear un punto importante en cuanto a las fechas en las que fueron realizadas las obras de este período, así como a su cronología. El fenómeno de fechas anticipadas y fabricación posterior de las obras en cuestión ha fomentado una idea muy engañosa respecto a la evolución del arte abstracto en Buenos Aires. Si uno fuese a aceptar como correctas las fechas alegadas para numerosas obras que han sido reproducidas y expuestas con frecuencia, incluso en los museos internacionales importantes, uno acabaría con la impresión de que, para cuando apareció *Arturo,* ya existía un estilo maduro y formado entre los jóvenes artistas que participaron en el lanzamiento de la publicación (situación que, de ser cierta, lo llevaría a uno a preguntarse: entonces, ¿por qué no fueron reproducidas estas obras en la revista?). Uno también concluiría que la producción artística más intensa de aquel período se produjo específicamente entre 1944 y 1946, o tal vez incluso antes. Un análisis más minucioso y riguroso de la documentación primaria del período indicaría, sin embargo, que entre 1944 y 1946 las deliberaciones pertinentes se realizaron mayormente por escrito, y que recién después del año 1946 empezó a discernirse un estilo visual coherente, que aun entonces se manifestaba a paso muy lento y tentativo. Lo cierto es que era muy modesta la producción de estos artistas en aquel entonces y que se ha conservado muy poco de esa obra original a lo largo de las décadas caracterizadas por una lamentable negligencia total por parte de museos, coleccionistas e historiadores de arte. Una historia más exacta de este período exigiría un esfuerzo considerable para volver a fechar y autentificar un porcentaje elevado de las obras que se encuentran actualmente en circulación. Dada la animosidad y el carácter pleiteador de los actores que aun viven, así como lo difícil que sería quitarles la autentificación a determinadas obras que forman parte de importantes colecciones públicas y privadas, este objetivo representa una tarea pendiente.

Entonces, pues, ¿qué podemos destilar de las páginas de *Arturo* que sirva como propuesta coherente? Esta pregunta tiene dos respuestas. Una de ellas afirma que la mera aparición de la revista es significativa en el sentido del papel catalizador que desempeñó y el efecto convocatorio que tuvo respecto a los pensadores más importantes de la siguiente generación. La otra respuesta remite a un análisis de la filosofía muy particular que en aquél entonces evolucionaba en torno a la idea de la invención. Varios textos que aparecen en las páginas de *Arturo* insinúan que se estaba produciendo una re-formulación de términos y significados en la que determinadas ideas que parecen estar intrínsecamente vinculadas a la historia del arte europeo (así como el Surrealismo y el automatismo) se volvían a alinear en conformidad con un concepto específico de la invención. En la portada interior de *Arturo* (figura 16) aparece una definición de tipo diccionario de la palabra 'invención' que dice así:

INVENTAR: Hallar o descubrir a fuerza de ingenio o meditación, o por mero acaso, una cosa nueva o no conocida./Hallar, imaginar, crear su obra el poeta o el artista/

INVENCIÓN: Acción y efecto de inventar. / Cosa inventada./HALLAZGO/

INVENCIÓN contra AUTOMATISMO

En la segunda definición, la palabra *hallazgo* está escrita en mayúsculas, poniendo de relieve el significado de la palabra. El hallazgo o el azar eran conceptos favoritos entre los Surrealistas y los Dadaístas, quienes pensaban que el automatismo (el *frottage* y la escritura automática, por ejemplo) era una manera de provocar precisamente este tipo de "hallazgo", anulando así la aportación de la mente conciente. Los comentarios que aparecen en la portada interior de *Arturo* aclaran que la invención no se logra por medio de una técnica específica (así como la escritura automática) sino por cualquier método: "a fuerza de ingenio o meditación, o por mero acaso", palabras que agregaron los redactores a la definición original del diccionario.[9]

El hecho de que se hayan agregado estas palabras adicionales implica que sí existe una diferencia entre la invención y el automatismo (entendido a través del Surrealismo), a saber: en la insistencia del segundo en cuanto a la aplicación de una técnica para superar las limitaciones conscientes, y en la libertad del primero para usar técnicas por su propio valor. Vista así, la postura anti-surrealista que se encuentra en la revista *Arturo* resulta ser mucho más complicada de lo que parece. El automatismo surrealista propone la supremacía del inconsciente y explora los mecanismos a través de los cuales se pueden reducir las acciones de la mente consciente. Pero si la invención puede resultar de la lógica, la meditación o el azar, entonces pertenece tanto al mundo consciente como el inconsciente. Lo que importa es el carácter inventivo de la obra final, no el medio empleado para realizarla. Esta distinción entre los medios y los fines inventivos es el verdadero meollo del proyecto vanguardista de esta generación: el deseo de crear un mundo de objetos no representativos inventivos en lugar de una exploración del subconsciente.

El concepto de la invención como el fin, en vez del medio, está subrayado en el texto tipo manifiesto de Arden Quin en *Arturo:* "Así la *invención* se hace rigurosa, no en los medios estéticos, sino en los fines estéticos". Esa misma idea está implícita en la afirmación final: "INVENCIÓN. De cualquier cosa; de cualquier acción; forma; mito; por mero juego; por mero sentido de creación: eternidad. FUNCIÓN".

El uso de la palabra FUNCIÓN aquí señala el otro factor determinante en el nacimiento de la abstracción en Buenos Aires: el Marxismo. Entre las proclamaciones manifestadas por los artistas durante los años 1945 y 1946, muchas son explícitamente marxistas, incluso estalinistas (figura 17). El Marxismo le brindó a esta generación un modelo materialista, funcional y social. Tal fue el entusiasmo que se sentía por el comunismo soviético que, en noviembre del año 1946, entre los estatutos de la Asociación Arte Concreto–Invención se podía encontrar la siguiente oración: "el invencionismo se solidariza

con todos los pueblos del mundo y con su gran aliado: la Unión Soviética".[10] Lo irónico de esta postura fue, evidentemente, que para los años cuarenta la Unión Soviética había invertido totalmente el apoyo que inicialmente había expresado por la abstracción geométrica experimental y se había declarado a favor del Realismo Social.[11] No obstante, hubo un período—que se extendió del año 1944 a 1946 ó 1947—durante el cual los artistas de la Asociación Arte Concreto–Invención (Maldonado, Hlito y Molenberg, entre otros) al parecer fueron tolerados por el Partido Comunista Argentino. Esto queda confirmado con la publicación del texto importante de Edgar Bayley "Sobre Arte Concreto" en la revista *Orientación,* el órgano semanal del Partido Comunista Argentino, que fue proscrita durante la Guerra pero que se volvió a establecer en agosto de 1945. En este artículo, Bayley planteó la idea de que el arte Concreto o el Invencionismo se debían entender como un idioma artístico verdaderamente marxista y revolucionaria. El ensayo de Bayley representa una justificación de la abstracción en el sentido de su relación con la lucha entre las clases, y manifestó que: "El arte concreto se define entonces, como una contribución ponderable a la liberación del hombre afirmando su dominio sobre el mundo. Y trabajando contra la ficción a través del acto inventivo y de las técnicas de propaganda y educación a cuyo progreso concurre".[12]

Los debates en torno a la definición del Invencionismo y el Arte Concreto que se mantuvieron entre la fecha de publicación de la revista *Arturo* y la consolidación de dos grupos artísticos—la Asociación Arte Concreto–Invención y Arte Madí —en el año 1946, se desenvolvieron en un período de muy escasa producción de arte visual. A pesar de la multiplicación de publicaciones, artículos y revistas en cuyas páginas se discutía el futuro del arte abstracto, no se registraba una presentación comparable de exposiciones. Al parecer, las ganas de polemizar en torno al tema y la necesidad de establecer una justificación teórica y política de la nueva expresión artística se anticiparon a la producción propiamente dicha. Recién a fines del año 1946 y a lo largo del siguiente, empezó a emerger de estas discusiones una estética coherente.

El marco recortado

El texto de mayor importancia que apareció en la revista *Arturo* es el último ensayo: "El marco: un problema de plástica actual" de Rothfuss. En su escrito, Rothfuss fue el primero en especular sobre el tema del marco recortado. El texto en sí es algo misterioso, en cierta medida porque el propio Rothfuss es una figura tan enigmática. No fue un escritor muy prolífico (existe el ensayo que aparece en *Arturo* y otros pocos artículos que se publicaron en *Arte Madí Universal*), y no se percibe como teórico en comparación con Arden Quin o Kosice—cuyas ambiciones literarias eran, como mínimo, tan pronunciadas como sus aspiraciones pictóricas. Rothfuss no escribió un texto editorial/manifiesto, como lo hicieron los otros tres redactores de la revista, y casi parece que la inclusión de su ensayo obedeció a una ocurrencia espontánea de último momento.

En la opinión de Rothfuss, ningún movimiento artístico europeo hasta la fecha había resuelto un problema clave en cuanto a la construcción de los cuadros: el marco. Señala que el marco rectangular, que fue inventado como apoyo para el ilusionismo y el realismo—una "ventana" al mundo, por decir—no concuerda con el anti-ilusionismo implícito en el arte abstracto. Al sugerir que el marco convencional desbarata la composición de la obra, Rothfuss propuso un método de composición más orgánico en el que las formas expanden de manera radial a partir del centro en lugar de ser determinadas a priori por el marco. Rothfuss espera hasta los últimos dos párrafos de su escrito para proponer explícitamente la solución al problema—estructurar el marco de acuerdo a la composición de la obra:

> Es por eso que la generalidad de esos cuadros siguieron en aquel concepto de *ventana* de los cuadros naturalistas, dándonos una parte del tema pero no la totalidad de él. Una pintura con un marco regular hace presentir una continuidad del tema que sólo desaparece cuando el marco está rigurosamente estructurado de acuerdo a la composición de la pintura.

La implicación de que una obra de arte debe ser una unidad autónoma concuerda con muchos aspectos del pensamiento modernista ortodoxo. Dawn Ades lo conectó con la demanda expresada por Gleizes y Metzinger en *Cubismo* (1912) por una pintura que tuviera "dentro de sí misma su propia razón de ser".[13] Clement Greenberg también ha identificado en el arte modernista la tendencia que muestra el plano a resistirse a los intentos de destruir sus propiedades físicas: "La historia de la pintura de vanguardia es la de una capitulación progresiva a la resistencia de su medio; resistencia que consiste principalmente en la denegación por parte del plano de la ilustración uniforme de los intentos de 'atravesarlo' con el fin de lograr un espacio perspectival realista".[14]

El ensayo de Rothfuss está acompañado de un cuadro de Kandinsky en el cual se palpa la evidente tensión que existe entre la composición orgánica y el marco rectangular. En la página siguiente está reproducida una obra de Mondrian (que ahora está en el Museo de Arte Moderno en Nueva York) junta a una obra de "marco recortado" de la primera época de Rothfuss.

La obra del propio Rothfuss, según la ilustración en el artículo, sorprende a varios niveles, y una obra comparable—*Sin título (Arlequín)*—se comenta en detalle en el presente catálogo. Pero aun más importante que la obra en sí es la colocación estratégica junta a la pintura de Mondrian, yuxtaposición que crea un reto visual para Mondrian y un mensaje implícito que dice que Rothfuss está resolviendo las contradicciones en el arte no figurativo europeo. Este enfoque crítico a la evolución del arte europeo resulta ser sintomático de una nueva confianza en cuanto al papel que desempeña la Argentina en la evolución del arte moderno. Para la generación anterior, el arte europeo era por definición más avanzado y por lo tanto instructivo. Rothfuss, de veinticuatro años de edad, jamás había visitado Europa (que entonces, claro, recién se volvía a normalizar después de la guerra), pero aun así ya se esforzaba por participar en las discusiones más avanzadas sobre el futuro del arte sin

sentir desventaja ninguna a raíz de su juventud o su ubicación geográfica. Esta actitud, bastante generalizada entre su generación, eventualmente creó un paradigma completamente nuevo para el desarrollo del arte moderno en la Argentina, en el cual la cuestión ya no era "alcanzarlos" a los demás sino tomar la delantera.

Del Invencionismo al Arte Concreto–Invención

Los cuatro editores de la revista *Arturo*—Arden Quin, Bayley, Kosice y Rothfuss—al poco tiempo formaron dos grupos, cada uno con sus propios discípulos. Se ha puesto en duda si el grupo original que integraba el equipo *Arturo* montó una exposición en la mueblería Comte en el año 1945,[15] pero de hecho quedaron bien documentados dos eventos de ese período: dos exposiciones presentadas en residencias particulares. La primera, titulada "Art Concret Invention" [en francés] tuvo lugar en la casa del psicoanalista Enrique Pichón-Rivière en octubre de 1945. Este evento fue la primera indicación de la ruptura que se producía entre los organizadores Kosice, Arden Quin y Rothfuss por un lado y, por el otro, Bayley y Maldonado, quienes al mismo tiempo reunían a los artistas que formarían la Asociación Arte Concreto–Invención en 1946. La documentación mencionada indica que asistieron al evento una amplia representación de los fundadores de la Asociación Psicoanalítica Argentina (APA) e ilustres personajes del medio cultural (aunque no de las artes visuales).

Las pocas obras de arte que se pueden ver al fondo en la fotografía sacada del grupo de asistentes al evento comprueban que, si bien se usaba de manera generalizada el marco irregular, las pinturas mismas definitivamente no representaban un arte netamente no figurativo y geométrico. Esta preferencia que se manifestaba por la organización y el impacto por encima de la creación del arte, así como en la búsqueda de públicos no tradicionales, ya empezaba a definir el futuro del movimiento Madí.

Dos meses después, el mismo grupo de artistas organizó otro evento, que duró un día entero, en la casa racionalista de la fotógrafa Grete Stern, ubicada en Ramos Mejía en los alrededores de Buenos Aires. Este acontecimiento, que ahora se nombraba "Movimiento de Arte Concreto–Invención", abarcaba una gran variedad de formas artísticas adicionales: música, danza, y hasta dibujos infantiles. Y, como en el caso anterior, la documentación indica que la forma de los cuadros expuestos aquí aun se veía algo tentativa. Entre los nombres de los artistas apuntados para el evento aparecen varios que muy posiblemente sean seudónimos: Sylwan Joffe-Lemme, Alejandro Havas, Raymundo Rasas Pet y Dieudone Costes.[16]

La Asociación Arte Concreto–Invención

Mientras Arden Quin, Kosice y Rothfuss se volcaron a la tarea de organizar eventos multimedia en residencias particulares (e inventando seudónimos artísticos), Tomás Maldonado y su hermano Edgar Bayley estaban juntando un grupo de artistas visuales para formar la Asociación Arte Concreto–Invención. Maldonado acudió a la Escuela de Bellas Artes para reclutar la mayoría de los integrantes de la Asociación,

especialmente a las clases nocturnas por ser las preferidas entre la clase obrera. Desde el primer momento, los artistas de la Asociación Arte Concreto–Invención se mostraron más rigurosos que sus compañeros en el grupo Madí; aspiraban a formar un movimiento que fuera colectivo, organizado y dedicado al análisis sistemático de todos los factores importantes relacionados con las artes visuales. Una simple comparación entre revistas, eventos y las propias proclamaciones de ambos grupos alcanza para contrastar el caos y la grandilocuencia del grupo Madí con la organización y racionalidad de la Asociación. Maldonado y Bayley sacaron la idea de invención de las páginas de la revista *Arturo,* la combinaron con una perspectiva marxista, y tomaron el marco irregular como su punto de partida inicial. No es nada difícil analizar el proceso de evolución de la Asociación Arte Concreto–Invención por medio de las obras de arte visual y los textos disponibles. Es más, la Colección Patricia Phelps de Cisneros posee ejemplos de cada una de estas etapas, las cuales se examinan en detalle en la sección del presente catálogo dedicada a los objetos presentados.

Debido al carácter colectivo de la Asociación, los integrantes individuales no se diferencian mucho los unos de los otros. A comienzos del año 1946, los artistas formaban sus lienzos al estilo del *Marco recortado n.º 2* de Melé (lámina 6). En su afán de crear objetos artísticos que fueran más tangibles y "reales" (es decir, más lejos aun de la idea de un marco que los encerraba), separaban las formas en el espacio para lograr un arreglo que definían como "coplanal," tal como se puede apreciar en *Relief* [*Relieve*] (lámina 4) de Lozza, y *Coplanal* (lámina 5) de Melé. En el año 1947, como resultado de las polémicas en torno a la nueva dependencia de la pared que apoyaba al coplanal, las tensiones que existían entre las intenciones marxistas del grupo por un lado y el creciente rechazo del propio Partido Comunista por el otro, así como el contacto más generalizado con el Arte Concreto europeo a través de Max Bill, el coplanal fue abandonado y los artistas volvieron a usar el marco tradicional. Poco a poco, las aspiraciones colectivas y sociales de la Asociación Arte Concreto–Invención buscaban manifestarse por medio del diseño gráfico e industrial a través de la dedicación de Maldonado y Hlito a la idea de encontrar un discurso racionalista en el mundo arquitectónico y del diseño durante la década de 1950. El interés que tenía la Asociación en la resolución de las contradicciones inherentes al coplanal dio otro giro cuando Raúl Lozza creó el Perceptismo en 1947–1948, enfocando los debates hacia una nueva forma de muralismo abstracto.[17]

Arte Madí

Arden Quin, Kosice y Rothfuss formarían el movimiento Madí en el año 1946. La palabra Madí apareció por primera vez en junio de 1946 en una serie de pequeños volantes, repartidos por las calles de Buenos Aires, con mensajes como: "¡Por un arte ESENCIAL abolida toda figuración romántico-naturalista! ¡Por una invención REAL!" Nuevamente cabe señalar que el afán de los artistas del movimiento Madí de provocar y de promocionarse se anticipaba a la exposición de su arte propiamente dicha. La distribución

de volantes de tipo manifiesto es una actividad muy típica de la vanguardia, e implica que los participantes tienen mayor interés en establecer una presencia provocativa que entablar un diálogo serio con el público.

La primera exposición del movimiento Madí tuvo lugar en agosto de 1946 en el Salón Peuser y duró sólo cuatro días. Conforme a su perfil, se anunció que la "exposición" también abarcaría "Literatura, pintura, escultura, dibujo, arquitectura, objetos, música y danza". En el manifiesto del grupo Madí de 1946/47 se incluyen definiciones para las obras Madí: pinturas, dibujos, arquitectura, danza, cuentos, música, etc. No se sabe si el Manifiesto, o alguna versión del mismo, fue leído durante el evento celebrado en el Salón Peuser.[18] El programa de la primera exposición del Madí nombra a catorce de sus integrantes, lista que ahora incluye el artista Martín Blaszko, el músico Esteban Eitler y la bailarina Pauline Ossona. También se nombran los cuatros artistas seudónimos mencionados anteriormente. Hay una contradicción interesante en el movimiento Madí: por un lado está su tendencia a ser abierto e incluir prácticamente cualquier expresión de arte experimental en la forma que sea, así como la música o la danza; por el otro está su idea casi esotérica en cuanto a la afiliación al grupo—con las consiguientes riñas internas y mistificaciones—que la caracterizaría a lo largo de su historia.

El grupo Madí montó otras dos exposiciones en 1946, siempre en espacios alternativos, y en 1947 publicó la primera edición de *Arte Madí Universal,* revista que seguiría en pie hasta el año 1954. *Arte Madí Universal* es la mejor representación que existe del mundo Madí: contaba con una lista admirable de colaboradores internacionales, muchos de los cuales, al parecer, no tenían una idea muy clara de exactamente qué era Madí.[19] En una versión típica de la revista se presentarían partituras musicales, fotografías de grupos, obras de Madí (a veces aparecía la misma obra en distintas ediciones firmado por distintos nombres), pronunciamientos grandilocuentes sobre la importancia de Madí, y reseñas de libros ficticios. Después de la publicación de la primera edición, Arden Quin se separó del grupo para trasladarse a París, donde volvió a formar su propio grupo Madí que continúan sus actividades hasta la fecha.

Si bien el conflicto posterior entre Kosice y Arden Quin en cuanto al origen de Madí ha resultado ser el tema dominante de la discusión sobre aquel período, no se debe interpretar esa lucha entre ellos exclusivamente como una expresión de su rivalidad personal. Aunque puede haber influido en el conflicto la personalidad de ambos, lo cierto es que también los separaban grandes diferencias estéticas y políticas. Arden Quin defendía una postura política más ortodoxa y una perspectiva universalista sobre el arte basada hasta cierto punto en las ideas de Torres-García.[20] Resulta sumamente difícil reconstruir la evolución de Arden Quin a partir de las escasas reproducciones primarias fiables de este período, pero podemos distinguir en sus composiciones la importancia de la sección dorada, que implica una creencia en un orden subyacente y fundamental. Según Arden Quin el plano del soporte, de la forma que fuera,

es la superficie sobre la cual se crea el arte; el marco, en cambio, por muy irregular que sea, sirve para separar esta composición del mundo exterior. De acuerdo a Kosice, la alteración del marco no es más que una etapa en el proceso de disolución de todas las formas artísticas rumbo a una re-evaluación radical del arte y de sus funciones. Este aspecto utópico y transformativo de las ideas de Kosice encontraría tal vez su más amplia expresión en el proyecto que emprendió en 1971 para la Ciudad Hidroespacial: un entorno suspendido en el espacio en el que el arte se disuelve en experiencia pura.

Mientras el objetivo de los artistas de la Asociación Arte Concreto–Invención era eliminar las diferencias entre ellos para expresar en su lugar una estética colectiva, los partidarios del movimiento Madí parecían interesarse menos en las obras en sí y mucho más en la organización de eventos y la publicación de proclamaciones. El movimiento Madí siempre tuvo un sentido bien agudo para las relaciones públicas y sus estrategias, en muchos casos, parecían haber sido expresamente diseñadas con el fin de darle al grupo una imagen determinada desde el exterior en lugar del interior. Su explotación de la ficción y el mito—así como en la invención de ciertos artistas o el tono grandilocuente de sus proclamaciones—se convertiría en aspecto esencial de sus actividades y de su aura de misterio posterior.

Entonces, dada la falta de una estética coherente, sus contradicciones internas y la escasez de producción fiable de este movimiento, ¿qué podríamos señalar como la importancia duradera del grupo Madí? Yo diría que Madí representa el primer movimiento verdaderamente de vanguardia en el ámbito de las artes visuales en la Argentina. Y cuando digo vanguardia, me refiero a la transgresión de un *modelo* en particular de producción artística y no *estilo*. Peter Bürger propone una distinción importante:

Los movimientos vanguardistas se pueden definir como un ataque contra la situación del arte en una sociedad burguesa. Lo que se niega no es una forma anterior de arte (un estilo) sino el arte como institución que esté desvinculada de la praxis de la vida del hombre. . . . La demanda no se presenta a nivel del contenido de las obras individuales, sino que se dirige ella misma a cómo el arte funciona en la sociedad, proceso que tiene la misma fuerza que la de su propio contenido para determinar el efecto que pueden tener las obras.[21]

En este sentido, a la hora de evaluar su importancia como movimiento, la distribución de los volantes del grupo Madí, por ejemplo, tiene la misma importancia que las pinturas sobre formas irregulares. Antes de la formación de Madí, Argentina nunca había tenido un movimiento artístico visual que hiciera lo que había hecho Dada por el arte europeo: introducir la fuerza de lo ridículo o lo inestable, poniendo en duda las expectativas en cuanto a cómo debería ser una obra de arte y cómo debería comportarse en el mundo. Con Madí, el tema del discurso se aleja de las discusiones sobre la geometría y se transforma en proclamaciones que explican cómo quedará transformado el mundo para siempre

por medio de las estéticas del grupo. Teniendo en cuenta esto, es importante considerar los elementos *destructivos* de Madí junto con los que eran netamente *constructivos*. Madí era mucho más que una importación argentina de una idea racionalista del Arte Concreto.

A sesenta años de la publicación de la revista *Arturo* aun es difícil evaluar el impacto que tuvo Arte Concreto–Invención y Madí a escala nacional o internacional. Si bien seduce la idea de dibujar una línea que conecte la década de 1940 en Argentina con los años cincuenta en Brasil o los sesenta en Venezuela, hay muy poco contacto o contexto real para apoyarla.[22] La indiferencia que se manifestó ante estos artistas en 1944 duró por muchas décadas, y no se hizo investigación ni se formaron colecciones ni se montaron exposiciones de manera seria hasta los años ochenta y noventa.[23] El entusiasmo que existe actualmente en el mercado internacional por este tipo de arte se produjo sin una previa mediación ni clasificación del período por parte de instituciones y especialistas—fenómeno que ha creado muchos de los problemas en cuanto a la autenticidad y exactitud histórica que hoy en día nos vemos obligados a enfrentar. Dentro de un contexto nacional, los movimientos de arte abstracto posteriores en la Argentina, así como Arte Nuevo o Arte Generativo en los años cincuenta y sesenta, volvieron a manejar un sentido de abstracción esencialmente decorativo, esquivando las aspiraciones sociales, literarias y transformativas de este primer grupo de pioneros utópicos.

Traducción de Tony Beckwith

Notas
1. Beatriz Sarlo, *Jorge Luis Borges: A Writer on the Edge* (Londres: Verso, 1993), 14.
2. Nicolas Shumway, *The Invention of Argentina* (Berkeley: University of California Press, 1991), 7–8.
3. John King, "Xul Solar: Buenos Aires, Modernity and Utopia", en Christopher Green, ed., *Xul Solar: The architectures* (Londres: Courtauld Institute Galleries, 1994), 11. Véase también Richard J. Walter, *Politics and Urban Growth in Buenos Aires 1940–1942* (Cambridge: Cambridge University Press, 1993), 235.
4. Jean Franco, *The Modern Culture of Latin America: Society and the Artist* (Londres: Pall Mall, 1967), 259.
5. John King, *Sur: A Study of the Argentine Literary Journal and its Role in the Development of a Culture 1931–1970* (Cambridge: Cambridge University Press, 1986), 7.
6. Julio Payró, *Pintura Moderna* (Buenos Aires: Nova, 1957), 227. Cita original: "El dadaísmo no se justifica en arte, y sería imperdonable de no mediar la causa horrible que lo motivó".
7. Un facsímile de *Arturo* fue publicado por la Universidad de Aberdeen in 1994. A raíz de la acción legal de Carmelo Arden Quin, fue retirado de circulación. Una documentación de la disputa legal se encuentra en los archivos del Blanton Museum of Art en Austin, Texas.
8. Derek Harris, "*Arturo* and the Literary Avant-Garde", en Derek Harris y Gabriel Pérez-Barreiro, *The Place of Arturo in the Argentinian Avant-Garde* (Aberdeen: University of Aberdeen, 1994), 3.
9. La definición que aparece en la edición actual del diccionario de la Real Academia Española, por ejemplo, es muy parecida a la que aparece en *Arturo*.
10. Estatutos inéditos de la Asociación Arte Concreto-Invención, 1948 (que afirman haber sido aprobados en 1946). Archivo del autor.
11. Para leer una ponencia sobre este tema, véase Ana Longoni y Daniela Lucena, "De cómo el 'júbilo creador' se trastocó en 'desfachatez'. El pasaje de Maldonado y

los concretos por el Partido Comunista. 1945–1948", en *Políticas de la memoria* no. 4, Anuario de investigación e información del CeDInCI, Buenos Aires (verano 2003–2004): 117–28.
12. Edgar Bayley, "Sobre Arte Concreto", *Orientación* 20 (febrero 1946). Texto reproducido en Nelly Perazzo, *Vanguardias de la década del cuarenta* (Buenos Aires: Museo Sívori, 1980), s. pág. Véase también Robert Alexander, *Communism in Latin America* (New Brunswick: Rutgers University Press, 1957), 171.
13. Dawn Ades, *Art in Latin America: The Modern Era, 1820–1980* (New Haven y Londres: Yale University Press, 1989), 242.
14. Clement Greenberg, "Towards a Newer Laocoon", en Francis Frascina, ed., *Pollock and After: The Critical Debate* (Londres: Harper and Row, 1985), 43.
15. Para leer una discusión más completa, véase Gabriel Pérez-Barreiro, "The Argentine Avant-Garde 1944–1950" (tesis doctoral, University of Essex, 1996), 86–89.
16. El uso de seudónimos ha sido tema de mucha discusión. Lo más probable es que Kosice usó Rasas Pet y Havas, mientras que Arden Quin usó Lemme y Costes. Sin embargo, tanto Arden Quin como Kosice disputan enérgicamente la propiedad específica de los nombres. Es interesante notar cómo las obras de algunos de estos "artistas"—firmados con esos nombres—han pasado a formar parte de colecciones públicas y privadas. El tema de los personajes ficticios que integraron el grupo Madí merece su propia investigación.
17. Véase la sección dedicada a los objetos presentados en el presente catálogo para leer una ponencia más completa de las ideas artísticas de Lozza.
18. Para leer una ponencia completa sobre la autoría y el fechado del Manifiesto Madí, véase Gabriel Pérez-Barreiro, *The Argentine Avant-Garde,* 287–97.
19. Por ejemplo, Nikolai Kasak y Masami Kuni, ambos representados en *Arte Madí Universal,* alegan no saber mucho sobre Madí. Correspondencia con el autor de varias fechas entre 1991 y 1996.
20. Carmelo Arden Quin, "Corta reseña histórica sobre la influencia de Torres García sobre la formación del arte abstracto en Uruguay, Argentina y Brasil" (c. 1992), texto mecanografiado inédito en los archivos del Blanton Museum of Art, The University of Texas at Austin.
21. Peter Bürger, *Theory of the Avant-Garde* (Minneapolis: Minneapolis University Press and Manchester University Press, 1984), 49.
22. Una nueva generación de especialistas en Buenos Aires ahora está investigando en mayor detalle las conexiones entre la Argentina y el resto de Latinoamérica y Europa. Se señalan como material de especial interés los escritos de María Amalia García en cuanto a las conexiones entre Buenos Aires y São Paulo, por ejemplo su ensayo "La construcción del arte abstracto: Impactos e interconexiones entre el internacionalismo cultural paulista y la escena artística argentina 1949–1953", en *Arte argentino y latinoamericano del siglo XX: sus interrelaciones,* VII Premio Fundación Telefónica a la Investigación en la Historia de las Artes Plásticas (Buenos Aires: Fondo para la Investigación del Arte Argentino [FIAAR], Fundación Espigas, 2004), 17–54.
23. La primera vista general de esta generación fue la exposición organizada por Nelly Perazzo en el Museo Sivori en 1980, *Vanguardias de la década del 40,* seguida por su libro *El arte concreto en la Argentina* (Buenos Aires: Gaglianone, 1983). Estas fueron las primeras recopilaciones del material primario, aunque le faltaba bastante rigor al marco crítico de las publicaciones. La primera presentación internacional se realizó en la muestra de Dawn Ades *Art in Latin America* en la Hayward Gallery en Londres en el año 1989. Desde entonces se han montado numerosas exposiciones tanto en la Argentina como en el ámbito internacional.

Mecanismos de lo individual y lo social: El Arte Concreto y São Paulo
Erin Aldana

Conocido como "Arte Concreta" en portugués o "Arte Concreto paulista", la versión de la abstracción geométrica que se originó en São Paulo, es el movimiento que a mucha gente le encanta detestar. El poeta neoconcreto Ferreira Gullar lo acusó de dogmatismo.[1] Ronaldo Brito fue aun más allá y dijo que el Arte Concreto "reprime la lucha de clases" y "parece absurdo en su cruda (aunque ambigua) sumisión a las pautas sociales dominantes, en su culto a la tecnología y en cuanto a su ingenuo proyecto de desear superar de esta manera el subdesarrollo. Hay algo obviamente colonizado en su imitación del formalismo racional suizo . . ."[2] Incluso el director del Museum of Modern Art de Nueva York, Alfred H. Barr, se refirió al Arte Concreto como a simples "ejercicios de Bauhaus".[3] Tales declaraciones o afirmaciones son de por sí simplistas, y hacen que el movimiento parezca limitado en su alcance, obsesionado con sus orígenes europeos, ignorante de las desigualdades sociales presentes en Brasil y como simplemente un paso para avanzar en el camino hacia el Arte Neoconcreto.

El Arte Concreto entró en auge durante los años cincuenta, particularmente en la primera mitad de la década. Sus seguidores crearon obras que por lo general eran en apariencia simples, usando los colores primarios e incorporando formas y líneas geométricas, con el propósito de crear imágenes de total precisión geométrica, y en apariencia desprovistas de cualquier emoción humana. Aunque una versión del Arte Concreto se había desarrollado simultáneamente en Rio de Janeiro, los artistas con sede en Rio pronto se apartaron de sus colegas paulistas, haciendo obras de arte que enfatizaban el color hasta el punto en que éste cobró cualidades afectivas y físicas que provocaron que el espectador entrara en una relación fenomenológica con la obra.[4] De mediados a fines de los años cincuenta, el contraste era tan marcado que los artistas cariocas formaron un nuevo movimiento, el Neoconcretismo, el cual se distinguía a sí mismo del Arte Concreto a través de un énfasis en la individualidad y la interrelación con el espectador.

Si uno ignora el contexto en el cual se desarrolló el Arte Concreto y considera el movimiento estrictamente en términos formales, entonces puede que parezca que los argumentos de sus detractores tengan algún fundamento. El énfasis en la geometría de las obras les da a muchas de ellas una apariencia banal. Los concretistas tenían fama de no tener preocupación alguna por el color, arguyendo incluso que uno podría cambiar por completo los colores de una pintura y no alterar nada significativo de la obra en si misma.[5] En la superficie, tales obras ciertamente pueden parecer secas, carentes de emoción y sosas. Sin embargo, si uno comienza a explorar el contexto en el cual fueron creadas—el São Paulo de principios de los años cincuenta—, entonces surge otra historia, una en la cual el Arte Concreto es el resultado de acontecimientos políticos y culturales contemporáneos cuyos orígenes datan de fines del siglo XIX.

Durante los años cincuenta en São Paulo, todo el potencial de la ciudad saltaba a la vista. La prosperidad se había generalizado, la gente disfrutaba de más actividades en su tiempo libre y los paulistanos proclamaban el estatus de São Paulo como el centro industrial de Brasil sin ninguna insinuación de negatividad:

"São Paulo es el centro industrial más grande de Latinoamérica . . ." Esto fue escrito con orgullo, para que lo leyeran los extranjeros. Ser el centro industrial más grande de Latinoamérica, observar el crecimiento de São Paulo era algo positivo . . . Obviamente los últimos diez, veinte, treinta años no han sido tan buenos, porque después vinieron todas las consecuencias negativas . . .[6]

El estatus recién adquirido de São Paulo como una ciudad industrializada les brindó a los paulistanos una razón para sentirse optimistas e incluso temerarios. Estas actitudes encontraron su forma arquitectónica en los primeros diseños de Oscar Niemeyer: los edificios del parque Ibirapuera, la Galería California y el Edificio Copan (figura 20). En las artes visuales, se pusieron de manifiesto en la abstracción de líneas elegantes del Arte Concreto.

Quizá la conexión entre el Arte Concreto y su contexto no sea tan aparente ahora porque hoy en día São Paulo tiende a evocar lo caótico e irracional más que la geometría y la precisión. En el transcurso del siglo XX, la población y la superficie de São Paulo han crecido tan rápidamente que parecen haber borrado cualquier sentido de su propia historia. El centro de la ciudad también fue el centro del Arte Concreto: el sitio original del Museu de Arte Moderna, la galería Domus (la primera en la ciudad en exhibir la abstracción geométrica) y la Biblioteca Municipal (figura 28), donde se reunían muchos de los artistas. Ahora los muchos problemas sociales de São Paulo han eclipsado la importancia histórica del centro de la ciudad: la gente sin hogar y los niños de la calle habitan los pocos espacios públicos del centro y cada vez con más frecuencia los comercios se mudan al cuadrante suroeste de la ciudad, la sección más nueva y opulenta.[7] Esto no quiere decir que el resto de la ciudad haya sido abandonada, pues con aproximadamente veintidós millones de habitantes, éste es un presente eterno de monotonía urbana, llena de embotellamientos de tráfico, muchedumbres en el metro y en la calle, el olor a gases de combustión y los edificios sin fin que se extienden hasta donde la vista alcanza.

Todo este caos urbano—que incluye la pobreza, las fábricas automotrices, los centros comerciales, los rascacielos, los museos de arte y el crecimiento exponencial—nunca habría existido de no ser por el auge propiciado por el café a fines del siglo XIX y la eventual transformación de la riqueza generada por el café en un capital industrial. El café fue la base agrícola para la posterior industrialización de la ciudad: creó una economía en base al dinero en efectivo, el uso de trabajadores inmigrantes asalariados en lugar del trabajo de los esclavos y el desarrollo de una infraestructura que al principio existió únicamente para servir las necesidades de una economía basada en el café. Los ferrocarriles y el puerto de Santos existían con el único propósito de exportar el café. Las primeras fábricas hicieron productos ya fuera directamente relacionados

al proceso de producción del café o para el uso de los dueños y los trabajadores de las plantaciones de café. Hacia 1920, los fabricantes locales producían ladrillos, baldosas, cemento y muchos otros materiales de construcción, así como una variedad de bienes de consumo. A principios del siglo XX, sin embargo, todas estas industrias se mantuvieron en segundo plano comparado con la que seguía teniendo la producción del café.[8]

Aquellos que eventualmente se convirtieron en los mecenas de São Paulo provenían de dos élites: las familias de los hacendados del café y los empresarios inmigrantes, los más exitosos de una vasta horda de gente que transformó a São Paulo de ser un lugar atrasado en una ciudad próspera. En 1872, la población de São Paulo contaba con sólo 23,000 habitantes; para 1920 había crecido a 580,000 y casi dos terceras partes eran de origen inmigrante. La mayoría de estas personas eran campesinos italianos que habían venido al Brasil a trabajar en las plantaciones de café y, o no habían tenido éxito, o se habían establecido en la ciudad sin haber llegado jamás a las plantaciones.[9] Un menor número de inmigrantes llegó de Siria y Líbano y eventualmente también del Japón y de Europa Central.[10]

Según el historiador económico, Warren Dean, las familias inmigrantes que tuvieron más éxito, tal como los Matarazzo, no eran de origen campesino sino más bien ya contaban con un capital proveniente de sus países de origen, el cual habían vuelto a invertir en Brasil. Esta aristocracia había existido anteriormente por generaciones y sus miembros se consideraban a sí mismos como los "verdaderos brasileños", clamando que ellos podían seguir la pista a su historia por un período de cuatro siglos en São Paulo (aunque en realidad esto rara vez era el caso). Ellos consideraban a los inmigrantes recientes como meros impostores. Esta relación permaneció contenciosa. Los miembros de la élite de los hacendados se casaban con los inmigrantes, pero todavía existía la tendencia de rechazar a los inmigrantes y de prohibirles la entrada a organizaciones sociales elitistas tales como los clubes hípicos y automovilísticos.[11]

El São Paulo que construyeron los magnates del café era muy distinto a la ciudad de hoy. Los visitantes europeos encontraron a principios del siglo XX sus bulevares bordeados de árboles, los edificios neoclásicos (diseñados por Francisco Paula Ramos de Azevedo, el arquitecto que diseñó el Teatro Municipal), y la estación de tren estilo inglés, la Estação da Luz (figura 22), reconfortantes de una manera extraña. En respuesta a esta situación, Georges Clemenceau se volvió famoso por decir: "La ciudad de São Paulo es tan peculiarmente francesa que por una semana no recuerdo haber sentido que estaba en una tierra extranjera".[12] El centro comercial, social y político de São Paulo era un área de unas cuantas cuadras conocida como El Triángulo, delimitada por las calles 15 de noviembre, Direita y São Bento. Hasta la segunda Guerra Mundial, aquí estaban ubicados los bancos más prestigiosos, las mejores tiendas (figura 23), las sedes de los partidos políticos, los periódicos y los mejores restaurantes de la ciudad.[13] La prosperidad, sin embargo, se limitaba a un área muy pequeña de la ciudad, mientras que una gran parte del resto de São Paulo, donde

vivían los obreros y sus familias, estaba atestada de viviendas de calidad inferior conocidas como *cortiços*. Casi se podría decir que existían dos São Paulos: uno, una masa de crecimiento descontrolado de trabajadores sobrecargados de trabajo quienes vivían en condiciones de hacinamiento y miseria, y otro que tenía la apariencia de una ciudad europea, lleno de tiendas elegantes con nombres europeos tales como "Au Printemps" y "Au Palais Royal".[14]

La pasión de la élite por todo lo europeo penetró hasta las artes visuales. Los artistas modernistas de Brasil de los años veinte establecieron un precedente para el Arte Concreto en su uso de fuentes europeas sin tener que excusarse de nada para crear un estilo singularmente brasileño e incluso produjeron algunos de los primeros ejemplos de abstracción geométrica: el diseño de Lasar Segall para el mural del cielo raso del "salón modernista" de Olivia Guedes Penteado, una mecenas muy conocida; el trasfondo de una pintura de Tarsila; o los diseños de alfombras art deco de Regina Gomide Graz.[15] Estos precedentes revelan un interés naciente por la abstracción geométrica ya a comienzos de los años veinte, socavando el argumento de que el Arte Concreto llegó como una importación netamente europea. La relación que los modernistas mantuvieron con Europa fue más que estilística. Muchos de los artistas y escritores de este período provenían de la aristocracia cafetalera y tenían apartamentos en París, adonde viajaban con frecuencia.

Los escritores vanguardistas Oswald y Mário de Andrade, el pintor Emiliano di Cavalcanti y muchos otros organizaron la Semana del Arte Moderno en 1922 bajo los auspicios de Paulo y Marinette Prado, un matrimonio proveniente de una de las familias paulistas más ricas. Ésta se llevó a cabo en el Teatro Municipal (figura 24), cerca del centro de São Paulo, e incluyó espectáculos de danza, música y poesía, así como una exhibición de arte. La Semana, como vino a ser llamada, surgió como respuesta a las tendencias pasadas de moda al interior de la producción cultural brasileña, regida en la literatura por el movimiento parnasiano, el cual

> reflejaba la estructura de clases arcaica y altamente estratificada de la sociedad brasileña, en donde la poesía era el privilegio de una élite intelectual y aristocrática.... Una forma correctamente metrificada era más importante que la sustancia, y la poesía se convirtió en un modo de expresión literario estático y decorativo, que había perdido el contacto con las rápidas transformaciones por las cuales atravesaba la sociedad brasileña.[16]

Los artistas visuales resolvieron este problema al combinar temas indígenas y afro brasileños con estilos artísticos cubistas y expresionistas, mientras que los escritores incorporaron en su obra elementos del discurso vernáculo, palabras en tupí guaraní, y parodia. La Semana estableció un vínculo para siempre entre São Paulo y el modernismo y el Futurismo, pero también puso al descubierto las contradicciones inherentes al modernismo brasileño que aceptaba algunas influencias europeas mas no otras, exageraba el grado en el cual el movimiento rompía con el pasado y creaba una imagen de la identidad

brasileña que en realidad pocos brasileños comprendían.[17]

Como resultado de estos problemas, algunos críticos acusaron a los primeros modernistas de ser elitistas y de haber perdido el contacto con la sociedad brasileña. Quizá esto fuera cierto. Después de todo, Olivia Guedes Penteado—buena amiga de muchos de los modernistas, incluida la pintora Tarsila do Amaral—declaró una vez, mofándose un poco de sí misma: "Cuando los escaparates de Mappin [el primer gran almacén de Brasil en esa época] comienzan a agradarme, sé que es hora de volver a París".[18] La misma Tarsila con el tiempo fue extensamente criticada debido a sus frecuentes viajes a París y su afición por la alta costura. Sus críticos sentían que su posición privilegiada quería decir que ella realmente no entendía lo que significaba ser brasileño.[19] Esta controversia alrededor del movimiento modernista de los años veinte marcó el comienzo de un acalorado debate, que duró toda una década, sobre la cuestión del regionalismo y el nacionalismo dentro del arte brasileño en oposición al internacionalismo.[20] También puso en evidencia un giro dentro de las bellas artes hacia un creciente interés por representar las vidas y las experiencias de la considerable clase obrera de São Paulo.

Para los años veinte, muchos grupos sociales, incluso los trabajadores urbanos, los militares rebeldes y los miembros de la clase media, estaban ansiosos por derrocar a la Primera República (1889–1930). Hubo muchas revueltas infructuosas durante este periodo. El año de 1922 no sólo presenció la Semana del Arte Moderno, sino también la fundación del Partido Comunista Brasileño (PCB) y la revuelta de los tenientes en Copacabana. Esto desencadenó una serie de acontecimientos: la Revolución de São Paulo de 1924, la Columna Prestes (de 1924 a 1927, en la cual Luis Carlos Prestes, líder del PCB, marchó con un grupo de soldados rebeldes por el campo), y la Revolución de 1930, la cual llevó a su vez al ascenso del presidente Getúlio Vargas, quien más tarde se convertiría en dictador.[21]

La agitación de la situación política afectó el mundo del arte. La transición de la Primera República al Estado Novo de Vargas se manifestó como un paso del modernismo propio de los artistas de clase alta de los años veinte al Realismo Social de los artistas de los años treinta. El arte comenzó a reflejar un interés creciente en la clase obrera y sus preocupaciones, como se encuentra representado en los grabados en madera de Lívio Abramo y en la fundación de O Homem Livre [El hombre libre] en 1933, una revista de izquierda a la cual el crítico de arte Mário Pedrosa contribuía con regularidad.[22] El grupo Santa Helena se componía de artistas de ascendencia italiana que habían trabajado como pintores de casas y luego se habían dedicado a la pintura de caballete, primero como un pasatiempo, pero después con un profesionalismo cada vez mayor.[23] El hecho de que el mundo del arte de la corriente dominante de São Paulo eventualmente los tomara en serio fue indicativo de los cambios importantes que habían sucedido a partir de la Semana del Arte Moderno. El ímpetu creciente por explorar las preocupaciones de la clase obrera, tanto en Brasil como en São Paulo,

con el tiempo obligó al escritor modernista Mário de Andrade a criticar a sus propios colegas de los años veintes al argüir: "Esta ausencia de un arte social es una omisión considerable entre nosotros, aun cuando comprendemos de sobra el diletantismo estético, característicamente burgués, en el cual persistimos".[24]

También durante este tiempo, el crecimiento y la diversificación del mundo del arte hicieron que la falta de museos de arte moderno fuera cada vez más notoria. En efecto, el único museo de arte importante era la Pinacoteca do Estado, el cual había sido fundado en 1905 y era un baluarte del arte académico. Aunque dos grupos de artistas, la Sociedad Pro-Arte Moderno y el Club de Artistas Modernos se formaron en 1932 para remediar este problema, estas fueron organizaciones inestables que carecían de fondos consistentes y a veces provocaban abiertamente la ira del régimen de Vargas, lo cual resultó en su clausura dos años después.[25]

Para fines de los años cuarenta, dos museos principales de arte moderno surgieron como resultado de la rivalidad entre dos empresarios de São Paulo, Ciccillo Matarazzo y Francisco de Assis Chateaubriand. Assis Chateaubriand era un periodista y el dueño de la primera red de comunicaciones de Brasil, la cual incluía periódicos, radio y televisión. Fundó el Museu de Arte de São Paulo (MASP) en 1949 y adquirió su colección permanente aprovechando la situación de la crisis de posguerra dentro del mercado de arte europeo para comprar obras de arte a precios muy bajos. Matarazzo heredó un negocio de metalurgia de un tío e invirtió una gran parte de su propio dinero en la fundación del Museu de Arte Moderna (MAM SP), también en 1949.[26] Mientras que la competencia entre Chateaubriand y Matarazzo existió a un nivel, también hubo un sentido más generalizado de competencia entre São Paulo, como la ciudad más grande y más industrializada de Brasil, y Rio de Janeiro, la cual a principios de los años cincuenta todavía era la capital de la nación y previamente había mantenido la reputación de ser el centro cultural de mayor importancia en el Brasil, remontándose hasta por lo menos el periodo imperial (1822–1889).[27]

Los museos que Chateaubriand y Matarazzo fundaron tuvieron sus ventajas y sus desventajas, ya que llevaron el mundo del arte internacional a las puertas de São Paulo y con éste la intervención política de Norteamérica.[28] La política internacional tuvo una fuerte influencia en el arte del periodo de posguerra y el estilo artístico adquirió nuevos niveles de significado. Después de la Segunda Guerra Mundial, se había empezado a desarrollar un sentido de oposición entre el realismo y la abstracción, el cual, según Aracy Amaral, en realidad enmascaraba un debate sobre el nacionalismo (arte figurativo) y el internacionalismo (arte abstracto) dentro del arte brasileño. En el contexto de la posguerra, el realismo vino a tener asociaciones con el humanismo, ya que éste le otorgaba importancia a la figura humana en vez de a la tecnología, la cual para los realistas era un símbolo de la guerra que se había manifestado con la bomba atómica.[29] Este entendimiento del estilo artístico a la larga avivó las ideas falsas de que el Arte Concreto era anti-humanista y que de alguna manera

también era una manifestación de imperialismo euro-estadounidense.

De hecho, la creciente popularidad de la abstracción geométrica (así como el desarrollo de instituciones y museos culturales nuevos) fue el resultado de la creciente prosperidad económica de Brasil a principios de los años cincuenta, concentrada alrededor de la ciudad de São Paulo. La primera ola del modernismo había ocurrido debido a la vasta riqueza acumulada a través de la exportación del café a principios de los años veinte. Después de 1929, la Gran Depresión ocasionó una caída en el precio del café que a la larga forzó a Vargas, a su pesar, a intervenir en la economía. Vargas proporcionó préstamos a negocios así como otros incentivos financieros, mientras que la Segunda Guerra Mundial abrió aquellos mercados que previamente habían estado cerrados para Brasil. Como resultado, la industria se expandió en los años treinta y cuarenta con la meta de reducir la dependencia de Brasil de los bienes importados al producirlos nacionalmente.[30] A principios de los años cincuenta cuando el Arte Concreto se estaba desarrollando, el país no había alcanzado aun la vasta expansión de la industrialización que ocurriría con el régimen de Kubitschek de 1956 a 1960. De todas formas, la economía crecía, la gente sentía una ola de optimismo como resultado del fin del régimen autoritario de Vargas (aunque todavía lo eligieron presidente en 1951), y había un optimismo sin precedentes en São Paulo.

Muchos consideran los principios de los años cincuenta como una época ideal en São Paulo. La ciudad era del tamaño justo con la cantidad adecuada de infraestructura, bienes de lujo y cultura para hacer de ésta un lugar muy agradable; principalmente desde un punto de vista de clase media y alta. El año de 1954 parece haber marcado una transición en São Paulo, cuando ésta se encontró suspendida entre lo que había sido y en lo que se convertiría con el tiempo. Durante la primera ola de modernismo, los principales logros en el desarrollo urbano de São Paulo habían sido muy básicos: calles pavimentadas, edificios que hacían eco al estilo neoclásico francés, el uso generalizado de electricidad y de teléfonos, la construcción de los primeros museos de la ciudad y el primer gran almacén. Durante el periodo del régimen Estado Novo de Vargas (1937–1945), Francisco Prestes Maia, un ingeniero civil, se convirtió en el alcalde de São Paulo. Él fue el responsable de elevar a São Paulo a un nuevo nivel de modernidad en términos de su diseño urbano. Amplió muchas de las calles del centro de la ciudad, haciéndolas más accesibles a los carros, y construyó una serie de puentes nuevos, incluso el nuevo Viaduto do Cha, lo que resultó en la reubicación y la expansión del centro de la ciudad.[31]

Después de las renovaciones de Prestes Maia, el punto focal de prosperidad de la ciudad fue transferido del Triángulo a la Praça Ramos de Azevedo, brindando a más paulistanos que nunca acceso a sus placeres. En un gesto altamente simbólico, el gran almacén Mappin se mudó a este sitio, en donde permaneció hasta su clausura. Durante los años cincuenta, la gente de São Paulo caminaba por las calles del centro de la ciudad, mirando los escaparates, visitando las casas de té, los bares y los teatros, y en general disfrutando de los placeres de la vida urbana. Fue una época en que las calles estuvieron limpias y la gente pudo vestir de manera elegante elegantemente en público sin temor de atraer el crimen, una época que hoy en día causa mucha nostalgia.[32]

São Paulo desarrolló en esta época un entorno en donde proliferaban los cafés y los bares. El *clubinho*, por ejemplo, era el lugar de reunión de los más famosos críticos de arte, escritores y artistas. "Todo el mundo sabe lo que es el *clubinho*", proclamó Paulo Mendes de Almeida, "es el Club de Artistas y Amigos del Arte, que todavía existe hoy, en su sede de Rua Bento Freitas # 306, en el sótano de un edificio en esa ubicación".[33] Éste era uno de los lugares de reunión favoritos de Waldemar Cordeiro, el autodesignado portavoz del movimiento de Arte Concreto. Era el lugar donde dejarse ver, donde discutir acerca del arte e incluso donde buscar pleitos. En esta atmósfera cargada, Cordeiro comenzó a reunir a un grupo de gente a su alrededor, entre ellos Luiz Sacilotto, Anatol Wladyslaw y otros. Muchos de estos artistas jóvenes habían participado en la exhibición *19 Pintores* de la Galería Prestes Maia en 1948 y a ratos discutían acerca de las maneras en que podrían impulsar su obra, la cual en un principio había estado fuertemente basada en el Expresionismo, a niveles más experimentales. Aunque algunos, tales como Sacilotto, ya habían empezado a moverse hacia la abstracción, Cordeiro, quien era un crítico para la *Folha da Manhã*, los impulsó a ir aun más allá con su profunda sabiduría de los movimientos del arte abstracto en Europa.[34]

Los artistas que se unieron al grupo de Cordeiro tenían antecedentes muy diversos que reflejaban el estatus de São Paulo como una ciudad de inmigrantes. Luiz Sacilotto y Geraldo de Barros eran brasileños. Sacilotto era hijo de inmigrantes italianos que creció en Santo André, un área industrial en las afueras de la ciudad. Lothar Charoux era austriaco, Kazmer Fejer y Anatol Wladyslaw eran polacos y el mismo Cordeiro era hijo de padre italiano y de madre brasileña, quien a la larga optó por la ciudadanía brasileña. Leopoldo Haar (húngaro) con el tiempo también se incorporó al grupo. Se convirtió en un instructor del MASP en el Instituto de Arte Contemporânea, donde una generación de algunos de los diseñadores más famosos de Brasil había recibido su formación. Entre ellos había gente como Alexandre Wollner, Mauricio Nogueira Lima y Antonio Maluf, quien diseñó el cartel para la primera Bienal de São Paulo. Muchos de estos artistas mantenían fuertes vínculos con Europa, ya fuera por sus familiares o porque su educación los llevaba allá y, como resultado, comenzaron a adherirse a un estilo abstracto que revelaba la influencia del Constructivismo suizo y ruso, y del Bauhaus. Max Bill, el director suizo de la Hochschule für Gestaltung (Escuela Superior de Diseño) en Ulm, donde se formaron muchos seguidores del arte abstracto en Brasil, fue otra influencia importante.[35]

Desde el mismísimo comienzo, el Arte Concreto generó controversia no tanto debido a su estilo, sino más bien debido a la reputación de su miembro fundador, Waldemar Cordeiro. Cuando el alto, guapo y extremadamente franco Cordeiro

se presentaba en el Instituto, los estudiantes susurraban: "¿No sabes quién es ese tipo alto que está allá? Sí, es Cordeiro, el agitador. No lo dejen entrar . . . ¡él es un peligro!"[36] El momento inaugural del Arte Concreto, la exhibición Ruptura de 1952, se volvió notoria por la distribución del manifiesto de Ruptura (figura 27) en la noche del estreno, el cual enfatizaba el radicalismo del grupo. En el manifiesto, Cordeiro argumentaba que "el naturalismo científico del renacimiento—el antiguo proceso de representar el mundo externo (tridimensional) en un plano (bidimensional)—había agotado su tarea histórica". Luego distinguió entre "lo antiguo", que incluía todo desde "todas las variedades e híbridos del naturalismo" a la "simple negación del naturalismo (p.ej. el Surrealismo, el arte de los locos)" y "la no-figuración hedonista, producto del gusto gratuito". En contraste, "lo nuevo" es "una intuición artística dotada de principios claros e inteligentes así como de grandes posibilidades de desarrollo práctico".[37] El manifiesto causó tal sensación que el crítico de arte Sérgio Milliet dedicó la mayor parte de su reseña sobre la exhibición a hacer una crítica de éste. Lo descartó como el producto de artistas jóvenes e impetuosos y se quejó de que no quedaba claro a quien atacaba.[38]

Cordeiro respondió a la crítica de Milliet en su ensayo de 1953 "Ruptura", en el cual explicó con mucho más detalle lo que quiso decir con "no-figuración hedonista", en otras palabras, se refería a un cierto sentimentalismo en la escritura del propio Milliet acerca de la obra de Cícero Dias, un pintor modernista brasileño que pasó la mayor parte de su vida en París. Cordeiro condenó además el trabajo de sus compañeros abstraccionistas Samson Flexor y Dias como "hedonistas". Criticó a Dias por crear composiciones abstractas en base a formas viejas, es decir, sus propias naturalezas muertas y paisajes, y a Flexor por sus pinturas que parecían evocar un sentido de perspectiva, dejando por ello de respetar el plano del lienzo.

Samson Flexor, artista nacido en Rumania, tenía un estudio en casa, el Atelier Abstração (figura 25), donde enseñaba técnicas de la pintura abstracta. Instruía a sus estudiantes a empezar con un objeto físico—una guitarra o una naturaleza muerta—y a reducirlo a una serie de formas geométricas, usando técnicas similares a las del Cubismo. Este método difería totalmente del de Cordeiro, quien concebía la obra de arte como algo libre de toda referencia representativa. Las diferencias estilísticas entre los artistas de la Ruptura y aquellos del Atelier Abstração llevaron con el tiempo a unos desacuerdos más vociferantes. Flexor se refirió a los artistas de la Ruptura como los "concretinoides" y Milliet se puso del lado de Flexor, criticando el Arte Concreto como puramente decorativo, inaccesible al público y carente de inventiva.[39]

La relación antagónica entre Cordeiro y otros artistas y críticos de arte a la larga se expandió geográficamente para incluir a sus colegas de Rio de Janeiro. La Exhibición Nacional de Arte Concreto, que ocurrió de 1956 a 1957, tanto en São Paulo como en Rio, fue el comienzo de una larga rivalidad entre los artistas y poetas concretos con sede en São Paulo y los neoconcretistas, sus contrapartes en Rio. Como lo señaló en una entrevista el artista concreto que trabaja en Rio, Hermilindo Fiaminghi, la meta de esta exhibición no era la de provocar una confrontación entre los dos grupos, sino más bien la de presentar una retrospectiva completa del Arte Concreto que incluyera la poesía y las artes visuales tanto de Rio como de São Paulo. Las obras que componían la exhibición tenían fechas de 1951 a 1953 y de años previos a esas fechas, mucho antes de que existiera cualquier rivalidad entre los dos grupos. Según Fiaminghi: "Los cariocas se daban crédito a sí mismos por lo progresivo de sus ideas y teorías, y les daban crédito a los paulistanos por nada más que ser obsoletos en todo lo que decían y hacían".[40] De todas formas, en lugar de alinearse con los paulistanos, Fiaminghi escribió una carta expresando oficialmente su ruptura con ellos. Según él, ellos se habían vuelto elitistas y se habían reducido a sí mismos a "unos cuantos gatos que maúllan cuando se les da permiso".[41]

Esta acusación de elitismo, en retrospectiva, parece inexacta. A diferencia de los modernistas de los años veinte, los artistas involucrados en el Arte Concreto eran por lo general miembros de la clase obrera que necesitaban ganarse la vida en algo distinto de su arte. Trabajaban como químicos, escritores, arquitectos y diseñadores y creaban sus obras de arte en su tiempo libre.[42] Pero los detalles de sus vidas se han perdido en el debate acerca del estilo. De manera similar, la misma franqueza de Cordeiro como escritor ha eclipsado el hecho de que él, como los poetas concretos, estaba interesado en una forma de populismo como se expresaba en la abstracción geométrica. Su forma particular de pensamiento izquierdista buscaba una forma de arte revolucionario que elevara intelectualmente a las masas. Su acercamiento difería de aquel de los neoconcretistas, quienes concebían del arte como una manera de crear conciencia entre las masas e incitarlas a la acción. Las circunstancias políticas y sociales cambiantes—la creación de Brasilia en 1955–1960 y su fracaso como utopía modernista, el ascenso eventual del gobierno militar en 1964—también condenaron al Arte Concreto, al ligarlo erróneamente al gobierno militar y por consiguiente empañando su imagen.

Mirando hacia atrás, parece ser que los críticos mal interpretaron el Arte Concreto. Precisamente debido a que los concretistas hicieron obras de arte que eran puramente abstractas, el Arte Concreto se expuso a cualquier lectura que sus observadores le impusieran. Después del ascenso al poder del gobierno militar, la ciudad de São Paulo adquirió muchas asociaciones negativas. Era el hogar de muchas organizaciones estudiantiles y empresariales ultra conservadoras quienes apoyaban sin reservas el autoritarismo, donde los Escuadrones de la Muerte de la policía militar asesinaron al líder de la guerrilla urbana y héroe izquierdista Carlos Marighella y donde las purgas de comunistas resultaron en la completa destrucción del edificio de la facultad de Filosofía de la Universidad de São Paulo.[43] Durante el Milagro Económico de 1969–1974, también los años de la peor opresión política y tortura en Brasil, el gobierno militar fomentó el desarrollo tecnológico e industrial. Esto contribuyó directamente al crecimiento

urbano desordenado por el cual se conoce hoy en día a São Paulo, a medida que miles y a la larga millones de personas del noroeste empobrecido de Brasil se trasladaron a la ciudad, en busca de un futuro mejor. Dado este contexto nuevo, uno puede imaginarse muy bien que las lecturas del Arte Concreto en ese momento iban de irrelevante a imperialista y hasta fascista por intentar imponer una visión del orden que en Brasil era sencillamente imposible.

Con el tiempo, São Paulo recobró un poco de su reputación de ciudad progresiva a fines de los años setenta con las protestas de los trabajadores metalúrgicos, los esfuerzos de la arquidiócesis católica por sacar a luz las continuas prácticas de tortura por parte del gobierno y el movimiento *Diretas, já!* (¡Elecciones ahora!) de mediados de los años ochenta que llevó a las primeras elecciones presidenciales verdaderamente democráticas en veinte años. Sin embargo, el Arte Concreto no se recuperó tan rápidamente.

De alguna manera, entre los conflictos políticos y el aumento de la popularidad de artistas cariocas tales como Hélio Oiticica y Lygia Clark, las metas originales del Arte Concreto quedaron relegadas al olvido. Pocos recuerdan el interés que Cordeiro sentía por Gramsci, su declaración de que: "Nosotros creemos, al igual que Gramsci, que la cultura sólo viene a existir históricamente cuando crea una unidad de pensamiento entre [las masas] y los artistas e intelectuales. En efecto, es sólo en esta simbiosis con las masas que el arte se purifica a sí mismo de elementos intelectualizadores y de su naturaleza subjetiva y cobra [realmente] vida".[44] Éste era un entendimiento radicalmente distinto de la relación entre la clase trabajadora y la intelectualidad que aquella propugnada por la mayor parte de los izquierdistas brasileños. Cordeiro sugirió la integración de los intelectuales y los trabajadores, mientras que muchos izquierdistas, entre ellos los miembros del Centro Popular de Cultura del mismo Ferreira Gullar, tenían un enfoque mucho más condescendiente, razonando que los artistas necesitaban mostrarle a la clase trabajadora las formas de arte apropiadas y llevarla a tomar conciencia de su propia opresión.[45]

A pesar de esta diferencia, es importante recordar que ambos movimientos buscaban maneras radicalmente nuevas de relacionarse con el espectador. Los concretistas crearon obras que ellos afirmaban eran puros productos de la imaginación, totalmente divorciadas de cualquier tipo de contexto, mientras que los neoconcretistas buscaban una integración completa de la obra de arte tanto con el espectador como con el medio ambiente. Ferreira Gullar a menudo cuestionaba la insistencia de Cordeiro sobre la obra de arte como producto, criticando la idea de que una obra de arte pudiera estar totalmente separada de su contexto. Al hacerlo, hizo una declaración que nos recuerda hoy la conexión del Arte Concreto con São Paulo y los años cincuenta. "Cordeiro, de hecho, está de acuerdo en que una obra de arte es el producto de su tiempo. No es una expresión, sino más bien el fruto de una inevitable coincidencia entre los mecanismos de lo individual y lo social".[46]

Traducción de Liliana Valenzuela

Notas

1. Ferreira Gullar, "Da Arte Concreta à Arte Neoconcreta", *Jornal do Brasil* [Rio de Janeiro] 18 julio 1959; reimpreso en Aracy Amaral, ed., *Projeto construtivo brasileiro na arte (1950-1962)* (Rio de Janeiro y São Paulo: Museu de Arte Moderna do Rio de Janeiro y Pinacoteca do Estado de São Paulo, 1977), 108.

2. Ronaldo Brito, *Neoconcretismo: vértice e ruptura do projeto construtivo brasileiro,* 2nd ed., *Espaços de arte brasileira* (São Paulo: Cosac & Naify, 2002), 51.

3. Citado en Beverly Adams, "Locating the International: Art of Brazil and Argentina in the 1950s and 1960s" (tesis doctoral, The University of Texas at Austin, 2000), 83–84.

4. *Carioca* se refiere a la gente de Rio de Janeiro. *Paulista* o *paulistano* a la gente de la ciudad de São Paulo.

5. Ferreira Gullar, "Concretos de São Paulo no MAM do Rio," *Jornal do Brasil* [Rio de Janeiro] 16 julio 1960; reimpreso en Amaral, ed., *Projeto construtivo,* 140.

6. El arquitecto y urbanista Ernesto Mange, citado en Cláudio Willer, "A cidade e a memória", *Cidade: Revista do Museu da Cidade de São Paulo* 1, no. 1 (1994): 7.

7. Nabil Bonduki, "São Paulo at the Turn of the Twenty-First Century: The City, Its Culture and the Struggle Against Exclusion", *Parachute* no. 116 (2004): 99.

8. Warren Dean, *The Industrialization of São Paulo, 1880–1945* (Austin: University of Texas Press, 1969), 4–10.

9. Dean, 51.

10. Michael Hall, "Imigrantes na Cidade de São Paulo", en Paula Porta, ed., *História da Cidade de São Paulo* (São Paulo: Paz e Terra, 2004), 121–51.

11. Dean, 73, 76–77.

12. Aracy Amaral, *Arts in the Week of '22,* trans. Elsa Oliveira Marques, ed. revisada (São Paulo: BM & F, 1992), 82.

13. Zuleika Alvim y Solange Peirão, *Mappin: Setenta anos* (São Paulo: Ex Libris, 1985), 28–30.

14. Para más información acerca del *cortiço,* véase Raquel Rolnik, "São Paulo in the Early Days of Industrialization: Space and Politics", en Lúcio Kowarick, ed., *Social Struggles and the City: The Case of São Paulo* (Nueva York: Monthly Review Press, 1994), 77–93.

15. Aracy Amaral, "Surgimento da Abstração Geométrica no Brasil", en Aracy Amaral, ed., *Arte Construtiva no Brasil: Coleção Adolpho Leirner,* trans. Izabel Burbridge (São Paulo: DBA Melhoramentos, 1998), 29–63.

16. Randal Johnson, "Brazilian Modernism: An Idea Out of Place?" en Anthony L. Geist y José B. Monleón, eds., *Modernism and Its Margins: Reinscribing Cultural Modernity from Spain and Latin America* (Nueva York: Garland, 1999), 193.

17. Dos fuentes que presentan una visión crítica del modernismo brasileño incluyen a Tadeu Chiarelli, *Um Jeca nos vernissages* (São Paulo: Edusp, 1995) y Annateresa Fabris, *O futurismo paulista* (São Paulo: Editora Perspectiva, 1994). Chiarelli arguye que los modernistas se aprovecharon de la dura crítica que Monteiro Lobato hiciera de la obra de Anita Malfatti para hacer hincapié en la naturaleza subversiva de su obra. Fabris analiza cómo los escritores futuristas construyeron una imagen de São Paulo como la ciudad modernista *par excellence.* El estudio de Daryle Williams acerca del uso de la cultura por parte de Vargas incluye una descripción del público abucheando a los escritores modernistas mientras éstos realizaban lecturas de su obra durante la Semana de Arte Moderno. Véase Daryle Williams, *Culture Wars in Brazil: The First Vargas Regime, 1930–1945* (Durham y Londres: Duke University Press, 2001), 41.

18. Dona Olivia Guedes Penteado, citada en Aracy Amaral, "Dona Olivia na cena modernista", en Denise Mattar, ed., *No tempo dos modernistas: D. Olivia Penteado, a Senhora das Artes* (São Paulo: Fundação Armando Alvares Penteado, 2002), 107.

19. Dawn Ades, *Art in Latin America* (New Haven y Londres: Yale University Press, 1992), 136.

20. Dos fuentes que exploran este debate en detalle son Adams, "Locating the International: Art of Brazil and Argentina in the 1950s and 1960s", y Aracy Amaral, *Arte para quê? A preocupação social na arte brasileira, 1930–1970* (São Paulo: Nobel, 1984).

21. Marshall Eakin, *Brazil: The Once and Future Country* (Nueva York: St. Martin's Press, 1998), 40–43.

22. Amaral, *Arte para quê?,* 36–38, 40.

23. Para más información sobre el Grupo Santa Helena, véase Paulo Mendes de Almeida, *De Anita ao museu* (São Paulo: Editora Perpectiva, 1976); Walter Zanini, *A Arte no Brasil nas Décadas de 1930-40: O Grupo Santa Helena* (São Paulo: Livraria Nobel, 1991); y Walter Zanini, *O Grupo Santa Helena* (São Paulo: Museu de Arte Moderno de São Paulo, 1995).

24. Mário de Andrade, citado en Amaral, *Arte para quê?,* 41.

25. Walter Zanini, *História Geral da Arte no Brasil,* vol. 2 (São Paulo: Instituto Walther Moreira Salles, Fundação Djalma Guimarães, 1983), 583.

26. Rosa Artigas, "São Paulo de Ciccillo Matarazzo", en Agnaldo Farias, ed., *50 Anos Bienal de São Paulo, 1951–2001* (São Paulo: Fundação Bienal de São Paulo, 2001), 50–51.

27. Leonor Amarante, *As Bienais de São Paulo, 1951–1987* (São Paulo: Projeto, 1989), 13.

28. Comenzando en 1932, la administración del presidente Roosevelt comenzó la "Política del buen vecino", la cual utilizó instituciones culturales estadounidenses, de cultura refinada como popular, para promover sus intereses políticos en América Latina. Nelson Rockefeller, dueño de Standard Oil y presidente del Museum of Modern Art (MoMA), trabajó con un grupo de gente que quería desarrollar y construir museos de arte moderno en Brasil usando a MoMA como modelo. Rockefeller donó trece piezas para que se repartieran entre el MAM Rio y el MAM SP. Este nuevo interés norteamericano en Brasil y su cultura tomó muchas otras formas, que abarcan desde la creación de Zé Carioca, una caricatura de Disney que representa a Brazil, hasta la proliferación de películas estadounidenses protagonizando a Carmen Miranda. Aunque a primera vista estas manifestaciones pudieran no parecer como una gran amenaza, a muchos brasileños les resultaron bastante insidiosas ya que perpetuaban ciertos estereotipos. Para más información acerca de la "Política del buen vecino" y la intervención estadounidense en Brasil, véase Artigas, 48–49; Donald Marquand Dozer, *Are We Good Neighbors? Three Decades of Inter-American Relations, 1930–1960* (Gainesville: University of Florida Press, 1959); Antonio Pedro Tota, *O imperialismo no sedutor: a americanização do Brasil na época da segunda guerra* (São Paulo: Companhia das Letras, 2000); y Sérgio Augusto, "Hollywood Looks at Brazil: From Carmen Miranda to Moonraker", en Randal Johnson y Robert Stam, eds., *Brazilian Cinema* (Nueva York: Columbia University Press, 1995), 351–61.

29. Amaral, *Arte para quê?,* 229–30.

30. Dean, 207–23.

31. Hugo Segawa, "São Paulo, veios e fluxos, 1872–1954", en *História da Cidade de São Paulo,* ed. Paula Porta (São Paulo: Paz e Terra, 2004), 381–84.

32. Para mayor información sobre la nostalgia acerca del pasado de São Paulo, véase Teresa P. R. Caldeira, *City of Walls: Crime, Segregation and Citizenship in São Paulo* (Berkeley y Los Angeles: University of California Press, 2000); Cristina Freire, *Além dos mapas: os monumentos no imaginário urbano contemporâneo* (São Paulo: SESC Annablume, 1997); y Cláudio Willer, "A cidade e a memória", *Cidade: Revista do Museu da Cidade de São Paulo* 1, no. 1 (1994): 4–21.

33. Mendes de Almeida, 197.

34. Maurício Nogueira Lima y Flávio Motta, citados en Enock Sacramento, *Sacilotto* (São Paulo: Orbitall, 2001), 56.

35. Nogueira Lima y Motta, 58.

36. Nogueira Lima y Motta, 57.

37. Waldemar Cordeiro, "Ruptura Manifesto", en Amaral, ed., *Arte Construtivo no Brasil: Coleção Adolpho Leirner,* 266. Para más información acerca de la exhibición Ruptura, véase Rejane Cintrão y Ana Paula Nascimento, "The Exhibition of the Rupture Group in the São Paulo Museum of Modern Art, 1952", en *Grupo Ruptura: revisitando a exposição inaugural,* trans. Anthony Doyle y David Warwick, *Arte concreta paulista* (São Paulo: Cosac & Naify, Centro Universitário Maria Antônia, 2002).

38. Sergio Milliet, "Duas exposições", *O Estado de São Paulo* 13 diciembre 1952; reimpreso en João Bandeira, ed., *Arte concreta paulista: documentos* (São Paulo: Cosac & Naify, 2002), 46.

39. Maria Alice Milliet, "Atelier Abstração", en Amaral, ed., *Arte Construtiva no Brasil: Coleção Adolpho Leirner,* 65–93.

40. Hermelindo Fiaminghi, citado en Fernando Cocchiarale y Anna Bella Geiger, "Interview with Hermelindo Fiaminghi", en Fernando Cocchiarale y Anna Bella Geiger, eds., *Abstracionismo: Geométrico e Informal* (Rio de Janeiro: FUNARTE/ Instituto Nacional das Artes Plásticas, 1987), 135.

41. Fiaminghi, 136.

42. Aracy Amaral, "Duas linhas de contribuição: Concretos em São Paulo/ Neoconcretos no Rio", en Amaral, ed., *Projeto construtivo brasileiro,* 312.

43. Dos fuentes excelentes que tratan acerca del gobierno militar en Brasil incluyen a Maria Helena Moreira Alves, *State and Opposition in Military Brazil* (Austin: University of Texas Press, 1985) y Thomas E. Skidmore, *The Politics of Military Rule in Brazil, 1964–1985* (Nueva York y Oxford: Oxford University Press, 1988). Para una descripción más concisa del ascenso al poder del régimen militar, véase Joan Dassin, ed., *Torture in Brazil: A Report by the Archdiocese of São Paulo* (Nueva York: Vintage Books, 1986), 60–67.

44. Waldemar Cordeiro, "O objeto", *Arquitectura e Decoração* [São Paulo] diciembre 1956; reimpreso en Cocchiarale y Geiger, eds., *Abstracionismo: geométrico e informal,* 224.

45. El movimiento neoconcreto duró desde finales de los años cincuenta hasta 1961. Después de eso, Ferreira Gullar se involucró en el Centro Popular de Cultura (CPC), una organización izquierdista que buscaba ayudar a las masas a desarrollar una conciencia de clase a través de obras de teatro de agitación y propaganda representadas en las calles y frente a las fábricas, la publicación de libros de poesía y la producción de libros y elepés. El CPC duró de 1962–1964 y fue disuelto después del ascenso del gobierno militar. Para un análisis crítico del CPC, véase Christopher Dunn, *Brutality Garden: Tropicália and the Emergence of a Brazilian Counterculture* (Chapel Hill: University of North Carolina Press, 2001), 40–43 y Carlos Estevam, "For a Popular Revolutionary Art," en Johnson y Stam, eds., *Brazilian Cinema,* 58–63.

46. Gullar, 109.

Rio de Janeiro: A cidade necessária
Paulo Herkenhoff

Nota: Este texto está reproducido en su idioma original.

Entre o fim da ditadura Vargas em 1945 e o início do regime militar de 1964, o Rio de Janeiro, a cosmopolita capital do Brasil até 1961, se tornou um centro cultural de relevância internacional, ainda que então a Europa e Estados Unidos não tivessem instrumentos críticos para conferir imediato reconhecimento metropolitano. Um exemplo desse despreparo é o ensaio de Bernard Myers "Painting in Latin América: 1925–1956". Myers compara, por frágil relação de formas, uma atípica colagem concretista de Ivan Serpa à obra de Willem de Kooning.[1] No pensamento predominante no Norte, a América Latina é espelho ou nacionalismo. Tudo se dissolvia num "continentalismo" sem diferenças de obras, artistas e países sob o rótulo geográfico "América Latina". O tecido de significantes específicos era desmontado. À região só cabia um lugar sem *outra* história.

O crítico Mário Pedrosa avalia o Brasil na IV Bienal de São Paulo no artigo "Pintura Brasileira e Gosto Internacional" (1957).[2] Ataca o júri internacional ("fingiram não ver Volpi") e focaliza em Alfred Barr, diretor do The Museum of Modern Art (MoMA). Acusa Barr de se irritar com o peso de Max Bill no Brasil e não entender a gênese do grupo argentino *Nueva Visión*. Pedrosa ironiza se os sul-americanos deveriam se deixar influenciar por Picasso, Rouault, Soutine ou mesmo pelas "gloriosas descobertas" do MoMA "gênero Peter Blume". Acusa os jurados de definirem "por autóctone tudo que indique primitivismo, romantismo, selvagismo, isto é, no fundo, exotismo".

Rio moderno

De 1923 a 1950, o Palace Hotel no Rio de Janeiro manteve o único espaço contínuo de arte moderna do Brasil. Desenvolveu o mais importante programa modernista no país, com mostras de Oswald Goeldi, Tarsila do Amaral, Lasar Segall, Tsuguharu Foujita, Cândido Portinari, Emiliano di Cavalcanti, Alberto da Veiga Guignard, Ismael Nery e outros. As condições econômicas favoráveis no pós-guerra impulsionaram o processo de industrialização do Brasil e impulsionaram as artes. A terrível miséria no campo acelerava a urbanização. Em 1945, inaugura-se no Rio a Galeira Askanazy, a primeira galeria comercial de arte moderna do país, exibindo arte condenada pelo III Reich (Marc Chagall, Lovis Corinth, Wassily Kandinsky, Paul Klee e Lasar Segall). São criados o Museu de Arte de São Paulo (1947), os Museus de Arte Moderna do Rio de Janeiro e de São Paulo (1948) e a Bienal de São Paulo (1951). O intenso processo cultural no Rio explodiu com nova sensibilidade nos vários campos de expressão.

O "projeto construtivo" brasileiro surge em fins dos anos 1940[3] com a articulação dos artistas Almir Mavignier, Ivan Serpa e Abraham Palatnik e Mário Pedrosa no Rio de Janeiro e a produção das Fotoformas, fotografias abstratas por Geraldo de Barros em São Paulo. Com Pedrosa, que havia estudado na Alemanha e trabalhado em Washington, finalmente a crítica de arte se profissionaliza e abandona o modelo modernista de escritor-crítico (Mário de Andrade, Oswald de Andrade, Manuel Bandeira e Murilo Mendes). Leitor de Edmund Husserl e Ernst Cassirer, Pedrosa faz inicialmente uma consistente crítica da cultura, embasada em filosofia e na arte internacional. Escrevia no Correio da Manhã, jornal de Niomar Muniz Sodré, presidente do Museu de Arte Moderna. Pedrosa representou um salto epistemológico no meio artístico brasileiro. A crítica e a arte converteram-se em produção de conhecimento. Em torno do Neoconcretismo—a diferença carioca—gravitarão discussões estéticas, idéias plásticas, posições filosóficas, entendimentos da História, teorias da percepção, estratégias de prática social da arte e o diálogo entre as artes.

Baile de *todas* as artes

O desejo resplende perturbador no teatro de Nelson Rodrigues. Só no Rio, a moral pequena burguesa se expõe no teatro com tão mordaz acuidade. Em 1945, surge uma geração de escritores no Rio de Janeiro, cidade de abundante literatura. O paradigma modernista do regionalismo se esgota com José Guimarães Rosa, Clarice Lispector e João Cabral de Melo Neto, todos vinculados á diplomacia, uma evidência do cosmopolitismo da cidade. O Rio é o centro literário do Brasil. João Cabral era um geômetra da língua. Serviu em Sevilha, quando conhece a Miró e Tàpies. Certos textos de Lispector podem ser aproximados do imaginário da escrita de Lygia Clark. Sua crônica *Mineirinho* (1962), sobre a morte a tiros de um bandido, é pungente reflexão sobre a marginalidade social urbana e a responsabilidade coletiva: "O décimo-terceiro tiro me assassina—porque eu sou o outro". Esse desejo de alteridade está na "Antropofagia" (1928) de Oswald de Andrade, a teoria da cultura brasileira formada com a metabolização de todas contribuições. No entanto, o desejo de alteridade se realiza na obra de Lygia Clark e Hélio Oiticica, das seguintes gerações como uma marca da arte do Rio contemporâneo, que hoje se espalha pelo país . O *Bolide* dito *Homenagem a Cara-de-cavalo* (1966) de Oiticica, relativo a outro bandido morto, tem algo do *ethos* de Lispector.[4]

Nos anos cinqüenta, a poesia concreta se consolida em São Paulo em alto nível e no Rio com variantes neoconcretas, sempre conectadas com a arte. As divergências opõem os irmãos Haroldo e Augusto de Campos ao poeta Ferreira Gullar em torno de questões semânticas, semiológicas, espaciais e temporais. Para Gullar, a poesia neoconcreta opera no tempo verbal e na duração, traço bergsoniano no Rio. Tem um espaço-tempo orgânico, não-objetivo, que se dá na percepção fenomenológica: "o motor do poema não é um automatismo de fatores formais externos externos . . . O motor do poema é a própria palavra".[5] Osmar Dillon deu corpo poético à palavra. No extremo da invenção, poetas como Reinaldo Jardim e a artista plástica Lygia Pape, com seu *Livro da Criação*, construíram o que Gullar denominou "o livro infinito"[6] diante da circularidade poética, também presente nos *Bichos* de Lygia Clark.

Desde *Limite* de Mário Peixoto (1931), o filme cult brasileiro, pouco cinema se produziu no Brasil, embora o país contasse com diretores do porte de Alberto Cavalcanti e Humberto Mauro.

Salvo exceções, no pós-guerra, explode o gênero musical de variedades, melodramas e humor das chanchadas. O politizado Cinema Novo se consolida com grandes dificuldades no início dos anos 60. Na integração das artes, Hélio Oiticica foi ator no filme *Câncer* (1968) de Glauber Rocha. Lygia Pape desenhou cartaz ou letreiros para filmes de diretores do Cinema Novo: *Mandacaru Vermelho* (1960) e *Vidas Secas* (1963) de Nelson Pereira dos Santos; *Ganga Zumba* (1963) de Cacá Diegues; *Deus e o Diabo na Terra do Sol* (1964) de Glauber Rocha; *O Padre e a Moça* (1965) de Joaquim Pedro de Andrade. O Cinema Novo, concentrado no Rio, era questão viva do ambiente cultural da cidade. O Cinema Novo enfocou a imobilidade social, a marginalidade e a alienação. Era processo brechtiano para Pereira dos Santos, Diegues, Glauber, de Andrade, Leon Hirzsman e outros. É um cinema autoral com um olhar agudo sobre a sociedade, a luta de classes, o nacional e o popular: o Terceiro Mundo ganha sua estética despojada.

Os anos cinqüenta eram a era do rádio. O Brasil se escutava na Rádio Nacional, o maior traço de união do país e transmitida do Rio. A televisão surgia, primeiro "exposta" no Rio em demonstração nos anos 30. A televisão brasileira surge em São Paulo em 1950 com a TV Tupi. Depois também se instala no Rio. O outro traço de união do país eram as duas revistas cariocas O Cruzeiro e Manchete, cujo foto-jornalismo, com profissionais como José Medeiros e Flávio Damm. Pela primeira vez, os veículos de comunicação de massas mostravam um retrato amplo da sociedade brasileira em sua diversidade cultural e brutais diferenças sociais. Era a auto-imagem do Brasil.

O Rio de Janeiro era o grande laboratório da música brasileira. "Todas as artes aspiram por alcançar as condições da música", escreveu o Pedrosa.[7] Na trilha de Roger Fry ou de Susanne K. Langer de *Philosophy in a New Key* (1948), Pedrosa discutiu a condição abstrata da música entre as linguagens artísticas. Depois do samba nos Parangolés, Oiticica desloca seu interesse para o rock. Anota Oiticica,

Cheguei à conclusão de q não só as categorias formais de criação plástica perderam suas fronteiras e limitações (pintura, escultura etc.) como as divisões das chamadas artes também: descobri q o q faço é MÚSICA e q MÚSICA não é 'uma das artes' mas a síntese da conseqüência da descoberta do corpo ...[8]

Deixemos de lado a presença do carioca Heitor Villa-Lobos. O grande paralelo musical do Neo-concretismo foi a Bossa Nova. Estaríamos ao centro daquilo que Hélio Oiticica denominou "vontade construtiva geral" como um ponto de chegada de processos experimentais.[9] Um grande número de músicos da cidade desenvolve o que se apuraria como Bossa Nova, a partir da gravação da música "Chega de Saudade" de Tom Jobim por João Gilberto em 1958, o ano-chave do Neoconcretismo. A Bossa Nova substitui a base da melodia memorizável da música popular, por uma construção que integra melodia (freqüentemente não diatônicas), harmonia, ritmo e contraponto.[10] Sua pouca variedade melódica valoriza a estrutura harmônica e alia-se à tensão harmônico-tonal. Diferentemente da música brasileira até então, os acordes da Bossa Nova atuam em funções harmônicas e percussivas. Um gênero musical urbano agrega elementos da tradição afro-brasileira, do cool jazz e do be-bop. As batidas rítmicas da Bossa Nova coexistem com letras cujo valor sonoro opera como elemento significante. A interpretação é intimista e despojada de efeitos retóricos, tem caráter construtivo, ou, segundo Dominique Dreyfus, "quase minimalista".[11]

O urbanismo brasileiro terá seu símbolo na construção de Brasília, a nova Capital Federal planejada por Lúcio Costa. Os edifícios são desenhados por Oscar Niemeyer. Pedrosa escreveu cerca de 25 artigos na imprensa carioca sobre arquitetura e urbanismo durante a construção de Brasília (1957–1961). Para ele, "a questão da arquitetura não era descobrir ou redescobrir o país. Este sempre estivera lá, presente com sua ecologia, seu clima, seu solo, seus materiais, sua natureza e tudo que nele há de inelutável".

Ao longo do século XX ocorreram grandes experiências nos espaços urbanos e sociais do Rio de Janeiro, metrópole centrífuga. A derrubada de morros e aterramentos do mar geraram uma geografia inventada sobre a natureza em harmonia com o exuberante determinismo natural. Desapareceu o centro colonial. Nenhuma cidade brasileira passou por alterações tão estruturais. O Rio é um misto de Trópicos e engenharia. Expande-se o uso democrático de espaços coletivos e populares da praia, carnaval e futebol (com a construção do estádio de futebol Maracanã para 200.000 pessoas).[12] Na pior face do déficit social, a exclusão está exposta no equilíbrio instável dos barracos das favelas.

No final dos anos 50, Brasília era a utopia social que se apresentava como realização do desenvolvimento e aceleração do tempo contra o atraso social. A nova capital do país é implantada sobre o nada geográfico no centro do país. A partir das obras da Pampulha em Belo Horizonte, capital do Estado de Minas Gerais, Niemeyer assume a sensualidade barroca na arquitetura. Brasília, a nova Capital do país, os símbolos arquitetônicos das cidades de Belo Horizonte e São Paulo (Parque do Ibirapuera e Edifício Copan) são projetados pela arquitetura do Rio de Janeiro. No paisagismo, Roberto Burle Marx articula vegetação tropical, desenho sensual dos canteiros, aplicação das plantas como valor plástico e história natural. Sua obra se espalha pelo Brasil e se integra ao urbanismo e à nova arquitetura da Venezuela desenvolvimentista dos anos 50.[13] Projeto nacional da social democracia desenvolvimentista do Presidente Juscelino Kubitschek, Brasília se tornou o símbolo nacional de expectativa da aproximação de um futuro promissor, que se frustra com o golpe de 1964. Na eclosão da ditadura militar, grande parte da arte geométrica brasileira já experimentava uma espécie de crise de sentido.[14]

O design no Rio toma dois rumos no pós-guerra. Joaquim Tenreiro surgiu da tradição da marcenaria portuguesa. Criou um móvel moderno orgânico, valorizando as madeiras brasileiras, a palhinha, a leveza estrutural e o conforto tropical. Em 1962, a designer Charlotte Perriand freqüenta o Rio. Realiza trabalhos na cidade e estreita relações com a arquiteta Maria Elisa Costa. A partir da Bauhaus, o design gráfico

produz obras primas como o projeto do Jornal do Brasil por Amilcar de Castro. Um jornal cotidiano vira obra de arte, enquanto seu Suplemento Dominical, dirigido por Gullar, torna-se porta-voz das vanguardas e do momento cultural brasileiro. Um curso de tipografia no MAM em 1961, proposto por Aloísio Magalhães, gerou um plano de Alexandre Wollner e Tomás Maldonado que resultou na fundação da Escola Superior de Desenho Industrial (ESDI) (1962). Nessa ocasião, Maldonado publica "O problema da educação artística depois da Bauhaus".[15] Primeira na América Latina, a ESDI seguia o parâmetro funcionalista de Ulm.

Excluída pela elite modernista, a cultura popular tem sua modernização própria no século XX no carnaval, música, literatura de cordel, etc.[16] Para Mikhail Bakhtin, uma forma de carnaval esvazia gêneros obsoletos.[17] No Rio não foi diferente. Se o carnaval é a "festa da raça", proclama Oswald de Andrade no "Manifesto da Poesia Pau-brasil" (1928), o Rio de Janeiro foi seu caldeirão de ritmos de africanos, indígenas e europeus. Em 1960, a escola de samba Salgueiro convidou Fernando Pamplona, cenógrafo do Teatro Municipal, para planejar seu desfile. Desde então, o carnaval mudou para a grandiosidade atual. Em 1963, a escola de samba da Mangueira chamou o escultor neoconcretista Amilcar de Castro para fazer um carro alegórico. Os componentes da Mangueira sentiram dificuldades em entender a proposta geométrica em verde e rosa dele.[18] É no processo de integração entre o carnaval, com muitas escolas sediadas em favelas, que Oiticica é levado à Mangueira pelo escultor Jackson Ribeiro. A Mangueira é a matriz de *Tropicalia*. Sob o impacto do carnaval do Salgueiro organizado por Pamplona e Arlindo Rodrigues em 1965, Oiticica desenvolve os Parangolés (1966), nas versões de capas e bandeiras, que guardam estreita relação com o carnaval e a fusão operística e popular dos sentidos. É uma culminância da suprasensorialidade, modo como Oiticica denominou o apelo aos múltiplos sentidos em circunstâncias coletivas abertas.[19]

Razão e Loucura

A psiquiatra Nise da Silveira introduziu a terapia ocupacional do Hospital Psiquiátrico Dom Pedro II, no bairro de Engenho de Dentro nos anos 40. Foi a mais fecunda experiência entre arte e terapia no Brasil. Convidou para auxiliá-la Almir Mavignier e, depois, Serpa e Palatnik. "Um dia o Mavingier me disse: vamos conhecer uns colegas. Eu não sabia que ele me levava para o Hospital. No caminho eu me surpreendia com as coisas que ele me dizia, pois eram as que me preocupavam".[20] Era primeiro agrupamento de artistas abstrato-geométricos do Rio. A tese *Da Natureza Afetiva da Forma na Obra de Arte* (1949) de Pedrosa marcou-os.[21]

A "praxisterapia" na Colônia Juliano Moreira no Rio considerava que a arte "mostrava aspectos incógnitos de enfermidades".[22] Nesse hospital, Arthur Bispo do Rosário, internado entre 1960–1989, realizou sua monumental obra de reconstrução do mundo com a produção de mil objetos. No entanto, as duas experiências terapêuticas se mantiveram isoladas. A orientação de Silveira se assentava nas teorias de Jung, incluindo os conceitos de "imagens arquetípicas",

"inconsciente coletivo" e sistemas de símbolos. Porque a arte solicita o nível não-verbal do sujeito, ela atua sobre os "inumeráveis estados do ser". Silveira criticava ferrenhamente a medicina do eletro-choque de Ugo Cerletti e aos abusivos tratamentos químicos da loucura institucionalizada. Sua prática almejava "a reabilitação do indivíduo para a comunidade em nível até mesmo superior àquele em que se encontrava antes da experiência psicótica".[23] Ela se opunha à noção cartesiana de sujeito na dicotomia corpo-psique.[24]

Nise da Silveira fora presa na ditadura.[25] Os hospitais psiquiátricos eram cárceres brutais. Pedrosa se envolveu com este trabalho de Nise da Silveira. Embora não fosse militante, ela tinha simpatia pelo trotskysmo.[26] Já Pedrosa, depois de militar no Partido Comunista Brasileiro, opôs-se à posição contra-revolucionária de Stalin na III Internacional. Desde então, engajou-se nas idéias de Trotsky, criando a Liga Comunista Internacionalista em 1931. O olhar solidário, miragem de utopia social através da arte, une o crítico à médica.

Na Alemanha, Pedrosa estudara a teoria da Gestalt. O crítico foi leitor atento de Freud, Roger Fry, Hans Prinzhorn, Rudolf Arnheim, Herbert Read e outros. Apesar da inconciliável diferença epistemológica entre as teorias de Freud e Jung, Pedrosa e Silveira compartilhavam o entendimento da expressão como utopia social. Tinham certa adesão à posição de Trotsky como pensamento que integra relações entre arte e vida. Diante da pujança visual da pintura de crianças e loucos, Pedrosa vê a inapreensibilidade da arte moderna: o público não consegue "discernir o fundamental do fenômeno artístico".[27] Era seu primeiro embate com o racionalismo mecânico do intelectualismo abstrato depois da compreensão do inconsciente. Pedrosa compreende que a arte como cura pode propiciar a "harmonia dos complexos do subconsciente e melhor organização das emoções humanas". Essa idéia da cura estará na produção de Lygia Clark, depois de suas experiência psicanalítica com Pierre Fédida em Paris e das atividades como professora na Sorbonne (1970–1975). Clark pesquisou o potencial terapêutico de seus *objetos relacionais* no contexto de sua teoria do infra-sensorial.

O hospital psiquiátrico guardava uma surpresa. Em 1949, Arthur Amora, um paciente diurno, pintava "pedras de dominó" reduzidas a quadrados negros sobre fundo branco. Organizava ritmos modulares, contrastes óticos, jogos ordenados de formas e desafios à percepção. Mavignier se impressionou com seu "geometrismo conseqüente".[28] Para Mavignier, Amora fazia terapia e não arte. No Rio, as primeiras experiências próximas de imagens racionais da forma concreta surgem num hospital psiquiátrico. É o contágio entre razão e emoção, que se interpõe nas bases remotas da tensão da proposta neoconcreta.

Museu de Arte Moderna

Em 1952, Maria Martins doou o *Portrait d'Antonin Artaud* (1947) de Jean Dubuffet ao Museu de Arte Moderna do Rio de Janeiro (MAM). Ela inscreve a obra do pensador da *Art Brût* e da figura do artista cuja estrutura psíquica havia sido estiolada pelo eletro-choque. Em 1945, Artaud

escreve uma carta desde o sanatório de Rodez: "O eletrochoque me desespera . . . faz de mim um ausente que se sabe ausente e se vê durante semanas em busca de seu ser".[29]

O MAM aprofundou nexos com as vanguardas desde sua fundação em 1948. Tendo o MoMA como modelo, os museus de arte moderna do Rio de Janeiro e de São Paulo em parte refletiam o envolvimento de Nelson Rockefeller com a América Latina. Como Assistant Secretary of State para assuntos inter-americanos (1944–1945), Rockefeller buscou criar as alianças anti-nazistas nas Américas.

A partir da Presidência de Niomar Muniz Sodré Bittencourt no MAM 1952, a arte concreta se imbrica com a instituição.[30] O museu funcionou primeiro no prédio do Ministério da Educação, projetado por Le Corbusier, Lúcio Costa, Oscar Niemeyer, Affonso Eduardo Reidy e outros. Bittencourt encomenda o projeto da sede do MAM a Reidy, amplia o acervo, patrocina mostras inovadoras e cria cursos. Essa são algumas bases para o surgimento do Neoconcretismo. Com Niomar Bittencourt, o acervo do Museu de Arte Moderna cresce com rapidez, com o objetivo de coerência histórica.[31] Sua coleção particular abrigava obras de Piet Mondrian, Mark Rothko e Alberto Giacometti.

Os jovens em formação no Rio passaram a conviver com obras cubistas, geométricas ou concretistas no MAM: Pablo Picasso (*Tête cubiste,* 1909), Constantin Brancusi (*Melle Pogany,* 1920), Fernand Léger, André Lhote, Paul Klee, Josef Albers, Max Bill, Friedrich Vordemberg-Gildewart, César Domela, Lucio Fontana, Bruno Munari, Michel Seuphor, Yacov Argam e dos sul-americanos Pedro Costigliolo, Maria Freire, Alfredo Hlito, Enio Iommi, entre outros. O Rio tinha vínculos significativos com o grupo surrealista. Vivendo em Paris entre 1927 e 1929, Pedrosa travara contato com Joan Miró, Yves Tanguy, André Breton e Benjamin Péret. A escultora Maria Martins, esposa do embaixador do Brasil em Washington, convivera com o círculo artístico de Nova York, incluindo Alfred Barr, Marcel Duchamp, Piet Mondrian, Jacques Lipchitz, William S. Hayter e Louise Bourgeois. Sob a orientação de Maria, o acervo surrealista do MAM foi formado por obras de Jean Arp, Salvador Dalí, Max Ernst, Alberto Giacometti, Jacques Lipchitz, René Magritte, Roberto Matta, Miró e Tanguy. O acervo justapunham o racionalismo do cubismo e da arte concreta à lógica do inconsciente do surrealismo, fricção transferida para o Neoconcretismo.

A Escola de Nova York e seu Expressionismo Abstrato penetram no Rio de Janeiro com a aquisição em 1952 de pinturas de Mark Rothko (*No. 4-A,* 1947 e *Orange and Yellow,* 1951), Baziotes, e as doações de Nelson Rockefeller de pinturas de Robert Motherwell e Jackson Pollock (*No. 16,* 1950). Entendendo as diferenças entre as cidades, Rockefeller reservou doação mais conservadora (Chagall) para o MAM paulista. Enquanto no Brasil se multiplicam os Clubes de Gravura, inspirados nos Talleres de Gráfica Popular mexicanos de orientação zdanoviana do Partido Comunista, os novos museus e a Bienal de São Paulo se tornam peças estratégicas no xadrez cultural da Guerra Fria. No entanto, a obra de Rothko e Pollock permanece irredutível à condição de peças desse jogo. No Rio como em Nova York, foram compreendidos como pensamento visual. Neoconcretismo e Minimalismo tomarim posição, em direções divergentes, com respeito ao Expressionismo Abstrato.

Educação

No pós-guerra, as escolas de arte brasileiras não respondiam à nova inquietação. A formação dos artistas muitos ocorria em ateliês privados. Lygia Clark estudou com Burle Marx, que era auxiliado por Zélia Salgado.[32] Dois *salons* no Rio nos anos 50 (a casa de Mário Pedrosa aberta aos artistas e a de Ivan Serpa aos domingos) eram espaços de debate crítico sobre a produção cultural.

O experimentalismo didático de Ivan Serpa no MAM teve o apoio conceitual de Pedrosa desde 1952. Serpa foi professor de Aluisio Carvão, Rubem Ludolf, João José Costa, Hélio e César Oiticica. O MAM virou um laboratório de investigação da forma, permeado por reflexões sobre a experiência da arteterapia psiquiátrica, discussões sobre a teoria da Gestalt e a fenomenologia da percepção. Os cursos do MAM conformam a segunda etapa carioca na Arte Concreta, pois dele surgem artistas que sucede ao trio do Engenho de Dentro (Mavignier, Palatnik e Serpa) antes da formação do Grupo Frente.

Ivan Serpa publica *Crescimento e Criação* em 1954, ano em que Oiticica, aos 17 anos, estudava com ele. No prefácio, Pedrosa aponta a fenomenologia e a Gestalt na "conceitualização percepcional" no método Serpa. Exalta as idéias de Arnheim em *Art and Visual Perception* (1954) sobre o destemor pelo emocional e a compreensão pela criança do processo de desenvolvimento do conceito visual. Para Pedrosa, o método Serpa superava certas observações de Arnheim quanto à questão do nascimento da forma. Reconhecia que o rigor exigido dos alunos afastava os meros efeitos liberatórios do desenho infantil que interferissem com o aparecimento da forma e levava à "crescente complexidade da forma".

Nos textos *Crianças na Petite Galerie* e *Frade cético, crianças geniais* de 1957, Pedrosa acentua aspectos da pluralidade e do desenvolvimento do entendimento do mundo no cotidiano da vida. No primeiro, observa os desenhistas infantis e adolescentes, como Carlos Val. Pedrosa denota familiaridade com posições de Read em *The Aesthetic Method of Education* (1946),[33] tais como a necessidade de abordar a "arte infantil" sob critérios específicos: as crianças não se tornariam necessariamente artistas. A arte é disciplinadora dos gestos mecânicos. A posição do professor é também de aprendiz da criança. No segundo artigo, reivindicou-se "o desarmar da arrogância do adulto em face da criança". Pedrosa estava em consonância com o que seria o primeiro movimento da moderna pedagogia no Brasil com Anísio Teixeira no Rio (a teoria da democratização pela educação, em parte inspirado em John Dewey), precedente da pedagogia do oprimido de Paulo Freire.

Reconhecido um aluno promissor, Serpa tratava-o como igual, incluindo-o em exposições. Carvão e Val participam da primeira mostra do Grupo Frente (1954) e, nas próximas, Ludolf e os irmãos Oiticica. O Grupo Frente refletia o ecletismo entre seus alunos. Os Metaesquemas

iniciais, ditos "secos",[34] de Hélio Oiticica seguiam a rigorosa orientação de Serpa para a geometria, precisão e limpeza na obra.[35] Serpa exigia a produção maciça entre as aulas. Produzir muito indicaria opção profissional. Isso explica porque em dois anos Oiticica pintou cerca de 450 Metaesquemas, divididos em séries em geral pintadas numa semana. Serpa estimulava o foco.

Rio construtivo

Existe um abismo entre o Rio de Janeiro e São Paulo, aberto por Mário de Andrade e pavimentado por certa produção historiográfica da Universidade de São Paulo, ao ignorar fontes de informação do Rio de Janeiro.[36] Nesse processo, sobrepõe-se o exclusivo "efeito Bienal" sobre o país em anulação de fatores históricos igualmente determinantes. "Antes de tudo a Bienal de São Paulo veio ampliar os horizontes da arte brasileira", lembra Pedrosa.[37] A importância de Max Bill, premiado na primeira Bienal, é inegável para o Concretismo, mas não deveria escamotear o papel da obra de Albers. No Rio houve menos a matemática solicitada por Bill, à exceção de Mavignier em Ulm, e nas Homenagens ao Quadrado a partir de Albers, como o *Livro da Criação* de Pape e as *Unidades* (1958) de Clark. O campo intelectual do Neoconcretismo incluía a teoria da Gestalt, a fenomenologia da percepção, a sensorialidade, o caráter simbólico da forma, a noção precisa da História da Arte, a correlação entre as artes, a duração, a geometria não-euclidiana. Valorizava-se o experimentalismo, até como resistência à opressão política: "a arte é o exercício experimental da liberdade", reiterava Pedrosa. Lia-se Langer e Maurice Merleau-Ponty. Em São Paulo prevaleciam interesses na semiótica de Peirce e na Teoria de Informação de Norbert Wiener. No Rio, pensava-se criticamente a partir de Paul Cézanne, Kasimir Malevitch, Piet Mondrian, Georges Vantongerloo, Albers, Alexander Calder, Pollock e Rothko. Os artistas cariocas tiveram o privilégio de contar com o conhecimento consistente de Pedrosa e a capacidade interpretativa do poeta Ferreira Gullar.

A "vontade construtiva geral" no Rio de Janeiro apresentou variedade de propostas, além do Neocontretismo. Havia desde experimentos tecnológicos até a geometria espiritual. O gestual e o informal tiveram a atuação consistente de Antonio Bandeira, Flávio Shiró e Iberê Camargo.

Rio concretista

A arte geométrica de Serpa, Mavignier e Palatnik fez a diferença concretista na I Bienal de São Paulo. O Grupo Frente (1952) abre um viés experimental com sua vontade de inventar espaços referidos aos paradigmas bauhausianos, neoplasticistas, Vantongerloo, Albers e Bill. Com determinação de Gestalt, a pintura Rubem Ludolf era campo de progressões geométricas e modulações que repousam ou vibram com pontos de tensão ótica da forma em ritmo dissonante e centrífugo. Os relevos de espelhos de Ubi Bava armavam a sedução cinética. José Oiticica Filho, pai de Hélio, foi o mais radical fotógrafo geométrico brasileiro. Sua visão de matemático alimentou seu olhar construtivo. A afiliação ao foto-clubismo preparou sua utilização do potencial ótico, químico e técnico da fotografia. No extremo experimental, a concretude da fotografia é isenta, de qualquer referente no real: "fotografia se faz no laboratório", diz.[38]

Rio cinético

Apesar da longa presença de Calder, no Rio de Janeiro nos anos 50, o Cinetismo tem caminho próprio na cidade. O debate sobre a crise da pintura como objeto, depois dos impasses previstos por Malevitch e Mondrian,[39] levam o engenheiro-pintor Abraham Palatnik a audaciosas experimentações. Sua pintura se reduziu à pura luz projetada sob uma superfície translúcida leitosa de uma caixa (cujo mecanismo motorizado movimenta fontes de luz). A pintura movente e desmaterializada é puro fenômeno luminoso. Precursor internacional da pintura cinética, Palatnik expõe na I Bienal de São Paulo (1951). Malgrado seu conhecimento de Brasil, Guy Brett apenas cita Palatnik na mostra *Force Fields* (MACBA, 2000), mesmo se incluiu artistas com valor cinético frágil como Sergio Camargo. Palatnik exemplifica a difícil inscrição na História de um artista operando fora dos centros hegemônicos.

Rio sensível

Fugindo do fascismo, Maria Helena Vieira da Silva e Arpad Szènes refugiaram-se no Rio de Janeiro (1940–1947), onde desenvolvem a mais radical pesquisa de espaço no Brasil até então. Em jogos de linhas, a malha espacial da pintura dela se expande e contrai em movimentos virtuais. Vieira da Silva foi a primeira matriz da geometria sensível no Brasil. Seu círculo envolveu Mavignier e Ione Saldanha. Em sua trajetória, Saldanha reduziu a paisagem a estruturas geométricas planas. Seu olhar matisseano foi o melhor diálogo brasileiro de Alfredo Volpi sobre acordes cromáticos e a leveza da pintura. Como poucos, Saldanha experimentou suportes prosaicos, como bambus e bobinas industriais, que situavam o objeto pictórico no espaço real.

Outro casal, Maria Leontina e Milton Dacosta, desenvolveu uma geometria poética. Ambos chegaram a abstração através da paulatina redução da forma. À pintura de Leontina e Dacosta se aplica com justeza o conceito de "geometria sensível", modo como Damian Bayón e Aldo Pellegrini designaram a geometria da América Latina.[40] Menos do que insuflar subjetividade na forma, pintavam sem o roteiro programático da objetividade excessiva. Frente os embates propostos pelo Concretismo, como a metralhadora verbal de Waldemar Cordeiro, Leontina e Dacosta se refugiaram na pintura, como fizera Giorgio Morandi durante a guerra.

Rio metafísico (tempo)

A intensa reflexão sobre o tempo na experimentação do Neoconcretismo tinha bases em Henri Bergson, como ocorreu com Boccioni no Futurismo e Malevitch no Suprematismo.[41] Joyce Medina demonstra o paralelo hermenêutico entre filosofia da imagem de Bergson e a prática pictóricas de Cézanne.[42] A duração bergsoniana servia às teorias da percepção, a metafísica e aos processos de subjetivação do Neoconcretismo, cujo traço marcante no tempo se assinalava na experiência da obra e em reflexões teóricas.[43]

Rio (sub)desenvolvido

Paralelamente ao Cinema Novo, Pedrosa, Gullar e Haroldo de Campos investigaram uma possível cultura autônoma no Terceiro Mundo.[44] Apoiados em Frederick Engels, Georg Lukács ou Karl Popper, afastam a idéia de progresso em arte. Em São Paulo, Campos abordou a falácia do determinismo do Brasil a produzir apenas cultura dependente. No ensaio *Da razão antropofágica: diálogo e diferença na cultura brasileira* (1980), ele explora possibilidades de uma literatura experimental e genuína, de vanguarda, em país periférico: "Com relação à arte, sabe-se que determinados períodos de florescimento não estão de modo algum em relação com o desenvolvimento geral da sociedade, nem, conseqüentemente, com a base material, a ossatura, por assim dizer, de sua organização". No artigo "Vicissitudes do Artista Soviético" (1966), Pedrosa deplora, no contexto da Guerra Fria, o papel regulador do mercado capitalista sobre a arte e a opressão pela burocracia soviética. No Terceiro Mundo o artista teria melhor possibilidade de escapar do condicionamento pelo capital ou da vassalagem ideológica. No livro *Vanguarda e Subdesenvolvimento* (1969), Gullar preconiza a resistência através da luta pela emancipação da cultura através da resistência à alienação.

Narcisismo das pequenas diferenças

Em *O Mal Estar da Civilização*, Freud chama de "narcisismo das pequenas diferenças" às aferradas disputas entre cidades,[45] aplicável ao caso São Paulo e o Rio. O manifesto Ruptura de 1952, matriz do Concretismo paulista conduzida pelo gramsciano Waldemar Cordeiro, introduzira um racionalismo. Opunha-se ao "velho", entendido como "o naturalmente errado" das crianças, loucos, 'primitivos' expressionistas, surrealistas—em suma, muito da experiência carioca já vista.[46] Os concretistas atinham-se à ortodoxia marxista do conhecimento objetivo. Era a tese defendida por Henri Lefèbvre em ataques ao existencialismo de Sartre.[47] Em defesa do escritor, Merleau-Ponty reivindica que o fenômeno social não se desligue da descrição do ser e da existência dos Outros. Argumenta que o idealismo e o existencialismo não compreendem a liberdade e a intersubjetividade. Seus argumentos sobre a percepção e a formação não-cartesiana do olhar ganham relevância. Pedrosa ajustou trotskysmo e fenomenologia.

Rio neoconcretista

Em 1959, o "Manifesto Neoconcreto"[48] de Gullar organiza os princípios do grupo, numa cisão com o Concretismo paulista. Para Pedrosa, o pintor concretista "gostaria de seu uma máquina de elaborar e confeccionar idéias". Contra tal objetividade excessiva, o Neoconcretismo resgatou a subjetividade, afirmou a presença do artista e converteu o público em sujeito de ação estética, convocado à "vivência" conformadora da própria arte, como nos Bichos de Clark. Participaram do Neoconcretismo: Lygia Clark, Hélio Oiticica, Lygia Pape, Aluisio Carvão, Décio Vieira, Amílcar de Castro e Franz Weissman do Rio e Hercules Barsotti, e Willys de Castro de São Paulo. O manifesto, consolidando algumas idéias de Pedrosa, proclama que

o neoconcreto, nascido de uma necessidade de exprimir a complexa realidade do homem moderno dentro da linguagem estrutural da nova plástica, nega a validez das atitudes cientificistas e positivistas em arte e repõe o problema da expressão, incorporando as novas dimensões 'verbais' criadas pela arte não-figurativa construtiva. . . . assim os conceitos de forma, espaço, tempo, estrutura—que na linguagem das artes estão ligados a uma significação existencial, emotiva, afetiva—são confundidos com a aplicação teórica que deles faz a ciência.

As discussões sobre a Gestalt e a fenomenologia da percepção desembocaram na "Teoria do Não-Objeto" (1959) de Gullar: "Ninguém ignora que nenhuma experiência humana se limita a um dos cinco sentidos do homem, uma vez que o homem reage com uma totalidade".[49] Em sua escrita, Gullar estabeleceu "paralelos hermenêuticos" à teoria do espaço, cor, caráter simbólico da forma, estatuto do objeto de Lygia Clark, Hélio Oiticica e demais neoconcretistas.

Passos para a autonomia

Não por acaso, o Neoconcretismo foi o primeiro acerto de contas da arte brasileira com a História da Arte. Se articularmos afirmações esparsas de críticos e artistas, poderemos construir conclusões sobre os procedimentos dos neoconcretistas para desenvolverem um posicionamento produtivo e estratégico frente a História da Arte.

1. A visão hegeliana e marxista da História, sustentada pela formação filosófica de Pedrosa, dissolveu os remanescentes positivistas de História da Arte no Brasil.

2. O método se introduz por primeiro na crítica brasileira com Pedrosa. Sua formação alemã propiciou uma entrada na Fenomenologia, instrumento para entender a produção e recepção da arte. Ao retornar ao Brasil depois do exílio em Nova York (1943–1945), Pedrosa reside no Rio, onde dá solidez a sua relação com a arte. O Rio de Janeiro foi o ambiente que melhor apreendeu a fenomenologia de Merleau-Ponty, com conseqüências fecundas sobre a arte—talvez melhor que a França e antes do Minimalismo.

3. Sem a ansiedade do novo, os neoconcretistas não almejavam impressionar no estrangeiro. No modernismo, Tarsila sempre quis fazer sucesso na França antes de expor no Brasil. Em 1923, cogita voltar ao Brasil para "com os processos de minha pintura atual buscar aí a minha futura exposição em Paris".[50] Sua primeira mostra brasileira foi Rio (1929), depois de duas exposições em Paris (1926 e 1928). Em "Pintura Brasileira e Gosto Internacional" (1957), Pedrosa afirma que os artistas brasileiros (ele destaca os cariocas, à exceção de Volpi) "não se importam se o que atualmente estão fazendo não é o que está em moda na Europa ou nos Estados Unidos".[51] O Neoconcretismo não solicitava legitimação externa nem tinha intenções oblíquas.

4. A História não mais se entende como seqüência de movimentos ou "ismos" a serem

superados sob o requisito da constante atualização como ocorrera com o modernismo. Revogam-se as concepções de "influência". Pedrosa criticava noções como "estilo", modelos que se substituem incessantemente.[52] Oiticica afirma que "não existe 'estilo': com Duchamp tudo isto já havia chegado ao limite".[53]

5. O Neoconcretismo ancorou-se em conhecimento da arte moderna, seus princípios teóricos, origens e desdobramentos, com um discernimento nunca ocorrido no Brasil.[54] A evolução neoconcretista nos anos 60, como outras manifestações de arte, rompe limites. Pedrosa argumenta que "já não estamos dentro dos parâmetros do que se chamou de arte moderna. Chamais a isso de arte pós-moderna, para significar a diferença" (1966).[55] Assim, o Rio foi um precursor mundial na construção da teoria do pós-moderno.

6. O Neoconcretismo se definiu frente a História da Arte. Gullar observa na "Teoria do Não-Objeto" que "é com Mondrian e Malevitch que a eliminação do objeto continua. . . . é a pintura que jaz ali desarticulada, à procura de uma nova estrutura, de um novo modo de ser, de uma nova significação".[56] Pedrosa avalia que o objeto enfrentou uma crise com Breton e se dissolve na vanguarda brasileira,[57] cujos marcos decisivos de 1959 foram os Bichos de Lygia Clark e a "Teoria do Não-Objeto", que conclui: "O não-objeto não é um antiobjeto mas um objeto especial em que se pretende realizada a síntese de experiências sensoriais e mentais: um corpo transparente ao conhecimento fenomenológico, integralmente perceptível, que se tende à percepção sem deixar rastro".

7. A História não seria uma plêiade de heróis admiráveis. Todos estão sujeitos a avaliação crítica. Em "Bienal, Panorama do Mundo" (1954), Pedrosa aponta que a arquitetura moderna não operava por "apanágio exclusivo das grandes personalidades".[58] Em seu aludido ataque, Pedrosa ironiza se Barr se frustra por não ver influência de Picasso no Brasil. Em Resposta a Cordeiro, Gullar alfineta os concretistas: "continuam a marcar passos e exercitar-se em ordem unida sob o apito de Max Bill. [. . .] a verdadeira lição dos mestres está na sua independência e na sua procura de expressão própria".[59]

8. A chave era a valorização da diferença. Vimos o libelo de Pedrosa em seu julgamento dos jurados da IV Bienal: o júri internacional não viu Volpi. O mundo produtivo já não tinha um centro.

9. Em "A dúvida de Cézanne" (1956), Merleau-Ponty afirma que o artista segundo Cézanne funda a cultura de novo, "fala como o primeiro homem falou e pinta como se nunca se houvesse pintado".[60] Assim, em sua rejeição ao mecanicismo concretista, Gullar afirma que "a obra de arte não pode ser a mera ilustração de conceitos apriorísticos".[61] Produzir arte não é tornar visível um pensamento pré-dado.

10. A História tampouco se constituiria como repertório de imagens a reinterpretar. Como observa Oiticica: "ao artista INVENTOR não cabe somar obras".[62] O Neoconcretismo foi processo de invenção.

11. Os neoconcretistas compreenderam que a História da Arte não era unívoca, mas um conjunto de problemas plásticos, como na ciência. A arte é processo de conhecimento, por isso a experimentação e a invenção são valores. Valia a lição de Cézanne sobre o processo cognitivo da pintura e seu caráter filosófico.

12. Ao artista caberia o desafio do legado de questões deixado pelos precedentes. Cabe-lhe o irresoluto. Sem "angústia de influência", Clark escreveu uma "Carta a Mondrian" (1959): "Você já sabe que eu continuo o seu problema, que é penoso".[63] O Mondrian que interessará a Clark, Oiticica ou Pape pode ser Broadway Boogie Woogie, mas a partir dos limites aos quais ele se ateve. Com noção de projeto, eles compreenderam sua tarefa ontológica. Com o Neoconcretismo, a produção brasileira inscreveu, pela primeira vez na moderna História da Arte, uma linguagem autônoma e uma poética singular.

As estratégias precisas do Neoconcretismo responderam às aspirações de emancipação cultural brasileira. A arte se deslocava dos modelos modernistas de representação nacionalista (como a tradução de parâmetros europeus em cor local) para uma vontade de linguagem própria sob nova semântica. Apesar do dinâmico furor modernista, a pintura permanecera pré-cubista, nacionalista e dependente dessas idéias regionalistas. O Neoconcretismo superou as limitações do meio sócio-cultural brasileiro.

A riqueza dos resultados estéticos e teóricos do Neoconcretismo e o modo como ele esteve envolvido com o Rio de Janeiro, propõem uma paráfrase conclusiva. Se em "A dúvida de Cézanne," Merleau-Ponty conclui sobre o pintor que "esta obra a fazer exigia esta vida", podemos argumentar que a produção do Neoconcretismo a desenvolver exigia esta cidade do Rio de Janeiro.

Notas

1. Em Charles M. Curdy (ed.). *Modern Art, a Pictorial Anthology.* Nova York: The MacMillan Company, 1958, p. 204.
2. Mário Pedrosa. O Brasil na IV Bienal. In Otília Arantes (org.). *Acadêmicos e Modernos.* São Paulo: EDUSP, 1998, p. 280. Todas as citações de Pedrosa saíram deste parágrafo.
3. A expressão ficou consagrada com a exposição *O Projeto Construtivo Brasileiro na Arte* organizada por Aracy Amaral e Ronaldo Brito na Pinacoteca do Estado de São Paulo e no Museu de Arte Moderna do Rio de Janeiro em 1977.
4. Este artigo consolida e expande algumas apresentações da cultura do Rio de Janeiro pelo autor desde a década de 1990, como *The Contemporary Art of Brazil: Theoretical Constructs in Ultramodern of Contemporary Brazil.* The National Museum of Women in the Arts, Washington, 1993; e na década de 2000: *Opaque Water Drops: Towards a Comparative Study of Neoconcretismo and Minimalism* (novembro de 2000) publicado sob o título de "Southern Boundaries of the Modern: The Case of Neoconcretismo". Em *Geometric Abstraction—Latin American Art from the Patricia Phelps de Cisneros Collection.* Cambridge, Mass.: Harvard University Art Museums; New Haven, Conn.: Yale University Press, 2001, pp. 105–131. Ver também o texto

de Paulo Venancio Filho sobre o Rio de Janeiro. Em Iwona Blazwick (org.). *Century City: Art and Culture in the Modern Metropolis*. London: Tate Modern, 2001.

5. Ferreira Gullar. Da Arte Concreta à Arte Neoconcreta. *Jornal do Brasil*, Rio de Janeiro, 18 julho 1959.

6. Ferreira Gullar. Palavra, Humor, Invenção. *Jornal do Brasil*, Suplemento Dominical, Rio de Janeiro, 10 dezembro 1960.

7. Mário Pedrosa. Pintores da Arte Virgem (1950). Em *Dimensões da Arte*. Rio de Janeiro: Ministério da Educação e Cultura, 1964 , p. 105.

8. Hélio Oiticica. DE HÉLIO OITICICA PARA BISCOITOS FINOS. Rio de Janeiro, datilografado, 11 novembro 1979, p. 2. Grafia conforme o original. Para uma síntese dos interesses de Oiticica em música, ver de Paulo Herkenhoff. "O q ele fazia era música" (I). *Letras & Artes*, Rio de Janeiro, ano V, janeiro 1991, pp. 30–31.

9. Hélio Oiticica. Esquema Geral da Nova Objetividade. Em *Nova Objetividade Brasileira*. Rio de Janeiro: Museu de Arte Moderna, 1967, páginas não numeradas.

10. Diana Goulart. *Bossa Nova: uma batida diferente*. Monografia não publicada para o Curso de Pós-Graduação em Educação Musical no Conservatório Brasileiro de Música do Rio de Janeiro, 2000.

11. Dominique Dreyfus. *O Violão Vadio de Baden Powell*. São Paulo: Editora 34, 1999, p. 85.

12. No texto Do Ato (1965), Lygia Clark percebe "a totalidade do mundo com um ritmo único global, que se estende de Mozart aos gestos do futebol".

13. Roberto Burle-Marx foi trazido pela primeira vez à Venezuela nos anos 50 por Diego Cisneros, sogro de Patricia Phelps de Cisneros.

14. Em todo o país mais de uma dezena de artistas geométricos abandonou o discurso racionalista como Geraldo de Barros, Lygia Clark, Waldemar Cordeiro, Milton Dacosta, Maria Leontina, Maurício Nogueira Lima, Hélio Oiticica, Lygia Pape, Ivan Serpa e Franz Weismann.

15. Tomás Maldonado. O problema da educação artística depois da Bauhaus. *Jornal do Brasil*, Suplemento Dominical, Rio de Janeiro, 7 janeiro 1961.

16. Mário de Andrade, por exemplo, exclui da Semana de Arte Moderna de 1922, qualquer músico popular do calibre de um Pixinguinha ou Ernesto Nazareth, de quem Darius Milhaud ressalta em 1920 "a riqueza rítmica, a fantasia indefinidamente renovada, a verve, a vivacidade, a invenção melódica de uma imaginação prodigiosa". Em Brésil. *Revue Musicale*, Paris, ano I, novembro 1920. Pixinguinha tocava em Paris em 1922.

17. Mikhail Bakhtin. *Rabelais and His World*. Hélène Iswolsky (trad.). Bloomington: Indiana University Press, 1984, p. 218.

18. As informações sobre as escolas de samba são de Sergio Cabral. Em *As escolas de samba do Rio de Janeiro*. Rio de Janeiro: Lumiar Editora, 1996.

19. Clark, por seu turno, desenvolvia sua infrasensorialidade como articulação dos sentidos nas relações de alteridade ou na própria interioridade do ser.

20. Abraham Palatnik. Em conversa com Paulo Herkenhoff, 2005.

21. Conforme carta de Mavignier a Aracy Amaral em 14 setembro 1976.

22. Exposição de Pintura dos Enfermos da C.J.M (Trechos do Relatório de 1950). *Boletim da Colônia Juliano Moreira*, Serviço Nacional de Doenças Mentais, Rio de Janeiro, vol. V, janeiro/julho 1951, p. 12.

23. Nise da Silveira. *O Mundo das Imagens*. Rio de Janeiro: Editora Ática, 1992 , p. 19.

24. Da mesma maneira, no Concretismo paulista enfrenta-se a persistência de um cartesianismo da forma.

25. Na prisão, conheceu o escritor Graciliano Ramos, cuja afiada literatura transita entre o drama social brasileiro e o memorialismo, com suas reflexões sobre o cárcere.

26. Segundo Luiz Carlos Mello, não se pode negar o interesse da Dra. Nise da Silveira pelas idéias de Trotsky, mas há, poucas as evidências, já que ela não era ativista. Em conversa com Paulo Herkenhoff, 5 junho 2006.

27. Mário Pedrosa. *Arte, Necessidade Vital*. Rio de Janeiro: Livrari-Editora da Casa do Estudante do Brasil, 1949, p. 142. Todas as citações seguintes neste parágrafo foram extraídas deste título.

28. Almir Mavignier. Museu de Imagens do Inconsciente. Em *Brasil: Museu de Imagens do Inconsciente*. São Paulo: Câmara Brasileira do Livro, 1994, p. 25.

29. Antonin Artaud. *Oeuvres Complètes*. Vol. XI. Paris: Gallimard, 1974, p. 13.

30. O acervo foi devastado no incêndio de 1978 baixo a direção de Heloisa Lustosa.

31. O melhor catálogo do acervo desta instituição anterior ao incêndio de 1978 é *Patrimônio do MAM*. Rio de Janeiro, agosto de 1966. Sem indicação de autoria.

32. Raramente referida, Zélia Salgado é a pioneira da escultura abstrata no Brasil. Sua exclusão da história se deve ao fato de que 95% de sua produção abstrata tenha se perdido numa exposição que circularia pela Europa. Salgada foi quem orientou Lygia Clark em 1950 a estudar com Isaac Dobrinsky em Paris, conforme entrevista a Paulo Herkenhoff, 16 setembro 2004. Segundo Clark, Dobrinsky foi seu melhor professor de arte.

33. Herbert Read é citado por Mário Pedrosa em 1947 numa sobre arte, abordando a educação, reproduzidos em *Arte, Necessidade Vital*, p. 219.

34. Conforme email de César Oiticica ao autor, 6 junho 2006.

35. Entrevista de Rubem Ludolf a Paulo Herkenhoff, 2004.

36. Mário de Andrade também construiu uma rede de silêncios em torno dos artistas modernistas do Estado de Pernambuco (os irmãos Vicente e Joaquim do Rego Monteiro e, a partir de 1931, de Cícero Dias), conforme Paulo Herkenhoff (curador), *Pernambuco Moderno*. Recife: Instituto Cultural Bandepe, 2006.

37. Mário Pedrosa. A Bienal de cá para lá. Em Aracy Amaral (org.). *Mundo, homem, arte em crise*. São Paulo: Editora Perspectiva, 1975, p. 251.

38. Em entrevista a Ferreira Gullar. *Jornal do Brasil*, Suplemento Dominical, Rio de Janeiro, 24 setembro 1958, p. 3.

39. A propósito, ver Yve-Alain Bois. *Painting as Model*. Cambridge, The MIT Press, 1991.

40. Conforme Roberto Pontual. Do Mundo, a América Latina entre as Geometrias, a Sensível. Em *América Latina Geometria Sensível*. Rio de Janeiro: Edições Jornal do Brasil, 1978, p. 8. Há outras atribuições de invenção do conceito.

41. Ver Charlotte Douglas. The New Russian Art and Italian Futurism. *Art Journal*, The College Art Association of America, XXXIV, spring 1975, p. 238.

42. Joyce Medina. *Cezanne and Modernism—The Poetics of Painting*. Nova York: SUNY, 1995.

43. Ferreira Gullar tratou do tempo em Da Arte Concreta à Arte Neoconcreta. Ver também seu Arte neoconcreta, uma contribuição brasileira. *Revista Crítica de Arte*, Rio de Janeiro, 1, 1962, p. 108. Hélio Oiticica escreveu Cor, tempo e estrutura. *Jornal do Brasil*, Rio de Janeiro, 26 novembro 1960.

44. "Terceiro Mundo" é um termo cunhado em 1952, conforme Eric Hobsbawm. *The Age of Extremes*. Nova York: Vintage Books, 1996, p. 357.

45. Sigmund Freud. *Civilization and its Discontents*. James Strachey (trad.). Nova York: W. W. Norton Company, 1961, p. 61.

46. Assinam o manifesto: Waldemar Cordeiro, Geraldo de Barros, Lothar Charroux, Fejer, Haar, Luiz Sacilotto e Anatol Wladyslaw.

47. Henri Lefèbre. Existentialisme et Marxisme: Réponse à une mise au point. *Action*, 8 juin 1945, p. 8.

48. Ferreira Gullar. Manifesto Neoconcreto. Originalmente publicado no *Jornal do Brasil*, Rio de Janeiro, 22 março 1959.

49. Ferreira Gullar. Teoria do Não-objeto. Originalmente publicado como plaquete do *Jornal do Brasil*, Suplemento Dominical, para a II Exposição Neoconcreta, Rio de Janeiro, 1960.

50. Tarsila do Amaral. Carta à família. Paris, 29 setembro 1923. Conforme Aracy Amaral. *Tarsila: sua obra e seu tempo*. São Paulo: Perspectiva/EDUSP, 1975, p. 96.

51. Pedrosa. O Brasil na IV Bienal. Op. cit. nota 2 supra.

52. Mário Pedrosa. Crise do conhecimento artístico. *Correio da Manhã*, Rio de Janeiro, 31 julho 1966.

53. Oiticica. DE HÉLIO OITICICA PARA BISCOITOS FINOS. Op. cit. nota 8 supra.

54. Mário Pedrosa teve um incansável trabalho de educar o público e as elites através de textos na imprensa. Publica *Panorama da Pintura Moderna* sobre a situação e a história da arte no século XX. Rio de Janeiro: MES, 1952.

55. Pedrosa. Crise do conhecimento artístico. Op. cit. nota 52 supra. O termo "pós-moderno" foi usado por Pedrosa inúmeras vezes nos anos.

56. Gullar. Teoria do Não-Objeto. Op. cit. nota 49 supra.

57. Mário Pedrosa. *Correio da Manhã,* Rio de Janeiro, 18 junho 1967.

58. Ferreira Gullar. *Dimensões da Arte.* Rio de Janeiro: Serviço de Documentação do MEC, 1964, p. 184.

59. Ferreira Gullar. Responsa a Cordeiro. *Jornal do Brasil,* Suplemento Dominical, Rio de Janeiro, 13 agosto 1960.

60. Marcel Merleau-Ponty. *Os Pensadores.* Vol. XLI. Nelson A. Aguilar (trad.). São Paulo: Editora Abril, 1975, pp. 303–316.

61. Gullar. Arte Neoconcreta uma contribuição brasileira. Op. cit. nota 43 supra, p. 108.

62. Oiticica. DE HÉLIO OITICICA PARA BISCOITOS FINOS. Op. cit. nota 8 supra, p. 3.

63. Lygia Clark. Carta a Mondrian. Em *Lygia Clark.* Barcelona: Fondació Antoni Tàpies, 1997, p. 115.

Cuadrados y manchas: la mezcla imposible en París durante la Guerra Fría

Serge Guilbaut

En una conferencia pronunciada durante el año 1944, poco después de la liberación de París, el crítico de arte e historiador suizo Pierre Courthion ofreció una penetrante descripción de lo que, en su opinión, aun constituía el núcleo de la civilización francesa, luego de una larga y complicada explicación emotiva sobre la nueva situación de la posguerra. Incluso a distancia, a través de la versión mecanografiada de la transcripción, se puede oír la voz temblorosa del orador y el paso lento y profundamente conmovedor de la recitación de lo que aun eran, aunque brevemente, vitalidades y dotes francesas:

El don de la transmisión es una característica constante de este pueblo. Los franceses son conscientes de que el hombre—para ser completo y entero—necesita alternativas: el sol y la niebla, el sueño y la realidad; y lejos de querer acaparar todo en un gesto soberbio, los franceses, al contrario, saben cómo acercarse a los demás, para comunicar, para difundir sus ideas a lo largo del universo. Francia es capaz de mantenerse entre la bestia y el ángel en un sutil equilibrio que surge de la confianza y la humildad, del conocimiento y la intuición, del material denso y el vuelo espiritual.[1]

Según Courthion y algunos otros franceses, la vida en Francia por fin estaba recobrando la normalidad. Después de la guerra, en la opinión de la clase dirigente y a nivel tanto cultural como político, Francia estaba creando un sistema social nuevo que incorporaba muchas características del Frente Popular. Esta reorganización política, que rechazaba la explotación humana, fue capaz de conseguir el respeto y la aprobación del Partido Comunista y del Demócrata Cristiano también. Fue precisamente este re-alineamiento que observó Courthion en Francia y particularmente in París, que fomentó en él un entusiasmo fulgurante: "El pueblo francés se anima hoy a sentir una gran esperanza; ¡sí, la grandeza y la realidad de Francia! Lo podemos expresar sin bombos ni platillos, ya que estamos expresando algo serio, seguro e innegable, porque todos los hombres libres sienten en sí mismo un poco de Francia y son mejores por ello".[2] A pesar de la hipérbole, Courthion indudablemente captó lo que se sentía en Francia durante ese período inmediatamente después de la liberación de París. Durante varios meses esta ilusión de transformar el estado burgués corrupto en un paraíso socialista parecía ser alcanzable. Lo cierto es que, después de la liberación y por unos años más, en Francia se hablaba abiertamente de la revolución y de una transformación radical del sistema de gobierno del país. Albert Camus, Jean-Paul Sartre, Maurice Merleau-Ponty, Louis Aragón, y hasta el católico Emmanuel Mounier estaban todos de acuerdo. Pero no duró mucho ese éxtasis de la posguerra. De hecho parecía que, después de las fiestas locas que acompañaron la liberación, el pueblo no sólo amaneció con tremenda resaca sino que se encontraba totalmente asombrado. Asombrado porque, si

bien se había terminado la guerra, la vida ya no era como antes del conflicto, para sorpresa de todos. El mundo había cambiado para siempre y a los franceses les esperaba un período de adaptación muy difícil. La liberación no sólo dejó a Francia con una memoria un tanto borrosa de la historia; también dejó al país con la economía en un estado catastrófico. Sólo pudo superar sus dificultades económicas iniciales gracias la ayuda externa. Sin embargo, a pesar de que estaba al borde del desastre, tal vez Francia podría recuperar parte de su aura simbólica anterior por medio de la resucitación de la hegemonía cultural parisién. La nueva elite promovió una reconstrucción francesa—un renacimiento, como fue denominada—mediante un reencuentro con sus gloriosas manifestaciones estéticas del pasado. Esta reconstrucción, pues, no sólo se lograría con cemento y hormigón, sino que también se alcanzaría a través del imaginario. El "renacimiento" no buscó su inspiración en el pasado griego, ya que los Nazis acababan de aprovecharlo para sus fines nefastos, sino que empezó remontándose a un pasado histórico para luego expresarse a través de las ideas de una vanguardia que había existido antes de la guerra. Esa estrategia de aprovechar y ampliar la visión de aquella vanguardia tuvo como objetivo devolverle a Francia su poder, su nobleza y su visibilidad, así como—lo que es más importante—su carácter universal.

Por lo tanto, durante el período inmediatamente después de la guerra, Francia se vio inmersa en una lucha larga y difícil para conquistar un paraíso perdido. Las relaciones internacionales vivían un momento difícil y el arte y la cultura empezaron a desempeñar un papel importantísimo en la política exterior de Oriente-Occidente durante los primeros años de la Guerra Fría. Luego de haber perdido casi todo durante la guerra y la ocupación alemana, Francia esperaba poder retomar su lugar en el ámbito internacional a través del arte. La gran incógnita—muy difícil de resolver, por cierto—giraba en torno a cuál sería la imagen idónea que convendría usar para lograr su reintegración. Existían grandes divisiones en la esfera política que, a su vez, afectaban violentamente el medio cultural. Los críticos que publicaban sus opiniones en las páginas y los suplementos de comentario artístico de periódicos partidarios de una filosofía u otra, proponían determinadas estrategias estéticas según sus propias creencias políticas.

La idea de la reconstrucción ya se había planteado entre varios grupos clandestinos y focos de resistencia cultural antes de que terminara la guerra. Resulta curioso notar que su primer teórico fue un erudito medievalista, Pierre Francastel. Durante la ocupación, delante de las mismas narices de los fascistas, Francastel ya articulaba una nueva apreciación de la antigua imagen de Francia usando las imágenes rurales de Pétain para contradecirse ellas mismas. Creó una especie de identidad elaborada subversiva que subrayaba la necesidad de regresar a las raíces medievales de Francia—pero el regreso que proponía era muy distinto al que promovían los fascistas. En su libro l'*Humanisme médièvale,* escrito en 1944 pero censurado por los Nazis, Francastel propuso un nuevo tipo de humanismo arraigado en la cultura rural del campo—

la misma cultura que fuera tan preciada por los fascistas franceses. Haciendo caso omiso del estilo gótico urbano e internacional, Francastel planteó que el arte Románico rural había sido la raíz verdadera de la especificad y la identidad francesa y era ésta la base fundamental a partir de la cual Francia podría reconstruir una identidad que se opondría a la versión simplista que proponía Pétain. Haría falta cierta pericia para diferenciar esta cultura Románica activa de la versión pasiva promulgada por Pétain.

En agosto del año 1943, inspirado por sus vivencias durante la guerra, Francastel se puso a escribir un libro sobre la importancia del arte moderno al mismo tiempo que se enteraba de que su obra sobre el humanismo medieval había sido censurada. A partir de las primeras páginas de este nuevo libro, *Nouveau dessin, nouvelle peinture: L'école de Paris* (publicado recién en 1946), es evidente que el autor es un historiador entregado a su trabajo quien se ha dedicado a la lucha antifascista (y por consiguiente, anti-alemán) precisamente donde importa más: en la lectura y la redacción de la historia. El libro entero representó un intento de demostrar que las innovaciones formales y sociales del arte francés durante el siglo XIX culminaban en la obra de un grupo de artistas jóvenes que se formaron durante la ocupación.[3]

Bajo la presión de dicha situación, esta generación aparentemente ha sido capaz de analizar la gran tradición francesa, no sólo de conservar la cultura moderna que se encuentra en peligro de extinción, sino también de continuar con la interrogación de la pintura misma a través de las investigaciones formales. Este estudio afirma las propuestas de Leon Gischia, pintor y teórico del renacimiento Románico, en cuanto a la importancia de distinguir entre la tradición y la academia.[4] Según Gischia, la tradición estaba activa, positiva y progresiva, mientras que la academia estaba muerta e inmóvil. Así, al inspirarse en el Arte Románico y los colores fauvistas, la generación que emergía de la ocupación de hecho estaba reorganizando los paradigmas de la pintura con el fin de reconectarse con lo que, en el pasado, había contribuido a la grandeza del arte francés pero que, durante un período decadente, había caído en el olvido. El texto de Francastel representaba una brillante aunque crítica defensa del arte modernista francés, así como también una reconstrucción incisiva de la identidad parisién acoplada a una tradición francesa específica y recientemente redescubierta: el arte Románico. El Arte Románico ahora podría representar un papel parecido al que desempeñaban el arte africano o el ballet ruso en las tradiciones vanguardistas de períodos anteriores. En este caso, sin embargo, los primitivos no sólo eran convenientemente franceses, sino que contribuyeron además al renacimiento de la identidad y la especificidad de los franceses. La propuesta de Francastel, pues, representaba un primitivismo nacional.[5]

Según Francastel, el estilo románico había influenciado al arte de la nueva generación y había tenido un papel similar al de la antigüedad para los artistas jóvenes del renacimiento. Ahora, sin embargo, el estilo plano y decorativo del diseño medieval reemplazaba la musculatura escultural alemana de Arno Brecker, tan

exagerada e influenciada por la idea griega. De este nuevo arte emanaba un tipo de humanismo que no estaba arraigado en la fuerza bruta y la exageración sino en una belleza delicada y mesurada.

El aspecto brillante del análisis de Francastel resultó ser su habilidad para aprovechar la atracción que sentía el público por todo lo agrario y lo primitivo, por una cierta simpleza que estaba en boga durante el régimen de Vichy, con el fin de re-inscribir a este público en la modernidad e invitar su apoyo a la tradición de arte moderno parisién. De esta manera podía liberar a todos los que habían sido atrapados y seducidos por el mito fascista del arcaísmo y volverlos a incorporar al mundo moderno. Estos artistas modernos, "Les Jeunes Peintres de Tradition Française",[6] habían estado articulando un modernismo flojo, recomendando la tradición y la evolución francesa en lugar de la revolución y la ruptura en su defensa de una idea determinada de la especificidad francesa fundamentada en el concepto del equilibrio entre la razón y la emoción; se habían volcado a un juego ambiguo pero peligroso de sentido y contrasentido en la Francia de aquella época. Después de la guerra, en sus escritos, Francastel logró esclarecer esas obras, otorgándoles a esos jóvenes una posición liberadora que antes no se había podido discernir detrás de tantos mensajes ambiguos. Tal fue su entusiasmo que aplicó su tesis humanista sobre el arte medieval directamente a la pintura moderna de aquellos artistas. En su opinión, la grandeza de estos nuevos pintores derivaba del hecho de que, a pesar de la lealtad que sentían por las técnicas modernas, mantenían vivos los temas tradicionales. Francastel creía que los temas facilitaban la comunicación entre el artista y el público y, en un giro en contra del elitismo, que le permitían al público entablar una relación con el arte moderno a través de un cuento legible: "No pueden haber grandes obras artísticas sin leyendas y sin antropomorfismo. Los hombres nos reconocemos únicamente por medio de nuestras acciones o nuestros sueños. No nos conformamos por mucho tiempo con la filosofía ni con el arte puro".[7] El papel del artista era el de "elevar a las multitudes hasta las cumbres, no inclinarse hacia ellas. Pero también me parece que el artista tiene el deber de ser un intermediario, iba a decir intercesor, entre las masas y la elite",[8] una descripción análoga a su comprensión de lo más grande del arte medieval, pero que a la vez ya anuncia un rechazo problemático de lo que se convertía en elemento esencial en la Francia de la posguerra: el arte abstracto.

Lo que entonces estaba en juego para Francastel era la posibilidad de salvar el modernismo de dos polos opuestos. Por un lado, el tipo de modernismo medieval de Francastel contrastaba con el espantoso estilo campechano del realismo por medio de la experimentación artística continua. Por el otro, evitaba las formas abstractas "no francesas" gracias a su conexión al humanismo. Eran estos los parámetros aceptados del renacimiento francés durante la posguerra: una cultura neo-medieval defendiendo a un individualismo humanístico erudito que eventualmente ayudaría a las masas a alcanzar la grandeza. El problema fundamental era que, así como los tradicionalistas Gaston Dile y Bernard Dorival,

Francastel arraigaba su construcción del arte de vanguardia en unas convicciones nacionalistas muy simplistas pero a la vez muy efectivas. La cultura medieval, alimentada desde el comienzo de la guerra por Vichy, se encontraba al finalizar la guerra tan plenamente infiltrada por las ideas de la resistencia que, a partir de su pesada coraza protectora, brotó una Francia joven y renovada. Esta Francia renovada, sin embargo, estaba profundamente marcada por la tradición. Por fin, a través de las palabras de Francastel, el sapo populista y fascista se había transformado en aparatoso héroe de la vanguardia.

Aunque Francastel había visitado el famoso y controvertido Salon d'Automne de 1944, que consagró a Picasso como el artista de la resistencia moderno por excelencia, su descripción del Salon en la breve conclusión de su libro implica que sólo vio las obras de los jóvenes "medievalistas". Tenía una fe inquebrantable. Según Francastel, el destino dictaba que París inevitablemente retomaría su posición como el centro del mundo: "Los americanos ya visitan este salón, y las galerías, ya visitan los estudios. La pintura francesa está lista para declarar su absoluta supremacía . . . No está agotada la Escuela de París".[9] El nuevo ministro de bellas artes, Joseph Billiet, un simpatizante comunista, reafirmó este optimismo en septiembre del año 1944 al manifestarse de acuerdo con el análisis de Francastel:

Investigaré con toda seriedad el papel que debe desempeñar el arte en el maravilloso renacimiento que promete la Resistencia que acompaña al General De Gaulle. Creo que en esta renovación, así como en la que le siguió el terror del primer milenio, el arte francés puede y debe, tal como lo hizo en el siglo XI, servirnos de guía y de agente unificador frente a las diversas formas de la nueva civilización que está por llegar y, al cumplir con esa función, se convertirá en un símbolo del resplandor de Francia.[10]

Como dijo Bernard Ceysson: "En cada caso uno necesitaba tener la certeza de que una Francia inmutable con valores eternos no había perecido con la derrota".[11] Francastel explicó que París continuaba la tradición moderna con las raíces en el Cubismo, pero su versión del Cubismo era la de Braques (el jefe) en lugar de la de Picasso (el obrero).[12] Mientras Francastel admiraba la obra de sus pintores medievales/ modernos, Picasso montaba, al lado, una retrospectiva de lo que había sido su producción durante los años de la ocupación. Esta galería se convirtió en el foco de la controversia en torno a la vuelta a París del arte modernista, así como al hecho de que Picasso recién se había afiliado al Partido Comunista y había sido nombrado director del comité para la "Purificación" [*Epuration*] de artistas colaboracionistas: ¡un modernista comunista! No cabe duda de que la inauguración de la nueva era de la posguerra fue acompañada de una palpable confusión. Lo que sí hubiera inquietado seriamente el planteamiento medieval/moderno de Francastel hubiera sido la *Bacchanal* de Picasso, pintada bajo la influencia eufórica de la liberación: un nuevo y violento *joie de vivre* dionisiaco que volvía a inyectar la fuerza y la violencia que Poussin, en su obra clásica y muy "francesa", *Triunfo de Pan* de 1638,

había controlado estupendamente por medio de la razón. A leguas del mundo medieval de los últimos tiempos, el placer y el júbilo de Picasso explotaron, liberando la atmósfera clásica de Poussin con su exuberancia y alegría, su paganismo y sexualidad, pregonando el retorno enérgico de lo mediterráneo, de los mitos griegos, de la música y la danza, todos entrelazados en una misma celebración de la libertad recién recobrada. Al restablecer la alegría de la expresión exuberante de los mitos griegos e insistir en el tono campechano de los bailes del folclore rural, Picasso pudo borrar tantos años de monumentales desnudos fascistas e imágenes religiosas medievales, tan tristes y mesuradas. Su regreso a la tierra no fue ni lamentable ni encantador, sino explosivo y carnal. El impulso dionisiaco erótico hizo polvo la doctrina de la iglesia: la lujuria, el frenesí y los torbellinos de agitación arrasaron con el sufrimiento y la redención y los discursos sobre la calma. En su descripción de aquel famoso Salon d'Automne, Francastel no menciona nunca a Picasso porque el artista español no encaja con su idea. Durante la posguerra brotaban posturas nuevas, más frescas y relevantes, que arrollaban el modelo forjado por Francastel durante el período de la ocupación.

La retrospectiva en el Salon confirmaba indudablemente que Francia, emergiendo de la resistencia y encabezada por el partido comunista, quería distanciarse del régimen Vichy y renovar sus valores progresivos. En cambio parecía que Francastel y el medio cultural establecido proponían una especia de "gran salto atrás" con el propósito de reconectar con el pasado brillante y así borrar la memoria de cuatro sombríos y espantosos años de ocupación y colaboración. Este ocultamiento terapéutico, sin embargo, no fue capaz de enfrentarse a las enormes transformaciones ideológicas y emocionales que se habían producido en el ámbito internacional durante el período de la posguerra. Los líderes de la esfera cultural y artística de Francia seguían librando una antigua guerra: querían salvar los avances logrados por la resistencia sin darse cuenta que el mundo había cambiado y que ahora, en la época de la Guerra Fría, los objetivos ya eran muy distintos. Seguían inmersos en una guerra nacional cuando las batallas ahora se libraban a nivel internacional. Según la elite francesa, que le daba la razón a Francastel, la única esperanza residía en la Escuela de París (que propugnaba aquellas cualidades cartesianas de claridad, encanto y organización). Gaston Diehl y Bernard Dorival, por ejemplo, en una edición especial de la revista *Confluencias,* defendieron un tipo de pintura tradicional que representaba los valores de una Francia imaginaria, cartesiana y clásica, capaz de elidir los cambios fundamentales causados por la guerra:

Deliberada, reservada, de sensibilidad intelectual, lógica y razonable, nuestra pintura francesa moderna parece continuar, o sea prolongar la de nuestro pasado. Como aquella, se merece la denominación de clásica. ¿Qué significa eso? Significa que un arte que se merece esta denominación tiene un atractivo universal, y un valor universal sólo puede emanar de un contenido intelectual y racional. . . . Siempre ha sido el propósito del arte

francés prestarles a todos los movimientos, incluso los más barrocos, sus modalidades clásicas y universales.[13]

Si bien se podría entender la necesidad de crear un arte como el que producían los pintores jóvenes de la tradición francesa bajo la ocupación, así como la publicación, bajo la misma presión, de textos nacionalistas por parte de los historiadores de arte, resulta sorprendente el hecho de que, al haberse acabado la guerra, estos arquitectos culturales aun mantenían su fe absoluta en sus propias construcciones caricaturales y en el idioma propagandista y nacionalista que empleaban durante la guerra para luchar contra las fuerzas de la ocupación. Su ceguera frente a las demás tendencias, posibilidades y actividades después de la guerra es asombrosa. Los críticos como Francastel, Dorival y Diehl buscaban un arte de realidad moderna que ampliaba las lecciones del Cubismo y el Fauvismo en una combinación equilibrada de razón y emoción. Según la idea que se manejaba en aquel entonces, si Francia tenía dos genios universales y complementarios—Picasso y Matisse—¿no sería maravilloso si la nueva generación pudiese unir sus fuerzas en un solo gesto? Fue esta imagen utópica del futuro artístico de Francia que la elite buscaba y pensó que había encontrado en artistas como André Marchand, Leon Gischia, Maurice Estève y Eduard Pignon. A fin de cuentas, el resultado de estas manipulaciones de genes estéticos no fue la creación de una serie de gigantes, sino de una serie de híbridos divertidos que, si bien eran pintorescos, estaban deformados. Estos artistas fueron enviados al exterior a partir del año 1946, en lo que resultó ser uno de los errores más trágicos cometidos en el ámbito cultural durante el período de la posguerra.[14]

Es fascinante, pues, notar que durante ese mismo año—1946—mientras el célebre historiador de arte Francastel defendía los "Jeunes Peintres de Tradition Française" de los ataques lanzados desde círculos académicos antimodernistas, algunos intelectuales vinculados al movimiento surrealista anunciaron que no encontraban absolutamente ningún valor en las recetas estéticas desfasadas de estos artistas. A su manera de ver, esta pintura moderna "tradicional" no se diferenciaba de la de los académicos. En unas pocas, pero bien seleccionadas palabras, los surrealistas lograron remitir a los jóvenes prodigios de Francastel a la remota oscuridad de un lejano pasado. El futuro, anunciaron los surrealistas, debería iniciarse lidiando con los problemas de hoy y no reciclando las soluciones de antaño. A medida que términos como 'lo nuevo', 'lo moderno' y 'el humanismo' se fueron convirtiendo en palabras clave que definían la cultura de la posguerra, las voces que representaban una gran variedad de posturas artísticas pudieron aprovecharlas para defender enfoques estéticos muy distintos, impulsando así un debate abierto y valioso pero a la vez bastante confuso.

El crítico de arte Charles Estienne, por ejemplo, podía ver que todas estas construcciones eran poco sólidas y muy vulnerables. Como buen marinero, describió el fenómeno por medio de una metáfora correspondiente: "Nos guste o no,

la figuración está tullida. En cuanto a todo eso, a todos estos temas antiguos—como dicen los marineros viejos cuando hablan de los barcos viejos—es la pintura que los mantiene en pie. Ya no tienen futuro".[15]

El crítico de arte Edouard Jaguer, en busca de una nueva forma de arte comprometido, pudo articular otra postura en un artículo importante titulado "Les Chemins de l'Abstraction", publicado en *Juin*, un periódico socialista, en el año 1946. Este escrito, de gran importancia a pesar de ser tan poco conocido, remitió las creaciones artísticas nacionalistas de Dorival, Francastel y Diehl inmediatamente al limbo. El artículo no miró hacia atrás, como había hecho Francastel al forjar una conexión con el arte Románico. Al contrario, alzó la mirada hacia el futuro, en busca de un nuevo arte con sabor internacional, en armonía con la tradición surrealista. Lo que buscaba Jaguer era un idioma internacional capaz de reflejar la nueva época abstracta y el nuevo mundo post-atómico. La contribución decisiva de Jaguer fue definir, en su artículo y con bastante exactitud, precisamente la discusión que sostenían los artistas jóvenes de aquellos tiempos: es decir, cómo y qué iban a pintar después del autoritarismo, después del holocausto, y después de Hiroshima y Nagasaki.

Fue, pues, en el año 1946 que Jaguer ya pedía una nueva abstracción—una que tuviera que ver con el mundo apocalíptico, una abstracción basada en el automatismo como la de Hans Hartung, cuya obra fue colocada simbólicamente, en el mencionado artículo, entre la de Mondrian y la de Kandinsky de su etapa temprana. Jaguer ofreció una descripción teórica, con un sabor indudablemente surrealista, del tipo de abstracción que dominaría a París dentro de algunos años, después de una larga y enrevesada batalla.

Varias corrientes artísticas que luchaban por hacerse visibles le hicieron frente a la potente presencia del arte que mantenía una afiliación a la antigua Escuela de París. 1946 fue un año decisivo en ese combate librado en las trincheras culturales de Francia. En la opinión de muchos, era de importancia primordial recuperar la fuerza moderna de la abstracción. Denise René abrió las puertas de su galería a este estilo progresivo (un arte de relevancia social según se proponía en los años treinta) en oposición directa a los "Jeunes Peintres de Traditions Françaises" que seguían cubriendo la figuración completamente con dibujos abstractos, en muchos casos empapando sus palabras con dejes espirituales, así como en la obra de Bazaine y Manessier. Los círculos más avanzados no siempre aprobaban este acuerdo estético: como dijo de manera burlona el crítico Leon Degand, "La figuración fue su esposa y la abstracción su amante". La duplicidad y la corrupción insinuadas en este comentario representan precisamente las cualidades rechazadas por los críticos en aquella época de la posguerra. La pureza y la autenticidad, en cambio, eran las características idóneas en el debate estético y político. Y fue por eso que al poco tiempo, hasta en los círculos más abstractos, se produjo una ruptura entre los que, como Auguste Herbin, exigían una adhesión absoluta a la geometría abstracta, y los que pensaban que era importante aceptar cierto

lirismo. Según argumentaban éstos, el lirismo reflejaría la recién descubierta importancia de la persona, cuyo valor se iba erosionando bajo el control autoritario de los regimenes comunistas y fascistas, así como frente a la incipiente cultura consumista. Si bien las exposiciones de arte abstracto presentadas en la Galerie Denise René abarcaban una amplia gama de expresiones abstractas (de las obras de Jean Dewasne, Jean Deyrolle y Marie Raymond a las de Hans Hartung y Gérard Schneider),[16] al poco tiempo resultaba imposible mantener tal eclecticismo liberal; las diferencias entre una abstracción que significaba un expresionismo individual y otra que expresaba una realidad ideal, construida racionalmente con el fin de proponer un espacio social común utópico coherente, cobraban un significado ineludiblemente político. El público ahora se encontraba frente a una situación radical y antitética en la que debía escoger entre unas expresiones egocéntricas por un lado y, por el otro, una utopía construida con una orientación social. El nuevo Salon des Réalités Nouvelles reflejaba este dilema. Cuando abrió sus puertas en el año 1946 permitió la exposición de una multitud de experimentos abstractos. Pero muy pronto se transformó en un escenario dedicado a la presentación de un Arte Concreto geométrico radical y algo autoritario que, bajo la dirección de August Herbin, excluía el uso de las formas curvilíneas en expresiones geométricas. Esta vigilancia tan intensa provocó la desilusión de muchos artistas jóvenes que temían precisamente un academismo sigiloso que eventualmente se manifestó en el año 1950 cuando Edgard Pillet y Jean Dewasne inauguraron una academia de arte abstracto, que fue denunciado violentamente por Charles Estienne en su folleto, *L'Art Abstrait est-il Académique?*

Rechazando la idea de que el atelier ofrecía una educación formal, Estienne denunció el efecto opresivo de lo que en su opinión era un énfasis en la técnica en lugar de en la poética de la pintura. Proponía una exploración de la vida interior, no la decoración feliz, como la base de un arte que reflejara el mundo contemporáneo. Estienne empleó la geometría impersonal y pura como código para representar a la antigua ilusión de la coherencia cultural. Citando extensamente a Kandinsky, atacó a los que querían codificar los sentimientos personales para convertirlos en elementos universales. El folleto provocó una reacción dramática en el mundo parisién del arte abstracto, sugiriendo nuevos caminos hacia la apreciación de las tendencias individuales y expresionistas que recién se ponían de moda. También amplió las posibilidades del salón, abriéndolo a muchas otras formas. Fue en este momento que varios artistas latinoamericanos, como Jesús Rafael Soto quien llegó a París en 1951, entraron en contacto con el salón, aprovechando la oportunidad para presentar su producción al público parisién, y abriéndoles el paso a otros artistas. Lygia Clark, por ejemplo, estudió con Fernand Léger de 1948 a 1950; Martha Boto estuvo en París de 1951 a 1955. Muchos de ellos participaron en la famosa e importante exposición montada en la Galerie Denise René titulada *Le Mouvement*, en la que Julio Le Parc y Soto presentaron sus obras

experimentales que impresionaron a Carlos Cruz-Diez, quien estaba de visita.

La nueva Guerra Fría: París en 1948

1948 fue un año de gran importancia en esferas políticas y culturales; para esa fecha ya era evidente que la producción artística, la pintura, el cine y la literatura indudablemente estaban envueltos en una lucha ideológica a gran escala. Cualquier acción o palabra alcanzaban para lanzar al autor a la polémica de la Guerra Fría; ya no quedaban ni remansos ni refugios apolíticos. En el ámbito de la pintura, los críticos se enfocaron en el realismo, que fue presentado sin cesar por la importante y muy visible prensa comunista. El cuadro de Fougeron, *Les Femmes au Marché,* se convirtió en una especie de foco alrededor del cual los artistas y los críticos se podían situar. Las teorías sobre el arte giraban en torno al concepto del público del artista, elemento central de la vida artística parisién. De la abstracción geométrica al Tachisme al Surrealismo, lo que fundamentalmente se discutía era, por un lado, la responsabilidad del artista de cara a su público y, por el otro, la protección de la creatividad individual de la interferencia política.

Cuando se vinieron abajo las alianzas insostenibles que se habían forjado durante la resistencia bajo la presión de la Guerra Fría, los artistas se vieron obligados a adoptar unas posturas muy bien definidas y, en este nuevo terreno que cambiaba constantemente, tomar unas decisiones estéticas y políticas muy difíciles. En julio de 1948, Jaguer y Michel Tapié organizaron una gran exposición grupal en la Galerie des Deux Iles, donde se presentaron muchos intérpretes de la nueva abstracción (Jean Arp, Camille Bryen, Jean Fautrier, Hans Hartung, Georges Mathieu, Francis Picabia, Michel Tapié, Raoul Ubac y Wols). El texto/manifiesto impreso en la invitación, que obviamente estaba dirigido al realismo social del Partido Comunista, se anticipó a futuros eventos. En la invitación, Tapié puso en duda la palabra clave "realidad" por medio de una estrategia surrealista bastante tradicional; en otro texto, breve y astuto, Jaguer les exhortó a los pintores a tomar en cuenta la nueva subjetividad de la posguerra:

Uno no puede vivir con el corazón abierto en casas antiguas. Y las rebanadas descomunales de las formas escogidas y del ... rectángulo no tienen nada que ver con un mundo volteado por la expresividad. Para los artistas aquí reunidos lo que está en juego es la conquista de un sitio subconsciente pero real, y no la satisfacción burlona de haber desempeñado una tarea plástica.

Ese puñetazo al arte geométrico o constructivista sirvió para anunciar una nueva vida para una abstracción conectada con Dada y el Surrealismo, o al menos con la subjetividad—la nueva palabra clave cultural de la época de la posguerra.

Lo cierto es que, en la opinión de muchos artistas en París, la belleza y los impulsos decorativos eran elementos residuales de otra época anterior, de un período cuando el artista sentía que vivía en armonía con el mundo, o al menos se creía capaz de organizar y dominar la naturaleza con el fin de representarla y reorganizarla en

términos plásticos. Pero debido a la ruptura política que se produjo en el Occidente en 1947–1948, y debido al temor cada vez mayor de una tercera guerra mundial que, como recalcaban constantemente los periódicos y las revistas de la época, sería un conflicto nuclear, muchos artistas se dieron cuenta repentinamente que ya no era factible una Frente Unida de ningún tipo. Por lo general, las líneas estéticas se trazaron según las líneas de demarcación política (el Realismo Social, el realismo burgués [que abarcaba tanto la versión optimista como la pesimista a la Buffet], la abstracción geométrica utópica y optimista, y la abstracción informal individualista y deprimida). Todos estos estilos parecían estar en negociaciones, tratando de colocarse para representar, es decir para ser la voz de Francia en el período de la posguerra.

En medio de esta barahúnda interminable de debates y erupciones violentas, a veces resultaba bastante difícil definir las posturas ideológicas de los mismos pintores. En la opinión de muchos artistas, el propio lenguaje de la pintura era una trampa; creían que el pintor no podía representar nada sin al mismo tiempo reproducir algún aspecto de las prisiones que desesperadamente quería eludir. Muchos artistas descubrieron que la posibilidad de hablar sin decir nada en definitiva, con el fin de evitar la autoridad de la expresión verbal, resultaba ser un proyecto que valía la pena en París en los años cincuenta. De hecho fue precisamente porque sabían tanto, tal vez demasiado, que debían hacer y decir tan poco, que debían desconectarse, dejando únicamente los rastros—algunos suntuosos, otros patéticos—de su lucha cotidiana.

Esta era la difícil situación de algunos de los artistas, como Wols y Bram Van Velde, que aun no habían sido reconocidos. Frente a esta sensación de indiferencia impotente pero alimentada por sus principios, algunos artistas sólo querían retirarse del campo de batalla y permitir que el mundo los dejara atrás, pero no sin antes soltar un grito adolorido para que no pasara desapercibida su categórica decisión de no participar. Wols y Bram Van Velde se negaron deliberadamente a responder de manera activa o directa al debate de la posguerra, pero estaban perfectamente conscientes de su existencia.

En cambio, decidieron desmantelar las estructuras de la propia pintura: la definición del estilo, la idea de la representación, e incluso la idea de lo que constituía la pintura o el arte. Esto no significa que pintores como Jean Dubuffet o Pierre Soulages no indagaban en estos asuntos; es que lo hacían de manera menos trágica, impulsados por un espíritu más analítico e irónico. No siempre era fácil ser artista o crítico responsables en aquella época. Por ejemplo, en el año 1947 Léon Degand aun escribía sobre la abstracción geométrica y la defendía en el periódico cultural comunista *Les Lettres Françaises* cuando el Partido Comunista Francés, en una contradicción estética, se volcó a promover el realismo por motivos netamente políticos.

Degand empezó a buscar otra alternativa a su carrera de periodista, que se encontraba constantemente en peligro debido a su gran interés en la abstracción, estilo que el Partido Comunista consideraba un nefasto complot para destruir la moral de la clase obrera. Fue en ese preciso momento que conoció a Francisco Matarazzo, un próspero negociante brasileño. Matarazzo buscaba un director para un nuevo museo de arte abstracto que quería montar en São Paulo con el fin de demostrar que tanto él como Brasil se estaban modernizando a gran velocidad y que en su país se encontraba en pleno desarrollo una sociedad urbana sofisticada que se merecía la atención de las naciones industrializadas encargadas de reorganizar al Occidente. Según Matarazzo, el arte abstracto simbolizaba estas ideas y representaba el progreso logrado en Brasil durante el período de la posguerra. La abstracción, en su forma pura, se convirtió en símbolo de la creatividad individual, de una entidad única, separada y moderna, libre de toda referencia a lo cotidiano; era la expresión filosófica de un mundo moderno, urbano y racional. Degand encajó bien en el programa de Matarazzo, ya que había defendido el arte abstracto en Europa desde el final de la guerra. A su forma de ver, la abstracción era una creación en lugar de una representación, un espacio libre para la expresión independiente de la creatividad y la experimentación individual. La visión que tenía Degand de la abstracción era paralela a la imagen pública del desarrollo económico en el Brasil. Lo cierto es que, luego de una breve etapa de democratización a partir del año 1945, el país estaba centralizando un gobierno muy controlado, impulsado por una fuerte economía libre. Así como el nuevo idioma abstracto del arte moderno deslumbró a Matarazzo, el movimiento urbano brasileño hacia la modernidad deslumbró a Degand. Parecía que el destino había juntado a estos dos hombres, aunque Degand nunca alcanzó entender las complicadas implicaciones simbólicas, políticas y geográficamente específicas relacionadas con la modernidad brasileña. Pero estaba decidido mostrarle a los franceses qué podía lograr en esta tierra virgen y fecunda: se propuso injertar en este nuevo mundo una malinterpretada idea europea y observarla florecer. Pensó que podría ser una manera liberadora de escaparse de las arenas movedizas de la vida intelectual conservadora de Francia. De hecho que, en París, Degand se había visto envuelto en una importante pero deprimente batalla. Se encontraba encarado con una ofensiva comunista bien organizada contra la abstracción y una promoción cada vez más generalizada del arte de Realismo Social, así como con la fuerza de la renovada, a veces abstracta Escuela de París promovida por Michel Ragon y Charles Estienne. En el Primer Congreso de Críticos de Arte Internacionales, al que asistió Degand unas semanas antes de partir hacia el Brasil en el año 1948, tuvo que escuchar varias ponencias que encomiaban la grandeza de la cultura parisién, pero que empleaban discursos generados con el fin de centralizar el consenso en torno a la antigua Escuela de París. Según estos discursos, el arte—y en particular el que se producía en París—era o debía ser naturalmente antinacionalista, internacional e, incluso en la opinión de Jean Cassou, universal. Cassou, que recién había sido nombrado director del reinaugurado Museo de Arte Moderno en París, le comentó con toda confianza a un público de críticos de arte que, "el arte es un idioma universal y . . . desde el siglo XIX el arte francés

ha sido universal. Representa una extraordinaria aventura espiritual que requiere la participación de todos los países. El arte francés siempre ha sido la encarnación del humanismo. . . ".[17] Frente a esa línea de defensa parisién tan tradicional, Degand abandonó París lleno de esperanza, pero la experiencia que le esperaba en São Paulo a la larga lo dejó desilusionado. Evidentemente, el mundo no estaba preparado para el tipo de abstracción que proponía Degand, a pesar de haber podido exhibir arte abstracto francés en Brasil y Argentina antes de regresar a su tierra.[18]

Después de haber regresado a París, Degand aun tuvo que luchar contra la definición imperante de las cualidades específicas de la pintura parisién según lo estipulado a partir del año 1946 en una serie de libros escritos por Bernard Dorival y Pierre Francastel. Ambos consideraban al arte francés como algo cartesiano, con estilo, delicadeza y una belleza razonable, y dotado de reconstrucciones profundamente arraigados en convicciones nacionalistas; en otras palabras, todo lo opuesto a lo que debía ser el arte alemán: expresionista. Según esta ideología, el hombre es parte de la naturaleza pero sin el efecto desestabilizador del instinto: en el hombre, la naturaleza se confunde con la razón porque el carácter del hombre no es más que el instinto controlado por la razón. De esa manera Dorival pudo descartar a Mondrian y Kandinsky, prefiriendo la elegante reserva de Leger y Modigliani. Fue esta, en gran medida, la razón por la cual Léon Degand pensó que la obra de Mondrian y Kandinsky era esencial para su proyecto y por qué además le encantaba tanto la obra de su amigo, el pintor Alberto Magnelli que, al introducir la fantasía y elementos formales emocionales, relajan considerablemente la pura pauta geométrica. Por un lado, pues, Degand odiaba la línea realista no sofisticada—incluso escribió en contra de la muestra en París del pintor brasileño Cândido Portinari, lo cual enfureció a André Fougeron, el pintor de Realismo Social del Partido Comunista Francés—y defendía la abstracción total, que consideraba la producción cultural más avanzada de su época. Pero, y este es un punto importante, ésta era una abstracción que no dependía totalmente de la definición estrictamente geométrica del grupo Cercle et Carré,[19] sino una abstracción abierta a las emociones, a la intuición, a una *peinture* afín a la música. Según Degand, había que contar con una simpleza tanto de la mente como del corazón para entender la pintura abstracta, para poder acceder al nuevo lenguaje sin ideas preconcebidas, sin querer automáticamente entrever en el texto la naturaleza. Fue por todo eso que, como se mencionó antes, Brasil le podía ofrecer la oportunidad de volver a empezar. En la búsqueda de un nuevo idioma para representar la época moderna, Degand pensó que la obra de Alberto Magnelli personificaba a la pintura moderna. A Magnelli, por ejemplo, le gustaba explicarle a Degand que la mancha, elemento central de la obra de Schneider y Deyrolle, era demasiado romántica. "Lo que necesitamos", decía Magnelli, "es una forma clásica como la pintura abstracta". Magnelli empleaba formas puras, sin exuberancia pero con humor, con aceite pero sin los horrendos derrames. Magnelli pensaba que Degand hablaba por

sí mismo, sin recurrir a ninguna propaganda visual. Este tipo de abstracción, clásica pero intuitiva sin ser salvaje, era el arte del "presente" porque generaba optimismo sin ser esclavo a la geometría.

En el año 1948 se otorgó el galardón Prix de la Critique a Bernard Lorjou y Bernard Buffet, dos pintores que Degand consideraba pésimos. Si bien los jueces escogieron a los pintores realistas para contrarrestar el éxito controvertido de André Fougeron, el pintor de Realismo Social, en el Salon d'Automne, la decisión sirvió para convencerle a Degand que la pintura moderna francesa por fin se había estrellado en el abismo. Para el año 1947 parecía que toda la vitalidad que había prometido la liberación se había estancado en un cenagal francés y que los sueños luminosos de una rápida modernización del país se estaban apagando. Y, para mayor deterioro de la situación, Jean Cassou inauguró el Museo de Arte Moderno en el año 1947 sin presentar ni Surrealismo ni abstracción, ni Expresionismo de ningún tipo.[20]

Para el año 1950, el entorno artístico se había polarizado. Degand escribía para la nueva revista *Art D'Aujourd'hui* y defendía la geometría y el formalismo; Charles Estienne se desplazó hacia una nueva abstracción que veía expresarse a partir del Surrealismo automático; y Michel Tapié, influenciado por Dada, prefirió apoyar lo que él llamaba Art Autre, una combinación de varios tipos de producción artística que no parecían encajar en ninguna de las categorías establecidas. Esta cobertura intensa hacía caso omiso de artistas como Wols y Bram Van Velde, quienes realmente no podían, dentro de su estilo deconstructivo, responder a la necesidad que sentía el medio artístico por la reconstrucción y la evolución. Sus comentarios, verdaderamente extraordinarios en cuanto a la situación catastrófica de la persona individual en la época de la posguerra, simplemente pasaron desapercibidos a pesar de los esfuerzos de George Duthuit y Jean Paul Sartre.

El año abstracto: La victoria en 1953

Sin duda se podría decir que para el año 1953 la abstracción había conseguido una gran victoria en París. Se publicaron varios libros que abarcaban el tema y muchas galerías exponían las obras a pesar de una demanda irregular entre sus clientes. Como siempre ocurre, la victoria simbólica se anticipó al triunfo en el mercado. El mercado hasta se encontraba dividido en torno a distintos tipos de abstracción, y cada galería se especializaba y promovía un estilo específico; Denise René, por ejemplo, promovía la abstracción geométrica; la Galería Drouin y el Estudio Facchetti, en cambio, preferían lo que Michel Tapié llamaba Art Autre. Tal vez de mayor importancia, la Galería Arnaud, una pequeña librería/galería, se dedicaba exclusivamente al lirismo y publicaba su propia revista artística, *Cimaise*, para promover este estilo. Ahora el lirismo, o el Art Autre, representaba la cultura parisién más avanzada. En 1953 el mismo André Breton, luego de muchos años de haberse resistido, ayudó a montar una galería Surrealista llamada L'étoile Scellée, donde presentó la obra abstracta de Marcelle Loubchansky y Jean Degottex, entre otros artistas. Si bien Estienne y Tapié tenían

gustos eclécticos, ambos desconfiaban de la abstracción geométrica y su mensaje social utópico. Así como muchos artistas, buscaban un arte capaz de representar el renovado interés por el individualismo como alternativa a la seguridad autoritaria de las certezas. Como parte de su deseo de dividir entre ellos el mercado en vías de desarrollo, crearon nuevas etiquetas artísticas. Tapié veía una versión unida y consolidada de Art Autre como la base de una nueva Escuela de París que abarcaría a varios artistas, tanto franceses como norteamericanos, bajo la filosofía de una expresión libre y diversa en un ambiente parisién que se había vuelto a despertar. Estienne también tenía un objetivo, el de definir una estética nacional,[21] pero le interesaba la producción de un arte vinculado a la tradición francesa de pintura distinta a la que le interesaba a Tapié. Tapié quería borrar completamente el pasado; promovía la inmersión orgiástica del artista en el presente y la liberación total del individuo. Estienne empleaba conceptos surrealistas con el fin de recuperar una revolución humana básica que había pasado al olvido. Según él, este era "el único camino entre el 'mesianismo político' del Partido Comunista y el pesimismo del filósofo de lo absurdo".

Para el año 1952, en una muestra presentada en una de las galerías que él mismo dirigía, Estienne pudo declarar que brotaba una nueva Escuela de París totalmente independiente de los viejos clichés parisienes. La importancia de esta declaración consistía en que Estienne sentía la confianza necesaria para afirmar que París aun era París, que había sido capaz de regenerarse y que una vanguardia determinada por fin se había adelantado a las facciones competitivas para dominar el mundo artístico francés. Así como Tapié, quien quería demostrar que París todavía determinaba el futuro de la cultura de Occidente (en fin, artistas como Matisse y Dufy aun ganaban premios en la Bienal de Venecia), Estienne anunció la victoria definitiva de su nueva abstracción sobre las fuerzas reaccionarias de todo tipo de realismo y geometría cartesiana.

Para ilustrar este punto Robert Lebel, en el año 1953, publicó un libro titulado *Bilan de l'art Actuel* en el que el autor investigó y comparó el arte producido en todo el Occidente. El libro afirmaba que, luego de hacer esta investigación internacional, Lebel había perdido toda esperanza de descubrir las obras "mágicas", heréticas y diferentes que buscaba; es que había descubierto que esas obras habían sido incorporadas a los mundos "seguros" de museos e interiores burgueses.[22] La magia, la sorpresa, la irreverencia: todos habían desaparecido para perderse en la banalidad de lo cotidiano. A pesar de esa conclusión, lo que sí afirmaba la investigación era que la abstracción estaba en todas partes, aunque la victoria le había quitado algo de su calidad agresiva: "Los artistas de hoy son, en relación a sus predecesores anteriores a la guerra, lo que una lluvia de paracaidistas representa para Ícaro".[23] El gran número de buenos artistas abstractos en París indicaba que la capital francesa mantenía su importancia, pero se podía apreciar una duda persistente a finales del ensayo de Lebel: la "apparition du continent Américain" (aparición del continente americano) e incluso la influencia de "l'Ecole du Pacifique" (la Escuela del Pacífico: Mark Tobey, Kenneth Callahan y Morris Graves), más o menos inventada para el consumo francés para contrarrestar la creciente influencia de la Escuela de Nueva York, parecía ser un homenaje a París pero al mismo tiempo reflejaba, en la opinión de algunos, una cierta amenaza norteamericana.

Si bien Tapié, Estienne y Lebel proclamaban el triunfo de una nueva vanguardia abstracta sobre las fuerzas de la tradición, creyendo en la renovada supremacía de París, y si bien estaban preparados para cosechar las riquezas que aportaría este éxito, la angustia invadía sus escritos. En un artículo publicado en la revista católica liberal *Esprit* en el año 1953, Camille Bourniquel planteó sin rodeos la pregunta que a todos les interesaba: "La Succession de Paris est-elle ouverte?" Tomando precauciones contra los peligros de la arrogancia cultural, Bourniquel demostró una astuta comprensión del funcionamiento de la cultural internacional. En su análisis de la importancia simbólica de la cultura de vanguardia en relación al reconocimiento en la esfera internacional, decidió en conclusión que no existía en el mundo ningún centro cultural que tuviera la misma importancia que tenía París. Al opinar de esa manera, no pudo evitar criticarle a Norteamérica y su "proteccionismo cultural", menospreciando lo que percibía como la desconfianza norteamericana en torno a la producción artística francesa. Pero lo que sí reconoció fue que la percepción tradicional de la cultura francesa en Estados Unidos como *la* cultura universal—es decir, en sus propias palabras "un hecho de la civilización"—se estaba evaporando. De hecho, la cultura francesa, ya sea la que describía Francastel, o la que había fotografiado Paul Strand para *La France de Profil,* ese país rural y terco, la estaba reemplazando una sociedad consumista americanizada y generalizada que floreció incólume después de la represión comunista en Hungría en noviembre del año 1956. Francia, desde luego, ya no era como antes, como mostró Jean Pierre Mocky en su película *Les Drageurs* en 1958. Los jóvenes ya no cantaban "Odio los domingos" como lo hacía Juliette Gréco, sino que ahora preferían leer *Bonjour Tristesse,* de Françoise Sagan, y ver la película *Et Dieu Créa la Femme* de Roger Vadim. Las cálidas y deliciosas curvas de Brigitte Bardot reemplazaban el humor negro de Juliette Gréco justo en el momento cuando llegaban, repletos, los primeros supermercados. El propio Roland Barthes, escribiendo sus *Mitologías,* transmitió un mensaje muy claro cuando dijo que una cultura masiva de la pequeña burguesía estaba sustituyendo a la profunda cultura popular. Un mundo desaparecía. 1955 también fue el año del movimiento, cuando Denise René abrió las puertas de su espacio de exposiciones a *Le Mouvement* (con Agam, Bury, Calder, Duchamp, Jacobsen, Soto, Tinguely y Vasarely), una muestra en la que el humor y la diversión por fin lograron penetrar la vieja abstracción geométrica. París estaba lista para este nuevo arte experimental y participativo. Los artistas latinoamericanos llegaron justo a tiempo para ayudarles a los franceses, sombríos en esa época de la posguerra, a darse cuenta que la vida podía ser divertida, incluso si se estaban tragando otro cliché

"orientalista". Pero ese es otro cuento, largo y enredado, que se dejará para otro día.

Traducción de Tony Beckwith

Notas

1. Pierre Courthion, Conférence 1944, "Réalité de la France", Courthion's Papers, Archivos Getty 89 0007-17, Los Angeles, California.

2. Courthion.

3. Manifestó un entusiasmo muy particular por una muestra de pintores jóvenes en la Galerie de France titulada *Douze Peintres d'Aujourd'hui*, en la que se exhibieron las obras de Jean Bazaine, Jean Estève, André Fougeron, Léon Gischia, Charles Lapicque, Jean Le Moal, Alfred Manessier, Edouard Pignon, Gustave Singier, Jacques Villon y Louis Chauvin.

4. Tal vez sería importante repetir aquí que, en lugar de una continuación, algunos intelectuales aun recomendaban una *ruptura* modernista; Breton en Nueva York, por ejemplo, y Michel Tapié en la revista clandestina *La main a plume*.

5. Para conocer las fuentes a las que acudieron los artistas franceses para redescubrir la Edad Media, véase Laurence Bertrand Dorleac, *Histoire de l'art Paris, 1940-1944* (Paris: Publications de la Sorbonne, 1986), 182-90.

6. Jean Bazaine, André Beaudin, Maurice Estève, André Fougeron, Léon Gischia, Charles Lapicque, Lucien Lautrec, Jean Le Moal, Alfred Manessier, Edouard Pignon, Gabriel Robin y Gustave Singier.

7. Dorleac, 174.

8. Dorleac, 173.

9. Pierre Francastel, *Nouveau dessin, nouvelle peinture: L'école de Paris* (Paris: Librairie de Médicis, 1946), 178.

10. Joseph Billiet, "La culture artistique dans la renaissance de la France", *Les lettres françaises,* Septiembre 23, 1944: 1.

11. Bernard Ceysson, *L'art en Europe, les années décisives 1945-1953* (Paris: Musée d'art moderne de St Etienne, 1987), 40.

12. Braque por supuesto era francés y, como lo planteó Jean Paulhan en "Braque le Patron" (publicado en *Poesie* no. 13 [marzo/abril 1943] como un texto *en* la resistencia), representaba la genialidad francesa. Picasso por supuesto era español y estaba vinculado a la clase obrera por medio de su afiliación al Partido Comunista. ¡Muy lejos del puesto del jefe! Todo aquello tiene sentido.

13. Michel Florisoone también decía algo similar en *Les Nouvelles Littéraires* en un artículo titulado "Le Patrimoine artistique": "Hay un ciclo de arte francés así como hay un ciclo para el agua, y para que los ríos tengan agua es imperativo que las nubes la traigan de muy lejos, del mar, de tierras lejanas, para alimentar los manantiales. El arte francés se transforma constantemente, se reproduce y es diseminado, pero se nutre de un humus empapado de lluvia. Requiere un mínimo esencial de productos importados".

14. Clement Greenberg aprovechó esta exposición para atacar la calidad del arte francés y para descartar la cultura francesa de la posguerra. Véase su "Review of an Exhibition of School of Paris Painters" (Reseña de una exposición de pintores de la Escuela de París), *Nation* 29 (Junio 1946); citado en John O'Brian, ed., *Clement Greenberg: The Collected Essays and Criticism,* vol. 2, *Arrogant Purpose* (Chicago: University of Chicago Press, 1986), 87-90.

15. Charles Estienne, "Salon d'Automne 1945 ou la bonne conscience", en *Terres des Hommes,* 6 Octubre 1945: 2.

16. En junio del año 1945, la Galería René Drouin ya había tanteado la reacción del público al presentar la muestra titulada *Art Concret,* organizada por Nelly van Doesburg, quien adoptó el nombre de Theo van Doesburg en 1930 para indicar una continuidad. Pero fue montada en clarísima oposición al grupo Cercle et Carré (en contra de Michel Seuphor y Piet Mondrian), con el fin de delimitar, sin mucho éxito, las fronteras de la abstracción de la posguerra.

17. Jean Cassou, "La critique d'art et la tradition français", *Arts,* Agosto 1948: 5.

18. Para la versión completa, véase Serge Guilbaut, "Dripping on the Modernist Parade: The Failed Invasion of Abstract Art in Brazil", en *Patrocinio, Colección y Circulación de las Artes* (México: Instituto de Investigationes Estéticas, Universidad Nacional Autónoma de México, 1997), 807-17.

19. Cercle et Carré fue un movimiento creado en París en el año 1930, cuyo objetivo fue agrupar a los artistas defensores de la geometría abstracta y madurar las ideas de la primera generación de artistas abstractos.

20. Véase la exposición de arte moderno francés enviada al Museo Whitney, Nueva York en la primavera de 1947, en la que todos los artistas jóvenes parisienses fueron representados con resultados inquietantes. Clement Greenberg escribió sobre el nivel mediocre de la muestra, tal como lo hicieron varios críticos de arte en Francia (Charles Estienne y Degand). Esta exposición, así como la muestra surrealista decepcionante organizada ese mismo año, motivaron a varios críticos a poner en duda el futuro de París como centro hegemónico.

21. Junto con André Breton, Estienne intenta incorporar el arte galo de la moneda. Fue una excelente idea que pretendió aprovechar una tradición abstracta que era típicamente "francesa", o al menos, ni griega ni latín, sino silvestre y libre, "brut", opuesta al poder dominante y el estilo artístico dominante de antaño. La vanguardia volvió a descubrir raíces norteñas, las cuales, por haber permanecido enterradas por tanto tiempo parecían haber retenido, según Breton, toda su vitalidad. Véase Serge Guilbaut, "1955: The Year the Gaulois Fought the Cowboy en *The French Fifties, Yale French Studies* no. 98 (New Haven, Conn.: Yale University Press, 2000).

22. Robert Lebel, *Premier bilan de l'art actuel, 1937-1953* (Paris: Soleil Noir, 1953), 12-13.

23. Lebel, 14.

Caracas: Escena constructiva
Luis Pérez-Oramas

1.

Me encontraba yo en Buenos Aires, a fines de un verano, en compañía de un grupo de viajeros norteamericanos quienes visitaban por primera vez una capital latinoamericana. Me había llevado a ello, accidentalmente, mi trabajo como curador y mi función allí consistía en aclararle dudas a mis compañeros de viaje, en fungir como "experto" en el imposible campo—por extenso—que es el arte latinoamericano, una ficción que sólo existe donde, precisamente, no existe América Latina. Me encontraba yo en Buenos Aires, pues, a fines de un verano, degustando algunos de los mejores vinos franceses que hubiese yo tenido la dicha de saborear en mi vida, agradablemente sentado en la sala imponente de un coleccionista de arte moderno quien había tenido la gentileza de abrirnos sus puertas. Durante aquellos días, mis compañeros de viaje habían podido admirar, probablemente por primera vez, un considerable número de obras de artistas concretos argentinos, vinculados a los grupos Madí y Arte Concreto–Invención: Raúl Lozza, Alfredo Hlito, Tomás Maldonado, Gyula Kosice, Carmelo Arden Quin, Enio Iommi, Grete Stern, Rhod Rothfuss, Gregorio Vardanega, Lidy Prati, Martin Blaszko, Juan Melé, Virgilio Villalba, etc. La enumeración, como un obstinato, puede suplir en el lector la experiencia de aquellos viajeros, cada vez que se veían responder la pregunta: ¿Quién es el autor? ¿Y la fecha?: 1946, 1948, 1945, 1950, 1949, 1952, etc. Me encontraba yo, pues, distraído, cuando uno de ellos se me acercó con el objeto de manifestarme su perplejidad: ¿Cómo era posible, dijo, que estos artistas, en un lugar tan lejano, no estuviesen "aislados" del mundo? ¿No era América Latina un continente "aislado"? ¿Qué había permitido a estos artistas producir en años tan tempranos obras tan impactantes? ¿Cómo era posible que en Buenos Aires alguien hubiese podido pintar, digamos, "antes de Kelly, a la manera de Kelly"?

Quizás fue esta inadvertida falta de exactitud, en todo sentido, lo que me hizo responder con cierta impaciencia, un argumento simplemente comparativo: la vinculación que pueden tener estos artistas con la tradición constructiva es análoga a la vinculación que tienen los versos de Sor Juana con la poesía del siglo de oro, a la vinculación que tienen las fachadas de las iglesias de Cuzco y Quito con las de Praga y Sevilla, a la vinculación que tiene la gran pintura del México virreinal con las obras de Alonso Cano y Zurbarán, a la vinculación que tiene la *Gramática de la lengua castellana* de Don Andrés Bello con la obra de Guillermo de Humboldt, a la vinculación que tienen las epístolas de Bolívar con el Sturm und Drang. En realidad, añadí, nunca ha existido "aislamiento" entre las naciones de América Latina y Europa. El problema es otro, muy diverso y vario.

Porque hay, sin duda, más de un problema, que cabe ser declinado tanto desde el punto de vista de la producción artística como desde el punto de vista de su recepción internacional. ¿Hasta qué punto puede pretenderse con propiedad, frente a las obras de artistas latinoamericanos, quienes en diversos momentos y lugares produjeron soluciones de carácter abstracto-geométrico, que ellas fueron parte de escenas artísticas auténticamente "constructivas"? ¿Hasta qué punto es legítimo utilizar el término "Constructivismo" para calificar el campo extendido—y necesariamente deformado—que implican los usos y disgresiones de los lenguajes artísticos no-objetivos en América Latina durante el siglo XX? Más que de una "'misplaced idea' of Constructivism",[1] se trataría de su "displaced" práctica, y por lo tanto no de su "asimilación", menos aun de su "inversión": se trataría, como la argumentaremos en estas líneas para el caso de Caracas, Venezuela, entre 1948 y 1976, de su "sobrevivencia", de su vida póstuma, de su alteración, y por lo tanto también de su deformación, manifestada a través de un repertorio de "alter-formas" constructivas.

La noción de "alter-forma" no es más que una variación suplementaria de conceptos tales como "sobrevivencia" o "vida póstuma" (nachleben) propuestos en el campo de la historia del arte por historiadores sensibles a la raigambre antropológica de los problemas artísticos, y por lo tanto críticos del genealogismo y del organicismo que prevalecen y regulan aun a la historia del arte concebida como una historia "biográfica" de los estilos.[2] No estamos discutiendo, pues, en estas líneas, la asimilación o la inversión de un supuesto "estilo constructivista" en América Latina—la frase es un oxímoron en la medida en que el Constructivismo aparece, en su primera iteración histórica, en Rusia a principios del siglo XX, precisamente como una impulsión anti-estilística—. Estamos discutiendo el eventual resultado, sobre la manifestación de lenguajes y formas constructivas, de un complejo proceso de traslados ideológicos y, sobre todo, la extensión del campo de aplicación de estos lenguajes a otros tópicos, a la vez en la topografía histórica—en el mundo físico y geográfico—y en la topología artística—en las obras de arte mismas, concebidas como lugares de acciones y transformaciones significativas. Es a una historia del arte concebida como topología de las formas artísticas a lo que nos referimos, no a una historia del arte concebida como pretexto para reivindicaciones postcoloniales en donde, inadvertidamente, un uso indefinido del concepto de vanguardia se vería invertido y, por lo tanto, también, prodigiosa y oportunísticamente multiplicado.

2.

La voluntad de modernización, acaso la voluntad moderna en Venezuela, llega a su extremo fallecimiento histórico, simbólica y materialmente, el 6 de enero de 2006. Ese día, en su modesta casa de campesino andino fue asesinado a golpes, presumiblemente, el más grande escultor popular de Venezuela, Antonio José Fernández; esa misma noche los pantanos de las montañas que rodean a Caracas se acumularon bajo las estructuras del inmenso viaducto que permite la comunicación vial entre la capital de Venezuela y su frontera marítima, conllevando su clausura definitiva. El viaducto, como la moderna autopista sembrada de túneles de la que formaba parte, habían sido obras emblemáticas de la voluntad modernizadora que privó en la nación desde fines de los años 40, y cuya ejecución

material se identifica generalmente con la dictadura de Marcos Pérez Jimenez: el acmé histórico del desarrollismo venezolano y la cifra simbólica de una voluntad autoritaria de modernización que ha guiado, como una ideología colectiva y de diverso signo, los destinos del país hasta su derrumbe definitivo. Que las grandes infraestructuras modernas de la nación ostenten un ruinoso aspecto, similar al que ofrecen las obras públicas concebidas por los artistas que este texto estudia—Jesús Soto, Gertrud Goldschmidt (Gego), Alejandro Otero, Carlos Cruz-Diez, Mateo Manaure, Victor Valera, Lya Bermúdez, etc—no debería extrañar a quien sepa que Venezuela padece un régimen populista para cuyo liderazgo estas obras son un símbolo del "antiguo régimen" democrático representativo, estigmatizado por las nuevas autoridades como ejemplo de ignominia burguesa y decadencia de los partidos. Que el más grande escultor popular del país haya sido asesinado a golpes y abandonado muerto en su humilde morada es, sin embargo, una paradoja en una nación que se precia de ser, hoy, una república de los pobres y el centro de una nueva forma de cultura popular. Cada uno de estos hechos, cada una de estas contradicciones, cada uno de estos emblemas deben ser integrados en nuestra comprensión de Caracas como escena artística moderna.

Muchos años antes, en junio de 1969, la modernidad artística venezolana había encontrado su límite crítico, algo así como su "conversión" en una forma contemporánea dónde se deshacían sus propios presupuestos, cuando Gego instala en la sala 8 del entonces Museo de Bellas Artes la primera versión de su *Reticulárea ambiental*.[3] No se puede argüir que Gego buscara voluntariamente clausurar con su obra un capítulo moderno de las artes venezolanas, particularmente el que encarnaron sus colegas y contemporáneos practicantes de lenguajes no-objetivos. Pero es obvio que la *Reticulárea* significa, en la intimidad del sitio museal, una conversión de aquel espacio neutro en un lugar marcado, practicado por decisiones aleatorias que crecen como un organismo sin centro, sin raíz, sin programa, sin destino: un organismo topológico, adherente, imprevisto, ínfimo, frágil, umbrío, accidental. En ese sentido la *Reticulárea* se opone a cada uno de los axiomas que regularon la voluntad moderna, en su versión constructiva, dentro del arte venezolano: el plan regulador, el programa tecno-racional, la centralidad política y estética, la teleología estructural, la megalografía pública, la voluntad estética de poder (y la voluntad de poder estético), la consistencia estructural, la ilusión óptica, la razón ornamental, la aniquilación de las sombras, la afirmación de trascendencia, la ideología de vanguardias. Esta oposición, que merece una mayor discusión, imposible de desarrollar en estas páginas, contiene una variable accidental y, por lo tanto, involuntaria. Fue posible manejando las mismas claves artísticas e ideológicas de sus contemporáneos modernos—acaso manejando la misma modernidad en clave menor—y seguramente con mayor conciencia técnica que muchos de ellos, con mayor apertura hacia la intuición que otros, que Gego alcanza a señalar, desde dentro, el agotamiento de estos lenguajes modernos en las artes plásticas venezolanas. Y lo hace, también, dentro del Museo,

convirtiendo ese lugar público y universal en un sitio íntimo, particular, marcado.

Desde la intimidad misma de una voluntad moderna, pues, Gego ofrece una versión artesana de la modernidad, produciendo una obra de delicados equilibrios y ostensibles precariedades materiales en la que el "habitus" factivo del arte constructivo se hace indistinto con el de los creadores populares: es la trama constructiva tejida, como labor manual, con materiales desprovistos de aura, a veces neutros, cuando no simplemente pobres. La obra de Gego no es jerárquica y no lo es hasta el punto de ser, inconfundiblemente moderna y contemporánea, también prorporcional a una labor artesana en la que la mano no cesa de dejar su huella, su pequeña sensación. Esto es pertinente para comprender porqué cabe señalar, para iniciar este ensayo, el derrumbe del viaducto moderno—el derrumbe de la modernidad como viaducto histórico, como fuente de estructuras que conducirían a un destino específico—y el asesinato en la indiferencia general de uno de los más grandes artistas populares de Venezuela. Habría que comenzar por entender, entonces, que la modernidad cinética y no-objetiva no fue la única en Venezuela, sino tan sólo la más visible y que, entre sus muchas virtudes artísticas y estéticas no se cuenta su capacidad para enracinarse en los contextos locales ni su voluntad para dialogar, fructíferamente, con las tradiciones populares de arte y artesanía. El "aduanero Rousseau" tuvo en Venezuela a otros interlocutores y no dejó, hasta hoy, de estar al desabrigo, y esto es quizás otra consecuencia, aun cuando involuntaria, de la primacía en Venezuela de una "escena constructiva".

3.

El lapso entre 1948 y 1952 posee una importancia capital para comprender la fundación de una escena de Arte Constructivo en Caracas, Venezuela. 1948 es un año luminoso y trágico en la historia política venezolana: el gran escritor y novelista de la venezolanidad, Rómulo Gallegos, es electo ese año en las primeras auténticas elecciones libres de la historia venezolana. La enorme figura cívica—civilista—de Gallegos al ocupar la Presidencia de la República el 15 de febrero de 1948 anuncia el inicio del fin de un ciclo histórico de autoritarismos salvajes en la vida del país. El Presidente es, por primera vez, el líder político y la cifra humanística de la nación: la encarnación del igualitarismo democrático, el reivindicador de las grandes aspiraciones sociales y el novelista "heráldico" de Venezuela.[4] Por primera vez accede al poder el país letrado, la inteligencia reformadora, no el país iluminado, no el país telúrico. A pesar de ello, o acaso por ello mismo, el 24 de noviembre de 1948 se instala en la jefatura de la nación, por efecto de un golpe de estado que clausura violentamente la presidencia de Gallegos, un régimen desarrollista, militar y tiránico que conducirá los destinos del país hasta 1957. En 1952, la dictadura osa un llamado a elecciones, que pierde abrumadoramente, con el consabido resultado de imponerse el Coronel Marcos Pérez Jimenez, Ministro de la Defensa, como Presidente de facto de Venezuela, hasta que sea derrocado por una rebelión cívico-militar al final de esa década. Hasta hoy, desafortunadamente, en el imaginario colectivo

de los venezolanos, la figura mediocre del dictador acapara la simbolización de los proyectos de modernización infraestructural iniciados por el régimen conservador y democrático de Isaías Medina Angarita, entre 1941 y 1945, y continuados o profundizados por los regímenes socialistas y democráticos de Betancourt y Gallegos entre 1945 y 1948. El hecho de que muchos de estos planes infraestructurales hayan sido materializados durante la dictadura ha contribuido a dos efectos: el desconocimiento de su raigambre política democrática, antes de la dictadura; y el desconocimiento de la inmensa contribución macro e infraestructural de los regímenes legítimos que sucedieron a la dictadura, entre 1957 y 1998.

Pero el lapso 1948–1952 es importante también en el ámbito específico de las artes: en 1948 se inaugura en Venezuela, en el recinto del Taller Libre de Arte, la primera exposición de arte no-objetivo en el país en donde, además de obras de los artistas venezolanos que constituyen al grupo organizador de la muestra, se presentan obras de algunos artistas argentinos pertenecientes a los movimientos de Arte Concreto en ese país.[5] En 1948 Carlos Raúl Villanueva, el arquitecto emblemático de la modernización venezolana, concluye el primer proyecto regulador de la Ciudad Universitaria de Caracas, sede de la Universidad Central de Venezuela, cuya construcción, durante los años 50, capitalizará la imaginación de lo moderno para las artes venezolanas y constituirá el primer lugar—acaso el único verdaderamente logrado—para estas dentro del ciclo histórico de la Venezuela moderna. En 1950 se cristaliza, en París, con la publicación de la revista que lleva su nombre, el grupo de Los Disidentes, primera agrupación de artistas claramente identificada con los lenguajes no-objetivos y opuesta a las tradiciones artísticas locales. En 1952, en fin, Jesús Soto parece lograr, también en París, la consagración internacional que lo llevará a ser el primer artista venezolano moderno en inscribir su obra, plenamente, en la escena seminal de un movimiento artístico europeo e internacional.

La revisión de ese período crítico se hace cada vez más imperiosa para comprender las contradicciones internas que signaron la constitución de una escena constructiva en Caracas, Venezuela; pero también son necesarias para refutar la suma de falacias que la crítica especializada en el arte de América Latina ha venido repandiendo acerca de la modernidad abstracto geométrica venezolana. Una de estas consiste en amalgamar sin mayores juicios a la escena de producción de obras abstracto-gemétricas en Venezuela durante los años 50 con la eclosión de un Arte Cinético durante los años 60 y 70, confundiendo así dos períodos históricos claramente distintos y dos tendencias artísticas diferentes. Así se pretende, por ejemplo, deducir una base común, estructural, entre "Torres-García, Madí y Neoconcretismo", extensible a los "Venezuelan Cinéticos" y al grupo paulista Ruptura.[6] Demasiado, por no decir que se trata de una tarea imposible, costaría demostrar que Torres-García ha sido una figura clave en la constitución de los lenguajes constructivos venezolanos. Salvo un caso marginal, más bien identificado con la práctica de una forma convencional de pintura de caballete,[7] ninguna de las grandes figuras que encarnaron los lenguajes no-objetivos en Venezuela se reconocen en la precedencia de Torres. Las fuentes son otras, y los artistas que aparecieron episódicamente en las muestras del Taller Libre de Arte, se habían distanciado por entonces del gran artista uruguayo.

La escena constructiva en Venezuela tiene, pues, dos momentos muy claros y distintos: el primero se extiende entre 1948 y 1957, orbitando básicamente alrededor de las grandes obras infraestructurales ejecutadas por la dictadura y específicamente del proyecto de síntesis de las artes en la Ciudad Universitaria de Caracas de Carlos Raúl Villanueva; el segundo coincide con dos eventos vinculados causalmente: el retorno de la democracia en 1959 y el retorno "a la patria" de los artistas exiliados en París durante los años 50, Jesús Soto, Alejandro Otero, Pascual Navarro, Carlos Cruz-Diez, Omar Carreño, etc. Este retorno es sólo simbólico: implica la decisión de inscribir la producción de sus obras en el incipiente mercado del arte nacional y de ofrecer respuesta a la creciente encomienda de obras públicas que terminaría por convertir, de facto, si no de principio, al Arte Cinético—inexistente como forma y como denominación durante los años 50 en Venezuela—en la manifestación simbólica más clara del desarrollismo democrático venezolano, entre 1959 y 1976.

La misma ligereza crítica con la que se confunden los períodos históricos, las tendencias dominantes en las artes y los protagonismos artísticos en Venezuela durante los lapsos 1948–1957 y 1959–1976, haciendo de la dictadura la edad dorada del optimismo moderno y concibiendo a la democracia civil como un tiempo de decadencia, en un acto de irresponsabilidad política que sólo el ejercicio alegre de la vocería curatorial es capaz de cometer, parece atacarse al caso emblemático del proyecto de Villanueva para la Ciudad Universitaria de Caracas, cuando se lo juzga—demasiado rápidamente—como un lugar monopolizado por la estética de la abstracción geométrica.

No hay duda de que tal proyecto es clave—instrumental y causalmente—para la emergencia de una escena constructiva en Caracas. Sin embargo, no es cierto que en ella se destaquen solamente los artistas del geometrismo abstracto venezolano, como tampoco es ajustado asimilarlo a la historia del Cinetismo venezolano. Sólo hay dos obras estrictamente cinéticas en la Universidad Central de Venezuela, y ambas poseen un carácter accidental: una estructura cinética de Jesús Soto, fechada en 1957, ofrecida por el artista, después de concluida la Ciudad Universitaria, al arquitecto como un regalo personal y que este convierte en el objeto de una conferencia y decide instalar en los espacios de la Facultad de Arquitectura; la otra es la propia obra del arquitecto, en la Plaza Cubierta del Aula Magna, bajo la forma de fascinantes membranas de "brise-soleil" en concreto que protegen del sol escalofriante del Caribe y filtran, accidentalmente, sus rayos proyectando sombras vibrantes sobre el piso, a ciertas horas de la tarde (figura 42).

Lo demás son obras abstractos geométricas—no cinéticas—, abstracciones líricas o sensibles concebidas por artistas venezolanos e

internacionales, pero también murales y esculturas figurativas, cuya importancia ideológica dentro del proyecto ha sido sistemáticamente desconocida. Yo quisiera argumentar que no se puede comprender la escena constructiva de Caracas, e incluso al Cinetismo venezolano, sin integrar el contrapunto, la tensión, la contradicción y el rol contextual de estas otras formas expresivas que constituyen, tanto como la abstracción constructiva y cinética, el cuerpo de la modernidad artística en Venezuela.

El proyecto de una "síntesis de las artes" hizo de la Universidad Central de Venezuela un lugar para las artes, acaso el primero por su ambición y completud en la historia de la nación. Pero el proyecto de Villanueva para la Universidad Central de Venezuela no fue sólo un lugar para las artes; también fue el espacio de un "combate" entre las artes: un espacio en donde coincidieron—a veces condensándose, a veces enfrentándose—todas las tendencias artísticas que pretendieron regir, desde los años 30 y hasta los 70, el destino de nuestra colectiva ideología modernizadora. En ese sentido cabe señalar que la primera "planta" concebida por Villanueva para la Ciudad Universitaria, en 1948, responde aun al esquema de una estructura "elísea", clásica, *beauxartiana*, heróica, desarrollándose radialmente desde el eje del hospital universitario hasta los estadios olímpicos. En 1952 este plan rector ha sido radicalmente modificado por Villanueva: una red de caminerías cubiertas opera una suerte de desconstrucción del modelo clásico, transfigurándolo en un proyecto moderno. En el proceso de este desenvolvimiento—la modernidad nace allí visiblemente de una ilusión "elísea"—también se oponen y combaten las artes: nativistas y universalistas, por una parte, ocupan los espacios de la Ciudad Universitaria con sus obras. Se organiza este "combate" de las artes en cuatro núcleos de artistas, de suerte que a los nativistas venezolanos se oponen los universalistas venezolanos; a los nativistas internacionales se oponen figuras universales de la vanguardia: Héctor Póleo, Pedro León Castro, Francisco Narváez, Alejandro Colina, Braulio Salázar, Oswaldo Vigas son algunos de los venezolanos que manejan lenguajes líricos o narrativos y tienen a sus "pendants" internacionales en las obras de Baltasar Lobo, Wifredo Lam, Jacques Lipchitz etc.; Alejandro Otero, Victor Valera, Pascual Navarro, Carlos González Bógen, Mateo Manaure, Alirio Oramas son los venezolanos identificados con la abstracción geométrica y sus "pares" internacionales son Victor Vasarely y Anton Pevsner—acaso los únicos practicantes rigurosos de la abstracción geométrica entre los artistas internacionales presentes en la Ciudad Universitaria—, junto a artistas de diversas tendencias abstractas y líricas como Jean Arp, Alexander Calder, Fernand Léger, etc. Aun hace falta un análisis inteligente de la función topológica de estas obras en el espacio de la Ciudad Universitaria, pero resulta evidente que las obras figurativas y nativistas ocupan espacios más bien íntimos y administrativos mientras que las obras abstractas y geométricas ocupan espacios públicos y monumentales. La excepción—como un rastro del combate— son las tres esculturas alegóricas de Francisco Narváez—*La Ciencia, El Estudio, El Atleta*—y el

monumento a María Lionza, diosa vernácula, por Alejandro Colina que, tras ocupar un sitio de capital importancia, como pebetero frente al complejo olímpico, fue exilada, por aparente decisión del arquitecto, y reubicada fuera del recinto de la Universidad.

Alguna razón yace en la imágen colectiva de la Universidad como un lugar de internacionalización para el arte venezolano y como el crisol de nuestras abstracciones geométricas, aun cuando la presencia de numerosas obras de signo distinto hace pensar que entre la posibilidad de un arte nacional y la continuidad de implantaciones estilísticas foráneas y legitimadoras las trincheras opuestas del nativismo y del universalismo artísticos, más que inconciliables y excluyentes, se manifiestan en la Ciudad Universitaria como las dos caras de una misma ideología modernizadora que, más de una vez, como un *ritornello* invencible, habría de desgarrarse en diversas transfiguraciones. Es así que estas dos tendencias adquieren la forma, a inicios de los años sesenta, de dos nuevas fronteras: informalismo político *versus* abstracción; luego Nueva Figuración *versus* Cinetismo. La escena, no obstante, había cambiado, la dictadura había concluído, el proyecto de la Ciudad Universitaria había quedado inconcluso, la infraestructura cívica concebida por los regímenes democratizadores de los años 40 había adquirido la forma de una infraestructura militar, hotelera y alegórica del poder dictatorial ejecutada por el régimen autoritario. Faltaban escuelas, faltaban universidades, faltaban carreteras rurales, faltaban dispensarios y hospitales, faltaban represas, complejos industriales, parques; sobraban cuarteles, puertos y aeropuertos militares, hoteles de lujo, salas de fiesta, mansiones presidenciales.

4.

En 1948 Villanueva había presentado el primer plan regulador de su proyecto de integración de las artes en el sitio de la Universidad en Caracas. Muy lejos, en los Estados Unidos, ese mismo año, Clement Greenberg publicaba en las páginas de una revista literaria y marxista el texto fundador del formalismo estético que devendría, con los años, el pensamiento dominante del arte más emblemático de la sociedad capitalista occidental, titulado "Hacia un nuevo Laocoonte". Retomando la clásica distinción de Lessing entre artes del tiempo y artes del espacio, Greenberg proponía, y con él todo el formalismo norteamericano, una tésis favorable a la separación de las artes. El arte moderno, en resumidas cuentas, se caracterizaba, para el crítico norteamericano, por buscar con ahínco la identificación entre las obras y los constituyentes materiales de sus propios medios formales. Las artes visuales, por ejemplo, deberían buscar, para aspirar legítimamente al calificativo de modernas, encarnarse en formas menos narrativas. La teoría greenbergiana no tuvo nunca resonancia—ni acogida—en Venezuela. El más cercano momento de colisión entre las artes venezolanas y el formalismo greenbergiano tuvo lugar, muchos años más tarde, indirectamente, en Nueva York: allí, en 1974, la primera retrospectiva de Jesús Soto en los Estados Unidos, en el Museo Guggenheim, se saldó por un estridente fracaso, confirmando la intraducibilidad entre ambos contextos.

El proyecto de integración de las artes de Villanueva respondía a una poética de integración de las artes, cuya fuentes pueden referirse a la retórica artística que había regido en Occidente desde los tiempos del humanismo. Su fundamento teórico reside en la teoría del *ut pictura poesis,* aquella pretensión humanista de concebir a las distintas artes como una sumatoria de "discursos", analogables los unos a los otros. Esta ideología humanística de equivalencia de las artes, cuyos principios fueron minados por Lessing en su tratado sobre *Laocoonte o de los respectivos límites de la poesía y de la pintura* subyace aun en los proyectos de totalidad artística de la primera mitad del siglo XX, y se manifiesta claramente en el proyecto de Villanueva, marcando así el orígen de la escena constructiva venezolana. La utopía de un lugar común para las artes alcanzó a materializarse en la Ciudad Universitaria de Caracas, no sin contradicción: en el imaginario colectivo y en la eficacia arquitectónica del proyecto, las artes que triunfan—las modalidades de internacionalismo abstracto y antivernáculo—son artes que no quieren tener lugar, son artes sin lugar, que desean enunciarse como formas universales, autónomas, emancipadas de todo localismo.

Esta contradicción marcará el devenir de la escena constructiva venezolana. Hacia 1961, en vías de ser superadas las primeras crísis políticas que amenazaron a la democracia naciente, Venezuela se embarca en un proyecto de transformación infraestructural marcado por tres frentes: estabilidad política, alfabetización masiva y consolidación de un capitalismo ampliamente subsidiado por el Estado. La idea central de este proyecto desarrollista puede resumirse en pocas palabras: la nación había sobrevivido con dificultad a la miseria de su historia, pero también había sido bendecida por una sobreabundancia de donaciones naturales, en forma de recursos explotables. Para superar la miseria secular que la alienaba de su tiempo, para emanciparse de la violencia y de la pobreza atávicas que la habían caracterizado durante 150 años, debía poner todo su esfuerzo en convertir esos recursos naturales en energías materiales, en fuente de divisas, en riqueza. Una teología natural de la donación—la diosa naturaleza—debía traducirse en una teleología de la promesa desarrollista, gracias a ingentes inversiones infraestructurales.

Este funcionalismo político—que desestimó la fuerza de los relatos míticos y el poder de la representación en los espacios públicos, reduciéndose a producir desnudas estructuras funcionales—encontró una estética involuntariamente proporcional en la obra de los artistas cinéticos: monumental, eficaz, ilusionante, las obras cinéticas estaban fundamentadas en la donación de ciertos constituyentes gestálticos elementales—líneas, planos, puntos, colores— que podían ser estructurados de suerte que su activación óptica produjera fascinantes ilusiones visuales, promesas ópticas. El país, alcanzada la estabilidad burguesa que trajo el fracaso de la guerrilla y el *boom* petrolero, a principios de los años 70, se llenó de obras maravillosas y monumentales, abstractas, cinéticas o paralácticas, realizadas por Jesús Soto, Carlos

Cruz-Diez, Narciso Debourg, Alejandro Otero, Mateo Manaure, Nedo, Francisco Salazar, Gert Leufert, Gego, Omar Carreño, Luis Chacón, Harry Abend, Carlos González Bogen, Juvenal Ravelo, Victor Valera, Oswaldo Subero, etc.

Hoy cabe afirmar que esta constelación constituyó un capítulo completamente distinto de la escena artística de los años 50, cuando prevaleció, junto a una discreta presencia de la abstracción geométrica, básicamente reducida al proyecto universitario de Villanueva, el arte oficial del régimen dictatorial bajo la forma de un muralismo nativista, a veces indigenista, frecuentemente heróico y siempre hagiográficamente bolivariano. Pero hoy cabe afirmar, también, que lo sucedido en Venezuela entre 1959 y 1976, al menos en términos de arte público, constituyó otra forma de muralismo: un muralismo sin relatos, en el que el único rastro de narratividad se reduce a su propio dinamismo óptico, el cual se percibe como un proceso de transfiguración óptica y se "lee" a la manera de una "escritura" abstracta, en multitud de configuraciones murales, en innumerables frisos que marcaron los espacios públicos de la ciudad y del país como hitos de un optimismo humanista y promisorio, hoy reducidos al estado inexorable de las ruinas.

5.

Bien que haya tenido yo la ventaja, que conmigo han compartido pocos españoles, de visitar sucesivamente a Caracas, La Habana, Santa Fé de Bogotá, Quito, Lima y México, y de que en estas seis capitales de la América española mi situación me relacionara con personas de todas las jerarquías, no por eso me permitiré juzgar sobre los diferentes grados de civilización a que la sociedad se ha elevado ya en cada colonia. Más fácil es indicar los diversos matices de la cultura nacional y el intento hacia el cual se dirige de preferencia el desarrollo intelectual, que comparar y clasificar lo que no puede ser comprendido desde un sólo punto de vista. Me ha parecido que hay una marcada tendencia al estudio profundo de las ciencias en México y en Santa Fé de Bogotá; mayor gusto por las letras y cuanto pueda lisonjear una imaginación ardiente y móvil en Quito y en Lima; más luces sobre las relaciones políticas de las naciones, miras más extensas sobre el estado de las colonias y de las metrópolis, en La Habana y en Caracas. Las múltiples comunicaciones con la Europa comercial y el mar de las Antillas que arriba hemos descrito como un Mediterráneo de muchas bocas, han influído poderosamente en el progreso de la sociedad en la isla de Cuba y en las hermosas provincias de Venezuela. Además, en ninguna parte de la América española ha tomado la civilización una fisonomía más europea.[8]

Así se expresaba Alejandro de Humboldt apenas llegado a Caracas, en Enero de 1800. Las observaciones del sabio alemán pueden servir, aun hoy, para comprender el ánimo novedoso, el gusto por lo reciente, la ambición contemporánea, el ardiente deseo de estar a tono con el tiempo del mundo transoceánico que han marcado, como *ritornelli,* algunas de las obsesiones

y voluntades colectivas de la sociedad venezolana. Acaso no hay aun distancia suficiente para juzgar el sentido de lo que fue, dentro del repertorio de las artes modernas y de las tendencias modernizadoras en Venezuela y en el continente americano, la escena constructiva de las artes que tuvo—y aun tiene—lugar en Caracas. Quizás están nuestros juicios e instrumentos cognitivos demasiado hipotecados por una historia del arte con demasiada vocación eurocéntrica que se debate, como un péndulo maníaco, entre dos opciones: la afirmación de una diferencia radical, vernácula, intraducible; la pretensión de una legitimidad europea, vanguardista, teórica, así sea a través del atajo heterotópico que Michel Foucault asociaba, en su célebre y mal citada conferencia, al traspatio para el juego de los niños, a la cama de los padres en cuyo inmenso océano de sábanas la virginidad de los adolescentes se pierde, al cementerio, los asilos, las prisiones.

Más bien cabría pensar en la escena constructiva caraqueña como una iteración de la inconmensurable antropología del traslado que ha regido, desde que Europa proyectara su utopía sobre América, los destinos de la cultura americana. En realidad no hace falta, porque el imaginario europeo nos haya otorgado el rol discutible de un traspatio para sus propias represiones o de una cama parental para una erótica de sus propias frustraciones colectivas, que nosotros nos acostemos en ellos. Es así que, a menudo, la historiografía del arte latinoamericano se asocia con el historicismo artístico europeizante en dos operaciones sólo aparentemente opuestas: afirmar una especificidad triunfante de lo latinoamericano donde se emancipan todas las frustraciones europeas—según esto, por ejemplo, nuestro arte conceptual sería mejor y anterior al de "ellos"; nuestro Constructivismo equivalente; y todos nuestros artistas habrían sido genios vanguardistas que hicieron, junto a sus obras, ingente labor de tratadistas y teóricos—o negar toda posibilidad de comprender nuestras artes modernas como manifestaciones legítimas de la modernidad—según lo cual no se podría, entonces, hablar de "Constructivismo" en América Latina, sino tan solo de un insulso decoratvismo formalista, ajeno a toda impulsión utópica, como han pretendido afirmar algunos profesores europeos—.[9]

Divagando sobre un fragmento de Darwin, Aby Warburg subrayó el valor antitético de algunas representaciones gestuales del Renacimiento con relación a sus modelos clásicos. El David de Andrea del Castagno, levantado su mano en signo de alegre heroismo juvenil, reproduce con exactitud el gesto de horror pánico de un Pedagogo helenístico. Warburg señaló, entonces, a imágen de este ejemplo, todo un repertorio de inversiones de sentido a través del cual los mismos gestos, las mismas formas clásicas adquirían significaciones antitéticas en el Renacimiento.[10] Quizás los "profesores europeos" que deniegan el estatuto constructivo de las escenas artísticas latinoamericanas durante la segunda mitad del siglo XX no se atreverían, sin embargo, a poner en duda el clacisismo de las obras del Renacimiento, a pesar de representar estas significaciones antitéticas con relación a sus modelos históricos.

Cabría pensar en un "Constructivismo" antitético y hasta en una modernidad "antitética" latinoamericana, si no existiera también un abuso crítico de los modelos invertidos. Yo he argüido por la idea de comprender algunas de nuestras escenas modernas como modernidades deformadas, es decir, por la necesidad de constatar que la aplicación y el traslado de modalidades modernas responde a complejos procesos, no todos ellos plenamente voluntarios ni conscientes, a través de los cuales formas análogas a soluciones canónicas de la modernidad europea adquirieron significados distintos, se vieron sometidas a transformaciones programáticas o accidentales hasta el punto de perder similitud con sus análogos modernos o fueron objeto de un trabajo de de-semejanza al ser concebidas como *formas transicionales,* esto es, como estructuras vinculantes entre el campo del arte y el espacio de la vida ordinaria.[11]

El acceso a la modernidad, planteado como una figura de deseo emancipador y como una fuente reguladora de producciones simbólicas tuvo, según esto, en algunos países de América Latina, la misma función antropológica que el re-acceso a la Antiguedad clásica en algunas sociedades de la cuenca mediterránea europea, a inicios del Renacimiento. La "escena constructiva", donde quiera que haya tenido lugar en la América hispano-lusitana es, pues, la deformación de una escena constructiva canónica de la misma manera que las figuras clásicas de Botticelli y Ghirlandaio fueron deformación de las formas antiguas. En ese sentido, la especificidad antropológica en ambos casos—Renacimientos clásicos y Sobrevivencias modernas—residió en el hecho, por lo demás palpable, de que acceder a la modernidad en el territorio extendido de su re-implantación americana era una empresa tan imposible como acceder a los verdaderos contenidos de las formas antiguas para los artistas del Quattrocento y que, en ambos casos, como lo comprendió lúcidamente Aby Warburg, la producción simbólica, la obra de arte, funcionó como sucedáneo—ficticio, ilusionante—de ese acceso, de esa utopía. En otras palabras, así como revivir la Antiguedad fue imposible cada vez que Europa se proyectó en esa utopía retrospectiva—pero sí fueron posibles las "formas a la antigua"—así mismo fue quizás imposible una modernidad canónica—esa utopía proyectiva, dondequiera que haya sido—pero fueron y aun son posibles las formas modernas.

Las abstracciones geométricas y no-objetivas practicadas durante la segunda mitad del siglo XX en algunos lugares de América Latina—y la escena constructiva de Caracas es un ejemplo de ello—deberían ser consideradas, pues, como formas de "vida póstuma" de la modernidad, como sobrevivencias de las soluciones abstracto-geométricas que identificaron a diversos proyectos modernos, como "alter-formas" constructivas sometidas a complejos procesos de transformación selectiva—a veces no programática y hasta involuntariamente—hasta el punto de analogarlas a un "desvío", a una "deformación", gracias a los cuales sin embargo se hacen funcionales, eficaces, en sus respectivas realidades contextuales, en sus espacios de traslado.

En los primeros años 70, Caracas fue magníficamente poblada de murales cinéticos, de

esculturas penetrables y sonoras, de refulgentes pirámides de aluminio que orbitaban al viento optimista de los trópicos; los autobuses portaban fisicromías y colores aditivos, así como los paseos peatonales, las aceras, las estructuras de contención. Los silos del puerto de La Guaira eran máquinas de color, como el muro que separaba los depósitos del puerto del territorio nacional: la frontera del país, simbólicamente, era una fisicromía de Carlos Cruz-Diez; los cubos virtuales de Mateo Manaure señalaban las paradas del transporte colectivo y las *Cuerdas* de Gego proyectaban su misteriosa sombra anudada sobre la estructura de concreto armado, a función habitacional, más ambiciosa del planeta para aquella época, las inmensas torres del Parque Central de Caracas.

Por entonces, otra generación de artistas, que padecería hasta hoy el peso ocultante del pensamiento poderoso de los maestros constructivos sobre su fortuna crítica, llevaba a cabo su inscripción seminal en la escena constructiva, anunciando su agotamiento: Claudio Perna y Eugenio Espinoza llevaban los *Impenetrables* de este último—lienzos inmensos sobre los cuales figuraba una retícula negra, que el artista extendía sobre un bastidor paralelo al piso de las salas de exposición para impedir el acceso del público—al desierto de Coro y envolvían con ellos el cuerpo desnudo de un jóven en fotografías que significaban la reinscripción del organismo humano en la desértica matriz constructiva; Héctor Fuenmayor cubría todos los espacios de la Sala Mendoza de color amarillo en alusión sarcástica, monocroma, obstinada al cromatismo óptico; Roberto Obregón disecaba sus pétalos de rosa en rítmicos e íntimos ensamblajes asociados al primer ícono serial del arte venezolano, la montaña del Avila; Antonieta Sosa se filmaría escalando un enorme andamio, una retícula metálica monumental, con la lentitud de las perezas. Todos ellos se reconocían en la imágen de lo que Gego hacía por aquellos años: Bichos, Chorros, estructuras abstractas pero orgánicas, Dibujos sin papel en los que la materia precaria del desecho encontraba un inesperado destino simbólico.

Entre 1976 y 1983, año de la primera crísis cambiaria que afectaría el destino entero de la ilusión venezolana y que anunciaría el final de la utopía desarrollista, otras obras monumentales y constructivas surgieron en los espacios públicos de las ciudades venezolanas: Reticuláreas monumentales de Gego en las estaciones del Metro de Caracas, alas de hierro de Lya Bermúdez, relieves de Harry Abend cubriendo la cúpula del inmenso Teatro Teresa Carreño, esferas y cubos virtuales de Soto en cada parque, encofrados de Max Pedemonte, jardines cromáticos de Carlos Cruz-Diez, Abras solares de Alejandro Otero como espejos de aluminio. Cuando Gego concluía el último re-montaje de su *Reticulárea ambiental,* esa capilla de cámara en cuyos nudos puede leerse la alegoría involuntaria del Constructivismo venezolano reducido a impensables e irregulados "impasses", Carlos Cruz-Diez concluía la enorme Sala de Turbinas de la represa de Guri, al sur del país—esa capilla sixtina del Constructivismo venezolano, donde la producción material de energía se convierte en el soporte mismo de las ilusiones ópticas—.

La obra pública culminante del Cinetismo venezolano, en la región donde Soto había nacido, donde había visto de niño cabalgando sobre el lomo de un burro la vibración enceguecedora de la luz en el aire que lo llevaría a concebir sus Penetrables muchos años después, coincide, cronológicamente, con la culminación de la obra que cierra su ciclo histórico, la *Reticulárea ambiental* de Gego.

No se puede ver el paisaje desde el interior de la *Reticulárea*. Tampoco se puede ver el paisaje en el interior de la Sala de Máquinas de Guri, hundida bajo el nivel de las negras aguas del Caroní; tampoco, en rigor, se veía el paisaje desde el interior de los Penetrables, donde desaparece, como nuestro propio cuerpo, en la opacidad de una lluvia de plástico. Ambos, cuerpo y paisaje, estan inscritos como figuras de ausencia, como enormes presencias negativas, como nichos enigmáticos en la historia y en la poética del Constructivismo venezolano. Ambos eran—y son—la clave de la utopía integradora de Villanueva en la Ciudad Universitaria de Caracas: es lo único que no ha sido representado allí porque todo ha sido hecho para ellos, para su movimiento, para su contemplación, para su desmaterialización.

Algunas semanas antes del 6 de enero de 2006, cuando expiraría el cuerpo maltrecho del más grande artista popular de Venezuela abandonado a los golpes de sus asesinos, cuando el símbolo del viaducto moderno, de *la modernidad como viaducto* se clausuraría para siempre dejando aislada psicológica y temporalmente a la capital de Venezuela, el alcalde revolucionario de la ciudad de La Guaira ordenó, sin consulta, la demolición del *Muro cromático* de Carlos Cruz-Diez que marcaba la frontera entre el puerto mercante más importante de la región capital y el interior del país. Las imágenes de obreros, vestidos de rojo, demoliendo con sus mazos la obra cinética que servía de membrana simbólica entre el mundo y Venezuela amaneció en todas las primeras páginas de los periódicos. La idea de un cuerpo que se mueve frente a una obra sin cuerpo, la idea de un paisaje cuya desconstrucción cromática y gestáltica se produce en obras sin paisaje daba lugar, con la violencia de la historia y la incertidumbre del error, a una escena desoladora en la que apenas se leen los rastros del cuerpo como lenguajes sin sentido, y en el paisaje las ruinas de una fallida modernidad constructiva que espera, en un país ya desprovisto de utopía y aferrado más que nunca al mito de sus donaciones naturales, alguna próxima, improbable "vida póstuma".

Notas

1. Cf. Mari Carmen Ramírez, "Vital Structures. The Constructive Nexus in South America", en *Inverted Utopias: Avant-Garde Art in Latin America* (New Haven, Conn.: Yale University Press in association with the Museum of Fine Arts, Houston, 2005), 191.

2. Para la noción de "vida póstuma" de las formas artísticas, véase Aby Warburg, *The Renewal of Pagan Antiquity: Contributions to the Cultural History of the European Renaissance* (Los Angeles: The Getty Research Institute for the History of Art and Humanities, Los Angeles, 1999) y Ernst H. Gombrich, *Aby Warburg: An Intellectual Biography* (Chicago: University of Chicago Press, 1986).

3. Para una revisión del proceso de concepción e instalación de la *Reticulárea ambiental,* véase el esclarecedor ensayo

de Mónica Amor, "Another Geometry: Gego's Reticulárea, 1969–1982", *October* 113, no. 1 (summer 2005): 101–25.

4. Debo esta calificación de Gallegos como novelista "heráldico" de Venezuela al escritor José Balza. Rómulo Gallegos (1884–1968) fue autor de novelas emblemáticas del paisaje y de la etnicidad venezolana, las cuales incluyen los textos fundacionales del imaginario del llano venezolano (*Doña Bárbara,* 1929, *Cantaclaro,* 1934), de la selva amazónica (*Canaima,* 1935), del Occidente extremo y la Goajira (*La brizna de paja en el viento,* 1952), del mestizaje (*Pobre negro,* 1937) y de la decadencia de la aristocracia nacional (*Reinaldo Solar,* 1930), entre otros.

5. Entre estos cabe mencionar a Juan Melé, Lidy Prati, José Mimó Mena, Jorge de Souza, Alfredo Hlito, así como a figuras más consagradas como Juan del Prete. Véase *Arte Constructivo Venezolano 1945–1965* (Caracas: Galería de Arte Nacional, 1979), 9.

6. Cf. Ramírez, 192.

7. Me refiero a la obra del artista Manuel Quintana Castillo, alejado de la constelación abstracto-geométrica y más bien un caso aislado en el arte venezolano de la segunda mitad del siglo XX.

8. Alejandro de Humboldt, *Viaje a las Regiones Equinocciales del Nuevo Continente,* II, trans. Lisandro Alvarado (Caracas: Monte Avila Editores, 1991), 330.

9. Argumento expuesto en público por el Prof. Eduardo Subirats en el panel de discusión organizado en la Americas Society con motivo de la muestra *Jump Cuts: Venezuelan Contemporary Art, Colección Mercantil,* 19 abril 2006, Nueva York.

10. Véase Kurt W. Foster, Introduction, in Aby Warburg, 38.

11. Véase Luis Pérez-Oramas, "Is there a Modernity of the South?", *Omnibus/Documenta X,* octubre 1997: 14–16; "¿Es concebible una modernidad involuntaria?", texto leído en el marco de la Maestría en Crítica y Práctica de los Sistemas de Representación Visual Contemporáneos, Instituto Universitario de Estudios Superiores en Artes Plásticas Armando Reverón, Caracas, 2000, inédito; "Gego, retículas residuales y modernidad involuntaria: la sombra, los rastros y el sitio", en *Questioning the Line: Gego in Context,* ed. Mari Carmen Ramírez con Teresa Papanikolas, International Center for the Arts of the Americas, no. 2 (Houston: The Museum of Fine Arts, Houston, 2003), 83–115; "Parangolé/Botticelli. Helio Oiticica, Geometric Abstraction and the Notion of Transitional Form after Aby Warburg", inédito, texto leído en Beyond Geometry International Roundtable, 30 noviembre 2004, Miami Art Museum, Miami.

Joaquín Torres-García
Construcción en blanco y negro,
1938
Óleo sobre papel montado en madera
43.2 × 64.5 × 0.3 cm
The Museum of Modern Art, New York,
fractional and promised gift of Patricia Phelps
de Cisneros in honor of David Rockefeller
331.2004

A pesar de que Torres-García es conocido sobre todo por sus síntesis de composiciones en cuadrícula y signos esquemáticos, esta obra (lámina 1) carece casi por completo de sus característicos símbolos. Sólo tres anotaciones interrumpen una cuadrícula que de otro modo habría permanecido impoluta: en el extremo inferior izquierdo, el artista anotó el año en que realizó la pintura (1938) y la firmó (reduciendo su nombre a las iniciales JTG); abajo a la derecha, pintó esquemáticamente las letras AAC para indicar su pertenencia a la organización artística que fundó en Montevideo, la Asociación de Arte Constructivo; abajo en el centro, pintó "ENE 1", una abreviación de "Enero 1". Torres-García anunciaba así la pintura como la primera obra de un nuevo año. Significativamente, esta obra presagiaba acontecimientos que tendrían lugar en ese mismo año: su semejanza visual con la técnica inca de mampostería tendría eco en una serie de conferencias que Torres-García pronunció a finales de 1938 y publicó en 1939, con el título de *Metafísica de la prehistoria indoamericana,*[1] así como en la finalización de su granito *Monumento cósmico;* la referencia a la AAC, por otra parte, marcaría el último año de existencia de dicha asociación. Esta pintura forma parte de una serie de composiciones con cuadrículas vacías que el artista empezó en 1935 y siguió realizando hasta principios de la década de 1940, y, como otras obras de la misma serie, evoca la cantería inca no sólo visualmente, sino a través de lazos metafóricos con conceptos sociales y culturales incas que sustentaban las propias ambiciones artísticas de Torres-García.

En su crucial ensayo "Grids" ["Cuadrículas"], de 1978, Rosalind Krauss escribió: "La cuadrícula anuncia, entre otras cosas, la voluntad del arte moderno de tender al silencio, su hostilidad a la literatura, a la narrativa, al discurso".[2] Sin embargo, el uso que Torres-García hace de la cuadrícula en esta obra (y en otras de la misma serie) no sólo no es silencioso sino que entabla un debate sobre el papel de la abstracción en el continente americano en particular, tanto desde un punto de vista social y cultural como formal.

Esta pintura, como todas las de cuadrículas vacías de Torres-García, difiere de sus demás composiciones no sólo por la ausencia de imágenes simbólicas sino también debido al juego que se establece entre luz y sombra. Aunque empleó el sombreado en otras obras, en estas pinturas recurrió a la luz y la oscuridad para crear un efecto de modelado, para imponer la sugestión de tridimensionalidad sobre una tela por lo demás geométricamente abstracta. Dejó a un lado sus habituales tonos terrosos a favor del blanco y el negro. Pintó la obra sobre papel, ahora montado sobre madera, y dejó sin pintar algunas partes del papel, sobre todo cerca de los bordes de las líneas negras que forman

la cuadrícula. Dichas áreas de papel en blanco permitieron a Torres-García reafirmar la bidimensionalidad de la obra e integrar el soporte a la imagen global. Jacqueline Barnitz escribió que estas pinturas interactúan realmente con la superficie en lugar de intentar crear un efecto tridimensional.[3] El espectador no puede evitar advertir, sin embargo, el empleo netamente deliberado de luces y sombras que modelan los compartimentos de la cuadrícula, que empiezan a parecerse a piedras en un muro.

Pintada cuatro años después de regresar a Uruguay tras su estancia en Europa, *Construcción en blanco y negro* refleja el profundo compromiso de Torres-García con el arte y la arquitectura de los pueblos nativos de América, especialmente con los incas y otros pueblos andinos, así como su deseo de incorporar lecciones de estos predecesores al arte moderno sudamericano. Cecilia de Torres señaló que Torres-García abrazó el arte incaico no sólo por su relativa proximidad geográfica al Uruguay, sino porque sentía que el arte de los incas representaba lo que denominaba "el pensamiento abstracto".[4] Torres también sostenía que su objetivo nunca fue imitar el arte precolombino, sino "identificarse con el espíritu de los creadores del gran estilo y de la cultura del continente americano".[5] Aunque eso es ciertamente así en el conjunto de su obra, esta pintura y otras de la misma serie sí imitan visualmente la propia mampostería inca. Fue quizás precisamente debido a su deseo de "identificarse con el espíritu" de los incas que Torres-García realizara estas pinturas, las cuales le permitieron presentar un complejo conjunto de ideas en un formato visual aparentemente simple.

Los estudiosos parecen estar de acuerdo en que la cantería fue uno de los logros estéticos más destacados de los incas. Reservaban la mampostería sin mortero para los espacios sagrados y destinados a la elite. Construidos para resistir los frecuentes terremotos, esos muros consisten en piedras cuidadosamente armadas, formando composiciones estéticamente armoniosas. A altitudes elevadas, el efecto de la luz solar sobre los bordes biselados de las piedras produce marcados diseños geométricos. Es precisamente ese agudo contraste entre luz y sombra que Torres-García pretendía captar en *Construcción.*

Con el objeto de construir sus muros sin mortero, los incas reclutaban por la fuerza a los trabajadores *mit'a,* procedentes de distintos grupos étnicos y que se desplazaban por todo el imperio trabajando en proyectos de construcción.[6] Como escribe Rebecca Stone-Miller, dichos muros constituían una metáfora del imperio inca: "Gentes diversas debían entrelazarse, ajustarse y reasentarse en un todo dinámico, poniendo en común sus variadas formas, alisando sus diferencias étnicas y manteniéndose unidos, aparentemente sin medios para afrontar un entorno hostil".[7] Dicha metáfora es igualmente aplicable a la visión que Torres-García tenía de la AAC, a través de la cual esperaba alcanzar un arte moderno sudamericano construido de forma muy similar a los muros incaicos: anónimamente, colectivamente y con la participación de artistas de distintos orígenes étnicos, geográficos y sociales. En *Construcción,* Torres-García transmitió estos ideales no sólo a través de la imitación visual de dichos muros, sino también reduciendo

su firma a meras iniciales y dando igual importancia a la AAC. Asimismo, Torres-García confiere a la obra—en palabras de Krauss—un carácter "centrífugo";[8] las líneas negras separan las unidades individuales de la pintura pero no delimitan sus bordes, permitiendo al espectador imaginar que la pintura se extiende infinitamente más allá de los límites de la tela. La pintura existe como un elemento más del proyecto más amplio de Torres-García; su carácter centrífugo la vincula a sus otras pinturas y a las de los demás artistas de la AAC.

Irónicamente, Torres-García descubrió el arte precolombino de los Andes no en América del Sur sino en París, donde su hijo trabajaba en el Museo de Etnografía del Trocadero realizando versiones de cerámica nazca.[9] Las exposiciones poco rigurosas y los caóticos almacenes de este museo, que descontextualizaba y estetizaba los objetos que exponía, debieron influir en su temprana interpretación del arte precolombino, al igual que lo hicieran para muchos otros artistas modernos.[10] Aunque Torres-García emprendió una investigación más académica del arte inca tras su regreso al Uruguay, la asimilación que realizó de la estética andina a su propio sistema artístico y la suposición de que el arte precolombino contenía algún tipo de verdad esencial plantea algunos problemas. ¿Hasta qué punto su adopción de formas y símbolos incaicos difería sustancialmente de la apropiación exotizante y primitivizadora del arte no europeo realizada a menudo por los modernistas europeos? Podemos afirmar con seguridad que, con independencia de si Torres-García entendía o no plenamente los significados culturales del arte andino que inspiró pinturas como *Construcción,* adoptó sus formas con el deseo de lograr un modernismo específicamente sudamericano, tanto a nivel estético como social y cultural, a través de la búsqueda de una modernidad basada en la geometría, que llevaba a cabo colectivamente con otros artistas de ideas afines.

Courtney Gilbert
Traducción de Jordi Palou

Notas

1. Joaquín Torres-García, *Metafísica de la prehistoria indoamericana* (Montevideo: Publicaciones de la Asociación de Arte Constructivo, 1939); extractos de esto texto son traducidos al inglés y reproducidos en Mari Carmen Ramírez, ed., *El Taller Torres-García: The School of the South and Its Legacy* (Austin: University of Texas Press, 1992), 74.
2. Rosalind Krauss, "Grids", en *The Originality of the Avantgarde and Other Modernist Myths* (Cambridge, Mass.: MIT Press, 1985), 91; para una traducción al español, véase Rosalind Krauss, *La originalidad de la Vanguardia y otros mitos modernos,* trad. de Adolfo Gómez Cedillo (Madrid: Alianza Editorial, 1996).
3. Jacqueline Barnitz, *Twentieth-Century Art of Latin America* (Austin: University of Texas Press, 2001), 132.
4. Cecilia Buzio de Torres, "La Escuela del Sur: La asociación de arte constructivo, 1934–1942", en Mari Carmen Ramírez, ed., *La Escuela del Sur: El Taller Torres-García y su Legado* (Madrid: Museo Nacional Centro de Arte Reina Sofía, 1991), 23; véase también pasajes de Joaquín Torres-García, *Metafísica de la prehistoria indoamericana* (1939).
5. Buzio de Torres, 23.
6. No está claro si Torres-García era conocedor del sistema de construcción inca basado en el trabajo *mit'a.* Su estudio del arte andino trascendía el ámbito de la estética y, según puso de manifiesto César Paternosto, había leído con atención la obra del etnohistoriador Luis E. Valcárcel. Véase

César Paternosto, *The Stone and the Thread: Andean Roots of Abstract Art,* trad. de Esther Allen (Austin: University of Texas Press, 1996), 219.
7. Rebecca Stone-Miller, *Art of the Andes from Chavín to Inca* (Londres: Thames and Hudson, 1995), 194.
8. Krauss, 18–19.
9. Jacqueline Barnitz, "An Arts and Crafts Movement in Uruguay: El Taller Torres-García", en Ramírez, ed., *El Taller Torres-García,* 143.
10. Para más información sobre este tema, véase James Clifford, "On Ethnographic Surrealism" (1981), en *The Predicament of Culture: Twentieth-Century Ethnography, Literature, and Art* (Cambridge, Mass.: Harvard University Press, 1988), 117–51; para una traducción al español, véase James Clifford, *Dilemas de la cultura: antropología, literatura y arte en la perspectiva posmoderna,* trad. de Carlos Reynoso (Barcelona: Gedisa, 1995).

Joaquín Torres-García
Composición constructiva 16, 1943
Óleo sobre cartón
43.2 × 64.5 × 0.3 cm
Colección Patricia Phelps de Cisneros
1997.33

En 1943 Joaquín Torres-García fundó el Taller Torres-García (TTG), en el que impartía clases de geometría, de estructura y sobre los significados de los símbolos místicos. Realizada ese mismo año, *Composición constructiva 16* (lámina 2) combina cuadrículas y pictogramas y ejemplifica el estilo maduro de Torres-García, basado en un sistema teórico—el "Universalismo Constructivo"—que había ido formulando desde el inicio de la década de 1930. Torres-García creía que él y sus discípulos podían crear un arte que tuviera sentido eternamente (lo universal) para todos aquellos que lo contemplaran, estudiando e incorporando las estructuras geométricas básicas (lo constructivo) de los mundos antiguo y moderno. *Composición constructiva 16,* que fusiona elementos precolombinos, símbolos masónicos y objetos de la vida contemporánea, encarnaba esos preceptos y probablemente habría servido como modelo para los artistas del TTG.

Torres-García empezó a desarrollar el concepto de Universalismo Constructivo cuando residió en París, entre 1926 y 1932. Allí trabó amistad con artistas como Piet Mondrian (1872–1944) y Theo van Doesburg (1883–1931), impulsores de un arte totalmente geométrico al que denominaron Neoplasticismo. Aunque Torres-García apreciaba el valor espiritual que los neoplasticistas asignaban a las formas geométricas, rehusó alinearse por completo en su círculo artístico. A su vez, los neoplasticistas criticaron a Torres-García por incorporar imágenes figurativas a su obra, que ellos consideraban que interferirían con la geometría "pura" de la retícula. Incluso un estrecho amigo de Torres-García, el pintor Jean Hélion, protestó en 1930 afirmando que "la geometría es una cosa y la humanidad otra cosa distinta; mezclarlas es antimatemático, además de antihumano".[1] Pero Torres-García sostenía que los pictogramas, al igual que la cuadrícula, eran en sí mismos estructuras intemporales; creía que reflejaban las formas básicas en que los humanos visualizan y organizan el mundo que les rodea. En su tratado *Metafísica de la prehistoria indoamericana* (1939), Torres-García afirma

que el hombre "ordena no sólo su pensamiento, sino también todo aquello que ve, estableciendo relaciones perfectamente polarizadas. Por este motivo podría decirse que, para el primitivo, *pensar es geometrizar*".[2]

Así, la intención de Torres-García con los pictogramas de *Composición constructiva 16* era conectar de nuevo al artista y al espectador con una tradición de arte geométrico y una forma de pensar que se remonta a las primeras civilizaciones humanas. El fondo gris, de color semejante a la piedra, expresa una idea de permanencia y pretende recordar los antiguos monumentos de América del Sur. Y el pictograma del sol radiante—que Torres-García y sus alumnos incorporaban con frecuencia a sus obras— denota la reverencia por Inti, la deidad inca.[3] Hoy podemos considerar estas pinturas, que reflejan el primitivismo de América Latina e idealizan la cultura precolombina, como algo problemáticas. En su momento, sin embargo, Torres-García respetó con convicción el arte antiguo y las diferencias culturales, al tiempo que exteriorizaba su prevención para con las copias superficiales del arte antiguo y folclórico. "Imitar o copiar lo típicamente folclórico es un error", escribió, "porque no es ahí donde encontramos el alma de las cosas, sino más bien en el carácter y en la estructura de su organización plástica".[4] Al aplicar el Universalismo Constructivo, Torres-García reduce un pez, un barco de dos mástiles, un ancla, un hombre junto a una pala, a poco más que sus componentes estructurales más elementales.

Torres-García no pretendía que el espectador interpretara estos pictogramas como si de jeroglíficos se tratara. Más bien dejaba el significado de sus formas abierto de algún modo a distintas interpretaciones, disponiéndolas según su intuición personal de equilibrio y composición. En *Composición constructiva 16,* la cuadrícula negra—que el artista pintó a mano alzada— posee una estructura más bien orgánica, con celdas variadas e irregulares. Los pictogramas llenan las celdas con un abanico de formas que Torres-García había repetido en sus pinturas y esculturas desde la década de 1930; su aplicación era casi un ritual.

Algunos de los símbolos esotéricos de *Composición constructiva 16* están vinculados a la masonería. Junto con el pintor español Luis Fernández, Torres-García había visitado una logia masónica cuando vivía en París.[5] El artista apreciaba el modo en que los masones usaban los símbolos relacionados con la arquitectura para representar sus creencias más sagradas. En *Composición constructiva 16,* las estructuras arquitectónicas de la antigüedad (el acueducto o arco de triunfo que se halla en el centro), así como las herramientas de albañil (el martillo situado en el extremo derecho y el yunque que aparece sobre la guitarra) sugieren el poder constructivo del hombre y de Dios—a quien los masones se refieren como "El Gran Arquitecto del Universo"—. Otros números y símbolos masónicos, como el pentagrama y el número cinco, suscitan también asociaciones entre lo mundano y lo espiritual.

Para Torres-García, lo que definía la modernización no era el desarrollo industrial, sino la recuperación de la espiritualidad dentro de la ciudad. En el centro de *Composición constructiva 16* incorpora el nombre de la ciudad en la que realizó la pintura, Montevideo, no sólo como referencia autobiográfica, sino también porque admiraba la forma de la palabra. En 1935 explicó que el nombre de la ciudad pronosticaba su inevitable grandeza: "El hombre en esta ciudad es tan excepcional como la propia ciudad, con esas diez letras en una hilera, que ni sobresalen ni caen, de igual tamaño e inquietantes en su pura falta de expresión: MONTEVIDEO."[6] Torres-García había regresado al Uruguay resuelto a hacer de Montevideo un centro artístico de primer orden. En la parte inferior derecha de la pintura (a la izquierda del pentagrama), una cruz marcada con una "N"—como una rosa de los vientos—alude al objetivo de Torres-García de reorientar el mundo del arte, en el seno del cual América del Sur habría alcanzado una posición dominante. En varios dibujos invirtió literalmente el mapa para destacar la posición geográfica de Montevideo. En esta línea, observó: "Nuestra brújula [...] apuntará irremediablemente y para siempre hacia el Sur, hacia nuestro polo. Cuando los barcos zarpen de aquí para viajar al norte, *viajarán hacia abajo, no hacia arriba* como antes".[7]

Inicialmente, los artistas de Montevideo abrazaron la idea de Torres-García sobre el Universalismo Constructivo. Y a pesar de que a finales de la década de 1930 menguó el apoyo del que gozaba, *Composición constructiva 16* señala una época en la que Torres-García había vuelto a dedicarse al estudio y propagación del Universalismo Constructivo. A través de conferencias y manifiestos y de la publicación de la revista *Círculo y cuadrado,* siguió promoviendo sus ideas sobre el arte abstracto. En particular, en el TTG instruía a jóvenes artistas, examinaba su obra cada semana y les familiarizaba con la historia del arte europeo e indoamericano. La propia obra de Torres-García revela su búsqueda sin tregua de la armonía cultural y el deseo de integrar distintos principios artísticos y espirituales.

Michael Wellen
Traducción de Jordi Palou

Notas

1. Jean Hélion, "Les problèmes de l'art concret—art et mathématiques", *Art Concret* [París] no. 1 (1930). Citado en Margrit Rowell, "Order and Symbol: the European and American Sources of Torres-García's Constructivism", en *Torres-García: Grid–Pattern–Sign; Paris–Montevideo 1924–1944* (Londres: Arts Council of Great Britain, 1985), 13.

2. Edición original: Joaquín Torres-García, *Metafísica de la prehistoria indoamericana* (Montevideo: Asociación de Arte Constructivo, 1940). Extractos reproducidos y traducidos al inglés en Mari Carmen Ramírez, ed., *El Taller Torres-García: The School of the South and its Legacy* (Austin: University of Texas Press, 1992), 74.

3. En su *Metafísica de la prehistoria indoamericana*, Torres-García trata sobre Inti y la relevancia de este dios para los sudamericanos contemporáneos. De este modo, afirma: "Si hoy podemos decir que Inti (el Sol) es nuestro padre, y que nuestra Madre es la Tierra, no nos limitamos a imitar, puesto que siempre lo hemos creído; formaba parte de nuestra concepción religiosa de la vida." En Ramírez, ed., 72.

4. Publicado originalmente en Joaquín Torres-García, "El nuevo arte de América", *Apex* [Montevideo] 1 (julio 1942). Traducido al inglés y reproducido en Ramírez, ed., 79.

5. Jacqueline Barnitz, *Twentieth-Century Art of Latin America* (Austin: University of Texas Press, 2004), 129.

6. Originalmente una conferencia de Torres-García pronunciada en 1935, el texto fue publicado en Joaquín Torres-García, *Universalismo constructivo: contribución a*

la unificación del arte y la cultura de América (Montevideo, 1944). Traducido al inglés y reproducido como "The School of the South" en Ramírez, ed., 55.

7. Torres-García, *Universalismo constructivo*, en Ramírez, ed., 53.

Rhod (Carlos María) Rothfuss
Sin título (Arlequín), 1944
Óleo sobre tela
176 × 86.5 × 2.5 cm
Colección Patricia Phelps de Cisneros
1998.38

Esta enigmática obra (lámina 3), algo desgarbada y probablemente inacabada es, a pesar de ello, un importante "eslabón perdido" en la evolución del arte abstracto en la región del Río de la Plata. Si esta pintura, como argumentaré, data de mediados o finales de 1945, muy posiblemente se trata del *marco recortado* proto-Madí más temprano del que se tiene noticia. Las repercusiones de esta obra para la historia—aun no escrita—de la abstracción geométrica en Buenos Aires son muy significativas, y proporcionan la piedra angular sobre la cual edificar una historia más exacta de los años—poco comprendidos, aunque cruciales—que median entre la publicación de *Arturo* en 1944 y la fundación del movimiento Madí en agosto de 1946.

La mejor pista contextual para fechar esta obra es una fotografía de la exposición/evento *Art Concret–Invention* celebrada en el domicilio del psicoanalista Enrique Pichón-Rivière el 8 de octubre de 1945. Esta fue la primera exposición de los artistas que al año siguiente acabarían formando el movimiento Madí: Carmelo Arden Quin, Gyula Kosice y Rhod (Carlos María) Rothfuss. En la fotografía de grupo tomada en esta ocasión, en el fondo puede verse una pintura que comparte algunas semejanzas con esta obra sin título en su temática semifigurativa y marco recortado.[1] Rothfuss empleó una obra muy parecida, basada en una guitarra, para ilustrar su texto/manifiesto "El marco: un problema en el arte contemporáneo", publicado en *Arturo*.

Existe una clara diferencia entre estas obras semifigurativas, de inspiración cubista, y las conocidas obras geométricas y bien definidas de Rothfuss de finales de los años cuarenta y principios de los cincuenta. No obstante, la antedatación endémica de estas obras geométricas más racionalistas (fechadas como si hubieran sido realizadas a mediados de la década de 1940) ha causado una gran confusión en relación con la historia y el desarrollo del movimiento Madí. Asimismo, la disparidad entre la ambiciosa y optimista denuncia de lo figurativo y el Cubismo realizada por Rothfuss en las páginas de *Arturo* y la obra que colocó junto a un Mondrian para mostrar la solución que proponía frente a las limitaciones del marco convencional, no han hecho sino aumentar dicha confusión. Todos estos factores sugieren que el marco recortado geométrico no nació completamente formado en las páginas de *Arturo* en 1944, ni en las primeras exposiciones *Arte Concreto–Invención* de 1945, sino que más bien, como sucedió en numerosos movimientos de vanguardia, los textos y ambiciones de estos jóvenes artistas iban muy por delante de su producción visual real.

Sin título (Arlequín)[2] difiere de obras posteriores de marco recortado realizadas por Arden Quin, Maldonado o incluso el propio Rothfuss, en que el marco irregular no señala el límite de la composición geométrica sobre la tela. Si bien en un principio el perfil del marco parece no guardar una relación directa con la composición semiabstracta del interior, de hecho las relaciones entre ambos elementos son bastante sutiles y el marco irregular crea incluso una especie de contrapunto que equilibra los planos pintados. Podemos ver un ejemplo de este diálogo un tanto juguetón entre forma pintada y marco recortado en la forma pintada que hay en la parte superior izquierda, que crea un ángulo que se hace eco del que presenta el marco en el centro, a la derecha, así como de la forma pintada a lo largo de la parte inferior. Todos estos diálogos formales, así como los complejos planos visuales de las formas que se solapan, crean un efecto casi barroco en su equilibrio de fuerzas opuestas. Más que una negación del ilusionismo visual (un tema que en la misma época debatían Tomás Maldonado y otros), esta obra parece explotar plenamente las posibilidades creadas por el ilusionismo y la perspectiva óptica dinámica.

Un caprichoso sentido del humor—particularmente en la elección de la temática—caracteriza a *Sin título (Arlequín)*. La inclusión del sombrero curvado y algo estrafalario hace que esta composición aparentemente abstracta tenga un carácter semirreferencial. Para un artista que criticaba a otros pintores europeos como Mondrian por no ser *suficientemente* abstractos, este salto referencial a una de las temáticas favoritas de la primitiva pintura moderna parece atípica. Hay dos posibilidades de interpretar este aparente paso hacia atrás: una es centrar la atención en la distancia entre las proposiciones teóricas y prácticas del artista, y la otra es subrayar un irónico sentido del humor que parecería estar reñido con la imagen común de Rothfuss como el más serio y riguroso de los artistas del grupo Madí. Naturalmente, la verdad probablemente se encuentre en una combinación de ambos factores: era más fácil identificar los problemas y contradicciones de la vanguardia europea que hallar soluciones prácticas, y por otra parte es posible que el enigmático Rothfuss, un artista sobre el que no se sabe casi nada, fuera capaz de recurrir a un cierto humor visual irónico y autocrítico. La escasez de información fiable sobre Rothfuss, uno de los pocos artistas de su generación que falleció joven, lo ha convertido en una especie de mito, un intelectual legendario no empañado por las ulteriores luchas intestinas entre los miembros originales del movimiento.[3]

En cualquier caso, esta obra, a pesar de todas sus aparentes contradicciones, constituye un útil recordatorio de que la historia no es siempre tan lineal e inevitable como parece en retrospectiva. *Arturo* dio pie a un amplio abanico de ideas y propuestas, desde el Expresionismo Abstracto de la cubierta de Maldonado a la poesía mítico-surrealista de Arden Quin, pasando por las proclamas de ciencia ficción de Kosice. Si hoy leemos el artículo de Rothfuss sobre el marco recortado como fundamento teórico para una ulterior investigación racionalista sobre los límites de la abstracción, deberíamos tener presente que el texto no sólo es vago en sus propuestas sino

que también pinturas como *Sin título (Arlequín)* ponen de manifiesto que el camino hacia el futuro de hecho era algo irregular.

Gabriel Pérez-Barreiro
Traducción de Jordi Palou

Notas
1. Gyula Kosice ha confirmado la autoría de Rothfuss, entrevista con el autor, abril 1993, Buenos Aires.
2. El título *Arlequim* (Arlequín en portugués) parece haber sido añadido recientemente. La obra en sí carece de título, y es probable que el subtítulo se le añadiera cuando pasó a formar parte de la Colección Patricia Phelps de Cisneros.
3. Mario Sagradini, "Rhod Rothfuss: vida y producción del artista uruguayo", proyecto de investigación no publicado, archivo del Blanton Museum of Art, y Horacio Faedo, "Un momento con Rothfuss: memorias de Horacio Faedo, dictado a Gabriel Pérez-Barreiro en Colonia del Sacramento, Uruguay 7/6/93", archivo del autor, 2 págs.

Raúl Lozza
Relief [Relieve], 1945
Caseína sobre madera y metal pintado
40.6 × 53.3 × 3.8 cm
Colección Patricia Phelps de Cisneros
1998.52

Juan Melé
Coplanal, 1947
Panel pintado sobre plexiglás
87.9 × 109.9 × 2.9 cm
Colección Patricia Phelps de Cisneros
1998.53

A pesar de que en un principio estas dos obras (láminas 4 y 5) parecen ser algo distintas en construcción y carácter, ambas son expresiones clásicas de la "forma coplanal" que la Asociación Arte Concreto–Invención promovió entre 1946 y 1948. Tras el desarrollo del *marco recortado* en 1944–1945, los artistas de la recién formada Asociación Arte Concreto–Invención, de la que formaban parte tanto Lozza como Melé, debatieron lo que percibían como las limitaciones del marco recortado hasta que, en 1946, propusieron el *coplanal* como sustituto. El análisis más completo del coplanal que se efectuó en aquel entonces fue el artículo de Tomás Maldonado "Lo abstracto y lo concreto en el arte moderno", publicado en *Arte Concreto Invención* (agosto 1946).

En este artículo, Maldonado empieza su crítica del marco irregular con el reconocimiento de que cualquier marca sobre una superficie generará una ilusión óptica figura-fondo: "Mientras haya una figura sobre un fondo, ilusoriamente exhibida, habrá representación".[1] Curiosamente, casi dos décadas más tarde, Clement Greenberg plantearía la pintura abstracta en términos similares: "La primera marca realizada en una tela destruye su lisura completa y literal, y el resultado de las marcas hechas sobre ella por un artista como Mondrian es todavía una especie de ilusión que sugiere algo así como una tercera dimensión".[2] Lo que tanto Maldonado como Greenberg buscaban era un arte completamente abstracto y no figurativo que no creara ningún tipo de representación ni ilusión visual. Para Maldonado y los artistas de la Asociación, los patrones contenidos en las pinturas de marco recortado de 1944–1945 (y, de hecho, en toda la pintura abstracta europea hasta la fecha) tenían aun un

carácter ilusionista y, por lo tanto, fracasaban en su propósito declarado de hacer obras de arte plenamente objetivas y concretas. El grupo Madí, por el contrario, no estaba interesado en esta búsqueda extrema de la pureza absoluta, concentrándose en cambio en las posibilidades lúdicas, vanguardistas y cuasidadaístas que permitían los marcos recortados.

El principio que se halla tras el coplanal es la separación física de las formas en el espacio. Al dar a cada forma su propia forma y color, los artistas de la Asociación creían que así evitaban por completo la ilusión visual. El coplanal es la afirmación más extrema del deseo de los artistas concretos argentinos de reducir el arte a sus elementos más severos y objetivos (antiilusionistas). Los estatutos de la Asociación, de 1945, lo plantean en términos que no dejan lugar a dudas: "La separación en el espacio de los elementos constitutivos, coplanariamente dispuestos, es lo definitorio de la estructura plástica concreta".[3]

La obra de Lozza presenta un coplanal clásico tal como se habría expuesto en 1946: formas de madera pintadas, separadas en el espacio por alambres rígidos. Dados los problemas de almacenar y manejar estas obras, muy pocas de ellas se han conservado. Los estudiosos suelen aceptar que *Función blanca* (colección privada, Buenos Aires), de Alberto Molenberg, fue el primer coplanal, el único reproducido en *Arte Concreto Invención* junto al artículo de Maldonado.[4] Si, por consiguiente, aceptamos que la primera expresión documentada de lo coplanal tuvo lugar en agosto de 1946, con el texto de Maldonado ejerciendo como manifiesto, parecería más probable que Lozza realizara esta obra en la más tardía de las dos fechas inscritas en el reverso: 1946. Según esta misma argumentación, el título original parecería ser *N.º 30* en lugar de *Relieve*.

Mientras que la composición de la obra de Lozza parece, a primera vista, ser aleatoria, de hecho su cuidadosa construcción crea relaciones formales precisas entre las piezas individuales. Las piezas individuales se relacionan las unas con las otras a través del espacio vacío; los bordes resuenan o son análogos o se intersecan unos con otros de maneras bastante sutiles. Para los artistas de la Asociación, el coplanal nunca podía ser móvil, puesto que los artistas planificaban cuidadosamente las relaciones entre las partes de las obras. Los artistas del grupo Madí, en cambio, produjeron varios coplanales móviles, en los que la interacción con el espectador era más importante que las relaciones formales precisas. Esta diferencia apunta a un profundo desacuerdo filosófico entre ambos grupos, que va mucho más allá de una mera expresión de la conocida animadversión personal entre sus respectivos líderes.

Mientras que la obra de Melé es ahora una construcción sobre una base transparente, hay indicios que apuntan a que, al igual que el *N.º 30* de Lozza, originalmente Melé conectó las distintas piezas con alambres o varillas. El artista ha descrito cómo posteriormente montó la obra sobre acrílico para protegerla.[5] Por otra parte, las formas individuales tienen todas agujeros de tornillos en el reverso, lo que indica una estructura anterior. Un dibujo preparatorio de esta obra muestra también líneas punteadas que conectaban las distintas formas. La inscripción

sugiere que el título original de esta obra era *N.º 15,* lo que reafirma las ambiciones cuasicientíficas de objetivación de estos artistas. A pesar de que el coplanal aspiraba a ser no sólo absoluto en su forma y composición, sino también colectivo (los artistas de la Asociación originalmente no firmaban sus obras, y acordaron trabajar colectivamente), existen significativas diferencias compositivas entre los distintos artistas. Mientras que Lozza se convirtió en un maestro de la composición centrífuga implícita en *N.º 30* y la desarrolló como el principio central de su movimiento perceptista (lámina 10) a partir de 1947, la obra de Melé parece más insegura, con una colocación aparentemente más azarosa de las formas individuales.

Durante un breve periodo de poco más de un año (entre mediados de 1946 y finales de 1947), los artistas de la Asociación Arte Concreto–Invención sintieron que, con el desarrollo del coplanal, habían logrado su propósito de hacer un arte plenamente objetivo y concreto. No obstante, a medida que creaban más obras coplanales, pronto se dieron cuenta de que, en su búsqueda de la autonomía absoluta de la forma, habían pasado por alto un hecho básico sobre lo coplanal: el espacio vacío intermedio estaba supeditado a su entorno. En otras palabras, esta misma obra colocada sobre una pared azul crearía relaciones formales diferentes que si se colocaba sobre una pared amarilla, por no hablar de un fondo decorado con algún motivo. La dependencia respecto a las circunstancias en que la obra debía exhibirse debilitaban alcanzar una afirmación completamente autónoma. A pesar de que esto podría parecer un punto menor para aquellos de nosotros que estamos habituados al cubo blanco como foro dominante para la presentación de la obra de arte, para estos artistas se trataba de un defecto catastrófico.

La combinación de este problema formal con la hostilidad creciente del Partido Comunista frente a estos artistas abstractos utópicos desencadenó una profunda crisis en la Asociación. En 1948 la mayoría de artistas (Maldonado, Alfredo Hlito, Lidy Prati, Juan Melé) habían adoptado un Arte Concreto más ortodoxo, en la línea de Max Bill, con marcos convencionales, y se interesaron por el diseño gráfico o industrial. Raúl Lozza, sin embargo, siguió desarrollando los principios de lo coplanal en su propio movimiento, el Perceptismo. Podemos considerar el breve periodo de lo coplanal como la expresión más radical y sintética del deseo de los artistas abstractos argentinos de alentar una "relación directa con las cosas y no con las ficciones de las cosas" de matriz marxista y utópica.[6]

Gabriel Pérez-Barreiro
Traducción de Jordi Palou

Notas

1. Tomás Maldonado, "Lo abstracto y lo concreto en el arte moderno", *Arte Concreto Invención* [Buenos Aires], agosto 1946, s. pág.
2. Clement Greenberg, "Modernist Painting" (1961), en Francis Frascina y Jonathan Harris, eds., *Art in Modern Culture: An Anthology of Critical Texts* (Londres: Phaidon, 1992), 311–12.3. Estatutos de la Asociación Arte Concreto–Invención (septiembre de 1948), documento no publicado. Archivo del autor, s. pág.
4. Si se examina con detenimiento, puede verse que el coplanal de Raúl Lozza reproducido en el mismo artículo es un dibujo a lápiz y no un objeto fotografiado.
5. Entrevista con el autor, mayo 1993, Buenos Aires.
6. Varios autores, "Manifiesto invencionista", publicado originalmente en el folleto para la *Exposición Asociación Arte Concreto Invención,* Salón Peuser, Buenos Aires, marzo 1946.

Juan Melé
Marco recortado n.º 2, 1946
Óleo sobre cartón piedra
71 × 46 × 2.5 cm
Colección Patricia Phelps de Cisneros
1997.102

Es posible pensar *Marco recortado n.º 2* (lámina 6) de Juan Melé como una sistematización analítica del quiebre de la estructura tradicional del cuadro, proceso que tuvo desarrollo en la escena porteña a mediados de los 40. El marco recortado, base teórica propuesta por Rhod Rothfuss en la revista *Arturo* (1944), implicó la ruptura de la ortogonalidad del cuadro—la "ventana" abierta al mundo de la visión renacentista—a la par que disparaba un nuevo concepto de obra de arte. Se imponía un objeto plástico cuyo ordenamiento se basaba exclusivamente en las condiciones objetivas de su realidad material. Sin embargo, es preciso comprender la propia revista *Arturo* y las primeras experiencias de marco recortado como desarrollos embrionarios que presentaron fisuras y contradicciones tanto en la conceptualización teórica como en sus realizaciones plásticas.

El marco recortado se constituyó en el eje de las investigaciones realizadas por los distintos grupos surgidos en 1945 a partir del núcleo inicial de *Arturo.* Este fraccionamiento estuvo provocado tanto por diferencias teórico-estéticas como por disputas personalistas entre sus miembros: se constituyó el grupo Madí—liderado en sus principios por Carmelo Arden Quin, Gyula Kosice y Rothfuss—y la Asociación Arte Concreto–Invención bajo la guía de Tomás Maldonado y Edgar Bayley, a la cual Juan Melé se integró en octubre de 1946. Fue precisamente entre los artistas de la Asociación que la propuesta del marco recortado decantó en una investigación sistemática sobre las posibilidades de la observancia no figurativa y los límites de la abstracción.

Hacia 1944 Juan Melé asistía a la Escuela Nacional de Bellas Artes "Prilidiano Pueyrredón" y participaba de la actividad estudiantil editando la revista *Inquietud,* órgano que agrupaba formaciones como CEBA (Centro de Estudiantes de Bellas Artes) y MEBA (Mutualidad de Estudiantes de Bellas Artes). En esta publicación publicó artículos como "Vivamos la hora" y "Hacia una conciencia histórica" en los cuales exaltaba el rechazo de los artistas a la guerra y a los totalitarismos.[1] Si bien *Inquietud* no adhería a la teoría marxista ni planteaba la carga de innovación estética presente en *Arturo,* ambas revistas compartían la preocupación por el compromiso social del arte. Este interrogante común a la generación del 40 encadenó la actividad de Melé durante los primeros años de esta década con su posterior adscripción a la propuesta concretista. En este período Melé trabó vínculos con artistas

activos en esas formaciones e instituciones estudiantiles como Albino Fernández, Gregorio Vardánega y Virgilio Villalba con quienes compartía un taller en la calle Juan B. Justo.

El contacto de Juan Melé con la Asociación Arte Concreto–Invención se estableció por medio de Tomás Maldonado, ex-compañero de la Escuela de Bellas Artes, quien a fines de 1945 lo invitó a una exposición de Arte Concreto en su taller de la calle San José. El propio Melé relata en sus memorias esta experiencia:

En mí el impacto fue tremendo . . . yo estaba familiarizado con el geometrizado cubismo, pero no con las obras constructivas; de estarlo, se hubiera amortiguado el choque ante éstas, no sólo puras y geométricas, sino que además presentaban una estructura nueva para mí: el "marco recortado".[2]

A partir de ese momento sería uno más de los miembros de la Asociación: su producción, con los Homenajes a Mondrian, los marcos recortados y seguidamente los coplanales, está en la línea de las investigaciones del grupo.

La primera aparición oficial de Melé como integrante de la Asociación fue en la exposición realizada en la Sociedad Argentina de Artistas Plásticos en octubre de 1946 y desde ese momento participó en todos los emprendimientos del grupo.[3] El artículo que publicó en el segundo número de *Arte Concreto Invención,* órgano de la Asociación, marcaría un distanciamiento con su antigua profesora: la escultora rumana Cecilia Marcovich.[4] Melé se había acercado a las enseñanzas de Marcovich en 1940 buscando salvar los vacíos de la formación académica. En aquel momento, Melé estaba interesado en comprender a fondo problemas de composición, la división del cuadro, la sección áurea y las estructuras armónicas. En este sentido, tanto la lectura de *Esthétique des proportions dans la nature et dans les arts* de Matila Ghyka como los escritos de Leonardo da Vinci y Luca Paccioli le permitieron acercarse a un sistema compositivo basado en la matemática como fuente de armonía.[5]

Aunque esta apuesta concretista por lo nuevo parecía irreconciliable con la tradición, las antiguas herramientas y el nuevo utillaje estético lograron conjugarse de un modo particular en la obra de este artista concreto. Analicemos detenidamente *Marco recortado n.° 2.*

Esta obra, orientada a "concretar el espacio y las formas"[6] se estructura a partir de un sólido sistema de proporciones. En una vista general este trabajo se presenta como un entramado de planos coloridos; la visión reticular está reforzada por las líneas negras horizontales y verticales cuyas fugas se proyectan fuera de la composición. El módulo central de esta construcción es un cuadrilátero al que se ensamblan cuatro "recortes" en cada uno de sus lados configurando el total compositivo. Precisamente la articulación de estas cinco figuras disímiles genera la estructura irregular. La confección de este cuadrilátero y las relaciones que se establecen entre las distintas secciones creadas por las líneas y los planos se constituyen a partir de la utilización de la proporción áurea. Aunque sin una exactitud extrema, la razón 1,6 es la base de las decisiones morfológicas que definen esta obra.

Marco recortado n.° 3 de este artista (colección Museo Sívori, Buenos Aires) presenta una propuesta similar; tanto el procedimiento como la denominación de las obras dan cuenta del interés de Melé por la utilización de conceptualizaciones científicas en el campo del arte.

El número de oro, aquel que los clásicos renacentistas habían aplicado para reconstruir un reflejo del mundo exterior, se transformaba en la producción de este artista en una de las herramientas que permitía explorar un sistema replegado sobre su propia materialidad.

María Amalia García

Notas
1. Juan Melé, "Vivamos la hora", *Inquietud,* no. 1, diciembre 1944, 12–13; Juan Melé, "Hacia una conciencia histórica", *Inquietud,* no. 2, julio 1945, 7–8.
2. Juan N. Melé, *La vanguardia del '40. Memorias de un artista concreto* (Buenos Aires, Ediciones Cinco, 1999), 87–88.
3. *Exposición Arte Concreto Invención,* Sociedad Argentina de Artistas Plásticos [Buenos Aires] 11 al 23 de octubre de 1946. En la inauguración Raúl Lozza expone "Lo inventivo como realidad concreta en el arte".
4. Juan Melé, "En torno al taller Escuela de C. Marcovich", *Arte Concreto Invención* [Buenos Aires] no. 2, diciembre 1946, 8.
5. Gabriela Siracusano, *Melé* (Buenos Aires, Fundación Mundo Nuevo, 2005).
6. Tomás Maldonado, "Lo abstracto y lo concreto en el arte moderno", *Arte Concreto Invención* [Buenos Aires] no. 1, agosto 1946, 5–7.

Alejandro Otero
Cafetera azul, 1947
Óleo sobre tela
65.1 × 54 cm
Colección Patricia Phelps de Cisneros
1998.23

Líneas coloreadas sobre fondo blanco, 1950
Óleo sobre tela
130 × 97 cm
Colección Patricia Phelps de Cisneros
1990.22

Cafetera azul (lámina 7) y *Líneas coloreadas sobre fondo blanco* (lámina 8) representan el compromiso de Alejandro Otero con la expresión de los ideales utópicos a través de la abstracción durante su prolongada estancia en París, entre 1945 y 1951. Estas pinturas al óleo no sólo reflejan la activa implicación de Otero en los debates teóricos de las vanguardias artísticas del París de la posguerra, sino que también son un anticipo de su papel pionero en el desafío a las tradiciones artísticas venezolanas. A partir de sus tempranas investigaciones sobre la abstracción cubista y la teoría existencialista, Otero halló un nuevo lenguaje de línea y color con el que expresar una libertad espiritual de carácter muy personal. Dicha expresión sería el punto de partida para una forma de abstracción específicamente venezolana. Observando el desarrollo artístico de Otero con *Cafetera azul* y *Líneas coloreadas,* así como el contexto histórico de esas obras, se advierte el carácter utópico subyacente a la evolución del artista.

Otero pintó *Cafetera azul* a poco de su llegada a París con una beca. En numerosas cartas al

crítico de arte e historiador Alfredo Boulton, el artista escribía entusiasmado sobre el hecho de poder ver de primera mano las obras de los maestros modernos en una ciudad cargada de energía por la fiebre de la renovación artística. En noviembre de 1946, Otero escribió que estaba haciendo algo "tan otra cosa" que sería de una gran importancia para Venezuela.[1] *Cafetera azul* es un bodegón de una serie de Cafeteras a las que Otero se refería como "tan otra cosa". Con esta serie, Otero empezó su fase inicial de la "desnaturalización de los objetos".[2]

Aunque inspirado por Cézanne durante sus estudios en Caracas, a la llegada de Otero a París, Picasso se convirtió en "su segundo Dios". *Cafetera azul* refleja la decisiva influencia de Picasso en la pintura de Otero por aquel entonces, por lo que se refiere a la fragmentación cubista del espacio, la multiplicidad de puntos de vista, el achatamiento de las superficies y la representación esquemática del objeto en los bodegones. El estilo personal de Otero se revela en la representación y la reducción de la estructura de la cafetera a sencillas líneas negras que empujan dinámicamente al observador y tiran de él, dentro y fuera del espacio insinuado. El azul cobalto claro de la cafetera, sobre capas ligeras de marrón y azul turbios, perfila y refuerza un sentido del ritmo y de incertidumbre espacial.

A finales de 1948, Otero redujo la forma del bodegón al esbozo más simple de líneas coloreadas o en blanco y negro. Las Cafeteras se convirtieron en objetos virtualmente inidentificables. Esas últimas Cafeteras anuncian la siguiente serie pictórica de Otero, Líneas inclinadas, de la que *Líneas coloreadas sobre fondo blanco* constituye un excelente ejemplo.

En *Líneas coloreadas,* el trabajo de Otero ya no está impulsado por el Cubismo, sino por un deseo de conseguir pintar lo que él denominaba la "nada" de Mondrian. Mientras que en *Cafetera azul* Otero hacía una clara referencia a la forma de la cafetera, en *Líneas* explora las teorías estéticas universalistas de Mondrian, el espiritualismo individual de Kandinsky y la filosofía existencialista entonces emergente en París. Otero creó con éxito una coherencia interna y un orden autónomo que establecían una libertad recién descubierta. Al romper con el uso de un objeto referencial, concibió un sistema independiente de valores en los que el color y la línea definen el espacio y el movimiento. En *Líneas coloreadas,* el tema es "nada", excepto el hecho de pintar en sí mismo. En una carta enviada a Boulton en febrero de 1950, Otero describió ese momento de su carrera como una fase en que trabajaba en varias telas "sin ninguna relación con la realidad". Las describe como "tan buenas" como sus pinturas figurativas, esperando con esta nueva obra "haber alcanzado la libertad de nuestro tiempo", punto desde el que "[la pintura] no puede más que expandirse".[3] Aplicando gruesas capas de pigmento blanco sobre vestigios de fragmentos azules, Otero reforzaba la materialidad de la superficie. Creó un sistema en que el color se transforma en línea, los contornos de la pintura en dibujo y la estructura interna transmite un orden pictórico. Estas opciones reflejan una muy personal expresión de libertad, que podría contrastar con la decisión con que otros artistas abstractos minimizan la

intervención personal del artista en la obra. Más aun, las superficies pintadas muestran intersticios en los que parecen flotar la luz y el espacio, y las líneas paralelas de color ofrecen un patrón rítmico que apunta al uso futuro, por parte de Otero, de las relaciones color/línea en su serie de Coloritmos.

Un examen de *Cafetera azul* y de *Líneas coloreadas sobre fondo blanco* en el contexto más amplio de los debates contemporáneos entre artistas, filósofos y críticos venezolanos ilumina nuestra comprensión del desarrollo de las obras. La temprana exposición de Otero, en 1949, de la serie de Cafeteras, en Caracas, supuso un hito para evaluar los significativos cambios que tenían lugar en la comunidad artística de Venezuela; también simbolizaba el compromiso del país con el universo artístico contemporáneo fuera del mundo académico de las instituciones culturales, como el Museo de Bellas Artes, los salones oficiales y las escuelas académicas de arte. Alfredo Boulton resumió la importancia de la exposición de las Cafeteras al decir que "despertó la conciencia y la presencia en Venezuela de una inquietud plástica que iba más allá de lo que en nuestro medio se había conocido".[4] Mientras que las Cafeteras parecen una respuesta al compromiso inicial de Otero con la vanguardia parisina, *Líneas coloreadas* es el resultado de una aplicación muy personal de las teorías de dicha vanguardia. Otero no sólo reaccionó a las teorías neoplásticas de los artistas de De Stijl, cuya obra vio en los Países Bajos a fines de 1949, sino que también encontró en las teorías existencialistas contemporáneas un modo de definir un futuro nuevo e independiente para los artistas latinoamericanos. El filósofo venezolano J.R. Guillent Pérez, cofundador de Los Disidentes, observó que los artistas y escritores venezolanos residentes en París en 1950 se convirtieron en copartícipes de la cultura occidental, al considerar el existencialismo como una forma de liberar a los artistas latinoamericanos de las limitaciones impuestas por las tradiciones estéticas europeas (al igual que sucedía con los artistas europeos). En particular, los aspectos nihilistas del existencialismo proporcionaron a los artistas los medios para ensalzar la preeminencia de la acción libre basada en la inexistencia previa de un orden, o "nada". Los venezolanos que vivían en París en 1950 podían servirse de ese punto de partida para situarse en pie de igualdad con sus colegas europeos y para aprovechar la oportunidad de pertenecer a su tiempo, en lugar de "nutrirse de cadáveres históricos".[5]

Desarrollando un método único de abstracción en *Líneas coloreadas,* basado en una primacía existencialista de la nada y de la libertad de acción, Otero creó más que un modo personal de expresión. Estaba proponiendo un camino para que los artistas latinoamericanos—y, en particular, los venezolanos—pudieran construir una estética independiente y contemporánea. Con esta visión utópica, Otero regresó a Caracas en 1952 para participar en uno de los intentos más optimistas de acercar al público los valores estéticos contemporáneos: la construcción de la Ciudad Universitaria con el arquitecto Carlos Raúl Villanueva. Mediante este y posteriores proyectos, Otero continuó encontrando más

expresiones expansivas de sus ideales utópicos sobre la abstracción.

Estrellita B. Brodsky
Traducción de Jordi Palou

Notas

1. Ariel Jiménez, *He vivido por los ojos: correspondencia Alejandro Otero/Alfredo Boulton, 1946–1974* (Caracas: Alberto Vollmer Foundation y Fundación Museo Alejandro Otero, 2000), 41.

2. José Blazo, *Alejandro Otero* (Caracas: Ernesto Armitano, 1982), 21.

3. Jiménez, *He vivido por los ojos,* 100.

4. Alfredo Boulton, *Historia de la pintura en Venezuela: Tomo III, Época contemporánea* (Caracas: Ernesto Armitano), 100.

5. J. R. Guillent Pérez, *Venezuela y el hombre del siglo XX* (Caracas: Ediciones Reunión de Profesores, 1966), 157.

Gyula Kosice
Escultura móvil articulada, 1948
Latón
165.1 × 30.5 × 1.3 cm
The Museum of Modern Art, New York, fractional and promised gift of Patricia Phelps de Cisneros in honor of Jay Levenson
321.2004

Las esculturas articuladas de latón de Kosice se encuentran entre las más logradas manifestaciones del nuevo espíritu subversivo que tuvo lugar en el Buenos Aires de mediados de la década de 1940, con reminiscencias dadaístas, transformación e interacción entre artista y espectador. La primera escultura de latón documentada de este tipo realizada por Kosice, aunque a una escala menor, aparece en la fotografía de grupo tomada en la primera exposición *Art Concret–Invention,* celebrada en el domicilio bonaerense del psicoanalista Enrique Pichón-Rivière, en octubre de 1945. Ese año, en Buenos Aires la pintura abstracta estaba todavía asimilando tentativamente el concepto del marco irregular, ilustrado a la perfección por la obra de Rothfuss *Sin título (Arlequín)* (lámina 3), comentada en este mismo catálogo. A pesar de que han sobrevivido pocos ejemplos materiales, las esculturas de Kosice de este periodo, varias de las cuales fueron documentadas fotográficamente por Grete Stern, encarnan algunas de las ideas más radicales y originales de la vanguardia argentina.[1]

Quizás Kosice sea mejor conocido por su escultura de madera *Röyi* (1944), que consiste en ocho piezas de madera torneada, unidas mediante bisagras de madera para configurar una escultura transformable. Al realizar *Escultura móvil articulada* (lámina 9), Kosice engoznó nuevamente una serie de elementos individuales con la intención de que el espectador los manipulara. No obstante, esta obra difiere de *Röyi* en que carece de base y, por consiguiente, de posición por defecto. *Röyi* tiende a caer de forma natural en la misma disposición compositiva, se ve mejor desde la parte frontal y casi siempre se muestra del mismo modo. No es el caso de la *Escultura móvil articulada,* que al ser manejada cambia de forma.

Uno de los aspectos más interesantes de esta escultura es el uso que hace de los materiales. Según Kosice, elaboró la obra a partir de las planchas de metal usadas para reforzar las carteras o bolsas de piel.[2] Los hermanos Kosice regentaban una pequeña marroquinería en Buenos Aires, y algunas de las primeras esculturas de Gyula, según las fotografías que de ellas realizara Grete Stern, parecen emplear materiales que podía haber encontrado en el taller: latón, resortes, corcho, etc. Aparte del mero ingenio y de la simplicidad de este proceso, los propios materiales apelan al deseo de transformar profundamente la naturaleza y la percepción de la creación artística en Buenos Aires. A lo largo del siglo XIX, y particularmente en las décadas de 1920 y 1930, el modelo del "artista refinado" fue un importante paradigma cultural para Buenos Aires. Las convenciones sociales requerían que cualquier artista que aspirara a entablar un diálogo con las tradiciones culturales avanzadas de Europa debía obtener fondos de los mecenas aristocráticos—como los Amigos del Arte—y viajar a Europa para aprender las últimas tendencias artísticas. A su regreso a Buenos Aires, el artista formaría parte de la elite cultural que se expresaba en revistas como *Martín Fierro* o *Sur.* De ese modo, los círculos culturales de elite argentinos comprendieron a grandes trazos los estilos de las vanguardias europeas. Por lo general, ignoraron algunas de las afirmaciones más radicales del deseo vanguardista de cambiar las condiciones de la relación del arte con la vida, como el Dadaísmo o el Futurismo, o bien domesticaron estas afirmaciones en un conjunto de elementos visuales, como en la obra de Emilio Pettoruti.

Vista así, la pura simplicidad e interactividad de la *Escultura móvil articulada* de Kosice sugiere un espíritu radicalmente novedoso en el arte argentino, que aspira a transformar las propias directrices del arte en lugar de limitarse a reemplazar un estilo por otro. Si comparamos la escultura de Kosice con cualquier escultura contemporánea realizada por algún otro miembro de la Asociación Arte Concreto–Invención, como Enio Iommi, también podemos ver cómo dos tendencias totalmente distintas estaban sirviéndose del lenguaje de la escultura constructivista en Buenos Aires. La refinada representación que hace Iommi de las direcciones en el espacio funcionan en un ideal clásico de escultura, aunque reducido a sus elementos más escuetos y elegantes. La escultura de Kosice, por el contrario, no busca la belleza o la expresión de valores absolutos, sino que más bien genera inestabilidad y una relación física directa con el espectador. Como tal, desafía los preceptos más tradicionales de la creación artística: la relación ideal entre obra de arte y espectador, en la que éste contempla un objeto realizado expresamente con dicho propósito. Las dimensiones de la *Escultura móvil articulada* son tales que manipularla requiere un considerable esfuerzo físico, lo que evita que el espectador alcance una distancia de contemplación cómoda y, por lo tanto, neutral.

A pesar de que las esculturas de latón de Kosice son anteriores a la formación del movimiento Madí en casi un año, plasman muchos de los principios que dicho movimiento desarrollaría posteriormente. El manifiesto Madí de 1946 define la escultura como "tridimensionalidad y ausencia de color. Forma total y sólidos con el entorno, con movimientos de articulación, rotación, cambio, etc." La idea del movimiento sería fundamental en la trayectoria de Kosice, particularmente en sus construcciones

hidrocinéticas de las décadas de 1960 y 1970. El movimiento también sería una idea primordial de la corriente neoconcreta brasileña de 1959, y las esculturas articuladas de Kosice de mediados de los años cuarenta prefiguraban muchas de las características formales de los Bichos de Lygia Clark, por ejemplo. Mientras que Clark basaba la interactividad de sus Bichos en exploraciones de la subjetividad psicológica y la teoría de la Gestalt, los artistas argentinos abordaban la interactividad desde un espíritu más anárquico y dadaísta, con ánimo provocador. Desde este punto de vista, sería erróneo asumir que el lenguaje de la abstracción geométrica siempre contiene ideales matemáticos, racionalistas y progresistas. Dawn Ades ha puesto de manifiesto las conexiones históricas entre el Constructivismo y el Dadaísmo a través de figuras como Kurt Schwitters y Theo van Doesburg,[3] una conexión que reapareció en la década de 1940 en Buenos Aires, donde en ocasiones los artistas pusieron el alfabeto formal del Constructivismo al servicio de la subversión de la propia idea del arte como expresión autónoma y absoluta.

Gabriel Pérez-Barreiro
Traducción de Jordi Palou

Notas

1. El recurso constante a la antedatación, la reconstrucción y la invención de obras de este periodo por parte de algunos artistas ha dificultado una mejor comprensión de la importancia de estas esculturas.
2. Entrevista con el autor, junio 1993, Buenos Aires.
3. Dawn Ades, *Dada—Constructivism* (Londres: Annely Juda Fine Art, 1984).

Raúl Lozza
Invención n.º 150, 1948
Esmalte sintético sobre madera
94 × 111.1 × 3.5 cm
Colección Patricia Phelps de Cisneros
1998.4

Todas las obras de Lozza posteriores a 1947 encarnan los principios que se hallan tras el movimiento que fundó, el Perceptismo. A pesar de que los especialistas sitúan el nacimiento del Perceptismo en 1947, año en que Lozza dejó de exponer con la Asociación Arte Concreto-Invención, no se presentó en público hasta octubre de 1949 con la *Primera exposición de pintura perceptista* en la Galería van Riel de Buenos Aires. Lozza publicó el primer número de la revista *Perceptismo: Teórico y Polémico* en 1950. Aunque en teoría el Perceptismo era un movimiento compuesto por varios miembros (dos hermanos de Lozza y el crítico de arte Abraham Haber), fue en gran parte una iniciativa personal de Lozza. La necesidad de crear un movimiento con un manifiesto, una revista y obras sin firmar refleja el fervor vanguardista y la búsqueda de una forma artística colectiva y universalista.

Mientras que la mayoría de artistas abstractos del Buenos Aires de la década de 1940 pasaron por un vertiginoso número de estilos y experimentos artísticos en un breve lapso de tiempo, la obra de Lozza después de 1947 destaca en solitario en su compromiso para con un conjunto de principios estéticos y estilísticos que sigue practicando hasta hoy. Por este motivo,

resulta casi imposible fechar la vasta producción de Lozza posterior a 1947 en términos de desarrollo estilístico. La mejor pista para fechar la composición de sus obras se encuentra en los dibujos que realiza para cada obra y en las reproducciones publicadas en su revista *Perceptismo: Teórico y Polémico* (1950–1953). El dibujo compositivo, fechado en 1948, para *Invención n.º 150* está enganchado en el reverso de la pintura, y el pie de foto que acompañaba a la publicación de esta imagen en 1950 fecha también la composición en 1948.[1]

Lozza rompió con la Asociación Arte Concreto-Invención justo cuando dicho grupo estaba discutiendo los problemas de la composición coplanal a finales de 1946. Mientras que Tomás Maldonado, Alfredo Hlito y otros regresaron al marco rectangular y se aproximaron estilísticamente al Arte Concreto suizo, Lozza intentó preservar las innovaciones desarrolladas en el *coplanal*.[2] Los artistas de la Asociación concebían el coplanal como una composición abierta y centrífuga, sin marco que limitara la composición ni la inscribiera en una "ventana" ilusionista. Mientras Lozza presentaba sus obras perceptistas, como *Invención n.º 150* (lámina 10), en un marco rectangular o cuadrado, el papel de dicho marco se oponía diametralmente al uso que hacían de él en aquel momento los artistas de la Asociación. Hlito, Maldonado, Lidy Prati y otros crearon composiciones que el marco normal delimitaba o determinaba, pero Lozza se limitaba a usar el marco como un campo de color, como un sustituto de la pared. De este modo, la construcción de Lozza del marco/soporte resolvía el problema que había atormentado al coplanal desde su desarrollo en 1946: la imposibilidad de controlar las relaciones compositivas y cromáticas entre formas cuando existe un espacio real entre ellas. El fondo azul de *Invención n.º 150* proporciona un campo neutral en el que destacan las tres formas coloreadas. Los límites del marco, sin embargo, no afectan ni interactúan con la composición de estas formas, que Lozza separó aun más del "marco" al montarlas, más que pintarlas, sobre el fondo.

Lozza definió las tres características esenciales del Perceptismo en los términos siguientes: la noción de campo, la estructura abierta y una nueva teoría del color.[3] La noción de campo se refiere a la necesidad de ubicar las formas contra un fondo visual uniforme que las aísle de su entorno. La estructura abierta es el método compositivo centrífugo de Lozza, en el que las líneas compositivas se extienden de las formas al área circundante, más que permitir que los límites de un marco las determinen (figura 1). La nueva teoría del color se vincula a la invención de Lozza de la *cualimetría,* un neologismo compuesto de *cualidad* y *geometría*. Lozza sostiene haber desarrollado una ecuación matemática que toma en consideración no sólo la descripción matemática de una forma, sino también su cualidad, determinada por su tamaño, forma y color. En otras palabras, dos formas iguales pero de colores distintos no son la misma cosa, y generarían distintos valores cualimétricos. Del mismo modo, dos formas con la misma superficie pero con distinta forma también arrojarían resultados diferentes. Se supone que la ecuación cualimétrica de Lozza toma estos

valores, incluyendo el color de base, y los calcula hasta llegar al valor cero, el punto en que no hay ilusión visual ni retroceso óptico de ningún tipo. Al contemplar *Invención n.° 150,* es cierto que ninguna forma parece sobresalir o retroceder en relación con las demás, con lo que se satisface el objetivo central de la Asociación Arte Concreto–Invención y del Perceptismo: la abolición de la ilusión pictórica en el arte. Una obra perceptista ideal es aquella en que no hay perspectiva visual de ningún tipo, en la que todas las formas coexisten sobre un solo plano visual.

Uno de los aspectos más interesantes del Perceptismo es su relación con la arquitectura y el muralismo. Lozza, como todos los artistas abstractos de su generación, persiguió una forma artística más colectiva y socialista. Mientras que los artistas del grupo Madí buscaban una provocación directa en la esfera pública (a través de la distribución de manifiestos y volantes, por ejemplo), y Maldonado y Hlito se interesaron cada vez más en el diseño gráfico e industrial, Lozza se replanteó un tema recurrente de la vanguardia europea: la relación entre arte y arquitectura. Desde la afirmación de Bruno Taut de 1918 de que "no habrá fronteras entre las artes aplicadas y la escultura o la pintura. Todo será una sola cosa: arquitectura",[4] a la declaración de De Stijl según la cual "afirmamos que la pintura separada de la construcción arquitectónica (es decir, el cuadro) no tiene derecho a existir",[5] el deseo de integrar el arte en el entorno construido ha ocupado siempre un lugar central en el proyecto de arte abstracto. Lozza sostiene un punto de vista similar al afirmar que "la pintura siempre ha necesitado un soporte: la pared. No es algo que puedas llevar bajo el brazo. La pintura es una pared, pero es un muralismo que no está en contradicción con el espacio del arquitecto. Armoniza con todo sin crear una ventana".[6] Aunque Lozza nunca fue capaz de llevar a cabo un entorno construido en el que el marco rectangular provisional pudiera desaparecer, produjo y publicó montajes o collages que mostraban sus formas en arquitectura. De hecho, el montaje publicado en el primer número de *Perceptismo* (1950) muestra esta misma obra en un entorno doméstico, con el título *Estructura perceptista de Raúl Lozza. Mural N.° 150 del año 1948* (figura 2). En esta imagen podemos ver cómo el marco provisional ya no es necesario, puesto que las formas están montadas directamente sobre la pared.

En muchos sentidos, la obra de Lozza representa dos sueños no realizados. Uno es la cualimetría, un concepto que probablemente existe más en la mente de Lozza que sobre el papel como ecuación real y utilizable. El otro es su deseo de ver cómo su obra forma parte de un nuevo entorno arquitectónico. Como tal, los espectadores no deberían abordar obras como *Invención n.° 150,* a pesar de su apariencia matemática e impersonal, como afirmaciones cerradas y definitivas, sino más bien como fragmentos de una nueva utopía que, en última instancia, sería también romántica.

Gabriel Pérez-Barreiro
Traducción de Jordi Palou

Notas

1. El sistema de numeración de Lozza es difícil de seguir, y parece no ser simplemente cronológico. La pintura que aparece en la cubierta del catálogo para la primera exposición perceptista en 1949 se titula *Pintura perceptista n.° 161.* Es posible que los números correspondan a algún cálculo contenido en la obra, o a algún otro sistema de clasificación.
2. Para más información, véase la entrada sobre los coplanales de Lozza y Mele en este mismo catálogo.
3. Raúl Lozza, entrevista con el autor, marzo 1993, Buenos Aires.
4. Bruno Taut, "A Programme for Architecture" (1918), en Ulrich Conrads, ed., *Programmes and Manifestoes of 20th-Century Architecture* (Londres: Lund Humphries, 1970), 41.
5. "Manifesto V:-□+=R₄" (1923), en Conrads, ed., *Programmes and Manifestoes,* 66.
6. Raúl Lozza, entrevista con el autor, marzo 1993, Buenos Aires.

Alfredo Hlito
Ritmos cromáticos III, 1949
Óleo sobre tela
100 × 100 cm
Colección Patricia Phelps de Cisneros
1997.67

Ritmos cromáticos III (lámina 11), de Alfredo Hlito, es una pintura de la serie titulada Ritmos cromáticos, realizada por el artista entre 1947 y 1949. En toda la serie, a pesar de la presencia de líneas verticales y horizontales y de pequeños planos de color, la composición obliga al espectador a centrarse en las amplias partes del cuadro que permanecen vacías. El poeta Edgar Bayley comentaba, acerca de una pintura de dicha serie realizada en 1948, que Hlito "utiliza en las pinturas presentadas elementos lineales cromáticos que son inscriptos en atención a un equilibrio a distancia, esto es, haciendo jugar en la composición los sectores 'vacíos' del plano".[1] Así, en las telas de Hlito de ese periodo, las porciones "vacías" se convierten en elementos activos en las composiciones.

Los estudios académicos sobre la obra de Hlito no han abordado el tema de estas áreas vacías en sus pinturas, a pesar de que desempeñaron un papel primordial en su práctica artística a partir de 1947. La inserción por parte del artista de espacios "vacíos" en el plano, como hacía ya en la serie Ritmos cromáticos, era el equivalente pictórico de las concepciones escultóricas y arquitectónicas del espacio como un elemento "abierto". Esto no es de extrañar, ya que el debate sobre el espacio "abierto" dominó la teoría y la práctica de los artistas concretos argentinos próximos a Hlito, es decir, Enio Iommi y Tomás Maldonado.[2] Al describir una escultura de Iommi en la crítica antes mencionada, Bayley sostenía que la obra "afirma prácticamente la tendencia concretista a exaltar el espacio, otorgándole el carácter de elemento fundamental en la escultura".[3] Bayley también describe la capacidad de Iommi para evocar "un tipo de estructura que llamaríamos *abierto,* cuyos elementos se desplazan en todos los sentidos y en donde la base física del objeto viene a jugar un papel mínimo".[4] Mientras que Bayley no relacionaba explícitamente las "áreas vacías del plano" de Hlito con los "espacios abiertos" de Iommi, dichas expresiones tenían una raíz común en la noción de

"espacialidad" asociada a la arquitectura moderna. En aquel momento se trataba de ideas sometidas a un intenso debate en un grupo fuertemente cohesionado de amistades que incluía a los artistas concretos y a estudiantes de arquitectura argentinos.[5]

En un artículo publicado en 1947 en la *Revista de Arquitectura,* de la Asociación Central de Arquitectos de Argentina, Tomás Maldonado, pintor y principal teórico del grupo de artistas concretos argentinos, afirmaba que los artistas y arquitectos modernos necesitaban centrar su atención en asignar al espacio un papel activo en sus obras y edificios, en lugar de limitarse a llenar el espacio con volúmenes.[6] Según Maldonado, los arquitectos siempre se habían concentrado en organizar los volúmenes en el espacio, más que en delimitar los espacios a recorrer, tanto física como visualmente. Esta concepción volumétrica había sido adecuada para la escultura y la arquitectura del pasado, que respondían a una concepción del espacio como un vacío negativo en el que existía el universo. Pero los últimos estudios científicos, afirmaba Maldonado, sugerían que el espacio era interdependiente respecto a la masa: el espacio y la masa se moldeaban recíprocamente. En la escultura, el Cubismo y el Futurismo habían explorado inicialmente esta nueva concepción del espacio y la masa, dado que estos movimientos desafiaban la idea de que una escultura consiste en un objeto que representa una figura—y, así, llenaría el espacio con un volumen—. Liberados de la obligación de representar figuras, los escultores "no figurativos" (los constructivistas rusos o los neoplasticistas neerlandeses) habían creado obras en que sin duda predominaba una concepción abierta y direccional del espacio, en oposición a una concepción volumétrica del mismo. Los arquitectos modernos que expresaban la noción de "espacialidad"—por ejemplo, Le Corbusier y Walter Gropius—se servían de planos y fachadas abiertos, así como de materiales transparentes que permitían una continuidad visual.

Estas ideas ofrecen claves para interpretar *Ritmos cromáticos III* como una obra que evoca la noción de espacio "abierto" o de la espacialidad arquitectónica. En esta pintura, unas líneas verticales y horizontales crean una cuadrícula, que "marca" literalmente el plano pictórico sin sugerir figuras—del mismo modo que el armazón metálico de un edificio de cristal delimita el espacio ocupado por éste, sin convertir a la construcción en un volumen—. Las franjas de color blanco, que se alternan con otras franjas coloreadas, funcionan como mirillas a través de las cuales el espacio prosigue sin interrupción. En esta obra, pues, Hlito utiliza una cuadrícula para dar forma al espacio de la pintura (el plano) y para señalar la ausencia de volúmenes (o figuras). En otras palabras, evoca el espacio real sin sacrificar la especificidad del medio pictórico (su carácter plano).[7]

Es posible que *Ritmos cromáticos III* sea el equivalente pictórico de una obra escultórica que, a su vez, guarda una estrecha relación con la arquitectura. Se trata del *Monumento a los caídos en los campos de concentración en Alemania,* proyectado por los arquitectos italianos Ernesto Rogers, Ludovico Barbiano di Belgiojoso y Enrico Peressutti, erigido en 1945 en un cementerio de Milán. Parece ser que Hlito vio fotografías de esta obra en el Salón de Nuevas Realidades de 1948, en el que participó.[8] La escultura consiste en un cubo vacío en el que una serie de varillas metálicas trazan direcciones lineales. Estas varillas colocadas dentro del cubo fragmentan el espacio interno, mientras que las vistas ininterrumpidas del paisaje circundante sugieren una continuidad espacial. En el interior del cubo, las varillas delimitan virtualmente varios planos cuadrangulares, algunos de los cuales están cubiertos por paneles blancos y negros que tapan una parte de la visión del espacio real. Podría ser que *Ritmos cromáticos III,* con sus delgadas líneas horizontales, bandas anchas y espacios vacíos, fuera una recreación de la abertura espacial del monumento erigido en Milán.

¿Por qué los artistas concretos estaban efectivamente interesados en explorar las estrategias escultóricas y pictóricas que evocaban la noción arquitectónica moderna de espacialidad? De nuevo, el ensayo de Maldonado nos da una respuesta. En dicho texto, rechaza una concepción volumétrica del espacio porque, según argumenta, esta concepción encarna un "estilo de vida" particular. Por ello escribía: "En la actualidad, la vivencia de forma cerrada, de forma-masa, con un exterior convexo y un interior cóncavo, perfectamente delimitados, resume las dos características más notorias del estilo de vida de nuestra sociedad: el individualismo y el temor".[9] Si, como afirma Maldonado, los volúmenes y figuras eran los significantes del individualismo y del temor, ello implicaba que los artistas y arquitectos que señalaban la presencia del espacio en sus obras—Hlito, Iommi, Maldonado y otros—lo hacían a fin de expresar su convicción en la comunión y la liberación sociales. Estas convicciones, de hecho, eran coherentes con los ideales que los artistas concretos argentinos habían defendido como parte de su programa revolucionario desde 1944.[10]

Ana Pozzi-Harris
Traducción de Jordi Palou

Notas

1. Edgar Bayley, "Nuevas realidades", *Ciclo* [Buenos Aires] no. 1 (noviembre/diciembre 1948): 89.
2. Al observar estas obras desde otra perspectiva, Gabriel Pérez-Barreiro afirmó que las obras de la serie Ritmos cromáticos "son muy parecidas, si no casi idénticas, a pinturas contemporáneas del artista suizo Richard Paul Lohse". Gabriel Pérez-Barreiro, *The Argentine Avant-Garde, 1944–1950* (tesis doctoral, University of Essex, 1996), 277.
3. Bayley, 88.
4. Bayley, 88. El énfasis es del original.
5. Unos cuantos documentos básicos, así como memorias de los arquitectos, dan testimonio de la interacción entre los artistas concretos y los estudiantes de arquitectura. Véase, por ejemplo, Tomás Maldonado, "Volumen y dirección en las artes del espacio", *Revista de Arquitectura* no. 32 (febrero 1947), reproducido en Tomás Maldonado, *Escritos preulmianos* (Buenos Aires: Ediciones Infinito, 1997), 59–62; Tomás Maldonado, "Diseño industrial y sociedad", *Boletín del Centro de Estudiantes de Arquitectura* no. 2 (octubre/noviembre 1949), reproducido en *Escritos preulmianos*, 63–65; Juan Manuel Borthagaray, "Universidad y política, 1945–1966", en *Contextos. 50 años de la FADU-UBA* (octubre 1997): 20–29; Carlos Méndez Mosquera, "Veinte años de diseño gráfico en la Argentina", *Summa* [Buenos Aires] no. 15 (febrero 1969).
6. Maldonado, "Volumen y dirección en las artes del espacio", 59–62.

7. Acerca del debate sobre los efectos pictóricos de la cuadrícula en la pintura moderna, véase Rosalind Krauss, "Grids", en Rosalind Krauss, *The Originality of the Avant-garde and Other Modernist Myths* (Cambridge, Mass.: MIT Press, 1985), 9–22.

8. En la crítica de Bayley "Nuevas realidades" se reproducían dos fotografías de esta obra, yuxtapuestas a fotografías de obras de los artistas concretos argentinos.

9. Maldonado, "Volumen y dirección en las artes del espacio", 62.

10. Algunos de los textos que tratan explícitamente sobre dichos "valores" son: Edgar Bayley, Antonio Caraduje, Simón Contreras, Manuel Espinoza, Claudio Girola, Alfredo Hlito, Enio Iommi, Rafael Lozza, Raúl Lozza, R. V. D. Lozza, Tomás Maldonado, Alberto Molenberg, Primaldo Mónaco, Óscar Núñez, Lidy Prati y Jorge Souza, "Manifiesto invencionista", *Arte Concreto Invención* [Buenos Aires], no. 1 (agosto 1946), reproducido en *Arte abstracto argentino* (Buenos Aires: Fundación Proa, 2002), 160; Edgar Bayley, "Sobre arte concreto", *Revista Orientación*, 20 febrero 1946, reproducido en *Arte abstracto argentino*, 160–61; Tomás Maldonado, "Los artistas concretos, el realismo y la realidad", *Arte Concreto Invención* [Buenos Aires] no. 1 (agosto 1946), reproducido en *Escritos preulmianos*, 49–50.

Anatol Wladyslaw
Abstrato [*Abstracto*], 1950
Óleo sobre tela
60 × 73 × 2.5 cm
Colección Patricia Phelps de Cisneros
1997.46

A primera vista, parece extraño que en la obra de Anatol Wladyslaw pueda advertirse más que una relación superficial con el movimiento Ruptura de São Paulo.[1] Numerosos historiadores del arte han observado una estrecha conexión entre el predominio de São Paulo como centro industrial del Brasil y el interés de los artistas del Grupo Ruptura por usar materiales industriales como la pintura al esmalte, el plexiglás, la madera aglomerada y el aluminio, y técnicas como la pintura con aerógrafo para crear obras con formas geométricas contundentes y colores primarios que aparentemente no transmitieran ningún contenido emocional.[2] Es conocida la afirmación de los artistas concretos de São Paulo, según la cual el color tenía tan poca importancia en sus composiciones, en comparación con la forma, que podían sustituir un color por otro sin alterar ninguna parte significativa de la obra. A la vista de estas afirmaciones, la pintura de Wladyslaw *Abstrato* (lámina 12) puede considerarse rebelde en el uso que hace de tonalidades pastel, como el azul lavanda y el amarillo limón, así como de líneas sensiblemente pintadas a mano.

Ana Maria Belluzzo observó el efecto de cloisonné presente en las composiciones de Wladyslaw, al pintar contornos de color alrededor de las formas rectangulares. Asimismo afirmó que las obras de Wladyslaw de este periodo pertenecen a una fase del Arte Concreto de São Paulo durante la cual los artistas centraban su atención en la línea y el plano en sus obras respectivas.[3] Aun siendo estos aspectos importantes en *Abstrato,* el rasgo más notable de la composición es sin lugar a dudas el uso que hace del color. De hecho, en las obras que realizó durante este periodo (1950–1952), Wladyslaw se centraba sobre todo en el color: el uso de verdes vibrantes y seductores tonos de rosa distraen el ojo de la presencia de la geometría en la obra.

El evocador uso del color por parte de Wladyslaw y su evidente desinterés por crear una obra de arte que parezca hecha por una máquina sugieren que, en realidad, sentía más afinidad con los ideales de los artistas neoconcretos que con los de sus colegas de São Paulo. Al cabo de muchos años, el portavoz de los neoconcretos, Ferreira Gullar, escribiría que el énfasis del Arte Concreto en lo mecánico socavaba la experiencia intuitiva que el espectador podía tener de la obra de arte. Sostenía que, en cambio, "el arte neoconcreto ... cree que el vocabulario geométrico que utiliza puede expresar las complejas realidades humanas".[4] La misma afirmación podría aplicarse a las tempranas composiciones geométricas de Wladyslaw, que tienen mucho en común con las obras del movimiento concreto de Rio, el Grupo Frente. Las primeras obras de Wladyslaw dan una importancia primordial al color, permiten que las pinceladas y las sutiles modulaciones del color permanezcan visibles y utilizan la geometría con una finalidad estética más que analítica.[5]

De hecho, Wladyslaw sólo mantuvo una breve relación con el Grupo Ruptura (entre 1952 y 1954), al que abandonó debido a su "temperamento emocional".[6] Las comisarias Rejane Cintrão y Ana Paula Nascimento consideran que probablemente Waldemar Cordeiro le invitara a participar en la exposición de Ruptura de 1952, tras haber visitado su exposición individual en la Galería Domus de São Paulo en 1951.[7] Uno se pregunta por qué Cordeiro se vio atraído por Wladyslaw, cuya obra guardaba muchos más paralelismos con la de los encarnizados adversarios de Cordeiro, Cícero Dias y Samson Flexor, que con la suya propia. De hecho, Wladyslaw se vinculó al Atelier Abstração de Flexor, lo que podría explicar su escaso interés por la teoría de la Gestalt y por la relación entre tiempo y movimiento, dos de las principales inquietudes de los artistas del Grupo Ruptura.

La formación inicial de Wladyslaw como ingeniero civil le proporcionó una experiencia similar a la de muchos otros artistas concretos radicados en São Paulo durante la década de 1950, quienes, como ha observado Aracy Amaral, trabajaban en áreas como el diseño industrial, la química, el diseño gráfico, la arquitectura y otras profesiones relacionadas con el crecimiento industrial de la ciudad.[8] Asimismo, al igual que los demás artistas del Grupo Ruptura, Wladyslaw era de origen europeo:[9] nacido en Varsovia, emigró a Brasil en temprana edad. Trabajando aun como ingeniero, se dedicó a la pintura y siguió el consejo de Lasar Segall, otro artista de origen europeo, que le animó a pintar más. Con el tiempo, hizo de la pintura su profesión y trabó amistad con el pintor abstracto Samson Flexor.

Alrededor de 1958, Wladyslaw abandonó por completo la abstracción geométrica y empezó a pintar en un estilo gestual que evocaba la técnica del *dripping* de Jackson Pollock. Aunque en apariencia ejecutadas de forma casi idéntica, él insistía en que sus pinturas diferían decididamente de las de Pollock: el arabesco en la obra de Pollock era rítmico, mientras que en la de Wladyslaw era dinámico; se podía cortar un fragmento de una pintura de Pollock sin rebajar la calidad de la composición, etcétera.[10] A la vez que defendía su obra contra las insinuaciones de que estaba copiando a Pollock, también explicó

su relación con el Tachismo, el término europeo y más general para el Expresionismo Abstracto o la abstracción informal o gestual, un término que los brasileños también utilizaban. Wladyslaw admitía que "el Tachismo es mucho más instintivo e intuitivo que la pintura que yo hago. . . . No hay duda de que existe cierta afinidad".[11]

Meiri Levin sostiene que "la espiritualidad en Wladyslaw tenía una connotación más religiosa, casi mística".[12] Tras leer *De lo espiritual en el arte*, de Kandinsky, Wladyslaw se dedicó a investigar sobre ese tema. Mientras que para muchos artistas concretos las formas geométricas tenían una trascendencia más material que espiritual, en Wladyslaw parece haber sido justamente lo contrario. Levin interpreta la obra de Wladyslaw como una expresión de su identidad judía, aunque se centra casi exclusivamente en su obra figurativa más reciente y establece comparaciones con otros artistas de ascendencia judía como Marc Chagall, Ben Shahn y Segall. Pero la cuestión de si la disposición de los rectángulos en la abstracción geométrica de Wladyslaw tiene o no alguna conexión con las ideas de Mondrian en relación con el Neoplasticismo—que también relacionaba la abstracción con la espiritualidad—sigue incomodándonos por su falta de respuesta.

A pesar de que recibió premios en la Bienal de São Paulo y participó en algunos de los movimientos más destacados del arte brasileño, la posición de Wladyslaw en la historia del arte del Brasil no está del todo clara, ya que se han publicado pocos estudios sobre su obra. Esto podría deberse a las dificultades para calificar su obra. La crítica de arte Radha Abramo sostenía que existían "tres tendencias" en la obra de Wladyslaw: según le había declarado el propio artista, "Soy Polonia, el judaísmo y el Brasil".[13] Pero al adscribirse a tres tendencias a la vez, acababa por no enmarcarse en ninguna de ellas. Es decir, al negar las etiquetas de la Abstracción Geométrica y del Tachismo, es posible que también se haya negado a sí mismo a desempeñar un papel de mayor relevancia en la historia del arte brasileño.

Erin Aldana
Traducción de Jordi Palou

Notas

1. Desearía expresar mi agradecimiento a Dalton Delfini Maziero, del Arquivo Wanda Svevo, en la Bienal de São Paulo, y a Francisco Zorzete por su ayuda a la hora de obtener información para este ensayo.
2. Ana Maria Belluzzo, "Ruptura e Arte Concreta", en Aracy Amaral, ed., *Arte construtiva no Brasil: Coleção Adolpho Leirner*, trad. de Izabel Burbridge (São Paulo: DBA Artes Gráficas, 1998), 139.
3. Belluzzo, 102.
4. José Ribamar Ferreira Gullar, "O Grupo Frente e a Reação Neoconcreta", en Amaral, *Arte construtiva no Brasil*, 160.
5. Por ejemplo, en las obras *Idéia múltipla* (1956), de João José da Silva Costa, *Sem título* (1959), de César Oiticica, y *Sem título* (de la década de 1950), de Rubem Ludolf. Véase Amaral, *Arte construtiva no Brasil*, 147, 148 y 150.
6. "Anatol Wladyslaw", en *Grupo Ruptura: revisitando a exposição inaugural*, trad. de Anthony Doyle y David Warwick (São Paulo: Cosac & Naify, 2002), 52.
7. Rejane Cintrão y Ana Paula Nascimento, "The Exhibition of the Rupture Group in the São Paulo Museum of Modern Art, 1952", en *Grupo Ruptura; Arte concreta paulista* (São Paulo: Cosac & Naify, Centro Universitário Maria Antônia, 2002), 67.
8. Aracy Amaral, "Duas linhas de contribuição: Concretos em São Paulo/Neoconcretos no Rio", en Aracy Amaral, ed., *Projeto construtivo brasileiro na arte (1950–1962)* (Rio de Janeiro y São Paulo: Museu de Arte Moderna do Rio de Janeiro y Pinacoteca do Estado de São Paulo, 1977), 312.
9. Cintrão y Nascimento, "The Exhibition of the Rupture Group in the São Paulo Museum of Modern Art, 1952", 67.
10. "Anatol Wladyslaw admite afinidades mas não filiação entre a sua pintura e o tachismo", *Folha da Tarde*, 10 enero 1959. Véase asimismo "Três pintores expõem na Galeria das Folhas", *Folha da Noite*, 22 diciembre 1958.
11. "Anatol Wladyslaw admite afinidades."
12. Meiri Levin, "Um artista da vanguarda brasileira dos anos cinqüenta/sessenta: Anatol Wladyslaw" (tesis de maestría, Universidad de São Paulo, 1997), 33.
13. Radha Abramo, "As tres vertentes na obra de Anatol", *Folha de São Paulo*, 12 mayo 1984.

Tomás Maldonado
Desarrollo de 14 temas, 1951–1952
Óleo sobre tela
201.5 × 211.5 × 2.5 cm
Colección Patricia Phelps de Cisneros
1998.46

En una primera consideración, *Desarrollo de 14 temas*[1] (lámina 13) parece una simple expresión visual de la admiración de Maldonado por los representantes europeos del Arte Concreto, especialmente Max Bill.[2] Maldonado conoció a Bill durante su primera visita a Europa, en 1948, y encontró altamente persuasivo el principio de la "buena forma" elaborado por el artista suizo.[3] Seguramente conocía la serie de Bill *Quince variaciones sobre el mismo tema,* pintada entre 1935 y 1938, en la cual, según Maldonado, Bill había explorado el concepto de variación no como un cambio limitado a partir de un mismo patrón, sino como una "infinita multiplicidad de posibilidades" proporcionadas por un limitado repertorio de formas.[4] Al igual que las pinturas de la serie de Bill, *Desarrollo de 14 temas* genera variación a través de la distribución irregular y no repetitiva de líneas, planos y puntos.

Esta lectura de la pintura confirmaría la idea aceptada de que, a partir de 1949, la obra y las ideas de Max Bill ejercieron una gran influencia en los artistas concretos argentinos.[5] No obstante, sin dejar de lado la influencia de Bill, quisiera explorar otra línea de ideas y encuentros personales que podrían haber contribuido a la creación de *Desarrollo de 14 temas:* los contactos del artista con el músico argentino Juan Carlos Paz y las concepciones musicales que éste promovió y defendió, de las que la más importante —como muestran los numerosos artículos y libros que escribió Paz—fue la escala dodecafónica de Arnold Schönberg.[6] Es posible que los artistas concretos argentinos hubieran conocido a Paz ya en 1944, pero los primeros contactos documentados se reflejan en las páginas de la revista *Nueva Visión: revista de cultura visual,* que Maldonado había fundado en 1951.[7] Paz escribió destacados artículos en los dos primeros números de la revista, publicados en 1951 y 1953.[8] Según Carlos Méndez Mosquera, antiguo secretario de *Nueva Visión,* Paz y otros músicos de la Agrupación Nueva Música a menudo ofrecían conciertos para los artistas concretos y estudiantes de arquitectura en el estudio

de Maldonado, ubicado en Cerrito 1371, en Buenos Aires.[9]

Así, es muy posible que a principios de la década de 1950 Paz hubiera tenido ocasión de dialogar sobre la "nueva música" con los promotores de la "nueva visión". El artículo de Paz "Música atemática y música microtonal", publicado en *Nueva Visión* en enero de 1953, probablemente refleja el contenido de esos debates. Paz expone en su artículo cómo la música atemática, tal como la desarrolla el compositor checo Alois Hába, es una consecuencia lógica de los doce sonidos de la escala de Schönberg. El término *atemática,* en palabras de Paz, "tiene origen y referencia en la antigua definición de trabajo temático, donde un tema, motivo, o frase melodica expuestos, reaparecen en el transcurso de una composición".[10] "Atemático", por el contrario, significaba un estilo carente de "reprises, secuencias, correspondencias y toda clase de repeticiones temáticas y melódicas".[11] Sin embargo, Paz observaba que, mientras que el estilo de Hába prescindió de las secuencias melódicas, siguió utilizando secuencias rítmicas, que se convirtieron en la estructura de sus composiciones.[12] Paz comenta la "música microtonal" como otra de las aportaciones de Hába; se trata de música que utiliza sonidos producidos por los compositores al dividir un semitono en sus sonidos intermedios: cuartos de tono, sextos, octavos, décimos, y así sucesivamente. Dichas divisiones serían el "punto de partida hacia un inédito universo sonoro", ya que implicaban una ampliación de lo que se conoce como "la escala natural". Paz comentaba que:

> Todos sabemos que esta escala, sobre la que se basa toda nuestra música culta [occidental] y gran parte de la popular, desde el Renacimiento hasta hoy, es tan convencional como todos los valores musicales.... Lo único que justifica la denominación de esta escala es que se basa en la percepción auditiva de quienes la establecieron y de los que luego la asimilaron y se habituaron a ella.[13]

La así llamada escala natural, sostenía Paz, "no excluy[e] en modo alguno, la posibilidad de nuevas escalas".[14] En resumen, la "escala natural" no era natural, sino una mera convención.

Los problemas visuales presentes en *Desarrollo de 14 temas,* ¿tienen paralelismos en los conceptos de música atemática y microtonal? En mi opinión, Maldonado halló en el concepto de música atemática una estimulante fuente para reformular su principal preocupación desde la década de 1940: cómo evitar la representación.[15] Mientras que, con los marcos irregulares y los *coplanales* de los años cuarenta, los artistas concretos habían tratado de evitar la representación alterando la forma del plano pictórico, en *Desarrollo de 14 temas* Maldonado evita la representación alterando la legibilidad de la obra como unidad coherente.[16] Para ser una representación, una imagen no sólo debe evocar el mundo natural, sino que también debe ser interpretable como estructura, como composición. Tanto la pintura como la música logran poder ser interpretadas a través de la repetición de formas; por ejemplo, a través de la simetría, el equilibrio y un uso coherente de la variación. Si se suprimen todos los patrones compositivos, no es posible

la legibilidad, como tampoco lo es la representación. Así, del mismo modo que la música atemática podía evitar un "tema" al renunciar a "reprises, secuencias, correspondencias y toda clase de repeticiones temáticas y melódicas", el Arte Concreto podía escapar la representación evitando repetir grupos de elementos pictóricos—"temas"—en una misma obra. De hecho, *Desarrollo de 14 temas* evita la repetición mediante la colocación de polígonos irregulares en lugar de rectángulos o cuadrados, y de líneas diagonales en lugar de líneas horizontales o verticales. Los ángulos internos creados por dichos planos poligonales y líneas diagonales son desiguales, al igual que la disposición general de las líneas y de los planos en el marco pictórico es asimétrica. De ese modo, las líneas y planos no generan relaciones repetitivas en la composición ni tampoco se hacen eco de la forma rectangular del marco. Mientras que Maldonado conserva un mínimo grado de ritmo al utilizar un repertorio limitado de formas (líneas rectas y planos cuadrangulares), reduce la legibilidad de la obra evitando las combinaciones repetitivas de dichos elementos en la tela.

La idea de que la escala musical natural no es más que una convención y de que puede desafiarse dicha convención dividiendo los sonidos es probablemente el origen de algunas estrategias pictóricas que hallamos en *Desarrollo de 14 temas.* De hecho, esta pintura cuestiona el papel convencional de las líneas en un medio bidimensional. Tradicionalmente, las líneas sirven para definir figuras. En el dibujo, son elementos deliberadamente visibles que separan las figuras respecto del fondo. En una pintura, son barreras imaginarias que separan extensiones de color. No obstante, en *Desarrollo de 14 temas* las líneas no desempeñan ninguna de esas funciones. Más que formar figuras cerradas, varias líneas se intersecan y describen explícitamente ángulos abiertos, mientras que otras tan sólo sugieren ángulos. Maldonado también coloca líneas alrededor de los bordes de los planos poligonales, pero esas líneas no coinciden con los bordes de los planos a los que parecen definir. Así, Maldonado pone de relieve el hecho de que las figuras silueteadas son convenciones ilusorias y, por lo tanto, que la representación no es más que una invención visual.

Tanto Maldonado como Paz buscaban evitar la representación—pictórica y musical, respectivamente—alterando el principio de la repetición y las convenciones de la percepción visual y auditiva. En sus campos respectivos, hallaron conceptos análogos para representar su antagonismo hacia las formas artísticas tradicionales. Quizá el aspecto más sugerente del diálogo entre Maldonado y Paz sea el título de esta pintura: *Desarrollo de 14 temas.* Los catorce temas son, probablemente, combinaciones diferentes de elementos pictóricos que no se repiten de manera sistemática, de modo que, irónicamente, no emergen coherentemente como "tema"—evocando así el proceso en el que se basa la música atemática—. El término *desarrollo* (en su significado de "despliegue" o "esclarecimiento") otorga al título un carácter temporal, en paralelo con los constantes cambios de la música atemática—lo que Paz denominaría "un desarrollo perpetuo del discurso

musical"—.[17] Con su disposición no repetitiva de líneas y planos, *Desarrollo de 14 temas* evoca un continuo cambio interno.

Los conceptos de música atemática y microtonal proporcionan un marco conceptual alternativo para la interpretación de *Desarrollo de 14 temas,* marco que incorpora una interesante conexión extraartística a la historia del Arte Concreto argentino. Quizás lo más importante sea que también socava la noción corrientemente aceptada de que los artistas argentinos cambiaron la orientación de su producción *sólo* después de haber entrado en contacto con el arte europeo. De hecho, en los primeros años de la década de 1950, los principios musicales de Paz supusieron una fuente local de ideas creativas que aportaron un nuevo vigor a la producción artística de los artistas concretos.

Ana Pozzi-Harris
Traducción de Jordi Palou

Notas

1. En un catálogo reciente (*Abstract Art from the Río de la Plata* [Nueva York: The Americas Society, 2001], pág. 117, lám. 25), se fecha *Desarrollo de 14 temas* en torno a 1947. Sin embargo, la obra seguramente se pintó en 1951 o 1952. La pintura se mostró en una exposición de la Galería Viau en 1952. Esta exposición, que también presentaba al Grupo de Artistas Modernos de la Argentina, incluía a cuatro artistas independientes (Hans Aebi, José Antonio Fernández Muro, Sarah Grilo y Miguel Ocampo) y a cinco artistas concretos (Claudio Girola, Alfredo Hlito, Enio Iommi, Tomás Maldonado y Lidy Prati). La organizó el crítico Aldo Pellegrini. Se publicaron dos imágenes de la exposición en *Nueva Visión* [Buenos Aires] no. 2/3 (enero 1953): 26. En una de esas fotografías puede verse *Desarrollo de 14 temas.*

2. Maldonado dejó repetidas muestras documentales escritas de su admiración por los artistas concretos suizos. Véanse, por ejemplo, "Georges Vantongerloo", *Nueva Visión* no. 1 (diciembre 1951), 19; "Vordemberge-Gildewart y el tema de la pureza", *Nueva Visión,* no. 2/3 (enero 1953): 12–18, así como su libro, profusamente ilustrado, *Max Bill* (Buenos Aires: Ediciones Nueva Visión, 1954).

3. "La buena forma" era un principio estético que no valoraba una forma o formas en particular sino su coherencia. En opinión de Maldonado, las formas de Bill adquirían coherencia estética cuando seguían su propia "ley de desarrollo". El principio de coherencia formal podía aplicarse a todos los objetos, "desde una cuchara hasta una ciudad". Así, los objetos de arte tenían un papel que desempeñar, paralelamente a los objetos de uso práctico.

4. Maldonado comenta las *Quince variaciones sobre el mismo tema* en su libro *Max Bill,* publicado por primera vez en 1955 y reeditado como "Max Bill" en Tomás Maldonado, *Escritos preulmianos* (Buenos Aires: Ediciones Infinito, 1997), 101–13 (cita de la pág. 106).

5. Se trata de un concepto bien arraigado en los estudios sobre el Arte Concreto argentino. Véase, por ejemplo, Nelly Perazzo, *El arte concreto en la Argentina en la década del 40* (Buenos Aires: Ediciones de Arte Gaglianone, 1983), 97; Mario Gradowczyk y Nelly Perazzo, "Abstract Art from the Río de la Plata: Buenos Aires and Montevideo", en *Abstract Art from the Río de la Plata* (Nueva York: The Americas Society, 2001), 48 y 51; Gabriel Pérez-Barreiro, "The Argentine Avant-Garde" (tesis doctoral, University of Essex, 1996), 273–85.

6. Compositor, profesor de música, crítico y escritor, Paz introdujo en Argentina la escala de doce tonos de Arnold Schönberg en 1934. En 1937 inició los Conciertos de la Nueva Música, que ofrecían una "antología de las tendencias contemporáneas". En 1950 dichos conciertos dieron lugar a la Agrupación Nueva Música, una institución dedicada a la promoción de las tendencias musicales más avanzadas. Con anterioridad a 1955, Paz había publicado sus escritos en varias revistas culturales además de *Nueva Visión,* tales como *Sur, Cabalgata* y *Contrapunto.*

7. En un artículo retrospectivo, el artista Gyula Kosice cita a Juan Carlos Paz como uno de los intelectuales que se reunían en los cafés Rubí y La Fragata, de Buenos Aires, y que fomentaban las ideas publicadas en el único número de la revista *Arturo* (verano 1944). Gyula Kosice, "A partir de la revista *Arturo*", *La Nación,* 1 octubre 1989.

8. *Nueva Visión* (subtitulada "Revista de Cultura Visual") publicó nueve números entre 1951 y 1957. Paz escribió en ella dos artículos: "Qué es nueva música", *Nueva Visión* no. 1 (diciembre 1951): 10–11, y "Música atemática y música microtonal", *Nueva Visión* no. 2/3 (enero 1953): 28–30.

9. Entrevista con el autor, mayo 2003, Buenos Aires.

10. Paz, "Música atemática y música microtonal", 28.

11. Paz, "Música atemática y música microtonal", 28.

12. Paz, "Música atemática y música microtonal", 28.

13. Paz, "Música atemática y música microtonal", 29.

14. Paz, "Música atemática y música microtonal", 29.

15. Varios escritos de Maldonado muestran esta preocupación; los tres siguientes se reeditaron en Tomás Maldonado, *Escritos preulmianos:* "¿A dónde va la pintura?" [1945], 35–36; "Manifiesto invencionista" [1946], 39–40; "Los artistas concretos, el 'realismo' y la 'realidad'" [1946], 49–50.

16. Respecto del debate sobre el marco recortado y el coplanal, véase el ensayo de Gabriel Pérez-Barreiro sobre *Relief* (1945), de Raúl Lozza, y *Coplanal* (1946), de Juan Melé, en este mismo libro.

17. Véase Paz, "Música atemática y música microtonal", 28.

Geraldo de Barros
Abstrato [*Abstracto*], de la serie Fotoformas, 1951
Plata en gelatina
28.2 × 30.4 cm
Colección Patricia Phelps de Cisneros
1995.37

"Pampulha"—Belo Horizonte, Brasil, 1951
Plata en gelatina
29.7 × 40.4 cm
Colección Patricia Phelps de Cisneros
1995.36

En sus fotografías de 1951, Geraldo de Barros captó maravillosos destellos de un mundo desconocido. Desde 1948, Barros había realizado fotografías abstractas con su cámara Rolleiflex mediante exposiciones múltiples, de modo que los objetos cotidianos se volvieran irreconocibles y las estructuras industriales se convirtieran en diseños geométricos. El artista bautizó a esta serie con el título de Fotoformas y, poco después de exponerlas en el Museo de Arte de São Paulo (MASP), en 1950, recibió una beca del gobierno francés para proseguir sus estudios artísticos en el extranjero. Barros pasó la mayor parte del siguiente año en París, donde estudió en la École des Beaux-Arts y conoció a algunos destacados fotógrafos, como Henri Cartier-Bresson y Georges Brassaï. Las fotografías que tomó en París muestran que seguía interesado en el Constructivismo y en el diseño geométrico. Las obras de este periodo—como *Abstrato* (lámina 14) y *"Pampulha"—Belo Horizonte, Brasil* (lámina 15)—se vinculan asimismo a la activa búsqueda por parte de Barros de una forma artística "concreta": un tipo de arte abstracto que no fuera figurativo ni simbólico y que fuera completamente autónomo respecto al mundo exterior.

En *"Pampulha"—Belo Horizonte, Brasil,* cinco líneas verticales oscuras se estrechan hacia la parte superior de la imagen: son los separadores

de un ventanal que reaparecen al menos en dos fotografías más entre las que tomó en París.[1] Girando noventa grados su Rolleiflex 1939 y creando una doble exposición, Barros usó los separadores de la ventana para crear una cuadrícula. Superpuesta a esta cuadrícula, la telaraña de formas orgánicas trazada por las ramas de los árboles produce una delicada textura que crea una contradictoria impresión de profundidad: la cuadrícula parece encerrar las ramas, pero también la textura parece cubrir la cuadrícula.

Mientras que los elementos arquitectónicos de la fotografía apuntan a que Barros creó esta imagen en París, el título de la fotografía recuerda su país nativo: "Pampulha" se refiere a un barrio de las afueras de Belo Horizonte, la capital del estado de Minas Gerais. En combinación con el título, la temática arquitectónica de la imagen recuerda que el artista tenía en cuenta y apreciaba los modernos edificios del arquitecto brasileño Oscar Niemeyer, cuyo proyecto poco convencional para la iglesia de San Francisco desató una controversia cuando fue construida en Pampulha en 1943. La fotografía de Barros, sin embargo, rehúye cualquier asociación con un lugar específico, ya sea en Francia o en Brasil, para crear, en cambio, un lugar aparte, más conceptual. Más que documentar un lugar en particular, sus imágenes desafían la percepción que el espectador tiene de la luz y la estructura.

La fotografía abstracta de Barros constituye un precedente de su ulterior participación en el movimiento de Arte Concreto, que arraigó con fuerza en el Brasil de principios de la década de 1950. No obstante, las Fotoformas de Barros, iniciadas a finales de los años cuarenta, indican que los artistas brasileños ya estaban explorando ávidamente la abstracción con anterioridad a 1950, creando así una atmósfera receptiva a las ideas de los artistas concretos europeos como Max Bill.

Poco antes de partir hacia París, Barros pudo conocer de primera mano la obra de Max Bill en la retrospectiva que el MASP le dedicó en 1951. Durante la instalación de la retrospectiva, Barros—al frente del laboratorio fotográfico del museo, después de que se le encargara su puesta en marcha en 1949—ayudó a desempacar las obras para la exposición. Impresionado por las pinturas y esculturas de Bill, Barros buscó a Bill en dos ocasiones cuando estaba estudiando en Europa. Primero viajó a casa de Bill en Zurich, en Suiza, y luego fue a Ulm, en Alemania, donde Bill era rector de la Hochschule für Gestaltung (Escuela Superior de Diseño). Bill recordaba perfectamente las Fotoformas de Barros. Comentó: "Me sedujo de inmediato su fuerza creativa y me impresionó la investigación fotográfica del autor, que llevaba a cabo paralelamente a su actividad como pintor".[2] En sus viajes a Europa y a través del contacto con Max Bill, Barros profundizó sus conocimientos de Arte Concreto y de diseño a escala internacional. Y aunque aplicó estrictos conceptos matemáticos a la creación de sus pinturas geométricas, las fotografías que realizó dependían mucho más de la improvisación. En sus propias palabras: "La creatividad fotográfica radica en el 'error', en la exploración y el dominio de la oportunidad."[3]

Rayando negativos de película y pintando sobre copias fotográficas, Barros combinaba elementos del dibujo con la fotografía. "Para mí, la fotografía es un proceso de grabado", afirmó en 1996.[4] De hecho, algunas de sus Fotoformas de 1951 reflejan la combinación de su interés por la fotografía y el grabado. Por ejemplo, en Abstrato, Barros rayó líneas diagonales, formas serpenteantes y triángulos sobre un negativo fotográfico. Aunque estas formas deambulantes parecen desvanecerse en el fondo blanco, también revelan indicios de una imagen subyacente que sugieren una actividad frenética. Es posible que el espectador desee saber qué es lo que el fotógrafo había representado originariamente, pero Barros ocultó la imagen de forma deliberada para crear una composición puramente abstracta.

Al regresar a Brasil tras su estancia en París, en 1952 Barros formó el Grupo Ruptura con otros artistas de São Paulo, entre los cuales se hallaban Waldemar Cordeiro y Luiz Sacilotto; juntos desempeñaron un papel fundamental en el movimiento concreto brasileño. En su manifiesto fundacional, el Grupo Ruptura exigía unos "nuevos principios artísticos" y la eliminación del arte figurativo: "El proceso de interpretar el mundo externo (tridimensional) en un plano (bidimensional) ha agotado su tarea histórica".[5] La fotografía parecía contradictoria con sus objetivos artísticos, ya que la cámara, por su propia naturaleza, nos permite captar imágenes del mundo exterior. No obstante, paradójicamente Barros usó la fotografía para liberarse de lo figurativo. A través de sus fotografías, transformó las formas y estructuras modernas que veía a su alrededor. Sus composiciones fotográficas liberaban a las imágenes de sus referentes. A medida que se fue implicando en las polémicas que rodeaban el movimiento de Arte Concreto y la modernización del Brasil, fue tomando cada vez menos fotografías. En 1954 se dedicaba principalmente al diseño industrial y creó Unilabor, una cooperativa dedicada a la producción de mobiliario. Aunque existen unas pocas Fotoformas basadas en los muebles de Unilabor, fueron sus obras de Brasil y París creadas entre 1948 y 1951 las que mejor representan su innovador enfoque de la fotografía abstracta.

Michael Wellen
Traducción de Jordi Palou

Notas
1. En Reinhold Misselbeck, *Geraldo de Barros, 1923–1998, Fotoformas* (Nueva York: Prestel, 2004) se reproducen dos obras en las que aparece la misma ventana, así como una vista de árboles, ambas tituladas *París* (1951). Véase las figs. 26 y 44.
2. Max Bill, "Geraldo de Barros", en *Geraldo de Barros, A Precursor* (São Paulo: Centro Cultural Banco do Brasil, 1996), 8.
3. *Geraldo de Barros, A Precursor*, 7.
4. *Geraldo de Barros, A Precursor*, 7.
5. El "Manifesto Ruptura" fue publicado y distribuido por Waldemar Cordeiro, Luiz Sacilotto, Geraldo de Barros y otros artistas abstractos, que en 1952 realizaron una exposición colectiva en el Museo de Arte Moderno de São Paulo. Para una reproducción (con la traducción al inglés) del manifiesto, véase Mari Carmen Ramírez y Héctor Olea, eds., *Inverted Utopias: Avant-garde Art in Latin America* (Houston: Museum of Fine Arts; New Haven: Yale University Press in association with the Museum of Fine Arts, Houston, 2004), 494.

Geraldo de Barros
Função diagonal [Función diagonal], 1952
Laca industrial sobre cartón piedra
60 × 60 × 0.3 cm
Colección Patricia Phelps de Cisneros
1995.16

Esta obra icónica de Geraldo de Barros ilustra a la perfección la combinación de geometría euclidiana y la percepción Gestalt característica del Concretismo brasileño de los años cincuenta. Su composición *Função diagonal* (lámina 16) es casi una ilustración de manual de las tres operaciones clásicas de la simetría: rotación, reflexión e inversión, tal como fueron formuladas según los axiomas básicos de Euclides relativos a la geometría plana. Cada forma es una consecuencia lógica del cuadrado formado por el borde del marco. La obra se estructura completamente a partir del principio de la división equidistante de una línea. De este modo, Barros trazó el cuadrado blanco mayor conectando los puntos medios de cada lado del marco, la siguiente forma negra a partir de los puntos intermedios del cuadrado blanco, y así sucesivamente. El efecto visual creado por estas divisiones es de rotación y recesión, con lo que parece que las formas menores del centro estén más alejadas, creándose la percepción de un vacío central en la composición.

En su lógica y deductiva composición, *Função diagonal* recuerda una obra clásica de la abstracción europea: *Composición aritmética* (1930), de Theo van Doesburg. Esa pintura fue el manifiesto visual de van Doesburg de los principios del Arte Concreto, articulados en el manifiesto del Arte Concreto publicado aquel mismo año. El Arte Concreto aspiraba a ser la forma artística más objetiva y alejada de lo simbólico, en la que "un elemento pictórico no tenga otro significado que 'sí mismo' y que, por tanto, la pintura no tenga otro significado que 'sí mismo'".[1] Tras la muerte de van Doesburg en 1931, Max Bill y otros artistas tomaron las riendas del Arte Concreto en Suiza, que más tarde llegó a São Paulo con una importante exposición de Max Bill en el Museu de Arte Moderna en 1950.

Mientras que la historia del arte generalmente ha interpretado la introducción del Arte Concreto en Brasil como un sencillo reflejo de la industrialización de dicha ciudad y el deseo de formar parte del movimiento racionalista e internacionalista, ha habido pocos estudios que analicen las diferencias entre el Arte Concreto suizo y el brasileño. El surgimiento del Arte Neoconcreto en Rio en los años sesenta ha alentado una lectura de la etapa concreta anterior como caracterizada por la ortodoxia matemática y la asimilación acrítica de los modelos europeos. A mi juicio, obras como *Função diagonal* apuntan a un interés por la percepción psicológica que las sitúa en un ámbito conceptual y fenomenológico distinto respecto a sus equivalentes europeos. Mientras que la *Composición aritmética* de van Doesburg utiliza una operación matemática casi idéntica (división por dos y rotación sobre una diagonal), las formas llegan a la parte superior izquierda, sugiriendo una continuación más allá del marco. Esta presentación de una estructura completa con todas sus partes constitutivas plantea la cuestión de la relación del todo con sus partes, uno de los principios básicos de la teoría Gestalt.

La teoría Gestalt se desarrolló en los años veinte como una forma de la psicología del comportamiento. Esta teoría se interesa por la resolución de los problemas y sus implicaciones para la comprensión de la mente humana. Según Max Wertheimer, el primer teórico de la Gestalt,

La cuestión fundamental puede formularse de forma muy simple: ¿están las partes de un todo dado determinadas por la estructura interna de ese todo? ¿O son los acontecimientos independientes, poco sistemáticos, fortuitos y ciegos, de modo que hacen que la actividad total sea una suma de las actividades parciales?

En pocas palabras, la teoría Gestalt afirma que el todo es mayor que la suma de sus partes. La percepción visual es una parte importante de la teoría Gestalt, ya que es aquí que ciertas formas de comprender el mundo se hacen tangibles. *Função diagonal* expresa muchas de las leyes que permiten comprender la teoría Gestalt, la más famosa de las cuales es el efecto de contraste simultáneo o "multiestabilidad", por la que una forma puede interpretarse de dos maneras alternativas, pero nunca en ambas simultáneamente (el ejemplo más típico es el perfil de una copa o candelabro que también puede interpretarse como dos caras opuestas). El deseo de la mente de ver un "todo" (gestalt) organizador determina la percepción más que las partes constitutivas. Así, una operación geométrica nunca puede contener un valor absoluto, puesto que cualquier valor estará sujeto a la percepción de la *Gestaltqualität:* la calidad de ser un todo. *Função diagonal* ilustra asimismo las otras operaciones características de la gestalt visual: emergencia (la capacidad de ver una forma completa emergiendo de un contexto), cosificación (la compleción mental de una forma incompleta) e invariancia (reconocer una forma como equivalente incluso cuando aparece rotada, redimensionada o distorsionada).

En este sentido, *Função diagonal,* junto con muchas otras obras del Concretismo brasileño, va más allá de una sencilla creencia progresista en el valor absoluto de las matemáticas en sí, en el sentido del Arte Concreto europeo. Al generar una tensión perceptiva entre la operación matemática (una simple subdivisión) y la percepción de un todo gestáltico (retroceso, rotación), la obra de Barros conlleva una profunda y significativa conexión con la percepción humana y la psicología, un aspecto que las aplicaciones más ortodoxas de la geometría al arte niegan tajantemente. Por otra parte, la belleza de la obra radica en su simplicidad y rigor. Barros no expresa la complejidad perceptiva a través de la pincelada individual o incluso del color, sino más bien a través de una profunda comprensión de la capacidad de la mente humana para organizar el material a través de la percepción.

Las repercusiones de esta aplicación de la teoría Gestalt al arte geométrico fueron enormes. A diferencia de los intentos argentinos por producir un arte anti-ilusionista absolutamente objetivo en la década anterior, los artistas paulistas reconocieron la subjetividad del espectador como parte de la ecuación. Esta combinación

de subjetividad con una geometría absolutamente clásica se desarrollaría plenamente no sólo en el movimiento neoconcreto, sino también en el Arte Cinético practicado en Caracas y París, en el que el color perceptivo determinaba la relación del espectador individual con el fenómeno visual.

Gabriel Pérez-Barreiro
Traducción de Jordi Palou

Notas

1. Carlsund, van Doesberg, Hélion, Tutundjian y Wantz, "The Basis of Concrete Painting", publicado originalmente en *Art Concret* [París], no. 1 (1930). Reproducido en Stephen Bann, ed., *The Tradition of Constructivism* (Nueva York: Da Capo, 1974), 193.

Alejandro Otero
Estudio 2, 1952
Gouache sobre papel
19.5 × 25 cm
Colección Patricia Phelps de Cisneros
1990.95

Estudio 3, 1952
Gouache sobre papel
19.5 × 25 cm
Colección Patricia Phelps de Cisneros
1990.96

Tablón de Pampatar, 1954
Duco sobre madera
320.5 × 65 × 2.5 cm
Colección Patricia Phelps de Cisneros
1990.58

Dado el carácter paradigmático de la serie Coloritmos (1955–1960), de Alejandro Otero, resulta difícil no considerar *Estudio 2* (lámina 17), *Estudio 3* (lámina 18) y *Tablón de Pampatar* (lámina 19) ante todo como obras que prefiguran dicha serie, sin duda mejor conocida. De hecho, presentan elementos compositivos—y, en el caso de *Tablón de Pampatar,* materiales y técnicas— que caracterizarían los posteriores Coloritmos. Sería un error, sin embargo, considerar estas tempranas abstracciones geométricas como meras precursoras. Generadas como parte de su compromiso con proyectos que perseguían una integración de las artes, nos permiten entender mejor cómo dichos proyectos contribuyeron al desarrollo de la versión que Otero elaboró del Constructivismo.

Otero regresó a Caracas desde París en 1952 para participar en la construcción de la Ciudad Universitaria, bajo la dirección del arquitecto Carlos Raúl Villanueva. Fue en París—ciudad en la que había estado viviendo desde 1945—donde se planteó por primera vez la cuestión de la integración de las artes. En 1951 Otero propuso enviar a Caracas una exposición internacional de arte abstracto que se titularía *Unidad en el arte.* Sobre esta exposición escribió:

Esto quiere decir la colaboración estrecha entre pintura, arquitectura, escultura, etc. … La pintura y la escultura en función de la arquitectura y viceversa. Sus interrelaciones y la influencia de todo esto en lo práctico, en los objetos de la vida en la casa, en la calle, etc., etc.[1]

Para Otero, la integración de las artes era fundamental para su objetivo de contribuir a "la armonía y equilibrio de la sociedad futura" a través del arte.[2]

La primera oportunidad que tuvo Otero de intentar una integración de las artes fue con el proyecto (completado en 1953) para realizar cinco pequeños paneles para el anfiteatro José Ángel Lamas en Caracas.[3] *Estudio 2* y *Estudio 3* son dos de los cinco estudios realizados para dichos paneles. Otero siguió con bastante fidelidad estos estudios en gouache sobre papel para realizar los paneles, que consisten en mosaicos colocados sobre una estructura de aluminio. Se trata de ejemplos tempranos del empleo de cuadrículas por parte de Otero y nos ayudan a comprender la trayectoria del desarrollo estilístico del artista. Inspirado por Mondrian, Otero usó cuadrículas por primera vez en los Collages ortogonales (1951). No obstante, las cuadrículas en estos dos estudios son distintas, puesto que el artista no las creó con líneas ortogonales sino con diagonales. Inclinadas, flotan en un espacio indefinido, de modo muy similar a las líneas de su serie Líneas inclinadas, aun anterior (lámina 8).

Estas pinturas presentan un carácter dinámico y que flota libremente, que en algunos aspectos recuerda las obras geométricas abstractas del Kandinsky del periodo Bauhaus (1922–1933). Eso no significa que la obra de Kandinsky influyera directamente sobre la de Otero, a pesar de que Otero lo consideraba, junto con Mondrian y Delaunay, uno de los vértices de "la gran trilogía" de artistas abstractos.[4] Quizás la afinidad que tienen con la obra de Kandinsky proceda más bien de un interés compartido por la sinestesia— y, más específicamente, el interés por sugerir la sensación de sonido a través de medios visuales—. Sus cuadrículas irregulares y oblicuas insinúan los altibajos del sonido, sus vibraciones variables. Los módulos de la cuadrícula rellenos de blanco, negro o colores vibrantes crean el ritmo. Estos estudios, pues, no sólo aspiran a la integración de la pintura y la arquitectura, sino también de la música.[5]

El propio Otero reconoció que los paneles no fueron plenamente satisfactorios como proyecto de integración.[6] A pesar de que la alusión a la música complementa la función del anfiteatro, formalmente los paneles no reafirman la estructura en sí. El uso de diagonales no paralelas en estos dos estudios produce una impresión de retroceso espacial que, pictóricamente, niega el plano de la pared. Incluso los dos paneles que no tienen diagonales parecen simplemente decorar la pared como pinturas convencionales, en parte debido a su reducida escala. En cambio, en otros proyectos de integración posteriores—como el doble mural que creó para la Escuela de Ingeniería de la Ciudad Universitaria (1956)—usó cuadrículas ortogonales que sí enfatizaban el plano de la pared. En la Escuela de Ingeniería, al colocar los dos murales uno encima de otro, uno en la primera planta y el otro en la segunda, subrayaba visualmente la continuidad de la pared entre ambas plantas. Dichos murales cubren toda la superficie visible de la pared, lo

que hace que aparezcan plenamente integrados en ella.

Cuando estaba involucrado en el proyecto de la Ciudad Universitaria, Otero realizó el *Tablón de Pampatar*,[7] una pintura que hace entrar en juego elementos ya presentes en los *Estudios,* que posteriormente utilizaría en otros proyectos de integración y en los Coloritmos. La obra consiste en una serie de módulos rectangulares de idéntico tamaño, pintados de blanco, negro, azul, rojo y amarillo. En conjunto crean una cuadrícula marcadamente vertical, como la de los estudios, pero de tipo ortogonal, como las que realizaría posteriormente para los murales de la Escuela de Ingeniería. Los colores, la composición cuadricular ortogonal, los bordes precisos y la suave superficie hacen de esta obra un tributo al periodo clásico de Mondrian. Otero logró este aspecto preciso y suave pintando, por vez primera, con un aerógrafo, aplicando duco a un tablón vertical de madera—los mismos materiales, técnica y formato que usaría en los Coloritmos—. En *Tablón de Pampatar*, a diferencia de sus *Estudios,* son los módulos de color, más que las líneas negras, los que definen la cuadrícula. Al igual que los *Estudios* y otras obras de la década de 1950, sin embargo, el *Tablón de Pampatar* también evoca la música. Incluso se aproxima formalmente a sistemas de notación musical: sus ocho registros alineados verticalmente sugieren pentagramas en los que se disponen los brillantes colores, que parecen resonar como si fueran notas.[8]

A primera vista, la obra parece bastante simple. Pero a partir de elementos simples, Otero creó una composición de una gran complejidad. Por ejemplo, cada uno de los ocho registros está conectado al de debajo y al de encima por módulos negros alineados verticalmente que se leen como barras continuas, excepto el cuarto y el quinto registros, separados por una estrechísima brecha. De este modo, dividió de hecho la composición por la mitad en sentido horizontal, evocando aun más la notación musical, que separa los pentagramas correspondientes a agudos y graves. Los módulos blancos, negros y de color se repiten sin seguir un esquema reconocible. Esta repetición variable y la brillantez de los colores crean una composición viva y dinámica, a pesar de la ausencia de líneas dinámicas.

Además de crear ritmo, los colores de Otero crean también espacio. En el *Tablón de Pampatar,* los módulos de color parecen retirarse hacia atrás o proyectarse hacia fuera, según su proximidad a los demás colores, al blanco o al negro. El uso por parte de Otero de colores planos para definir el espacio es similar al modo en que un arquitecto utiliza las paredes y evidencia su interés por el espacio arquitectónico, así como una comprensión cada vez mayor de dicho espacio. Este uso espacial del color se vincula asimismo con el de Delaunay, quien exploró por primera vez la interacción espacial de los colores en cuadrículas en sus *Ventanas simultáneas* de 1912. Pero a pesar de que los colores en *Tablón de Pampatar* creen una sensación de espacio, la precisión del acabado y el uso de la composición cuadricular ortogonal subrayan la superficie plana y continua de la pintura, que obra en contra de la ilusión espacial. En términos de espacio pictórico, el *Tablón de Pampatar* crea

una maravillosa ambivalencia, que Otero desarrollaría en los Coloritmos.

Sin conocer las apasionadas y utópicas declaraciones de Otero, resulta difícil ver cómo tales obras, tanto si se trata de pinturas independientes como de murales integrados en edificios, podían contribuir a un cambio social. De hecho, desde la perspectiva del siglo XXI, las reivindicaciones utópicas de Otero y sus colegas pueden parecer ingenuas, ampulosas e, irónicamente, con poca visión de futuro. Aunque el arte constructivista fracasó en su intento de hacer realidad una utopía social, la visión utópica de Otero logró crear un Constructivismo altamente refinado y estimulante que nos recuerda lo vibrante y creativo puede ser la esperanza.

Gina McDaniel Tarver
Traducción por Jordi Palou

Notas

1. Alejandro Otero a Alfredo Boulton, 5 octubre 1951, reproducido en español y traducido al inglés en *Geometric Abstraction: Latin American Art from the Patricia Phelps de Cisneros Collection/Abstracción Geométrica: Arte Latinoamericano en la Colección Patricia Phelps de Cisneros* (New Haven y Londres: Yale University Press, 2001), 150.
2. "Alejandro Otero polemiza con Mario Briceño Iragorry", *El Nacional* [Caracas], 5 julio 1952; reproducido en *Alejandro Otero* (Caracas: Museo de Arte Contemporáneo de Caracas, 1985), 22.
3. Actualmente este anfiteatro se llama la Concha Acústica de Bello Monte. Construido en el municipio de Baruta (en el área metropolitana de Caracas) en 1953–1954, fue concebido como la sede de la Orquesta Sinfónica de Venezuela.
4. "Alejandro Otero polemiza con Mario Briceño Iragorry", en *Alejandro Otero,* 21.
5. La integración de la música con las artes visuales y la arquitectura era también uno de los objetivos de Villanueva, que incluso concibió su plan para la Ciudad Universitaria como una partitura musical, proyectando las áreas del campus como "movimientos". Para una breve explicación, véase Jacqueline Barnitz, *Twentieth-Century Art of Latin America* (Austin: University of Texas at Austin, 2001), 171.
6. Acerca del proyecto de la Concha Acústica, así como de sus proyectos para la Ciudad Universitaria, Otero escribió: "Pero nada de esto coincidía verdaderamente con las posibilidades que había entrevisto". De "Alejandro Otero polemiza con Mario Briceño Iragorry", en *Alejandro Otero,* 21.
7. Pampatar es una ciudad colonial en la isla venezolana de Margarita. Alfredo Boulton, amigo y mecenas de Otero, encargó al artista la creación del *Tablón de Pampatar* para una enorme casa que tenía en dicha ciudad; de ahí el nombre de la pintura. Luis Pérez-Oramas, correspondencia con la autora, 3 julio 2006.
8. Jiménez observó que Otero y otros artistas disponían los colores y las formas rítmicamente con el objeto de introducir el tiempo, "acercándose incluso formalmente a los sistemas de notación musical". Ariel Jiménez, "Geometrías", en *Geo-metrías: Abstracción geométrica latinoamericana en la Colección Cisneros* (Caracas: Fundación Cisneros, 2003), 42.

Jesús Rafael Soto
Desplazamiento de un elemento luminoso, 1954
Plexiglás y témpera sobre madera
49.8 × 80 × 3.2 cm
Colección Patricia Phelps de Cisneros
1989.36

Desplazamiento de un elemento luminoso (lámina 20) es una obra crucial de Jesús Soto, tanto desde el punto de vista artístico como

crítico. Mostrada en la histórica exposición *Le Mouvement*, en París, en la Galerie Denise René en abril de 1955,[1] forma parte de una serie de construcciones de plexiglás en las que Soto renunció a la primacía de la pintura y creó un nuevo lenguaje con el que expresar el movimiento a través de los efectos visuales. *Desplazamiento* no sólo amplía el uso de la repetición y la progresión por parte de Soto para negar la representación y los conceptos tradicionales de la perspectiva y la ilusión espacial, sino que también interactúa con el espectador a través de la vibración y anticipa las piezas cinéticas más complejas que realizaría con posterioridad. Por otra parte, la inclusión de *Desplazamiento* en la exposición *Le Mouvement* y la crítica que recibió confirman el papel decisivo de esta obra para que Soto pasara a formar parte de la comunidad internacional de artistas de vanguardia.

A poco de su llegada a París en 1950, Soto pasó por una serie de sucesivas y rápidas fases de experimentación. La serie de pinturas que realizó en 1951, Búsquedas dinámicas, socava cualquier idea convencional de forma o composición mediante una repetición rítmica de elementos de idéntico color sobre estructuras de madera, generando una aparente continuidad infinita más allá del marco. En 1952, inspirado por la teoría de la música dodecafónica, Soto pintó dos nuevas series de obras tituladas Progresiones y Rotaciones, en las que sistematizó el papel del artista individual a la hora de decidir la composición, la forma y las armonías de los colores. En ambas series, la lógica compositiva es arbitraria pero al mismo tiempo regular. Soto aplicó una gama limitada de colores, siguiendo un orden secuencial seleccionado al azar y asignando a cada color una posición en la retícula del soporte de madera. El resultado en ambos casos es el de socavar cualquier composición central o punto de fuga tradicional. Visualmente, las obras podrían cortarse en cualquier punto dado, a la vez que presentan múltiples posibilidades para el espectador. Éste puede decidir entre experimentar la obra como una entidad autosuficiente o proseguir el patrón más allá de los límites del marco.[2]

Con *Desplazamiento*, Soto aplicó sus exploraciones sobre la repetición y la rotación al plexiglás, un material nuevo para él. Transfirió la composición global y la pintura no figurativa a una estructura consistente en un plano transparente de plexiglás superpuesto sobre una superficie opaca de madera. La distribución seriada de puntos blancos que se ven a través de la retícula rectangular negra fijada sobre la superficie de madera y la de los que aparecen en el plano de plexiglás son idénticas.[3] No obstante, al alterar el ángulo del plexiglás superpuesto, Soto desestabiliza y anima la composición. La ambigua perspectiva de *Desplazamiento* produce una sensación de movimiento que confunde figura y fondo. El marco de referencia compositivo del espectador se disuelve en una titilante pantalla de puntos que se fusionan y separan al compás del movimiento del espectador. En última instancia, es el espectador—y no el artista—quien determina el resultado de la obra como una vibración óptica cinética.

Desplazamiento pertenece a un grupo de obras en las que Soto colocaba el plexiglás directamente sobre un soporte plano de madera.

Pero a finales de 1955 Soto separó el plano de plexiglás de la superficie y realizó, a su propio modo, su primera estructura cinética, *Espiral*.[4] Inspirado por las obras Rotoreliefs (1935) y *Rotative Demi-sphère* (1950), de Marcel Duchamp, que el artista había visto en la exposición *Le Mouvement*, utilizó una forma en espiral pintada tanto sobre el recubrimiento de plexiglás como sobre el soporte de madera. Estas estructuras de plexiglás más complejas brindaban a Soto nuevos métodos para crear una vibración óptica dinámica: "La destrucción metódica de toda forma estable, el estallido molecular de los sólidos, la disolución del volumen".[5] Para Soto, este movimiento era fundamental para incorporar el tiempo real a la pieza, o lo que posteriormente llamaría "las situaciones espaciotemporales".[6] Por otra parte, la cambiante forma luminiscente desafiaba al espectador a participar activamente en la "creación de la obra", que el artista ya no codificaba mediante una forma artística predeterminada.

Muchos contemporáneos de Soto en París compartían su deseo de introducir el movimiento en la abstracción, rechazaban la expresión subjetiva del artista y buscaban la participación activa del espectador. A principios de la década de 1950, los artistas del grupo Madí habían expuesto en París obras que incorporaban el dinamismo al arte geométrico abstracto. Jean Tinguely y Yaacov Agam, con quienes Soto expuso en *Le Mouvement*, también habían investigado alternativas no pictóricas para conferir al objeto visual un papel activo.[7] No obstante, el artista cuya obra está más estrechamente vinculada al *Desplazamiento* de Soto es Victor Vasarely. Posiblemente la figura más conocida e influyente de la generación más joven de artistas que expusieron en *Le Mouvement*, Vasarely había estado experimentando ya desde 1952 con los efectos ópticos producidos mediante el uso de collages transparentes en blanco y negro, tanto en plexiglás como con papel de calco. Al definir cómo el arte no figurativo podía triunfar sobre *l'anecdote* de Manet, Vasarely observó, en el "Manifiesto amarillo" que acompañaba a la exposición, que el efecto de las "perspectivas opuestas"—lo positivo y lo negativo—"causan tanto la aparición como la desaparición de un 'sentimiento espacial', creando así la ilusión de movimiento y de duración".[8] Esta descripción está directamente relacionada con la técnica que Soto desplegó en *Desplazamiento*. A pesar de que posteriormente Soto se distanció de Vasarely, obras como *Desplazamiento* ilustran la temprana importancia que éste tuvo para Soto.

La obra de Soto, incluyendo el *Desplazamiento*, recibió una amplia atención por parte de la crítica al formar parte de la exposición *Le Mouvement*. La prensa de París cubrió exhaustivamente la exposición y sus participantes, subrayando el impacto del nuevo movimiento sobre la abstracción. Louis-Paul Favre, en particular, hizo un elogio de la exposición en la crítica que publicó en *Le Combat*.[9] De repente, los críticos consideraron que Soto, cuya obra había recibido un limitado eco en la prensa artística de París, formaba parte de una importante nueva ola de artistas vinculados a la vanguardia internacional. A pesar de que Léon Degand, el entusiasta defensor de la abstracción en *Art d'Aujourd'hui*, criticó

a los defensores de *Le Mouvement* como poco originales y citó específicamente a Soto por no considerarlo aun un auténtico *creador,* Carlos Raúl Villanueva, el destacado arquitecto venezolano de la Ciudad Universitaria de Caracas, apreció las destacadas repercusiones del grupo y de Soto en particular. El apoyo crítico de Villanueva impulsó la trayectoria artística de Soto, tanto en Venezuela como en Europa. Poco después de mostrarse *Desplazamiento* en *Le Mouvement,* Villanueva organizó importantes exposiciones de Soto en Caracas y en Bruselas, refiriéndose al artista como "un genio".

A pesar del éxito de crítica cosechado en general por *Desplazamiento,* podría interpretarse esta obra como una forma ingenua de homenaje neoplasticista a las composiciones suprematistas de Malevich o a las construcciones/collages de Moholy-Nagy; también recuerda mucho los murales realizados por Vasarely en plexiglás. Sólo después de que Soto desarrollara su propio lenguaje cinético personal—en obras como *Espiral*—y creara composiciones cada vez más osadas, fue consolidando su lugar como líder de la vanguardia internacional, tanto venezolana como europea.

Estrellita B. Brodsky
Traducción de Jordi Palou

Notas

1. Frank Popper escribió que, a pesar de que los orígenes del Arte Cinético como movimiento artístico de primer orden se remontan a la década de 1920, no tomó forma hasta los años cincuenta y quedó finalmente consolidado en la influyente exposición celebrada en la Galerie Denise René, *Le Mouvement.* Frank Popper, introducción a *Lumière et mouvement* (París: Galerie Denise René, 1996), s. pág.
2. Al analizar la obra de Mondrian, Rosalind Krauss cuestiona si puede interpretarse como "una sección de una supuesta continuidad", o bien si "la pintura se estructura como un todo orgánico y autónomo". Rosalind Krauss, "Grids", en *The Originality of the Avant-Garde and Other Modernist Myths* (Cambridge, Mass.: MIT Press, 1985), 19.
3. En una entrevista con Ariel Jiménez, Soto describió la construcción de esta obra. Explica que el rectángulo negro fijado al soporte de madera era una rejilla de metal usada habitualmente en componentes de radio, adquirida en unos grandes almacenes de París. Luego pintó los puntos blancos sobre el plexiglás a través de la rejilla. En Ariel Jiménez, *Conversaciones con Jesús Soto* (Caracas: Fundación Cisneros, 2005), 50.
4. Jean Clay, *Visages de l'Art moderne* (París: Éditions Rencontre, 1969), 300–301.
5. Clay, 301.
6. Ariel Jiménez, *Conversaciones con Jesús Soto,* 65.
7. Véase Arnauld Pierre, "L'immatériel de Soto et la peinture du continuum", en *Jesús Rafael Soto* (París: Galerie Nationale du Jeu de Paume, 1997), 22–23.
8. Reproducido en Victor Vasarely, "Notes pour un manifeste", *Aujourd'hui: art et architecture* 6 (marzo/abril 1955): 10.
9. Louis-Paul Favre, "Le mouvement", *Combat* 5 (mayo 1955): 6.

Carlos Cruz-Diez
Proyecto para un mural, 1954
Acrílico sobre madera
40 × 55.2 cm
Colección Patricia Phelps de Cisneros
1997.144

A primera vista, el *Proyecto para un mural* (lámina 21), de Carlos Cruz-Diez, parece una obra de arte relativamente simple. El artista presenta una serie de cilindros de madera de distintos tamaños y colores. Dadas las dimensiones de la obra y su semejanza con un juguete para niños, algunos espectadores pueden sentir el impulso de tocar los objetos o recolocarlos para formar disposiciones distintas. Aunque Cruz-Diez montó los cilindros sobre un fondo blanco que casi refleja los colores con que están pintados, *Proyecto para un mural* no produce los efectos ópticos de las obras icónicas que el mismo artista realizó con posterioridad. Los cilindros no están tan densamente colocados, por ejemplo, como para permitir al espectador la percepción de una interacción de colores complementarios y opuestos; tampoco parecen brillar como si la obra en su conjunto contuviera alguna forma vibrante de energía. A pesar de ello, aunque no produzca estos efectos visuales, *Proyecto para un mural* destaca como ejemplo representativo de las estrategias y objetivos artísticos a largo plazo de Cruz-Diez; la obra revela el constante interés del artista por ampliar el papel que desempeña el arte en la sociedad contemporánea. En lugar de crear obras de arte para galerías o museos, Cruz-Diez intentaba lanzar sus proyectos a la arena pública, ofreciendo al público en general la oportunidad de participar e interactuar con sus obras. *Proyecto para un mural,* pues, revela un aspecto distinto de la trayectoria de un artista que es conocido sobre todo por sus exploraciones en torno a los efectos ópticos del color.

Nacido en Caracas en 1923, Cruz-Diez completó su formación artística en la Escuela de Bellas Artes. Al comentar su aprendizaje artístico, el artista explica que el año en que realizó *Proyecto para un mural* fue un momento crucial en su vida:

> En 1954 empecé a tener los mismos pensamientos que, en principio, se plantean todos los artistas en un momento u otro de su vida, cuando dudan sobre la validez y trascendencia de las pinturas que realizan. En ese momento, estructuré una plataforma conceptual que hasta ahora me ha permitido llevar a cabo mi obra basándome en una perspectiva no tradicional sobre el color.[1]

Cruz-Diez se dio cuenta de que no podía limitarse a considerar el color como un elemento secundario en su producción artística. En lugar de ello, exploró los colores y los efectos ópticos que estos pueden producir en el espectador como forma de animar al público a interactuar con sus objetos de arte. En sus Fisicromías, por ejemplo, Cruz-Diez unía un gran número de tiras semitransparentes perpendicularmente sobre un soporte, y escogía ángulos y colores específicos para dichos elementos. Una vez acabada la obra de arte y colgada en la pared, el espectador puede experimentar una transformación continua de la Fisicromía; a medida que uno se mueve de un lado para otro frente a ella, la obra parece cambiar de forma y color, produciendo la sensación de que nunca está acabada, sino que más bien la completa el propio espectador cada vez que decide interactuar con la obra de arte.[2]

De este modo, aunque el *Proyecto para un mural* carezca de los efectos ópticos de una

Fisicromía, ambos objetos artísticos encarnan el deseo de Cruz-Diez de producir obras de arte que trasciendan la mera observación visual. En otras obras realizadas en 1954, Cruz-Diez creó objetos que requerían algo más que la observación pasiva. En *Proyecto para un muro exterior manipulable,* por ejemplo, el artista creó unas columnas de tubos de colores perforados por alambres montados, una disposición que permitía a los espectadores hacer rotar los cilindros a su antojo. En *Muro de cilindros excéntricos manipulables,* una obra que, en sus aspectos materiales, guarda parecido con *Proyecto para un mural,* Cruz-Diez colocó cilindros coloreados sobre un tablero blanco, de modo que el espectador podía manipular su colocación como si de damas de colores se tratara.

En este sentido, *Proyecto para un mural* y otras obras del artista de principios de la década de 1950 anticipan las exploraciones que Cruz-Diez llevaría a cabo en los años sesenta y setenta, los proyectos a gran escala que trascenderían sus modelos anteriores para transformar literalmente los espacios públicos de ciudades como París y Caracas. En su *Cromosaturación* de 1968, situada a la salida de una estación de metro de París, por ejemplo, Cruz-Diez pedía al público en general que atravesara varias salas conectadas entre sí; había iluminado cada una de ellas con un color distinto, con lo que el público se veía totalmente inmerso en una luz coloreada. En otro proyecto monumental, transformó una de las autopistas de Caracas pintando rayas rojas, verdes y azules sobre una larga pared de aproximadamente 1.3 kilómetros paralela a la carretera, sumergiendo así en sus investigaciones artísticas a los venezolanos que se desplazaban a diario por dicha vía. Por último, en una serie de proyectos que precisaron una amplia colaboración con las autoridades locales, Cruz-Diez intentó transformar la totalidad del centro de Caracas a través de una "acción cromática". Durante los meses de diciembre de 1975 y enero de 1976, recubrió el pasaje peatonal de una avenida de la ciudad con sus típicas combinaciones de colores. Simultáneamente, autobuses pintados con "inducciones cromáticas"—es decir, tiras de distintos colores que recordaban las Fisicromías—transportaban a sus pasajeros por toda la ciudad. Durante quince días, el artista proyectó haces de luz contra las nubes que cubrían la ciudad, produciendo efectos visuales que describió como *Cromoprismas* o esculturas hechas de luz.[3] Los peatones y habitantes de París y Caracas participaron, pues, en distintas experiencias de contemplación artística, incluso aunque nunca hubieran sentido el impulso de visitar un museo o galería de arte tradicionales.

En pocas palabras, difícilmente podemos considerar el *Proyecto para un mural* como un ejemplo anómalo de los proyectos de Cruz-Diez. Al contemplar los cilindros coloreados y considerar la totalidad de la trayectoria de este artista, podemos entender que afirmara lo siguiente:

Los proyectos de obras manipulables para instalar en la calle, que realizaba en los años 54, no parten de una reflexión puramente estética, sino motivadas por una inquietud social. Consideraba pretencioso que "el

artista" expresara sus inquietudes o su fantasía sobre una tela para que la gente viniera pasivamente a "venerar ese producto".[4]

Como espectadores actuales, es posible que debamos recordar a Cruz-Diez no sólo como el hábil artista que desplegaba espectaculares sensaciones de color. Por el contrario, deberíamos tener presente cómo el artista fue coherente en su intento de transformar la percepción del público, en ocasiones incluso exigiéndole que cambiara sus movimientos o sus acciones, caminando por vestíbulos coloreados o haciendo girar objetos de colores. De este modo, los intentos de Cruz-Diez son análogos a los de otros artistas de vanguardia del siglo XX que se propusieron redefinir el papel del arte en la sociedad contemporánea.

Alberto McKelligan
Traducción de Jordi Palou

Notas

1. Carlos Cruz-Diez, "My Reflections on Color", publicado por el artista en www.cruz-diez.com [acceso: 1 enero 2006].
2. En este mismo catálogo hay un análisis más extenso sobre las Fisicromías de Carlos Cruz-Diez y su relevancia.
3. Para una descripción detallada de estos proyectos y otros, véase *Exposición: Carlos Cruz-Diez, del 11 de febrero al 18 de marzo* (Madrid: Galería Aele), s. pág.
4. Carlos Cruz-Diez, "Obras de los años 50", publicado por el artista en http://www.cruz-diez.com/espanol/obracol1.htm [acceso: 1 enero 2006].

Lygia Clark
Composição n.º 5 [Composición n.º 5], 1954
Óleo sobre tela
106.5 × 90.7 × 2.5 cm
Colección Patricia Phelps de Cisneros
1997.54

Composição n.º 5 se remonta a la participación de Clark en el Grupo Frente, la rama carioca del Constructivismo brasileño. En el auge desarrollista que siguió a la Segunda Guerra Mundial, miembros del Grupo Frente y sus colegas del Grupo Ruptura de São Paulo emprendieron una nueva investigación del lenguaje geométrico, inspirada en parte por la abstracción matemática de Max Bill y el proyecto de la escuela de Ulm, en el sentido de integrar el arte en la moderna sociedad industrial. A pesar del interés compartido de ambos grupos por el Constructivismo, surgieron desacuerdos en torno a la interpretación teórica y práctica de las cuestiones planteadas por el Concretismo a escala internacional.[1] El contingente de Rio rechazaba lo que percibía como el proyecto de São Paulo: la búsqueda de la objetividad a través de una estricta adhesión a los métodos científicos. Los cariocas abogaban por un enfoque más "espontáneo" de la geometría, basado en la "intuición creativa". De este modo, el Grupo Frente se proponía mejorar el amenazador racionalismo doctrinario que percibían (quizás erróneamente) en las obras del Grupo Ruptura.[2] *Composição n.º 5* refleja este surgimiento inicial y polémico de la estética concreta en Brasil. A la vez que pone de manifiesto la fe de Clark en el potencial expresivo del Constructivismo, esta obra expresa asimismo

su frustración respecto de las limitaciones de la ortodoxia racionalista y anticipa la desviación "neoconcreta".

La I Exposición Nacional de Arte Concreto, organizada en São Paulo en 1956, desencadenó una radical escisión entre ambos grupos. Declarándose a sí mismos legítimos representantes del Concretismo en Brasil, la facción de São Paulo acusaba a los artistas de Rio de desviarse de las normas concretistas como prueba de su mala interpretación de los postulados básicos del Constructivismo.[3] No obstante, Clark quedó curiosamente libre de críticas y se vio cómodamente adscrita a ambas escuelas. Posteriormente advirtió la ironía de esta involuntaria adscripción al programa de São Paulo, y recordaba: "Los paulistas empezaron a citarme como la artista más similar a lo que ellos hacían, cuando en realidad yo era quizás la más distinta de todos nosotros".[4] Pinturas como la *Composição n.º 5,* que Clark mostró en esta exposición, ayudan a explicar la aceptación que tenía su obra entre sus compatriotas. La segmentación de la composición en divisiones rectangulares análogas, pintadas en colores complementarios—rojo y verde—, produce una relación ambivalente figura-fondo y una tensión visual característica de los ejercicios ópticos basados en la teoría de la Gestalt, de capital importancia para gran parte del Concretismo brasileño inicial. Aun así, las formas descentradas y la mesurada área gris en la esquina inferior izquierda—que interrumpe el marco negro—sugieren que, en lugar de participar en una búsqueda de pura visualidad, en realidad Clark era indiferente a ella.

El simple gesto de pintar sobre el marco como una extensión de la tela desafiaba la regularidad de las formas concretas y revelaba en su lugar la dimensión filosófica, incluso existencial, de las exploraciones geométricas de Clark. "En realidad", explicó Clark, "lo que quería hacer era expresar el espacio en y por sí mismo, y no componer dentro de él".[5] *Composição n.º 5* inició esta búsqueda de lo que la artista denominaba la línea y el espacio "orgánicos". La aplicación de color al artefacto supuestamente neutro que separa la pintura de la pared permite a Clark abrir los bordes tradicionales de la pintura, tanto hacia las formas pintadas en ella como a la arquitectura de la sala que se halla a su alrededor. Este poroso perímetro, pues, se convertía en un conducto para la fusión del arte y la vida, trastocando la función del marco como dispositivo para dividirlos. Mientras que la aplicación del color transformaba el marco en un elemento formal, el espacio físico real entre la tela y el marco—la línea en que lindan la pintura y el marco, que no sería "compuesta" sino que más bien existiría en el mundo del espectador—se convertía en el fundamento de la "línea orgánica", que Clark seguiría explorando en varios ámbitos de su obra posterior. El concepto de una "línea orgánica" reflejaba el deseo de Clark de liberar la línea de su condición inanimada y su función descriptiva, dando así rienda suelta a la vitalidad de los elementos formales y transformando el espacio.[6] Al tiempo que mantenía una disciplina estructural, *Composição n.º 5* desafiaba las promesas normativas de objetividad; la obra proclamaba que la percepción y la interpretación eran altamente subjetivas y fundamentalmente indecisas. Es más, la negociación por parte de Clark de la ambigüedad entre el espacio protegido de la tela y el espacio vivido por el espectador implicaba algo más que una mera visión, interactuaba cognitiva y espacialmente con el espectador e invitaba a una mirada háptica.

Aunque no era excepcional en el Concretismo de Rio de Janeiro, esta indagación incipiente en la subjetividad humana y la mecánica de la percepción más allá de la vista prefiguraba el surgimiento del Neoconcretismo. La impaciencia colectiva con lo que los artistas cariocas consideraban el carácter cada vez más dogmático y reduccionista de las interpretaciones más ortodoxas del Concretismo llegó a un punto crítico en 1959, cuando una serie de artistas geométricos descontentos organizaron la I Exposición de Arte Neoconcreto en Rio de Janeiro. Sin abandonar los principios básicos del Constructivismo, el movimiento aspiraba a contrarrestar lo que consideraba una dependencia excesiva del Concretismo respecto de fórmulas preestablecidas, a través del tratamiento individual e idiosincrásico de unos postulados teóricos. El "Manifiesto neoconcreto", que codificó los principios del movimiento, advertía contra la "peligrosa hipertrofia del racionalismo" y denunciaba la "objetividad mecanicista".[7] Trazaba un programa artístico basado en los principios de la fenomenología, en particular en los textos de Maurice Merleau-Ponty y Susanne K. Langer, que abogaban por el estímulo no sólo de la vista, sino de múltiples sentidos simultáneamente, con el objeto de aproximarse más a la experiencia corpórea de la realidad.

La *Composição n.º 5* deja traslucir que, para Clark y el grupo de artistas de Rio de Janeiro, el Arte Concreto era un punto de partida y no el objetivo final. En la trayectoria personal de la artista, esta obra señaló un punto de inflexión y abrió un amplio abanico de posibilidades expresivas dentro del lenguaje geométrico. La obra dio pie a una investigación sistemática de las dimensiones espaciales y temporales del plano, dirigida a proporcionar un nuevo ímpetu a un formalismo moribundo. *Composição n.º 5* marcó la transición entre la pintura geométrica y obras como Superfícies moduladas (1956–1958), que yuxtaponían y solapaban planos en composiciones geométricas planas, y Casulos (Capullos, 1959–1960), planos tridimensionales superpuestos que se desplegaban en el espacio físico. En 1960 Clark abogó por la "muerte del plano" como paso necesario hacia una resolución de la fragmentación del sujeto moderno.[8] Al atribuir la invención del cuadrado al instinto del hombre por el equilibrio, la artista razonaba que "el plano diferencia arbitrariamente los límites de un espacio, con lo que da a la humanidad una idea completamente falsa y racional de su propia realidad".[9] Con su eliminación, declaraba, "empieza la experiencia primordial".[10] Este cambio hacia los medios del proceso con fines existenciales, que se originó con el giro neoconcreto, anunciaba la posterior orientación artística de Clark, a medida que la artista subordinó gradualmente el objeto al sujeto y pasó del espacio físico del arte al metafísico.

Edith Wolfe
Traducción de Jordi Palou

Notas

1. Véase la introducción de Fernando Cocchiarale y Anna Bella Geiger a *Abstracionismo geométro e informal: vanguarda brasileira nos anos 50* (Rio de Janeiro: FUNARTE/Instituto do Livro, 1987) extractada en *Abstração geométrica 1: concretismo e neoconcretismo* (São Paulo: FUNARTE, 1987), 7.

2. A pesar de que historiadores del arte como Ana Maria Belluzzo han sugerido que esta división era el resultado, en parte, de una interpretación incorrecta del Constructivismo de São Paulo, los miembros de la rama carioca del movimiento—en particular el teórico y crítico Ferreira Gullar—promovieron esta división en aquel momento, y siguen manteniéndola aun hoy: São Paulo sería más racionalista y teórica, mientras que Rio de Janeiro sería más espontánea y experimental. Véase, por ejemplo, Belluzzo, "Ruptura e arte concreta", en Aracy Amaral, ed., *Arte construtiva no Brasil: Coleção Adolpho Leirner* (São Paulo: Companhia Melhoramentos/DBA Artes Gráficas, 1998), 118, y Gullar, "O Grupo Frente e a reação neoconcreta", en Amaral, 143–81. Sobre la división original entre ambos grupos (gran parte de cuyo lenguaje se atribuye a Gullar y al crítico Mário Pedrosa), véase Ronaldo Brito, *Neoconcretismo: Vértice e ruptura do Projeto Construtivo Brasileiro na arte* (São Paulo: FUNARTE, 1985), 11–12, y Belluzzo, 119–21.

3. *Abstração*, 7–8.

4. Citado en Geiger y Cocchiarale, *Abstracionismo geométrico e informal,* 146. Véase asimismo Ricardo Nascimento Fabbrini, *O espaço de Lygia Clark* (São Paulo: Editora Atlas, 1994), 25.

5. De un texto inédito en los archivos de Lygia Clark. Citado en Suely Rolnik, "Molding a Contemporary Soul: The Empty-Full of Lygia Clark", en Rina Carvajal et al., eds., *The Experimental Exercise of Freedom: Lygia Clark, Gego, Mathias Goeritz, Hélio Oiticica, Mira Schendel* (Los Angeles: Museum of Contemporary Art, 1999), 72.

6. Rolnick, 71.

7. "Manifiesto neoconcreto", *Jornal do Brasil* [Rio de Janeiro] 22 marzo 1959: suplemento dominical, 4–5; traducido al inglés en Yve-Alain Bois, "Nostalgia of the Body: Lygia Clark", *October* 69 (verano 1994), 91.

8. Lygia Clark, "A morte do plano", en Lygia Clark et al., *Lygia Clark* (Rio de Janeiro: FUNARTE, 1980), 13. Traducido al inglés en Mari Carmen Ramírez y Héctor Olea, eds., *Inverted Utopias: Avant-Garde Art in Latin America* (New Haven: Yale University Press in association with the Museum of Fine Arts, Houston, 2004), 524–25.

9. Clark, "A morte do plano", 13.

10. Clark, "A morte do plano", 13.

Hélio Oiticica
Sin título, de la serie Grupo Frente, 1955
Gouache sobre papel
40 × 40 cm
Colección Patricia Phelps de Cisneros
2001.92

Pintura 9, 1959
Óleo sobre tela
116.2 × 89.2 cm
Colección Patricia Phelps de Cisneros
1996.44

En 1972 Hélio Oiticica observó en tono desdeñoso, hablando de su propia obra: "No hay motivo para tomar en serio la producción que hice antes de 1959".[1] A pesar de la modestia aparente de esta propuesta, una exploración de la obra del artista anterior a 1959 pone de manifiesto la influencia de varios factores históricos e ideológicos. El año 1959 no fue simplemente un momento de transformación personal para Oiticica. Ese año varios artistas y poetas organizaron la primera exposición neoconcreta en Rio de Janeiro y firmaron el manifiesto que el poeta Ferreira Gullar escribió con motivo de la misma, en el que anunciaban su deseo de romper con el Arte Concreto y reinterpretar los movimientos fundacionales de la abstracción geométrica europea, con la mirada puesta en la fenomenología y la expresión.[2] Aunque la palabra *neoconcreto* no aparece en su texto de 1972, Oiticica reiteraba la separación entre el Arte Concreto y el Neoconcreto al sugerir que el periodo anterior a 1959 era simplemente un "aprendizaje" en el Concretismo.

Contrariamente a lo que sostenía Oiticica, varios hilos conectan su producción anterior y posterior a 1959, y sus obras tempranas merecen un serio estudio. Como lo demuestran el gouache de 1955 (lámina 22) y el óleo de 1959 (lámina 23), Oiticica se involucró en algunas de las actividades requeridas en el "Manifiesto neoconcreto" desde el principio de su carrera artística: pasó por encima de las tendencias artísticas concretas contemporáneas y centró su atención en un replanteamiento de las propuestas de los maestros europeos de la abstracción geométrica, particularmente Piet Mondrian y Kasimir Malevich.[3] De estos artistas extrajo el vocabulario geométrico, la organización en cuadrícula y un perdurable interés por los efectos del color y el espacio negativo, así como por la aspiración de imbuir el arte de una expresión humana y universal.

La obra sin título de 1955 pertenece a una serie de gouaches que Oiticica realizó entre 1955 y 1956, titulada Grupo Frente.[4] El título de la serie proviene del grupo artístico del mismo nombre formado en Rio de Janeiro (Grupo Frente) que, junto con su equivalente de São Paulo, el Grupo Ruptura, practicaba la poesía y el Arte Concreto. El profesor de pintura de Oiticica, Ivan Serpa, lo presentó al grupo, del cual formaban parte Lygia Clark y Lygia Pape. En 1955, con apenas 18 años, se convirtió en el miembro más joven de lo que sin duda era el círculo más vanguardista de Rio.

En esta pintura de 1955, Oiticica dispuso una serie de formas geométricas planas en una estructura cuadricular implícita, que él mismo se apropió de Mondrian. El artista limitó también la gama de colores y repitió los mismos tonos en su obra. No obstante, el gouache se aleja del prototípico vocabulario neoplasticista de líneas ortogonales negras que enmarcan áreas blancas y de colores primarios y, en cambio, se aproxima más a la estética tardía de Mondrian. En *Broadway Boogie-Woogie* (1942–1943), expuesta en el invierno de 1953–1954 en la II Bienal de São Paulo, Mondrian empleó múltiples tonalidades azules y creó una serie de líneas ortogonales palpitantes y multicolor.[5] De hecho, la pintura de Oiticica—con sus tensos contrastes de color y rectángulos subdivididos—podría ser un estudio de detalle de la tardía obra maestra de Mondrian.

El borde que Oiticica reservó en la periferia de su papel y los elementos de la organización compositiva distancian esta obra de la de Mondrian. Oiticica colocó los cuatro rectángulos en el borde exterior de la composición y amplió su fondo azul vibrante con un perímetro trazado con regla, delimitando así una clara separación entre el espacio pictórico situado dentro del borde y el espacio no pictórico del exterior. Oiticica optó por no recurrir a la estrategia de Mondrian de sugerir la continuación de la composición más

allá de sus límites, un enfoque que consideraba fallido para transformar el objeto de arte en una entidad dinámica y vital.[6] En su lugar, prefirió concentrarse en intensificar la actividad visual dentro del plano de la pintura y, por consiguiente, los ojos del espectador recorren rápidamente el vívido fondo y las formas autónomas y similares entre sí.

Pintura 9 se cuenta entre varios óleos que Oiticica realizó alrededor de 1959, relacionados formal y conceptualmente con la serie de gouaches Metaesquemas (1957–1958). En los Metaesquemas, Oiticica multiplicaba las formas geométricas en una cuadrícula sobre un fondo rectangular blanco o sin tratar rodeado por un borde. Según el propio artista, esta estructura cuadricular se inspiraba en Mondrian, y describió la serie como una "mondrianestructura infinitesimada".[7] La cuadrícula rectilínea no sólo se repite sino que también parece vibrar: los polígonos irregulares y fuera de eje y los espacios disparejos entre las formas se convierten en la norma. En la mayoría de Metaesquemas, Oiticica interrumpía su exploración del contraste entre colores y creaba obras monocromas. Como resultado, esta serie recuerda las pinturas suprematistas de Malevich.

A primera vista, es imposible distinguir *Pintura 9* de un Metaesquema. Los cuadrados y rectángulos negros ocupan la misma cuadrícula agitada sobre fondo blanco. No obstante, Oiticica alteró sutilmente varios elementos. La técnica cambia del gouache al óleo, que el artista siguió cultivando durante los primeros años de la década de 1960, cuando logró ricos y saturados campos de color. Optó por emplear una tela tensada, de tamaño mucho mayor que sus anteriores obras sobre papel. Estos cambios hacia una técnica y un soporte más sustanciales físicamente contribuyen a transformar la obra de arte en algo más "objetual", una modificación que se consolidaría en la década siguiente con el uso que hizo de materiales como la madera, el vidrio, la tierra y la tela.

Oiticica eliminó asimismo el borde del soporte sin tratar que el artista había utilizado en sus obras tempranas. Esta alteración sitúa a *Pintura 9* en compañía formal de la obra de Malevich, en la que el fondo blanco enmarca en solitario una serie de formas a menudo colocadas en el centro. A diferencia de Malevich, Oiticica abarrotaba el fondo blanco con un diseño casi regular de formas monocromas relacionadas y, como resultado, los fragmentos de fondo blanco visible, así como las figuras geométricas, atraen y mantienen la atención del espectador. Como el gouache de 1955, *Pintura 9* obliga al espectador a pasear la mirada de aquí para allá por toda la composición. Más que las formas geométricas icónicas de Malevich o el sistema infinitamente en expansión de Mondrian, Oiticica intentaba alcanzar sus extremos, "pura sensibilidad" y "pura vitalidad", a través de medios formales alternativos, concretamente mediante la creación de espacios de energía visual condensada y abigarrada.[8]

En el texto que escribió en 1972, Oiticica sugirió que 1959 era el indicador de otra ruptura más: el fin de la pintura. Sin embargo, aquí tiene que avanzar con cautela porque no fue hasta 1960 que tanto él como sus colegas neoconcretos empezaron sus experimentos tridimensionales. Acerca de la serie Monocromáticos (1959), escribió: ". . . Prevén posibilidades más allá de la pintura". Inserto en esta lógica, se plantea un problema relativo al estudio de las obras realizadas por los artistas neoconcretos en 1959. Sin haberse dado a conocer aun, sin incitar todavía a la participación del espectador, sin ser aun plenamente neoconcretas, obras como *Pintura 9* y *Ovo [Huevo]*, de Lygia Clark, tienden a interpretarse de modo que reflejen la intensa influencia de las ideas y el arte de los años subsiguientes.[9] Lo que presenciamos en estas dos pinturas de Oiticica, sin embargo, son los cimientos de las innovaciones que estaban por venir: una evaluación increíblemente inteligente de las propuestas formales y conceptuales de la vanguardia histórica.

Adele Nelson
Traducción de Jordi Palou

Notas

1. Primera línea de "Metaesquemas 57/58", en *Metaesquemas 57/58* (São Paulo: Galería Ralph Camargo, 1972), reproducida y traducida en *Hélio Oiticica* (Rotterdam: Witte de With, 1992), 27–28.

2. La exposición tuvo lugar en el Museo de Arte Moderno de Rio de Janeiro (MAM-Rio). Ferreira Gullar, "Manifesto neoconcreto", *Jornal do Brasil,* 22 de marzo de 1959, suplemento dominical. Oiticica no participó en la exposición de Rio ni firmó el manifiesto, pero participó en otra exposición neoconcreta en Salvador (noviembre de 1959), así como en posteriores exposiciones (1960 y 1961).

3. Oiticica fue un prolífico escritor y, en sus primeros textos, tanto publicados como inéditos, trataba sobre Mondrian y Malevich, a quienes describía como los únicos artistas—junto con la vanguardia rusa—que llevaron la representación a sus límites en "Maio 1960", *Aspiro ao Grande Labirinto,* Luciano Figueiredo, Lygia Pape y Waly Salomão, eds. (Rio de Janeiro: Rocco, 1986), 18. Mondrian centró particularmente su atención. Por ejemplo, "Cor, tempo e estrutura", *Jornal do Brasil,* 26 de noviembre de 1960.

4. El título de la serie, Grupo Frente, usado como mínimo desde mediados de la década de 1980, no aparece en los primeros catálogos de exposición.

5. Es muy posible que Oiticica asistiera a la II Bienal. No obstante, periodistas de varias publicaciones de Rio trataron largo y tendido de la II Bienal, incluyendo importantes ensayos ilustrados sobre Mondrian. Además, el MAM-Rio—del que Oiticica era estudiante—recibió y vendió numerosos textos de Estados Unidos sobre Mondrian como parte de su intercambio con The Museum of Modern Art de Nueva York; los textos de Oiticica demuestran que se aprovechó de este nuevo influjo de obras de arte y escritos de y sobre el artista. Por ejemplo, Oiticica cita a menudo frases y textos de Mondrian, incluyendo un largo pasaje de "Plastic Art and Pure Plastic Art" en su "Natal de 1959", *Aspiro ao Grande Labirinto,* 17.

6. Oiticica, "Cor, tempo e estrutura".

7. Oiticica, "Metaesquemas 57/58".

8. Gullar caracteriza la contribución de Malevich al reconocer la primacía de la "pura sensibilidad" en el "Manifesto neoconcreto". Oiticica escribió que Mondrian buscaba la "pura vitalidad" en "Cor, tempo e estrutura".

9. Lygia Clark, *Ovo [Huevo]* (1959), madera/pintura industrial, 33 cm de diámetro, colección Adolpho Leirner. Oiticica hablaba concretamente de "liberar la pintura al espacio" en un texto sin título de abril de 1962. Reproducido y traducido en Mari Carmen Ramírez y Héctor Olea, eds., *Inverted Utopias: Avant-Garde Art in Latin America* (New Haven y Londres: Yale University Press in association with the Museum of Fine Arts, Houston, 2004), 522.

Waldemar Cordeiro
Idéia visível [Idea visible], 1956
Acrílico sobre mazonite
59.9 × 60 cm
Colección Patricia Phelps de Cisneros
1996.190

Idéia visível (lámina 24), de Waldemar Cordeiro, forma parte de una serie de pinturas realizadas en su mayoría en 1957, todas con el mismo título. Cada pintura consiste en composiciones dinámicas de líneas y muchas de ellas contienen formas que se reflejan mutuamente. De hecho, ya en 1955 Cordeiro realizó un estudio de triángulos solapados con sencillas líneas negras sobre un fondo blanco, con el mismo título.[1] La obra que nos ocupa representa dos conjuntos de líneas en espiral, uno blanco y el otro negro, sobre un fondo rojo. Los dos conjuntos son idénticos, con la diferencia de que Cordeiro rotó el negro 180 grados y lo superpuso parcialmente al blanco. Los puntos exteriores de los triángulos permiten trazar unas líneas curvas que sugieren la curvatura de una espiral logarítmica, sin representarla en su totalidad. La base de la espiral logarítmica es el rectángulo áureo, que tiene una proporción de 1:1.618. Esta forma ha sido una de las más importantes en la estética occidental y se remonta como mínimo a la Grecia clásica. También era bien conocida por los artistas abstractos geométricos, como Piet Mondrian y los miembros del movimiento Madí, en Argentina, quienes la usaron en muchas de sus composiciones. En parte, a lo largo de la historia, los artistas han encontrado tan atractivos el rectángulo áureo y la espiral logarítmica (figura 1)[2] porque ambos se dan con frecuencia en la naturaleza—en las proporciones del cuerpo humano, en las espirales de muchos tipos de conchas y en la disposición de las semillas en los girasoles, piñas y otras plantas—.

Cordeiro estaba interesado en las propiedades dinámicas de las espirales y basó al menos otras dos composiciones en la espiral de Arquímedes, en la que el espacio entre todos los niveles de la espiral es equidistante. Se trataba de *Desenvolvimento ótico da espiral de Arquimedes [Desarrollo óptico de la espiral de Arquímedes]*, de 1952, y una construcción de plexiglás, titulada también *Idéia visível*, de 1956.[3] Crear una ilusión de movimiento a través de formas rotatorias fue un interés que Cordeiro compartía con otros artistas concretos, como Judith Lauand, Lothar Charoux y Mauricio Nogueira Lima. La obra de Cordeiro presenta un asombroso parecido con el *Triângulo espiral* (1956) de Nogueira Lima, que consiste en una serie de triángulos que se despliegan siguiendo el diseño de una espiral.[4] Además, Cordeiro diseñó por lo menos un jardín residencial en São Paulo que incorporaba el dibujo de una espiral.

La fascinación de Cordeiro por la espiral sugiere un interés en la simetría dinámica, un término acuñado por el diseñador canadiense Jay Hambidge en relación con el uso de proporciones armónicas en el diseño. Aunque el término pueda haber sido introducido por Hambidge, el concepto es anterior. A pesar de que ninguno de los escritos de Cordeiro menciona a Hambidge, su interés por las espirales indica que podría haber tenido algún conocimiento del concepto de simetría dinámica, quizás a través de los escritos y la obra de los artistas abstractos europeos. Hambidge explica que la simetría estática supone "el empleo de figuras regulares de la geometría tales como el cuadrado y el triángulo equilátero", mientras que la simetría dinámica implica el uso de números que son literalmente "inconmensurables".[5] El dominio de los principios de la simetría dinámica pasa por el estudio de formas como los rectángulos y las espirales, los cuales incorporan proporciones visualmente gratas "que evocan la vida y el movimiento".[6] El frontispicio del libro de 1966 *Dynamic Symmetry: A Primer* ilustra una serie de rectángulos construidos a partir de la diagonal de un cuadrado que se despliega en forma de espiral (figura 2).[7] Tal diagrama podría haber inspirado la creación, por parte de Cordeiro y de Nogueira Lima, de sus propios estudios de espirales, más idiosincrásicos y libremente basados en disposiciones de triángulos.

Hambidge sostenía que esta geometría es el fundamento del buen diseño y expresaba ideas que sin duda Cordeiro habría suscrito: "La composición eficaz es imposible sin diseño. Cuando el diseño es débil, es probable que el realismo sea dominante".[8] Esta afirmación ilustra las inquietudes compartidas entre los campos del diseño y la abstracción geométrica. Cordeiro desarrolló una noción similar de la obra de arte como "producto" más que como ilusión o expresión de la belleza, basándose aparentemente en los escritos de Conrad Fiedler, un crítico de arte alemán del siglo XIX que influyó en Cordeiro con su concepto de "visualidad pura". En "Ruptura", ensayo que escribió en 1953, Cordeiro citaba a Fiedler en dos ocasiones. En uno de sus textos, Fiedler criticaba las nociones tradicionales de belleza: "Una obra de arte puede ser ofensiva y valiosa al mismo tiempo… Aquellos que juzgan las obras de arte únicamente desde el punto de vista del gusto, muestran que consideran las obras de arte como poco más que un medio de excitación estética".[9] Dado el periodo en que Fiedler escribía, parece que estaba criticando la persistente influencia—aunque ya pasada de moda—de la pintura académica alemana. Cordeiro se encontraba probablemente en una tesitura similar, en una lucha—con unas pinturas que no eran sino austeras formas geométricas—tanto contra el legado del modernismo de la década de 1920 como del realismo social, cuya popularidad había ido en aumento a lo largo de los años treinta.

Según el diseñador y artista concreto Alexandre Wollner, los principios geométrico-científicos del diseño visual que influyeron en el arte moderno a través de las enseñanzas de la Bauhaus llegaron a Brasil por dos caminos distintos aunque relacionados: los brasileños que estudiaron en la Hochschule für Gestaltung (Escuela Superior de Diseño) de Ulm, fundada por el constructivista suizo Max Bill en 1952, conocían Fibonacci y de las proporciones presentes en la música, las matemáticas, la física cuántica y la naturaleza, mientras que en 1951 Pietro Maria Bardi, el primer director del Museo de Arte de São Paulo (MASP), fundó el Instituto de Arte Contemporáneo (IAC), la primera escuela brasileña de diseño moderno.[10] A pesar de que Cordeiro no estudió en ninguna de estas dos instituciones, estaba

en contacto con varios artistas que sí lo hicieron y probablemente conoció los principios de la simetría dinámica a través de sus amistades o bien en sus propios estudios artísticos en Italia, antes de emigrar al Brasil.[11]

Las dos curvas de las espirales en *Idéia visível* giran una alrededor de otra como los dos brazos de una galaxia (otra manifestación natural de la espiral logarítmica), desenrollándose lentamente en el espacio y creando así una triple rotación: las de las dos agrupaciones individuales de líneas, además de la de las formas agrupadas. La composición empieza a aproximarse al nivel de lo cósmico. Aunque a primera vista parece tratarse de un rígido estudio de líneas geométricas casi monocromo en su simplicidad, en realidad es mucho más complejo: una colección de líneas intuitivamente reunidas que alude a los diagramas usados en los estudios de proporción y diseño, sin llegar a reproducirlos.[12] *Idéia visível* es una celebración de la geometría, no como la base subyacente de otra composición, sino más bien como un fin en sí mismo.

Erin Aldana
Traducción de Jordi Palou

Notas

1. Estas obras están reproducidas en el catálogo *Waldemar Cordeiro: uma aventura da razão* (São Paulo: Museu de Arte Contemporânea de São Paulo, 1986), 25, 38, 40, 44 y 45. La pintura de la Colección Patricia Phelps de Cisneros no está incluida en ese catálogo.

2. Jay Hambidge, *The Elements of Dynamic Symmetry* (Nueva York: Brentano's, 1926), 6.

3. Ana Maria Belluzzo, *Waldemar Cordeiro: Uma aventura da razão*, 20.

4. Reproducido en Aracy Amaral, ed., *Projeto construtivo brasileiro na arte, 1950–1962* (Rio de Janeiro y São Paulo: Museu de Arte Moderna do Rio de Janeiro y Pinacoteca do Estado de São Paulo, 1977), 218.

5. Jay Hambidge, *Practical Applications of Dynamic Symmetry*, 17.

6. Hambidge, *The Elements of Dynamic Symmetry*, xviii.

7. Christine Herter, *Dynamic Symmetry: A Primer* (Nueva York: W. W. Norton, 1966), ii.

8. Hambidge, *Practical Applications of Dynamic Symmetry*, 3.

9. Waldemar Cordeiro, "Ruptura", *Correio Paulistano*, 1 enero 1953: suplemento, 3; reproducido en *Waldemar Cordeiro: Uma aventura da razão*. Conrad Fiedler, *On Judging Works of Visual Art*, trad. de Henry Schaffer-Simmern (Berkeley y Los Angeles: University of California Press, 1949).

10. André Stolarski, *Alexandre Wollner e a formação do design moderno no Brasil*, trad. de Anthony Doyle (São Paulo: Cosac & Naify, 2005), 90–91; Alexandre Wollner, "The Emergence of Visual Design in Brazil", en Aracy Amaral, ed., *Arte Constructiva no Brasil: A Coleção Adolpho Leirner* (São Paulo: DBA Artes Gráficas, 1998).

11. Para más información sobre el Constructivismo en Italia, véase George Rickey, *Constructivism: Origins and Evolution* (Nueva York: George Braziller, 1967), 63. Véase asimismo *MAC: movimento arte concreta* (Milán: Electa, 1984) y *Arte Concreta: der italienische Konstruktivismus* (Münster: Westfalischer Kunstverein, 1971).

12. Guy Brett sostenía que él percibía algunas composiciones de Arte Cinético—algunos de los móviles de Alexander Calder, por ejemplo—como modelos del cosmos. Guy Brett, "Force Fields: Phases of the Kinetic", conferencia pronunciada en The University of Texas at Austin, 23 marzo 2006. Al poner un énfasis similar en el movimiento, el grupo de Arte Concreto surgido en São Paulo también podría ser considerado como un precursor del Arte Cinético.

Jesús Rafael Soto
Doble transparencia, 1956
Esmalte industrial sobre plexiglás y madera ensamblada con tornillos
55 × 55 × 32 cm
Colección Patricia Phelps de Cisneros
1989.35/3

Aunque presenta una forma poco convencional, *Doble transparencia* (lámina 25) es en esencia la obra de un pintor. La pieza consiste en líneas pintadas y rectángulos repetidos, dispuestos en capas y yuxtapuestos en una composición cuadrada que cuelga de la pared. Mientras que *Doble transparencia* utiliza un lenguaje geométrico formal cada vez más extendido tras la Segunda Guerra Mundial, Jesús Rafael Soto llevó su obra un paso más allá que muchos de sus colegas, que en aquel momento producían pinturas concretas bidimensionales de tipo tradicional. Descomponiendo y distribuyendo los elementos geométricos por tres superficies transparentes superpuestas, deconstruyó la pintura, dando igual importancia a cada línea, diseño y forma, independientemente de la composición en la que estuvieran (la del fondo, la intermedia o en primer plano).

Tras sus estudios de pintura en Venezuela en la década de 1940, Soto se trasladó a París en 1950, donde abrazó el lenguaje geométrico que dominaría su trayectoria artística. Tras su llegada, empezó a trabajar con soportes y pinturas industriales, y en 1953 fue uno de los primeros artistas en incorporar el plexiglás a su obra. A pesar de dedicarse a la pintura, Soto estaba interesado en lo que llamaba la "vibración" óptica que tiene lugar cuando dos líneas se intersecan. Al describir este efecto, el curador y crítico de arte Guy Brett escribió: "La interferencia óptica [entre dos elementos] libera una tercera—la vibración—que es real para el ojo, pero que carece de existencia material".[1] Soto utilizó los principios matemáticos comunes de la repetición y la geometría para originar una reacción óptica o "vibración" carente de propiedades materiales. La transparencia del plexiglás le permitió separar sus diseños y superponerlos unos sobre otros, creando la posibilidad de un número infinito de "vibraciones". El éxito de sus experimentos y de este nuevo tipo de composición se basaba en otro elemento crucial: el espectador. Estas reacciones ópticas sólo se desencadenan al ser vistas por el ojo humano, con lo que el papel del espectador pasa a ser fundamental en todo el proyecto de Soto. Con cada paso que hace, se altera la percepción, por parte del espectador, de la relación entre el primer plano y el fondo, provocando ondas de nuevas "vibraciones" que sólo cesan con la inmovilidad del espectador. Lamentablemente, las fotografías de las obras de Soto no pueden transmitir esta dimensión dinámica, debido a la naturaleza estática del medio fotográfico. Las "vibraciones" sólo existen literalmente en el ojo del espectador/observador.

Soto realizó *Doble transparencia* en París, cuando estaba llevando a cabo algunos de sus primeros experimentos con la "vibración". Empezó superponiendo piezas de plexiglás pintadas con diseños basados en formas repetidas, tales como puntos, rayas y espirales. Luego

amplió su experimento y se planteó los efectos visuales del choque de distintos colores, trabajando inicialmente con colores primarios y secundarios, así como con el blanco y el negro, como en el ejemplo que nos ocupa. Las obras de este periodo solían consistir en un panel de plexiglás atornillada a una tabla cuadrada de más o menos el mismo tamaño. La tabla cuelga de la pared como si fuera una pintura, mientras el plexiglás sobresale de la superficie y se proyecta en el espacio de la sala. La distancia entre los paneles del fondo y el primer plano difiere de una obra a otra, ya que esta es una de las variables con las que juega Soto. En *Doble transparencia,* el artista juega con el efecto creado por rayas pintadas en varios colores y direcciones, yuxtapuestas sobre un fondo uniforme de rayas verticales de color azul. Vale la pena observar que esta obra extrema un poco el experimento, puesto que Soto fue más allá de lo que en aquel momento suponía para él la "vibración" previsible de dos superficies e incorporó un tercer panel. En esta obra, Soto bifurcó la característica pieza de plexiglás que sobresale del fondo de madera. Estos dos paneles de plexiglás—que representan la "doble transparencia" a la que alude el título—sobresalen a distancias diferentes y se solapan en el centro de la composición, ya que ninguno de los dos es del mismo tamaño que la tabla de madera. La obra, por consiguiente, consta de tres registros verticales—un panel de plexiglás a la izquierda, los paneles de plexiglás que se solapan en el centro y otro panel de plexiglás a la derecha—, camuflándose con las rayas que llenan la obra. Los efectos de avance, retroceso y superposición de las líneas paralelas juegan con el espacio tridimensional y crean la oportunidad de "vibraciones" aun más activas. El añadido del segundo panel de plexiglás en *Doble transparencia* insinúa el interés posterior de Soto por la ambigüedad del espacio que queda entre los paneles. A pesar de que sólo trabajó con plexiglás durante unos pocos años, estas obras le proporcionaron un trampolín para años de experimentación con las "vibraciones" ópticas. Por ejemplo, en la década de 1960, dio un nuevo vigor a las rayas coloreadas y repetidas en instalaciones del tamaño de una sala, en las que los espectadores podían entrar. Estas obras, tituladas *Penetrables,* envolvían al visitante en una "vibración".

Tras su llegada a París, Soto entró en contacto con la galerista Denise René y los artistas a quienes representaba, muchos de los cuales trabajaban con un lenguaje geométrico. En 1955 participó en la pionera exposición que organizara René en su galería, titulada *Le Mouvement,* referencia clave del Arte Cinético y óptico de varias generaciones. En esta exposición Soto presentó algunas de sus obras en plexiglás, y al año siguiente (la fecha en que fue realizada esta obra) realizó una exposición unipersonal en la misma galería. A pesar de que nunca estuvo formalmente afiliado a ningún grupo, Soto participó en los movimientos de Arte Cinético y *Op Art* que hallaron eco en la Galerie Denise René y se extendieron por toda Europa, Estados Unidos y América del Sur en la década de 1950, alcanzando su apogeo en los años sesenta.

Aleca Le Blanc
Traducción de Jordi Palou

Nota
1. Guy Brett, "Introduction", en *Soto* (Nueva York: Marlborough-Gerson Gallery, 1969), s. pág.

Judith Lauand
Concreto 61, 1957
Pintura sintética sobre madera
30.5 × 30.5 cm
Colección Patricia Phelps de Cisneros
1996.37

La obra *Concreto 61* (lámina 26) consiste en cuatro conjuntos de barras negras que giran alrededor de un vacío central, sobre un fondo blanco. Esta pintura es similar a otras realizadas por Lothar Charoux, Waldemar Cordeiro y Mauricio Nogueira Lima que representan formas rotatorias, normalmente en blanco y negro. La ausencia total de color en estas obras refuerza el intento de crear una ilusión de movimiento en el espacio, una de las principales preocupaciones de los artistas concretos en aquel momento.[1] En *Concreto 61,* uno de los extremos de las barras negras es oblicuo, lo que enfatiza la apariencia de movimiento. Cordeiro sostenía que la representación del movimiento era uno de los elementos más importantes del Arte Concreto: "La pintura espacial bidimensional alcanza su apogeo con la obra de Malevich y Mondrian. Ahora está surgiendo una nueva dimensión: el tiempo. El tiempo como movimiento. La representación trasciende el plano, pero no es perspectiva, es movimiento".[2] Esta afirmación pone de manifiesto el interés de los artistas concretos por la experiencia y la percepción del espectador de la obra de arte, a diferencia de la típica interpretación del Arte Concreto de São Paulo, en el sentido de que sólo se preocupaba de la representación de la geometría pura.

Al igual que en la obra de muchos otros artistas concretos, la de Lauand revela la influencia de la teoría de la Gestalt en la representación de la ilusión de movimiento en una imagen pintada. El psicólogo Rudolf Arnheim escribió profusamente sobre el uso de la teoría Gestalt a la hora de aprender cómo las personas interpretan las imágenes; sus ideas también son útiles para entender la obra de Lauand. Según Arnheim, el espectador sabe que las formas que aparecen en la imagen no se están moviendo realmente, aunque sí parecen estar esforzándose para desplazarse en ciertas direcciones—lo que él denomina la "tensión dirigida".[3] Las líneas de fuerza se irradian hacia el exterior desde el centro de las formas geométricas; en el caso del cuadrado, que a menudo constituye la base de composiciones concretas, las líneas de fuerza fluyen hacia afuera, tanto hacia los lados como a las esquinas. El principio gestaltiano de agrupación tendría como resultado que el espectador interpretara la disposición de barras negras similares como si se tratara de unidades individuales, como los brazos de un molino de viento, pero pareciendo girar y estirarse hacia el plano de la pintura. El cambio de tamaño de las barras implica un grado de profundidad en la pintura, a pesar de que todas las formas son bidimensionales; la simplicidad del blanco y negro, a su vez, pone de relieve las ilusiones ópticas que tienen lugar en la composición sin la distracción del color.[4]

Lauand se adhirió relativamente tarde al movimiento de Arte Concreto de São Paulo y no participó en la exposición del Grupo Ruptura de 1952, sino que se sumó a los demás artistas concretos algunos años más tarde, en la Exposición Nacional de Arte Concreto. Esta exposición, que se presentó en São Paulo en 1956 y en Rio de Janeiro al año siguiente, reunió a artistas de ambas ciudades que estaban trabajando por primera vez en el lenguaje de la abstracción geométrica, junto a algunos poetas concretos. La exposición profundizó la relación entre la poesía y el arte concretos, lo que permitió explorar los paralelismos entre la imagen visual y la palabra escrita. Según el poeta concreto Décio Pignatari:

La muestra de poesía concreta tiene un carácter casi didáctico: fases de evolución formal, el paso del verso al ideograma, del ritmo lineal al ritmo espacio-temporal: nuevas condiciones para nuevas estructuraciones del lenguaje; esa relación de elementos verbivocovisuales, como diría Joyce.[5]

Los poemas concretos no tenían ritmo ni versos en un sentido tradicional. Más bien solían consistir en unas pocas palabras sueltas, que a menudo incorporaban algún juego de palabras que se diferenciaba sólo en unas pocas letras o en una sola sílaba. El aspecto visual de las palabras era muy importante, y a menudo su disposición en la página contribuía a descifrar el significado del poema o sugería la existencia de movimiento físico, como una "caída" a la parte inferior de la página o saltos adelante y atrás. El entrelazamiento de palabras e imágenes entre artistas y poetas concretos se hizo más intenso cuando estos últimos incorporaron el color a sus obras mediante el uso del papel carbón, a la vez que las austeras composiciones concretas en blanco y negro de algún modo recordaban la disposición de palabras en una página. La interrelación palabra/imagen (en muchos casos incorporando asimismo el aspecto del movimiento) se completó finalmente con los diseños de logotipos de Alexandre Wollner, Willys Castro y Hércules Barsotti. Estas relaciones amplían las posibilidades de interpretación de una obra aparentemente tan simple como *Concreto 61*.[6]

La Exposición Nacional de Arte Concreto fue el inicio de una creciente división entre los grupos de artistas concretos de São Paulo y Rio de Janeiro. Los críticos de arte de Rio lamentaban que el Concretismo de São Paulo pareciera fríamente racional, incluso dogmático en su búsqueda de formas geométricas puras. Desde luego, la obra de Lauand parece reforzar esta idea, al menos a primera vista. "Porque amo la síntesis, la precisión y el pensamiento exacto", respondió la artista en una ocasión a la pregunta de por qué se había involucrado en el Arte Concreto.[7] Es más, su comentario de que "Un cuadro no representa nada. Simplemente es" implica cierta afinidad con la idea de Waldemar Cordeiro de la obra de arte como producto, no como representación.[8] Por otra parte, Lauand realizó algunas afirmaciones que contradirían una interpretación de su obra según la cual ésta tendría una base teórica: "[Mi obra] carece de base filosófica, literaria, social o del tipo que sea; se basa en elementos inherentes a la propia pintura: forma, espacio, color y movimiento".[9] Los múltiples significados—en ocasiones contradictorios—que surgen de la obra aparentemente simple de Lauand sugieren que trasciende la mera disposición de formas y colores.

Lauand era una de las pocas artistas concretas que no procedía de Europa y que no desarrolló otra ocupación o trayectoria además de la puramente artística. Había nacido en el estado de São Paulo y estudió en la Escuela de Bellas Artes de Araraquara, donde trabajó con Lívio Abramo, un artista conocido por sus grabados de trabajadores manuales de São Paulo en la década de 1930.[10] En 1950, Lauand se trasladó a São Paulo y empezó a trabajar en un estilo expresionista que en aquel momento era popular allí y que otros artistas abstractos como Luiz Sacilotto habían practicado. Su biografía indica que pasó por una fase concreta entre 1953 y 1958, aunque podría afirmarse que toda su carrera, a partir de 1953, se mantuvo en los parámetros del Arte Concreto.

Lauand fue la única mujer entre los miembros del movimiento concreto de São Paulo y uno de sus adeptos más estrictos, puesto que siguió trabajando en dicho estilo incluso entrados los años setenta, mucho después de que la mayoría de los otros artistas lo hubieran abandonado. En 1960 participó en la exposición *Konkrete Kunst*, que tuvo lugar en Zurich,[11] y en 1961 en la exposición inaugural de la Galería Novas Tendências, que reagrupó a muchos de los artistas que habían participado en el movimiento concreto y que en ese momento intentaban hallar una nueva dirección para su obra, en un periodo en que el Arte Concreto ya no se consideraba relevante. Lauand experimentó con los materiales, produciendo obras en que las grapas reemplazaban a las líneas en las composiciones, aunque permanecía la rigidez geométrica.[12] En 1972, Lauand volvió a trabajar en un estilo estrictamente concreto.

Erin Aldana
Traducción de Jordi Palou

Notas
1. La pintura de Cordeiro *Idéia visível*, de 1957 (tal como se reproduce en la pág. 45 de *Waldemar Cordeiro: Uma aventura da razão*, no la versión de la Colección Patricia Phelps de Cisneros), presenta una disposición similar de barras que parecen flotar en el espacio, lo que sugiere que Cordeiro y Lauand podrían haber visto sus obras respectivas.
2. Waldemar Cordeiro, "O objeto", *Arquitectura e Decoração* [São Paulo] diciembre 1956: 225; reproducido en Fernando Cocchiarale y Anna Bella Geiger, eds., *Abstracionismo: geométrico e informal* (Rio de Janeiro: FUNARTE/Instituto Nacional das Artes Plásticas, 1987).
3. Rudolf Arnheim, *Art and Visual Perception: A Psychology of the Creative Eye* (Berkeley y Los Angeles: University of California Press, 1969), 336.
4. Arnheim, 340–41.
5. Décio Pignatari, "Arte concreta: objeto e objetivo", *Arquitetura e Decoração* [São Paulo], diciembre 1956; reproducido en Aracy Amaral, ed., *Projeto construtivo brasileiro na arte (1950–1962)* (Rio de Janeiro y São Paulo: Museu de Arte Moderna do Rio de Janeiro y Pinacoteca do Estado de São Paulo, 1977), 103.
6. Véase los diseños de logotipos incluidos en Amaral, *Projeto construtivo brasileiro*, 210 y 227. Los artistas usan un tipo de letra *sans serif* con el objeto de reducir al máximo el espacio entre palabra e imagen.
7. "Judite [*sic*] Lauand entre os concretistas que vão expor na Galeria de Arte das 'Folhas'", *Folha de Manhã*, 7 enero 1959.
8. "Judite Lauand".
9. "Judite Lauand".

10. Para más información sobre Lívio Abramo, véase Aracy Amaral, *Arte para quê? A preocupação social nas artes, 1940–1970* (São Paulo, 1983).

11. Amaral, *Projeto construtivo brasileiro*.

12. Daisy Peccinini, *Figurações Brasil anos 60* (São Paulo: Edusp, 1999), 49; José Geraldo Viera, "Judith Lauand", *Folha Ilustrada,* 23 septiembre 1961.

Alfredo Volpi
Composição concreta em preto/branco [Composición concreta en negro/blanco], 1957
Gouache sobre tela
50.1 × 67 × 2 cm
Colección Patricia Phelps de Cisneros
1999.68

A primera vista, *Composição concreta em preto/branco* (lámina 27) no parece tener gran cosa que ver con la obra mejor conocida de Volpi: sus imágenes abstractas de fachadas de edificios cubiertas con las banderas de brillantes colores de las fiestas *juninas,* una serie que empezó a principios de la década de 1950.[1] Volpi pintaba las fachadas de los edificios de los barrios obreros de São Paulo desde el nivel de la calle, y las formas cuadradas de las banderas establecían una conexión no deliberada con la abstracción geométrica. Gracias a la técnica de la témpera, las pinceladas y la tela que había debajo eran visibles en estas obras, lo que añadía ciertas variaciones de tono y un toque personal a los cuadros. A diferencia de las pinturas con las banderas, *Composição* no alude en absoluto al mundo exterior; en otros aspectos, sin embargo, comparte importantes rasgos con la serie anterior.

Como las pinturas de banderas *juninas, Composição* utiliza líneas rectas que Volpi rellenaba de color—en las obras *juninas* usaba la témpera, pero en esta obra recurrió al gouache para alcanzar un nivel de opacidad que no habría sido posible con la témpera—. Esta obra es casi idéntica a una serigrafía sin título reproducida en *Arte Construtiva no Brasil: Coleção Adolpho Leirner.* La técnica elegida por Volpi establece una diferencia fundamental entre ambas obras: las modernas técnicas de grabado confieren a la serigrafía—de bordes más definidos—una apariencia precisa, casi mecánica, mientras que la presencia visible de las pinceladas en el gouache genera una tensión entre las prácticas artísticas modernas y las tradicionales, típica de la obra de Volpi.

El singular estilo pictórico de Volpi procedía de su experiencia como pintor de decoración de interiores entre las décadas de 1910 y 1930, y posteriormente como artista autodidacta. Durante los años treinta y cuarenta estuvo vinculado al grupo Santa Helena, una agrupación de artistas de origen italiano (el propio Volpi era inmigrante italiano) que alquilaban estudios en el edificio Santa Helena, en el centro de São Paulo. Muchos de estos artistas procedían de entornos obreros y habían trabajado pintando casas antes de empezar a pintar sobre tela. Los artistas de Santa Helena seguían estilos directamente opuestos al modernismo de los años veinte, bajo la inspiración e influencia de Cézanne, el Impresionismo y la pintura académica. Otros adoptaron estilos que revelaban una falta absoluta de formación

académica. Volpi no llegó a alquilar ningún estudio, pero se benefició de las sesiones semanales de dibujo figurativo que los demás artistas organizaban, además de sumarse a las excursiones que hacían los fines de semana a las afueras de São Paulo para pintar paisajes.[2]

Al igual que los demás artistas de Santa Helena, Volpi pintó la vida cotidiana de los inmigrantes italianos de São Paulo durante la primera mitad del siglo XX. Pintó esculturas de santos de las iglesias católicas y paisajes de Mogi das Cruzes, uno de los barrios periféricos de São Paulo. La crítica de arte brasileña Sônia Salzstein ha observado que "el inicio de la fase 'urbana' y abstracta de la pintura de Volpi—la célebre fase de las banderas—coincidió con el principio del fin de un tipo de vida saludable en São Paulo, que giraba alrededor de los barrios".[3] Con la llegada de la industrialización masiva durante la década de 1950, São Paulo empezó a transformarse en la megalópolis actual, un cambio que se ve reflejado en la obra de Volpi. Salzstein también ha indicado que la repetición seriada de formas en las pinturas más abstractas de Volpi son consecuencia de su experiencia como pintor de casas, en cuyo trabajo repetía motivos florales y de otras clases.[4] En contraste con las contundentes formas y las referencias a la industrialización presentes en la obra de los artistas concretos, la repetición en la obra de Volpi se desarrolló a partir de las tradiciones artesanales de decoración arquitectónica y de sus pinturas de banderines con motivo de las fiestas populares. De este modo, la obra de Volpi representa una tensión de la artesanía a la mecanización, paralelamente a las transformaciones que estaban teniendo lugar en la sociedad brasileña de la época.

El historiador del arte Walter Zanini afirma que el creciente interés de Volpi por la abstracción geométrica pura se derivaba de la poderosa influencia de la Bienal de São Paulo. No obstante, mientras que su obra se había ido haciendo cada vez más contundente y purista en su exploración de la geometría, Volpi seguía negando cualquier conexión teórica con los artistas concretos.[5] Rodrigo Naves sugirió que un viaje a Italia en 1950 habría dado a Volpi la oportunidad de contemplar las obras de Giotto y Paolo Uccello, lo que explicaría su intenso interés en la "rigidez" y la "bidimensionalidad del soporte".[6] A pesar de la afirmación del propio Volpi de que no mantenía ninguna conexión con la abstracción geométrica, muchas de sus obras de mediados de la década de 1950—incluyendo *Composição*—ponen de manifiesto un interés por los mismos principios que estaban explorando los artistas concretos, como por ejemplo su interés en la representación del movimiento a través de formas giratorias, el énfasis en la forma por encima del color y la exploración de la teoría de la Gestalt—evidente en la ambigüedad con la que *Composição* representa el espacio y la tensión entre forma y fondo—.

En una entrevista, el poeta concreto Décio Pignatari contaba cómo aprendió a pintar con témpera al huevo a principios de los años sesenta, cuando compartía casa y estudio con Volpi. Pignatari decía que a menudo le preguntaban por qué los artistas concretos iban a aceptar a un pintor que trabajase con una técnica tan antigua como la témpera al huevo, pero él explicaba

que parte de la paradoja del Arte Concreto y de la cultura brasileña en general radicaba en que podían incluir tanto la técnica premoderna de la témpera al huevo como la moderna pintura de esmalte.[7] Según Maria Alice Milliet, los artistas concretos consideraban a Volpi como uno los suyos, a pesar de que él rechazaba sistemáticamente cualquier conexión con ellos.[8] Su periodo concreto fue sólo una breve fase en su larga carrera artística, que se extendió a lo largo de varias décadas y exploró un amplio abanico de temáticas y estilos artísticos.

Según Paulo Sérgio Duarte, "Volpi solucionó por anticipado el problema que el arte brasileño afrontaría posteriormente en sus movimientos concreto y neoconcreto".[9] Este autor ha afirmado que el Arte Neoconcreto puso un énfasis excesivo en lo personal y lo subjetivo, mientras que el Arte Concreto fue en dirección opuesta, llegando a una extrema impersonalidad. El logro de Volpi consistió en establecer un equilibrio entre estos dos extremos, combinando al mismo tiempo el Arte Concreto, a menudo acusado de elitista, con un estilo carente de formación académica que exploraba las temáticas populares— la vida de los trabajadores inmigrantes de origen italiano establecidos en São Paulo—.

Erin Aldana
Traducción de Jordi Palou

Notas

1. Las fiestas *juninas,* celebradas durante el mes de junio, se iniciaron en el nordeste del Brasil y conmemoraban la cultura rural, con vestimentas y bailes tradicionales, así como banderines de papel de brillantes colores colgados entre los edificios. Para aquellos que habían emigrado a São Paulo, estas festividades contribuían a mantener lazos con la cultura *nordestina* que habían dejado atrás y aportaban una nota de color a las grises calles de la ciudad.

2. Para más información sobre el grupo Santa Helena, véase Paulo Mendes de Almeida, *De Anita ao museu* (São Paulo: Editora Perspectiva, 1976) y Walter Zanini, *O Grupo Santa Helena* (São Paulo: Museu de Arte Moderna de São Paulo, 1995).

3. Sônia Salzstein, "Moderno no Suburbio", en *Volpi* (Rio de Janeiro: Campos Gerais Edição e Comunicação Visual, 2000), 17.

4. Salzstein, 21.

5. Walter Zanini, *História Geral da Arte no Brasil,* vol. 2 (São Paulo: Instituto Walther Moreira Salles, Fundação Djalma Guimarães, 1983), 679.

6. Rodrigo Naves, "Anonimato e singularidade em Volpi", en *A forma difícil: ensaios sobre arte brasileira* (São Paulo: Editora Ática, 1996), 191.

7. Fernando Cocchiarale y Anna Bella Geiger, "Décio Pignatari", en *Abstracionismo: geométrico e informal* (Rio de Janeiro: FUNARTE/Instituto Nacional das Artes Plásticas, 1987), 75, 77.

8. Maria Alice Milliet, "From Concretist Paradox to Experimental Exercise of Freedom", en *Brazil: Body and Soul,* Edward J. Sullivan, ed. (Nueva York: Guggenheim Museum, 2001), 394–95.

9. Paulo Sérgio Duarte, "Modernos Fora dos Eixos/ Modernity on the Fringes", en Aracy Amaral, ed., *Arte Construtiva no Brasil: Coleção Adolpho Leirner,* trad. de Izabel Burbridge (São Paulo: DBA Artes Gráficas, 1998), 203.

Jesús Rafael Soto
Pre-Penetrable, 1957
Pintura industrial sobre estructura de acero
165.5 × 126 × 85 cm
Colección Patricia Phelps de Cisneros
1997.118

Penetrable, 1990
Acero, aluminio y mangueras plásticas
508 × 508 × 508 cm
Colección Patricia Phelps de Cisneros
1998.84

Desde los inicios de su investigación plástica, Jesús Soto parece haber seguido la intuición que lo llevaría a producir, en su madurez, una forma de obra en la que pudiese experimentarse con ella la integración plena del cuerpo del espectador. En este sentido la producción de Soto se explaya, entre otras, a través de dos tipologías de obras cuyos funcionamientos con relación a la presencia del espectador parecen excluirse: por una parte, Soto produjo obras que funcionan como máquinas de efectos ópticos para los cuales el movimiento del espectador es requerido, siempre y cuando este mantenga una distancia insalvable. Se puede trazar una continuidad en esta tipología, desde obras seminales como *Dos cuadrados en el espacio,* 1953, sellada en su caja e inaccesible por lo tanto a toda forma de experiencia táctil, hasta la serie de formas virtuales que como ostensorios cinéticos ofrecen sus ilusiones visuales desde estructuras que impiden el acercamiento corporal. Por otra parte, Soto ha realizado una serie de obras en las que la experiencia del contacto— y por lo tanto del tacto—es requerida, desde los llamados Pre-Penetrables a los llamados Penetrables, pasando por Penetrables sonoros y por Vibraciones que invitan a la activación óptica o sonora de la obra a través del contacto físico.

La estructura cinética llamada *Pre-Penetrable,* 1957 (lámina 28), forma parte de un conjunto de obras realizadas por Soto inmediatamente después de la serie de vibraciones en plexiglás genéricamente denominadas como "Dobles transparencias" (lámina 25). En estas Soto había logrado acomodar su aspiración de, a la vez, multiplicar y desaparecer—gracias a la transparencia del plexiglás—el plano pictórico. El resultado eran objetos tridimensionales cuyos efectos ópticos sucedían en un ámbito delimitado por diversos planos de plexiglás, en donde figuran tramados de líneas, sostenidos a un soporte de madera por varas fijas de metal: una estructura volumétrica y, por lo tanto, virtualmente penetrable. Los Pre-Penetrables surgen de la ampliación de esta experiencia a una serie de estructuras compuestas por planos y varillas metálicas coloreadas, ensamblados a piso. La primera de estas obras fue ofrecida por el artista al arquitecto Carlos Raúl Villanueva quien la integra en su proyecto de de la Universidad Central de Venezuela, como una escultura convencional, sobre un zócalo, instalándola en los espacios de la Facultad de Arquitectura. La coincidencia—si es tal—no deja de ser significativa: la única, y relativamente discreta, presencia de la obra de Soto en el proyecto de Villanueva anticipa la ambición arquitectónica y topológica

que Sotvendrá a realizar a fines de los años 60 a través del Penetrable.[1]

Algunos años más tarde, Soto vería a los nietos de Alfredo Boulton jugar en el jardín de la casa del historiador, donde se encontraba el Pre-Penetrable. Al rememorar el espectáculo de sus menudos cuerpos accediendo a la estructura de la obra, inicialmente concebida para ser apreciada a distancia, Soto decide atribuirle el título de Pre-Penetrable, reconociendo así, anacrónicamente, la complejidad de un proceso a través del cual había logrado, gracias al Penetrable, materializar su vieja ambición de producir una obra capaz de "envolver al espectador".

El primer Penetrable fue concebido en 1967 como proyección lógica de una obra in-situ, aun no penetrable, concebida por Soto para la Bienal de Venecia en 1966.[2] "Brillantes invenciones de visualidad—ha escrito Guy Brett—aunque carecen de superficie o plano", los Penetrables "amplían la contradicción entre el espacio pictórico y el mundo a la arena pública", de suerte que el espectador puede "pasar corporalmente de uno a otro estado".[3] El Penetrable (lámina 29) es, así, el lugar donde se sintetizan y condensan, a la vez, las contradicciones y las utopías implícitas en el proyecto artístico de Jesús Soto. Obra óptica, el Penetrable funciona como una máquina de desmaterialización cuando se lo ve desde la distancia absorbiendo en la prodigiosa transparencia de su interior a los cuerpos que lo penetran; obra táctil, el Penetrable funciona como una máquina de asperidad y saturación visual cuando se lo experimenta corporalmente, cuando nuestro cuerpo penetra en el ovillo de sus hilos plásticos, quedando inmerso en su ámbito opaco. En algún momento Soto dice haber soñado con la idea de un Penetrable capaz de absorber el planeta entero: imaginación utópica y humanística que requiere, para ser realizada, el supuesto negado de un punto de vista fuera del mundo, ideal.

En ese sentido, el Penetrable es la culminación teórica de la obra de Soto y representa un punto de inflexión dentro del repertorio moderno y constructivo. Obra modular, virtualmente infinita, el Penetrable es capaz de acomodarse en toda superficie, explayándose como una "película topológica" sobre cualquier topografía. Esta dimensión de indiferencia del Penetrable con relación a la topografía lo vincula, en los orígenes imaginarios de la obra de Soto, a una experiencia del paisaje: aquella del niño Soto, en su Guayana natal, cabalgando al mediodía enceguecedor a campo abierto, fascinado por "la vibración del aire por la reverberación del sol . . . esa masa vibrante que flotaba en el espacio".[4] Una vez más, no en balde, el Penetrable es ambivalente en términos de paisaje: visto en el paisaje, el Penetrable aparece como una sorpendente extensión artificial, homotópica; experimentado, visto el paisaje desde su interior por el espectador allí inmerso, el Penetrable aparece como la clausura misma de la experiencia del paisaje. En este sentido cabe mencionar que hacia 1967, en la escena crítica norteamericana dominada por las discusiones alrededor del Minimalismo y por las figuras de Clement Greenberg y Michael Fried, entre otros, el repertorio de la modernidad tardía aparecía ante una disyuntiva entre obras signadas por su potencia de absorción y obras signadas por su teatralidad. El Penetrable, producido por Soto fuera de esta polémica, tiene la virtud de neutralizarla: es, a la vez teatral, por exigir la participación del espectador, y absorbente, por realizar su desmaterialización; a la vez capaz de una absorción "pastoral", en la que la obra funciona como un objeto visual autosuficiente y de una absorción "dramática" en la que el espectador se ve introducido en su funcionamiento.[5] Acaso esto se explica porque en realidad ambos, la teoría "friediana" de la absorción pictórica y la imaginación del Penetrable comparten una referencia: la fascinante presencia de una ilusión pictórica hecha realidad dentro del mundo, y a la vez distinta del mundo, en la imágen de *Las Meninas* de Diego Velázquez.

Luis Pérez-Oramas

Notas

1. Ariel Jiménez, *Conversaciones con Jesús Soto,* Cuaderno 6 (Caracas: Colección Patricia Phelps de Cisneros, 2001), 59.
2. Jiménez, 70.
3. Guy Brett, "El siglo de la cinestesia," en *Campos de Fuerza: Un ensayo sobre lo cinético* (Barcelona, MACBA, 2000), 31.
4. Jiménez, 9.
5. Véase Michael Fried, *Absorption and Theatricality: Painting and Beholder in the Age of Diderot* (Chicago: University of Chicago Press, 1988).

Lygia Clark
Casulo [Capullo], 1959
Nitrocelulosa sobre estaño
30 × 30 × 11 cm
Colección Patricia Phelps de Cisneros
1999.65

A primera vista, la obra *Casulo*, de Lygia Clark, parece ser una simple composición geométrica bidimensional de formas triangulares blancas y negras. En un examen más atento, puede verse que es una disposición cuidadosamente calculada de cinco triángulos que forman un cuadrado de aproximadamente 30 × 30 centímetros. Clark empleó únicamente líneas diagonales, eliminando a propósito las líneas horizontales y verticales, exceptuando las que forman el perímetro de la obra. Si la examinamos con mayor minuciosidad aun, nos daremos cuenta de que en realidad cada forma triangular es un elemento individual cuidadosamente superpuesto y unido a los demás. Este descubrimiento convierte una obra que al principio parecía ser una pintura geométrica bidimensional en un relieve. La sutileza de las piezas superpuestas hace que el espectador se acerque más a la obra, y sólo con la proximidad física cae en la cuenta de que, en realidad, estos elementos cuidadosamente solapados crean una pequeña cavidad protectora. (Esto resulta casi imposible de ver en una reproducción fotográfica de la obra.) Este espacio someramente escondido, de unos diez centímetros de profundidad, sólo es accesible desde el cuadrante superior derecho de la obra y, al parecer, inspiró el título de Clark, *Casulo [Capullo]*. Este descubrimiento aporta una nueva perspectiva; lo que originalmente parecía ser una pintura geométrica bidimensional se ha metamorfoseado silenciosamente no sólo en un relieve, sino también en una escultura tridimensional, cuyo título imbuye a la obra de una

calidad orgánica aparentemente discordante con los postulados del Arte Concreto.

Mientras que este enfoque rigurosamente compositivo es coherente con la tradición de pintura concreta dominante en el Brasil de mediados de la década de 1950, la forma y el título de *Casulo* señalan el inicio de una transición que se aleja de un lenguaje estrictamente concreto. El Grupo Frente, del que Clark formaba parte, representaba el movimiento concreto en Rio de Janeiro entre 1954 y 1958. No obstante, al final de la década, Clark y muchos otros artistas miembros del grupo dejaron atrás la severidad del Arte Concreto. Aunque conservaron muchas de las pautas de su lenguaje formal, empezaron a expandir su noción del objeto de arte en sí para incorporar el espacio tridimensional, el movimiento y la participación del espectador, así como temas y materiales orgánicos, al tiempo que calificaban sus nuevas creaciones de "neoconcretas". En 1959, Clark realizó una serie de obras similares tituladas *Casulo*. Cada una de ellas estaba formada por múltiples capas que ocultaban y revelaban pequeños espacios escondidos. Unas veces cuadradas y otras en forma de rombo, todas colgaban de la pared y se proyectaban hacia la sala, ejemplificando este momento de transición.

No es de extrañar que la verdadera estructura de la obra surja sólo al examinarse minuciosamente, dada la naturaleza contrapuesta de los colores de la misma. El contraste entre el blanco y el negro casi ahoga sus aspectos tridimensionales. A pesar de que la pintura se ha oscurecido y desconchado con el paso del tiempo, el espectador debería esforzarse por imaginar la versión original de Clark, ejecutada en un blanco inmaculado y un negro azabache. La artista trabajaba con pinturas y bases industriales, en este caso nitrocelulosa sobre estaño, de modo que las pinceladas se hacen casi invisibles y, por lo tanto, se elimina cualquier rastro de la mano de la artista. Las técnicas y materiales elegidos ponen de manifiesto el carácter industrial y totalmente no figurativo de la obra. Sólo cuando el espectador empieza a percibir sombras grises advierte la sutileza de la construcción y la tridimensionalidad de la pieza.

Al igual que la tensión entre el blanco y el negro, el título pone de relieve otra oposición plasmada en la obra. Un capullo es un objeto orgánico, creado para proteger una frágil larva durante su proceso de maduración. El carácter orgánico del título parece estar en contradicción con la fría racionalidad del Arte Concreto en blanco y negro. La temática y la ejecución parecen estar frontalmente opuestas. Esta tensión entre lo orgánico y lo geométrico es común al conjunto de la obra de Clark y se da en varias piezas de este mismo periodo. De hecho, estas obras representan el intento de la artista de sintetizar las propiedades—en apariencia dialécticamente opuestas—de lo orgánico y lo geométrico, en un momento en que empezaba a realizar cada vez más obras orgánicas. Por ejemplo, estos "capullos" dieron origen a una serie que empezó en 1960, los Bichos, también basados en la tensión entre una temática orgánica y una forma geométrica.[1]

Poco después de que Clark empezara sus Bichos, el poeta Ferreira Gullar publicó su ensayo "Teoria do não-objeto" ["Teoría del no-objeto"], que analizaba las nuevas obras que se estaban creando bajo la rúbrica neoconcreta.[2] Recurriendo a uno de los Bichos como principal ejemplo de este movimiento, su ensayo abordaba la naturaleza híbrida de estas obras, que poseían aspectos de la pintura y la escultura y, sin embargo, no pertenecían a ninguna de estas dos categorías. Clark también escribió considerablemente durante esa época, generando una documentación textual que explicaba el desarrollo formal que tenía lugar en sus obras visuales. En un ensayo de 1960, "O morte do plano", trataba sobre las limitaciones de trabajar exclusivamente en dos dimensiones, y afirmaba que "el plano separa arbitrariamente los límites de un espacio . . . Eliminar el plano de la pintura como medio de expresión equivale a tomar conciencia de la unidad como un todo orgánico y vivo. Somos un todo, y ha llegado el momento de volver a armar todas las piezas del calidoscopio en el que la humanidad se ha descompuesto y se ha hecho pedazos".[3] *Casulo* es una de las primeras obras en que Clark empezó a transgredir estos "límites arbitrarios" del plano, los restos de la pintura concreta. Al volver a unir "todas las piezas del calidoscopio" en un objeto orgánico, *Casulo* actuaba como el predecesor evolutivo de sus Bichos y del no-objeto de Gullar.

<div align="right">

Aleca Le Blanc
Traducción de Jordi Palou

</div>

Notas

1. Véase el ensayo de Jodi Kovach sobre los Bichos en este mismo catálogo.
2. Ferreira Gullar publicó "Teoria do não-objeto" en el *Jornal do Brasil* [Rio de Janeiro], 11 de noviembre de 1960, suplemento dominical.
3. Lygia Clark, "Death of the Plane, 1960", en *Geometric Abstraction: Latin American Art from the Patricia Phelps de Cisneros Collection/Abstracción Geométrica: Arte Latinoamericano en la Colección Patricia Phelps de Cisneros* (Cambridge, Caracas, New Haven y Londres: Harvard University Art Museum, Fundación Cisneros, Yale University Press, 2000), 159.

Lygia Pape
Livro da Criação [Libro de la creación], 1959–1960
Instalación libro-arte: gouache y cartón
30.5 × 30.5 cm cada hoja
The Museum of Modern Art, New York, fractional and promised gift of Patricia Phelps de Cisneros
1349.2001.a–r

El poema/libro/escultura de Lygia Pape titulado *Livro da criação [Libro de la creación]* (lámina 30) es una de las obras arquetípicas del Arte Neoconcreto de la primera hornada. A pesar de que la fama de Hélio Oiticica y Lygia Clark posteriormente la eclipsaron, a finales de la década de 1950 y principios de la de 1960, Pape fue una de las figuras centrales en el escenario artístico de Rio de Janeiro y suscribió el "Manifiesto neoconcreto" de 1959. El *Livro da criação* es uno de los tres libros que Pape realizó entre 1959 y 1962; los otros dos fueron el *Livro do tempo [Libro del tiempo]* y el *Livro da arquitetura [Libro de la arquitectura].*[1] El *Livro da criação* consiste en dieciseis "páginas" de cartulina, cada una de las cuales mide 30.5 × 30.5 cm sin ensamblar.[2] Como muchas otras obras interactivas del

movimiento neoconcreto, como los Bichos, de Clark, o los Parangolés, de Oiticica, para apreciar efectivamente este libro se requiere una cierta participación del espectador. Éste sólo puede comprender y *sentir* plenamente la intención original de la artista al manipular las páginas con sus manos, como si estuviera leyendo un libro de verdad. Las fotografías que acompañan a este texto muestran las páginas completamente ensambladas.

En el *Livro da criação,* Pape no eligió el formato de libro para crear una escultura interactiva puramente abstracta, un proto-Bicho, sino que se sirve de una serie narrativa de títulos para acompañar la obra, creando pues una historia que se desarrolla a medida que el espectador maneja y ensambla cada página. Estos títulos proporcionan a la vez una secuencia y un significado a la obra. La "historia" es la creación del mundo, desde la separación de las aguas al descubrimiento del fuego y la agricultura, pasando por la caza, la navegación y otros momentos clave del desarrollo humano. El relato no se corresponde con precisión a un mito existente sobre la creación, de modo que la secuencia puede resultar difícil de seguir.[3] Algunas de las páginas son más poéticas que descriptivas; por ejemplo, "la quilla", o la última página: "luz". La relación de estas "leyendas" con las páginas individuales es básicamente flexible. Si Pape hubiera deseado una relación más determinada, podría haber inscrito el texto en las propias páginas. En lugar de eso, lo que tenemos es más parecido a la letra de una canción que se cantaría a medida que se pasan las páginas, una evocación poética de la situación que el espectador luego proyecta sobre la página abstracta. Al mirar la página en blanco perforada, por ejemplo, y escuchar que corresponde al momento en que el hombre empieza a sembrar, tiene lugar un cambio de percepción y el espectador interpreta el plano blanco como un campo. Del mismo modo, la rotación de un disco rojo se convierte en el descubrimiento del tiempo, recordándonos las manecillas de un reloj.

Como ha señalado Guy Brett, la idea de la creación en esta obra presenta dos vertientes: por un lado, el relato de la creación del mundo; por el otro, el propio proceso creativo del espectador al ensamblar las páginas y comprender su narración poética.[4] Pape confirmó esta naturaleza abierta del libro al afirmar:

Es importante decir que hay dos posibles interpretaciones: para mí es el libro de la creación del mundo, pero para otros puede ser el libro de la "creación". A través de las experiencias de cada persona hay un proceso de estructura abierta mediante el cual cada estructura puede generar su propia interpretación.[5]

El hecho de compartir este proceso creativo entre artista y espectador *mediante* una obra de arte es uno de los legados del arte neoconcreto, y una de las formas en que los artistas de esta generación superaron la distinción entre razón y emoción que ha determinado el arte europeo desde el Renacimiento, particularmente en la tradición abstracta/constructivista. El "Manifiesto neoconcreto" de 1959 afirmaba que el Neoconcretismo "niega la validez de las

actitudes científicas y positivistas en el arte, y propone nuevamente el tema de la expresión, incorporando las nuevas dimensiones 'verbales' creadas por el arte constructivo no figurativo".[6] Este concepto de una dimensión "verbal", aunque no esté del todo explicado en el manifiesto, parece referirse a una cierta gramática o sintaxis que implicaría una secuencia, incluso en el marco de un lenguaje formal y abstracto.

El texto desempeñaba un papel fundamental en el desarrollo del Neoconcretismo. Un poeta, Ferreira Gullar, escribió el "Manifiesto neoconcreto", y desde el principio artistas de todo tipo se involucraron en el movimiento. Los poetas Haroldo y Augusto de Campos, así como Décio Pignatari, desarrollaron la poesía concreta a través del grupo *Noigandres,* y compartieron muchos intereses con el grupo neoconcreto. El *Ballet neoconcreto* (1958) de Pape es otro ejemplo del interés de la artista por cruzar los límites de las disciplinas tradicionales, en este caso colaborando con un músico para crear una composición totalmente abstracta de formas geométricas en movimiento. Al incorporar textos a su *Livro da criação,* Pape refleja su conocimiento de la poesía concreta, pero cuestiona también la noción greenberguiana de que cada medio artístico tiene sus propias cualidades innatas. El Neoconcretismo, y la obra de Pape en particular, abrazó la contaminación productiva de técnicas y medios, así como la búsqueda de una experiencia multimedia inestable y abarcadora.

Como parte de esta búsqueda de una experiencia multimedia ajena al entorno museístico, Pape colaboró con el fotógrafo Mauricio Cirne para producir una serie de fotografías del *Livro da criação* en situaciones cotidianas en la ciudad de Rio de Janeiro: en un bar, junto a una cabina telefónica, apoyado contra una pared, etcétera. Durante muchos años estas fotografías fueron el principal formato a través del cual fue conocida esta obra.[7] La interacción con la vida cotidiana que sugieren estas imágenes refleja el deseo neoconcreto de crear un arte geométrico que pueda integrarse con toda naturalidad en la cultura vernácula del Brasil.

Gabriel Pérez-Barreiro
Traducción de Jordi Palou

Notas

1. Pape declaró que el *Livro da criação* y el *Livro da arquitetura* fueron originalmente concebidos como un solo proyecto, y que luego decidió dividirlos en dos libros. Denise Mattar, *Lygia Pape: Intrinsecamente anarquista* (Rio de Janeiro: Relume Dumará, 2003), 68.

2. Pape ha reconstruido el *Livro da criação* en varias ocasiones, ya que al manejarlo los espectadores se destruía el original. En algún momento de los años ochenta o noventa editó tres ejemplares de la obra, con dos pruebas de artista. Véase *Lygia Pape Entrevista a Lúcia Carneiro e Ileana Pradilla* (Rio de Janeiro: Lacerda Editores, Centro de Arte Hélio Oiticica y Secretaria Municipal de Cultura do Rio de Janeiro, 1998), 34.

3. En 2001 ensamblé este libro con la artista para una exposición en The Americas Society, en Nueva York. Las constantes variaciones y adaptaciones de Pape indicaban que había un cierto grado de flexibilidad en la secuencia de las páginas. Asimismo, la redacción exacta de los títulos era difícil de precisar y, por lo que yo sé, no constan formalmente en ningún lugar. La presentación más completa de la obra se publicó en *Lygia Pape: Gávea de Tocaia* (São Paulo: Cosac & Naify, 2000), 133–55, aunque sólo se reprodujeron 15 páginas.

4. Guy Brett, "The Logic of the Web", en *Lygia Pape* (Nueva York: The Americas Society, 2001).

5. Denise Mattar, 68.

6. Ferreira Gullar el al., "Manifesto neoconcreto" (1959), reproducido en Ronaldo Brito, *Neoconcretismo: Vértice e ruptura do projeto construtivo brasileiro,* segunda edición (São Paulo: Cosac & Naify, 1999), 10.

7. Se reprodujo una selección de estas fotografías, acompañadas de pies de foto, en Dawn Ades, ed., *Art in Latin America: The Modern Era, 1820–1980* (Londres: Yale University Press, 1989), 270 y 271, así como en *Lygia Pape: Gávea de Tocaia.*

Lygia Pape
Sem título [Sin título], de la serie Tecelares [Tejidos], 1959
Xilografía sobre papel
49.5 × 49.5 cm
Colección Patricia Phelps de Cisneros
1998.146

Sem título [Sin título], de la serie Tecelares [Tejidos], 1960
Xilografía sobre papel
21.9 × 27.7 cm
Colección Patricia Phelps de Cisneros
1993.45

Lygia Pape realizó la serie de grabados titulada Tecelares [Tejidos] a lo largo de media década de cambios trascendentales en el arte brasileño.[1] Empezó la serie en 1955 como cofundadora del Grupo Frente de Arte Concreto, formado en Rio de Janeiro en 1954, y siguió realizando estos grabados más allá de la disolución de dicho grupo en 1957 y la llegada del grupo neoconcreto en la primavera de 1959. Los primeros Tecelares de Pape fueron interpretados como obras emblemáticas del Arte Concreto al exhibirse en la Exposición Nacional de Arte Concreto en 1956–1957 en São Paulo y Rio. Sin embargo, unos años más tarde Pape también seleccionó varios Tecelares para contribuir a la primera exposición neoconcreta en 1959, y Ferreira Gullar ilustró con una obra de esta serie el "Manifiesto neoconcreto", publicado ese mismo año. Los Tecelares, pues, son obras concretas y neoconcretas al mismo tiempo.

Dadas las contradicciones a la hora de fechar estas obras y su falta de "desarrollo" estilístico, resulta imposible trazar un mapa de los cambios efectuados entre los primeros y los últimos Tecelares. Por ejemplo, hay obras casi idénticas a estos grabados de 1959 y 1960 (láminas 31 y 32) fechadas en 1957 y 1956, respectivamente.[2] Es más, al observar la serie como un conjunto, los Tecelares de Pape no ponen de manifiesto un cambio similar al que experimentó la obra de su colega Hélio Oiticica durante el mismo periodo, que pasó de obras concretas más controladas y geométricamente rígidas a un vocabulario geométrico más flexible y expresivo en sus obras neoconcretas. En lugar de ello, Pape creó grabados similares con años de diferencia, y en las obras de 1958 y 1959 aparecen formas geométricas precisas, al igual que en obras anteriores. En realidad, Pape podría haber tenido la intención de poner a prueba nuestra incapacidad actual de averiguar los cambios experimentados en la serie Tecelares. La artista se describió a sí misma como "intrínsecamente

anarquista" y creó una obra heterogénea y por momentos esporádica que ignoraba la presión del mercado para establecer una identidad clara y una evolución coherente en su trayectoria artística.[3] Por consiguiente, incapaces de rastrear cambios formales o conceptuales entre los distintos Tecelares, nos quedamos más bien con preguntas más interesantes sobre Pape, el Neoconcretismo y la serie de grabados: ¿cómo enfocar adecuadamente la heterogénea producción de Pape? ¿Cómo podemos interpretar fielmente los Tecelares, dada su doble adscripción como obras concretas y neoconcretas a la vez? A la luz de esta serie, ¿es posible seguir sosteniendo la habitual y sencilla distinción entre Arte Concreto y Arte Neoconcreto?

Los grabados de Pape de 1959 constan de los componentes mínimos: planos de tinta negra y delgadas líneas que revelan un papel de arroz blanco y traslúcido. La producción de la obra parece igualmente sencilla. La artista grabó toda la superficie de la plancha con delgadas líneas paralelas más o menos precisas, y, en este campo de líneas paralelas, añadió varias líneas no ortogonales. No obstante, la complejidad de la composición se hace patente cuando el espectador advierte que las dos grandes líneas diagonales orientadas en sentido horizontal que abarcan la composición a lo ancho de la misma alteran la continuidad de las líneas verticales. En estas diagonales, las líneas paralelas que cubren la composición se ven desplazadas a la izquierda. El resultado es que las áreas limitadas por estas diagonales parecen ser planos diferenciados, separados del fondo de líneas paralelas y uniformes. Con esta pequeña alteración adicional en su ya de por sí reducida técnica, Pape crea una sugestión de espacio y movimiento en una obra que de otro modo permanecería estática y bidimensional.

Los juegos de manos de Pape no tienen como resultado una distorsión de moaré de alto octanaje debido al modo en que maneja sus materiales. A pesar de que la artista usó un borde pautado y un compás para crear las líneas que componen la obra, existen pequeñas variaciones en las marcas que realiza y en el tamaño de las líneas que delatan que las formas fueron trazadas por una mano y no por una máquina. El delicado soporte en papel de arroz también absorbe la tinta y crea bordes suaves e imprecisos. Además, la superficie ocupada por la tinta negra tampoco es uniforme, sino que pone delicadamente de manifiesto el veteado de la madera original. Pape escribió sobre Tecelares: "La línea está totalmente controlada. . . . Lo único que me permitía era dejar que la porosidad de la madera aflorara en los espacios negros como una pequeña vibración".[4] En lugar de una obra pulida y contundente en sintonía con las ideas de los artistas concretos de São Paulo, el trazo más sensible de Pape imbuye su obra de las cualidades expresivas y no mecánicas exigidas en el "Manifiesto neoconcreto", rasgos asimismo característicos de una elaboración manual y que lleva tiempo, lo que se refleja asimismo en el título de la serie.

El grabado de 1960 deja a la vista el veteado de la madera de la matriz de forma mucho más evidente. La mitad inferior registra el nudo y las vetas de la superficie de la madera, mientras que la mitad superior revela una superficie

de madera más regular, apagada, como la que podía verse en la obra de 1959. Como en la obra anterior, varios cortes diagonales o disyunciones en la plancha original crean una distorsión en el grabado. En la mitad inferior de la composición, dos grandes diagonales surgen de una ruptura en la continuidad de los anillos de crecimiento. A la derecha, esta línea revela un cambio en dos planos de madera, mientras que a la izquierda la línea está más disimulada y sugiere una onda en el papel. Una vez más, estas diagonales parecen crear un plano diferenciado, de modo que el espacio se introduce en un objeto plano. No obstante, el plano y el espacio que crean las diagonales son más sutiles e inciertos que los de la obra de 1959.

Con la serie Tecelares, Pape ofrece una metáfora operativa alternativa a la noción de construcción que los artistas brasileños de la posguerra adoptaron de la vanguardia europea: el tejido. El tejido evoca no sólo el trabajo hecho a mano, sino también un vínculo con la cultura tradicional. Pape demostró toda su vida un interés por las culturas indígenas del Brasil y hablaba de cómo los indígenas usaban la geometría para expresar conceptos fundamentales, como el de identidad colectiva.[5] Para Pape, la geometría no era un vocabulario nuevo o industrial, sino un lenguaje trascendente. En este contexto, podemos entender la elección de Pape de la plancha de madera en lugar de otras técnicas de grabado más precisas o mecanizadas y su sutil insinuación de espacio dentro de las obras; Pape vincula su práctica a una artesanía táctil y, de ese modo, la aleja del arte mecanizado. En lugar de una composición regular en cuadrícula, Pape combina la geometría natural con la diseñada, transformando las líneas grabadas y las vetas de la madera en urdimbre y trama entrelazadas.

Junto con el *Livro da criação*, de 1959–1960 [lámina 30], el *Livro da arquitetura* (1959–1960) y el *Livro do tempo* (1960–1961), la serie Tecelares constituye la parte de la obra temprana de Pape que busca los temas esenciales más que los modernos o actuales. Por consiguiente, la Pape que vemos en Tecelares es una artista concreta sólo marginalmente. Estos grabados deberían interpretarse como modelos y encarnaciones de la idea neoconcreta radical según la cual una obra de arte puede incorporar expresión sin ser expresionista. En lugar de utilizar el gesto o reflexionar sobre el contenido para crear una energía expresiva, Pape altera mínimamente los sencillos materiales que utiliza, dejando brotar la vitalidad intrínseca en las vetas de la madera, el papel de arroz y la tinta. Ella misma escribió sobre esta serie aludiendo a "las relaciones de espacio abierto y cerrado, la cosa sensible y no discursiva".[6] Las sutiles disposiciones y la materialidad de los Tecelares crean precisamente eso: cosas sensibles y no discursivas.

Adele Nelson
Traducción de Jordi Palou

Notas

1. La serie se realizó entre 1955 y 1960, véase *Lygia Pape: Gávea de Tocaia* (São Paulo: Cosac & Naify, 2000). Los grabados de Pape no se expusieron con el título Tecelares en la década de 1950. Los títulos originales fueron *Xilogravura 1–8* [Grabados 1–8] (III, IV y V Bienales de São Paulo, 1955–1959), *Composición*, 1956 (*Arte Moderno en Brasil*, en el Museo Nacional de Bellas Artes, Buenos Aires, 1957) y *Sem título*, 1954–1955 (exposiciones del Grupo Frente, 1954–1956).

2. Estas obras más tempranas aparecen en *Lygia Pape: Gávea de Tocaia y Lygia Pape* (Nueva York: Americas Society, 2001), respectivamente. Pape cedió las obras y participó directamente en la organización de ambas exposiciones y publicaciones.

3. La expresión "intrínsecamente anarquista" aparece citada en Denise Mattar, *Lygia Pape: Intrinsecamente anarquista* (Rio de Janeiro: Relume Dumará, 2003).

4. Pape en Mattar, 63–64, reproducido en *Lygia Pape* (Rio de Janeiro: FUNARTE, 1983), 49.

5. *Lygia Pape Entrevista a Lúcia Carneiro e Ileana Pradilla* (Rio de Janeiro: Nova Aguilar, 1998), 14–19.

6. Pape en Mattar, 64.

Carlos Cruz-Diez
Amarillo aditivo, 1959
Acrílico sobre papel
40 × 40 cm
Colección Patricia Phelps de Cisneros
1997.176

Physichromie No 21, 1960
Metal sobre cartón, acrílico y material plástico
103.4 × 106.4 × 6.5 cm
Colección Patricia Phelps de Cisneros
1997.145

La obra del artista venezolano Carlos Cruz-Diez gira en torno a la teoría del color, particularmente la mezcla y manipulación de los colores para obtener un efecto físico o psicológico. Realizadas aproximadamente con un año de diferencia, *Amarillo aditivo* (lámina 33) y *Physichromie No 21* (lámina 34) son obras que ponen de manifiesto la investigación incesante de Cruz-Diez y sus ideas acerca de cómo el espectador percibe y procesa conceptualmente el color.

A primera vista, *Amarillo aditivo* parece ser un cuadrado negro dividido por una delgada línea que biseca diagonalmente la imagen en dos mitades. Al examinarlo más atentamente, sin embargo, se aclara más esta intervención. Cruz-Diez compuso la diagonal a partir de dos líneas casi superpuestas que forman una X comprimida y alargada. Esta intrusión de color aparentemente imperceptible—aunque crucial—en un vacío negro, por lo demás austero, pretende jugar con la visión del espectador. Al colocarse directamente frente a la obra, cerca del papel, estos colores bien diferenciados, su solapamiento y la interacción de las rayas se hacen claros e inequívocos. Pero cualquier movimiento a partir de esta posición de observación estable desestabiliza dicha lectura. Al contemplar la pintura a mayor distancia, por ejemplo, las dos delgadas líneas de color—una verde y la otra roja—parecen mezclarse y, en los puntos en que se cruzan, aparecen toques de amarillo. Esta interacción de colores crea la ilusión de un tercer color, aunque en realidad no esté físicamente presente en la obra. Como explica Cruz-Diez, "La yuxtaposición de estas dos fragmentaciones transformadas en módulos de acontecimiento cromático es el origen de un tercer color cambiante, inestable y condicionado por la distancia, el ángulo de visión del espectador y las variaciones de la luz-ambiente".[1]

Con la inestable y volátil naturaleza del color en mente, Cruz-Diez entra de lleno en un debate

que tiene siglos de antigüedad: ¿qué es más importante, la forma o el color? Estudiando teóricos del pasado como Isaac Newton y J. W. Goethe, así como la teoría del color más contemporánea de Josef Albers, Cruz-Diez empezó la obra de su vida: el estudio del color y sus posibilidades cambiantes e infinitas. Su investigación y su obra le llevaron a concluir que vivimos en una sociedad "hiperbarrocamente policromada", una sociedad que exige a los artistas cuestionarse nociones preconcebidas sobre el color que, con el paso del tiempo, han quedado fijadas. En gran medida, según Cruz-Diez, las convenciones y creencias culturales específicas controlan nuestra respuesta al color, convirtiéndonos en "sordos visuales" y "ciegos auditivos".[2] Trabajando a partir de esta idea, Cruz-Diez empezó una serie de investigaciones dirigidas a explorar el impacto fisiológico y psicológico del color sobre el espectador y a desafiar lo que creía que eran respuestas socialmente programadas frente al color.

En *Amarillo aditivo*, como implica su título, Cruz-Diez emplea la síntesis aditiva del color, una teoría que aborda los efectos de color inducidos por estímulos luminosos cambiantes. Mientras que la síntesis sustractiva del color explica el uso de pigmentos y tintes para crear colores,[3] la síntesis aditiva del color se ocupa sobre todo de los efectos de color de la luz, como en un monitor de TV de rayos catódicos, que emplea una combinación de puntos fosforescentes rojos, verdes y azules. A una distancia suficiente de la pantalla de televisión, el ojo no distingue los puntos individuales, sino que los combina para crear la imagen final. *Amarillo aditivo* funciona de un modo similar. Es decir, cuando se contemplan de cerca, las delgadas rayas verde y roja de la imagen se solapan sin hacer aparecer ningún otro color, pero al verse desde más lejos, surge un tercer color, un color fugaz que depende de una serie de variables. El interés de Cruz-Diez por las propiedades del color demuestra su convencimiento de que el color no es algo fijo, sino que cambia según las circunstancias externas, como la interacción entre luz y sombra o la posición del espectador. Así, lo que importa aquí no es sólo la fugaz experiencia de un tercer color generado por la interacción de las líneas roja y verde. También es significativa la experiencia del espectador, cuya particular posición, tanto si permanece inmóvil ante el cuadro como si deambula alrededor de él, desestabiliza una obra que de otro modo sería estable, al tiempo que crea nuevos efectos ópticos y sensoriales.

Llevando esta idea aun más lejos, Cruz-Diez empezó una serie de obras llamadas Physichromies, un término que inventó a partir de la expresión "cromatismo físico". Mientras que *Amarillo aditivo* es un estudio sobre la teoría aditiva del color, la serie de Physichromies combina las síntesis aditiva, sustractiva y reflectiva del color.[4] Cruz-Diez realizó su primera Physichromie en 1959—un año antes de trasladarse a París con carácter permanente—, poniendo en juego lo que denominaba la "radiación del color". A través de la radiación del color, el reflejo de las superficies pintadas adyacentes "colorearía" las partes de una obra en blanco o sin pintar. Esto, naturalmente, no sólo dependía de la intensidad de la luz que impactaba sobre la propia obra, sino también del ángulo de visión del espectador, lo

que causaba un efecto siempre cambiante. En *Physichromie No 21,* por ejemplo, un movimiento lateral frente a la obra altera continuamente la percepción que uno tiene de la pieza. Como resumió el crítico de arte Julio César Schara en su análisis del lenguaje del color de Cruz-Diez: "El color en mutación continua crea *realidades autónomas*. Realidades, porque estos acontecimientos se producen en el tiempo y en el espacio. Y autónomas porque no dependen de aquello que los espectadores están acostumbrados a ver en una pintura. De este modo, se inicia otra *dialéctica* entre el espectador y la obra".[5]

Las Physicromies de Cruz-Diez consisten en una sucesión de tiras largas y estrechas de madera, cartón o metal, colocadas perpendicularmente sobre una tela o alguna otra superficie. El artista pintaba los lados de estos delgados paneles con distintos colores; el espectador apenas advierte estos colores cuando ve la obra frontalmente. No obstante, a medida que se desplaza a uno u otro lado de la obra, estas delgadas tiras asumen una existencia individual y parecen flotar como si no estuvieran adheridas a ningún soporte. Al igual que *Amarillo aditivo,* la *Physicromie No 21* entabla un activo diálogo visual y perceptivo con el espectador, pero lo lleva un paso más allá. Al cambiar su posición frente a *Physicromie No 21,* para el espectador la imagen parece estar en continuo movimiento, y las distintas tiras de color adoptan variadas formas geométricas. Con un tamaño que casi triplica el de *Amarillo aditivo,* la *Physicromie No 21* añade el blanco a la mezcla de verde, rojo y negro. Al confluir los colores y fundirse unos con otros, creando un tercer color proyectado sobre el soporte blanco, surge una dinámica cromática interna.

En busca de una recepción más favorable a su obra que la que obtuvo en Caracas, Cruz-Diez se trasladó a París, donde estuvo en contacto con otros artistas latinoamericanos que trabajaban en una línea similar. El éxito que obtuvo posteriormente en París, en gran parte impulsado por Denise René y su galería, llegó en un momento estratégico en la Francia de la posguerra, en donde el público buscaba una alternativa artística al estilo más individualista de la abstracción lírica y gestual. Un público cansado del lenguaje elitista de los críticos de arte acogió con simpatía este arte participativo que parecía romper la barrera entre el espectador cotidiano y el arte de tipo más "elevado".

Martha Sesín
Traducción de Jordi Palou

Notas
1. Julio César Schara, *Carlos Cruz-Diez y el arte cinético* (Ciudad de México: Arte e Imagen, 2001), 71.
2. Schara, 68.
3. La síntesis sustractiva del color emplea pinturas, tintas, tintes y otros colorantes naturales para crear color, al absorber algunas longitudes de onda de la luz y reflejar otras.
4. Schara, 73. Al referirse a sus fisicromías, Cruz-Diez define el color reflejo como "la luz [que] golpea los 'módulos' del fondo y rebota sobre los elementos perpendiculares de la estructura".
5. Schara, 69.

Willys de Castro
Objeto ativo—amarelo [Objeto activo—amarillo], 1959–1960
Óleo sobre tela montada sobre madera
35 × 70 × 0.5 cm
Colección Patricia Phelps de Cisneros
1997.56

Objeto ativo [Objeto activo], 1961
Esmalte y pintura acrovinilica sobre tela y madera
155 × 100 × 100 cm
Colección Patricia Phelps de Cisneros
1996.81/2

En un ensayo en un catálogo de 1967 de una exposición en el Museo de Arte Moderno de Rio de Janeiro, el artista Hélio Oiticica identificaba y definía lo que consideraba las características generales del arte brasileño contemporáneo, un conjunto de esfuerzos un poco sui géneris que denominaba la "Nueva objetividad".[1] La "Nueva objetividad" no consistía en objetos de arte que el espectador pudiera disfrutar pasivamente, sino en proyectos que requerían que los miembros del público percibieran los objetos con la totalidad de su cuerpo para captar las radicales proposiciones de una forma de arte diferente. Los artistas brasileños de la "Nueva objetividad" eran aquellos que trabajaban con técnicas artísticas que se resistían a una clasificación clara, que producían obras que no podían definirse fácilmente como "esculturas" o como "pinturas". Los Objetos ativos de Willys de Castro, una serie de obras pintadas de distintas formas y colores que creó durante la década de 1960, surgió en este contexto de experimentación radical. *Objeto ativo—amarelo* (lámina 35) y *Objeto ativo* (lámina 36) ejemplifican el giro de Castro de un arte que pueda ser captado a través de la mera observación a otro que exige la participación activa de la memoria y la percepción del público. La comprensión de los Objetos ativos de Castro permite a su vez comprender mejor los objetivos y aspiraciones de la vanguardia artística brasileña de los años sesenta.

Al situarse frente a *Objeto ativo—amarelo*, el espectador se enfrenta a una pintura casi monocroma: un plano aparentemente vasto de color amarillo, roto por una delgada franja azul en su lado izquierdo. En el centro de esta delgada franja, sin embargo, encontramos un pequeño cuadrado amarillo, como si el plano amarillo se hubiera expandido hacia la franja. Castro se hace eco de esta pequeña forma geométrica colocando un cuadrado azul del mismo tamaño en la parte derecha de la obra. Por un lado, estos detalles no distraen completamente al espectador del hecho de que está observando un objeto real, una tela cubierta de pintura. La delgada franja azul y el minúsculo cuadrado, sin embargo, inducen a los miembros del público a experimentar la obra de formas particulares; el espectador "recuerda" la ausencia deliberada en la parte izquierda de la tela y halla su resolución en la parte derecha.

En palabras de Renato Rodrigues da Silva, estos detalles representan una estrategia artística "positiva-negativa", un proceso a través del cual Castro logra interrelacionar distintas áreas de la obra acabada para producir un todo unificado.[2]

No obstante, esa estrategia no sirve meramente como soporte compositivo: "El desplazamiento crea un espacio negativo—o una ausencia— que la mirada del espectador intenta rechazar repetidamente a través de la reconstrucción de los planos originales; estos intentos provocan una dinámica temporal que culminan en la integración de la pintura".[3] El propio acto de mirar y experimentar la obra a través de nuestros sentidos pasa a formar parte de la obra de arte. En otras palabras, la obra sólo desempeña la función de arte cuando los sentidos del espectador interactúan y se integran con el Objeto ativo. La pieza depende de la percepción del público, una decisión que hace de los Objetos ativos de Castro obras de arte subjetivas, totalmente dependientes de un continuo redescubrimiento.

Castro siguió desarrollando esta estrategia "positiva-negativa" en obras como el *Objeto ativo* de 1961. Más que colgarlo de la pared como una pintura, este *Objeto ativo* se coloca en el suelo de la galería como si fuera una escultura. El espectador, pues, se enfrenta a un delgado poste geométrico de madera con áreas pintadas de rojo y blanco. La particular disposición del color produce una interacción que podría describirse como rítmica, revelando el interés y la participación del artista en la poesía y la música concretas, como en el grupo Ars Nova de la década de 1950. Una vez que el público interactúa con el objeto, la estrategia "positiva-negativa" del artista se hace patente. Al encararse a la pieza, el espectador compara las áreas coloreadas que tiene ante sus ojos con las que ha experimentado con anterioridad, un proceso que, una vez más, se hace eco de los objetivos de los artistas de la "Nueva objetividad". Debido a que el espectador no puede ver simultáneamente todas las caras de este *Objeto ativo* en particular, Castro parece aun más decidido a hacer trabajar la memoria de su público. Al pintar el artista sobre superficies planas, uno no puede evitar pensar en la relación de la obra con la pintura tradicional, aunque la obra se presente como un objeto tridimensional en medio de una sala. A través de su serie de Objetos ativos, Castro participaba en los debates sobre las "categorías" y "técnicas" artísticas de la vanguardia brasileña. Un *Objeto ativo* de 1960, por ejemplo, consistía en una "pintura" que colgaba perpendicularmente respecto a la pared de la galería. Cada una de las superficies pintadas de este *Objeto ativo* de 1960 podía funcionar como una pintura geométricamente abstracta, pero la obra no estaba colgada plana sobre la pared. De hecho, la tela ni siquiera parece ser perfectamente "rectangular", ya que el artista pintó ciertas áreas para crear una "abolladura" en la estructura, una ilusión óptica que depende de si se contempla el Objeto ativo desde una perspectiva particular contra el fondo blanco de una pared de la sala. Otros Objetos ativos, como los que el artista realizara en 1962, consisten en cubos que parecen romperse en piezas más pequeñas, como si el artista hubiera juntado bloques de tamaño más reducido. Castro creaba estos efectos visuales pintando estratégicamente algunas áreas de las superficies planas con distintos colores, creando la ilusión de que un cubo blanco, por ejemplo, estaba unido a una estructura tridimensional mayor y de color rojo.

Estas distintas investigaciones podrían parecer ejercicios formales o efectos ópticos orientados a deslumbrar al espectador. Castro, sin embargo, no hacía un uso de estos efectos con la intención de crear un espectáculo. Sus innovaciones reflejan un deseo de llevar más allá los límites de las categorías artísticas, de cambiar el modo en que el público percibe la pintura o la escultura, ocasionando la "desintegración de la pintura tradicional, luego del plano, del espacio pictórico…".[4] Al explorar los límites de la pintura y la escultura tradicionales, al producir obras de arte que representan algo completamente distinto de esos ámbitos, Castro seguía el deseo de alterar radicalmente la práctica artística, de crear obras de arte que transformaran al público y, en última instancia, a la sociedad. Con esta idea en mente, uno puede entender cómo el propio artista describía estos objetos: "Tales obras … al penetrar en el mundo, lo alteran, puesto que su surgimiento desencadena un torrente de fenómenos perceptivos y expresivos, portadores de nuevas revelaciones hasta entonces inéditas en ese mismo espacio."[5] Al experimentar los Objetos ativos en el espacio de la galería, proseguimos ese proceso activo e interminable de revelación y transformación que el artista esperaba producir a través de su obra.

Alberto McKelligan
Traducción de Jordi Palou

Notas

1. Hélio Oiticica, "General Scheme of the New Objectivity", reproducido en *Hélio Oiticica* (Minneapolis: Walker Art Center, 1992), 110–20.
2. Véase Renato Rodrigues da Silva, "Os Objetos ativos de Willys de Castro", *Estudos Avançados*, vol. 20, núm. 56 (2006): 254.
3. Rodrigues da Silva, 254.
4. Oiticica, 111.
5. Willys de Castro, "Objeto ativo", *Habitat* núm. 64 (1961): 50, citado en Rodrigues da Silva, 264–65.

Hélio Oiticica
Relevo neoconcreto [Relieve neoconcreto], 1960
Óleo sobre madera
96 × 130 cm
The Museum of Modern Art, New York, fractional and promised gift of Patricia Phelps de Cisneros in honor of Gary Garrels
325.2004

Ni escultura ni pintura convencional, esta obra no figurativa procede del periodo neoconcreto de Hélio Oiticica, como su propio título indica. Producto de las obras concretas que realizó a mediados de la década de 1950, momento en el que formaba parte del Grupo Frente, *Relevo neoconcreto* (lámina 37) es una excelente muestra de los poderes generativos que surgieron a partir del frío enfoque analítico exigido por el Arte Concreto. Oiticica empezó a ensanchar su noción de objeto de Arte Concreto abrazando el lenguaje formal abstracto de la misma y, al mismo tiempo, alejándose del estricto método de aplicación que requerían sus defensores, como puede verse en esta obra.

A finales de los años cincuenta y principios de los sesenta, numerosos artistas establecidos en Rio de Janeiro—como Lygia Clark, Lygia Pape y Franz Weissmann, entre otros—aprovecharon el legado del Arte Concreto como trampolín para la experimentación, formando lo que se conocería como el grupo neoconcreto. A pesar de que sólo expusieron juntos como grupo oficialmente constituido entre los años 1959 y 1961, muchos de sus conceptos e inquietudes hallaron un eco en sus obras tanto antes de la disolución del grupo como mucho después. En 1960, el influyente ensayo "Teoria do não-objeto" ("Teoría del no-objeto"), del poeta Ferreira Gullar, abordaba la nueva obra que estos artistas estaban realizando.[1] En su mayoría, estas obras escapaban a una clasificación estricta como pinturas o esculturas, y en lugar de ello presentaban propiedades de ambos géneros, situándose en un punto intermedio.

El *Relevo neoconcreto* de Oiticica constituye un excelente ejemplo de este estado intermedio. Utiliza los materiales convencionales de la pintura—pigmento y tabla—, pero sin observar el modelo tradicional del marco rectangular. Tres puntas triangulares sobresalen por la parte superior e inferior del soporte horizontal de madera, de forma irregular, con lo que la obra adopta un carácter más bien escultórico. Carece de marco o pedestal—lo que anunciaría la obra como una pintura o una escultura, respectivamente—que la separe del espacio del espectador. A pesar de estar colocada en una pared, la obra no se apoya en ella sino que se proyecta a unos cuantos centímetros de ella, aislando la tabla en el espacio como una escultura, aunque el espectador no pueda caminar a su alrededor. Se proyecta en el espacio del espectador de un modo que recuerda un relieve, como apunta de nuevo su propio título. Muchos de estos experimentos neoconcretos jugaban con el espacio, a menudo mediante métodos de instalación poco frecuentes. Por ejemplo, además de utilizar el concepto de relieve en este híbrido de pintura y escultura, Oiticica también había colgado tablas pintadas del techo en medio de una sala, exacerbando aun más la ambigüedad entre pintura y escultura en sus obras.

Considerado en el contexto más amplio de su trayectoria, *Relevo neoconcreto* es una importante obra de transición en la carrera artística de Oiticica. Entre 1957 y 1958 experimentó con cuadrículas y triángulos, usando el lenguaje formal del Arte Concreto, realizando centenares de composiciones geométricas en gouache sobre papel. Muchas de estas obras, posteriormente denominadas Metaesquemas, guardan una fuerte relación formal con las pinturas sobre tabla que ejecutó en años posteriores. Cuando realizó el *Relevo neoconcreto,* ya estaba explorando las posibilidades del espacio tridimensional. La tridimensionalidad ocuparía por completo gran parte de su producción a lo largo de la década siguiente, al ir deconstruyendo y jugando con los conceptos de pintura, escultura, instalación y performance con sus series Bólides, Núcleos, y Parangolés. *Relevo neoconcreto* representa un puente crucial en su evolución entre los Metaesquemas de la década de 1950 y su obra posterior en los años sesenta.

A lo largo de su carrera, Oiticica fue un prolífico escritor y publicó profusamente en revistas y catálogos, mantuvo una activa correspondencia

con otros artistas e intelectuales brasileños mientras viajaba y escribió asimismo numerosos diarios personales. Los escritos de Oiticica son tan importantes como sus obras visuales para explicar su evolución como artista.[2] En el mismo año en que realizó el *Relevo neoconcreto,* escribió sobre la relación entre color, tiempo, espacio y estructura. Consideraba estos elementos como inseparables y omnipresentes en cada una de sus obras. *Relevo neoconcreto* aborda no sólo esta preocupación por la estructura y el espacio, sino que también muestra su apasionado interés por el color. El color desempeñó un papel dominante en cada uno de sus proyectos, y las sucesivas obras de Oiticica ponen de manifiesto su irresistible deseo de dar una existencia material al color. En el *Relevo neoconcreto* bisecó la obra en dos zonas de color: pintó la parte izquierda con un beige aterciopelado y la derecha con un color cobre cremoso. Para un artista que trabajaba principalmente con colores densos y brillantes como el amarillo, el azul, el rosa, el naranja y el rojo, el uso de tonos cremosos en *Relevo neoconcreto* representa una cierta anomalía. No obstante, su yuxtaposición de dos colores en una misma obra era coherente con algunos de los proyectos que realizó en 1960 y posteriormente. Al igual que *Relevo neoconcreto,* muchos eran compuestos de formas geométricas como paralelogramos, rectángulos, triángulos y cuadrados, a menudo pintados con dos colores similares, como amarillo y naranja, o blanco y gris. En el mismo año en que experimentaba con los colores cremosos de *Relevo neoconcreto,* también escribió sobre sus experimentos con el blanco, afirmando que "el encuentro de dos blancos distintos tiene lugar de forma apagada; uno tiene más blancura y el otro, naturalmente, es más opaco y tiende a un tono grisáceo".[3] Oiticica estaba tan interesado en la sutil distinción entre los matices de un solo color (el blanco) como en el diálogo entre los tonos saturados del beige y del color cobrizo. A pesar de que el *Relevo neoconcreto* constituye una muestra algo infrecuente en la experimentación con el color que Oiticica llevaba a cabo en 1960, es coherente con una obsesión que mantendría durante décadas.

Aleca Le Blanc
Traducción de Jordi Palou

Notas

1. Ferreira Gullar publicó "Teoria do não-objeto" en el *Jornal do Brasil* [Rio de Janeiro] 11 de noviembre de 1960, suplemento dominical.
2. Guy Brett, "Note on the Writings", en *Hélio Oiticica* (Rio de Janeiro: Centro de Arte Hélio Oiticica, 1992), 207.
3. Hélio Oiticica, "Cor, tempo e estrutura; 21 de novembro de 1960", en *Hélio Oiticica,* 34.

Lygia Clark
Bicho, 1961
Aluminio
70 × 70 cm
Colección Patricia Phelps de Cisneros
1998.68

Pliegues afilados y puntiagudos, bordes circulares y superficies de metal altamente reflectantes, de color bronce, animan los elegantes planos de aluminio del *Bicho* de Lygia Clark, que

se asemeja a una delicada papiroflexia. Según como se exhiba, *Bicho* puede presentar también los severos rasgos industriales y el carácter frío y agresivo de una escultura minimalista reduccionista. No obstante, su reducida escala y su aparente flexibilidad la hacen accesible al público, que debe recordar la intención de Clark de que cada espectador hiciera cobrar vida a este objeto mediante la activa manipulación de sus componentes.

Bicho forma parte de una serie de formas escultóricas con láminas de aluminio plano, articuladas con bisagras, que Clark realizó en Rio de Janeiro entre 1959 y 1966. Mientras que este *Bicho* mide más de 60 cm de diámetro, algunos se pueden abarcar con la mano, y las dimensiones de cada uno cambian según los pliegues que de él haga el espectador. Cada vez que alguien manipula el *Bicho,* su respuesta táctil a los materiales y la interacción con sus propiedades físicas, espaciales y de movimiento otorgan a los objetos un carácter formal distinto. Si bien Clark realizó estas obras con metal, las concibió como "formas vivas" o prolongaciones transmutables del cuerpo del espectador que estimulan una actividad dinámica. Al igual que en todas las obras de la misma serie, la austera geometría plana de este *Bicho* expresa un carácter prístino muy próximo a la escultura minimalista, lo que al principio facilita la comprensión inmediata de su forma. No obstante, su mutabilidad obliga al espectador a tocar el objeto de metal y a comprender su significado a través de una experiencia palpable con sus propiedades físicas—un significado variable que surge cada vez que un espectador interactúa con el objeto y responde a las formas en que éste se convierte—. Esta interacción estimula una respuesta visual y táctil por parte del espectador y da lugar a un diálogo entre el sujeto activo que contempla la obra—a diferencia del espectador pasivo—y el objeto artístico.[1]

La ambivalencia entre la fría austeridad geométrica de *Bicho,* por un lado, y la mutabilidad orgánica, por otro, también es análoga al antagonismo entre una obra de arte vanguardista que busca independizarse del ámbito de lo cotidiano y otra que interactúa directamente con la vida real.[2] El componente interactivo de *Bicho* recuerda las estrategias constructivistas rusas y europeas para sumergir el objeto de arte en la vida cotidiana, como los proyectos *Proun* ejecutados por El Lissitsky entre 1919 y 1924, que proponían un sentido práctico de los diseños abstractos para los carteles, la arquitectura o los proyectos urbanísticos. Clark introducía el diseño abstracto en la experiencia vivida, uniendo así al sujeto y al objeto en una actividad efímera que da vida a la forma y, al mismo tiempo, a los sentidos del espectador-participante. La artista transformaba pues la obra de arte abstracta y autorreferencial en una estructura viva que se abre y se interrelaciona con el florecimiento del sujeto humano.[3] De este modo, *Bicho* ejemplifica los principales objetivos del movimiento neoconcreto, que Clark encabezó a finales de la década de 1950 en Rio de Janeiro junto con Ferreira Gullar, Franz Weissmann, Lygia Pape, Amilcar de Castro, Theon Spanudis y Reynaldo Jardim. Estos artistas y poetas incorporaron a sus respectivas prácticas las modernas estrategias estéticas brasileñas

e internacionales, generando un proyecto vanguardista peculiarmente brasileño, que tendió un puente entre el arte entendido como forma material objetiva y el arte como agente de la expresión humana, una distinción hasta entonces convencional.[4] No obstante, debido a que los museos y galerías que hoy exhiben *Bicho* tienden a impedir que los visitantes puedan tocarla, eliminan así la subjetividad del espectador como elemento de la obra de arte. Se pierde, por consiguiente, la dialéctica objeto-sujeto, esencial para el significado variable y contingente de *Bicho*.

Al concebir los Bichos, sin embargo, Clark transformó sus abstracciones geométricas anteriores—consistentes en entidades u objetos visuales autónomos, unificados—en "no-objetos" fenomenológicos.[5] Esta transformación en su enfoque formalista refleja la ruptura entre el entorno paulista de artistas concretos, también conocido justamente como el Grupo Ruptura, y el Grupo Frente, de Rio, cuya denuncia del racionalismo concreto dio paso a la aparición del Arte Neoconcreto a finales de los años cincuenta y principios de los sesenta. Durante este periodo, el uso del vocabulario geométrico abstracto por parte de Clark evolucionó desde las modulaciones planas de las superficies bidimensionales—orientadas a ser interpretadas a través de modos de percepción objetivos, intelectuales y ópticos—a las estructuras volumétricas y articuladas de los Bichos. Este singular componente interactivo de Bicho rechaza los procesos de visualización racional explorados por el Grupo Ruptura y suscita momentos de expresión creativa individual. *Bicho,* por lo tanto, ejemplifica la teoría neoconcreta de la percepción háptica, que vincula el sentido del tacto al de la vista para intensificar la percepción de la tangibilidad del objeto y anima a los sujetos activos a realizar o percibir la obra de arte a través de una mayor conciencia de su propio estado corporal.[6] Más que mantener una postura distante u objetiva, en *Bicho* el observador participa en una actividad que estimula una respuesta multisensorial y produce significado mediante la transformación del objeto.[7] Como resultado, el espectador se convierte en participante de la experiencia que realiza tanto la obra de arte como el yo, y el significado de la obra dependerá de la experiencia que cada individuo haya llevado a cabo con el objeto de arte.[8]

La desestabilización por parte de Clark del significado unitario de la obra de arte y del sujeto homogéneo que la contempla invoca asimismo las tempranas estrategias vanguardistas de la Antropofagia brasileña, a partir de la década de 1920. El concepto moderno de antropofagia, o canibalismo ritual, proponía descodificar o "devorar" simbólicamente los mecanismos europeos de poder, como la autoridad, la estructura y la razón, para poner de manifiesto los ideales primordiales del colectivismo, la libertad y la magia.[9] Inspirándose en este legado, Clark desmanteló la primacía de la mirada objetivadora europea, demostrando que la subjetividad depende de la interacción física con el objeto de arte, que existe independientemente del cuerpo y la psique de uno mismo. Al doblarse, torcerse y transformarse en reacción a los movimientos del participante, *Bicho* pone de manifiesto nuevas e

inesperadas formas y dimensiones que, a su vez, afectan al siguiente movimiento del participante. Clark hace que éste se implique en una acción física y dinámica con la obra de arte, abriendo una forma subjetiva de percibir y experimentar el mundo material.

Jodi Kovach
Traducción de Jordi Palou

Notas

1. Véase Paulo Herkenhoff, "The Hand and the Glove", en *Inverted Utopias: Avant-Garde Art in Latin America,* Mari Carmen Ramírez y Héctor Olea, eds. (New Haven y Londres: Yale University Press in association with the Museum of Fine Arts, Houston, 2004), 327–37; también Yve-Alain Bois, "Some Latin Americans in Paris", en *Geometric Abstraction: Latin American Art from the Patricia Phelps de Cisneros Collection/Abstracción Geométrica: Arte Latinoamericano en la Colección Patricia Phelps de Cisneros* (Cambridge: Harvard University Art Museums; Caracas: Fundación Cisneros; New Haven y Londres: Yale University Press, 2001), 86–89.
2. Véase Peter Bürger, *Theory of the Avant-Garde,* trad. de Michael Shaw (Minneapolis: University of Minnesota Press, 1984); también Theodor Adorno, "Commitment", en *The Essential Frankfurt School Reader,* Andrew Arato y Eike Gebhardt, eds., introducción de Paul Piccone (Nueva York: Urizen Books, 1977), 300–18.
3. Véase Mari Carmen Ramírez, "Vital Structures: The Constructive Nexus in South America", en *Inverted Utopias,* 191–201.
4. Véase Ferreira Gullar y otros, "Manifesto neoconcreto", *Jornal do Brasil,* 22 marzo 1959. Archivos de Ferreira Gullar. Traducido al inglés y reproducido en *Inverted Utopias,* 496–97.
5. Véase Ferreira Gullar, extracto de la "Teoria do não-objeto", *Jornal do Brasil,* 21 noviembre 1960, suplemento dominical. Traducido al inglés y reproducido en *Inverted Utopias,* 521.
6. Véase Herkenhoff, "The Hand and the Glove", 329; también Herkenhoff, "Zero and Difference: Excavating a Conceptual Architecture", en *Beyond Preconceptions: The Sixties Experiment,* Milena Kalinovska, ed. (Nueva York: Independent Curators International, 2000), 57.
7. Herkenhoff, "The Hand and the Glove", 330–31.
8. Véase Gullar, extracto de la "Teoria do não-objeto"; también Gullar, "Manifesto neoconcreto", 496–97; también Hillings, 57.
9. Véase Oswald de Andrade, "Manifesto Antropófago", en *Revista de Antropofagia* [São Paulo] 1, no. 1 (mayo 1928): 3, 7, en *Oswald de Andrade: Obra escogida,* ed. y prólogo, Haroldo de Campos; cronología, David Jackson; trad. de Héctor Olea (Caracas: Biblioteca Ayacucho, 1981), 67–72.

Gego (Gertrud Goldschmidt)
Ocho cuadrados, 1961
Hierro soldado y pintado
170 × 64 × 40 cm
Colección Patricia Phelps de Cisneros
2000.99

Ocho cuadrados (lámina 38) no descuella sobre el espectador ni envuelve su cuerpo por completo; este objeto escultórico no acapara una sala grande ni todo un patio público. No obstante, a pesar de su escala, *Ocho cuadrados* exige mucho más que una apreciación pasiva por parte del público que la contempla. La obra consiste en ocho planos de metal que se intersecan en el aire, como si hubieran caído uno encima del otro para crear esta particular formación. Aunque las "líneas" o "tubos" específicos que configuran los planos parecen estar todos dispuestos de forma horizontal, la cuidadosa estructura de la artista

confiere a la obra un énfasis vertical. Por otra parte, la obra emite una particular tensión, como si el objeto inanimado estuviera dispuesto a expandirse, una zumbante sensación de energía acentuada por las múltiples cuadrículas que los planos forman al intersecarse unos con otros. A medida que el espectador se desplaza alrededor de la escultura, las relaciones entre las retículas y los planos parecen cambiar, generando la apariencia de un movimiento dinámico.

A pesar del complejo sistema de relaciones entre líneas, cuadrículas y planos de *Ocho cuadrados,* Gego imbuye la obra de un sentido global de armonía y ritmo. *Ocho cuadrados,* como todas las exploraciones estéticas de Gego, transmite un sentimiento de equilibrio que evoca el de las creaciones de la naturaleza, incluso cuando la artista empleaba técnicas y materiales industriales para realizar sus obras. Esta comparación con la naturaleza, sin embargo, no tiene gran cosa que ver con cualquier vestigio figurativo en la obra de Gego. Como señaló la crítica de arte Marta Traba, la obra de Gego "no se relaciona con la *imagen* de la naturaleza . . . , sino con su sentido y sus estructuras profundas".[1]

Un estudio de *Ocho cuadrados* en relación con otra de las creaciones de la artista, la *Reticulárea* de 1969, arroja luz sobre las aspiraciones y objetivos artísticos de Gego. En esta obra, la artista empleó una considerable cantidad de cable metálico para crear una malla que ocupaba toda una sala. Al entrar en el espacio de la galería, el espectador se enfrentaba a una maraña de alambre que le envolvía en todas direcciones. Como los Penetrables de Jesús Rafael Soto de finales de la década de 1960, el espectador no podía percibir simplemente la obra de arte desde una única posición inmóvil; debía usar su cuerpo para interactuar físicamente con la obra a medida que se desplazaba por el espacio de la galería. Cuando el espectador se movía alrededor de la *Reticulárea* y penetraba en su interior, empezaba a percibir los componentes individuales—los "módulos"—, que sólo tienen sentido como parte del conjunto de la obra de arte en un sentido más amplio. De modo similar, los componentes y piezas que forman *Ocho cuadrados* tendrían escaso impacto sobre el espectador individualmente considerados; sólo interactúan con el público intersecándose entre sí y produciendo la armonía y los ritmos definidos de la propia obra. Como Marta Traba escribiera sobre la obra esmeradamente compuesta de Gego, ésta contiene "las adecuadas relaciones de las partes con el todo".[2]

Ocho cuadrados, sin embargo, también se vincula a otra cuestión que resulta crucial en la obra de Gego: sus meditaciones sobre los distintos géneros artísticos, los propios elementos que hacen que un conjunto específico de materiales se conviertan en una pintura o en una escultura. Dado que *Ocho cuadrados* ocupa un espacio tridimensional, uno podría simplemente clasificarla como escultura y no darle más vueltas. Pero el papel dominante que desempeña la línea en los cuadrados individuales y los planos y retículas entrelazados indican que la obra se mueve entre lo bidimensional y lo tridimensional, o más concretamente, entre el dibujo y la escultura. De algún modo, *Ocho cuadrados* anticipa el cuestionamiento de Gego del papel que desempeña el dibujo en su serie Dibujos sin papel (lámina 47),

en la que manipuló cables metálicos y otros materiales industriales para crear objetos tridimensionales que también funcionaran como "dibujos". En esas obras posteriores, Gego incluso "pintaría" formas particulares en las mallas metálicas usando materiales de distintos colores.[3] En una pieza posterior, *Espiral roja* (1985), Gego logró crear una espiral que aparentemente flota libremente, una forma que podría dibujarse fácilmente sobre una hoja de papel, pero que exige una considerable reflexión para producirla en tres dimensiones. Mientras que *Ocho cuadrados* puede apartarse de todos estos proyectos estéticos debido al uso que hace de un solo color y a su estructura relativamente simple, uno se pregunta: ¿por qué Gego optó por un medio tridimensional para crear estos efectos de zumbido en la intersección de las líneas? Al igual que los Dibujos sin papel, *Ocho cuadrados* no es un mero ejercicio para crear formas o diseños particulares. Más importante aun: la obra destaca como una investigación en torno a los materiales y el proceso físico a través del cual Gego manipula sus materiales. Al torcer y girar las distintas piezas de metal, Gego produjo una obra que puede asemejarse a un dibujo cuando se reproduce en fotografía, pero el espectador debe experimentar la pieza real para apreciar cómo Gego manejó los materiales, como parte necesaria del proceso creativo de la artista.

En pocas palabras, podría ser que los *Ocho cuadrados* de Gego carecieran del irresistible poder de espectáculo que la canónica *Reticulárea* poseía. También podría carecer de la fisicidad masiva de los proyectos públicos de Gego, como la escultura de varios pisos que se alza en el Banco Industrial de Venezuela, y que se asemeja mucho a las formas y planos de *Ocho cuadrados.* No obstante, si nos movemos alrededor del objeto escultórico y consideramos el modo en que ilustra el conjunto de los experimentos artísticos de Gego, difícilmente podemos considerar la pieza como un ejercicio menor, como una pequeña maqueta que ayudara a la artista a preparar otros proyectos de mayor envergadura. Con *Ocho cuadrados,* Gego creó un objeto que arroja luz sobre el conjunto de su trayectoria artística, sus inquietudes en torno al solapamiento entre pintura y escultura, o las distintas formas en que los elementos de una obra armonizan entre sí. Al contemplar *Ocho cuadrados* en el espacio de la galería, comprendemos mejor una figura clave del movimiento artístico moderno de Venezuela, una artista que no necesitaba depender de la escala o del tamaño para captar nuestra atención.

Alberto McKelligan
Traducción de Jordi Palou

Notas
1. Marta Traba, *Gego* (Caracas: Museo de Arte Contemporáneo, 1977), 7.
2. Traba, 7.
3. Véase, por ejemplo, el ensayo por Luis Pérez-Oramas sobre la *Reticulárea cuadrada 71/6* y el *Dibujo sin papel 76/4* en este catálogo.

Jesús Rafael Soto
Leño, 1961
Hierro y alambre sobre madera
75 × 25 × 16 cm
Colección Patricia Phelps de Cisneros
1991.60

Hommage à Yves Klein [Homenaje a Yves Klein], 1961
Alambre, pintura industrial sobre cartón piedra y madera
55 × 96 × 4 cm
Colección Patricia Phelps de Cisneros
1995.21

Dos obras de 1961, *Leño* (lámina 39) y *Hommage à Yves Klein* (lámina 40), reflejan la reacción de Soto al lenguaje poético de los artistas vanguardistas de París a finales de los años 50.[1] Un análisis de dichas obras en este contexto debe prestar una atención especial a los Nouveaux Réalistes y a su líder no oficial, Yves Klein, dado que su obra se enfrenta a los mismos desafíos que Soto: introducir lo "real" en el arte no figurativo, huyendo de la abstracción mecánica y geométrica, a menudo calificada de "fría", y buscar aproximaciones a la *perceptive du réel,* a una percepción de la realidad basada en su esencia inmaterial.

El crítico francés Pierre Restany acuñó el término Nouveau Réalisme en un manifiesto que acompañaba a una exposición colectiva en la galería Apollinaire, de Milán, en abril de 1960. En la exposición figuraban artistas como Arman, César, Christo, Daniel Spoerri, Jean Tinguely e Yves Klein, entre otros. Restany reconoció en dichos artistas una nueva trayectoria: el reciclaje poético de lo real, apropiándose de materiales y objetos ordinarios en la creación de un arte activamente comprometido con la sociedad. Describió esa nueva y apasionante aventura como una búsqueda utópica:

> La apasionada aventura de lo real percibido en sí mismo y no a través del prisma de la transcripción conceptual o imaginativa . . . ya sea por lo que se refiere a las opciones o a la laceración del cartel, al aspecto del objeto, a basuras domésticas o a una pérdida de sensibilidad más allá de los límites de la percepción.[2]

Aunque técnicamente Soto no llegó a ser miembro del grupo del Nouveau Réalisme, hacia 1961 ya había participado con entusiasmo en numerosas exposiciones y actividades con los artistas del grupo, especialmente Klein, Spoerri y Tinguely, del mismo modo que con los del grupo Zero, de Düsseldorf—Otto Piene, Günther Uecker y Heinz Mack. De hecho, era tan sólido el compromiso de Soto con Klein, el más influyente y seguramente el más atípico de los Nouveaux Réalistes, que discutía con su galerista, Denise René, sobre el rechazo de ésta a aceptar a Klein en su galería.[3] En 1962, tras la prematura muerte de Klein y la gradual disolución del grupo del Nouveau Réalisme, la obra de Soto regresó de repente a un lenguaje geométrico básico. Significaba el final de un periodo de tres años durante el que Soto buscó usar la propia materialidad de los elementos estructurales de su arte para revelar su

esencia, de un modo inusitadamente personal y expresivo. *Leño* y *Hommage à Yves Klein* representan esa fascinante ruptura de tres años con la estricta geometría óptica de los relieves murales de Soto. *Leño* muestra una reacción física y personal frente a la rigidez dominante de la abstracción geométrica y la estética popular de la abstracción lírica o Art Informel, mientras que *Hommage à Yves Klein* muestra una reacción más conceptual.

Con *Leño,* una combinación de madera, metal, alambre y clavos, la tranquila sensibilidad de los collages de Soto explotó en forma de una obra escultórica tridimensional. En este ejemplo en particular, Soto se desvió radicalmente de sus prístinos estudios de vibración óptica anteriores a 1959, en los que superponía paneles pintados de plexiglás sobre madera. *Leño* es de un tamaño relativamente pequeño, de 75 centímetros de altura, pero tiene un gran poder expresivo. Usando materiales encontrados, a fin de integrar la vida cotidiana en la obra de arte—una estrategia muy propia del Nouveau Réalisme—, Soto afirmaba el papel del "arte como objeto" (el arte como objeto en y de sí mismo, más que la representación de un objeto) y reforzaba el materialismo subyacente a los elementos pictóricos de la obra, que ya no podían seguir divorciados del mundo real. Abandonó el uso anterior de un soporte rectangular plano de madera con capas de plexiglás, que sugería una fría modernidad, en favor de una pesada viga de madera que impone por su carácter macizo. El título, *Leño,* indica la crudeza de la obra. Los clavos de borde irregular, incrustados directamente en los laterales rugosos, crean una silueta poco amable, agresiva e incluso violenta. Soto añadió un fragmento de hierro y pintó tenues líneas blancas y negras en un panel rectangular. Incrustó alambres enmarañados de forma aleatoria en el espacio así rayado y eliminó sus tempranas líneas geométricas gruesas y de colores vigorosamente definidos, sustituyéndolas por fragmentos de pintura comercial roja y azul, aplicada al azar sobre los alambres clavados. El impacto de la alusión de la obra a un cuerpo humano con clavos incrustados supera la sutil sensación de vibración que Soto buscaba conseguir mediante la interferencia visual del alambre. Sin embargo, a pesar de ello Soto halló en este nuevo uso de materiales y en el formato totémico una alternativa a las "frías" soluciones ópticas de Vasarely, a la abstracción geométrica del grupo Madí y a la abstracción lírica *informel.* Retornó al uso de materiales encontrados y cotidianos para crear lo *immatériel,* definido como la esencia de la percepción visual, el espíritu, la cosa en sí misma, la vibración más que su representación.

En contraste con la fuerza primaria de *Leño, Hommage à Yves Klein* supuso un reconocimiento de la relación personal integral de Soto con Yves Klein. *Hommage* formaba parte del diálogo conceptual de Soto con Klein sobre su diferente tratamiento de la luz, el movimiento y el espacio. Su respeto por Klein provenía de su reconocimiento de que éste, "de todos nosotros . . . era quien más creía en la esencia inmaterial".[4] En una entrevista con Jean Clay, en 1969, Soto identificaba el significado de las pinturas monocromas de Yves Klein como su capacidad de expresar lo real, de forma paralela a la obra de Kasimir Malevich:

Pintando blanco sobre blanco, Malevich quiso decir: pintemos la luz en tanto que luz. Pongámosla directamente sobre la tela.... Es la misma propuesta que formulara Yves Klein en sus *Monochromes bleus*.... Es el *signo* de lo real lo que él nos trae, y no una "versión" académica y naturalista.[5]

Hommage hace referencia al mismo tiempo al tratamiento de lo "real" por parte de Soto y de Klein. Los alambres, evocadores de gestualización, clavados en la superficie rascada y pintada con líneas, permitían a Soto presentar su investigación acerca de las sensaciones vibratorias del movimiento. Además, intercalaba una discreta referencia a los monocromos azules de Klein. El pequeño fragmento de metal pintado de azul, en el ángulo derecho, transmitía la vibración de la luz, a la manera de Klein. En *Hommage,* como en muchas de sus obras, Soto creaba un híbrido de pintura y escultura para comunicar la "sensibilidad" de la luz y el movimiento a través de la vibración. Sus dos versiones de *Vibration bleu cobalt [Vibración azul cobalto]* (1959) también vinculaban sus obras a las de Klein: Soto emparejó sus soportes, que llevaban alambres clavados y pintados con líneas negras, con zonas pintadas de azul, en clara referencia a Klein, creando una unión de sus ideas, codo con codo.

En 1963, Soto había vuelto a prescindir de elementos geométricos o de formas abiertas, frente a un soporte plano de madera. La *passionante aventure du réel* había finalizado, pero siguió ejerciendo influencia en su obra de un modo más sutil. Sus creaciones posteriores dejaron de condensar el carácter físico y emocional de los rudos y toscos materiales cotidianos, del alambre frenéticamente doblado o de las superficies densamente pintadas. La muerte de Klein y la posterior disolución de los Nouveaux Réalistes, junto con la reciente implicación de Soto con el optimismo del modernismo venezolano, reorientaron la obra del artista; sus investigaciones se decantaron hacia una voz más sofisticada de razonamiento y se alejaron de la cuasi mística presencia de Klein.

Estrellita B. Brodsky
Traducción de Jordi Palou

Notas

1. Soto rechazaba el término muy utilizado de "barroco" para este periodo de su obra, por considerarlo impreciso. Reconocía que, si bien no llegó a participar de ellos por completo, movimientos artísticos contemporáneos como el Nouveau Réalisme y el Tachisme ofrecían un nuevo vocabulario para investigar el "espacio temporal". Véase Ariel Jiménez, *Conversaciones con Jesús Soto* (Caracas: Fundación Cisneros, 2005), 95–103.
2. Pierre Restany, "'Les Nouveaux Réalistes', 16 avril 1960, Milan (1er manifeste)", en Restany, *Les Nouveaux Réalistes* (París: Planète, 1968), 204.
3. Entrevista de Denise René con la autora, 5 diciembre 2004, París.
4. Pierre Restany, "Soto l'immateriale", *Corriere della Sera* [Milán], 6 julio 1969.
5. Jean Clay, *Visages de l'Art moderne* (París: Rencontre, 1969), 132.

Lygia Clark
O dentro é o fora [El adentro es el afuera], 1963

Acero inoxidable
35.5 × 45.7 × 38.1 cm
Colección Patricia Phelps de Cisneros
1997.138

Al pararnos frente a *O dentro é o fora*, de Lygia Clark, es difícil no advertir sus peculiares características físicas: la obra consiste en una delgada lámina de metal enrollada sobre sí misma que produce sensuales curvas, las cuales resultan aun más atractivas debido al brillo industrial que emana del metal. Las grietas y curvas se asemejan tanto a las formas de organismos naturales que uno casi podría imaginar que *O dentro é o fora* fuera una escultura figurativa, como si la artista hubiera intentado reproducir el tronco de un árbol retorcido, por ejemplo. A pesar de esos atractivos rasgos, sin embargo, Clark no creó *O dentro é o fora* para ofrecer al público una experiencia de placer puramente visual. En lugar de ello, este objeto escultórico está relacionado con los objetivos de la vanguardia neoconcreta brasileña y sus esfuerzos por inducir al espectador a reflexionar sobre el modo en que percibe su entorno a través de los sentidos y cómo procesa el continuo aluvión de estímulos sensoriales en su vida cotidiana.

En el texto que definió y contribuyó a establecer el Neoconcretismo brasileño como estrategia estética particular, Ferreira Gullar explicaba que las obras que este movimiento producía no serían simples máquinas u objetos. En lugar de ello, Gullar proponía la idea del cuasicorpus, "algo que equivale a más que la suma de sus elementos constituyentes; algo que el análisis puede descomponer en varios elementos pero que sólo puede ser comprendido fenomenológicamente".[1] Los proyectos estéticos concebidos por Gullar no son completos en sí mismos; estas obras nunca están acabadas, sino que el espectador las crea y completa continuamente, interactuando físicamente con el objeto. Mediante modificaciones que dependen de la participación del público, la obra de arte "se hace presente continuamente".[2]

Los Bichos de Clark, realizados durante el mismo periodo que *O dentro é o fora,* ilustran este ingrediente de la participación del público en el Arte Neoconcreto brasileño. El Bicho invita al espectador a "jugar" con la obra de arte, a sentir la interacción de fuerzas físicas entre la persona y el objeto. A pesar de que *O dentro é o fora* carece de las bisagras metálicas de los Bichos, también provoca esta misma reacción en la persona que la contempla, induciéndola a retorcer los sensuales arcos de metal con las manos. Aunque el espectador no llegue a tocar el objeto escultórico, fácilmente se imagina deslizando sus curvas y disponiéndolas de modos distintos, intentando percibir plenamente la estructura y la forma del objeto.

No obstante, uno no puede limitarse a explicar *O dentro é o fora* como un intento de Clark de provocar al público para que interactúe físicamente con el objeto. Al igual que los Bichos, *O dentro é o fora* se vincula a otro aspecto crucial del movimiento neoconcreto: la sospecha que recae sobre las obras de arte excesivamente

centradas en la racionalidad. Al principio del manifiesto neoconcreto, Gullar enfatizaba el distanciamiento del movimiento respecto "a un tipo de Arte Concreto influido por un racionalismo peligrosamente agudo".[3] Más que centrar simplemente su atención en las innovaciones formales del arte abstracto de tipo geométrico, los artistas brasileños del movimiento neoconcreto querían que el espectador reflexionara sobre las limitaciones de la razón; deseaban que el público se resistiera a una visión puramente científica y potencialmente limitadora del mundo en que vive. En otras palabras, los artistas como Clark querían que el espectador considerara el modo en que su cuerpo elabora continuamente significado y una comprensión del mundo.

A lo largo de su vida, Clark expresó repetidamente su interés en crear obras de arte que produjeran ese tipo de efectos en su público. En una carta escrita a Oiticica desde París, Clark expresaba su insatisfacción con el arte que halló en dicha ciudad: "Ya ves, lo que falta es la trasposición que *va más allá* del objeto. Es la ausencia absoluta de la metafísica".[4] Incluso antes de pasar un tiempo en París, ya había expresado interés por el papel de la humanidad en la sociedad contemporánea, nuestra existencia en un universo que describía como denso y complejo. En su texto "O morte do plano", afirmaba que "nos sumimos en la totalidad del cosmos; somos una parte de este cosmos, vulnerable por todos lados—pero es una parte que incluso ha dejado de tener lados—arriba y abajo, izquierda y derecha, delante y detrás, y, en última instancia, bueno y malo—tan radicalmente se han transformado los conceptos".[5]

O dentro é o fora constituye un esfuerzo por ir más allá del objeto en el que Clark intenta modificar los propios procesos perceptivos de su público. La lámina retorcida de metal no sólo plantea al espectador que considere si está "dentro" o "fuera" de la obra de arte, sino que también lo empuja a preguntarse si la obra de arte tiene algún lado. *O dentro é o fora* representa el equivalente metálico de las exploraciones de Clark con la cinta de Möbius, los trozos de papel que la artista giraba y unía por los extremos de modo que tuvieran una sola cara. Si uno se limita a *ver* la cinta de Möbius—si se aborda tan sólo a través de la visión—, la tira de papel parece tener dos caras. Pero si sigue el trazo del papel, si se interactúa con él tocándolo y sintiéndolo, a la larga se da cuenta de que sólo tiene una cara. Los distintos significados que la visión y el tacto producen son análogos a los efectos de *O dentro é o fora*.

De este modo, *O dentro é o fora* anticipa el uso posterior que hizo Clark del arte como terapia, en virtud del cual envolvía a individuos con máscaras, guantes y trajes de varios tipos. En obras como *Estruturação do self* (1970–1980), Clark intentaba transformar o alterar la mente del espectador bombardeando sus sentidos con una amplia variedad de estímulos, como los sonidos de triturar cáscaras o el olor del café. En comparación, *O dentro é o fora* puede parecer relativamente insulsa, una estrategia menos osada realizada por la misma artista. Aun así, en medio del espacio donde se exhibe, podríamos preguntarnos si el silencioso objeto escultórico de Clark

conjura tanto poder como sus terapias artísticas cargadas de estímulos sensoriales.

Alberto McKelligan
Traducción de Jordi Palou

Notas
1. Ferreira Gullar, "Neo-Concrete Manifesto", reproducido en *Geometric Abstraction: Latin American Art from the Patricia Phelps de Cisneros Collection/Abstracción Geométrica: Arte Latinoamericano en la Colección Patricia Phelps de Cisneros* (New Haven y Londres: Yale University Press, 2001), 154.
2. Gullar, 155.
3. Gullar, 152.
4. Lygia Clark, "Letter to Oiticica, 1/19/64", reproducida en *Geometric Abstraction*, 156.
5. Lygia Clark, "Death of the Plane", reproducido en *Geometric Abstraction*, 159.

Carlos Cruz-Diez
Physichromie No 126
[Fisicromía n.º 126], 1964
Tinta, pintura industrial y papel metalizado sobre aglomerado
143 × 31.8 × 4.5 cm
Colección Patricia Phelps de Cisneros
2001.87

Physichromie No 126 (lámina 41) llama la atención del espectador de un modo que la distingue de las demás fisicromías de Carlos Cruz-Diez. A diferencia de esas obras, *Physichromie No 126* no se basa en la mutabilidad de las propiedades del color, ni en la capacidad de los distintos colores para combinarse con nuevos tonos y formar patrones geométricos dinámicos y flotantes. En lugar de ello, *Physichromie No 126* recuerda las obras del artista húngaro Victor Vasarely, y de modo particular sus pinturas en blanco y negro de la década de 1950 y principios de la de 1960. En esas obras, Vasarely confiere a la tela plana una tercera dimensión virtual, al distorsionar la relación figura/fondo de tal forma que la figura aparece y desaparece simultáneamente de la línea de visión del espectador, a menudo con la ayuda de una base cuadriculada. De modo similar, Cruz-Diez centra su atención en la interacción ilusoria entre primer plano y fondo, con el objeto de estimular el sentido del espacio del espectador e iniciar una experiencia participativa y comprometida con la obra de arte.

Cruz-Diez dividió *Physichromie No 126* en cuatro paneles o recuadros iguales. Vistos desde lo lejos, estos recuadros, llenos de forma predominante de rayas verticales blancas y negras, se mezclan y producen el efecto de varios tonos de gris. No obstante, un examen más minucioso revela que una serie de zigzags interrumpen esta repetición continua de líneas verticales e inician una ilusión óptica, que aparentemente oscurece o aclara partes de cada recuadro. A medida que el espectador se acerca a la obra, su carácter táctil se hace más patente; el plano de la pintura no es una superficie homogénea, sino que consiste en delgadas tiras de cartón pegadas perpendicularmente al soporte. Interesado por los efectos del color y la luz en la retina del observador, Cruz-Diez incorpora asimismo una dimensión temporal, al iniciar un diálogo perceptivo y fenomenológico basado en la posición del espectador con respecto a la obra.[1]

Al tratar el color—o, en este caso, el blanco y negro—como un agente activo, Cruz-Diez transforma *Physichromie No 126* en algo más que un objeto estático y bidimensional. Se convierte en la plasmación de una experiencia sensorial.

Desafiando la noción renacentista de que la pintura actúa como una "ventana abierta al mundo", una imagen fija y eterna, la obra de Cruz-Diez, por el contrario, entabla un diálogo entre espectador y objeto, una danza perceptiva que sitúa en primer plano la relación entre el sujeto que observa y el objeto visual. Cruz-Diez escribió profusamente sobre su exploración de la teoría del color y describió estas obras de la siguiente manera:

> Las fisicromías son estructuras que revelan diferentes comportamientos y otras condiciones del color. Se modifican según el desplazamiento de la luz ambiente y del espectador, proyectando el color en el espacio y creando una situación evolutiva. La acumulación de módulos de acontecimiento cromático hace aparecer y desaparecer diversos "climas de color" aditivo, reflejo o sustractivo.[2]

Es esta continua evolución de la imagen lo que hace que las obras de Cruz-Diez parezcan superficies animadas, incluso cinéticas, más que obras de arte estables.

Tras su llegada a París en 1960, Cruz-Diez encontró una red de apoyo—que ya llevaba un tiempo en activo—en la Galerie Denise René, donde su compatriota venezolano Jesús Rafael Soto y los argentinos Julio Le Parc, Martha Boto, Gregorio Vardánega y Luis Tomasello, entre otros, intercambiaban ideas y exponían su obra a un público entusiasmado con las posibilidades interactivas de este nuevo arte. Estos artistas sudamericanos recién llegados formaban un grupo más bien flexible cuyo objetivo principal era crear un arte orientado hacia la cultura de masas, que incentivara al público a interactuar con el objeto en cuestión, a conectar físicamente con él.

En el centro de esta obra, como lo demuestra *Physichromie No 126,* de Cruz-Diez, se halla la cuestión de la percepción individual, o de cómo el espectador llega a comprender la obra de arte y a hacer que ésta adquiera sentido para él. Cruz-Diez se interesó por la fenomenología y, como muchos otros artistas latinoamericanos de la década de 1960, acudió a los escritos de Maurice Merleau-Ponty. Preocupado por los efectos ópticos y sus correspondientes reacciones físicas y conductuales, el objetivo de Cruz-Diez era usar las experiencias visuales y perceptivas para involucrar visceralmente al espectador en sus entornos de color, con el objeto de desafiar lo que él denominaba la respuesta media "programada" del espectador al color.[3]

Con el tiempo, la serie de fisicromías de Cruz-Diez le condujo a sus Cromosaturaciones, obras que no sólo jugaban con el campo de visión del espectador y su percepción de la forma y el color, sino que, de hecho, transformaban su entorno cotidiano en escenarios monocromáticos. Su *Cromosaturación* (1968) consistía en tres salas o cabinas cubiertas con acetato traslúcido de color rojo, verde y azul colocado en armazones de aluminio. El artista situó las cabinas a la salida de la estación de metro Odéon, en París. A medida que el espectador atravesaba cada una de las cabinas,

su visión de las calles y edificios circundantes se transformaba momentáneamente, ya que en cada una de ellas quedaban bañados en distintos colores. Cruz-Diez obligaba al espectador a mirar de otra manera una escena cotidiana, literalmente "bajo una luz distinta". Al igual que en su serie de fisicromías, *Cromosaturación* demuestra el interés de Cruz-Diez por redefinir los términos de la experiencia estética, otorgando poder al espectador para "sentir" más que "pensar" el significado de la obra de arte. Al explorar el fenómeno de la percepción humana a través del color, la opticidad y el movimiento, Carlos Cruz-Diez y otros artistas latinoamericanos de su generación abrieron un espacio para la experiencia sensorial y física del espectador, permitiéndole intervenir y participar directamente en la obra de arte.

Martha Sesín
Traducción de Jordi Palou

Notas

1. Julio César Schara, *Carlos Cruz Diez y el arte cinético* (México: Arte e Imagen, 2001), 80.
2. Schara, 73.
3. Schara, 68.

Jesús Rafael Soto
Vibración—Escritura Neumann, 1964

Alambre, pintura industrial y nylon sobre cartón piedra y madera
102 × 172.5 × 16 cm
Colección Patricia Phelps de Cisnero
2001.16

Vibración—Escritura Neumann (lámina 42), de Jesús Rafael Soto, consiste en una serie de finos alambres que parecen flotar en el espacio, con formas retorcidas suspendidas frente a un gran fondo rectangular compuesto de delgadas tiras blancas sobre un fondo negro, o a la inversa, delgadas líneas negras sobre fondo blanco. Con su estructura íntegramente geométrica, esta obra recuerda las abstracciones geométricas de décadas anteriores realizadas por artistas como Josef Albers o por el grupo neerlandés De Stijl, salvo que a una escala mayor. No obstante, con sus elementos esculturales hechos a mano colgando frente a la tela, la obra de Soto trastoca el punto de vista habitual de la pintura abstracta posterior a la Segunda Guerra Mundial, que sitúa a un espectador estático e incorpóreo directamente frente al plano de la pintura.

En lugar de ello, *Vibración—Escritura Neumann,* que usa tanto el alambre como la rejilla para producir una experiencia óptica y visceral basada en la vibración de los alambres frente al fondo de tiras, estimula la interacción física con el espectador. El movimiento de los alambres como respuesta a los cambios en las corrientes de aire y al propio movimiento del espectador alrededor de la obra inicia una extraña experiencia perceptiva. A través de varias estrategias de juego, Soto no sólo manipula el sentido espacial del espectador, sino que establece un diálogo entre éste y la obra, en el que el cuerpo del espectador provoca el movimiento o la compleción (en perpetuo movimiento) de la propia obra de arte. Al combinar un fondo bidimensional de estructura geométrica con objetos tridimensionales

tales como varillas, alambres y cordel de nylon, Soto incorpora elementos cinéticos al juego que propone, extraídos de la moderna tecnología y de materiales industriales.

Soto se estableció en París en 1950, por lo que fue uno de los primeros de la generación de artistas abstractos que se trasladó a Francia desde su Venezuela nativa. Participó en la crucial exposición *Le Mouvement* (1955), en la Galerie Denise René, con obras que—al igual que las de otros artistas óptico-cinéticos contemporáneos—buscaban imbuir el lenguaje abstracto geométrico tradicional de una nueva dinámica.[1] Soto, influido por las obras de Piet Mondrian y Kasimir Malevich, buscaba el modo de transformar el movimiento "virtual", presente en la producción vanguardista de principios del siglo XX, en formas tridimensionales.[2] *Vibración—Escritura Neumann,* cuyo título alude al industrial y coleccionista venezolano Hans Neumann,[3] atrae al espectador a la interacción que se establece entre el fondo y el primer plano. En ocasiones, los alambres de aluminio distorsionan el fondo de tiras, perfectamente dispuesto, mientras que otras veces las espirales retorcidas parecen fusionarse en él. A medida que uno se desplaza adelante y atrás y de un lado a otro frente a la obra, los elementos colgantes adoptan vida propia, desafiando y cuestionando nuestra agudeza visual. Invariablemente vinculada a la presencia del espectador, *Vibración—Escritura Neumann* produce una ambigua sensación espacial en la propia obra de arte, lo que a su vez depende de la distancia real entre la obra y el espectador.

Al igual que Carlos Cruz-Díez, otro artista óptico-cinético venezolano, y los artistas argentinos Luis Tomasello, Julio Le Parc y Martha Boto, Soto abandonó su patria en busca de un clima más fértil para la producción de su arte, y de una ubicación que pudiera conferir legitimidad a su obra. En última instancia, París satisfizo ambos objetivos. Como punto neurálgico en la historia de las vanguardias artísticas, París ofrecía a Soto y a otros componentes de este variado grupo un lugar en el gran relato de la historia del arte y, lo que es más importante, un público entusiasmado con las posibilidades del Arte Cinético.

Vibración—Escritura Neumann forma parte de una serie de Escrituras que Soto empezó en 1957, en las que suspendía delgados alambres que formaban lazadas interactivas ante fondos o pantallas geométricamente abstractos, creando la impresión de garabatos trazados en un pedazo de papel. Inicialmente interesado en las "vibraciones" o efectos ópticos, como demuestran sus Repeticiones de 1951, Soto pasó a elaborar obras con varias capas, en las que superponía dos o tres superficies de plexiglás de distintos colores y texturas para crear la impresión de ambigüedad espacial y movimiento óptico a través de la activa participación del espectador. Este interés por el movimiento—ilusorio o real—constituye la preocupación principal de la obra de Soto. Tras su temprana serie de plexiglás, empezó a suspender elementos entre una superficie estriada de plexiglás y otra opaca, incorporando vibraciones ópticas y movimiento real en la misma obra. Eso le condujo a una serie de pinturas geométricas en las que suspendía objetos—como varillas de metal o alambres retorcidos—que trastocaban

el fondo de la pintura con vibraciones visuales. En su serie Escrituras, Soto literalmente "detiene el espacio", liberando al artista de cualquier tipo de restricción impuesta por el soporte material.[4] El término *escritura* como título de la serie surgió posteriormente, después de que los espectadores mencionaran en varias ocasiones la semejanza de los alambres retorcidos con muestras reales de escritura, con la curiosidad consiguiente por descifrar el contenido del mensaje.[5] Soto compartía el deseo de realizar un arte abstracto socialmente relevante con los artistas óptico-cinéticos con quienes se relacionaba en París. Así, pueden interpretarse como parte de una tradición constructivista, en términos más que formales, a pesar de que no se inspiraran en el compromiso político de los constructivistas rusos. En lugar de ello, pretendían realizar un arte público al alcance de las masas. Al dar un nuevo ímpetu a la tradición de la abstracción geométrica, que a finales de los años cuarenta y principios de los cincuenta parecía en gran parte superada, a pesar de la defensa que de ella habían hecho grupos anteriores como Cercle et Carré y Abstraction–Création, los artistas óptico-cinéticos latinoamericanos conmocionaron a un público acostumbrado a la estética introspectiva de la abstracción lírica y a una postura pasiva o distante del espectador. No obstante, los factores que se hallaban tras el éxito de estos artistas condujeron asimismo a su desaparición. De hecho, la buena acogida pública de la obra de Soto y de otros artistas ópticos y cinéticos llevó a numerosos críticos a la conclusión de que este arte aparentemente caprichoso y juguetón no debía tomarse demasiado en serio. Lamentablemente, esta postura ha influido en los críticos e historiadores del arte posteriores, que todavía tienen pendiente una adecuada evaluación del impacto de esta obra en un momento crítico de la Francia de la posguerra y en la evolución del arte moderno en general.

Martha Sesín
Traducción de Jordi Palou

Notas

1. Al usar la expresión "abstracción geométrica tradicional", me refiero en particular a los artistas y colectivos de principios de siglo y de las décadas de 1920 y 1930 que intentaron reavivar la tradición constructivista, como César Domela, Georges Vantongerloo, Jean Arp, Max Bill y grupos como Abstraction–Création y Cercle et Carré, entre otros.

2. Jacqueline Barnitz, *Twentieth-Century Art of Latin America* (Austin: University of Texas Press, 2001), 203. Esta idea me la sugirió inicialmente una entrevista con Luis Tomasello en 2003. Al mostrarme sus obras, insinuó que si Mondrian hubiera vivido más tiempo y hubiera continuado por el mismo camino, el movimiento *virtual* que intentaba aprehender en sus obras se habría transformado en algo más tridimensional.

3. Ariel Jiménez, *Conversaciones con Jesús Soto* (Caracas: Fundación Cisneros, 2005), 103. En su diálogo con Jiménez, Soto cuenta cómo Neumann le prestó su estudio de Caracas en 1961 para acabar una de sus obras.

4. Jiménez, 195. "Con ellas [las escrituras] puedo realmente dibujar en el espacio, liberado incluso de la obligación de superponer las líneas paralelas."

5. Jiménez, 195.

Lygia Clark
Obra mole [Obra blanda], 1964
Caucho recortado
Diámetro: 49.5 cm
Colección Patricia Phelps de Cisneros
1998.67

A pesar de que, en retrospectiva, Lygia Clark calificaría este organismo amorfo de goma que depende de la participación del espectador como de una regresión, esta obra, sin embargo, constituyó un importante paso adelante para la artista en su trayectoria personal, así como en el desarrollo general del Arte Neoconcreto brasileño.[1] En la transición que va desde las radicales investigaciones de la superficie que engendraron el Neoconcretismo en 1959 hasta la erradicación final del objeto por la que Clark abogara en la década de 1970, *Obra mole* ocupa una decisiva fase intermedia caracterizada por la teorización del no-objeto neoconcreto. La *Obra mole* forma parte de una serie más amplia de Bichos con los que la artista desafiaba los géneros escultóricos tradicionales, al abandonar la monumentalidad y liberar el objeto de las limitaciones físicas y conceptuales del pedestal.

En "Teoría del no-objeto", texto publicado por el crítico y teórico Ferreira Gullar con ocasión de la segunda exposición de Arte Neoconcreto celebrada en Rio de Janeiro en 1960, se presentó la misión fundacional del movimiento en el sentido de trascender la "contradicción figura-fondo".[2] Según Gullar, el Arte Concreto había fracasado en su búsqueda de una vía para impedir la lectura de marcas sobre una superficie plana como "objetos" contra un "fondo". En su razonamiento de que esta paradoja era inherente a todas las categorías de representación—incluso las más abstractas—, propuso un replanteamiento total de la noción de arte. Sin confundirlo con un "anti-objeto", o la negación del objeto, Gullar definió el no-objeto como algo que surge "directamente en y del espacio", concibiendo en él "una recreación del espacio y, al mismo tiempo, su refundación".[3]

Esta "transformación espacial" llevaba implícito un énfasis en la materialidad que interpelaba los principios neoconcretos interrelacionados de "multisensorialidad" y "cuasi corpus". Sin abandonar el vocabulario geométrico ni el compromiso social del Constructivismo, el Arte Neoconcreto desafiaba la supuesta universalidad de la razón y de la visión. Invocando al arquitecto funcionalista suizo Le Corbusier, que había ejercido una enorme influencia en el urbanismo del Brasil de la posguerra, los neoconcretos rechazaban la noción del arte como una "máquina", comparándolo en su lugar con un "organismo viviente".[4] El "cuasi corpus" o "casi cuerpo" pretendía enmendar una "peligrosa hipertrofia del racionalismo" a la que, según acusaban los neoconcretos, el Arte Concreto había "sucumbido"; pretendía restaurar la primacía del objeto por encima de la teoría de su realización y, en este proceso, reintegraba al sujeto o espectador activo.[5] Como muestra de estos objetivos, Clark realizó sus Bichos (1960–1964), objetos metálicos articulados pensados para que fueran manipulados por el espectador. Compuestos de planos triangulares y rectangulares conectados por múltiples bisagras, estos "seres" tridimensionales carecían de orientación normativa; los espectadores podían doblarlos y cambiar su posición, otorgándoles una vida animada gracias a su relación independiente e idiosincrásica con el público.

Los esfuerzos de Clark para crear algo más "ambiguo" la llevaron a la amorfa *Obra mole.*[6] A diferencia de los rígidos Bichos, estos flácidos montones de goma doblada y retorcida carecían de otra estructura que la que les daba el espectador. El participante podía colgarla en la pared, cubrir objetos con ella, o bien colgarla de los árboles, según le pareciera. Como tal, la *Obra mole* era el prototipo del "no-objeto": era a un tiempo el producto y el motor de la "transformación espacial" que se originaba una y otra vez en el mundo real del espectador. Por otra parte, la goma estándar y duradera de *Obra mole* subrayaba la accesibilidad de la obra, a la vez que desacralizaba aun más el objeto artístico al mantener el espíritu constructivista original. En un esfuerzo por eliminar la divisoria entre arte y vida, los constructivistas de la primera generación, tanto rusos como de otras procedencias, abandonaron las técnicas tradicionales—como el óleo y el mármol—, ahora convertidas en rarezas, incorporando en su lugar materiales ordinarios de diseño industrial (por ejemplo, vidrio, hojalata, láminas de metal, cuerdas y contrachapado) que atrajeran al espectador proletario en lugar de intimidarlo. Clark recordaba con placer la reacción del crítico Mário Pedrosa, que al ver esta obra la tiró sin miramientos al suelo y exclamó: "¡Por fin, una obra de arte a la que puedo patear!"[7]

A pesar de su resistencia a la causalidad mecanicista y las nociones de objetividad artística, las *Obras moles* reflejaban sin embargo el moderno contexto urbano que condicionó sus orígenes. Mientras que la generación anterior de seguidores de la abstracción geométrica en Brasil había abrazado con entusiasmo la tecnología mediante el uso del plástico, el aluminio y la reluciente pintura industrial, Clark regresó a materiales industriales más familiares y menos fetichizados, profundamente arraigados en la existencia cotidiana del entorno urbano del Brasil, como la goma corriente que suele hallarse en los talleres de automóviles. Por otra parte, la polisémica *Obra mole* no renunciaba a la geometría euclidiana, sino que, por el contrario, buscaba el potencial expresivo y las implicaciones existenciales latentes en los postulados físicos y matemáticos. Clark estaba particularmente interesada en la cinta de Möbius, que se inscribe en el espacio euclidiano a la vez que desafía las expectativas racionales. La *Obra mole* surgía de una serie de meditaciones sobre la cinta de Möbius exploradas en primer lugar con metal blando en *O dentro é o fora [El adentro es el afuera],* de 1963, y *O antes é o depois [El antes es el después],* también de 1963, y luego en 1964 con los *Trepantes [Trepadores],* de acero inoxidable. La cinta de Möbius es una forma de dos caras con una sola superficie y extrae la tridimensionalidad de un plano bidimensional, además de ejemplificar el infinito. Hablando del atractivo de la cinta de Möbius, Clark explicó en una ocasión: "Rompe con nuestros hábitos espaciales: derecha/izquierda, delante/detrás, etc. Nos obliga a experimentar un tiempo ilimitado y un espacio continuo".[8]

La *Obra mole* y su relación con la cinta de Möbius constituyen un indicador de que las

investigaciones sobre el plano que efectuaba Clark le permitían explorar temas más profundos de la existencia humana. Durante largo tiempo había sostenido que la invención abstracta del plano era sintomática—si no responsable—de la fragmentación del sujeto. La inútil búsqueda humana del equilibrio a través de la razón, argüía, suscitaba los "conceptos contrarios de alto y bajo, delante y detrás, exactamente lo que contribuye a la destrucción en la humanidad del sentimiento de integridad".[9] La continuidad de la cinta de Möbius se dirigía a la restauración de lo "orgánico" en el plano. "La abolición del plano de la pintura como medio de expresión equivale a ser consciente de la unidad como un todo orgánico y viviente".[10] La *Obra mole* representa la culminación de esta búsqueda, del plano llano que no es una superficie, que envuelve objetos y se dobla y se pliega en las esquinas. Es el plano que responde a fuerzas ambientales como un organismo vivo, que obedece a las leyes de la física y el tiempo, de la gravedad, la inercia y la entropía.

El imperativo interactivo de la *Obra mole* indicaba la dirección de la estética de Clark, a la vez que acercaba el significado del "no-objeto" un paso más hacia la desmaterialización del objeto. Al privilegiar el acto, el objeto adquiría una función subordinada. De modo similar, la experiencia física subsumía a la visual. Como observó Clark, "El espacio es ahora una especie de tiempo metamorfoseado incesantemente a través de la acción. El sujeto y el objeto se identifican esencialmente en el acto mismo".[11] No obstante, Clark consideraba la *Obra mole* como una regresión, ya que fue realizada justo después de su primera performance, *Caminhando* (1964), en la que cortaba cuidadosamente por la mitad una y otra vez una cinta de Möbius de papel. Con cada corte, la forma pasaba a ser paradójicamente más larga, hasta que el papel ya no podía cortarse más. Clark reconocía la necesidad de "regresar al objeto", aclarando, sin embargo, que "de hecho [la *Obra mole*] anunciaba mis experiencias con lo sensorial: su sensualidad y elasticidad indicaban de forma inconsciente lo que vendría después".[12] Es decir, mientras que la materialidad de la *Obra mole*—la mera presencia física del objeto— puede haber llevado a Clark un paso atrás en su evolución hacia los experimentos psicoterapéuticos puros representados a través del cuerpo que ocuparían su trayectoria artística posterior, el carácter orgánico y somático de estos objetos se acercaban y anticipaban el cuerpo real, fusionando así el objeto y la representación en su mutua e inevitable destrucción.[13]

Edith Wolfe
Traducción de Jordi Palou

Notas

1. Citado en Guy Brett, "Lygia Clark: The Borderline between Art and Life", *Third Text* (1987): 75.
2. Ferreira Gullar, "Teoria do não-objeto", *Jornal do Brasil* [Rio de Janeiro] 21 noviembre 1960; traducido al inglés por Tony Beckwith en Mari Carmen Ramírez y Héctor Olea, eds., *Inverted Utopias: Avant-Garde Art in Latin America* (New Haven: Yale University Press in association with the Museum of Fine Arts, Houston, 2004), 521–22.
3. Gullar, "Teoria do não-objeto".
4. "Manifesto neoconcreto", *Jornal do Brasil* [Rio de Janeiro] 22 de marzo de 1959, suplemento dominical, 4–5; traducido al inglés en Yve-Alain Bois, "Nostalgia of the Body: Lygia Clark", *October* 69 (verano 1994): 93.
5. "Manifesto neoconcreto," en Bois, 91.
6. Brett, 75.
7. Citado en Ricardo Nascimento Fabbrini, *O espaço de Lygia Clark* (São Paulo: Editora Atlas, 1994), 84.
8. Lygia Clark, "Trailings" (1964), en Bois, 99.
9. Lygia Clark, "Death of the Plane" (1960), en Bois, 96.
10. Clark, "Death of the Plane".
11. Lygia Clark, "About the Act" (1965), en Bois, 104.
12. Citado en Brett, 75.
13. A pesar de que después de 1968 Clark se fue distanciando cada vez más del objeto, la artista se opuso categóricamente a las comparaciones de su obra psicoterapéutica con los cuerpos individuales y colectivos del *Body Art*, los *happenings* o incluso las *performances*, que, por definición, daban por supuesta la presencia de un *voyeur* pasivo. Mientras que Clark nunca etiquetó explícitamente los "cursos" que realizó en París a lo largo de los años setenta y principios de los ochenta, Yve-Alain Bois recuerda que los comparaba a "una especie de electroshock social". Véase Bois, 88.

Hélio Oiticica
Box bolide 12, "archeologic", 1964–1965

Pintura sintética con tierra sobre estructura de madera, malla de nylon, cartón corrugado, espejo, vidrio, piedras, tierra, y lámpara fluorescente
37 × 131.2 × 52.1 cm
The Museum of Modern Art, New York, fractional and promised gift of Patricia Phelps de Cisneros in honor of Paulo Herkenhoff
326.2004.a–d

Incluso cuando se expone colocada encima de un pedestal, *Box bolide 12* (lámina 43), de Hélio Oiticica, difícilmente satisface los parámetros tradicionales de una "escultura". Oiticica yuxtapone un surtido de materiales de distintos colores y texturas que parece discordante; un trozo de tela naranja arrugada aparece dentro de una caja pintada de un tono amarillo reluciente, mientras que un rosa pastel cubre otras partes de la obra. El artista no se esmera en una impecable presentación de los distintos colores y materiales; capas de pintura irregularmente aplicada cubren la caja rosada y amarilla, que a su vez contiene algunos pedazos sueltos de escombros. Al examinarla minuciosamente, el espectador advierte incluso trozos de cuerda que parecen surgir del borde de las cajas, como si fueran restos de una construcción o de algún tipo de proceso de manufactura industrial. Con *Box bolide 12*, Oiticica no pretendía crear un objeto escultórico que se ajustara a los ideales de belleza, ni le interesaba construir una obra geométrica o abstracta que hablara un lenguaje "universal" y que trascendiera las fronteras nacionales. Lo que pretendía el artista con esta obra era explorar la producción artística, las formas en que unos materiales específicos—un retazo de tela, escombros—adquieren el estatus de arte. ¿Es el trozo arrugado de tela naranja arte simplemente porque el artista decidió etiquetarlo como tal? ¿Tiene alguna importancia que el artista eligiera materiales baratos como los escombros y la pintura irregularmente dispuesta para crear la pieza? *Box bolide 12* constituye el resultado final de los intentos de Oiticica por redefinir la práctica artística, una tarea que lo situó en el centro de la vanguardia brasileña.

Como su propio título indica, *Box bolide 12* no es sino un ejemplo entre otros de una serie de obras. En un texto fechado en 1963, el artista explicaba que su intención original era explorar la "estructura del color" con los Bolides, una palabra que podríamos traducir libremente como *núcleos*.[1] Oiticica creó objetos tridimensionales que contenían pigmentos, la materia prima con la que se elaboran los colores para pinturas y otros materiales artísticos. Su *Glass bolide 4 Earth* (1964), por ejemplo, consiste en un recipiente de vidrio abierto lleno de tierra coloreada y un pedazo de tela del mismo color. Guy Brett puso de manifiesto el poder inmediato que estas exploraciones sobre el color ejercían sobre el público al afirmar que "cuando vi por primera vez algunos de los Bolides de Oiticica, en 1965, lo primero que me llamó la atención fue el color".[2]

Sin embargo, como Oiticica explicaba en su escrito, a la larga los Bolides le condujeron a exploraciones que iban más allá del color. A medida que creaba los Bolides con materiales como escombros, pigmentos, trapos y tarros de vidrio, empezó a cuestionar el proceso a partir del cual los materiales pasan a formar parte de una obra de arte. Por un lado, el artista descartaba la idea de que se limitara a transformar los materiales cotidianos confiriéndoles un nuevo contexto y etiquetándolos como arte: "Lo que hago, al transformarlo en una obra, no es simplemente convertir el objeto en algo 'lírico' o situarlo fuera de lo cotidiano".[3] *Box bolide 12* no pretendía hacerse eco de los *ready-mades* de Marcel Duchamp. En lugar de ello, Oiticica estaba interesado en crear una categoría intermedia entre lo cotidiano y el "arte", en la que pudieran existir los objetos que presentaba. En cierto modo, quería que su público advirtiera que los materiales arrugados y ondulados que insertaba en sus Bolides conservaban todas sus características físicas, su condición de "cosas", incluso después de reunirlos en una obra de arte. En sus propias palabras, al incorporar los montones de escombros y las superficies irregularmente pintadas a "una idea estética, haciendo que ésta forme parte de la génesis de la obra, asume así un carácter trascendental, al tiempo que participa de una idea universal sin perder su estructura previa".[4] El espectador percibe esta tensión entre la condición original de los materiales como objetos cotidianos y su nuevo estatus como elementos de una obra de arte—una tensión que hace del Bolide un "trans-objeto", un término acuñado por el propio Oiticica—. Al contemplar el Bolide acabado, el carácter desgastado de los materiales empleados por el artista se hace esencial para la obra de arte. Lo que logró Oiticica con los Bolides no es destruir la estructura de sus materiales, sino "transportarlos, cerrados y enigmáticos, de su condición de 'cosas' a la de 'elementos de la obra'".[5]

La condición de *Box bolide 12* como "trans-objeto" convierte a esta obra en característica de las prácticas vanguardistas de Brasil, tal como el propio Oiticica las identificara y definiera en su texto "Plan general de la Nueva Objetividad", de 1967.[6] Oiticica explicaba cómo los artistas brasileños se esforzaban por crear obras de arte que redefinieran radicalmente la práctica artística.

Los artistas agrupados en torno a la Nueva Objetividad, entre los cuales se hallaba Lygia Clark, no querían simplemente crear pinturas o esculturas, sino que desafiaban estas estrictas definiciones creando objetos que obligasen al espectador a cuestionarse el carácter rígido de esas distinciones, a la vez que intentaban transformar la sociedad mediante la plena participación del público. Hay que reconocer que otras obras de Oiticica pueden ejemplificar mejor los objetivos de la vanguardia brasileña. Por ejemplo, los espectadores tenían que ponerse sus simbólicos Parangolés y moverse con ellos con el objeto de activarlos como obras de arte. Por otra parte, estas obras representaban con más claridad "un compromiso y una toma de posición sobre los problemas políticos, sociales y éticos",[7] como cuando Oiticica animó a los residentes de las *favelas* de Rio de Janeiro a participar en una inauguración en el Museo de Arte Moderno de la ciudad, ataviándose con los Parangolés y deambulando y bailando entre los miembros de la alta sociedad carioca.

Aunque el *Box bolide 12* no exija la participación corporal del espectador como sí lo hacían los Parangolés, sin duda se ajusta a los objetivos de la Nueva Objetividad de Oiticica. La intención del artista era que los espectadores interactuaran continuamente con la obra, tocando los distintos materiales, sintiendo las diferentes texturas y características de las partes del Bolide. Como espectadores, deberíamos deslizar las manos sobre el Bolide y permitir que nuestra vista, tacto y olfato percibieran la obra de múltiples formas. Al inducir al espectador a interactuar con el Bolide, pidiéndole que lo interprete como un "trans-objeto", Oiticica lo desafía a cambiar el modo en que interpreta todo su entorno, el modo en que percibe los objetos materiales que lo rodean. Si un montón de escombros y una tela raída podían ser necesarios para completar una obra de arte, otros objetos aparentemente inútiles de nuestro entorno también pueden convertirse en parte de algo más grande. Así, el Bolide pedía al espectador que mirara el mundo de forma distinta, a través de una visión que no dependiera exclusivamente de la racionalidad o que redujera el mundo a una masa de objetos físicos y materiales. Oiticica deseaba que esta nueva visión diera pie a nuevos comportamientos y condujera a una sociedad de otro tipo, una sociedad que no intentara clasificar a los individuos en categorías simples. Los espectadores actuales de la obra de Oiticica ya no son capaces de interactuar con ésta del modo multisensorial imaginado por el artista, por lo que deben decidir si estas aspiraciones representan ideales utópicos alejados de la realidad o bien si constituyen un desafío que sigue siendo actual y válido aun hoy.

Alberto McKelligan
Traducción de Jordi Palou

Notas

1. Véase Hélio Oiticica, "Bolides", reproducido en *Hélio Oiticica* (Minneapolis: Walker Art Center, 1992), 66. Inicialmente, en sus exploraciones con los Bolides, Oiticica estaba interesado en presentar el color en su forma "más pura". Posteriormente el artista venezolano Carlos Cruz-Diez se hizo eco de este deseo de Oiticica con la creación de entornos llamados Cromosaturaciones, en los que inundaba

salas enteras con luces de un solo color. Las diferentes estrategias con las que ambos artistas intentaban presentar el color puro revelan las distintas relaciones que cada uno de ellos mantenía con los materiales.

2. Guy Brett, "The Experimental Exercise of Liberty", en *Hélio Oiticica*, 224.

3. Oiticica, "Bolides", 66.

4. Oiticica, "Bolides", 66.

5. Oiticica, "Bolides", 66.

6. Hélio Oiticica, "General Scheme of the New Objectivity", reproducido en *Hélio Oiticica*, 110–20.

7. Hélio Oiticica, "General Scheme of the New Objectivity".

Hélio Oiticica
Parangolé P16 capa 12. Da adversidade vivemos [Parangolé P16 capa 12. De la adversidad vivimos], 1965/1992
Yute, tela, plásticos diversos, estopa y virutas de madera
127 × 75 × 22 cm
Colección Patricia Phelps de Cisneros
1996.208

Parangolé P16 capa 12 (lámina 44), de Hélio Oiticica, es una prenda similar a una capa, elaborada con materiales cotidianos que el artista recogía del entorno urbano y rural de Rio de Janeiro y sus alrededores, tales como yute, tela, plásticos diversos, arpillera y virutas de madera. Este Parangolé particular forma parte de la serie de pancartas, carpas y capas realizadas con múltiples elementos que Oiticica empezó a mediados de la década de 1960. A pesar de que ahora se exhiban en galerías como objetos de arte, inicialmente el artista quitaba importancia a los componentes materiales de los Parangolés, y de hecho los describía como meras bases estructurales de una forma colectiva de expresión creativa que el espectador o participante que llevara el Parangolé activaría a través de la interacción corporal con la capa. Oiticica creó este objeto como un vehículo estético para una expresión colectiva improvisada que reflejara la espontaneidad y la dimensión colectiva de los festivales y bailes populares brasileños.

Cuando el cuerpo del participante pone en movimiento el Parangolé, se despliegan capas de color y textura que dejan al descubierto una inscripción sobre una tela blanca que reza: "Da adversidade vivemos" ("De la adversidad vivimos"). Oiticica usó este lema para singularizar la sociedad, la cultura y el arte brasileños durante un periodo de creciente dependencia económica de América Latina respecto a Estados Unidos. Al aplicarse al Parangolé, el mensaje entra y sale de los pliegues con el movimiento de la persona que lleva la capa. Constituye una parte de la propuesta vanguardista de Oiticica para cultivar nuevas posibilidades creativas a partir de la discrepancia entre los conceptos modernos que caracterizaban su práctica artística y las crisis sociales ocasionadas por las desigualdades en los procesos de modernización y desarrollo del Brasil. Al trabajar siguiendo las premisas del arte europeo y, al mismo tiempo, recuperando las raíces culturales populares brasileñas en su obra, Oiticica intentaba crear un contrapunto a la cultura europea.

Con los Parangolés, Oiticica intentaba revolucionar las formas occidentales de hacer arte,
la subjetividad y la sociabilidad. Su diseño pretendía generar una interacción entre el cuerpo del participante, la forma geométrica y el color, así como transformar la relación entre el participante y aquellos que observan la performance, que pasaría de la dinámica observador/observado a una iniciativa creativa de carácter colectivo en la que todos serían actores.[1] Los Parangolés constituyen la culminación de la integración experimental entre color, estructura, espacio y tiempo que Oiticica había iniciado a finales de la década de 1950, con sus pinturas geométricas abstractas y bidimensionales llamadas Metaesquemas. En 1960 incluyó el color en el espacio físico del espectador con sus pinturas monocromas a doble cara denominadas Bilaterales y Relieves espaciales, así como con los espacios arquitectónicos llamados Penetrables. Todas estas obras obligan al espectador a moverse alrededor de ellas y entre los espacios articulados por el objeto. Con los Parangolés, Oiticica proponía que los movimientos del participante, como en un baile, activaran el color y la forma en el espacio para transformar la obra de arte, que pasaría de ser un reflejo visual del acto creativo a convertirse en una acción en sí. De este modo, llevó las propiedades de la pintura más allá de los confines bidimensionales de la tela y hacia el ámbito de la experiencia. Al poner el Parangolé en movimiento en el espacio, el participante pasa a ser el foco de una experiencia perceptiva y creativa de carácter colectivo, o lo que Oiticica describía como un "sistema ambiental Parangolé", en el que la acción artística se imbrica con las experiencias vividas y reales de los participantes que observan desde el exterior.[2]

El nombre Parangolé, que Oiticica tomó prestado de un modismo coloquial brasileño referido a una "situación animada y confusión repentina y/o agitación entre personas", transmite el carácter dinámico, interactivo e intersubjetivo de la obra.[3] Los Parangolés de Oiticica son análogos a las manifestaciones artísticas colectivas de los festivales populares brasileños, escuelas de samba, arte callejero espontáneo y los *happenings*, en los que la participación desinhibida del grupo estimula la transferencia de energía simbólica entre los individuos.[4] El deseo de Oiticica de alcanzar la interactividad social y un auténtico contacto humano a través de un proceso creativo fenomenológico se inspira en el legado de la modernidad brasileña, particularmente la Antropofagia de la década de 1920.[5] Oiticica recuperó este discurso en los años sesenta, en su conceptualización de la estrategia vanguardista del Tropicalismo, que pretendía individualizar la cultura y el arte brasileños a nivel internacional asimilando conceptos y metodologías del arte europeo e incorporando elementos de la cultura popular local a la música y el arte.[6]

Al crear los Parangolés, Oiticica abrazó rasgos culturales y formas populares de expresión creativa singularmente brasileños. Su exploración de la samba en la Escuela de Samba Mangueira, en una de las *favelas* más antiguas de Rio, lo llevó a experimentar personalmente una completa inmersión corporal y psíquica en el baile. La fluida estructura del Parangolé y la construcción orgánica con materiales encontrados

recuerdan asimismo la arquitectura improvisada de la *favela*, que exploró con mayor detenimiento a finales de la década de 1960 con las estructuras sueltas y aleatorias de instalaciones como *Tropicalia*. Oiticica insistió en que su inmersión en la cultura afrobrasileña de las *favelas* no reflejaba un retorno del folk o de la estética primitivista. Recordaba más bien los objetivos de la Antropofagia, al explicar que contribuía a definir un regreso a una sensibilidad primigenia en el arte que liberaba la creatividad y las formas de percepción, creando asimismo una experiencia de marginalidad que ayudaba a liberarlo de las limitaciones burguesas de su propia clase social elitista.[7] No obstante, su deseo de alcanzar una auténtica experiencia dentro de una cultura periférica sigue indicando una exótica evasión de la sociedad burguesa.[8]

La exploración de Oiticica de la interactividad y los procesos perceptivos proviene asimismo de su vinculación a los artistas neoconcretos, con quienes trabajó estrechamente en la década de 1960. Los neoconcretos proponían que los sujetos activos producen la obra de arte a través de la interacción con el objeto artístico, otorgándoles una mayor conciencia de su propio estado corporal. Inspirados por la fenomenología de Maurice Merleau-Ponty y las ideas del teórico y crítico de arte brasileño Mário Pedrosa, los artistas neoconcretos sostenían que el espectador/participante podía alcanzar esa especial sensibilidad por medio de la experiencia de la percepción háptica o táctil, que vincula el sentido del tacto con la vista para intensificar la comprensión fenomenológica del objeto.[9]

De modo similar, Oiticica exigía que los espectadores/participantes se pusieran el Parangolé, en lugar de limitarse a observarlo, para evocar una experiencia total y multisensorial. El participante experimenta un proceso de conciencia y expresión personal con el despliegue de las propiedades formales del Parangolé.[10] A pesar de que Oiticica hizo resaltar los aspectos del Parangolé vinculados a la performance por encima de su función como objeto estético, su obra guarda distancia respecto a las estrategias conceptuales para subvertir la institucionalización del arte poniendo énfasis en los conceptos e ideas por encima de la obra de arte material. En lugar de eliminar el objeto de la percepción, Oiticica redefinió el proceso perceptivo como una "experiencia subjetiva", en que la interacción del cuerpo del participante con el Parangolé provoca una correlación física entre cuerpo y objeto.[11] Describía el Parangolé como "anti-arte por excelencia", o aquello que socava la integridad del museo o de la galería, al estimular la actividad creativa espontánea y colectiva en los espacios públicos.[12] Paradójicamente, Oiticica contaba con el apoyo de las principales instituciones para exhibir su obra, como The Museum of Modern Art de Nueva York y la Whitechapel Art Gallery de Londres, a finales de la década de 1960, e incluso en 1970 aceptó una beca Guggenheim de investigación. A pesar de que insinuaba que la exhibición del Parangolé en un museo elimina el componente abierto y participativo del concepto artístico en su conjunto y presenta inadecuadamente la obra de arte como un objeto artístico, la ambivalencia del propio Oiticica respecto a las prácticas

institucionalizadoras del museo socava los objetivos éticos y sociales formulados por su programa vanguardista.

Jodi Kovach
Traducción de Jordi Palou

Notas

1. Hélio Oiticica, "General Scheme of the New Objectivity", en *Hélio Oiticica* (París: Galerie Nationale du Jeu de Paume; Rio de Janeiro: Projeto Hélio Oiticica; Rotterdam: Witte de With, Center for Contemporary Art, 1997), 110–20.

2. Hélio Oiticica, "Fundamental Bases for the Definition of the Parangolé", en *Hélio Oiticica,* 88; véase también Hélio Oiticica, "Notes on the Parangolé", en *Hélio Oiticica,* 93.

3. Véase Oiticica, "Fundamental Bases for the Definition of the Parangolé", 88; también Oiticica, "General Scheme of the New Objectivity", 119.

4. Oiticica, "General Scheme of the New Objectivity", 110–20.

5. Véase Oswald de Andrade, "Manifesto Antropófago", *Revista de Antropofagia* [São Paulo] 1, no. 1 (mayo 1928): 3, 7, en *Oswald de Andrade: Obra escogida,* ed., Haroldo de Campos; trad. Héctor Olea (Caracas, Venezuela: Biblioteca Ayacucho, 1981), 67–72. La vanguardia literaria y artística brasileña articuló el concepto de *antropofagia,* una forma de canibalismo ritual que se creía que habían practicado las sociedades del Brasil precolonial, como acto simbólico a través del cual el caníbal incorpora y activa en su interior las cualidades que posee la persona cuyo cuerpo consume. Para estos artistas y escritores, la antropofagia servía como metáfora para consumir la cultura occidental y defenderse del colonialismo cultural, presentando asimismo un modelo no europeo para alcanzar la armonía social.

6. Véase Carlos Basualdo, ed., *Tropicalia: A Revolution in Brazilian Culture [1967–1972]* (Chicago: Museum of Contemporary Art, 2005).

7. Véase Oiticica, "Fundamental Bases for the Definition of the Parangolé", 88; también Lygia Clark y Hélio Oiticica, *Cartas 1964–74* (Rio de Janeiro: Editora UFRJ, 1996), 102.

8. Robert Stam, "Of Cannibals and Carnivals", en *Subversive Pleasures: Bakhtin, Cultural Criticism, and Film* (Baltimore y Londres: The Johns Hopkins University Press, 1989), 156. Según Stam, "El tropo de la marginalidad, al fin y al cabo, es una inexactitud eurocéntrica, ya que la vida se vive desde el centro allí donde haya sujetos humanos".

9. Véase Oiticica, "Notes on the Parangolé", 93; también Paulo Herkenhoff, "The Hand and the Glove", en *Inverted Utopias: Avant-Garde Art in Latin America,* Mari Carmen Ramírez y Héctor Olea, eds. (New Haven y Londres: Yale University Press in association with the Museum of Fine Arts, Houston, 2004), 329–31, y Paulo Herkenhoff, "Zero and Difference: Excavating a Conceptual Architecture", en *Beyond Preconceptions: The Sixties Experiment,* Milena Kalinovska, ed. (Nueva York: Independent Curators International, 2000), 57.

10. Oiticica, "Notes on the Parangolé", 93.

11. Oiticica, "Notes on the Parangolé", 96.

12. Oiticica, "Environmental Program", en *Hélio Oiticica,* 103.

Mira Schendel
Droguinha, 1966
Bolsas de arroz trenzados
66.6 × 26 × 15 cm
Colección Patricia Phelps de Cisneros
1997.163

Mira Schendel emigró a Brasil de adulta y prefirió la compañía de filósofos y poetas más que de artistas. No obstante, empezó su carrera artística en su país adoptivo y compartió el interés generalizado por la abstracción geométrica entre los artistas brasileños de las décadas de 1950 y 1960. Creada durante la fase más experimental

de la trayectoria de Schendel y en un periodo de agitación política y artística en Brasil, *Droguinha* (lámina 45) constituye una muestra excelente de su época, a pesar de no sintonizar con las prioridades de la generación más emergente de ese momento.

A diferencia de Hélio Oiticica, Antonio Dias y Cildo Meireles, Schendel optó por no afrontar abiertamente las condiciones de degradación política interna precipitadas por el golpe militar de 1964.[1] En lugar de ello, la obra que llevó a cabo a mediados de la década de 1960 proseguía con una exploración más de tipo formal que social. En esa época, la artista creó una obra que se aleja de sus primeras pinturas figurativas y geométricamente abstractas para explorar una línea y un lenguaje fragmentado con técnicas basadas en el papel de arroz. Entre estas obras se cuentan dos series de dibujos, Monotipias [Monotipos] y Objetos gráficos, así como las obras escultóricas Droguinhas y *Treninho [Trenecito]*. Esas obras de mediados de los años sesenta—como la obra de muchos otros artistas de la época—se basaban en el reciente legado del Neoconcretismo por lo que respecta a sus condiciones de exhibición, alejadas de la pared y adentrándose en el espacio del espectador.[2] Así, los dibujos y esculturas crean una nueva experiencia perceptiva; nos obligan a abandonar nuestra posición estática y nos invitan a movernos alrededor de los objetos artísticos y a mirar a través de ellos.

A primera vista, esta obra de 1966 se asemeja a una maraña de cuerda, pero a medida que uno se acerca a ella y advierte el material de que está hecha—papel de arroz—, se ponen de manifiesto varias peculiaridades. La factura es poco común. Schendel trenzó y anudó hojas de papel de arroz formando una masa de abultadas cuerdas. Luego la artista colgó esta red interconectada de material por un punto, con un sedal, y dejó que el resto del material cayera por su propio peso. El papel enrollado a modo de cuerdas entretejidas y anudadas evoca una manía nerviosa o compulsiva más que una técnica de bellas artes. Schendel sigue llamándonos la atención sobre su proceso creativo con el título, *Droguinha,* que en argot portugués significa "pequeña nada". El título sugiere que se trata de una escultura de poca importancia y que fue creada mediante la actividad superflua de centenares de "pequeñas nadas". Es más, la frágil apariencia de la obra y la bidimensionalidad del fino papel de arroz han sido transformadas en una forma en tres dimensiones. A pesar de que *Droguinha* parece casi flotar en el espacio, la materialidad del objeto continúa siendo enigmática, ya que nos persigue la primera impresión de la obra como una pesada masa sujeta a la gravedad.

Además de esta *Droguinha,* Schendel creó unas cuantas obras más con el mismo título y técnica entre 1964 y 1966, incluyendo dos obras de tamaño similar y varias esculturas de dimensiones más reducidas. Las Droguinhas de tamaño similar a esta pertenecen a la hija de Schendel, Ada Schendel, y al crítico británico Guy Brett, quien en 1966 organizó por primera vez una exposición de las Droguinhas en la Signals Gallery de Londres.[3] La existencia de estas otras obras confirma que la *Droguinha* no era un experimento aislado, desvinculado de la obra de Schendel, sino más bien un proyecto que mantuvo a lo largo de varios años.

Algunas fotografías muestran a Schendel con una Droguinha sobre los hombros, llevando otra en los brazos, hecha un ovillo, y Brett escribió que la artista amontonó las Droguinhas en una exposición de 1966 y dejó que los visitantes las manipularan a su antojo.[4] Otros estudiosos y la hija de la artista han puesto en tela de juicio esta versión de Brett.[5] Sin embargo, esos testimonios gráficos demuestran que Schendel no pretendía que las obras tuvieran una composición única y estable. Por ejemplo, la Droguinha de la colección de Ada Schendel suele exhibirse colgada, pero hay fotografías que la muestran plana y extendida, como el ejemplar de la colección de Brett. Así, debemos resistirnos al deseo de comprender esta escultura como algo inmutable, o de interpretar cada encantador detalle formal de su configuración actual como un rasgo permanente de la obra. El proceso y los materiales usados por Schendel muestran claramente que la artista no llegó a los pliegues y brechas específicos de la composición siguiendo una disposición consciente. Cuando volvamos a encontrarnos con el objeto o incluso tras una corriente de aire, los matices en el interior de la obra habrán cambiado. Esta mutabilidad expresa a la perfección el replanteamiento neoconcreto de la obra de arte como un objeto en transformación.

En 1963 la artista neoconcreta Lygia Clark creó la obra *Caminhando,* una serie de fotografías acompañadas de texto. El texto y las imágenes dan instrucciones al espectador para crear una cinta de Möbius a partir de un trozo de papel y a cortarla por la mitad con unas tijeras hasta que no sea posible seguir cortando. Aquí la experiencia del espectador es primordial y sustituye al objeto de arte, puesto que Clark nos dice que la obra de arte es nuestra experiencia, más que el montón de papel resultante. La Droguinha de Schendel es análoga a la espiral de papel que resulta del experimento de Clark, pero aquí es la artista—y no el espectador—quien crea la forma y, en lugar de tirar el producto de la acción repetitiva, Schendel lo exhibe. Schendel también crea nudos de distintos tamaños y áreas de densidad variable, lo que produce como resultado un objeto de mucho más interés y variedad formal que el objeto cortado que se crea en *Caminhando.*

Al igual que *Droguinha* y sus otras obras de mediados de la década de 1960 muestran cómo Schendel respondía a la llamada neoconcreta para activar al espectador, las obras también demuestran que Schendel difiere fundamentalmente de los artistas neoconcretos por lo que respecta a la cuestión de la autoría. Schendel pierde el control de la autoría al sustituir el trabajo repetitivo y sin sentido por una técnica calificada de bellas artes y asegurándose de que la composición de *Droguinha* se transformará constantemente. Estimula al espectador colgando la obra lejos de la pared y usando una técnica de manufactura cotidiana que podemos imaginar que nosotros mismos seríamos capaces de ejecutar. No obstante, Schendel aprovecha todas estas estrategias innovadoras para intensificar nuestra contemplación de esta obra de arte, sorprendentemente hermosa. La introspección

es parte y terreno consubstancial de la experiencia perceptiva de *Droguinha,* y su factura nos incita a reflexionar sobre los peculiares matices de nuestra actividad diaria que resultan inexplicables para los demás o incluso para nosotros mismos, pero que aun así llenan nuestros días. Los artistas neoconcretos, sin embargo, pretendieron dar al espectador una experiencia que trascendiera la mera contemplación mental y visual de una obra de arte, para comprobar el dominio del artista y para transformar físicamente al espectador en participante. Aunque el espectador de Schendel se mueva e interactúe con la obra de arte, *Droguinha* es el acontecimiento principal y Schendel sigue siendo su única autora.

Adele Nelson
Traducción de Jordi Palou

Notas

1. Por ejemplo, Schendel participó en la X Bienal de São Paulo en 1969. Numerosos artistas brasileños e internacionales boicotearon esta convocatoria de la Bienal como protesta contra la represión del régimen sobre artistas e intelectuales. Una posible excepción a las obras más bien formales de mediados de los años sesenta es la serie de dibujos en tinta china titulada Bombas. Estas obras no parecen reflejar específicamente la situación política brasileña y es posible que su título derive más de la técnica de dibujo, en que la tinta se deja caer sobre el papel húmedo. El título, sin embargo, contiene una carga sociopolítica.
2. Paulo Herkenhoff afirma que Schendel y otros "son ejemplos de arte brasileño que se autoalimenta a partir de su propia experiencia. Su madurez, a mediados de la década de 1960, puede vincularse directamente a la nueva era cultural que inauguró el movimiento neoconcreto". Herkenhoff, "Divergent Parallels: Toward a Comparative Study of Neo-concretism and Minimalism", en *Geometric Abstraction: Latin American Art from the Patricia Phelps de Cisneros Collection/Abstracción Geométrica: Arte Latinoamericano en la Colección Patricia Phelps de Cisneros* (Cambridge: Harvard University Art Museums; Caracas: Fundación Cisneros; New Haven y Londres: Yale University Press, 2001), 116.
3. Esta obra se encuentra actualmente en la colección de The Museum of Modern Art de Nueva York.
4. Las fotografías de Schendel en Londres en 1966 aparecen reproducidas en Sônia Salzstein, ed., *No Vazio do Mundo: Mira Schendel* (São Paulo: Editora Marca D'Água, 1996), 89, y Maria Eduarda Marques, *Mira Schendel* (São Paulo: Cosac & Naify, 2001), 121. Brett escribe sobre la exposición de 1966 en el Museo de Arte Moderno de Rio de Janeiro en Brett, *Kinetic Art: The Language of Movement* (Londres: Studio Vista, 1968), 46.
5. Según la hija de la artista, Schendel no pretendía que el público tocara las Droguinhas. Sophia Whately, de la Galería Millan Antonio, de São Paulo, dio a conocer la correspondencia que mantuvo con Ada Schendel. A pesar de que los especialistas no han rebatido la versión de Brett en sus escritos actuales, Salzstein y otros no comparten su interpretación de estas obras.

Gego (Gertrud Goldschmidt)
Reticulárea cuadrada 71/11, 1971
Metal, cobre, y acero inoxidable
205 × 140 × 55 cm
Colección Patricia Phelps de Cisneros
2005.47

Dibujo sin papel 76/4, 1976
Alambre de acero, metal y plexiglás
67.5 × 73 × 19.3 cm
Colección Patricia Phelps de Cisneros
2002.4

La primera Reticulárea fue instalada por Gego en julio de 1969 en el Museo de Bellas Artes de Caracas. El título definitivo fue producto de discusiones con Miguel Arroyo, entonces director del Museo y el crítico Roberto Guevara, quien lo acuñaría como una contracción de dos conceptos topológicos: "retícula" y "área". Esta obra contenía ya los elementos definitivos del modelo de obra reticular y ambiental que Gego sometería a diversas variaciones a lo largo de los años 70. El proceso que condujo a la primera Reticulárea ambiental tiene tres claras etapas, que la misma Gego se encargó de dejar asentadas en un breve reporte escrito a la atención de la poeta Hanni Ossot, en 1977, por entonces a cargo del primer gran texto analítico sobre la obra de la artista. Escribe Gego, refiriéndose al año 1969:

Liberación del esquema de líneas paralelas o casi paralelas entrecruzadas. Comienzo de dibujos con líneas claramente entrecruzadas formando redes planas y redes moduladas. Acentuación de puntos de cruces. Para dar a estas mallas realidad en el espacio con cruces articulables para controlar la modulación, los campos entre las líneas tenían que ser triangulares. Retícula Area . . .[1]

Las dos siguientes etapas son, con la mediación del sistema de Chorros—"otra vez las líneas paralelas, pero la acumulación de las líneas no produce planos . . . sino origina masa"[2]—la producción en 1971 de un tipo de Reticulárea cuadrada, suspendida al techo, que no posee el carácter ambiental e instalativo de la gran Reticulárea y que parece surgir como un estadio de definición en el proceso: "Reticulárea cuadrada con diferentes soluciones manuales de cruces y con canutillos de cobre que acentúan perfecto los cruces de alambre, así los campos entre el alambre quedan bien definidos".[3]

La *Reticulárea cuadrada 71/11* (lámina 46) pertenece a esta serie de obras seminales en las que Gego, tras experimentar la potencia rizomática y topológica de la Reticulárea ambiental, sintió necesidad de revisitar el principio modular de la obra, produciendo una serie de Reticuláreas "puras" en las que la forma y el sistema que la genera se manifiestan con una claridad ejemplar. En 1972, siempre según el mismo manuscrito, Gego afirma haber comenzado a experimentar "con superficies de doble curvatura y con superficies tubulares autoportantes y esféricas suspendidas",[4] refiriéndose de esta forma al inmenso repertorio de Reticuláreas que produciría en los años siguientes. Es curioso—ciertamente algo más que un azar, como argumentaremos a continuación—que el documento se concluye con la mención de los Dibujos sin papel,

creados el año 1976: "Los dibujos sobre papel son reemplazados por dibujos sin papel y en consecuencia sin marcos",[5] a cuya tipología pertenece el *Dibujo sin papel 76/4* (lámina 47).

La obra de Gego estaría hecha, a partir de este momento, básicamente, de anudamientos. Esto implica mucho más que la superación definitiva de las soldaduras en su obra escultórica: allí donde la elocuencia del nudo se disemina en un espacio rigurosamente impensable, es decir en la Reticulárea ambiental, no se puede hablar más de direcciones o de puntos cardinales, de orígen o de centro, de teleología estructural. Si la Reticulárea es una estructura sin finalidad—la incoación de su propia potencia estructural—, la Reticulárea cuadrada es lo más próximo a la concresión de su unidad potencial, de su principio generativo. Vale la pena, entonces, destacar la importancia otorgada por Gego a las "líneas claramente entrecruzadas", a la "acentuación de puntos de cruces". Pudiéramos evocar la afirmación de Karl Ioganson en lo que constituye el verdadero momento iniciático de toda la tradición "constructivista", a saber la discusión alrrededor de los conceptos de Construcción y Forma Espacial en Moscú, durante los años 20: "Todo estructura, sea nueva o antigua, y aun las más grandiosas, están formadas sobre la cruz".[6] Esta discusión es fundamental para comprender el aporte de Gego a la "sobrevivencia" de la tradición constructiva en Venezuela. En ese sentido, la *Reticulárea cuadrada 71/11,* como toda Reticulárea, es una "alter-forma" de la "forma espacial" constructivista: su variación, producto del desplazamiento, de un contexto diferente, de la distancia temporal, de una subjetividad distinta, etc. y por lo tanto también su modificación, su deformación. La Reticulárea es, pues, una sobrevivencia—y una nueva iteración—de esa tipología constructivista que "avanza al proprio espacio, el espacio 'vacío' como material 'concreto'. Organiza el material pero no lo llena, declara el volumen sin recurrir a masa ni peso, y disuelve la distinción habitual entre forma exterior e interior".[7] Culminación de un repertorio formal de estructuras en las que "una serie de componentes discontinuos y compresivos interactua con una serie de componentes tensiles continuos para definir un volumen estable en el espacio",[8] la Reticulárea tiene antecedentes tan importantes como Karl Iogansen y Vladimir Tatlin, Buckminster Fuller y Kenneth Snelson.

Las diferencias son, sin embargo, fundamentales: no sólo es la Reticulárea, más que la concresión de un resultado, la manifestación de su principio generativo; también parece reposar sobre un principio de analogía orgánica. En un documento de invalorable importancia, producido por Gego durante el proceso de montaje de la primera *Reticulárea ambiental,* la artista deja caer, como en un poema concreto, los conceptos a través de los cuales se define su obra: "Moleculum Gegum, Trazo, Constelum, Encadenamiento, Reticuroom, Enredada, Red Hada, Redada . . .".[9] Algo como una transfiguración moderna y tropical de una antigua identificación germánica con un eden forestal tendría, pues, en la Reticulárea una de sus formas simbólicas más elocuentes. Ámbito a la vez artificial y orgánico en donde todas las líneas potenciales se concretan en un espacio real, la Reticulárea procede también de una inquietud tempranamente manifestada por Gego: "con cada línea que dibujo, cientos de ellas esperan por ser dibujadas".[10] El surgimiento de los Dibujos sin papel en 1976 es, entonces, uno de los resultados lógicos de la Reticulárea: transformar no sólo estructural sino también poéticamente el campo de la práctica dibujística, dando a la luz de lo visible la línea potencial y, sobre todo, haciéndola ver como líneas de sombra, como sombras de líneas en el espacio. No deja de sorprender, en la configuración formal del *Dibujo sin papel 76/4* la reminiscencia lejana de Paul Klee, una de las referencias seminales de Gertrud Goldschmidt. Salvo que aquí, por efecto de una radical emancipación de la línea hacia el espacio real y del dibujo hacia el mundo, Gego alcanza al fin a materializar—para usar sus propias palabras—"el encanto de la nada entre las líneas".[11]

Luis Pérez-Oramas

Notas

1. Gego, *Sabiduras y otros textos de Gego,* María Elena Huizi y Josefina Manrique, eds. (Houston: International Center for the Arts of the Americas, Museum of Fine Arts; Caracas: Fundación Gego, 2005), 150.

2. Gego, 150.

3. Gego, 150.

4. Gego, 150.

5. Gego, 150.

6. Maria Gough, *The Artist as Producer: Russian Constructivism in Revolution* (Berkeley, Calif.: University of California Press, 2005), 53.

7. Gough, 66.

8. Anthony Pugh, *An Introduction to Tensegrity* (Berkeley: University of California Press, 1976), 3. Citado en Gough, 210.

9. Gego, 70–71.

10. Gego, 169.

11. Gego, 169.

Alpuy, Julio
Composición óvalo [Oval Composition], 1967
Ink and paint on wood relief
50.8 × 71.8 × 5.9 cm (20 × 28 × 2⁵⁄₁₆ in.)
Blanton Museum of Art, gift of John and
Barbara Duncan, 1971
G1971.3.4

Arden Quin, Carmelo
Trio 2, 1951
Varnish and pigment on wood panel
51.4 × 26.0 × 2.5 cm (20¼ × 10¼ × 1 in.)
Colección Patricia Phelps de Cisneros
1998.54

Barros, Geraldo de
Abstrato [Abstract], from the series Fotoformas
[Photoforms], 1951
Silver gelatin photograph
28.2 × 30.4 cm (11⅛ × 11¹⁵⁄₁₆ in.)
Colección Patricia Phelps de Cisneros
1995.37

Barros, Geraldo de
"Pampulha"—Belo Horizonte, Brasil, 1951
Silver gelatin photograph
29.7 × 40.4 cm (11¹¹⁄₁₆ × 15⅞ in.)
Colección Patricia Phelps de Cisneros
1995.36

Barros, Geraldo de
Função diagonal [Diagonal Function], 1952
Lacquer on cardboard
60 × 60 × 0.3 cm (23⅝ × 23⅝ × ⅛ in.)
Colección Patricia Phelps de Cisneros
1995.16

Barros, Geraldo de
Objeto plástico [Plastic Object], 1952
Enamel on wood
36.8 × 45.1 × 2.5 cm (14½ × 17¾ × 1 in.)
Colección Patricia Phelps de Cisneros
1999.67

Barsotti, Hércules
Desenho—nanquim [Drawing—Indian Ink], 1960
Ink on paper on board
29.5 × 29.5 cm (11⅝ × 11⅝ in.)
Colección Patricia Phelps de Cisneros
1996.100

Barsotti, Hércules
Desenho—nanquim [Drawing—Indian Ink], 1960
Ink on paper
29.5 × 29.5 cm (11⅝ × 11⅝ in.)
Colección Patricia Phelps de Cisneros
1996.102

Barsotti, Hércules
Desenho—nanquim [Drawing—Indian Ink], 1960
Ink on paper on board
29.5 × 29.5 cm (11⅝ × 11⅝ in.)
Colección Patricia Phelps de Cisneros
1996.103

Barsotti, Hércules
Desenho—nanquim [Drawing—Indian Ink], 1960
Ink on paper on board
29.5 × 29.5 cm (11⅝ × 11⅝ in.)
Colección Patricia Phelps de Cisneros
1996.104

Barsotti, Hércules
Desenho—nanquim [Drawing—Indian Ink], 1960
Ink on paper on board
29.5 × 29.5 cm (11⅝ × 11⅝ in.)
Colección Patricia Phelps de Cisneros
1996.105

Barsotti, Hércules
Desenho—nanquim [Drawing—Indian Ink], 1960
Ink on paper on board
29.5 × 29.5 cm (11⅝ × 11⅝ in.)
Colección Patricia Phelps de Cisneros
1996.106

Barsotti, Hércules
Desenho—nanquim [Drawing—Indian Ink], 1960
Ink on paper on board
29.5 × 29.5 cm (11⅝ × 11⅝ in.)
Colección Patricia Phelps de Cisneros
1996.107

Barsotti, Hércules
Desenho—nanquim [Drawing—Indian Ink], 1960
Ink on paper on board
29.5 × 29.5 cm (11⅝ × 11⅝ in.)
Colección Patricia Phelps de Cisneros
1996.108

Barsotti, Hércules
Desenho—nanquim [Drawing—Indian Ink], 1960
Ink on paper on board
29.5 × 29.5 cm (11⅝ × 11⅝ in.)
Colección Patricia Phelps de Cisneros
1996.109

Barsotti, Hércules
Desenho—nanquim [Drawing—Indian Ink], 1960
Ink on paper on board
29.5 × 29.5 cm (11⅝ × 11⅝ in.)
Colección Patricia Phelps de Cisneros
1996.110

Barsotti, Hércules
Desenho—nanquim [Drawing—Indian Ink], 1960
Ink on paper on board
29.5 × 29.5 cm (11⅝ × 11⅝ in.)
Colección Patricia Phelps de Cisneros
1996.111

Barsotti, Hércules
Desenho—nanquim [Drawing—Indian Ink], 1960
Ink on paper on board
29.5 × 29.5 cm (11⅝ × 11⅝ in.)
Colección Patricia Phelps de Cisneros
1996.112

Blaszko, Martín
Ritmos verticales [Vertical Rhythms], 1947
Oil on wood
93 × 44.1 × 3 cm (36⅝ × 17⅜ × 1³⁄₁₆ in.)
Colección Patricia Phelps de Cisneros
1998.7

Carreño, Omar
Relieve 1 [Relief 1], 1952
Industrial paint on wood
106 × 105 × 4.5 cm (41¾ × 41⁵⁄₁₆ × 1¾ in.)
Colección Patricia Phelps de Cisneros
1998.64

Carvão, Aluíso
Construção 8 [Construction 8], 1955
Enamel on board
71.5 × 51 cm (28⅛ × 20¹⁄₁₆ in.)
Colección Patricia Phelps de Cisneros
1995.25

Carvão, Aluíso
Construção VI [Construction VI], 1955
Industrial paint on wood
84.6 × 59 cm (33⁵⁄₁₆ × 23¼ in.)
Colección Patricia Phelps de Cisneros
1996.17

Castro, Amilcar de
Sem título [Untitled], 1960
Iron
50 × 99.5 × 87.5 cm (19¹¹⁄₁₆ × 39³⁄₁₆ × 34⁷⁄₁₆ in.)
Colección Patricia Phelps de Cisneros
1998.72

Castro, Willys de
Composição modulada [Modulated Composition], 1954
Enamel on hardboard
40 × 40 × 0.3 cm (15¾ × 15¾ × ⅛ in.)
Colección Patricia Phelps de Cisneros
1997.21

Castro, Willys de
Objeto ativo [Active Object], 1959
Gouache on cardboard mounted on wood
32.2 × 1 × 5.5 cm (12¹¹⁄₁₆ × ⅜ × 2³⁄₁₆ in.)
Colección Patricia Phelps de Cisneros
1996.63

Castro, Willys de
Objeto ativo—amarelo [Active Object—Yellow], 1959–1960
Oil on canvas mounted on hardboard
35 × 70 × 0.5 cm (13¾ × 27⁹⁄₁₆ × ³⁄₁₆ in.)
Colección Patricia Phelps de Cisneros
1997.56

Castro, Willys de
Objeto ativo [Active Object], 1961
Enamel and acrylic-vinyl paint on canvas and wood
155 × 100 × 100 cm (61 × 39⅜ × 39⅜ in.)
Colección Patricia Phelps de Cisneros
1996.81/2

Clark, Lygia
Composição n.° 5 [Composition No. 5], 1954
Oil on canvas
106.5 × 90.7 × 2.5 cm (41¹⁵⁄₁₆ × 35¹¹⁄₁₆ × 1 in.)
Colección Patricia Phelps de Cisneros
1997.54

Clark, Lygia
Planos em superfície modular n.° 4—Serie B [Planes on Modular Surface No. 4—Series B], 1957
Formica and industrial paint on wood
100 × 100 × 5 cm (39⅜ × 39⅜ × 1¹⁵⁄₁₆ in.)
Colección Patricia Phelps de Cisneros
1997.15

Clark, Lygia
Contra relevo [Counter Relief], 1958
Enamel on wood
100 × 100 × 3 cm (39⅜ × 39⅜ × 1³⁄₁₆ in.)
Colección Patricia Phelps de Cisneros
1997.112

Clark, Lygia
Casulo [Cocoon], 1959
Nitrocellulose paint on tin
30 × 30 × 11 cm (11¹³⁄₁₆ × 11¹³⁄₁₆ × 4⁵⁄₁₆ in.)
Colección Patricia Phelps de Cisneros
1999.65

Clark, Lygia
Bicho [Critter], 1960
Aluminum
40 × 40 × 40 cm (15¾ × 15¾ × 15¾ in.)
Colección Patricia Phelps de Cisneros
1992.38

Clark, Lygia
Bicho [Critter], 1961
Aluminum
70 × 70 cm (27⁹⁄₁₆ × 27⁹⁄₁₆ in.)
Colección Patricia Phelps de Cisneros
1998.68

Clark, Lygia
O dentro é o fora [The Inside Is the Outside], 1963
Stainless steel
35.5 × 45.7 × 38.1 cm (14 × 18 × 15 in.)
Colección Patricia Phelps de Cisneros
1997.138

Clark, Lygia
Obra mole [Soft Work], 1964
Cut rubber
49.5 cm (19½ in.) diameter
Colección Patricia Phelps de Cisneros
1998.67

Cordeiro, Waldemar
Idéia visível [Visible Idea], 1956
Acrylic on Masonite
59.9 × 60 cm (23⁹⁄₁₆ × 23⅝ in.)
Colección Patricia Phelps de Cisneros
1996.190

Cruz-Diez, Carlos
Proyecto para un mural [Project for a Mural], 1954
Industrial paint on wood
40 × 55.2 cm (15¾ × 21¾ in.)
Colección Patricia Phelps de Cisneros
1997.144

Cruz-Diez, Carlos
Amarillo aditivo [Additive Yellow], 1959
Acrylic on paper
40 × 40 cm (15¾ × 15¾ in.)
Colección Patricia Phelps de Cisneros
1997.176

Cruz-Diez, Carlos
Physichromie No 21, 1960
Metal on cardboard, acrylic, and plastic
103.4 × 106.4 × 6.5 cm (40¹¹⁄₁₆ × 41⅞ × 2⁹⁄₁₆ in.)
Colección Patricia Phelps de Cisneros
1997.145

Cruz-Diez, Carlos
Physichromie No 126, 1964
Ink, industrial paint, silver metal paper on sheetrock
143 × 31.8 × 4.5 cm (56⁵⁄₁₆ × 12½ × 1¾ in.)
Colección Patricia Phelps de Cisneros
2001.87

Cruz-Diez, Carlos
Physichromie 500, 1970
Red Plexiglass and screenprint on plywood
183 × 484 × 8 cm (72¹⁄₁₆ × 190⁹⁄₁₆ × 3⅛ in.)
Colección Patricia Phelps de Cisneros
1988.18

Féjer, Kazmer
Cristal [Crystal], 1956
Glass
59 × 17.5 × 12 cm (23¼ × 6⅞ × 4¾ in.)
Colección Patricia Phelps de Cisneros
1997.133/4

Fiaminghi, Hermelindo
Alternado II [Alternated II], 1957
Enamel on hardboard
60.7 × 60.9 cm (23⅞ × 24 in.)
Colección Patricia Phelps de Cisneros
1997.62

Flexor, Samson
Abstrato [Abstract], 1954
Oil on canvas
60 × 137 × 4.4 cm (23⅝ × 53¹⁵⁄₁₆ × 1¾ in.)
Colección Patricia Phelps de Cisneros
1997.18

Fonseca, Gonzalo
Graneros III [Granaries III], 1971–1975
Red travertine
20.3 × 54 × 49.8 cm (8 × 21¼ × 19⅝ in.)
Blanton Museum of Art, Archer M. Huntington
Museum Fund, 1983
1983.14

Fonseca, Gonzalo
Untitled, 1977
Black ink with orange and purple washes on
paper
52.1 × 69.1 cm (20½ × 27³⁄₁₆ in.)
Blanton Museum of Art, Barbara Duncan Fund,
1985
1985.16

Gego (Gertrud Goldschmidt)
Ocho cuadrados [Eight Squares], 1961
Welded and painted iron
170 × 64 × 40 cm (66¹⁵⁄₁₆ × 25³⁄₁₆ × 15¾ in.)
Colección Patricia Phelps de Cisneros
2000.99

Gego (Gertrud Goldschmidt)
Sin título [Untitled], 1967
Ink on paper
65.1 × 50.2 cm (25⅝ × 19¾ in.)
Colección Patricia Phelps de Cisneros
1998.287

Gego (Gertrud Goldschmidt)
Chorro n.º 7 [Gush No. 7], 1971
Iron and aluminum
175 × 42 × 27 cm (68⅞ × 16⁹⁄₁₆ × 10⅝ in.)
Colección Patricia Phelps de Cisneros
2000.42

Gego (Gertrud Goldschmidt)
*Reticulárea cuadrada 71/11 [Square Reticularea
71/11],* 1971
Metal, copper, and stainless steel
205 × 140 × 55 cm (80¹¹⁄₁₆ × 55⅛ × 21⅝ in.)
Colección Patricia Phelps de Cisneros
2005.47

Gego (Gertrud Goldschmidt)
Esfera [Sphere], 1976
Steel wire
97 × 88 cm (38 × ³⁄₁₆ × 34⅝ in.)
Colección Patricia Phelps de Cisneros
1977.6

Gego (Gertrud Goldschmidt)
Tronco decagonal [Decagonal Trunk], 1976
Steel, lead, and metal base
215 × 56 × 58 cm (84⅝ × 22¹⁄₁₆ × 22¹³⁄₁₆ in.)
Colección Patricia Phelps de Cisneros
1988.25

Gego (Gertrud Goldschmidt)
*Dibujo sin papel 76/4 [Drawing without Paper
76/4],* 1976
Steel wire, metal, and Plexiglas
67.5 × 73 × 19.3 cm (26⁹⁄₁₆ × 28¾ × 7⅝ in.)
Colección Patricia Phelps de Cisneros
2002.4

González Bogen, Carlos
Homenaje a Malevitch [Homage to Malevich],
1953
Lacquer on Masonite
81.5 × 81.5 cm (32¹⁄₁₆ × 32¹⁄₁₆ in.)
Colección Patricia Phelps de Cisneros
1999.70

Gurvich, José
Untitled, n.d.
Recto: pen, ink, and watercolor wash; verso:
charcoal, graphite, and watercolor
Sheet: 16.4 × 22.2 cm (6⁷⁄₁₆ × 8¾ in.)
Image: 12.7 × 17.8 cm (5 × 7 in.)
Blanton Museum of Art, gift of Mrs. Julia A.
de Gurvich, 1995
1995.68

Hlito, Alfredo
Ritmos cromáticos II [Chromatic Rhythms II],
1947
Oil on canvas
70 × 70 × 2 cm (27⁹⁄₁₆ × 27⁹⁄₁₆ × ¹³⁄₁₆ in.)
Colección Patricia Phelps de Cisneros
1998.39

Hlito, Alfredo
*Curvas y series rectas [Curves and Straight
Series],* 1948
Oil on canvas
70 × 70.5 cm (27⁹⁄₁₆ × 27¾ in.)
Colección Patricia Phelps de Cisneros
1997.53

Hlito, Alfredo
Ritmos cromáticos III [Chromatic Rhythms III],
1949
Oil on canvas
100 × 100 cm (39⅜ × 39⅜ in.)
Colección Patricia Phelps de Cisneros
1997.67

Hlito, Alfredo
Development of a Theme, 1952
Oil on canvas
60.3 × 70.2 cm (23¾ × 27⅝ in.)
Colección Patricia Phelps de Cisneros
1997.100

Hlito, Alfredo
Estructura lineal [Linear Structure], 1952
Oil on canvas
100 × 70 cm (39⅜ × 27⁹⁄₁₆ in.)
Colección Patricia Phelps de Cisneros
1998.17

Iommi, Enio
*Continuidad interrumpida [Interrupted
Continuity],* 1946
Steel and marble
54.3 × 28.9 × 25.7 cm (21⅜ × 11⅜ × 10⅛ in.)
Colección Patricia Phelps de Cisneros
1996.89/2

Kosice, Gyula
*Escultura móvil articulada [Mobile Articulated
Sculpture],* 1948
Brass
165.1 × 30.5 × 1.3 cm (65 × 12 × ½ in.)
The Museum of Modern Art, New York,
fractional and promised gift of Patricia
Phelps de Cisneros in honor of Jay Levenson
321.2004

Lauand, Judith
Concrete 37, 1956
Synthetic paint on wood
30.5 × 30.5 cm (12 × 12 in.)
Colección Patricia Phelps de Cisneros
1996.38

Lauand, Judith
Pintura [Painting], 1956
Synthetic lacquer on wood
30.4 × 30.4 cm (11¹⁵⁄₁₆ × 11¹⁵⁄₁₆ in.)
Colección Patricia Phelps de Cisneros
1996.42

Lauand, Judith
Concreto 61 [Concrete 61], 1957
Synthetic paint on Eucatex panel
60 × 60 cm (23⅝ × 23⅝ in.)
Colección Patricia Phelps de Cisneros
1996.37

Lauand, Judith
*Quatro grupos de elementos [Four Groups
of Elements],* 1959
Gouache on cardboard
59.8 × 59.9 × 0.5 cm (23⁹⁄₁₆ × 23⁹⁄₁₆ × ³⁄₁₆ in.)
Colección Patricia Phelps de Cisneros
1996.7

Lozza, Raúl
Relief, 1945
Casein on wood and painted metal
40.6 × 53.3 × 3.8 cm (16 × 21 × 1½ in.)
Colección Patricia Phelps de Cisneros
1998.52

Lozza, Raúl
Invención n.º 150 [Invention No. 150], 1948
Enamel on wood
94.0 × 111.1 × 3.5 cm (37 × 43¾ × 1⅜ in.)
Colección Patricia Phelps de Cisneros
1998.4

Maldonado, Tómas
Desarrollo del triángulo [Development of the Triangle], 1951
Oil on canvas
80.6 × 60.3 cm (31¾ × 23¾ in.)
Colección Patricia Phelps de Cisneros
1998.6

Maldonado, Tómas
Composición 208 [Composition 208], 1951
Oil on canvas
50.2 × 50.2 cm (19¾ × 19¾ in.)
Colección Patricia Phelps de Cisneros
1998.9

Maldonado, Tómas
Desarrollo de 14 temas [Development of 14 Themes], 1951–1952
Oil on canvas
201.5 × 211.5 × 2.5 cm (79⁵⁄₁₆ × 83¼ × 1 in.)
Colección Patricia Phelps de Cisneros
1998.46

Maldonado, Tómas
Tres zonas y dos circulares [Three Zones and Two Circulars], 1953
Oil on canvas
100 × 100 × 2.5 cm (39⅜ × 39⅜ × 1 in.)
Colección Patricia Phelps de Cisneros
1997.68

Maldonado, Tómas
Composición [Composition], c. 1959
Oil on canvas
101.6 × 71.1 cm (40 × 28 in.)
Colección Patricia Phelps de Cisneros
1998.37

Manaure, Mateo
El negro es un color [Black Is a Color], 1954
Lacquer and industrial paint on hardboard
76.5 × 51 × 3.4 cm (30⅛ × 20¹⁄₁₆ × 1⁵⁄₁₆ in.)
Colección Patricia Phelps de Cisneros
1996.29

Melé, Juan
Marco recortado n.º 2 [Irregular Frame No. 2], 1946
Oil on Masonite
71 × 46 × 2.5 cm (27¹⁵⁄₁₆ × 18⅛ × 1 in.)
Colección Patricia Phelps de Cisneros
1997.102

Melé, Juan
Coplanal [Coplanar], 1947
Painted wood panel mounted on acrylic
87.9 × 109.9 × 2.9 cm (34⅝ × 43¼ × 1⅛ in.)
Colección Patricia Phelps de Cisneros
1998.53

Melé, Juan
Planos concretos n.º 35 [Concrete Planes No. 35], 1948
Oil on Masonite
65.1 × 45.1 cm (25⅝ × 17¾ in.)
Colección Patricia Phelps de Cisneros
1994.1

Molenberg, Alberto
Composición [Composition], 1946
Painted wood mounted on acrylic
99.7 × 69.9 × 3.2 cm (39¼ × 27½ × 1¼ in.)
Colección Patricia Phelps de Cisneros
1998.82

Nuñez, Rubén
Arítmico articulado [Articulated Arhythmic], 1955
Acrylic and oil on Masonite
27.7 × 77 cm (10⅞ × 30⁵⁄₁₆ in.)
Colección Patricia Phelps de Cisneros
1998.44

Oiticica, Hélio
Untitled, from the series Grupo Frente [Frente Group], 1955
Gouache on paper
40 × 40 cm (15¾ × 15¾ in.)
Colección Patricia Phelps de Cisneros
2001.92

Oiticica, Hélio
Metaesquema [Metascheme], 1956
Gouache and ink on cardboard
39 × 43 cm (15⅜ × 16¹⁵⁄₁₆ in.)
Colección Patricia Phelps de Cisneros
1998.109

Oiticica, Hélio
Metaesquema [Metascheme], 1957
Gouache on cardboard
32 × 38.5 cm (12⅝ × 15³⁄₁₆ in.)
Colección Patricia Phelps de Cisneros
1996.123

Oiticica, Hélio
Grupo Frente [Frente Group], 1957
Enamel on wood
39.7 × 39.6 cm (15⅝ × 15⁹⁄₁₆ in.)
Colección Patricia Phelps de Cisneros
1997.82/1

Oiticica, Hélio
Metaesquema [Metascheme], 1957
Gouache and ink on paper
45 × 53.5 cm (17¹¹⁄₁₆ × 21¹⁄₁₆ in.)
Colección Patricia Phelps de Cisneros
1998.107

Oiticica, Hélio
Metaesquema [Metascheme], 1957
Ink on cardboard
42 × 49 cm (16⁹⁄₁₆ × 19⁵⁄₁₆ in.)
Colección Patricia Phelps de Cisneros
1998.108

Oiticica, Hélio
Pintura 9 [Painting 9], 1959
Oil on canvas
116.2 × 89.2 cm (45¾ × 35⅛ in.)
Colección Patricia Phelps de Cisneros
1996.44

Oiticica, Hélio
Relevo espacial [Spatial Relief], 1959/1991
Industrial paint on particleboard
104 × 114.5 × 13.5 cm (40¹⁵⁄₁₆ × 45¹⁵⁄₁₆ × 5⁵⁄₁₆ in.)
Colección Patricia Phelps de Cisneros
1996.76

Oiticica, Hélio
Relevo espacial [Spatial Relief], 1959/1991
Industrial paint on particleboard
123 × 137 × 10 cm (48⁷⁄₁₆ × 53¹⁵⁄₁₆ × 3¹⁵⁄₁₆ in.)
Colección Patricia Phelps de Cisneros
1996.77

Oiticica, Hélio
Relevo neoconcreto [Neoconcrete Relief], 1960
Oil on wood
96 × 130 cm (37⅞ × 51¼ in.)
The Museum of Modern Art, New York, fractional and promised gift of Patricia Phelps de Cisneros in honor of Gary Garrels
325.2004

Oiticica, Hélio
Parangolé P16 capa 12. Da adversidade vivemos [Parangolé P16 Cape 12. We Live from Adversity], 1965/1992
Yute, fabric, various plastics, burlap, and sawdust, suspended from wooden beam
127 × 75 × 22 cm (50 × 29½ × 8¹¹⁄₁₆ in.)
Colección Patricia Phelps de Cisneros
1996.208

Otero, Alejandro
Cafetera azul [Blue Coffeepot], 1947
Oil on canvas
65.1 × 54 cm (25⅝ × 21¼ in.)
Colección Patricia Phelps de Cisneros
1998.23

Otero, Alejandro
Líneas coloreadas sobre fondo blanco [Colored Lines on White Ground], 1950
Oil on canvas
130 × 97 cm (51³⁄₁₆ × 38³⁄₁₆ in.)
Colección Patricia Phelps de Cisneros
1990.22

Otero, Alejandro
Líneas coloreadas sobre fondo blanco II [Colored Lines on White Ground II], 1951
Oil on canvas
81 × 81 × 2 cm (31⅞ × 31⅞ × ¹³⁄₁₆ in.)
Colección Patricia Phelps de Cisneros
1989.10

Otero, Alejandro
Estudio 1 [Study 1], 1952
Gouache on paper
19.5 × 25 cm (7¹¹⁄₁₆ × 9¹³⁄₁₆ in.)
Colección Patricia Phelps de Cisneros
1990.94

Otero, Alejandro
Estudio 2 [Study 2], 1952
Gouache on paper
19.5 × 25 cm (7¹¹⁄₁₆ × 9¹³⁄₁₆ in.)
Colección Patricia Phelps de Cisneros
1990.95

Otero, Alejandro
Estudio 3 [Study 3], 1952
Gouache on paper
19.5 × 25 cm (7¹¹⁄₁₆ × 9¹³⁄₁₆ in.)
Colección Patricia Phelps de Cisneros
1990.96

Otero, Alejandro
Estudio 4 [Study 4], 1952
Gouache on paper
19.5 × 25 cm (7¹¹⁄₁₆ × 9¹³⁄₁₆ in.)
Colección Patricia Phelps de Cisneros
1990.92

Otero, Alejandro
Estudio 5 [Study 5], 1952
Gouache on paper
19.5 × 25 cm (7¹¹⁄₁₆ × 9¹³⁄₁₆ in.)
Colección Patricia Phelps de Cisneros
1990.93

Otero, Alejandro
Tablón de Pampatar [Pampatar Board], 1954
Lacquer on wood
320.5 × 65 × 2.5 cm (126³⁄₁₆ × 25⁹⁄₁₆ × 1 in.)
Colección Patricia Phelps de Cisneros
1990.58

Otero, Alejandro
Coloritmo 38 [Colorhythm 38], 1958
Lacquer on wood
197.6 × 57.5 × 3 cm (77¹³⁄₁₆ × 22⅝ × 1³⁄₁₆ in.)
Colección Patricia Phelps de Cisneros
1989.26

Otero, Alejandro
Sin título [Untitled], 1959
Tempera on cut paper
22.5 × 8.9 cm (8⅞ × 3½ in.)
Colección Patricia Phelps de Cisneros
1998.120

Otero, Alejandro
Coloritmo 62 [Colorhythm 62], 1960
Lacquer on wood
200 × 54.3 × 2.5 cm (78¾ × 21⅜ × 1 in.)
Colección Patricia Phelps de Cisneros
1989.27

Pape, Lygia
Livro da Criação [Book of Creation], 1959
Gouache on cardboard
Each leaf 30.5 × 30.5 cm (12 × 12 in.)
The Museum of Modern Art, New York;
fractional and promised gift of Patricia
Phelps de Cisneros
1349.2001.a–r

Pape, Lygia
Sem título [Untitled], from the series Tecelares
[Weavings], 1959
Woodblock print on paper
49.5 × 49.5 cm (19½ × 19½ in.)
Colección Patricia Phelps de Cisneros
1998.146

Pape, Lygia
Sem título [Untitled], from the series Tecelares
[Weavings], 1960
Woodblock print mounted on cardboard
mounted on wood
23.4 × 23.6 cm (9³⁄₁₆ × 9⁵⁄₁₆ in.)
Colección Patricia Phelps de Cisneros
1993.44

Pape, Lygia
Sem título [Untitled], from the series Tecelares
[Weavings], 1960
Woodblock print on paper
21.9 × 27.7 cm (8⅝ × 10⅞ in.)
Colección Patricia Phelps de Cisneros
1993.45

Rothfuss, Rhod
Sin título (Arlequín) [Untitled (Harlequin)], 1944
Oil on canvas
176 × 86.5 × 2.5 cm (69⁵⁄₁₆ × 34¹⁄₁₆ × 1 in.)
Colección Patricia Phelps de Cisneros
1998.38

Sacilotto, Luiz
Concreção 58 [Concretion 58], 1958
Enamel on metal and wood
20 × 60 × 30.5 cm (7⅞ × 23⅝ × 12 in.)
Colección Patricia Phelps de Cisneros
1997.131/3

Schendel, Mira
Sem título [Untitled], 1964
Monoprint
47 × 23 cm (18½ × 9¹⁄₁₆ in.)
Colección Patricia Phelps de Cisneros
1998.96

Schendel, Mira
Sem título [Untitled], 1964
Monoprint
47 × 23 cm (18½ × 9¹⁄₁₆ in.)
Colección Patricia Phelps de Cisneros
1998.97

Schendel, Mira
Sem título [Untitled], 1964
Oil tempera on wood
146 × 114 cm (57½ × 44⅞ in.)
Colección Patricia Phelps de Cisneros
2005.53

Schendel, Mira
Sem título [Untitled], 1965
Monoprint
47 × 23 cm (18½ × 9¹⁄₁₆ in.)
Colección Patricia Phelps de Cisneros
1998.99

Schendel, Mira
Sem título [Untitled], 1965
Monoprint
47 × 23 cm (18½ × 9¹⁄₁₆ in.)
Colección Patricia Phelps de Cisneros
1998.100

Schendel, Mira
Sem título [Untitled], 1965
Monoprint
47 × 23 cm (18½ × 9¹⁄₁₆ in.)
Colección Patricia Phelps de Cisneros
1998.101

Schendel, Mira
Sem título [Untitled], 1965–1967
Ink on paper
47.4 × 65.5 cm (18¹¹⁄₁₆ × 25¹³⁄₁₆ in.)
Colección Patricia Phelps de Cisneros
1998.103

Schendel, Mira
Sem título [Untitled], 1965–1967
Ink on paper
47.5 × 65.5 cm (18¹¹⁄₁₆ × 25¹³⁄₁₆ in.)
Colección Patricia Phelps de Cisneros
1998.104

Schendel, Mira
Droguinha [Little Nothing], 1966
Woven rice paper bags
66.6 × 26 × 15 cm (26¼ × 10¼ × 6³⁄₁₆ in.)
Colección Patricia Phelps de Cisneros
1997.163

Schendel, Mira
Sem título [Untitled], n.d.
Monoprint
47 × 23 cm (18½ × 9¹⁄₁₆ in.)
Colección Patricia Phelps de Cisneros
1998.102

Schendel, Mira
Perfurados I [Perforated I], n.d.
Perforated paper
48.7 × 48.7 cm (19³⁄₁₆ × 19³⁄₁₆ in.)
Colección Patricia Phelps de Cisneros
2004.10

Serpa, Ivan
Sem título [Untitled], 1954
Oil on canvas
116.5 × 89.5 × 1.9 cm (45⅞ × 35¼ × ¾ in.)
Colección Patricia Phelps de Cisneros
1996.24

Soto, Jesús Rafael
*Proyecto maqueta para mural UCV [Project
Sketch for the UCV Mural],* 1952–1953
Mixed media on wood
28 × 50 × 4 cm (11 × 19¹¹⁄₁₆ × 1⁹⁄₁₆ in.)
Colección Patricia Phelps de Cisneros
2003.2

Soto, Jesús Rafael
*Desplazamiento de un elemento luminoso
[Displacement of a Luminous Element],* 1954
Plexiglas and tempera on wood
49.8 × 80 × 3.2 cm (19⅝ × 31½ × 1¼ in.)
Colección Patricia Phelps de Cisneros
1989.36

Soto, Jesús Rafael
Doble transparencia [Double Transparency],
1956
Industrial paint on Plexiglas mounted on wood
55 × 55 × 32 cm (21⅝ × 21⅝ × 12⅝ in.)
Colección Patricia Phelps de Cisneros
1989.35/3

Soto, Jesús Rafael
Pre-Penetrable, 1957
Industrial paint on steel structure
165.5 × 126 × 85 cm (65³⁄₁₆ × 49⅝ × 33⁷⁄₁₆ in.)
Colección Patricia Phelps de Cisneros
1997.118

Soto, Jesús Rafael
Pre-Penetrable, 1957
Steel
165 × 64.5 × 44 cm (64¹⁵⁄₁₆ × 25⅜ × 17⁵⁄₁₆ in.)
Colección Patricia Phelps de Cisneros
1991.61

Soto, Jesús Rafael
Sin título [Untitled], 1958
Iron on wood
100 × 100 × 38 cm (39⅜ × 14¹⁵⁄₁₆ in.)
Colección Patricia Phelps de Cisneros
1999.71

Soto, Jesús Rafael
Sin título [Untitled], 1959
Wire, industrial paint on sheetrock and wood
59 × 185 × 20 cm (23¼ × 72¹³⁄₁₆ × 7⅞ in.)
Colección Patricia Phelps de Cisneros
2001.17

Soto, Jesús Rafael
Tronco [Trunk], 1960
Painted wood and wire
56 × 24 × 11 cm (22¹⁄₁₆ × 9⁷⁄₁₆ × 4⁵⁄₁₆ in.)
Colección Patricia Phelps de Cisneros
1988.30

Soto, Jesús Rafael
Vibración [Vibration], 1960
Oil and wire on wood
99.7 × 99.7 × 4.3 cm (39¼ × 39¼ × 1¹¹⁄₁₆ in.)
Colección Patricia Phelps de Cisneros
1994.41

Soto, Jesús Rafael
Leño [Log], 1961
Iron and wire on wood
75 × 25 × 16 cm (29½ × 9¹³⁄₁₆ × 6⁵⁄₁₆ in.)
Colección Patricia Phelps de Cisneros
1991.60

Soto, Jesús Rafael
Hommage à Yves Klein [Homage to Yves Klein],
1961
Steel wires, metal, and industrial paint on
sheetrock
55 × 96 × 4 cm (21⅝ × 37¹³⁄₁₆ × 1⁹⁄₁₆ in.)
Colección Patricia Phelps de Cisneros
1995.21

Soto, Jesús Rafael
Vibración—Escritura Neumann [Vibration—
Neumann Writing], 1964
Wire, industrial paint, and nylon on sheetrock
and wood
102 × 172.5 × 16 cm (40³⁄₁₆ × 67¹⁵⁄₁₆ × 6⁵⁄₁₆ in.)
Colección Patricia Phelps de Cisneros
2001.16

Soto, Jesús Rafael
Baguettes rouges et noires [Red and Black
Rods], 1964
Industrial paint, metal, and nylon on wood
57 × 172.5 × 16 cm (22⁷⁄₁₆ × 67¹⁵⁄₁₆ × 6⁵⁄₁₆ in.)
Colección Patricia Phelps de Cisneros
1991.62

Soto, Jesús Rafael
Penetrable, 1990
Steel, aluminum, and plastic hoses
508 × 508 × 508 cm (200 × 200 × 200 in.)
Colección Patricia Phelps de Cisneros
1998.84

Soto, Jesús Rafael
Cubo de nylon [Nylon Cube], 1990
Painted nylon
276.5 × 120.5 × 120.5 cm (109¹⁄₁₆ × 47⅝ × 47⁷⁄₁₆ in.)
Colección Patricia Phelps de Cisneros
1990.63

Soto, Jesús Rafael
Cubo n.° 6 [Cube No. 6], 1996
Industrial paint printed onto acrylic
60 × 60 × 60 cm (23⅝ × 23⅝ × 23⅝ in.)
Colección Patricia Phelps de Cisneros
1997.152

Torres-García, Joaquín
Sin título [Untitled], 1928
Oil on canvas
100.3 × 83.5 × 2 cm (39½ × 32⅞ × ¹³⁄₁₆ in.)
Colección Patricia Phelps de Cisneros
1997.29

Torres-García, Joaquín
Peinture constructif [Constructive Painting],
1931
Oil on canvas
74.9 × 55.2 cm (29½ × 21¾ in.)
Colección Patricia Phelps de Cisneros
1997.32

Torres-García, Joaquín
Gare [Station], 1932
Oil on canvas
65 × 54 × 1.5 cm (25⁹⁄₁₆ × 21¼ × ⁹⁄₁₆ in.)
Colección Patricia Phelps de Cisneros
1982.2

Torres-García, Joaquín
Constructivo con una maderita superpuesta
[Constructive with Small Piece of Wood
Superimposed], 1932
Oil on wood
44.5 × 26 × 3.8 cm (17½ × 10¼ × 1½ in.)
Colección Patricia Phelps de Cisneros
1996.88

Torres-García, Joaquín
Composición [Composition], 1933
Ink over pencil on paper
18.1 × 11.1 cm (7⅛ × 4⅜ in.)
Blanton Museum of Art, gift of John and Barbara
Duncan, 1971
G1971.3.50

Torres-García, Joaquín
Locomotora con casa constructiva [Locomotive
with Constructive House], 1934
Oil on canvas
72.8 × 59.3 cm (28¹¹⁄₁₆ × 23⅜ in.)
Colección Patricia Phelps de Cisneros
1980.1

Torres-García, Joaquín
Untitled, c. 1938
Ink with pencil on paper mounted on heavy
paper
22.1 × 16.7 cm (8¹¹⁄₁₆ × 6⁹⁄₁₆ in.)
Blanton Museum of Art, gift of Charmion von
Wiegand, 1969
G1969.2.2

Torres-García, Joaquín
Pintura constructiva [Constructive Painting],
1942
Oil on canvas
79 × 47.5 cm (31⅛ × 18¹¹⁄₁₆ in.)
Colección Patricia Phelps de Cisneros
1983.7

Torres-García, Joaquín
Composición constructiva 16 [Constructive
Composition 16], 1943
Oil on cardboard
43.2 × 64.5 × 0.3 cm (17 × 25⅜ × ⅛ in.)
Colección Patricia Phelps de Cisneros
1997.33

Vardánega, Gregorio
Composición [Composition], c. 1948
Oil on canvas
82.5 × 63 cm (32½ × 24¹³⁄₁₆ in.)
Colección Patricia Phelps de Cisneros
1997.93

Villalba, Virgilio
Sin título [Untitled], 1955
Oil on canvas
90.2 × 109.9 cm (35½ × 43¼ in.)
Colección Patricia Phelps de Cisneros
1998.3

Volpi, Alfredo
Composição concreta [Concrete Composition],
c. 1950
Gouache on canvas
58 × 116 × 2 cm (22¹³⁄₁₆ × 45¹¹⁄₁₆ × ¹³⁄₁₆ in.)
Colección Patricia Phelps de Cisneros
1997.60

Volpi, Alfredo
Composição concreta em preto/branco
[Concrete Composition in Black/White], 1957
Gouache on canvas
50.1 × 67 × 2 cm (19¾ × 26⅜ × ¹³⁄₁₆ in.)
Colección Patricia Phelps de Cisneros
1999.68

Weissmann, Franz
A torre [The Tower], 1957
Industrial paint on soldered and assembled iron
196.5 × 77 × 43 cm (77⅜ × 30⁵⁄₁₆ × 16¹⁵⁄₁₆ in.)
Colección Patricia Phelps de Cisneros
1997.132

Weissmann, Franz
Escultura neoconcreta [Neo-Concrete
Sculpture], 1958/1984
Painted and soldered iron
30 × 30 × 20 cm (11¹³⁄₁₆ × 11¹³⁄₁₆ × 7⅞ in.)
Colección Patricia Phelps de Cisneros
1996.66

Wladyslaw, Anatol
Abstrato [Abstract], 1950
Oil on canvas
60 × 73 × 2.5 cm (23⅝ × 28¾ × 1 in.)
Colección Patricia Phelps de Cisneros
1997.46

The following bibliography lists many of the writings that have been useful in the making of this book. It is by no means a complete record of all the works and sources consulted. Rather, it indicates the most significant literature available concerning geometric abstraction in Latin America and it is intended to assist researchers, writers, and the general reader seeking to further pursue the subjects addressed in this catalogue and exhibition.

General

Abstract Art from the Río de la Plata: Buenos Aires and Montevideo, 1933–1953. New York: The Americas Society, 2001.

Ades, Dawn, ed. *Art in Latin America: The Modern Era, 1820–1980.* New Haven, Conn.: Yale University Press, 1989.

Barnitz, Jacqueline. *Twentieth-Century Art of Latin America.* Austin: University of Texas Press, 2001.

Biller, Geraldine P., ed. *Latin American Women Artists, 1915–1995.* Milwaukee: Milwaukee Art Museum, 1995.

Bois, Yve-Alain, et al. *Geometric Abstraction: Latin American Art from the Patricia Phelps de Cisneros Collection/Abstracción Geométrica: Arte Latinoamericano en la Colección Patricia Phelps de Cisneros.* Cambridge, Mass.: Harvard University Art Museums; Caracas: Fundación Cisneros, 2001.

Brett, Guy. *Carnival of Perception: Selected Writings on Art.* London: Institute of International Visual Arts, 2004.

———. *Force Fields: Phases of the Kinetic.* Barcelona, Spain: Actar, 2000.

———. *Kinetic Art: The Language of Movement.* London: Studio Vista/Van Nostrand Reinhold, 1968.

Franco, Jean. *The Modern Culture of Latin America: Society and the Artist.* London: Pall Mall Press, 1967.

Geo-metrías: Abstracción geomética latinoamericana en la Colección Cisneros. Caracas: Fundación Cisneros, 2003.

Kalinovska, Milena, ed. *Beyond Preconceptions: The Sixties Experiment.* New York: Independent Curators International, 2000.

Martin, Susan, and Alma Ruiz, eds. *The Experimental Exercise of Freedom: Lygia Clark, Gego, Mathias Goeritz, Hélio Oiticica, Mira Schendel.* Los Angeles: Museum of Contemporary Art, 1999.

Pérez-Barreiro, Gabriel, ed. *Blanton Museum of Art, Latin American Collection.* Austin: Blanton Museum of Art, 2006.

Pontual, Roberto, ed. *América Latina Geometria Sensível.* Rio de Janeiro: Edições Jornal do Brasil/GBM, 1978.

Ramírez, Mari Carmen, and Héctor Olea, eds. *Inverted Utopias: Avant-Garde Art in Latin America.* New Haven, Conn.: Yale University Press in association with the Museum of Fine Arts, Houston, 2004.

Rasmussen, Waldo, Fatima Bercht, and Elizabeth Ferrer, eds. *Latin American Artists of the Twentieth Century.* New York: The Museum of Modern Art, 1993.

Schimmel, Paul, and Guy Brett, eds. *Out of Actions: Between Performance and the Object, 1949–1979.* Los Angeles: The Museum of Contemporary Art; New York: Thames and Hudson, 1998.

Traba, Marta. *Art of Latin America, 1900–1980.* Baltimore: John Hopkins University Press, 1994.

Zegher, M. Catherine de, ed. *Inside the Visible: An Elliptical Traverse of Twentieth-Century Art in, of, and from the Feminine.* Cambridge, Mass.: MIT Press, 1996.

Zelevanksy, Lynn, ed. *Beyond Geometry: Experiments in Form, 1940s–1970.* Cambridge, Mass.: MIT Press, 2004.

Montevideo

A Vanguarda no Uruguai: Barradas e Torres-García. Rio de Janeiro: Centro Cultural Banco do Brasil; São Paulo: Museu de Arte Moderna, 1996.

The Antagonistic Link: Joaquin Torres-García, Theo van Doesburg. Amsterdam: Institute of Contemporary Art, 1991.

Barran, J.P., G. Caetano, and T. Porzecanski, eds. *Historias de la vida privada en Uruguay.* 3 vols. Montevideo: Taurus, 1996.

Duncan, Barbara. *Joaquín Torres-García, 1874–1949: Chronology and Catalogue of the Family Collection.* Austin: Archer M. Huntington Art Gallery, The University of Texas at Austin, 1974.

Grid–Pattern–Sign: Joaquin Torres-García, Paris–Montevideo. 1924–1944. London: Arts Council of Great Britain, 1985.

Guignon, Emmanuel. *Joaquín Torres-García: Un mundo construido.* Madrid: Museo Colecciones ICO; Paris: Musee d'art moderne et contemporain/Hazan; Strasbourg: Musees de Strasbourg, 2002.

Los veinte: El proyecto uruguayo: Arte y diseño de un imaginario, 1916–1934. Montevideo: Museo Municipal de Bellas Artes Juan Manuel Blanes, 1999.

Payró, Julio. *Joaquín Torres-García, 1874–1949.* Buenos Aires: Editorial Codex, 1966.

Peluffo Linari, Gabriel. *Historia de la pintura uruguaya.* 2 vols. Montevideo: Ediciones de la Banda Oriental, 1986.

Pintura Uruguaya: Breve selección del período 1840–1980. Montevideo: Capital AFAP, 1999.

Ramírez, Mari Carmen, ed. *El Taller Torres-García: The School of the South and Its Legacy.* Austin: University of Texas Press, 1992.

Torres-García, Joaquín. *Historia de mi vida*. 1939. Reprint, Barcelona: Paidós, 1990.

——. *La ciudad sin nombre*. 1941. Reprint, Montevideo: Ministerio de Educación y Cultura, 1974.

——. *Universalismo constructivo: Contribución a la unificación del arte y la cultura de América*. 1944. Reprint (in 2 vols.), Madrid: Alianza, 1984.

Buenos Aires

Elliot, David, ed. *Art from Argentina, 1920–1994*. Oxford: Museum of Modern Art, 1994.

Giunta, Andrea. *Arte de posguerra. Jorge Romero Brest y la revista Ver y Estimar*. Buenos Aires: Paidós, 2005.

——. *Vanguardia, internacionalismo y política: Arte argentino en los años sesenta*. Buenos Aires: Paidós, 2001.

Kosice, Gyula. *Arte Madí*. Buenos Aires: Ediciones de Arte Gaglianone, 1982.

——. *Teoría sobre el arte y otros escritos*. Buenos Aires: Editorial Universitaria de Buenos Aires, 1986.

López Anaya, Jorge, et al. *Kosice: Obras 1944–1990*. Buenos Aires, Museo Nacional de Bellas Artes, 1991.

Maldonado, Tomás. *Escritos preulmianos*. Buenos Aires: Ediciones Infinito, 1997.

Melé, Juan. *La vanguardia del cuarenta en la Argentina: Memorias de un artista concreto*. Buenos Aires: Ediciones Cinco, 1999.

Pacheco, Marcelo, ed. *Arte abstracto argentino*. Buenos Aires: Fundacion Proa; Bergamo, Italy: Galleria D' Arte Moderna, 2002.

Perazzo, Nelly. *El Arte Concreto en la Argentina en la década del 40*. Buenos Aires: Ediciones de Arte Gaglianone, 1983.

——. *Vanguardias de la década del cuarenta*. Buenos Aires: Museo Sívori, 1980.

Siracusano, Gabriela. *Melé*. Buenos Aires: Fundación Mundo Nuevo, 2005.

Wechsler, Diana Beatriz, ed. *Desde la otra vereda: Momentos en el debate por un arte moderno en la Argentina, 1880–1960*. Buenos Aires: Ediciones del Jilguero, 1998.

Rio de Janeiro and São Paulo

Andrade, Oswald de. *Oswald de Andrade: Obra escogida*. Ed. Haroldo de Campos. Trans. Héctor Olea. Caracas: Biblioteca Ayacucho, 1981.

Amaral, Aracy. *Arte para quê? A preocupação social na arte brasileira, 1930–1970*. São Paulo: Nobel, 1984.

Amaral, Aracy, ed. *Arte Construtiva no Brasil: Coleção Adolpho Leirner/Constructive Art in Brazil: The Adolpho Leirner Collection*. São Paulo: Companhia Melhoramentos/Dórea Books and Art, 1998.

——. *Projeto construtivo brasileiro na arte (1950–1962)*. Rio de Janeiro: Museu de Arte Moderna do Rio de Janeiro; São Paulo: Secretaria da Cultura, Ciência e Tecnologia do Estado de São Paulo, Pinacoteca do Estado, 1977.

Bandeira, João. *Arte concreta paulista: Documentos*. São Paulo: Cosac & Naify/Centro Universitário Maria Antônia, 2002.

Bandeira, João, and Lenora de Barros. *Arte concreta paulista: Grupo Noigandres*. São Paulo: Cosac & Naify/Centro Universitário Maria Antônia, 2002.

Basualdo, Carlos, ed. *Tropicália: A Revolution in Brazilian Culture, 1967–1972*. Chicago: Museum of Contemporary Art; New York: Bronx Museum of the Arts; São Paulo: Gabinete Cultura, 2006.

Belluzzo, Ana Maria, ed. *Modernidade: Vanguardas artísticas na América Latina*. São Paulo: Memorial, Editora UNESP, 1990.

——. *Waldemar Cordeiro: Uma aventura da razão*. São Paulo: Museu de Arte Contemporânea de São Paulo, 1986.

Bois, Yve-Alain. "Nostalgia of the Body: Lygia Clark," *October* no. 69 (summer 1994): 85–109.

Brett, Guy. "Hélio Oiticica: Reverie and Revolt." *Art in America* 77 (January 1989): 110–21.

——. "Lygia Clark: In Search of the Body." *Art in America* 82 (July 1994): 56–63.

——. "The Proposal of Lygia Clark." In *Inside the Visible: An Elliptical Traverse of Twentieth-Century Art in, of, and from the Feminine*, ed. Catherine M. Zegher. Cambridge, Mass: MIT Press, 1996.

Brett, Guy, Catherine David, Chris Dercon, Luciano Figueiredo, and Lygia Pape, eds. *Hélio Oiticica*. Minneapolis, Minn.: Walker Art Center; Rotterdam: Witte de With Center for Contemporary Art, 1993.

Brito, Ronaldo. *Neoconcretismo: Vértice e ruptura do projeto construtivo brasileiro na arte*. 2nd ed. São Paulo: Cosac & Naify, 2002.

Cintrão, Rejane. *Grupo Ruptura: Revisitando a exposição inaugural*. São Paulo: Cosac & Naify/Centro Universitário Maria Antônia, 2002.

Clark, Lygia. *Cartas, 1964–1974*. Rio de Janeiro: Editora UFRJ, 1996.

Clark, Lygia, Ferreira Gullar, and Mario Pedrosa. *Lygia Clark*. Arte brasiliera contemporanea. Rio de Janeiro: FUNARTE, 1980.

Cocchiarale, Fernando, and Anna Bella Geiger, eds. *Abstracionismo, geométrico e informal: A vanguarda brasileira nos anos cinqüenta*. Rio de Janeiro: FUNARTE/Instituto Nacional de Artes Plásticas, 1987.

Geraldo de Barros. New York: The Americas Society, 2001.

Geraldo de Barros: A Precursor. São Paulo: Centro Cultural Banco do Brasil, 1996.

Gullar, Ferreira. "Arte neoconcreta: Uma contribuição brasileira." *Crítica de Arte* [Rio de Janeiro] no. 1 (December 1961/March 1962).

Hélio Oiticica, aspiro ao grande laberinto. Rio de Janeiro: Rocco, 1986.

Herkenhoff, Paulo. "The Hand and the Glove." In *Inverted Utopias: Avant-Garde Art in Latin America*, ed. Mari Carmen Ramírez and Héctor Olea. New Haven, Conn.: Yale University Press in association with the Museum of Fine Arts, Houston, 2004.

——. "Zero and Difference: Excavating a Conceptual Architecture." In *Beyond Preconceptions: The Sixties Experiment*, ed. Milena Kalinovska. New York: Independent Curators International, 2000.

Lygia Pape: Entrevista a Lúcia Carneiro e Ileana Pradilla. Rio de Janeiro: Nova Aguilar, 1998.

Lygia Pape: Gávea de tocaia. São Paulo: Cosac & Naify Edições, 2000.

Lygia Pape. New York: The Americas Society, 2001.

Mackenzie, Beatriz Eugenia. *Cuasi-corpus: Arte concreto y neoconcreto de Brasil: Una selección del acervo del Museo de Arte Moderna*

de São Paulo y la colección Adolpho Leirner. Mexico: Instituto Nacional de Bellas Artes/ Museo de Arte Contemporáneo Internacional Rufino Tamayo, 2003.

Mattar, Denise. *Lygia Pape: Intrinsecamente anarquista*. Rio de Janeiro: Relume Dumará, 2003.

Misselbeck, Reinhold. *Geraldo de Barros, 1923– 1998, Fotoformas*. New York: Prestel, 2004.

Naves, Rodrigo. *A forma difícil: Ensaios sobre arte brasileira*. São Paulo: Editora Ática, 1996.

Schendel, Mira, and Maria Eduarda Marques. *Mira Schendel, 1919–1988*. Espacos da arte brasileira. São Paulo: Cosac & Naify, 2001.

Stolarski, Andre. *Alexandre Wollner e a formação do design moderno no Brasil*. São Paulo: Cosac & Naify, 2005.

Sullivan, Edward J., ed. *Brazil: Body and Soul*. New York: Guggenheim Museum, 2001.

Zanini, Walter. *História geral da arte no Brasil*. Vols. 1 and 2. São Paulo: Instituto Walther Moreira Salles/Fundação Djalma Guimarães, 1983.

Paris

Art abstrait constructif international. Paris: Galerie Denis René, 1961.

El arte abstracto y la Galeria Denise René. Las Palmas de Gran Canaria: Centro Atlantico de Arte Moderno, 2001.

Bois, Yve-Alain. "Lygia Clark, Palais des Beaux Arts, Paris." *Artforum* 27 (January 1999): 116–17.

———. "Lygia : L'art hors des enceintes." *Réforme* [Paris], March 8, 1969.

———. "Some Latin Americans in Paris." In *Geometric Abstraction: Latin American Art from the Patricia Phelps de Cisneros Collection/ Abstracción geométrica: Arte Latinoamericano en la colección Patricia Phelps de Cisneros*. Cambridge, Mass.: Harvard University Art Museums; Caracas: Fundación Cisneros, 2001.

Clay, Jean. "Lygia Clark: Fusion généralisée." *Robho* [Paris] no. 4 (1968): 12–14.

———. *Soto, de l'art optique à l'art cinétique*. Paris: Galerie Denise René, 1967.

Cruz-Diez: Integrations a l'architecture; realisations et projets. Paris: Galerie Denise René, 1975.

Guilbaut, Serge. "1955: The Year the Gaulois Fought the Cowboy." In Susan Weiner, ed., *The French Fifties*. Yale French Studies no. 98. New Haven, Conn.: Yale University Press, 2000.

Lebel, Robert. *Premier bilan de l'art actuel, 1937– 1953*. Paris: Soleil Noir, 1953.

Lier, Van. *Vasarely (Victor Vasarely)*. Paris: Galerie Denise René, 1965.

Medalla, David. "Participe présent: L'arte de Lygia Clark." *Robho* [Paris] no. 4 (1968).

Millet, Catherine. *Conversations avec Denise René*. Paris: Adam Biro, 1991.

Paris 1937–Paris 1957: Créations en France. Paris: Centre Georges Pompidou, 1981.

Popper, Frank. *Art et mouvement—Art optique et cinétique*. Preface by Jean Cassou. Paris: Galerie Denise René; Tel-Aviv: Pavillon Helena Rubinstein, 1965.

Restany, Pierre. "Soto l'immateriale." *Corriere della Sera* [Milan], July 6, 1969.

Rolnik, Suely. "Lygia Clark et la production d'un état d'art." In *L'art au corps, 276.83*. Marseilles: Musée de Marseille; Paris: Réunion des Musées Nationaux, 1996.

Caracas

Alejandro Otero. Caracas: Museo de Arte Contemporáneo de Caracas, 1985.

Boulton, Alfredo. *Cruz-Diez*. Caracas: Ernesto Armitando, 1975.

———. *Historia de la pintura en Venezuela*. Caracas: Editorial Arte, 1968.

———. *Soto*. Caracas: Ernesto Armitando, 1973.

Calzadilla, Juan. *El arte en Venezuela*. Caracas: Círculo Musical, 1967.

———. *Movimientos y vanguardia en el arte contemporáneo en Venezuela*. Caracas: Litografia Tecnocolor, 1978.

Caracas Cenital: Colección Fundación para la Cultura Urbana. Caracas: Criteria Editorial, 2005.

Gasparini, Graziano, and Juan Pedro Posani. *Caracas a través de su arquitectura*. Caracas: Fundación Fina Gómez, 1969.

Gego (Gertrud Goldschmidt). *Sabiduras y otros textos de Gego/Sabiduras and Other Texts: Writings by Gego*. Eds. María Elena Huizi and Josefina Manrique. Houston: Museum of Fine Arts/International Center for the Arts of the Americas; and Caracas: Fundación Gego.

Guevara, Roberto. *Arte para una nueva escala*. Caracas: Maraven, 1978.

Guillent Pérez, J.R. *Venezuela y el hombre del siglo XX*. Caracas: Ediciones Reunión de Profesores, 1966.

Jiménez, Ariel. *Conversaciones con Jesús Soto/ Conversations with Jesús Soto*. Caracas: Fundación Cisneros, 2005.

———. *He vivido por los ojos: correspondencia Alejandro Otero/Alfredo Boulton, 1946–1974*. Caracas: Alberto Vollmer Foundation y Fundación Museo Alejandro Otero, 2000.

Moholy-Nagy, Sibyl. *Carlos Raúl Villanueva and the Architecture of Venezeula*. New York: Praeger Press, 1964.

Ossott, Hanni. *Gego*. Caracas: Museo de Arte Contemporáneo, 1977.

Pérez-Oramas, Luis. *Toward Twentieth-Century Venezuelan Art: Academicism and Imports*. Caracas: Fundación Cisneros, 2001.

Peruga, Iris, et al. *Gego: The Complete Works*. Caracas: Fundación Cisneros, 2004.

Ramírez, Mari Carmen, and Theresa Papanikolas, eds. *Questioning the Line: Gego in Context*. Houston: Museum of Fine Arts, International Center for the Arts of America, 2003.

Rodríguez, Bélgica. *La pintura abstracta en Venezuela, 1945–1965*. Caracas: Relaciones Publicas de Maraven, 1980.

Schara, Julio César. *Carlos Cruz Diez y el arte cinético*. Mexico City: Arte e Imagen, 2001.

Sierra, Eliseo. *Gego: Dibujos, grabados, tejeduras*. Caracas: Editorial Ex Libris, 1996.

Traba, Marta. *Gego*. Caracas: Museo de Arte Contemporáneo, 1977.

———. *Mirar en Caracas: Critica de arte*. Caracas: Monte Avila, 1974.

Villanueva, Carlos Raúl. *Caracas en tres tiempos*. Caracas: Ediciones de la Comisión de Asuntos Culturales del Cuatricentenario de Caracas, 1966.

Erin Aldana is a doctoral candidate in art history at The University of Texas at Austin. The subject of her dissertation is the artist group 3Nós3, who performed urban interventions in São Paulo from 1979–1982. In 2005, she received the College Art Association Professional Development Fellowship. She has taught art history at The University of Texas at Austin and at Southwestern University in Georgetown, Texas and has worked at both the Museum of Contemporary Art and the J. Paul Getty Museum in Los Angeles. She contributed essays to the *Blanton Museum of Art: Latin American Collection* and the *Blanton Museum of Art: American Art since 1900* catalogues.

Estrellita B. Brodsky is a doctoral candidate at the Institute of Fine Arts, New York University. Her dissertation is titled *Latin American Artists in Paris, 1950–1970: Soto, Le Parc and Clark*. In 1997, she co-organized the exhibition *Taíno: Pre-Columbian Art and Culture of the Caribbean* at El Museo del Barrio (New York) and co-edited the catalogue. Later she served as Chairperson of the museum's board of trustees. A Commissioner on the New York City Art Commission, she also serves on the Metropolitan Museum of Art's Multicultural Audience Development Committee, Tate Modern's Latin American Acquisitions Committee, Harvard's David Rockefeller Center for Latin American Studies Arts Advisory Committee, and the International Council of The Museum of Modern Art.

María Amalia García has a B.A. in art from the Universidad de Buenos Aires. She is a doctoral candidate at the "Julio E. Payró" Institute of the Faculty of Philosophy and Art at the Universidad de Buenos Aires, with a grant from the Consejo Nacional de Investigaciones Científicas y Técnicas (CONICET). Her field of study is Concrete Art in Argentina and Brazil. She was awarded the first prize for art historical writing *FIAAR* in 2003.

Courtney Gilbert is the Curator of Visual Arts at the Sun Valley Center for the Arts, Sun Valley, Idaho. Before taking her position at the Sun Valley Center, she worked at the Blanton Museum of Art, where she was the Cisneros Seminar Coordinator and Managing Editor for the *Blanton Museum of Art: Latin American Collection* catalogue. She has taught Latin American art at Columbia College, Chicago, and at Texas State University, San Marcos, Texas. She holds an M.A. and a Ph.D. in art history from the University of Chicago.

Serge Guilbaut is a professor in the Art History, Visual Art, and Theory Department at the University of British Columbia, Vancouver. He holds a Ph.D. in art history from the University of California at Los Angeles. His area of special interest is postwar American and French history, including the history of postwar Franco-American relations as they relate to art. Among his many publications is the academic best-seller *How New York Stole the Idea of Modern Art: Abstract Expressionism, Freedom and the Cold War* (1983), which has been translated into French, Spanish, German, and Polish.

Paulo Herkenhoff is a curator and writer based in Rio de Janeiro. He was director of the Museu de Belas Artes in Rio de Janeiro and Adjunct Curator at The Museum of Modern Art New York. He has held various positions as director and coordinator of art collections and institutions. Among these, he has served as Curator of the Fundação Eva Klabin Rapaport, Consultant to the Colección Patricia Phelps de Cisneros, Caracas and to Documenta 9, Kassel in 1991. From 1997 to 1999 he was Chief Curator of the XXIV Bienal in São Paulo.

Jodi Kovach is a doctoral candidate in the Art History Department at Washington University in St. Louis. She has a B.F.A. from Miami University and an M.A. in art history from Washington University. Her studies focus on international avant-gardes, particularly in contemporary Latin American art.

Aleca Le Blanc is a doctoral student at the University of Southern California, studying modern art with a focus on Latin America. She holds an M.A. in art history from Columbia University. During the summer of 2005, she conducted research in Rio de Janeiro with the assistance of a Getty Memorial Scholarship for Summer Research Abroad. She served as a Curatorial Assistant in the Modern and Contemporary Art Department at the Los Angeles County Museum of Art, where she worked on the exhibition *Beyond Geometry; Experiments in Form, 1940s–70s*. She regularly contributes to *Art Nexus*.

Alberto McKelligan received his B.A. in art history at The University of Texas at Austin in 2003, beginning his graduate studies there the same year. While earning his M.A. in art history, he served as a curatorial intern in the Latin American Department of the Blanton Museum of Art, contributing research and an essay to the *Blanton Museum of Art: Latin American Collection* catalogue. He is currently a doctoral student in Latin American art at The Graduate Center, City University of New York. His research interests include contemporary art and gender studies.

Adele Nelson is a curatorial assistant in the Painting and Sculpture Department at The Museum of Modern Art, New York and a doctoral candidate at the Institute of Fine Arts, New York University. Her dissertation, entitled "The São Paulo Biennial and Latin American Artistic Exchange, 1951–1969," is under the advisement of Robert Storr and Edward Sullivan. She has taught courses on modern and contemporary art of the Americas and Europe in the Fine Arts Department at New York University and has contributed several publications and conference papers on the history of Brazilian art.

Gabriel Pérez-Barreiro is Curator of Latin American Art at the Blanton Museum of Art. He was Director of Visual Arts at The Americas Society in New York, and Curator of the University of Essex Collection of Latin American Art. He holds a Ph.D. from the University of Essex in art history and theory.

Luis Pérez-Oramas is a writer, poet, and art historian. He received his Ph.D. at the Ecole des Hautes Etudes en Sciences Sociales, Paris in 1994 and has been a professor of art history at universities in France and in Caracas. He worked as a curator for the Colección Patricia Phelps de Cisneros, Caracas from 1995 to 2002 and now works as a consultant to that collection. Currently, he is Adjunct Curator in the Drawings Department of The Museum of Modern Art, New York. His distinguished publications are too numerous to list.

Ana Pozzi-Harris took up art history when she moved to the United States in 1993. She earned a B.A. in art history at the University of Delaware and obtained her M.A. from Queen's University at Kingston, Ontario. Currently, she is finishing her Ph.D. at The University of Texas at Austin, writing on Concrete and Madí art and its interaction with the political and cultural expressions of its local context.

Martha Sesín is a Ph.D. candidate in the Art History, Visual Art, and Theory Department at the University of British Columbia, Vancouver. Her dissertation considers the development and subsequent success of Kinetic and Optical art in postwar France. With a particular focus on Latin American artists, her work reexamines the contributing factors, social, political, and cultural, that made Paris their city of choice.

Gina McDaniel Tarver holds an M.A. in art history from the University of New Mexico and is a Ph.D. candidate in art history at The University of Texas at Austin. Her dissertation, titled "Isolated Iconoclasts and Ambitious Institutions: Early Conceptualism in Colombia and its Antecedents," grew out of research she conducted in Bogotá with the support of a Fulbright grant. She has taught art history at The University of Texas at Austin and Southwestern University in Georgetown, Texas and has worked on several Latin American art exhibitions at the Blanton Museum of Art and the Museum of Fine Arts, Houston.

Cecilia de Torres is internationally recognized as the leading authority on the work of Joaquín Torres-García and the artists associated with him. She is a regular consultant to Christie's, Sotheby's, and the major European and South American auction houses. She has curated and contributed to numerous museum exhibitions, including *El Taller Torres-García: The School of the South and Its Legacy*, which was held at the Blanton Museum of Art in 1992. She writes extensively on Torres-García and the artists of his workshop and is currently compiling Torres-García's catalogue raisonné.

Michael Wellen is a doctoral student in art history at The University of Texas at Austin. He specializes in modern Latin American art and has interned at El Museo del Barrio (New York), The Smithsonian National Museum of American History (Washington, D.C.), and the Blanton Museum of Art.

Edith Wolfe has a Ph.D. in art history from The University of Texas at Austin and an M.A. in Latin American studies from the University of California at Los Angeles. She completed her dissertation, "Melancholy Encounter: Lasar Segall and the Brazilian Avant-Garde (1924–1933)," in 2005. She was Co-curator of *Re-Aligning Vision: Alternative Currents in Latin American Drawing*, organized by the Blanton Museum of Art in 1996. She has taught art history and Latin American studies at Tulane University and is currently Assistant Director of Tulane's Stone Center for Latin American Studies.

Index